THE BEST OF
THE TIMES

THE BEST OF
THE TIMES

Words and images from the year 2000

Edited by Peter Stothard

TIMES BOOKS
London

First published in 2000 by
Times Books
HarperCollins*Publishers*
77-85 Fulham Palace Road
London W6 8JB

British Library Cataloguing in Publication Date:
A catalogue record for this book is available from the British
Library

Printed and bound in Great Britain by the Bath Press Ltd

ISBN 0 0071 0838 9

Contents

Introduction

THIS WAS THE YEAR when our war correspondent, Anthony Loyd, faced a night of Russian secret police interrogation to the sounds of Elvis Presley singing *Love Me Tender*. It was the year when our opera critic, Rodney Milnes, had a horrible evening at the London Coliseum with Handel's "stocking-and-suspender tarts", when TOPS stood for the Turfed Out Peers Society and we all hated the Millennium Dome.

Much of the best newspaper journalism – including most of the investigation and news reporting which won *The Times* the title of Newspaper of the Year – does not bear being reprinted between hard covers. Who wants to read again the "scoops" which once set the agenda but which now have settled into the messy first draft of history?

But this was also the year when our sports columnist, Simon Barnes, hymned history's best ever Olympics and the "spiralling" delights of French rugby, when Boy George told us how difficult it was to find a good boyfriend and Kate Muir produced her millennium baby amongst a brilliant fanfare of words on suburban life in the capital of the free world.

Our Washingtonian baby was perhaps the most lasting good from a new year celebratory season whose fireworks quickly faded. *Times* editorials showed the Dome for the empty shell that it was. Tony Blair, as our cartoonist Peter Brookes made clear, was soon to wish that he had been elected at some less numcrological section of the century.

Sometimes a newspaper writer sets down a truth for all time: this year we might nominate Danny Baker's description of the "mind-altering cataract, the hideous glaucoma" that blinds English football fans into dreaming of triumph within minutes of the end of every disastrous defeat. But most of us are happy that what we write should still be true at Christmas – and, as those letter-writers who so entertained us in December on the subject of fir-tree labelling might have said, this book could also carry an "Ideal for Christmas" tag.

Newspaper anthologies are traditionally known as "bedside books", an especially suitable name this year since the Editor was struck down in March by dreaded lurgies and spent much of the year literally in bed. As a result both readers and writers should give special thanks to Hannah Betts and her researcher, Tom Dart, and to the book's picture editor, Jacqui Spray, for the chance to be given this book by their nearest or dearest. I hope that every one who gets it enjoys it.

Peter Stothard
Editor
The Times

THE TIMES

November
1999

Les Bleus make it an All Black day for Lomu

Simon Barnes savours a French triumph that ranks as one of the greatest upsets in sport

THERE ARE TWO things that keep us coming back to sport, two things that keep us hooked. And neither of them is excellence. No, there is something very deep in us that responds to something more profound than mere excellence. These two things are (1) sheer beauty and (2) the underdog victory. Yesterday, at Twickenham, we had both as France impossibly beat New Zealand 43-31.

Simon Barnes
..................................

France came into the semi-finals of the rugby World Cup as the lowest and least dogged of all possible underdogs. All that could be done after their undistinguished and, to tell the truth, decidedly lucky

progression to this stage of the tournament was to predict a New Zealand victory by a margin of 20 points and then, to cover yourself, add "but you can never write off the French".

This is one of rugby's abiding sayings and it covers a world of mistrust. "Gallic flair", people say, in much the same way as they might say "plutonium". We know that it is dangerous stuff, but we don't understand why;

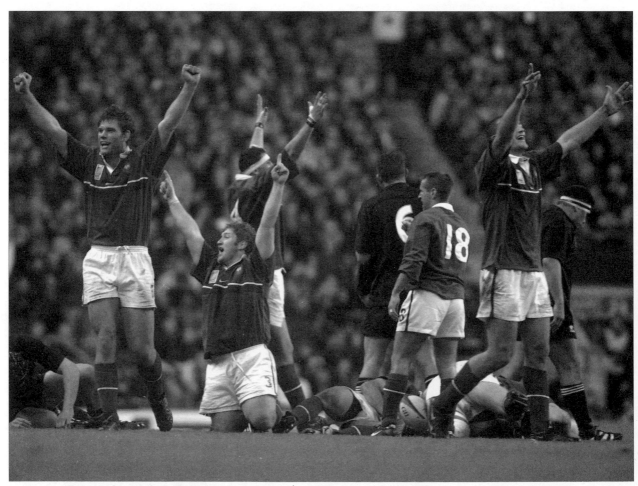

France players show their delight at the final whistle after their surprise victory over New Zealand

we know it can be handled safely, but we don't know how. Best way to deal with this amazing, volatile, untrustworthy stuff is to make sure you never get exposed to any.

Rex Bellamy, the former tennis correspondent of *The Times*, loves bad wine, bad shirts and good jazz. He used to divide tennis players into two varieties: those that need the sheet music and those that do not.

Yesterday was a victory for the jazzmen of sport, for the improvisers and spirallers. "Solos in soul have corners," Joey the Lips said angrily in the film *The Commitments*, to the saxophonist who was slipping jazz into Motown standards. "You were spiralling, brother."

And the French were spiralling yesterday, far beyond the reach of the score-reading New Zealanders. With the France rugby team, brilliance is a fickle ally, capriciously late in arriving, generally leaving the party just when it is needed most.

But yesterday, for once, brilliance arrived early and stayed on until the bitter end. France were brilliant as if brilliant was the only possible way to be, as if any other mode of existence were unthinkable. They played as if they had never known anything except brilliance, their recent past of fumbling mediocrity and confused gameplans a figment of somebody else's imagination.

I am trying to put this afternoon on a logical scale of great events I have seen. It is a hard job, like assessing one of one's better nights out while still drunk. But it was up there with much of the best, for its perfect combination of beauty and underdoggery. And what is more, Twickenham bayed its heart out for France. I don't think there can have been a single non-Kiwi soul who did not rejoice in the French victory. This was rum, because there were many Britons here, and, in case you hadn't noticed, there are some serious bad vibes between this country and France right now.

Typical of the French, isn't it? They have been sneering at British food for centuries and all the time they have been feeding their cattle on crepes. At least, I think that is what the row is all about. But life is life and sport is sport, and everyone with sporting blood in their veins had been hoping all along that France would give New Zealand – who had looked easily the best side in the tournament – a taste of French cattle feed.

And that, roughly, is what happened. I remember walking round the Victoria and Albert Museum with Jean-Pierre Rives, a former France rugby captain, while he was expatiating on the guiding principle of life: "Go for eet."

That seems to sum up the French game-plan yesterday. They decided that the only way they could defeat the organisation and rat-trap efficiency of the New Zealand defence was to go for eet. And, well, it really shouldn't have worked, because the New Zealanders are much too good, too experienced to get rattled, and so experienced on the counter-attack that they would make a reckless player pay heavily.

The French game-plan gave them nothing to fall back on but their own brilliance. And with nothing to declare but their genius, they created sporting mayhem and sporting joy.

Their basic tactic was beauty. Doubtless that was incidental to the France plans, but that was the way it worked. Ball-handling, pace, the wild, slaloming kick-and-chase: these are beautiful to watch.

It seemed that the game had touched beauty just once, when Dominici launched a demented run through the New Zealand defence to set up a Lamaison try. But trailing to a Lomu try at half-time, the French try looked like nothing more than a pleasant decoration to a routine sporting event. When Lomu gained his second try, it seemed all over.

But then the momentum changed, as

if the gods of sport had gone through a paradigm shift. Lamaison kicked the French back towards parity, and then Dominici scored again, chasing down Galthie's kick like Rikki-Tikki-Tavi in pursuit of a cobra.

It was here that the audacious thought of victory first uncurled itself in French minds, but it was a day when not even victory was frightening. Dourthe ran down a kick from Lamaison, which popped up in front of him like a frightened bird: Dourthe leapt on it like a hungry caracal.

The French even outdid their own hubris, refusing a kickable penalty and promptly surrendering possession. But sound rugby thinking was no sort of tactic on a day such as this. Instead, Bernat-Salles scored a fourth try.

The final will be a disappointment after this, but then so will most other games of rugby and, for that matter, most sporting events. It was a very rare one, this, and one to savour. It was a feast of – well, what is the exact opposite of what the French feed their cattle?

"AND HOW CONTAMINATED WOULD SIR LIKE HIS BEEF?"...

Farewell to the finest club in Europe

HEREDITARY PEERS might look mournfully on the prospect of losing their right to shape the laws of Britain, but some are even more unhappy at losing their membership of what Harold Macmillan called "the best club in Europe".

The House of Lords boasts some of the finest facilities on offer in London and makes many St James's clubs look rather tawdry in comparison. However, West End clubland is expecting a boost in membership numbers when 750 hereditary peers are turfed out into the street in search of new sanctuaries.

Some lords are members of various clubs near Westminster already, but many others will need a new hide-away, where they can find a comfortable chair, a warm fire and an ever-present waiter.

Anthony Lejeune, author of *The Gentleman's Clubs of London*, said that many peers hoping to join a club would face a long wait. "The waiting lists at White's is about five to seven years, two years at Brooks's, two years at Boodle's," he said. "They would certainly have to wait."

Peers in a hurry would have to apply instead to different clubs with less demanding membership rules. One Pall Mall club, the Oxford and Cambridge, is so keen for members that it has started advertising in the press.

Nevertheless, few clubs can match the facilities of the House of Lords. The bars are cheap and well stocked. The subsidised restaurants are open until late in the evening, with meals often costing less than £10 a head. The food, while not haute cuisine, is better than in most clubs. More importantly, they never run short of teacakes and crumpets.

In the gilded royal palace of Barry and Pugin, the walls are wood-panelled, the ceilings ornate and the lavatories marble and clean. The reception rooms are ideal for parties. The terrace is the most peaceful place to have a drink on a hot summer's evening while the rest of London sweats through the traffic. For many peers, of course, the most valued perk is free parking in the heart of the capital – and which other club would pay for your travel up to London and then pay you a £35.50 allowance for the day and a further £80.50 if you stay overnight? In return, all peers have to do is clock in.

Most of the older, more exclusive London clubs are poor in comparison. Many have small premises, complete with woodworm and faded grandeur. The more modern clubs, such as the Royal Automobile Club in Pall Mall, are different, catering for young professionals, not aged noblemen.

One alternative would be for peers to set up shop themselves and, not surprisingly, one has mooted the idea already. Lord Newall, a Tory, has proposed a club called Tops, an acronym for Turfed Out Peers Society.

James Landale

HAUNTS FOR A HOST OF LORDS

The House of Lords, Westminster

Membership: 1,200

Annual sub: None. Members have to work for their club rights.

Waiting list: Long – depends entirely on prime ministerial whim

Established: 1200s

Facilities: Subsidised restaurants and bars, best library and staff in London, riverside terrace, free parking, rifle range, gym. Allowances: £80.50 overnight; £35.50 daily; £34.50 for secretary; free travel between home and Parliament.

The Royal Automobile Club, Pall Mall

Membership: 14,000

Annual sub: £650

Waiting list: Months

Established: 1897

Facilities: Three restaurants, two bars, 71 bedrooms, four squash courts, a library, pool, smoking room, billiard room and Turkish baths. Plus a country club near Epsom with two courses.

Brooks's, St James's

Membership: 1,400

Annual sub: £750

Waiting list: Two years

Established: 1764

Facilities: Dining room, smoking room, library, card room, private rooms, 12 bedrooms. No parking. Very exclusive.

Peers toe party line as end of era nears

HEREDITARY PEERS are to mark the end of their families' 800-year occupation of the House of Lords with a frantic round of parties, group photos and even an unlikely tree planting.

With only two weeks left before they finally leave Parliament, peers have been filling their diaries with a series of events to commemorate the end of an era.

Regular attenders have arranged final drinks with old friends, especially life peers staying on, and dinner parties with fellow departees. Less well known hereditaries have also emerged to sit on the red benches one last time and attend the final debates on the House of Lords Bill.

Lord Londesborough last week attended Parliament for the first time since his father, the 8th Baron, died in 1968. Lord Catto, a leading banker and Tory peer, took the oath on Monday for the first time since his father died in 1959.

Baroness Arlington, 60, delivered her maiden speech on the dangers of speeding two weeks ago after recently winning a 25-year battle to inherit her title which had been in abeyance since 1936.

The most significant end-of-an-era party took place last week when hundreds of Tory peers – both life and hereditary – journeyed to Hatfield, the Hertfordshire family seat of their former leader, Viscount Cranborne.

Some peers refused to go because they could not bring themselves to attend a party before the Bill expelling them had actually become law. Some were also upset at Lord Cranborne's decision to back the Bill

The Earl of Lauderdale who formerly reported for *The Times*: he failed to be elected

in return for temporarily saving 92 hereditaries.

One peer said: "It could so easily have been a wake but it actually turned into a rather good party."

Some peers have agreed to pay for a new arboretum to be planted at Hatfield to commemorate their passing. They are also arranging a mass group photo to capture the moment the hereditary peerage left the British legislature.

The Liberal Democrats are holding a dinner for their 70-odd peers to celebrate the hereditaries' departure. But

Labour is refusing to do anything, keen to avoid accusations of insincere triumphalism.

The date of the final day when hereditary peers can attend the Lords is uncertain but they are expected to flood into the chamber for the final ceremony of prorogation, at which the last Bills are given Royal Assent in old Norman French.

The final party of all, an all-comers' drinks reception in the House of Lords, is expected to be held immediately after the prorogation ceremony.

James Landale

Ronnie Biggs and Bruce Reynolds

RONNIE BIGGS and Bruce Reynolds are planning to make a computer game devised around their finest moment, the Great Train Robbery. They are being aided and abetted by SCi Entertainment, a games company, and it will have them dodging the long arm of Superintendent Jack Slipper of the Yard. "It's a cops and robbers story, like Monopoly. Go directly to jail. Do not pass go. Do not collect £200," explains Reynolds.

Ian McEwan

IAN MCEWAN, upon receiving the prestigious German Shakespeare Prize at the country's embassy, rose to make his speech. "Hegel said that at the age of 50 no man should speak for longer than he can make love." He then sat down.

Mark Inglefield

PUGH

// THIS IS RIDICULOUS — ONE OF US SHOULD BE ABLE TO AFFORD SOMETHING ''

Held as a spy in the Chechen war

Anthony Loyd, the only Western reporter to witness Moscow's drive into Chechnya in the past week, tells of his three days imprisoned by the Russian military. A veteran reporter of the 1995-96 Chechen war, he returned last month, and was arrested on Thursday while trying to find his way back into the breakaway republic. Loyd was interrogated through the night by men in balaclavas, to the surreal accompaniment of Elvis Presley's *Love Me Tender*

Anthony Loyd

....................................

"HARRY" WAS my principal interrogator. I don't even know what his face looks like, for he was always masked in a black balaclava during questioning.

"Do you like Elvis?" he asked me suddenly during my first night of captivity.

"Uh, yeah," I responded dully, mind already fuddled by the barrage of questions I had received in the previous hours. He produced a tape recorder and pressed play. Star shells and flares illuminated the darkened Chechen plain around us, bathing the western battlefield in a weird purple glow, punctuated by shining trails of tracer fire and the flashes of field guns.

"Love me tender, love me true," the King crooned, as thunderous Russian artillery rocked the night.

"So Anthony," Harry began again, leaning forward, eyes staring out from

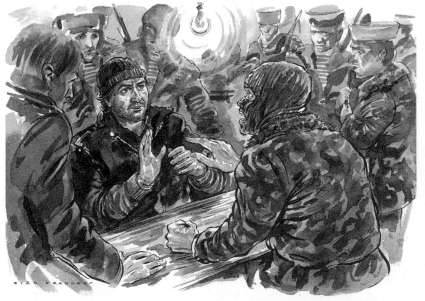

Anthony Loyd was questioned by a Russian intelligence officer whom he knew only as Harry and whose face was constantly hidden by a balaclava

the mask. "Let's go back to the beginning one more time..."

From the bowels of the Russian war machine, the view was as surreal as any I have had in my life.

Harry knows a lot about me now, but all I know of him is that he was aged 30, an officer in the KGB's successor, the FSB, and had learnt English in a "special school". Our first meeting was by a roadside in Chechnya, as I stood guarded by Russian troops while my clothing and belongings were being given an extremely professional search by a special police unit.

Russian forces had sealed the Chechen-Ingush border six days previously, before two brigades advanced slowly into the west of separatist Chechnya. I had been trapped by the move in Ingushetia, and was trying desperately to get back into Chechnya with a friend and colleague, a 30-year-old American photographer, Tyler Hicks.

Mulling our chances in a hotel in the Ingush capital, Nazran, we had got to know a very strange character. Mojumder Amin was a wealthy Bangladeshi, and representative of an Islamic organisation liaising with the Chechen leadership in an effort to reach a negotiated settlement to the war.

Among his documents was a fax from Vladimir Putin, the Russian Prime Minister, apparently granting him permission to enter Chechnya. Last Thursday, in the middle of the afternoon, Mr Amin announced that he was embarking for Grozny in a large Volga and asked if we would like to accompany him. We had ten minutes to make a decision.

"The plan sounds so crazed that it might just work," Tyler remarked, scratching his beard thoughtfully. So with this indisputable logic, we leapt into the Volga.

The plan, of course, failed dismally. Though we cruised through the first two Russian checkpoints, Mr Putin's fax doing its work, right on the border we bumped into a Russian brigadier.

In no time Mr Amin, his own docu-

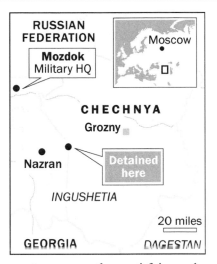

ments apparently satisfying the Russians, was sent packing back to Nazran, while Tyler and I were dragged off at speed over the border, and our time in custody began.

Harry could play both good and bad cop, sometimes being friendly; at others, if he noticed a discrepancy of detail in our accounts, cold and officious. He seemed to be able to recall tiny pieces of information from our answers and confront us with them if subsequently they contradicted anything else we said. He never worked alone, and was usually accompanied by another FSB officer as well as an armed escort.

Inevitably, we were presented with "the spy" scenario at first. "What is your rank and duty?" was the first question I was asked, as Harry leafed through my passport, itself stacked with visas from the world's shadier quarters: Afghanistan, Pakistan, Syria, Lebanon, and Yugoslavia to name but a few. Indeed, "Good morning spies", became one commander's ritual greeting to us.

My biggest concern was that the Russians would discover who my contact was inside Chechnya. I had managed to eat the page of my notebook with his name and telephone number on it before we were pulled out of the car.

In the seconds before we were separated, I murmured to Tyler that he should say that I alone had the details of who we were meeting, so that our stories would

not contradict each other. Harry never did get the man's real name.

Between interrogation sessions we were held in a field tent with a platoon of federation special forces, surrounded by artillery positions and firebases. These troops appeared genuinely amused by our company. We slept, as they did, on planks on the ground, huddled around a wood stove wrapped up in thick greatcoats, and ate their thin stew and bread three times a day.

"Good guns, shit food, not enough water," one of them told me of his army as he cleaned his PB silenced assault rifle, complete with Cobra laser telescopic sight, a piece of technology so efficient that it can kill a person with no more sound than a soft cough.

They were a tough, capable team, a balanced unit of specialists from all over Russia, including medics, snipers and communications experts, but few seemed to care one way or another for the war in Chechnya, in spite of the propaganda they were subjected to.

Their own officers, as well as Russian radio, informed them regularly that there were no civilians left in the capital, Grozny, and that all Chechens, apart from terrorists, wanted Russian troops to take over the state again so that they could live peacefully.

"I just do this for the money," one of them, Nicolai, told me as I struggled to understand the rules of a card game, appropriately named "Russian Fool". His wage of 1,500 roubles (£37.50) a month was considered a reasonable pay packet by Russian standards, though it barely kept his wife and six-month-old son, who lived in Moscow. He was aged 24 and had been in the army since he was 18, first as a paratrooper, then in two subsequent anti-terrorist special units.

"Russia is stuck halfway between the old communist system and capitalism," he explained, "so our economy is totally screwed up. It is not a question of wanting to be a soldier or not, it is a question of doing whatever you can to have enough money to get by."

Harry and the other officers I encoun-

tered knew exactly what they wanted out of the war. "We lost it last time," he said bluntly, "and this time we are going to win it."

That was the last time I saw Harry. He had hinted that we might be moved elsewhere, possibly to a jail, and asked if there was anything we wanted. I asked for some vodka and a ride to the frontline, but he just laughed and asked more questions.

On the third day of our detention, with the fighting moving deeper into Chechnya, a helicopter landed beside the position. Tyler and I wondered optimistically if it carried someone with enough authority to order our release. By that stage we thought it was possible that we could be sent to a prison for a while, but that it was unlikely.

Our greatest fear was born from an understanding that a vast, lumbering organisation had incarcerated us in a time and place of great confusion, and that we might just be stuck in limbo for weeks, sitting in a cell somewhere for no other reason than that no one had the clout to let us go.

The army was doing its thing, the Government something else; everybody wanted a slice of Chechnya for their own reasons and the fate of two foreigners was of no great importance. If there was a chain of command running back to Moscow, I never felt it.

No one disembarked from the helicopter but we were loaded on to it. Inside there was a death-charged teenager at the machine gun in the nose cone, dressed from head to toe in black with a leather flying cap and blue sunglasses; there were two pilots and three soldiers. The machine started up into the air, hovered briefly, then swooped away northwards.

Below us, scores of tank tracks crawled over a landscape pitted by shell explosions, while two villages burned furiously to the east. The helicopter's nose dipped as the machine gunner strafed targets below us, the chattering of his fire scarcely audible above the throb of the rotors. All in all it was quite a ride, and Tyler and I grinned happily away at each other, like boys, the way

men always smile in helicopters.

Our good humour soon ended. The helicopter dropped us in Mozdok, the main Russian base in the north Caucasus, a dull grey sprawl of malicious officialdom and Cold War shadows. New guards received us with hostility, bundling us into a car to a new interrogation centre. Separated from Tyler again, I found myself seated in front of a military intelligence colonel who was patting my passport from one hand to the other, sneering.

"Your passport has now disappeared," he said, sliding it into a drawer, his voice little more than a whisper. "Without it you have no identity. You do not exist. And that is what we can do to you if we wish – make you disappear."

It was not the most promising start, but after a couple of hours had passed we had got to the stage of drinking vodka toasts to the British Army, and his questioning technique was hopeless. His so-called "computer expert", called in to check my laptop files for the umpteenth time, was so inept he could barely turn the machine on. These guys were clowns compared with Harry and his boys. I felt quite insulted.

Tyler got the same treatment, and afterwards they seemed unsure of what to do with us. So in true Russian pass-the-buck style, at nightfall they handed us back to another FSB cell in Mozdok.

Lenin stared down from a wall in every room in the grimy, dust-laden building, which stank of decay, apathy and stagnation, a vestige of a half-dead system.

Bellies full of vodka but little else, we again went through our stories. It seemed that we were just being shunted from one group to another, getting interrogation after interrogation from a variety of security forces that never communicated with each other.

Six men were inside this building, a nightshift commanded by a youthful looking man named Sasha. They had grey, nondescript faces, and were among the most stupid people I have met.

The atmosphere was already tense as

Tyler and I, believing that serious diplomatic efforts were under way to secure our release, were getting more confident, as well as tired and angry. Rather than just answer the questions, we were starting to refuse to co-operate unless granted access to a phone to call our embassies and tell them of our whereabouts.

After one screaming match, they left us to sleep on the floor, then rushed in at 4am to question me again. I did end up answering them, as silence just added to the pervading sense of purposelessness and futility.

Next I was shut in Sasha's office, while in the next room I could hear Tyler getting the treatment again.

"You will answer my questions," Sasha's voice rose through the wall.

"I'm sick of your bullshit," Tyler yelled back.

Later in the morning a new FSB officer arrived, a more intelligent and sophisticated man. He escorted us to the central phone office where we were allowed to make a phone call. (We could not call from the FSB building, he told us, as it was a secret.)

I rang Giles Whittell at *The Times* bureau in Moscow. "Tell the embassy I'm being treated like a dog by the FSB in Mozdok," I complained loudly, "as well as beginning to act like one."

Unseen and unheard, after Giles's subsequent call to the British Embassy, the spirits of the diplomatic community's nether world of intelligence gatherers spoke: Russians, English, and American. I do not know who said what to whom, only that within 20 minutes of that call the FSB took us out to breakfast at a restaurant, and half an hour later got us a taxi back to Ingushetia.

Mr Amin was sitting in the hotel restaurant in Nazran as Tyler and I walked in. "Hello boys," he smiled widely, gold-embroidered skull cap twinkling. "I'm going back to the Chechen border again tomorrow with a new fax to try for Grozny. Do you want to come?"

I looked at him in disbelief, but the man was absolutely serious.

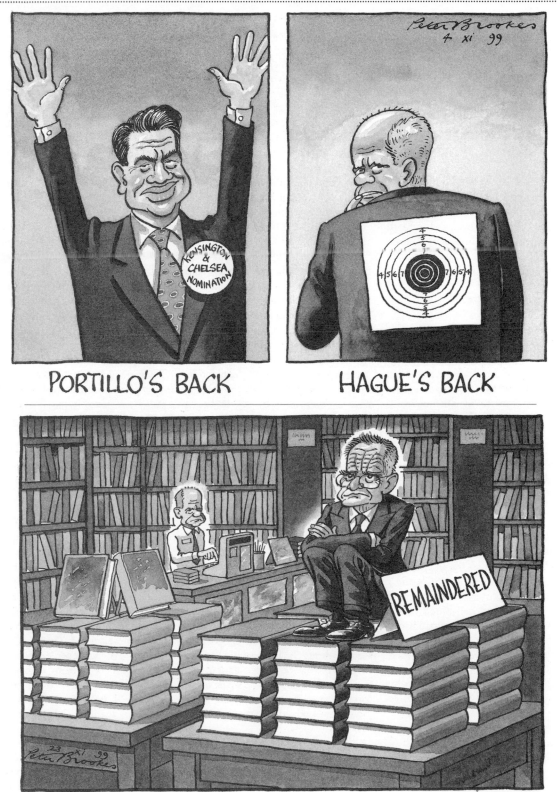

PORTILLO'S BACK　　　HAGUE'S BACK

After a proper Charlie, a real man

Is that a pitchfork in your pocket, or... oh, never mind.
It's obvious, isn't it? Monty Don. He rocks

Caitlin Moran

I AM ONE of a legion of mental gardeners absolutely swollen with knowledge on how to discourage carrot-fly, edge a lawn and pollard hazel, but resolutely unbowed in their determination not to bugger up nice shoes actually doing it. But the mental gardener, like the dirty physical gardener, must still have a firmly appointed leader.

So far, the line of succession has gone Thrower, Hamilton, Titchmarsh, Dimmock – we have sat and nodded at them all, as our suede uppers remained virgin in the hallway. We knew whom to casually defer to in pub conversations about our imaginary gardens ("Dimmock says palms are frost-hardy in urban areas"), sure in the knowledge that Dimmock was The Truth.

But we were wrong. On Sunday, our true leader made himself known, and we realised we had been following tinsel and dust. Although she gave us one of the best-ever slang phrases for bras – "Dimmock's Hammocks" – Charlie Dimmock is no longer the mental gardener's godhead. Face it – *Charlie's Garden Army* was awful, and a true god would never appear half-kitted in the *Daily Mail*. Dimmo is grimmo, Charlie is gnarly.

This is the first week in the First Century Of Don. *Fork To Fork* started on Sunday and we were all Donnists by Monday. Don. Monty, Monty Don. Say it twice, and it sounds like praying.

Don – The Don – is huge. Huge in every conceivable way. He dwarfs most of the fruit-trees he surgeons, his thighs are the length and width of an eight-year-old child, and his shoulders and

chest are like Brian Blessed's banqueting table. Even his name sounds like the Macedonian for "very big". "E deficieta l'budget est donn. E montie montie donn." He is the mythic "montidon", and his child, the mastodon. He is built for frontier-breaking – he could fence your acres, raise a roof and have smoke out of the chimney by sunrise. He could build an Ark in an hour.

He's fit. He carried an armful of 12ft branches down his garden path like he was passing round Matchmakers. He filled a raised bed with soil in the way we would spoon tinned fruit into a pie-case. Within ten minutes of the first episode of *Fork To Fork*, my husband was curled in the foetal position, whimpering, possessed half by fear, and half by the kind of crush very small boys have on very big boys. "If he saw me on his garden path, he'd stamp on me," he trembled, transfixed. "He is manhood."

The Don's been around for a while now: he used to pop up incongruously on the Richard and Judy show, blinking slowly in the studio lights like the animated Cyclops from the Sinbad films, possibly working out which of the crew to eat first in event of a disaster. As soon as he was "on", though, he changed in an instant: gesticulating and half-dancing his monologue on how we should never mow our lawns, and let them grow into hot wild organic meadows where animals can hang out. Judy stood awkwardly, unscrewing her wedding ring from her finger as if it were the top of a bottle of Jamesons. As Monty came to the end of his monologue, she nudged Richard, in a "Tell him!" way.

"You've got to have a lawn, Monty," Richard said confidently, angling to show the camera the line of his new suit. The Don stared at him as a bunch

of bears would at a very small boy called Leopold wearing a tutu.

But now the Don has his own show, and he does what he likes, the way he likes it. In the first episode, what he mainly liked doing was driving 34ft poles into the winter earth with a sledgehammer. He then took the 12ft-long branches and wove them into a fence as easily as a girl plaits her hair. "I won't have to do that again for another five years," he said, slightly disappointedly, before chopping down a tree with the circumference of a house in consolation.

Mind you, it is not just the raw power of a man who would clearly punch a stampeding buffalo in the face rather than go through the inconvenience of stepping aside that thrills the Donnists so. He is possibly the most enthusiastic man in the world – he makes Brilliant! from *The Fast Show* look like Sir Edward Heath doing an Eeyore impression in the rain. He's completely organic, free-range and self-sufficient, and proselytises lyrically ("I like my insecticides and aphid-killers the size of a woman's fingernail, red with black spots"). He even enjoys prepping up veg. "Some people think this is the boring bit," he said, holding 20 parsnips in one hand and ripping their tops off with the other, "But I LOVE converting vegetables from a CROP to an INGREDIENT! I think it's FANTASTIC!" He can do everything. There isn't a useless bit on him. Not even eyebrows, almost entirely absent from the manly Don visage. Presumably they slowed him down. "I need to wash my parsnips before the SUGARS CONVERT BACK TO STARCH! This useless eye-hair MUST GO!"

And then there's the sex. He's obviously awesomely, birthdayish, traction-engine hot in bed. Any man who

can serve his wife a plate of boiled potatoes for tea and nothing else, as he did in the first episode, is obviously pretty confident she isn't going to consider going anywhere else. He clearly gardens because sex isn't something you can't do all the time.

"I think he is a nice man," my husband said, still foetally curled, as the credits rolled. "I think when the cameras aren't on he actually digs with a spade in each hand, like Terminator, but he doesn't want us to see that just yet. He knows it might break us."

Cowardice is still the drug of choice

Mary Ann Sieghart

WE WERE milling around outside the studio, the three MPs and I, before a recording of BBC's *Question Time*. The conversation turned to drugs, and both the Labour and the Liberal Democrat politicians joined me in arguing for legalisation, against the lone opposition of the then Tory minister. Just ten minutes later, when the question came up on air, the three-to-one ratio was instantly reversed. With all three politicians mumbling platitudes about "setting the young a bad example", I found myself alone defending our previous position. It was the televisual equivalent of an offside trap.

It seems to me inconceivable that these politicians could not have come across drugs in their student days, even if they didn't inhale themselves. I don't expect people of my parents' generation to understand the problems of drug prohibition (though many of them, to their credit, do). But I did nurture hopes that, with a new generation of liberal-minded fortysomethings in charge of the country, there would be a more commonsense attitude from our new leaders.

Instead we have mandatory drug testing proposed in the Queen's Speech. And we have Tony Blair telling Middle England how "petrified" he is of his children taking drugs, as if he were not aware that most of his successful colleagues and friends probably spent their Saturday nights as students giggling stupidly and

passing the joint round.

The truth is, as he should know, that it is not drugs that should petrify him, but addiction and crime. Occasional and moderate use of drugs such as cannabis or alcohol does not wreck lives. Addiction, whether to heroin, alcohol, crack cocaine or nicotine, is what kills people or breaks up families or ruins careers or turns people to crime.

When we were teenagers my father gave us very sensible advice. "Don't do anything irreversible," he warned us, such as having an unwanted baby, allowing a drunken friend who might crash the car to drive us home, covering our arms with tattoos, or becoming addicted to anything.

It was a bit rich coming from him, a lifelong chain-smoker who did eventually die early from lung cancer. But this excellent advice helped me to resist the peer pressure to take up smoking when I was 13, and the equally strong pressure to try heroin at 16, when so many of my "cool" teenaged friends succumbed. Even now, they are paying the price. Several contracted hepatitis C decades later; one or two are still hooked. Others have problems with alcohol, for an addictive personality finds it hard to take any mind-altering drug in moderation.

Addiction is the social menace that needs to be addressed. Cannabis is an unnecessary distraction for the police and the criminal justice system. It causes very little harm to anyone and is not physiologically addictive. But when politicians lump it in with truly dangerous substances, such as heroin

and crack cocaine, under the broad label of "drugs" that "petrify" people, they are almost encouraging this generation of teenagers to try harder drugs. After all, once young people find that cannabis is pretty harmless, why should they trust what adults say about heroin and crack?

Drug testing also encourages this escalation. Because traces of cannabis remain in the bloodstream for about a month, while heroin and crack disappear within 48 hours, anyone scared of being caught by a test would be tempted to switch to the much more addictive and hazardous drugs. This is what may have happened in prisons since drug testing was introduced there. Home Office figures show that, in the past five years, the number of heroin seizures in UK jails has trebled, from 350 to 1,079, while cannabis finds have halved.

Addiction to an expensive illegal drug such as heroin is almost bound to lead to crime. Apart from the odd aristocratic junkie, most heroin users must either deal or steal to finance their habit. Each dealer will then create a pyramid of other heroin users below him, who will also eventually be tempted to deal or steal. The result? Organised crime makes a fortune, while the rest of us have our houses burgled, handbags snatched and cars driven away.

Incarcerating addicts in prisons swimming with heroin is hardly the answer. Treating them helps. The best solution is to allow doctors to prescribe the drug, which would pull the rug from under the organised criminals' feet. Without the base of existing addicts to support them, it would not pay to import heroin solely for the purpose of trying to find new recruits. And the young would get the message that heroin addiction is a medical problem, not an attractive pastime. In The Netherlands, where drug laws are much more sensible, the average age of heroin users is 39 and rising: in Britain it is 26, and falling.

Politicians treat these ideas as taboo. They do not form part of any party's

discourse (in public at least; I have many allies in private, some even in the Tory party). But I wonder how illiberal the British public really is these days. Yes, the *Daily Mail* would go berserk – as it did yesterday anyway over taxing traffic congestion. But each time I express liberal views on drugs I get stacks of supporting letters from the least likely sources: police officers, doctors, probation officers, grandmothers.

It is an idea whose time will come – eventually. So far, only the Liberal Democrats have dared even call for a royal commission on drugs. But if Charles Kennedy risks going further, he may be pleasantly surprised by the support he wins. There is a huge political constituency out there, just waiting for a lead.

My desire for romance frightens men away

Boy George has been single for four years. Part of the problem, he says, is that while he is hugely romantic, many gay men have terrible problems with intimacy

Penny Wark

BOY GEORGE is indignant. People are so rude, he says, always commenting on how he isn't as pretty as he used to be. What he does not acknowledge is that they are probably fascinated by the contrast between the cosmetically enhanced George as he appears in artfully lit photographs (see next page) and George as he looks when he sits over a sandwich in a café. Or indeed in front of me.

Had I seen him, as people sometimes do, in a greasy spoon, I would not have recognised him. Had I see him in The Ivy, which he also patronises, I might have done; but out of celebrity context he is identified only by his camp voice and trenchant views.

We meet in the offices of his record company (his Gothic pile by Hampstead Heath is being reborn according to the edicts of a feng shui man and is covered in dustsheets) and, because photographs are to be done later, George is in mufti: camouflage combat trousers, Prada shoes and a black T-shirt with PERVERT written across the chest.

He is tall and round-shouldered (one of his first cosmetic tricks was to pin socks into his T-shirts), with a fleshy body, meaty hands and black, cropped hair. He could be a builder, as his father was, were it not for his clear, unlined skin.

He does not look like a once-wrecked rock star, a man whose heroin habit almost killed him; he looks bright-eyed and healthy, a youthful 38.

That he can no longer be bothered to dress up all the time is a measure of how far he has come since the heady days of Culture Club when, at 22, he catapulted to fame with *Do You Really Want To Hurt Me* and declared, somewhat disingenuously it transpired, that he would rather have a cup of tea than sex.

Of course the image of a wisecracking male-female hybrid was always an illusion. "The camera tells filthy lies," he says, with satisfaction.

His problem now is that the fakery was convincing enough for people to believe in it. This does not make his private life easy.

"A lot of people think of me as being feminine and I'm not. I'm a complete gay chauvinist pig. Image-wise, my femininity has been a defence. It's a clever defence, because it disarms men. People are intimidated by me because my sexuality has become part of what I am. I'm not a mincing fairy, though I can be. I'm not inoffensive. Plus, with men I am quite full-on. I'm not shy at telling people I fancy them. I treat men in the way a really bullish man treats a woman. I think people prefer you to be a little bit dainty and vulnerable because it gives them power. I find it hard to be like that."

Our interview has been arranged to mark Culture Club's forthcoming album, the first collection of new songs for 15 years. George also has a lucrative career as one of the country's top club DJs. He has a record label, a radio programme and a newspaper column. Professionally, he is possibly too busy, he admits, and this is where the insecurity surfaces; inevitable, perhaps, in a man who soared to fame without trying and crashed back to near-oblivion almost as quickly.

Unlike some of his friends, he survived, but the humiliation of once playing to a club in Newcastle where there were more sandwiches than people is still acute. He quotes the following day's local billboard: "'20 people turn up to see Boy George. Do you really want to hurt me?' It was embarrassing and hideous.

"I think work is a way of avoiding life – oh, I'm too busy for a relationship. I have to force myself to have pockets of time where I am more social, though there's a part of me that panics, thinking that if Culture Club goes wrong and I give up my DJ work, then I'm back to

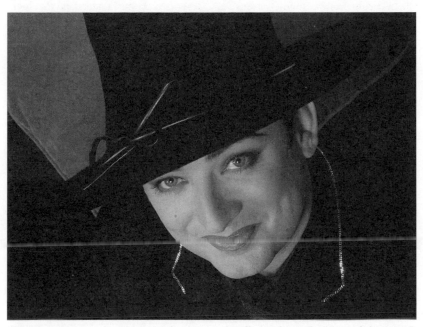

"I'm not very good with men who are my intellectual equals. Most of the men I associate with are younger than me"

square one again. I can't take that risk."

Not that George is lonely. Having grown up in southeast London in the Irish Catholic O'Dowd household, where there was more shouting than communication, he makes time to see his family, which after numerous crises and much therapy, is supportive. He has plenty of strong women friends, too, he says. It is relationships with men that he finds difficult.

"I haven't been in a relationship for four years. For a good part of that I haven't slept with anybody. For about three years I was completely celibate. Not out of choice. I ended a 12-year relationship (with Michael Dunne; this followed another long relationship with Jon Moss, Culture Club's drummer) and I couldn't think about being in another one.

"Now I want to make finding a man a priority." He smiles. "But I keep meeting twits. This is the price you pay for being famous. You either get people who've got a crafty hidden agenda or people who are weak and impressionable and want a daddy. A lot of the boys

that I meet are people who only see the surface.

"If I meet a guy I fancy, I go overboard. I frighten them. I am scarily romantic and I do silly things. My friends say, 'Don't send them flowers, you've only just met them, that's going over the top'. I would love to meet somebody a bit older than the ones I normally have, somebody who had a bit of money, or if not money then morality, someone who's big enough to hold me, who can see beyond the hat and eyebrows. It's hard to find and I realise you've got to make space for that person. I'm not very good with men who are my intellectual equals. Most of the men I associate with are younger than me."

They are usually poorer, too. This means that if George wants to go to The Ivy, he pays. He would appreciate the odd coffee in return but understands, doubtless because it has come up in therapy, that his generosity has an ulterior motive.

"It's also about being in control. My Dad was like that. He would buy me a

pair of Vivienne Westwood bondage trousers for £60 but probably wouldn't give me a hug. It's like buying people; a lot of famous people do that, like, 'I've been horrible to you so I'll fly you to New York on Concorde'.

"I suppose a decent person doesn't want that. But I get turned on by vulnerability. If I meet a guy and there's a softness to him, that will catch me straight away. I like broken people because that's what I am. People think I'm strong, outspoken, in control. Really, I'm not at all. But if they're attracted to that and find out you're vulnerable, they run.

"A lot of the people I fancy aren't mature. I meet people, I'm blinded by lust and sometimes I'm just going to go to bed with them because I fancy some warm flesh. But I know it's not going anywhere."

One beautiful boy of 20, whom he saw for two weeks, turned up at the recording studio on a skateboard. George slaps his thighs and howls with laughter. "I had a row with him because I knew he was telling me lies. I told him to get lost. I'm too old for this. I knew he was too young, all my friends said what are you doing? I said, he's beautiful. But I got a good song (*Black Comedy*) out of it."

All this is delivered as a cheerful and relaxed monologue as we sit on overstuffed sofas, George smoking and tapping ash with an exaggerated flick of his fingers. There is no small talk, no attempt at faux intimacy. It is not that he is unfriendly, although during the moments before and after our allotted 90 minutes he is so uncommunicative as to seem shy. Rather, I suspect, it is that he recognises that our chat is a business transaction and is honest enough not to pretend that we are new best friends. The effect of this is that while he is blindingly open, you do not get close to him. It is like a performance; it is not a conversation.

George has always had savvy. Call it a survival instinct, or just a bedrock of common sense, he seems always to

have understood what was happening to him. He got into drugs – which he has not touched for 12 years – because, marooned in hotel rooms on tour, there was nothing else to do, apart from try out eyeshadows and backcomb wigs, he says. More to the point, he got out of a heroin and cocaine habit said to be costing £800 a day for him and his friends. But even during the years of excess, even when he was freebasing cocaine in a hut in Jamaica, he was fearful and knew what he was doing, he claims.

He never spent all his money and has always paid his taxes. He could charge more for his club DJ appearances, but he likes the notion of continuing to work for people who employed him "when I couldn't mix concrete".

"I like money but I'm not a breadhead. Of course I could go for more. Short term, it would be great. Long term, it makes people resent you. I'm very conscious of that."

He has exercised similar caution in his sex life, he says. "I haven't really been promiscuous. There was a period in the mid-Eighties when I was a little more free sexually, but it's like the drug thing, I was always aware that I shouldn't do this, I don't know this person, I should be careful. I've always been very careful. I'm not the sort of person that goes out to bushes and toilets. I'm much more into taking a man out for dinner and buying him flowers. I'm not saying there's anything wrong with that and that there isn't a part of me that wishes I had the guts to do it. But I'm too much of a coward to go to Hampstead Heath in the pitch-black. That terrifies me. I think toilets smell. I like a nice, clean bed, cotton sheets, candle burning in the corner. I'm very romantic.

"Gay people have terrible problems with intimacy. For me, the most shocking aspect of homosexuality is intimacy. When you see two men kissing, that frightens people much more than seeing them having sex, because people already think they have sex.

"You don't see gay men on television being intimate with each other. You see them being camp, funny, offensive, nasty. You rarely see two men being loving. That disturbs people. If you say, 'This is a love song about men', it bugs people.

"In *Outside* George Michael says, 'There's nothing here but flesh and bone, let's go outside'. My interest is more about going inside. I think that's what George should be doing because there's much more than flesh and bone.

"The problem historically is that gay people are denied emotional development by the culture that we live in. Often, the first time you discover what you are is through sex, so no wonder we have such huge issues with relationships. George is typical: he had a boyfriend and he was going off to the toilet to get laid. That's how people see us – as being hungry for sex. They don't see us as being committed and romantic."

But surely society is more tolerant of homosexuality than it was in the Seventies when Boy George came out at the age of 15?

"No, because parents never plan for their child being gay. When I was 16 I believed it was some sort of unfortunate twist of nature, but as I've got older I believe we're all born with a multitude of possibilities and whatever you believe you are is what you are. A hundred years ago men were having sex with each other quite frequently, but they didn't define it as homosexuality. As the gay movement has become more defined, there's been more to fear. Aids means that there is another risk involved – so they feel even more fearful."

Yet three members of the Cabinet are known to be gay. Michael Portillo has spoken of his homosexual past and is likely in time to return to the Shadow Cabinet.

"It doesn't change anything," George replies. "I don't see what difference Chris Smith has made. To me, being queer is no big deal. I want the laws of consent to be the same as for heterosexuals. I want employment rights, I want gays in the military to be dealt with and

forgotten about. I understand that legislation can't change the way people feel, but over a period of time the law can change the way they behave.

"Not long ago a newspaper called me a bent bastard. I laughed but I couldn't help thinking what the reaction would have been if it had been black bastard. Homosexuality is the only minority it's cool to ridicule, with words like bender and poofter – yet no one would dare write an anti-Semitic or racist term.

"I'm not talking about living in a totally PC world where there is no humour. I'm talking about the big world out there, where it's very difficult to be 15 and homosexual if you're living on a council estate. Go to any comprehensive school and be effeminate. Kids have this unnerving ability to poke fun where it hurts, to say 'You're not like us, you can't kick a football, you walk funny'. The fact that there's nothing to help kids of that age is almost a form of child abuse. There is this notion that to raise it is to encourage it.

"My point is that it's there, anyway. In my first year at secondary school I kept collapsing. I was taken for tests. They never found out what it was. What it was, was that I didn't want to be there. It was almost like a stage school faint: what do I do to get out of here? Later, I discovered I could avoid school by spending time in the local shopping centre or finding a fellow pupil with the same problem. That was sad because I missed out on huge chunks of my education."

George was 12 when he decided that he did not like the way he looked. "I thought, I'm going to spend my life being someone else, and that's what I've done."

I ask about the transformation of his house. When he first became famous he had no taste, he says wryly. Jayne Mansfield meets Joan Collins: pink, frilly stuff. And now? "It is more reflective of my personality," he replies. "I just want something that I find comfortable, beautiful, classy." He pauses. "But not poncey."

A week of emotion, confusion and joy

Michael Binyon recalls Germans' euphoria when the Wall came down in 1989

AT 8.20 on a dank Sunday morning, the cruellest symbol of Europe's division and the long suffering of Berlin was swept away with the first official handshake across a gap where once the Wall had stood and a torrent of human freedom that streamed from East to West.

I was among the throng of journalists, politicians and excited West Berliners who had gathered to watch this first official breach in the Wall, the historic reopening of Potsdamerplatz, once the busiest crossroads in Europe. For 28 years it had been sealed shut by a deathly barren wasteland over which Western leaders had gazed in silent horror from the famous viewing platform. Now, less than 48 hours after the lifting of the crossing-point barriers, East and West Berlin met for the ceremony that began a week of riotous jubilation that was to end, less than two years later, in the reunification of the divided city and country.

Walter Momper, the Mayor of West Berlin, greeted his East Berlin counterpart as soldiers and border guard construction teams tore away the last slabs of this section of concrete wall, levelled the ground and opened the old cobbled road, neglected and overgrown with weeds.

Perched on roofs, hanging from trees, we watched the East Berliners come over. A huge crowd had gathered behind a line of green-uniformed border guards, then surged forward, barely pausing at the temporary checkpoint tent to have their passes stamped. They raced across to the Western side, and the waiting crowd cheered, sang and whistled, huge Alpine horns sounded a triumphant welcome and emotions flowed as freely as the champagne that greeted the astonished and delighted visitors.

Church bells rang in West Berlin. Two British military policemen in red berets, representing the "protecting

 Michael Binyon
...

power" in this British sector of the city, stood atop their Land Rover to observe the scene, while near the crossing point British squaddies had set up their own welcome stand and were handing out cups of tea to anybody wanting one.

Near by, young people were sitting astride the Wall, where until recently anyone approaching it would have been arrested, possibly even shot. A day earlier I, too, had scrambled up the high concrete structure, pushed and shoved from below, to gaze in wonder at the guards standing idle around the Brandenburg Gate. I lost my keys in the melee, but it was worth such minor inconvenience for the extraordinary feeling that here was history in the making, and that Berlin, Europe and indeed the world would probably never be the same again.

Below, Berliners with hammers and chisels were hacking away at the graffiti-covered concrete, chipping off souvenirs of a division that was already obsolete and was likely soon to be torn down. I still have my own few chunks that I managed to break off. Gaping holes had appeared in the Wall, through which streams of people gathering on the other side stared across at no man's land. The guards had almost disappeared; only East German army bulldozers, cranes and construction teams were to be seen tidying up after working all night to erect pedestrian railings at the reopened crossing point.

Berlin abandoned all rules that week. Cars were allowed to park anywhere, and people rode free on public transport. The West Berlin underground, which was already stopping at a newly

opened station in the East, was so dangerously overcrowded that one line had to be closed. Only at the traffic lights did the old German instinct for discipline show itself, when pedestrians, from East as well as West, waited patiently for the crossing light to go green even where the streets had been barred to traffic.

For a week there were spontaneous parties along the Kurfurstendamm. Bands played, people embraced in the street, hotels handed out soup, firms distributed chocolate, fruit and souvenirs. The big stores were overwhelmed with excited East Berliners marvelling at the cornucopia of unimaginable prosperity and scrambling to find something to take home. Those who had exhausted their precious cash were given money by passers-by, while long queues built up outside the savings banks. West Berlin opened its hearts and purses to "fellow citizens from the East". Everything was free for them: entry to a football match, public transport, beer, accommodation. Even some ladies in the red light district offered their wares for free.

In the southwest of the city another chilling symbol of the Cold War was transformed. The Glienicke bridge, linking Berlin with Potsdam and where once only spies and dissidents crossed, was opened to a stream of East Germans coming over in their quaint Trabant cars. As they arrived, West Berliners thumped on the roofs and handed plastic beakers of champagne to the bemused families squashed inside.

Bells pealed throughout the city and churches were filled as people gave thanks. "Now thank we all our God," was the banner headline in Berlin's biggest paper. It was a week of confusion, emotion and joy. I shall never forget it.

BERLIN'S CHILDREN
The dust from the Wall will take years to settle

Ten years ago today, in scenes of delirious rejoicing, tens of thousands of Germans surged through the newly opened gashes in the Berlin Wall. Like the storming of the Bastille exactly 200 years earlier, which yielded up only a handful of prisoners, the end of the Wall was not quite what it seemed. Memory, aided by the camera, picks out the spontaneous assaults by young men with pickaxes; but this was in many ways an orderly affair. East German soldiers and border guards made most of the holes; officials from both sides shook hands across the newly breached divides.

Yet in 1989 as in 1789, symbol outweighed precise circumstance; the demolition of Europe's most hated structure released a country from prison, and heralded the unstoppable liberation of vast stretches of the entire European Continent from the suffocating cruelty of a bankrupt ideology and from tyrannical systems in which political controls were exerted for their own benefit by a corrupt, ruthless, privileged few.

The heady months that followed differed from the French Revolution of 1789 in two important respects. First, there was no Terror. The precipitate collapse of European communism was as remarkably unbloody as it was rapid. At the end of 1989, most of Europe's communist regimes were, it is true, still clinging on; but they were surviving only by renouncing the Communist monopoly on power and by promising elections which almost

all went on to lose. The miserable exceptions were Romania, where the hideous Ceausescu regime refused to bend and ended in a hail of bullets, and Yugoslavia, where Slobodan Milosevic was to foment war as a means to get and hold power.

The communist elites went not gladly but at least quietly because they had lost their patron: Mikhail Gorbachev was not prepared to defend the indefensible with Soviet arms. It was with the words not of Marx but of Heraclitus – "Everything flows and nothing stays" – that Mr Gorbachev assented to the rebirth, within a year of the Wall's fall, of a united Germany. To recall his role is no disrespect to the courage of those who led Eastern Europe's revolutions.

The second great difference was that while the French Revolution, like most of history's other great religious or political uprisings, proclaimed new ideals, what happened a decade ago was that people bravely and stubbornly reasserted old truths against a modern lie. Defying the Marxist doctrine of historical inevitability, they demanded the restoration of hard won values and freedoms – the liberty to speak and write without fear, to move around freely, choose where to work and what to do with their earnings, and to call their leaders to account in free elections. The fall of the Wall, Marx would unhesitatingly have said, was worthy of the name of counter-revolution.

History will also show, however, that

1789 and 1989 share two cardinal, overriding characteristics. The fall of the Wall, like that of the Bastille, sent up plumes of dust and debris that will take decades to settle. This was no "end of history"; it was more as though Central European history, which Yalta had put on ice for 50 years, had been reheated at top speed in the microwave. Dormant quarrels, between and within nations and minorities, could again find outlets; it is remarkable that for the most part they have been controlled.

Secondly, both upheavals transformed contemporary debate about the future shape, character and organisation of Europe. Consider Germany alone: the old "German Question" was resolved only to create new ones. Immediately, as David Marsh observed, Germany added 7 per cent to its economy, 25 per cent to its population, 40 per cent to its size, 50 per cent to its unemployment rate – and 100 per cent to its problems. After 1989 Germany's neighbours, western as well as eastern, feared its new strength as Europe's undisputed anchor and powerhouse. Yet ten years on, Helmut Kohl's legacy is that they have more reason to worry about its social tensions and economic as well as political weaknesses. The "cost of Kohl" to Europe has been exorbitant. At home, his equalising of currency, wages and welfare in the eastern *Länder* cushioned early shocks only to destroy jobs and breed eastern discontent and western German resentments. Those mistakes were paid for

by all Europeans, in the form of stubborn and prolonged recession and mounting joblessness. The fallout has been to warp rich Europe's sense of strategic priorities and to intensify the hazards of transition to the east.

Herr Kohl's obsession – naturally shared by France – with lashing the new Germany to "Europe" through deeper political integration, using monetary union as the catalyst, was a colossal misjudgment for Europe which will have lasting consequences. The new democracies looked West to the European Union; but instead of grasping this historic opportunity to heal communism's wounds, EU governments continued oiling the Franco-German axis. To be successful, a strategy of speedily flinging the EU's doors wide open to the new Europe would have required the EU to change its ways, seeking to maximise the Continent's innate strengths – its diversity, inventiveness and adaptability –

rather than squeezing all national modes of operating into the same frame. Instead, after initially promising the Central European front-runners entry by 2000, the EU has further overloaded the rulebooks in the past decade. Coupled with monetary union and the refusal to reform EU agriculture, this sets the barriers to entry higher and higher – which is just what the French, Spanish, Italians and perhaps even Germans may tacitly desire. Europe's "age of uncertainty" will last longer than, with more flexible and imaginative Western policies, it need have done.

Left to work out their own salvation, the new democracies have made a courageous fist of it. First, most have stayed democratic, no minor feat in the early years when GDP and living standards plummeted. Secondly, although old elites have grabbed huge stakes in the new order and the old, civil servants and blue-collar workers in

uneconomic industries have conspicuously lost ground, life for most is clearly better and millions of small businesses fuel growth that, 6 per cent in dynamic Poland, is at last picking up overall. Corruption, rife under communism, may merely have been "modernised", along with organised crime; many civil institutions are still weak. But these are hangovers from what to most people, not just the young, stands confirmed as an evil empire.

The picture is still confused, but contains many hopeful landmarks. If EU politicians can only grasp that frontiers in Europe may have less meaning, but nationhood is a pride newly recovered and entitled to respect, the second decade after the Wall's fall could see dynamic, and increasingly stable, European nations make the most of the links and loyalties that have historically bound them.

Vandals take the Handel

Amateur hour goes on and on in the Guildhall School's *Rinaldo*, says Rodney Milnes

THE CURTAIN rises on a military command post with a corpse hanging outside the door. Crates of ammunition, cases of Budweiser. A soldier in fatigues with white angel's wings. A flying motorcycle. A burnt-out van. Where are we? Why, at a performance of Handel's *Rinaldo* of course. Silly question.

Before curtain-rise persons with X-ray images on their suitcases had paraded across the stage, monks had waved censers and a priest in a beret had celebrated Mass. At least, I think they had done all this, but cannot be sure as it all took place in impenetrable darkness. As Gore Vidal put it in a throwaway remark during an intense political discussion: "Nothing ever remains the same, with the possible

exception of avant-garde theatre."

Yes, yes, *Rinaldo* is drawn from Tasso's epic about the Crusaders capturing Jerusalem and, as the producer Thomas de Mallet Burgess reminds us in his insufferably pompous programme note, calling Maronites, Stormin' Norman Schwarzkopf and Tony Blair in evidence, war is a frightfully bad thing. But the general idea behind college performances is surely to help students perform at their best, and Burgess was so busy with his epically politically correct and smug dramaturgy that this detail was overlooked. The cast mostly stood around looking awkward, as in bad old stagings of Baroque opera, only in different frocks.

Even more depressing was the musical

performance, sung by a multinational cast in indifferent Italian – when you could tell, that is. Some of them might as well have been singing in Esperanto.

The conductor, Christian Curnyn, has done some good Handel in London, mostly with his Early Opera Company, but here he had a serious off-night. Maybe professional singers can argue with conductors over matters of tempo and phrasing, but students might feel shy about doing this. Curnyn took the fast numbers at breakneck speeds, rushing the poor soloists off their feet, and in contemplative arias risked slow tempos that would test the most seasoned professional. Musical phrasing took second place to simply stringing the notes together, embellishments

were clumsy and clumsily executed. Arch pauses and glutinous rallentandos compromised the music's natural flow.

Predictably the students, however talented, were hardly allowed to demonstrate their true potential. Sally Matthews, playing the sorceress Armida with Spiderwoman facial tattoos, showed great spirit and a most promising soprano technique, and the blame for some ungainly shrieks must be laid at the door of the conductor for harrying her so mercilessly through her music. The same goes for Howard Kirk as the Crusader general, his tenor bumpily used until his final, slow aria.

Margriet van Reisen, the Dutch mezzo playing Rinaldo with designer stubble painted on her face, is admirably confident on stage; as of now her mezzo is slightly one-dimensional but it should develop interestingly, and might have done on Tuesday with some encouragement.

The Belgian soprano Sophie Karthauser slightly oversang the heroine's lyrical music – less is usually more in Handel – and Hans Voschezang, from Holland, should never have been allowed to phrase the villain's arias with such coarseness. Siân Wigley Williams did well enough in the wet role of a crusading officer that Handel cut, rightly. The mermaids, got up as stocking-and-suspender tarts, were unacceptable in every way. A horrible evening.

PVGH

WHICH LORD MAYOR OF LONDON CANDIDATE ANNOYS YN THE LEAST ? "

Some day, my son, all this will not be yours

Matthew Parris

Parliamentary
Sketch

NOT SINCE the gallows were dismantled at Tyburn has London witnessed quite so public an execution. Dukes and earls were jostled into the Lords chamber to sign their own death warrants. This was their last afternoon. At the Bar of the House, MPs from the chamber which has sealed their fate watched, fascinated, like tricoteuses at the guillotine.

The Baroness Thatcher came in black. Miladies Buscombe, Rawlings, Park of Monmouth, and Farrington of Ribbleton, came in black. Everybody – every lord and lady, every doorkeeper and policeman, shared a sense of occasion, a sense of melancholy. But not all. Not the Baroness Jay of Paddington. The Leader of the House, King Tony's vice-regent in this noblest of his provinces, came without her father, Lord Callaghan of

Cardiff, the last Labour ruler before King Tony. A new Labour dynasty is installed as the forces of conservatism are repelled: Lady Jay was arrayed in imperial purple with a purple buttonhole. The Queen hates purple.

Questions were a distracted affair, as the gallows were readied. Lord Grenfell did his best, sticking determinedly to his question. Baroness Scotland of Asthal, a Minister also in black, had the grace to say that he would be missed.

And then the dreadful business. Peers were to consider Commons amendments to the House of Lords Bill: their last chance to spoil the legislation. Lord Stanley of Alderley (for the chop) spoke to an amendment of his own, unacceptable to the Government. The Earl of Caithness (reprieved) supported him. Would they push this to a vote? It could have brought the whole compromise crashing down.

Lord Elton, once one of Margaret Thatcher's senior ministers in the

Lords, described the upper chamber's role in restraining governments – even the noble Baroness's. He smiled at Lady Thatcher. She peered bleakly at him, no doubt trying to remember who he was.

As Lord Strathclyde spoke, the penny dropped. He would not be pushing this to a vote. The beguilingly bufferish Tory leader in the Lords was signalling surrender. Hopes fell. Tempers rose. Lord Clifford of Chudleigh, who is for the chop, tried to speak – possibly on the wrong amendment, but everyone was in a muddle. Lady Jay silenced him. He tried again, but she forced the business forward. Peers became upset at her impatience. The popular Earl Ferrers (reprieved) intervened bravely on Clifford's behalf. Everyone was agitated. Jay had misjudged.

She nearly lost it. When it came to the vote, the Labour roar of "content!" was followed by a scattering of tentative Tory "not contents". Jay

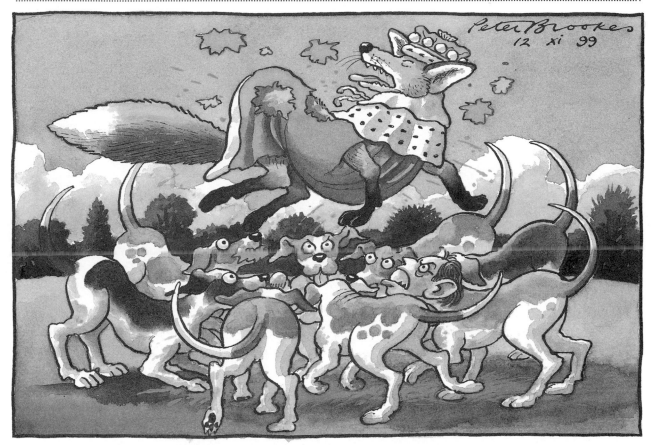

THE LAST TALLY-HO...

tried to ignore it. Dissent grew angrier. Could she not just let this fellow speak? Might the discontent that simmers beneath the surface of Tory submission boil over at the last minute? But the minute passed.

Around the throne where the heirs of hereditary peers are by custom allowed to sit, a boy was perched, surveying the gilt and leather. Some day all this will not be his.

Finally, as Parliament was prorogued, came the list of enactments by way of declaration and response. "The House of Lords Act

"*La reine le veult.*"

And that was it. There was something brutal in the way they were dispatched, and, in the way they went, something craven.

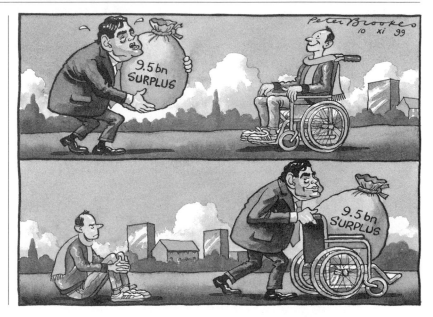

Waterstone's favourite author survey

Giles Coren

EVEN AS the hats of the literati hang in the winter air, thrown there in jubilation at the results of a Waterstone's survey that proves that people still read books, a darker question looms for the fiction writers themselves.

For the 50,000 people surveyed were asked, among other things, who their favourite authors were. And, such being the tenor of the age, the results were published in the form of a league table. Happy days, then, for the Binchys, McEwans and de Bernières who topped the chart. But what of the rest? When a political party underperforms in a poll, it adjusts its approach, promises to try harder and even borrows some of the more successful tactics of its rivals. Had not our lower placed authors best do the same? Shakespeare, for example, might look to his laurels. He props up the front-runners at a lowly 29, one place behind someone called Robert Goddard (do not pretend to know who he is, or look him up and then write a smug letter, it will not wash).

What would the Bard's agent say? It is easy to imagine him racing through the streets of Southwark with the grim news, bumping into orange sellers and men in ruffs coming out of taverns with white walls and black beams and pointy roofs (if you are having trouble, think *Shakespeare in Love*). Not stopping to knock, he races up the stairs to the room where the Swan of Avon sits scratching his head, wondering whether Thomas More is really worth a whole play, and believing all is well with the world.

"Terrible news! Terrible news!" he cries. *"They hate you. You've*

come in 29 in the big Waterstone's survey."

"Twenty nine? But I invented modern English. Ungrateful sods. Who do they like better than me?"

"Sebastian Faulks, Ted Hughes, Stephen King, Terry Pratchett. We'll have to do something, Will. You have to respond. You can't ignore public opinion."

"Do what, exactly?"

"Well, the Pratchett fellow seems to be on to a winner at number six. Any chance you could move the scene of some of your plays to a world that is actually a disc? Henry V, perhaps."

"Eh?"

"Your play about Henry and the big..."

"Yes, yes, I know what it was about."

"Well, you know, 'May we cram within this wooden O the very casques...' and all that. You could just go back and make it a bit more literal."

"You mean, 'May we cram on to this disc the very casques..'?"

"'This disc, supported on the back of four elephants...'"

"What?"

"'Four elephants who are themselves supported by a giant turtle.' It's what the public wants, Will."

"What about quotability? Who is going to walk away from the Globe to their hovel beneath the pin-maker's on London Bridge, saluting the night sky with what they remember of the speech that went, 'May we cram on to this disc on the back of four elephants

and a turtle the very casques that did affright the air at Agincourt'?"

"Well, Terry Pratchett isn't the only one who beat you, Will. Bill Bryson came top."

"And what does he do?"

"Travel writing. You could always try that. He writes mainly about America."

"America? I can't spend two years sailing to the New World and back just to look at some squawking Quakers in silly hats and write a book about how funny it is that they are making a killing selling potatoes. Anyway, I've tackled the colonial thing in *The Tempest.*"

"Perhaps you could follow the example of Nick Hornby, who trounced you with his tales of young fellows belabouring pigs' bladders about the open fields of Highbury. He writes in a trite, homiletic style, which, by his occupation of fourteenth place on the list, appears to go down well with what he calls 'the punters'. Or then again perhaps a drama set in the courts, in the manner of eleventh-placed Mr Grisham."

"Ah, court. Now that I can do. It's a sort of *As You Like It* meets the flattery bits from *King Lear*, is it?"

"Not exactly. Different kind of court. The law courts."

"What, a whole play? I did a bit of legal metaphor in that sonnet about the sessions of sweet silent thought, and there was the big trial scene in *The Merchant of Venice.*"

"That was a small trial scene. The big trial scene is in The Jew

of Malta, *Will. By Christopher Marlowe.*"

"Really? Bugger."

"*You might have a look at Ruth Rendell. She came in at 17.*"

"But I've done murder and suspense. I'm better than Rendell. What about Macbeth, Othello, Julius Caesar?"

"*With all due respect, Will, I'm not sure the suspense element is there. We've known who killed Caesar for 1,600 years. You could always try and think up a new plot.*"

"A what?"

"*You know, one that hasn't been done thousands of times before.*"

"But that's what I always do. People like it. Look at Jeffrey Archer, he does it and they love him."

"*Yes, but you beat my Lord Archer. He came thirtieth.*"

While the Bard tears his hair out in the search for popularity, you might be able to hear, if you listen very carefully, the rustling of Jane Austen's petticoats, as she turns in her grave.

"Austen too hot for US censors!"

screamed the tabloids at news that a raunchy new film of *Mansfield Park* has had to be cut to get a family rating. Yes, it is hard to imagine *Mansfield Park* with no Fanny, but I can only suppose that the makers of the film have for once returned to the original, seedy manuscripts that Miss Austen presented for publication, rather than the more delicate bowdlerisations that have come down to us.

The one that got away, however, was *Northanger Abbey*. What, I wonder, would the film censors make of Austen's announcement, on the first page, that at 15 Catherine Morland "began to curl her hair and long for balls"?

Ancient and Modern: Big Ben rubs shoulders with the London Eye, the Millennium Wheel

England'll walk it, a voice says

Danny Baker

WOULD EVERYONE please stop saying, "the funny thing is, we'll probably go on and win it now". We won't. I know I said it myself a few weeks back but, at last, I think I understand why.

Look, I don't know how much time I've got left in which to write this, so I'll try to be brief. I believe there is a mind-altering cataract, a hideous glaucoma, a bug that is planted deep within the football third eye in us all. It is a living thing, a wanton mischievous intelligence. Who put it there and what purpose it serves I haven't yet fathomed, but our reason and soccer self-determination are without question at its mercy. I believe the seemingly chaotic calendar of international football matches is far from random but falls into a precise pattern that mirrors the strengths and potency of this creature inside us as surely as the Moon controls the oceans.

If my calculations are correct, through the actions of this controlling parasite, we forget everything really awful – and I mean really awful – about the England team approximately 72 hours after they leave the field.

It is then that the experience of our own eyes is replaced with the idea that bad performances are merely unrepresentative individual blips that fall short of how great this squad actually are. The real England team will be here next time. England's worth always remains charitably in the past tense. It's always "England were useless against the Scots", suggesting a mere below-par outing, when in fact the sentence should simply be: "England are useless." No matter how rank the game and how long the break in any sort of good form, the illusion of disconnected greatness persists.

This must not be confused with hope. To hope is natural and human. This, this England thing, is a harmful lying imp, an imprisoning malevolent attacker of the intellect which makes goats of us all. During the recent Euro 2000 play-offs, the weaker its influence grew in the aghast England support temporarily free of its grip, the stronger it took hold in Scotland fans with the generally agreed post-match bromide being that the better team lost. Which better team? All the workaday Jocks proved was that any side prepared to raise their game by even an iota will panic England into confusion. However, in terms of a prospective challenger for honours in Europe next summer, here, as was said of the Falklands conflict, were two bald men fighting over a comb.

England are rotten. Their players are no good. Their players are always no good. Their plans, methods and rhythms are no good. They have been no good for ages and will be no good when we go to Belgium next year. We are no good. Please, say it aloud or, better yet, write it down and stick it behind the door on the bathroom cabinet. Write "England – No Good". Then after the filthy little imp with its feet up in your memory has oozed out its bamboozle juice and you begin to have serious chats with fellow zonked-out victims about our prospects, you will come across it. A hole could be punched in the make believe long enough for you to phone a few close friends and loved ones and croak out the information, "England… they're no good…".

Undoubtedly the hypnotised voice on the other end will start up, "Oh, I don't know. I've got a sneaking suspicion we might do really well… I mean remember Denmark in 1992…" and on and on they will go, doing their inner master's bidding until you too, once again, have been reined in.

Even now I feel the forces of True Thought weakening. This window of reason will soon be fast shut. Have I done enough? Already, reading back the harsh words above I feel a distant chill that, should we win the European championship, I will be open to accusations of being a Charlie. Should we win. You see? Already the possibility exists.

Come springtime we will be third favourites. Germany and France will have faltered here and there and our drums will start to grow in volume. After all, nobody wants to meet England. Yes, I can see that, having touched bottom on Wednesday, final triumph is still a possibility and a very exciting one at that. In fact, what was I thinking of? Kindly disregard everything you have been asked to believe above. Think: England – champions of Europe. I mean... why not?

STICKS AND STONES MAY BREAK MY BONES BUT WORDS WILL NEVER HURT ME
EXCEPT EUROPHILE OF COURSE

In a flash of empathy

Libby Purves
.................................

LATE ON Thursday night I pulled the car into a layby and rang home. "Switch on the radio! Quick! Cherie Blair!" There followed the usual pleasantries of a journalist household – "Next election sewn up, then", and "That'll show Ken where he gets off". But this was camouflage. You don't ring your husband from the A12 just to make political jokes. The subtext was pure exultation; a glorious, gleeful, irrational buzz which ran through the freemasonry of women with nearly-grown families. Go, Cherie, go! I have consulted my own fortysomething coven, and all of us feel the same about this late surprise baby and the Blairs' endearing admission of "shock".

It is only to reassure our husbands that we make cynical cracks and chunter: "Gosh, poor thing, at our age, just when you'd have given away the cot, sleepless nights. What about her job?" Family men need reassuring because they tend to go rigid with terror at the thought of 45-year-old wives going back into production. Among ourselves, in the samizdat of women, we punch the air with cries of "Yesss! Oh wow! What a joke, what a comeback, good on her!"

For when your youngest child is at secondary school and your career is sloping upward again, you become aware that you have moved into a new land: the country of the middle-aged. There are still parental duties and a family life to be managed and enjoyed, but you have moved away from muck and muddle, mopping and romping, babytalk and bedtime stories. Your 11-year-old may play at babies now and then, but both of you know it is a performance. You begin, by infinitely subtle stages, to let your children go. You have mixed feelings about younger mothers draped in warm dribbly infants; passing the primary school gate you reflect that a 16-year-old's pure maths homework will never carry the visceral thrill of his first paintings. After a while, to your horror, you catch yourself thinking about grandchildren.

Silently, sullenly, you accept it. You look outward from the hearth and tell yourself that this is a fine fresh start. The idea of sleepless nights and nappies is genuinely unappealing at your age. The 65-1 risk of Down's syndrome is not to be dismissed either. When, as happens, you have pregnancy scares, you yelp with a dismay that is not feigned.

And yet, and yet ... news like Mrs Blair's, and the sheepish grins that accompany it, bring on that crazy, air-punching, vicarious triumph. In a flash of empathy you imagine how you would feel: appalled, delighted, proud that the old gear still works, the sap still rises and there's life in the old trout yet. One more lap of honour, one more great gala comeback when the fat lady sings her final song. Besides, when you love your existing children there must be a thrill in shaking the kaleidoscope one more time, just to see what happens when the same genes combine. Who's in there? What final piece of the family jigsaw?

Medical bores and psychological doomsayers shake their heads and urge caution. We middle-aged women just anarchically rejoice at the life-affirming idea of even the most Blairishly well-organised families ruefully accepting the caprice of fate. Husbands shudder and head for the pub in disgust.

When I told mine that a menopausal friend rang just now to announce that Mrs Blair's news had brought on her first period in a year, he growled: "Now perhaps you understand why men keep women out of their clubs. You're all crazy. There has to be somewhere to hide."

Proud to be crazy, I say. An afterthought baby is unexpected, awkward, a career nightmare, a glorious boon. It is going to make the Prime Minister start the new century by falling asleep in Cabinet and turning up at Question Time smelling of sour milk. Isn't life grand? In an age of tyrannical reasonableness, against all reason a new shoot has gaily, spontaneously, forced its way through into life.

Yess!

> 'In a flash of empathy you imagine how you would feel: appalled, delighted, proud that the old gear still works and there's life in the old trout yet'

THE TIMES

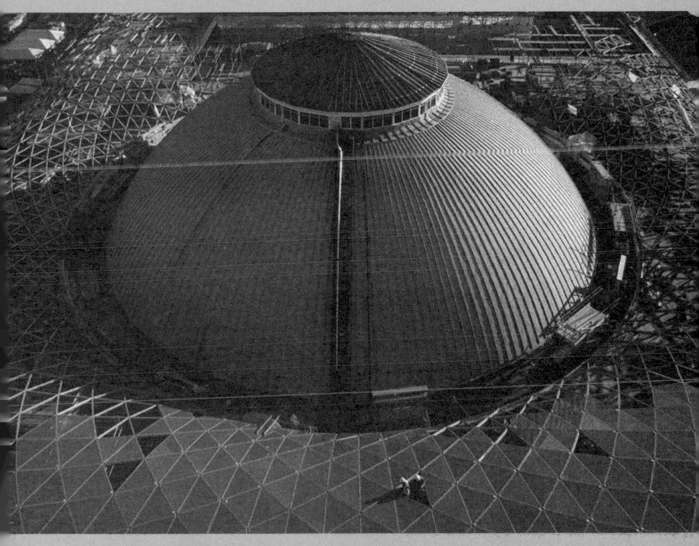

December
1999

No Turner, but Tracey's already cleaned up

IN THE ART world's answer to the Nobel Prize, a man who rolled a metal barrel filled with three cameras through the streets of Manhattan beat off competition from a woman who decided that a bed soiled with bodily fluids was art.

Steve McQueen took the £21,000 Turner Prize, confounding predictions that it would go to Tracey Emin's bed. McQueen, 30, also saw off Steve Pippin, who had locked himself in the lavatory of the London-to-Brighton train to take photographs of himself with a camera placed in the bowl, and twins Jane and Louise Wilson, who specialise in photographs of empty buildings, including the abandoned Berlin headquarters of the East German secret police.

McQueen's exhibition included a video piece called *Prey*, in which an old tape recorder is filmed on a bed of grass, its spools rotating to the sound of a tap dancer, before being lifted in the air by a balloon.

In awarding him the prize at a Tate Gallery reception last night, the jury "admired the poetry and clarity of his vision, the range of his work, its emotional intensity and economy of means".

His earlier pieces include *Bear*, which documents a brief encounter between two naked men. They circle each other before locking arms and heads "in an inconclusive struggle", says the Tate exhibition catalogue. "What first appears to be an aggressive confrontation is gradually transformed into something closer to an erotically charged tussle."

Emin shrugged off her defeat: "I knew I wouldn't win … art is not my strong point, life is. It's good that they gave it to an artist. I'm a brilliant loser."

There was, however, a consolation prize: in the past six weeks she had made enough money from the Turner

Steve McQueen in front of *Dead Pan*, one of the works for which he was awarded the this year's Turner Prize

Prize to buy a house and retire.

McQueen thanked his mother for helping him "big time" in becoming an artist. Asked what he would like to do next, he added: "To be with my mum. Then a bit of hoovering." His prize money will go towards buying a house with a garden.

His admirers included Simon Wilson, the curator of interpretation at the Tate Gallery, who felt that the artist was taking to an extreme the idea of Impressionist painters of finding beauty in everyday scenes. Sir Nicholas Serota, the Tate's director, applauded McQueen's "very subtle use of film" and his "great emotional intensity".

Others lamented the win as a reflection of just how low contemporary art had sunk. David Juda, a director of the Annely Juda Gallery, whose artists include David Hockney and Howard Hodgkin, said the art was simply not interesting.

The leading dealer Bernard Jacobson

said that the shortlisted works had "as much depth as tissue paper".

The prize, sponsored by Channel 4, was presented at a Tate Gallery reception attended by several hundred guests.

Dalya Alberge

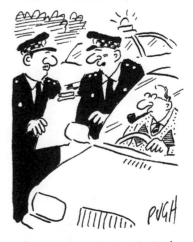

ANOTHER ONE, SARGE, SAYS HE WAS FLEEING THE PAPARAZZI

All inhuman life is here

The National Theatre is staging Ted Hughes's adaptation of *The Oresteia* to welcome the new millennium

 Peter Stothard

FEW OF US who work in newspapers want to ask ourselves what it would be like in a home for broken-down journalists. Even fewer would expect to find the answer in Aeschylus's trilogy, *The Oresteia*, the National Theatre's symbolic production for the millennium.

Yet there we all are, a wheelchair-bound and slipper-wearing chorus for the first of the three plays, pointlessly pushing our typewriter keys, painfully playing cassettes of speeches, occasionally roaring at the misdeeds of the great, more often acquiescing, always ready to read a bit of tattered copy or retell an old story to an old colleague. It takes a while to work out why the original venerable Argives of Aeschylus's Agamemnon should be made, 2,500 years later, into a newsroom of moaning hacks. But by the time Katie Mitchell's vision is over there have been enough new fractured images to make the singing journalists seem almost commonplace.

This five-and-a-half-hour epic, spread over two evenings at the National's Cottesloe auditorium, is not for the faint-hearted. Anyone wanting to relive schoolday ideals of white-cloaked poetry readings among laurel-wreathed statuary would be happier staying at home. Mitchell also spurns the spirit of Sir Peter Hall and those who seek the elemental truths of tragedy through abstraction and mask. She prefers to dig down into the raw material from which Aeschylus made his plays, to find the parallels with tragic events of our own time, to bend angles and vent anger. In doing so she creates some irritating distractions: but she also finds

truths and triumphs that are as gripping as any seen in a classical play on the English stage in recent years.

The simple story from which Aeschylus made his trilogy in the mid-5th century BC is the curse upon succeeding generations of the House of Atreus. This was part of the history and self-definition of the classical Greeks, what made them different from the peoples around them and what made later Western cultures absorb Greek thought into their own. Thyestes steals his brother Atreus's wife. Atreus puts Thyestes's children in a stew for their father to eat. Atreus's son, Agamemnon, sacrifices his own daughter to win a fair wind from the gods for his expedition to Troy. Agamemnon's wife, Clytemnestra, responds by having an adulterous affair with Thyestes's son Aegisthus and killing her husband and his concubine Cassandra when the war is over. Orestes, the son of Clytemnestra and Agamemnon, avenges his father by killing his mother and her lover.

Aeschylus adapts these revengers' tragedies to make a work in which the morals of prehistoric chaos become the order of civilised life. The final play, entitled here *The Daughters of Darkness*, describes how Orestes finds a new Athenian justice in which even a man who has killed his own mother can escape the avenging Furies and win a fair hearing. When first presented before its Greek audience, *The Oresteia* was a work which began in myth and ended in the controversies of contemporary politics. Apart from a bizarre Nazi version for the 1936 Olympics and an occasional Russian oddity, the political aspect of modern productions has tended to be subservient to enlightened Hellenism. But Mitchell's political ambitions, alien

though they may seem to many, are not in every way at odds with the aims of Aeschylus himself.

The original text is a maze for scholars and a minefield for critics. It would be possible to sit through this production (as one or two did) and complain that Michael Gould's Agamemnon was too sympathetic or that Anastasia Hille's Clytemnestra was muddled in motivation; but there is not a great deal of point. Ted Hughes, whose version is the starting base for this production, does little to smooth all the very many inconsistencies in the ancient texts. The authors of Greek trilogies did not see the development of character through time in the way that we do. Mitchell's production is dedicated to one of the greatest classical scholars of our generation, the late Colin Macleod, who once described *The Oresteia*'s themes as the "disturbance and distortion of nature which results from human crimes". To this director each disturbing act and every distorting mirror is a true end in itself.

She is not the first to note that the Argos of Agamemnon is close to Milosevic's Kosovo. But she is the first to telescope history so tightly and to make geography loom so large. The black arrows fly over Clytemnestra's map of the Balkans as on a Nato general's briefing chart. Bloodstained evidence is labelled with prosecutorial tags in bags of clear plastic. Apollo is a Red Cross doctor. The Furies' cave is the torture chamber. Video-cameras, brilliantly deployed by the director and designers, record what they can. The journalists' chorus, back home in Argos, confuse, moan and speculate.

Mitchell skates lightly over the characters' progression through time. Lest anyone be worried by this, she inserts

into *The Daughters of Darkness* the lines from T.S. Eliot's *Burnt Norton* about "the still point of the turning world" where "only through time time is conquered". Her overarching idea is of tragic fragments existing virtually at a single moment. Her methods are a challenge to her actors. Orestes is frozen so utterly as a tool of fate that Paul Hilton has to struggle to be more than a gormless squaddie. Hille's Clytemnestra has better opportunities and holds them with a compelling mixture of manic insincerity and emotional trauma. Sebastian Harcombe strikes a single sombre note as the dinner-jacketed, sexual harasser Aegisthus, symbol of all those Balkan men in suits who order killings but do not carry them out.

The vision of Lilo Baur's Cassandra in the opening play is an awesome coup. Agamemnon's tiny prophet slave, swathed in bridal white, foresees her master's death in breathless oriental wailings before ripping her clothes to reveal bitten breasts and caked menstrual blood: in a single short space of stage and time she compresses all *The Oresteia*'s time. When Clytemnestra has killed her husband and his trophy prisoner, the giant palace gates rumble as though from hell and the Queen, bloodied from elbow to every part of her prim yellow dress, shows the two dead bodies openly entwined in the bath.

By the end of the work, Orestes has killed his mother in return and found a sort of forgiveness. As Macleod put it, the disturbances are calmed and the distortions straightened. The squabbling hacks' chorus of the opening becomes a more cohesive group of slaves in the second play and a tightly drilled squadron of besuited, faceless Furies in the finale. Orestes is a winding-down clockwork toy in his sister's hand. There is a resolution that is as uncomfortable today as it would have been in the 5th century: but it is a resolution nonetheless.

In the closing courtroom scenes Mitchell moves forward from the justice of democratic Athens to the justice of Tom Paine, Wilfred Owen and the prescriptive definitions of the dictionary: passages from all these books are projected on to the giant screen above the action which earlier showed bloody wounds and wailing faces. This is a genuine millennial *Oresteia*. Its moral values are those of the UN inspector; its art that of the Post-Modern and the multimedia practitioner. But there remains enough of Aeschylean religion to retain the trilogy as one, more than enough dramatic fire to inspire the jaded modern audience, and enough of theatre's foundation stone for the National to have a well-earned place at the turning of the new calendar for the West.

The scene in the restored Floral Hall as the audience gathers for the gala reopening of Covent Garden Opera House

End global hunger. Eat Miss World

Hey, if you happen to see the most beautiful girl in the world ... enjoy

Caitlin Moran

DURING LAST WEEK'S Channel 5 hell-fest I forgot to mention the two things C5 has that are viable alternatives to actual proper TV: *Xena – Warrior Princess* and the classic, much-loved Sharons' AGM, *Miss World*. Since ITV insanely stopped broadcasting the *Miss World* finals in 1988, it's been in exile, firstly on satellite and then, since last year, at its true spiritual home: Channel *Win Beadle's Money*. And they will not regret sacrificing heating and lighting and their staff's Christmas baguettes to buy it; for we, the faithful, will flock to its feet tomorrow night.

You simply don't miss *Miss World* – it's live TV, for starters, and all live TV is worth watching. However swish the production or international the event broadcast, live television instantly gives it the knife-edge, low-budget feel of a pub talent show. At any moment a drunken man could just stumble into *Miss World* and start shouting about how there wouldn't be any of these tongue-piercings if Hitler was still around, before collapsing in a heap. And, as it's live TV involving five costume changes, 50 languages and escalating hysteria that culminates in one girl hyperventilating into a mascara-streaked paper bag and another 85 having their lives ruined, you'd have to be actually on it to miss it.

Aside from being able to bitch about 86 mismatching dresses and lipsticks, *Miss World* has, for me, two real highlights. The first is the National Costume Round, where, every year, Miss Canada tries not to look heartbroken in a Mounties hat not even Meg Mathews would wear. The second is getting the precious annual glimpse of

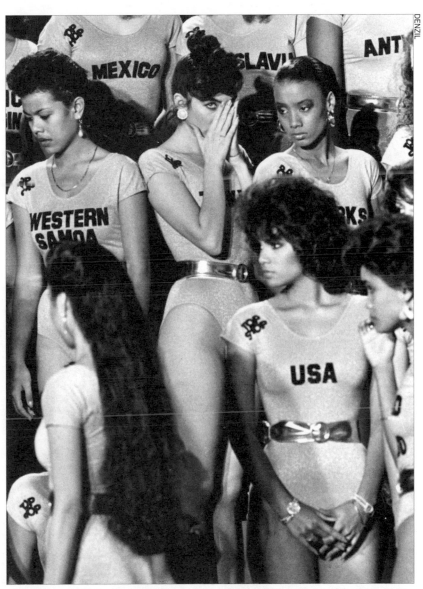

It's always 1972 (or thereabouts) in *Miss World* world, a place of fasting, semi-nakedness and full Brazilian bikini-waxes

Eric Morley, the man whose idea this whole thing is. And think, for a moment, what a weird old idea that was.

Morley is a man who appears to have found the secret of eternal late-middle-age: he's looked 59 for the past 20 years. People who have watched far too many episodes of *Buffy the Vampire Slayer* might infer some darker meaning from a yearly collecting of the world's most beautiful young women by a man who seems not to

age. But I haven't watched *Buffy* for three weeks now, and would therefore scoff at such hysteria. Why, Morley's equally youthful wife, Julia, sits right next to him as he judges more than 80 girls in one night. What could be more reassuring or natural than that?

Miss World's primary addictive quality, however – the little nugget of televisual nicotine that has you coming downstairs in your dressing-gown for just one more hit – is its staggering uselessness. It's even more useless than its nearest TV cousin, *The Eurovision Song Contest*. Often Eurovision singles get into the charts; and the contestants, however Maltese they are, never have to show their knickers.

Miss World, on the other hand, is a year-long quest of semi-nakedness and fasting for absolutely nothing. All those sequins and dermabrasions and little walks and fuchsia-coloured dresses are hurled into a screaming void. It's an amateur beauty contest still in love with Farrah Fawcett, and therefore as useless as an unrollable £10 note to the real beauty industry.

In *World* world, Kate Moss, Sophie Dahl and Devon are asymmetrical, piggle faced witches to be kept away from the *World* girls, lest they scare them. Tall, over-tanned Texans with 16th-birthday nose-jobs and loads of slap are what fatten *Miss World*'s goose: its tastes are draggy, almost transvestite, and currently only shared by Taiwanese businessmen raised on lobster thermidor and repeats of *Falcon Crest*. This means that the Most Beautiful Woman In The World is invariably The Most Invisibly Nosed Orange Woman From 1972. The young Judith Chalmers, with judicious use of the rack, would have walked it.

But she's doing far better reviewing all-in over-fifties Mediterranean cruises on UK Living. Because, unless you want to bed George Best – a prospect only slightly grimmer than that of having to wash, comb and bring him round beforehand – the benefits of being the Most Beautiful Woman In The World seem to be negligible. I mean, you just don't see Miss World around, do you? She doesn't seem to be able to get in the obvious stop-off places for your D-list celeb – *OK!* magazine, the Met Bar, round the late, lamented Supernova Heights. Not even the launch party for a Simply Red album, surely the natural habitat for draggy-looking blondes.

There hasn't even been a *Miss World* docusoap which, in 1999 terms, is really rough. Traffic wardens are into their third series, and can get a spread in *Bella* any time they want. The scientifically proven Most Beautiful Woman In The World, however, as deduced by a computer operated by Eric Morley and Eddie "I bedded Ronan Keating's wife" Irvine, can't even blag on to any other Channel 5 programme, not even *Fort Boyard*.

Of course, it's this loser element that actually makes *Miss World* the finest bit of hardcore feminist propaganda ever conceived. Our mothers weren't lying to comfort us, they were actually telling us the truth: being the most beautiful woman in the world gets you nothing. Absolute sweet Fanny Adams. You can strive all your life to eat very small amounts of the right things, do your roots every two weeks, have a full Brazilian bikini-wax, show your bottom to two billion people and – nothing. No Hollywood. No modelling contract. No Mick Hucknall. Just a couple of excited Taiwanese businessmen faffing around on your doorstep, and a year of doing charity work in a polyester sash. I'd rather win Crufts.

" YOV SAY YOV HAVE REASON TO BELIEVE YOVR LIFE IS IN DANGER "

Chocolate racing car comes to sticky end

A CHOCOLATE replica of a Formula One racing car has been smashed hours before it was to become the star attraction at a London exhibition. Disaster struck as the full-scale 1,300lb chocolate sculpture, which took 400 hours to craft and was worth £40,000, was transported from France to Britain in a lorry. When it arrived and the doors were opened, the organisers of the International Festival of Chocolate were left staring at piles of bite-sized chunks. Rene Dee, the festival's organiser, said: "It's a disaster." The car was unique, he said. "It's an exact copy of Alain Prost's Formula One car." It was made using the moulds used to build Prost's car. The car's creator, the Paris-based Pascal Guerreau, was told of the disaster after flying from France to London yesterday for the exhibition. He was aghast. Organisers of the festival at the Royal Horticultural Halls in Westminster beginning today, are hoping to rebuild the prize exhibit during the event. M Guerreau will work in front of visitors to the festival to recreate his masterpiece from pictures and a car parked next to it. Luckily, the sculpture is not made out of edible chocolate, so there should be no pieces missing.

'Pagan' carols lose their Christian base

CAROLS HAVE nothing to do with Christmas or Christianity and are in fact pagan in origin, according to a book published today.

Although it would seem now impossible to celebrate Christmas without them, even their name derives from the Greek *choros*, a circling dance associated with fertility rites, according to the book's editor, the Rev Ian Bradley.

Many carols have come down from a medieval tradition of wassailers going from door to door, singing and drinking a potent brew to the health of those they have visited.

But most have lost their original wording, having been rewritten this century "to wit the demand for social realism and political correctness", he says.

One modern carol, written by Michael Forster, a Baptist minister, even portrays Mary as a "blessed teenage mother".

Mr Bradley criticises contemporary efforts to rewrite carols to eliminate overtly Christian or "gender-exclusive" language. "With the arrival of the politically correct, multi-faith carol, purged of any reference to men, Christ, cribs or angels, we have come back to where we started – with carols disconnected from Christmas or Christianity," he said.

According to Mr Bradley, a lecturer at St Andrews University, one of the most popular carols, *O Come, All Ye Faithful*, often used as the final hymn at Midnight Mass on Christmas Eve, in fact started life as a Jacobite hymn lauding the Roman Catholic Stuart cause.

"Stuart ciphers on the manuscript have led some historians to speculate that the carol may have been intended to rally Jacobites in Britain on the eve of Bonnie Prince Charlie's rising," Mr Bradley said.

He argues that *Away in a Manger*, Britain's second most popular carol according to a 1996 Gallup survey, is one of the most unscriptural carols of all. Instead, it is closer to the "gnostic" heresy, which denies that Jesus is fully human, because the carol asserts that He did not cry.

Deck the Hall with Boughs of Holly is a translation of a Welsh dance song sung on New Year's Eve, when merrymakers would dance in a ring around a harpist.

God Rest You Merry Gentlemen and *Good Christian Men, Rejoice* are examples of carols that have suffered by being purged of gender-specific language.

Mr Bradley said: "Born out of late medieval humanism, carols were suppressed by Puritan zealots after the Reformation, partly reinstated at the Restoration, sung by Dissenters and Radicals to the distaste of the established Church in the 18th century, rediscovered and reinvented by Victorian antiquarians and romantics."

Ruth Gledhill

Carey's doubts over tough angels with licence to thrill

TRADITIONALISTS in the Anglican Church are bristling at a nativity play being staged in the Archbishop of Canterbury's diocese which portrays angels as black-clad Bond-style special agents.

Forty teenagers are rehearsing the play, *Secret Angels*, which puts a contemporary twist on the ancient tale of Christ's coming by turning it into Operation Emmanuel. The interpretation is modern, the story traditional, but Lambeth Palace has expressed concern that it may be an advent too far.

"There are quite a few people who have expressed concern that all this is a little bit over the top for a nativity play; it is without doubt the most unusual nativity play I think has ever been staged anywhere," a spokesman for the Canterbury diocese said last night. "I can confirm that the archbishop has expressed his concern."

The play's director has a villainous real name every bit as Bond-like as the fictional Rosa Klebb. Alis Vile, 37, a mother of two and a regular churchgoer, last night defended the production, which is being staged in St Mary Bredin Church, Canterbury, on December 19 to raise funds for the Oasis Trust, a charity for the homeless.

"It is retelling the traditional nativity story with a little more prominence given to angels to give them a better press; it's not exactly radical theology," Mrs Vile said.

"People should realise that angels are not fairies; the Bible makes it clear that they are carrying fiery swords. Angels are not the tutued and tinselled little cherubs of most nativity plays, but God's warriors."

Mrs Vile denied earlier reports that the angels would be brandishing imitations of the Walther PPK automatic pistol that was Bond's firearm of choice. "There was a suggestion that the angels should be armed like 007, but there will be no gun-toting on stage; the recent sword incident at a Catholic church in London would make that very inapproporiate," Mrs Vile said.

Phil Cansdale, 26, curate at St Mary Bredin, supported the play. "The Christmas story told in a modern way engages people; it brings relevance to the story in an age when many people are saying the Church is irrelevant."

Alan Hamilton

Restless in Seattle

Mike Hume

WHEN KARL MARX suggested that capitalism would create its own gravediggers it seems unlikely that he had in mind a motley collection of individuals dressed as turtles and butterflies, jigging around with giant inflatable dolphins to the beat of native drums, whose slogans ranged from "Barbie Kills" and "Trust Jesus" to "Free Tibet" and "Go Vegan" and whose aims were apparently endorsed by the President of the United States. The "demonstration against capitalism" in Seattle (and its runt offspring in London), staged during the World Trade Organisation conference, captured well the degraded state of radical politics at the century's end.

As the face of faceless multinational capital, with a Director-General who looks as if he personally put the fat in "fat cat", the WTO makes the perfect Bond villain against whom a global diaspora of the disaffected can vent its frustrations. Protest organisers claim that the wide range of issues raised shows their movement's strength. In fact, those who protest against everything end up challenging nothing in particular. The disparate demonstrations against capitalism represented more of a general moan about life than a movement to change the world.

For many of the protesters this kind of gesture politics is primarily an exercise in self-flattery. Those who claim to speak for the masses often end up expressing a kind of exclusive moral elitism. Their message is that "I am a better person than you", because they don't eat at McDonald's, or buy clothes from stores with politically incorrect names such as Banana Republic, and they were once pushed by a policeman.

A century is a long time in politics. At the start of the 20th century anti-capitalists wanted to go beyond the best that the market economy could offer to build on the achievements of capitalism and raise productivity further. By contrast, the Seattle protesters' basic complaint was that capitalism has gone too far, too fast, and that economic growth should be reined in. One does not need to be a fan of the WTO to see that developing nations need to develop, and that the alternative on offer from these backward-looking anti-capitalists is even worse than that which they attack.

For all of their talk about protecting the world's poor, many of the *fin de siècle* anti-capitalists' proposed measures of environmental protectionism would hit Third World economies hardest. Whatever the intention, their approach ends up endorsing a new neo-colonial division between the moral West and the immoral rest – or, as the boss of the American Teamsters union put it, between "good citizens of the world" such as the US, and "these renegades" with their "low standards". Many who complain about the global domination of the WTO applauded Nato's air war against the "renegade" Serbs.

If this is what anti-capitalism has become it poses less of a threat to the powers that be than at any time over the past two centuries. So, while President Clinton proclaimed that the critics should be inside the WTO conference, the media treated the protesters in fancy dress like teenage hero turtles, and even the Seattle riot cops put on the nearest thing they have to kid gloves. Those who tried to compare the Seattle state of emergency to the repression of past civil rights and anti-war protests might recall that the National Guardsmen sent to pacify American campuses in 1970 used not rubber pellets but live ammunition. Those protests were sparked by the decision to send US forces into Cambodia. If Washington invaded South-East Asia again, it would probably have the support of today's anti-capitalists – so long as the President pledged to use the napalm and Agent Orange to end unsustainable logging.

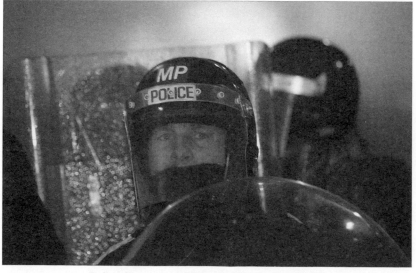

Police face up to anti-capitalist demonstrators

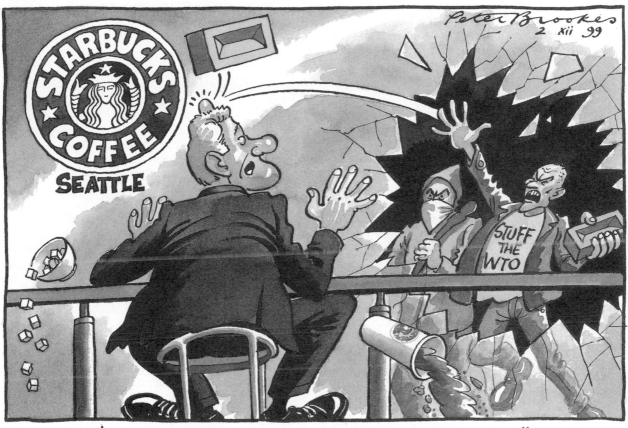

"ONE LUMP OR TWO, MR. PRESIDENT?"

ENUF e-mail lingo, AOK?

IT'S ENUF 2 LV U 8UP. IJMHO bt EMSG R GM&M diff 2 R BTD, IYKWIM

OR, FOR THOSE of you who have not quite got the hang of this e-mail thing yet, I was trying to say: "It's enough to leave you all ate up (crazy). It's just my humble opinion, but e-mail messages are getting more and more difficult to read by the day, if you know what I mean."

With hundreds of millions of e-mails zipping back and forth every hour, the speed of cyberspace conversation has accelerated so rapidly that fingers blurring across keyboards are seeking ever quicker and more truncated ways of communicating.

The result is the emergence of an e-mail lexicon that can sometimes take considerably longer to translate than it does to write.

The medical and legal professions, the Defence Department and technical fields have always had their jargon. But the Internet is creating a universal language of economy, and it is evolving so fast that some of us need help in keeping up. To this end, a California company has compiled a dictionary (www.chatdictionary.com) with 1,358 terms.

Many of the acronyms seem simple

enough. It is just remembering them. I scribbled down examples for inclusion in this piece, certain that they were obvious. But staring at my notebook now I can't begin to figure them out.

Others are bizarre, but apparently essential when chatting with American teenagers. If one tells you IJASKAW, he or she would "just as soon kiss a Wooky". WTMPI is a warning: "Way too much personal information."

Just be aware that some terms can have more than one meaning.

AOK? C U L8R. TTFN.

Damian Whitworth

Blair well covered in region of doubt

Tony Blair came North promising to bury regional stereotypes. But he came prepared

AT ALMOST the moment that the Prime Minister's Jaguar crossed Manchester's city boundary, the rain came. By the time that he went walkabout in the city centre, it was teeming down.

A giant canopy of umbrellas appeared from nowhere as the prime ministerial entourage strained to keep Mr Blair dry. Little wonder that the crush of Mancunian shoppers pressed forward, keen to shake his hand.

The episode may have been a triumph of forward planning but it hardly helped the Prime Minister in his efforts to persuade Britons to cast aside the crude regional clichés that hang over different parts of the country.

Mr Blair's aim on a two-day visit to Manchester and Liverpool is to illustrate that the difference between rich and poor in every part of the country is as significant as the economic and social diversity between regions themselves – the North-West divide rather than the North-South divide.

Although the day started in Chester, the Prime Minister may as well have landed in a slice of corporate America. The Maryland Bank of North America, which has its European headquarters on the city outskirts, is a company where the staff chant "good morning" in unison when the boss bids them the time of day.

As the Prime Minister was given a short tour of the building, he noticed the exhortation "think of yourself as a customer" above every door frame, even the one into the lavatories. The bank was announcing up to 1,000 new jobs and was congratulated by Mr Blair for its contribution to Chester's economic growth.

From there he crossed one divide, passing through Manchester's poorer outskirts, before crossing another into the thriving city centre.

Alongside Lord Macdonald of Tradeston, the Transport Minister, Mr Blair took the inaugural tram-ride through the new Metrolink station at Salford Quays.

A few brief remarks were delivered from the safety of a passenger shelter before the Prime Minister stunned onlookers and security guards by jumping down from the platform to cross the tracks and pump hands with onlookers on the other side. Bridging the divide indeed.

> As the Prime Minister was given a short tour of the building, he noticed the exhortation "think of yourself as a customer" above every door frame, even the one into the lavatories

"Stay off the tracks, please," a Metrolink employee implored hordes of pursuing cameramen, which seemed slightly unfair as they were only following the Prime Minister's example.

Mr Blair's journey threatened to hit a rough patch when he submitted himself to questions from callers to a phone-in on Greater Manchester Radio. Clare, from Bury, was one of several suspicious of his attempts to recast inherited wisdom on the North-South divide.

She did not like the suggestion that pockets of poverty in the South may be in line for government help when it should be addressed to large swaths of the North.

Mr Blair made clear that he wanted to help the less well-off wherever they were rather than picking and choosing according to their postcodes.

A short speech at Manchester Town Hall was followed by the wet walkabout in the city centre accompanied by Mo Mowlam, as of yesterday Mr Blair's new "poverty czar", a shrewd appointment given her popularity with Labour's core voters who may be suspicious that Mr Blair's brand of One-Nation politics means a bit too much cuddling up to Middle England and not enough targeted help to traditional heartlands.

Despite the purpose of his visit, regional disparities do not appear to be focusing the mind of most of the crowd. Mr Blair was besieged with questions about his wife's wellbeing and congratulations on her pregnancy.

The Prime Minister even managed to break into a few sentences of French and Italian as he greeted tourists before giving in to the shouted demands of hard-hatted builders up nearby scaffolding with a wave.

Despite Manchester living up to its reputation for rain, there was optimism among the Downing Street party that Mr Blair's message of a country united rather than divided was not lost after all.

It was a grim day down South, too.

Roland Watson

Writers score

TWO *TIMES* writers appear in a list of the 100 names that shaped football, published in January's *Match of the Day* Magazine. Matt Dickinson was placed 83rd and Danny Baker, the columnist, 86th.

Elizabeth Gaskell got there first – courtesy of Charles Dickens

ELIZABETH GASKELL originally wanted to entitle her 1854 novel of contrasts between the satanic mills of Manchester and the country life of Hampshire *Death and Variations*. But the editor of the weekly magazine who had commissioned it wanted something snappier and, frankly, more cheerful.

Household Words, a popular journal of the time, liked Mrs Gaskell's plot of the gradual entanglement of the southern country girl Margaret Hale with Nicholas Higgins, a humble toiler in a northern factory. "Why don't you call it *North and South*?" suggested the editor, a sharp-nosed populist hack named Charles Dickens.

Mrs Gaskell did not invent the phrase "North-South divide", but she launched the concept into popular Victorian literature. Her aim was not division, but understanding.

"Mrs Gaskell understood that the divide was not as great as most people of her time thought," Dr Kate Flint, Reader in Victorian literature at Oxford University, said yesterday. "She knew that there was both hardship and economic growth at each end of the country, and she knew that there had to be an understanding between social classes. At the time she was writing, there was great agricultural depression in the South of England. Not all the ills were in the industrial North."

In *North and South*, the Hampshire country girl tells the northern mill hand, who thinks his salvation would be to move to the rich South, that his kind "would be labouring from day to day in the great solitude of steaming fields, and never stopping or lifting up their poor, bent, downcast heads".

Higgins gets the message. "North an' South have each getten their own troubles," he concurs, having learnt a little of the brutality of southern rural life. The North, he concludes, may not be all bad.

England has had its North-South divide since at least Roman times, when a line in Northumberland separated colonised and settled Britannia from the wilder frontier provinces of the border. Later, Scandinavian invaders held the Danelaw of the North and East against Mercia's more settled Anglo-Saxons.

Even William the Conqueror wrestled with a divided land, appointing the prince-bishops of the Palatinate of Durham to deal with the rowdy northerners as best they could. Only in the time of the Industrial Revolution was the North patently in the ascendant, but that did not last long.

George Orwell made much of the divide, and in 1927 even Winston Churchill, perhaps in an early rehearsal for his 1946 Iron Curtain speech, noted that different conditions seemed to prevail north of a line drawn from Cardiff to Hull.

However, neither Orwell, Churchill, nor Mrs Gaskell appears able to lay any claim to have invented the phrase "North-South divide". Its origins do not lie in England at all, but in the wider global debate between rich and poor nations.

The phrase first gained wide currency about 1975, at the time a world trade conference was held in Paris to debate the gulf between the rich Industrialised nations of Europe and North America (the North) and the poor underdeveloped nations of Africa and Latin America (the South).

Alan Hamilton

The sexiest of Midsummer dreams...

MY FIRST experience of *A Midsummer Night's Dream*, like that of thousands of others, was of cute Mendelssohnian sprites prancing around Regent's Park sward and a Titania who received Bottom rather the way a tactful Mayfair hostess might cope with a guest in an unsuitable wig. If they had cut as loose as Josette Simon and Daniel Ryan at the Barbican, my mother would have removed me at half-time, as several primary school teachers reportedly removed their charges when Michael Boyd's production was staged at Stratford last spring.

The revival is not for eight-year-olds, but it boldly and brilliantly restores sex, excitement and danger to a play that can be bland and staid. Mark you, this is not what those embattled teachers must have expected when the lights rose on a bare stage, a curved beige wall, and a respectful circle of Athenians in fur hats and black overcoats. Theseus's courtiers look as likely to run amok as visitors to Lenin's tomb on one of the Soviet Union's high and holy days.

But then poppies sprout from the floor. Aidan McArdle's Philostrate, a bowler-hatted blend of mortician and Kafka clerk, is transformed into Puck, a lascivious, subversive mix of tramp and clown. Nicholas Jones's Theseus abandons his evangelical-preacher look to become a stealthy Oberon with a tattooed skull and a bare chest. Simon's elegant, aloof Hippolyta transmutes into Titania, complete with long, lissom limbs, feathery hair, fierce grace and irresistible charisma.

It is hardly the first time a director has suggested that Shakespeare's fairyland is a therapy centre in which human super-egos confront the

repressed ids beneath, but Boyd brings a rare fullbloodedness to the idea.

This approach reaches, well, several climaxes with Ryan's hirsute Bottom jubilantly humping Simon's orgasmically writhing Titania as their bed rises above fairies who themselves look as they have just tottered out of a rave. And there is plenty of sinuous fondling and leggy squirming to come.

The grey-suited mechanicals could be more fun, although their version of Pyramus and Thisbe, with Peter Kelly's ponytailed Quince transformed into a Shakespeare lookalike who presides over actors in Elizabethan costumes, proves as original as almost everything else. Puck does not merely pour magic juice into people's eyes, but gleefully throws earth over them, sticks flowers in it, and sprays them with a watering-can. That partly explains why the production's refreshingly robust lovers end up looking like muddy, tattered low-lifers just emerged from a punch-up on the *Jerry Springer Show*.

The physical volatility of the acting adds meaning to the ending, too. It is not a conventional dance that follows Pyramus and Thisbe. Everyone in Athens, from Theseus to Snug, clatters about with a verve that even Zorba would have found too anarchic. People have discovered the fairy in themselves. Those midsummer fantasies have produced a new human wholeness – and it's terrific.

Benedict Nightingale

Vulcan fails to quell the swamp creature

SO HE IS a Vulcan. It was a top Tory spin doctor who gave the game away - unwittingly. Privately, she was preparing journalists for a muted performance by John Redwood as he prepared to open the attack on the Deputy Prime Minister in yesterday's Opposition Day debate.

"Redwood's been ill," she confided. "Over the weekend, he was running a temperature of 110 degrees fahrenheit."

As *The Times*'s Dr Thomas Stuttaford has confirmed to this sketch, no human runs a body temperature like this. I rang my Vulcanologist.

"Vulcans do succumb to fever, and it's intense," he explained. "It's called pong-fah and brings on a kind of hot-blooded madness, which is very distressing to a Vulcan. It occurs once every 40 or 50 years."

The moment Mr Redwood entered the Chamber, it was clear that pong-fah was upon him. This was lucky for jet-lagged John Prescott, who himself seemed to have caught buffalo-fever in the Indian rice-paddies and was bellowing a lot.

Redwood was even worse. The Tory Vulcan simply cannot do aggression, and should not try. It is hard to say which was more chronic: the personal attacks on Prescott ("from Jags to riches"), the rhetorical flourishes

Matthew Parris

Parliamentary
Sketch

("motorists fleeced at the pump") culled from Redwood's trusty Earthling Speechmaker's Companion, or the dissection of transport policy. To declaim "When will there be action on the Welwyn viaduct?" with conviction is more than human – let alone Vulcan – flesh can manage.

So Prescott's opening line "I don't think your speech was worth coming back from India for" worked well. Unfortunately it was all that did.

Like something trying to climb out of a swamp, the Deputy Prime Minister floundered all over the place. Recording "Prescottisms" (those sad casualties of the Secretary of State's friendly fire on his own syntax) is becoming tedious, so we will restrict ourselves to suggesting that Mr Prescott's joke – "of all the trees in the world, the dentist is the Redwood" – may have muddled "densest" with "dentist"; to proposing that "vote of no conference" gains intelligibility if for "conference" we substitute "confidence"; to remarking that "I want to take it out of that political football" might better be rendered "I want to stop playing political football with it";

and to wondering what is meant by prefacing a announcement to a House in full session, with the phrase "tomorrow I'm going to announce that …".

Prescott survived not so much through lucidity as by making a confident noise. New Labour poodles had been packed in to cheer him, and fitfully did.

Nobody won. Labour versus Tory spats these days resemble those circus-ring battles between teams of clowns, in which the two teams never quite lock horns, having tripped up on their own shoelaces, assaulted their own neighbour or punched themselves in the head by mistake.

Exit the clowns. Or so we thought. Then Michael Portillo rose for his first speech as Member for Kensington and Chelsea. He had carried in with him something weird in a plastic bag, which he now brandished. It was an inflatable portable pillow, he told surprised MPs, imported from Australia, trademarked "The Portillo".

To our amazement, the by-election victor then read out the label. "Portillo for unrivalled comfort. Portillo for ease and convenience. 1001 uses … Grab Portillo in right hand; insert thumb into opening and grip firmly; inflate it to its full size and shape."

This, honestly, is what he said. Pong fah – or what?

Panic – moi? Never

Jane Shilling
...............................

THE COUNTDOWN to the Millennium calendar hanging on the kitchen wall says there are 24 days left to the end of the year – which means the shopping days before Christmas are slipping away at an alarming rate.

I have not bought a single present. I made a half-hearted expedition to Oxford Street earlier this week but it wasn't really shopping weather. I was still bracing myself for that inimitable Christmas blast of hot, scent-laden air and tinkly festive Muzak that comes belching towards you as you push your way into the hard, bright light of the department stores when it began to rain, providing the perfect excuse for a retreat to the top of a No 73 bus, from which I looked down in dismay on the heads of the shoppers milling below, rolling this way and that like pebbles on a stormy beach.

I haven't exactly been ignoring the approach of Christmas. All year, at junk shops, craft fairs and WI stalls, I have been picking up bits of this and that and stowing them in the disorderly glory hole in Alexander's room known as the present cupboard. At the start of Advent I sorted out this magpie collection – a tangle of necklaces in Venetian glass, strung on illusion wire; some brightly patterned purses woven from tiny glass beads; fluted white porcelain baskets with gold-painted handles – the very thing, I thought in July, for holding the first season's snowdrops; and so on. Every object, when I bought it, had a particular magic: the potential to give this friend or that a moment of pleasure. But their long stay in the cupboard had taken the bloom off them. They seemed suddenly tawdry. I couldn't imagine giving them to anyone.

So this is why I am starting from scratch. Apart from the family and my strong-minded goddaughter, whose tastes are as clearly formed and peremptorily expressed as those of the late Diana Vreeland, though she is only four, I have a dozen friends to buy for, of both sexes and varying ages, all with pronounced and idiosyncratic tastes completely at variance with one another.

Am I panicking? Nah. I have adopted the approach to Christmas shopping of the Bertie Woosterish subalterns you see ambling around Peter Jones and the General Trading Company at 5.55pm on Christmas Eve, gloriously unperturbed by the fact that they have five minutes in which to find presents for their mother, sister, girlfriend and dear old nanny. "Never hurry, it only panics the men," seems to be their motto. And I am determined to make it mine. I have experimented before now with a rigidly organised approach to shopping. Last year I bought everyone cashmere gloves from N Peal, on the ground that I would be pleased if someone bought a pair for me. But they were received with such different degrees of rapture that this year I've reverted to a more personal approach. My mistake in the past has been to succumb, under that panicky sensation of a metal band tightening around your head as Christmas Eve draws closer, to making ineffectual lunges at the problem. This time I am creeping up on it from an obliquer angle.

Presents for men I shall leave until next week. They are much more difficult to buy for than women because they claim to be completely uninterested in acquiring more stuff (to hear them talk you would think they had taken monastic vows of poverty).

Women, on the other hand, seem to have a much less furtive and emotionally complicated relationship with things. We are pleased by prettiness, charmed by a grand label, but also disarmed by evidence of effort having been made. Every Christmas I find myself harbouring a clutch of what the American writer Betty MacDonald, in *The Plague and I*, brilliantly identified as "toecovers" – inscrutable items conforming to neither of William Morris's dicta about beauty or usefulness, to which I nevertheless feel some sense of obligation or pity, because they represent the love of someone I care about. The reverse of the rule applies, too. Nothing chills the heart like a present that comes swathed in efficient shop gift wrapping, with the unmistakable air of having been ordered in bulk by the donor's beleaguered secretary.

My new theory of shopping for women is to divide them into four psychological types. Anyone who isn't a Fairy Princess, Cinderella, Minimalist or Bohemian is probably eccentric enough not to give too much trouble when it comes to finding her Christmas present.

Perfect timing

From Mr Martin Turner

Sir, Has consumer labelling gone too far? In Sainsbury's recently I saw Christmas trees labelled "Ideal for Christmas".

Your obedient servant, Sir,
MARTIN TURNER,
9 The Hill,
Northfleet, Kent DA11 9EU.
December 14.

Lumberjacks urged to discover sensitive side

IF YOU'RE a lumberjack and you're not OK, then you need to get in touch with your inner soul, according to a new management philosophy in the US timber industry. It is bringing touchy-feely self-analysis to the burly world of the American woodsman.

Disagreements between lumberjacks have traditionally been settled with a lump of two-by-four and some choice epithets, but at the Louisiana-Pacific timber mill in Houlton, Maine, management has begun an "enriched business environment programme" to encourage timber workers to "take responsibility for their feelings" rather than beat each other to pulp.

"What we're doing is freeing up the human spirit," Mark Suwyn, chief executive of Louisiana-Pacific, the biggest producer of plywood substitutes, said. "If you give workers the chance to talk about their vulnerabilities, you're in a better position."

Under the Rapid Change Technologies philosophy, employees are encouraged to foster "team-building skills" and "emotional intelligence", and to practise the "two-for-one rule of criticism", in which an admonition is accompanied by two words of praise. Shouting is out; hugging is in.

In the past, as memorably lampooned in Monty Python, lumberjacks were a byword for hirsute machismo, expected simply "to sleep at night and work all day". Some American timber workers have found the transition to a more sensitive "caring-and-sharing" culture rather a shock.

When Gerry Nason, the Houlton plant manager and an army veteran, was told that the mill was being "socially engineered" to encourage greater sensitivity and dialogue among staff and management, he concluded: "The bosses have totally lost it."

Until now, Mr Nason said, his management technique to encourage productivity had been based on screaming.

The old days when lumberjacks were expected to be rough, tough and primitive were "reptilian", according to the jargon of the new approach. It encourages the beefy, tartan-shirted workers to get in touch with their "nurturing, mammalian brains". Monty Python revealed the rich and complex interior life of the American lumberjack; now, at long last, he is free to express it in the workplace.

Ben Macintyre

Full groan

From Dr John H. Greensmith

Sir, Martin Turner (letter, December 15) is absolutely right to be concerned about Sainsbury's Christmas trees labelled "Ideal for Christmas".

The case should be referred to the Office of Fir Trading.

Yours sincerely,
JOHN H. GREENSMITH,
36a North Street,
Downend, Bristol BS16 5SW.
December 14.

From Mr David Himsworth

Sir, Dr John H. Greensmith suggests (letter, December 17) that the matter of the Sainsbury's Christmas trees labelled "Ideal for Christmas" should be referred to the Office of Fir Trading.

We will be happy to advise on the subject if he writes to our branch office at the address below.

Yours faithfully,
DAVID HIMSWORTH (Director),
Fir Trading Ltd,
Hanging Hill Farm,
Kennythorpe, Malton,
North Yorkshire YO17 9LA.
December 17.

Joanna Coles
in New York

WHAT HIGHER recommendation for the authenticity of *The Sopranos*, the brilliant TV series about the modern Mob (starring James Gandolfini as a troubled don suffering from anxiety attacks) than from mobsters themselves?

Secret FBI tapes released to a Manhattan court last week revealed a bunch of New Jersey Mafiosi discussing the show and poring over plotlines for mentions of themselves.

Scalfani (a minor member of the notorious DeCavalcante family): "Hey, what's this (expletive) thing *The Sopranos*? What the (expletive) are they?

Ralphie (an informant): "You ever watch it?"

Scalfani: "Is that supposed to be us?"

Rotundo (DeCavalcante captain): "You're in there. They mentioned your name in there. Every show you watch, more and more you pick up. Every show." (He goes on to mention a restaurant featured in the show.) "It's supposed to be Sacco's."

Scalfani: "Is it?"

Rotundo: "They always sit outside."

Billy: "I'm telling you, you gotta watch."

Scalfani: "You gotta watch."

Rotundo: "Aren't they funny? I'm telling ya. You ever watch that? What characters. Great acting."

David Chase, the writer-director (whose family name was shortened from De Cesare by his grandfather), says, suitably gnomically, that the show's authenticity comes from "hearing things from people who know people".

TWO THOUSAND YEARS

A millennial journey from Bethlehem to cyberspace

The turn of the key on a thousand years in the human calendar is itself an invention of the human brain. None of us would consider ourselves to be entering the year 2000 had not a 6th-century Scythian, Dionysius Exiguus, conceived the idea of the *anno domini* calendar which took its date from the birth of Christ. We would have entered the next millennium about four years ago, had he not got the date of the Nativity wrong; and we would be celebrating it next year, except that in Dionysius's day, the concept of zero had not yet entered mathematics and he began with one. The Venerable Bede, who detected that error a thousand years ago in his *De Temporum Ratione*, sensibly decided that the emotive power and practical uses of the concept – which the most rigorous humanist would have to admit was an improvement on the Roman system of counting backwards – were more important than strict accuracy.

Bede was right. Humankind needs its common markers and the dullest imagination will stir all over the world as, in a fortnight, the stroke of midnight ushers in, by popular reckoning, the third millennium AD – and the seventh in known human history. It is a figurative scraping of time's tectonic plates across cultures and civilisations. It awakens a sense of myth, demands its reckonings, invites perspectives on the grand sweep of history and excites curiosity and anticipation as well as the streaks of Spenglerian or apocalyptic gloom that speak to millennial anxieties.

Between now and January 1, *The Times* will make its own necessarily selective survey of influences that, over 2,000 years, have shaped our societies, our minds and our prospects today. Christ was born into a world where, in most societies, the great majority of men and almost all women were illiterate, where demography, natural resources and military organisation were overriding factors in the competitive position of nations or empires. The diffusion of learning, the most remarkable phenomenon of the ensuing centuries, has profoundly changed the ways that power is held and projected, prosperity forged and the human spirit nourished. As we follow the centuries two at a time, therefore, we have chosen to concentrate on major inventions or revolutions in thinking that have altered the ability of individuals or nations decisively to influence the rest of the world through ideas, machines, exploration or – by means undreamt of by an Alexander the Great – through warfare.

These markers can be as momentous as Christianity, whose dawning we survey on Monday, or as humdrum in today's thinking as soap, the conceptual ancestor of inventions that, many centuries later, were to revolutionise surgery. They can be as simple as the stirrup, which spurred Turkic armies across the Asian steppes into the Middle East and prefigured the technology of highly mobile warfare, or as the deceptively obvious concept of zero, a product of Arab mathematical

skills at a time when Christendom was deep in the miserable insecurities, even if not the utter darkness, of the Dark Ages.

Originality lies in social organisation as much as in tools; Iceland takes the palm for devising constitutional democracy, with the Althing which first met in AD 930. In England a century later, it was the keeping of records in the Domesday Book that made feasible organised taxation of the feudal world – but which also contributed indirectly to the demise of the feudal system, by prompting demands that the taxing power be held publicly to account. Social organisation has altered more than the political landscape; when the great princely palaces and merchant houses began to displace the fortified castle and rival the magnificence of ecclesiastical architecture, there arose the patronage of the arts which bequeathed to us the art and architecture of the Renaissance.

These centuries were the worlds of elites in which the poor, vivid though they may seem to us in the Bayeux tapestry, books of hours or the capitals of Gothic cathedrals, were poor also in memorials. But that was to change dramatically when – four centuries after the Chinese tried out movable type – Gutenberg invented the printing press. Vernacular literatures came into their own and, because knowledge was shared, power began increasingly to be shared too. An essential foundation for the nation state, whose origins in the Treaty of Westphalia of 1648 we

examine, was laid. And, as scholarship spread more effortlessly across frontiers and the ecclesiastical taboos that constrained a Galileo weakened, modern science came into its own.

A great surge of energy flowed into physics, chemistry and the discovery of a universe of mechanistic laws. The interval that separates us from Mendel, great-grandfather of the mapping of the genome, or between the publication of Darwin's *Origin of Species* and the cloning of Daisy the sheep, is a mere blip on the 2,000-year historical map, yet in this brief space of years, humankind has rushed through industrial, and now post-industrial revolutions.

With science, "time gallops withal". Yet 2,000 years ago, the three wise men who navigated to Bethlehem by the light of a singular star were familiar with the constellations as our neon-lit and increasingly urbanised world, for all that man has walked on the moon and probed the secrets of Jupiter, no longer is. This millennial generation cannot contemplate the distances crossed since then without sharing the humility of those ancient travellers before the marvellous, strange and new.

Anti-cat software

FOR THE computer geek who has everything: anti-cat software. This will prevent your cat from sending offensive e-mails or downloading porn by "analysing key-press timings and combinations to distinguish cat typing from human typing".

Grace Bradberry
in Los Angeles

Lara Croft joins The Times

PETER STOTHARD, Editor of *The Times*, has appeared in print for much of his life. Today he is appearing in pixels, opposite a digitised heroine of worldwide renown and fearsome reputation – Lara Croft, virtual star of the *Tomb Raider* games.

From today *The Times* launches an exclusive level of *Tomb Raider* beginning in the offices and labyrinthine archives of the newspaper, and featuring Mr Stothard himself. *The Times* is the first national newspaper to team up with a computer game in such a way and has come up with a unique special edition adventure for its readers.

Appearing in a full motion video (FMV), Mr Stothard appears in his office in Times House, briefing Ms Croft about a new adventure. Hitherto undiscovered tunnels have been found in Tutankhamun's tomb by *The Times*'s Egyptian correspondent. Can Ms Croft help to explore the tomb?

To enter the realm of computer games, Mr Stothard had to have photographs taken of his face, which were then digitally mapped and affixed to a blank computer character.

A voice studio in London's West End was hired to record his dialogue. Thus the face you see and the voice you hear on the *Times* level are a dead ringer for the Editor. The game will show Ms Croft and Mr Stothard studying the Times reports of the discovery of Tutankhamun's tomb.

She delves into the archives to look up the original notes of Howard Carter, the archaeologist who found the tomb, then reported his findings exclusively to *The Times* throughout the 1920s. Suitably prepared, Ms Croft travels to Egypt to tackle fiendish puzzles and to battle deadly foes as she discovers the hidden recesses of the pharaoh's tomb.

Adrian Smith, operations director at Core Design, believes that the level "combines the appeal of *The Times* with that of Lara Croft" and should

give even seasoned Tomb Raider players two or three hours of brain-teasing adventure.

The real Peter Stothard says: "I never thought I would feature in a computer game but this proves that on the Internet absolutely anything is possible."

George Pendle

Open door policy?

From Mr Howard Self

Sir, I have reluctantly come to terms with a "Bob the Builder" Advent calendar, but I can't help feeling that "Action Man" and "Match of the Day" Advent calendars send out a rather confused message.

Yours faithfully,
H. J. SELF,
68 Fountain Street,
Manchester M2 2FB.
December 1.

WISE MEN...

Peter Brookes
20 xii 99

Christmas Cheat

Henry Harris

VACHERIN Mont d'Or from the south east of France has a rich alpine creaminess that borders on the sinful.

A good bottle of red wine and a fresh baguette are all that are needed to enjoy it. This week it is me that has really cheated as I lifted and adapted the recipe from the bottom of the Vacherin box. I didn't think that heating this splendid cheese would do it any favours, but after a quick experiment I have become a convert.

On Christmas Eve, after the final preparations have been done, this is what we shall be sitting down to.

Melted Vacherin Mont d'Or

1 small Vacherin Mont d'Or
1 soup spoonful of white wine
1 small clove of garlic, crushed to a purée
2 generous portions of small waxy potatoes boiled in their skins
A good green salad

Preheat the oven to 180C. Remove the plastic film from around the box of Vacherin. Take off the lid and place it underneath the bottom half of the box.

Make a small V-shaped incision in the middle of the cheese and carefully pull back this flap. Dig a little hole in this area and add the spoonful of white wine and the garlic, then fold back the flap.

Put the box in a small oven-proof dish, place it in the oven and cook for 25 to 30 minutes, or until the cheese is completely liquid. Serve immediately, with the potatoes and green salad.

Henry Harris is head chef at Hush, Mayfair, W1

A tale of two foes

AFTER FIVE weeks of acrimony in Court 13, for the victor and the vanquished it will be a tale of two Christmases.

For Mohamed Al Fayed, Christmas will be spent with family, nieces and nephews at Balnagown Castle, near Invergordon, Ross and Cromarty. The estate was the scene of one of the Hamiltons' undeclared visits in August 1989.

For Mr Al Fayed, a fleet of Harrods lorries will toil north from London filled with food and drink for the festivities. Later, it will be on to Chalet Ursa, his residence in Gstaad in the Swiss Alps, to see in the new year.

The contrast to the scene in Nether Alderley, Cheshire, could not be more stark. For Neil and Christine, it will be the last time that their Christmas lights are on in the Old Rectory, which is now up for sale for £700,000 – and there will be no Harrods hampers.

Tim Reid

" THE LIAR –HE SAID HE'D WIN "

WHAT THEY SAID

MOHAMED AL FAYED

"You can call me Al Capone if you want."
When asked why he uses the prefix 'Al'

"He had discovered the golden goose ... he is someone who would sell his mother for money."
On Mr Hamilton

"Let MI5 and MI6 sue me. Let Prince Philip sue me, then I will go through everything. They killed my son."
On the death of his son, Dodi, and Diana, Princess of Wales

"He took maybe £30,000 in cash ... he's a prostitute, a homosexual."
On Mr Hamilton

"I'm not listening because you talk garbage ... it's none of your bloody business."
To Desmond Browne, QC, when asked about his personal finances

"He is the Ali Baba of deceit."
Mr Browne on Mr Al Fayed

"My Lord, I have finished. Thank you, Mr Fayed. For me, at any rate, it has been a memorable four and a half days."
Mr Browne, on finishing his marathon cross-examination of Mr Al Fayed

ALISON BOZEK

"He took out a wodge of cash and put it into an envelope ... and he scrawled on the envelope Neil Hamilton's name."

THE PARIS RITZ

"What they did in their six days at the Paris Ritz draws back the curtain on their characters and attitude to life. It is a story of uncontrolled greed and unbridled extravagance."
George Carman, QC

"Every single stamp they bought went on the bill."
Mr Carman

"In 1987 it would cost a dog £47 to spend the night and that's before the wretched animal had anything to eat."
Mr Browne on the high cost of the Ritz

"A saint might have turned down the invitation to the Ritz or at least resisted the champagne. He is not a saint but he was not a sinner."
Mr Browne

"We went over the top a bit."
Mr Hamilton on the Ritz visit

"I wish we had never set foot over the threshold of that beastly hotel."
Christine Hamilton

LIONEL BLUMENTHAL, MOBIL'S FORMER TAX DIRECTOR

"There is no doubt in my mind at all we were buying off Mr Hamilton for what he had done."
On the £10,000 cheque sent to Mr Hamilton after he had inquired about the terms of a "consultancy agreement"

NEIL HAMILTON

"But for the devastating impact of Mr Fayed's lies I could have expected to take a front-rank position in the Conservative Party and there is every possibility I would have been in the Shadow Cabinet."

"I'm very happy to exclude from the damages any possibility of being a front bench spokesman. I'm quite happy to exclude that point."
24 hours later

"That's a pack of lies from start to finish."
Denying that he took cash from Ian Greer to ask parliamentary questions

"Save your insults for my wife, Mr Carman. She's more than able to answer for herself."

"The reason I am here today is not because I was corrupt as a minister, but because I wasn't. I could have had cash by the Harrods vanload."

"I did not lie ... the only thing I can be accused of is a lack of candour in extreme circumstances."

"Oh, if I win this action, I think I will be completely vindicated and I will be able to pursue a career in many walks of life."

"You have never hidden your light under a bushel, Mr Carman."

CHRISTINE HAMILTON

"I told him that I had never had, to my knowledge, a Harrods sausage."

"We did not eat four courses of Desperate Dan mountains of food every night. A course may have been a little bit of fruit salad or a sliver of cheese."

"If he had had it, he would have given it to me, because I empty his pockets of change every night."

"There is no way my husband could conceal them ... no vouchers, no money, no collection, no couriers, nothing."

BRIAN DODD, Former Harrods Head of Security

"Mr Fayed, he's the biggest bloody crook in town."

HAMILTON'S BEST MOMENT

George Carman: *"Do you have difficulty in paying close attention to anything you find disagreeable?"*

Neil Hamilton: *"I'm paying close attention to you, Mr Carman."*

HAMILTON'S WORST MOMENT

Mr Carman: *"If, when you answer someone's question with a lack of candour, do you still say you are telling the whole truth?"*

Mr Hamilton: *"It is impossible to answer a question couched in terms of such generality."*

Mr Carman: *"Do you understand the words 'to tell the whole truth'?"*

Mr Hamilton: *"Yes."*

Mr Carman: *"If you answer a question with lack of candour, do you think you have given the truth?"*

Mr Hamilton: *"I find it difficult to give an answer to that question ..."*

AL FAYED'S BEST MOMENT

Mr Browne: *"Are you suggesting that maybe I have paid Mr Loftus? (Bob Loftus, Mr Al Fayed's former bodyguard)*

Mr Al Fayed: *"He will take money from anybody."*

Christine and Neil Hamilton leave the High Court in London after losing their libel case to Mohamed Al Fayed

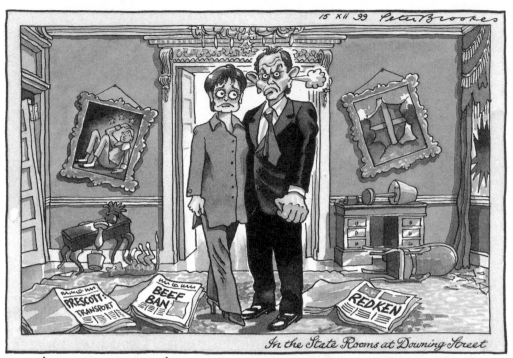

'MORE SEVERE' CARD FOR BLAIRS THIS CHRISTMAS...

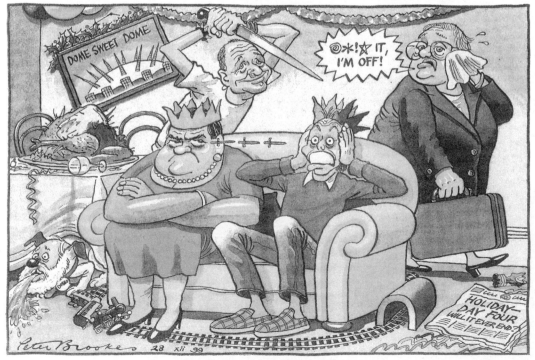

HAPPY FAMILIES...

How to take over M&S in ten easy stages

The takeover of Britain's most famous retailer was once unthinkable. Now the door is open for anyone with the right ideas and right people

 Fraser Nelson

WHAT DO YOU get the man who has everything? Tina Green, wife of Philip, must have had to stretch her imagination to the limit in recent years. But this year, her millionaire, Monaco-dwelling financier husband has something special in mind: the £8.1 billion Marks & Spencer.

In an era in which the City rewards exceptional talent with blank cheques, a one-man bid for M&S – once a laughable dream – is now very achievable. Green managed a £548 million Sears; what's to stop him, or anyone else, going that bit further?

Taking over the great M&S, once an unthinkable heresy, can, in theory, be accomplished by anyone with the right ideas and the right people. Money is no object. Our step-by-step instructions are intended as a little Christmas fantasy game. Nonetheless, it is a game that Green and quite a few other retailers will be playing for real to liven up these cold winter nights.

1 Start bending some highly paid, fee-hungry ears. If you are a loner, you need some serious players willing to listen. Luckily, the after-hours price of these financiers is normally a glass of vintage champagne. No better place to find them than City wine bars.

You can rule out Cazenove and Merrill Lynch, who are advisers to M&S. But most of the rest are for hire. Ideally, choose one capable of raising billions of pounds through the bond market. You will need this to pay off backers later on.

2 Work out what it will all cost. Recent takeovers have seen the initial offer pitched at a 35 per cent premium to the pre-speculation share price.

With M&S, this works out at 337p a share, or £9.7 billion. The final blow is normally a 55 per cent premium to the pre-speculation share price. This means 387p a share, or £11.1 billion. Add an extra 13 per cent for luck and M&S is yours for £12 billion.

3 Can you afford this? Raising the £12 billion – in a mixture of cash, bonds, debt and equity – is no problem. With your advisers behind you, and the City hungry for any form of mischief-making deal, all you need is a telephone and a couple of hours. The real question is whether you can make M&S worth much more than £12 billion in five years' time.

This should be easy. Even on its knees, M&S is more powerful and impressive than many of its rivals. As Gucci has shown, any well-known brand can be revived. M&S is rich in talent and steeped in retail know-how. This is, after all, what you are bidding for – a giant, down on its luck.

Exactly how much treasure a raider can sell off is an important consideration. Some interesting break-up valuations for the property and financial services divisions appeared last week in *The Scotsman* newspaper, owned by Green's friends, the Barclay brothers. We reprint these, with recent valuations from Salomon Smith Barney, the broker. This puts the core M&S retail business at about £2.4 billion.

Remember, your first year of M&S ownership will be the year ending March 2001. Look only at forecasts for this year, which, for UK retail, is £460 million.

If you have sold and are leasing back all the M&S stores and offices, expect new rent bills to shave about £150 million from the profit (landlords will charge about 5.4 per cent of the current book value). Your upper limit is 420p a share. Deduct the 200p a share from the sum of the parts and you will, in effect, be buying the UK retail business for 22 times forecast earnings.

Remember, Green picked up dodgy old Sears for 25 times forecast earnings. Wal-Mart nabbed Asda at 22 times. You will be going home with one of the world's most famous retailers for the price of an Asda. And, at £12 billion, you are paying £7.5 billion less than it was capitalised at a little more than two years ago. Bargain.

4 Your Big Plan. Or how to pull M&S out of its current mess. A few suggestions: if the market wants a price war, who better to start it than the company that pays virtually no rent? By owning most of its stores, M&S has the lowest occupancy costs in retailing. It should be thriving in these hard times, not dying. You can save any property sell-off (or bond issue) until after the battle has been won.

Staff are next. M&S aborbed the cream of British graduates through most of the 1980s and 1990s, but few have reached the upper echelons of the company. M&S is rich in under-promoted young talent; it already has the tools to recover, although you must never admit this. All they need is the right leadership. This is where you come in.

5 Assemble a crack turnaround team. If Sir Brian Pitman quit Lloyds TSB tomorrow and asked the City to lend

him £22 billion so he could take over NatWest, they would do it. In today's world of finance, reputations are quickly converted into cash. Fund managers are star-followers, so give them the stars. The task should not be difficult. M&S has amazing allure – and few people in UK retail do not have an opinion on how they would run M&S better.

Archie Norman should be your first call. Bring his Knutsford takeover vehicle on side, with its property gurus and Julian Richer. This will rally the troops – in particular, Steven Cain from Carlton. Stuart Rose is another former M&S insider getting bored with the unglamorous world of cash-and-carry. He would sell Booker in an instant and jump at the chance for M&S.

You'll need some pretty serious financial whiz-kids on board, because you can make this deal only by financially re-engineering M&S. No matter if they're not retailers.

Because your bid is based on personalities, you can easily pay the front men or women £1.5 million each. For a company that has lost £35 million of market value each day for the past four months, that's pocket money.

6 Portray yourself as the saviour of M&S, not an executioner. M&S is no ordinary company. With the monarchy and the BBC, M&S is seen as the trinity of the British establishment. It is still held in deep, personal regard by City institutions. You must see this as your weapon, not a threat. Your pitch will be to save Marks & Spencer from either its current management or an overseas predator.

This theme must dominate every move you make: you are saving M&S from poor management, returning it to Britain and refocusing it on the world. Sentimental old guff, but you must embrace it. This battle will be fought on emotional grounds.

7 Find allies. You need the inside story. Luckily, M&S has been shedding scores of top managers, many of whom will be available for some "consultancy".

Dare one suggest that a credible bidder, dressed in the robes of Britannia herself, pops in for morning coffee with Sir Richard Greenbury, the former M&S chairman? He is never short of opinions and is thought to have several ideas about how to stop the current management making a drama out of a crisis. It's worth a shot.

Most importantly, woo the institutional investors. You will need the nod from them before you move. Fortunately, M&S has been deserted by the UK pension funds, none of which owns more than 3 per cent of the shares. No single City firm has the power to block you.

The most powerful at present are two investment funds based in California – Brandes Investment Partners and Franklin Resources - who could not care less about M&S and its independence. The private M&S shareholders may object, but with only 21 per cent of the shares, they don't really matter. With the Americans on side, it is a case of divide and conquer.

8 Subterfuge. Well, their advisers will be doing the same thing. The brutal truth is that you need to do as much as you can to weaken the M&S share price before making your move.

Hire a PR firm. M&S is using Brunswick – try calling Tony Carlisle, at Citigate Dewe Rogerson, which has spun for Punch Taverns (versus Allied Domecq) and Granada (versus Forte and LWT). Whoever you pick, keep the team tight - no teenage scribblers.

Now leak some bad news. Find out the week-by-week trading figures (M&S sends these to all 297 store managers; they are easily obtainable). Leak these to the Sunday

papers (stories are thin on the ground this time of year).

How about mutinous whispers at Baker Street? The recent restructuring of the M&S top management will create even more unhappy bunnies. Sprinkle a touch of unrest into those enterprising Sunday papers as well. All grist to the mill.

9 Choose your timing. With takeover bids, just like cooking, timing is all. M&S comes out with its trading statement in mid-January (no date set). This should be disastrous. If it makes a full profits warning, so much the better. Feign disinterest, then pounce.

It could also be worth waiting for the new M&S chairman. If M&S appoints a non-entity with no City profile, this will lead to despair and drive down the shares further. The shares could easily hit 220p, allowing you to get away with paying less than £10 billion.

10 Bidding. This is done largely on autopilot these days. First, make a firm bid – 35 per cent above the pre-speculation price. Use platitudes such as "full and fair", then wait for M&S to wheel out the "derisory price" cliché.

But you will produce your dream team. Make a second bid, maybe 355p a share, and listen to lots of umming and ahing. Then come in with the 420p bid, ask Sir Brian Pitman to smile for the cameras and watch the City roll over and have its tummy tickled. Peter Salsbury, the M&S chief executive, could make a virtue of handing the company to your talented retail team and seeing shareholder value increased in the process.

The fund managers will have found an honourable way out of a dismal situation, and helped to usher in one of the most talented line-ups in British retailing along the way. As for you, congratulations – you are now the proud owner of Marks & Spencer plc.

Joanna Coles
in New York

ANYONE WHO'S overdosed on Christmas lunch may yet be in trim for their millennial celebrations. New York's plastic surgeons are reporting a last-minute surge in demand for their services as people determine to look their best to greet the new year.

December is usually a quiet month in the hushed surgeries which line Park Avenue, but the millennial deadline has apparently inspired people to fork out at the last minute for short-term work which will have healed by New Year's Eve. Among the most popular treatments is eyelid work, which heals faster than many more invasive surgeries, and can be just squeezed in between Christmas and New Year's Eve. Another favourite, Botox – involving injections of a paralysing poison which freezes the facial nerves and reduces the appearance of wrinkles – is also in serious demand. The injections take only minutes.

The New York Times even reports on one 24-year-old who turned up at the offices of Dr Helen Colen, a leading surgeon, brandishing a red dress which she was desperate to wear. "She had to have the liposuction done in her hips immediately because she had to wear the dress on New Year's Eve," Dr Colen said.

Other surgeons have reported patients demanding that they work on Sundays, to give them an extra healing day in time to look good for the new year. And Dr Lloyd Hoffman, at New York Presbyterian Hospital, took on a patient who had realised she was too plump for the ballgown she was planning to wear. "She wanted her abdomen suctioned to fit the tight waistline," he said, unfazed. You will be glad to know, the dress should now fit perfectly.

Oliver the Timelord
An extraordinary memory reminds us of the ambiguities of time

Simon Jenkins

A MAN of my acquaintance was addressed, when a child, on the subject of Oliver Cromwell. The speaker was a lady of 91. She told him sternly never to speak ill of the great man. She went on: "My husband's first wife's first husband knew Oliver Cromwell – and liked him well." It was an admonition my friend has not forgotten.

At first hearing, the story is unbelievable. This was not a great-grandfather who knew a great-grandson. Here at the dawn of the new century is someone able to recall a single matrimonial generation linked directly with the mid-17th century*. I know of no comparable leap of history, no domestic arrangement that can gather dynasties, revolutions and empires so effortlessly in its embrace. We can wipe out civilisations in a flash, yet extend the experience of a single human imagination over a third of a millennium. What a thing is man (and in this case woman).

This being the week of anniversary, I found myself at breakfast reading the following words by the Astronomer Royal. "In about five billion years," announced Professor Martin Rees, "the Sun will die and the Earth with it." I paused to grasp the enormity of this news, toast in mid-air. He went on. "At about the same time the Andromeda Galaxy will crash into our own Milky Way. Our own galaxy will surely end in a great crash." And then? What possible interest could I have in reading further? But the professor asked of his readers: "Will our Universe go on expanding for ever?" He was not sure. Yet it is our capacity to ask and seek to answer such questions, to ponder the nature of time,

that apparently separates Homo sapiens from lesser animals. We are lords of the past and future tenses, monarchs of the realm of grammar. We strive without ceasing to master "time out of time".

Above all, we have learnt to treat dates for what they are, mere dates. We know that we shall wake up tomorrow with our cells, if not our guts, in the same order as when we went to sleep. Nor does it matter whether we have the "right" date for the millennium. We have freed ourselves from the dictatorship of magic, of medieval astrology or pagan hierarchy. A superb exhibition, *The Story of Time*, currently at the Greenwich Observatory, charts mankind's steady release from superstition. Human beings today can witness the spinning heavens above and the passing seasons on Earth without fear of Aion or Kronos, of the Aztec priest-gods, of the Chinese Shou Lau with his scroll, or of our own Grim Reaper. We do not shudder as Time sheers Cupid's wings on the grounds that: "Love conquers all, but Time conquers love." We know that this is not true.

Civilisation has stretched time. We have almost doubled our life expectancy since the Middle Ages. Science has expanded our temporal awareness from the biblical six millennia to tens of billions of years. Stephen Hawking's *Brief History of Time* broached concepts of relativity that I cannot understand, of time curved and distorted, hinting at new ways of comprehending the limits of space-time. From measuring the decay of the carbon atom to managing climate change, we can read the future of the planet from its past. We may not

be masters of the Earth, but are no longer completely at its mercy.

I find each new twist in the history of science exhilarating, but in this I remain in a minority. The public treats innovation in nuclear physics, in genetics, in "tampering with nature" with deep suspicion. Advances in human fertilisation are viewed much as the Inquisition did the discoveries of Copernicus and Galileo, as an offence to God's law. Likewise did doctors refuse Queen Victoria the new childbirth anaesthetics. Yet the search to liberate humans from the bonds of superstition constantly defeats the censors. You can burn the thinker at the stake, said the ancients, but you cannot burn his book. Somehow it survives. When Milton's God took up His golden compasses and declared "Thus far extend, thus far thy bounds/ This be thy just circumference, O World," we bowed respectfully and told God, or at least Milton, to get lost. Science and the imagination broke the compasses and flew free.

Science is simple. It proceeds by prescribed rules from evidence to conclusion, its progress axiomatic. In a remarkable book published earlier this year the American, E.O. Wilson, predicted science's imminent conquest of such fields as religious belief, political theory, aesthetics and sex. Men in white coats were already wrestling with "cultural genetics", the pharmacology of music appreciation and the antics of the pheromones. His science was not arrogant; it was confident. But even he had trouble handling free will and bringing to Earth the astronauts of the human imagination.

While science seems lashed to time's arrow, the imagination seems to know neither limit nor progress. The muses wander at random over time, and suffer frequent relapses. I refuse to believe that painting, sculpture, music or poetry soar today as they have done in the past. Whole areas of creative imagination seem dulled. Nor do I presume that the subtle arts of human intercourse have "progressed" since the days of Sappho or Omar Khayyam or Shakespeare or Donne or Tolstoy. Do we love each other any better than of old? I doubt it. We are more comfortable, but opinion polls claim that comfort has not brought whatever we call happiness. If anything, we are ever more lonely, disorientated unfulfilled. The scientist may explore the Universe, but when he gets home at night, he does not "understand" his wife the better.

This quest for happiness, in which science is a mere mercenary, is renewed in each generation. Alexander Pope referred to it as "that something still which prompts th'eternal sigh,/ For which we bear to live, or dare to die". History is the story of that struggle. Some primitive tribes regard history as always in the present. The storyteller relates the glories of a tribe's past, but only to establish its present identity. To his hearers there is no point in dates, for history is like Dick Whittington's bundle, carried everywhere in a sack.

I love the study of history because, without it, I would find the present intolerably complicated and the future intolerably frightening. History may tell of scientific progress, but of scant progress in other fields. The historian Barbara Tuchman sought to analyse the astonishing vitality of folly in world politics, and was forced to conclude that foolishness was as endemic to politics as it was to human nature. From Troy to Vietnam (and even to Kosovo), men seem incapable of learning from past mistakes, or looking beyond immediate pride or machismo. They court folly in war as they court folly in love. Human behaviour seems to spurn scientific advance and defy time's arrow.

But that is too pessimistic. Britain is an incomparably better place today than a thousand years ago. And if there were ever a turning point, a moment of no going back, it was in the mid-17th century under Oliver Cromwell. For all his "warts", he raised his banner for the human spirit against intolerance and arbitrary central power. More than any man before or since, he cleaved his path through history, "to ruin the great work of time," said Andrew Marvell, "And cast the kingdom old / Into another mould." He is a prophet for every age. And there is a man alive today who heard a woman say: "My husband's first wife's first husband knew that Cromwell – and liked him well."

*The remark was made in 1923 by a lady born in 1832. At the age of 16 she had married an 80-year-old man named Henry. Sixty-four years earlier, in 1784, the young Henry had, for reasons obscure, married an 82-year-old woman. Her first marriage, in 1720, was to an 80-year-old who had served Cromwell before his death in 1658.

Occupational hazard

From Ms Ann Rachlin

Sir, I find it alarming to note from your Obituary pages that people are now dying in thematic groups.

Last month a quartet of composers conveniently arranged their final codas so that you could feature them all on one page (November 18).

A few months before, three ventriloquists threw their various voices into the great beyond – all chronicled on consecutive *Times* Obit pages (June 4 and 5).

Please inform me when it is the turn of music educators so that I can take extra care crossing the road.

Yours sincerely,
S. ANN RACHLIN,
2 Queensmead,
St John's Wood Park, NW8 6RE.
December 21.

HOW TO BECOME AN INTERNET MILLIONAIRE BY THE END OF 2000

1 Come up with an unoriginal idea. Start a free Internet service, launch a "portal", or offer e-commerce services to businesses.

2 Think of a trendy and nonsensical name. Stick "dot-com" or "dot-net" on the end, and register it quickly. Try freejellyboot.com.

3 Get backers. You need at least one B-List celebrity (for picture opportunities) and a non-executive director from a FTSE 100 company. Pick up a couple of million quid from a venture capitalist; they can be found hanging around on street corners in Soho.

4 Hire a "technogeek" finance director from Harvard Business School. Pay him or her only in shares. They will be able to impress investors with phrases such as "it's not part of our strategic gameplan to be EBITDA positive right now" (we don't make any money).

5 Hire a 21-year-old PR to produce at least 20 incomprehensible press releases every day. Pay them nothing, but reassure them that they've got a powerful job in the media.

6 Make a "strategic alliance" with Microsoft. In other words, buy a copy of Microsoft Office from your local Dixons. Get your PR to write a gushing press release. Ask Tony Blair to endorse the deal.

7 Float the company as soon as possible. Steps one to six should not have taken more than three months. Remember, the Internet boom is a freak economic event that could end any time.

8 Sell, sell, sell. You can only buy things with hard cash, unless you're acquiring another worthless Internet company. So sell as many of your own shares as you dare on flotation. Claim to the press that the sale was a selfless act to "satisfy institutional demand".

9 Spend all your company's flotation proceeds on marketing gimmicks. See television and press for details.

10 Get the hell out. With any luck your company will have frightened a competitor enough for it to buy you out. Offer to stay on as a non-executive director while praising your new owners for their forward thinking. Retire to somewhere where PCs have not yet been invented.

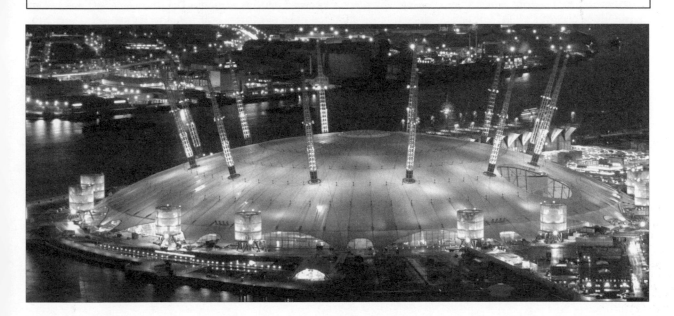

How to survive tonight

On the eve of the millennium Dr Thomas Stuttaford explains how over-enthusiastic partygoers can celebrate without getting a crushing hangover

Thomas Stuttaford
..

CHRISTMAS IS over but this year, before the Christmas trees can be put out with the rubbish, our weakened bodies, already battered by an excess of turkey, plum pudding and bubbly, will have to withstand another onslaught. Record sales of champagne, and it is reported condoms (10 per cent higher than usual at this time of the year), demonstrate that much of the general public is intent on celebrating the millennium night in a way which might not entirely meet the approval of the Archbishop of Canterbury.

How many revellers will wake up tomorrow feeling that if this is how they feel in the new century, death might have been a better option?

Even the most extrovert partygoers feel a slight frisson of trepidation before they join a crowded, noisy room. Shakespeare taught us "that all the world's a stage" and that we are merely players upon the stage of life. Many extroverts, like introverts, will be tempted to have a drink before they have to look cheerful, chatty and outgoing in preparation for strutting their hour or two among a boisterous, chattering mob. Furthermore, at the millennium party there will be no escape until a decent interval has elapsed after Big Ben has struck midnight. The only path to escape from an excruciating party may seem to be through a bottle.

HALT – hungry, angry, lonely and tired – is the acronym that is supposed to be blazoned into the thinking of all potentially heavy drinkers. The lonely introvert, the tired extrovert, the angry misanthrope forced into partygoing and the overworked person who has had to scurry around to be on time, are all candidates for overdoing the pre-party drink.

A pre-party drink, if accompanied by a snack, can not only be part of a civilised family ritual, but will also serve a valuable medical purpose. Even if dinner is going to be served during the evening, some stilton or other rich cheese – don't worry about the cholesterol – and a few biscuits should be served with the drink before going to the party. Those who have not lost their nursery tastes should also accept the time-honoured advice of having a glass of full-cream milk before setting off.

The stilton and biscuits have a double effect. Fatty food delays gastric emptying and as alcohol is absorbed more slowly from the stomach than it is from the small intestine, the longer it stays in the stomach the less quickly will the drinker become drunk. The second advantage of cheese and biscuits as preparation for a party is that this combination of carbohydrate, fat and protein will keep the blood sugar level high.

One of the dangers of partygoing is that the initial drinks lower the inhibitions. For after a quick boost to the blood sugar level by a couple of glasses of champagne or some comforting gin and tonics, there is a compensatory excessive production of insulin. Blood sugar levels then fall, jollity turns to irritability and nit-picking querulousness. In no time the true colours of apparently kindly old uncles may be rapidly unfurled and the party atmosphere strained.

Never allow your guests to have more than a couple of drinks without providing them with at least protein-rich canapes. If dinner is to be served, the pre-dinner drink should not be prolonged.

Hypoglycaemia must be avoided if old friends are to remain friends and families stay united.

A saloon bar expert may still be heard explaining the evils of mixing grape with grain, dark drinks and light drinks, long drinks and chasers. Physiologically, and in the eye of the policeman's breathalyser, it is all nonsense so far as becoming intoxicated is concerned. The hangover next day will indeed vary according to the nature of the drinks, but the degree of drunkenness is solely dependent on how much alcohol has been taken.

The speed of drinking is all-important. In the battle to survive the party, it is permissible to have two quick drinks, but thereafter partygoers should try to restrict their consumption of alcohol to one unit, a small glass of wine, a tot of spirits or half a pint of standard strength beer per hour. The downside of this simple rule is that wines and beers vary enormously in strength and so it is just as well to be aware how strong any drink is. The upside is that regular drinkers whose livers are still in good order can metabolise alcohol one third faster than the occasional drinker. However, once the liver is shot to pieces the seasoned old cask may not be able to manage a couple of glasses of sherry without making a fool of him or herself.

In general men can drink more than women, become drunk more slowly and sober up faster. Women's capacity varies according to the time in their reproductive cycle, and, in both sexes, the build of the person is important. Large, muscular people can drink more than short, fat ones. Strong-

minded people who can stick to the rule of a drink (one unit every hour) are unlikely and unlucky to have a hangover the next day.

The atmosphere at the party is a factor in making or avoiding a hangover. If fellow guests are heavy-going, distant, intimidating or bores, the hangover is likely to be greater.

Other than the happiness of the occasion and the quantity of alcohol taken, the hangover, unlike the level of intoxication, is dependent on the drink chosen. The hangover is in part caused by the amount of congeners present in the drink. The congeners are the complex organic chemicals that give each type of alcoholic drink its particular taste. Congeners make the difference, for instance, between east coast and west coast whisky, armagnac and cognac, burgundy and claret. However delicious the taste imparted by them, the heavier the concentration of congeners, the greater the liability to a hangover.

In general the lighter (in colour) the drink, the less the hangover. A pale malt whisky is less likely to cause a hangover than the darker ones, vodka less liable to result in a splitting headache than brandy.

As straight alcohol is metabolised (broken down) in the body it forms acetaldehyde, which is comparatively innocuous in its effects compared with those of formaldehyde. Many of the congeners as they are metabolised give rise to formic acid, which imparts the deadly sting to ants, not a substance that brain cells welcome - and to formaldehyde. Formaldehyde courses through our veins and into our nerve cells after too close a communion with the brandy bottle.

The hangover has several causes. Whatever other troubles the alcohol may have caused his or her constitution, the heavy drinker is severely dehydrated. Wise drinkers, however, will have had at least a pint of fluid, more if they can manage it, before they go to bed. Some swear by a particular mineral water, others by tap water and lime juice; the choice is immaterial, it is the quantity that matters.

Such is the diuretic effect of alcohol on the kidneys that even this precaution won't stop everyone from becoming dehydrated. Many will wake with a parched mouth and a dry skin. The sooner they rehydrate themselves with long drinks the better. Too much coffee is, however, a mistake for the caffeine may provide a lift; but it is also a diuretic and gastric irritant. Alcohol dehydrates every part of the body other than the brain. Alcohol is a neurotoxin, the brain cells are damaged, become waterlogged and swell. The brain no longer fits snugly into the skull and as a result is compressed. Unfortunately, although the damage to the brain cells may be temporary, while they are squashed and poisoned they hurt like hell, as every drinker who has ever had a classic hangover knows.

The other major problem of the hangover is hypoglycaemia. The intake of alcohol causes the islets of Langerhans in the pancreas to produce far too much insulin. Blood sugar in consequence falls dramatically. This may endanger the lives of young children who have had too much to drink, but more commonly it is their grown-up relatives who wake sweating, shaking and headachy. The cure is to restore the blood sugar level as quickly as possible. Sweet tea should be followed by porridge or a large plateful of cereals so that the blood sugar level is maintained throughout the morning. If the stomach is willing, bacon and eggs are ideal.

Too much alcohol, very often accompanied by rich food, plays havoc with the guts. Heavy drinking exacerbates gastroenteritis, the lining of the stomach and intestines becomes inflamed and oozy and in consequence the person feels sick, may be sick, and may have diarrhoea. Those with a tendency to IBS will spend a particularly uncomfortable day. The standard antacids will help the sufferer with their gastritis. Motillium will ease some of the gut problems; others may need Imodium. One of the tricks of treating a hangover is to deal with a headache without making the gastritis worse. Both paracetamol and aspirin, combined with an antacid, are available in a fizzy, soluble form.

There are many other popular remedies for a hangover. One of the most commonly practised, and most natural, is sex. The only possible scientific justification is that in many people this induces somnolence, and possibly the victims, who have had a sleepless night, may then return to some much-needed sleep.

The hair of the dog retains its popularity. There is some scientific justification for this as paradoxically a very small quantity of alcohol next day reduces gastric irritability, and the sugar in the mixer eases the hypoglycaemia. This is not a remedy usually recommended by the average doctor, but is dispensed with glee by nearly every barman.

Those who have survived the party, had their fluids before they went to bed, hot sweet tea upon waking, as hearty a breakfast as they can manage, will find that the next step on the road to recovery is fresh air and a brisk walk.

All partygoers should not only be intent on surviving themselves, but should remember those to whom all parties are an ordeal. Some of them will have the extreme form of social discomfort known as the avoidant personality disorder. These luckless people are hurt by every implied criticism or disapproving look, have few, if any, friends and have a horror of getting involved with people until they can be certain of a good reception. Those of us who are by nature tougher skinned, or whose skins have been hardened by a couple of stiff whiskies, should give them a welcome.

THE TIMES

January
2000

Here's to the new millennium

Alan Hamilton

LIKE THE shadow of the summer eclipse, midnight rolls across the face of the earth at 775 mph. By the time Big Ben tolled the magic hour in our little grapefruit segment of the globe, the islanders of Kiribati in the Pacific had been partying for 14 hours.

When it came at last to the headquarters of measured time at Greenwich we welcomed it, like our distant ancestors, with goblins and fire. That the celebrations were essentially pagan was appropriate enough; we were marking, not a religious milestone, but a round number.

Eighteen seconds after passing the meridian line, the notional midnight hour was deemed to have reached Tower Bridge, when the Thames blazed to a curtain of fire that followed midnight for a further 10.8 seconds upriver to Big Ben. With 39 tonnes of explosives involved, it formed part of the biggest fireworks display in British history, although the music written by Handel for a previous one has proved more enduring than some of last night's offerings are likely to.

Fire figured last time, too. The sermon in the Vercelli manuscript of 1000 predicting the first millennium warned of resounding flames burning up the blood-mingled earth, destroying all those engaged in great boasting and in the useless sight of gold and silver, fine cloth and ill-gotten property. That preacher would not have liked the £758 million Millennium Dome, which is where the goblins danced last night.

In a 90-minute entertainment to which the Queen, the Duke of Edinburgh and the Princess Royal were welcomed by Tony and Cherie Blair, the only overtly religious element was a two-minute slot allotted to the Archbishop of Canterbury and three Barnardo's children to say prayers.

The Queen wore an apricot coat, Cherie a long purple dress, while between them in the royal box, the Prime Minister sported his usual dark suit, glistening white shirt and red tie. As they took their seats the last stragglers from the chaos of Stratford station were still struggling to their places.

At a quarter to midnight the Queen unhooked a rope on the royal box and released a group of children from the Meridian Primary School in Greenwich who raced across the arena and grabbed eight ribbons, causing a ring of curtains to fall away in a spectacular waterfall effect, exposing the inside of the structure's saucer roof. Martians who gazed down on it from their planet appeared to be right; it will never fly.

The organisers were particularly proud of an elaborate stunt shortly before midnight. As the young choristers began to sing the anthem Sir John Tavener's *New Beginning*, they approached centre stage where the world's third largest diamond had been positioned to be targeted by laser beams, creating the effect once produced by a rotating glass ball in dance halls. As the delicate first notes sounded, they placed their hands over the diamond to reduce the arena to darkness.

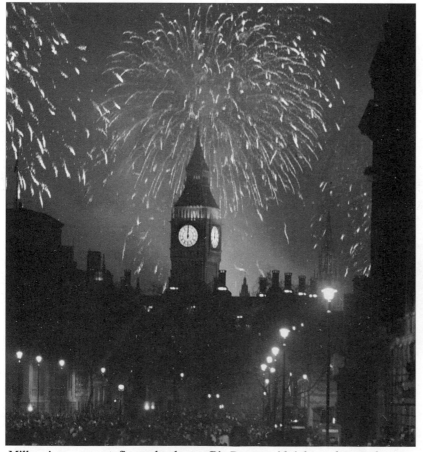

Millennium moment: fireworks shower Big Ben at midnight as thousands teem down Whitehall towards the Thames

Dome acrobats rehearse for New Year's Eve

Finally, as the quarter chimes of Big Ben sounded, tradition returned. The entire audience rose to its feet cheering. On the midnight stroke the Queen and Mr Blair toasted each other with champagne and within moments the monarch and her first minister had linked hands with the entire front row of the royal box for *Auld Lang Syne*.

And then, the goblins. Five hundred dancers performed a carnival entitled *Blueprints for Paradise*; some hung on bungee ropes from the roof. The dancers on the ground were costumed fantastically, from Tolkien out of Notting Hill Carnival, gyrating through the three movements of Wisdom, Essence and Passion. What it was all about was open to the widest speculation, but then the Dome itself is the very essence of virtual reality rather than any philosophy, in this secular age of Blairism, that you could actually get your teeth into.

It may, in its strange way, have been perfectly appropriate. The holy men of the first millennium regarded humanity as a race of hobbits inhabiting a Middle Earth between heaven and hell, wiser than cattle but lower than angels.

Since then, of course, we have had a thousand years of progress, which means there are far more opportunities for things to go wrong. The Millennium Wheel on the Thames was deemed unsafe on Thursday, and 250 guests who had been looking forward to an inaugural ride had to be content with a ground-based party and free British Airways tickets to a destination of their choice. Tony Blair stopped by and opened it anyway.

The dampening threat of rain did little to deter a tidal wave of revellers from pouring into Central London. As midnight approached, numbers were estimated at more than two million in spite of the real millennium bug, the epidemic of colds and flu which has laid half the nation low.

At least the Queen followed tradition, particularly her new one of paying more attention to the disadvantaged. She and Prince Philip began their Millennium Eve with a visit to a Crisis hostel for the homeless in Southwark Street, before making a brief appearance at an all-night vigil in Southwark Cathedral and lighting the first millennium candle.

Embarking on the Thames cruiser *Millennium of Peace* at Bankside Pier and joined by the Princess Royal and her husband, Commodore Tim Laurence, the Queen sailed downriver like her ancestor George II enjoying his celebratory fireworks. At Tower Bridge she paused to light a fuse to fire a laser to ignite the Thames millennium beacon. But it took almost a minute to light the torch which, in the wind and drizzle, was as reluctant as a sodden log fire. Finally lit, it seemed to flicker and go out again before completing its task. "I thought it had blown out," the Queen said. Further downriver, as her launch crossed the meridian line near Greenwich, the destroyer *HMS Westminster* was waiting to fire a 21 gun salute.

By 12.30, having heard the Dome concert with a jazzed-up National Anthem, the Queen was on her way back to the peace of Sandringham by car. And the shadow of midnight was racing across the Atlantic at 775 mph to an expectant New York.

Revellers celebrate among the throng

kate muir

that woman

I HAVEN'T liked to mention this for the last nine months because it's too embarrassing, but it has now become quite plain that I am about to have a millennium baby, officially due today, January 1. The timing was in no way intentional, and when we confessed to our friends, many laughed cruelly. One said: "A millennium baby? How vulgar." Another e-mailed back: "Tacky!" Third time around, you just don't get the same sympathy.

Now the magazine, as you might expect, is printed a week or so ahead, so I may already be the proud mother of a baby girl – and three years' free supply of "Organic TushieWipes" – if we delivered in the early hours of this morning. At this very moment, television crews may be surrounding my hospital bed waving lucrative contracts for lifetime documentaries about Millennia, Millicent, or Millweed. Negotiations may be under way for the five-page spread in *Hello!* magazine.

On the other hand, given the computer crashes, the news that Washington hospitals are said to be only "60 per cent Y2K ready", the anticipated power cuts, and the fact that delivery rooms will be staffed by howling drunk medical students and Serbian-speaking cleaners, if we're lucky, we have been trying to persuade the baby to get going pronto.

I'm relying on the traditional labour-inducing techniques of trampolining and consuming what is known in my home town of Glasgow as an FBI (F Big Indian) of vindaloo strength, because there's a pretty good millennium party I want to go to along with Le Tout Washington. Having surfed chatrooms filled with other MillenniMoms, I know it's one club I don't want to join.

Two centuries of changing Times

In its 225-year history, *The Times* has reported on everything from Napoleon to the war in Chechnya. Brian MacArthur charts its past and looks ahead

Brian MacArthur

ON JANUARY 1, 1800, John Walter, who had founded *The Times* exactly 25 years earlier, was still scarred by his experience of 16 months in Newgate Prison. Ten years earlier he had been found guilty of libelling both the Prince of Wales and Duke of York, fined £50, sent to Newgate, and sentenced to stand in the pillory at Charing Cross – a sentence eventually remitted. He had set a noble precedent by refusing to disclose his sources.

Walter, who was known as the "conductor" of *The Times*, was now out of prison and the paper was edited by his son William, but the managing editor, the Old Etonian William Combe, had been arrested for debt and imprisoned. He worked for *The Times* as a prisoner on parole.

Wars usually boost the sales of newspapers and Britain was at war with Napoleon Bonaparte – but sales in 1800 had fallen from a peak of 4,800 during the French Revolution to about 2,000. A century later, the British were again at war, now with the Boers and under siege at Ladysmith and Mafeking, but sales of *The Times* were falling again. They had reached a peak of more than

Robert Barrington-Ward's Editor's conference, 1946

60,000 under John Thadeus Delane, Editor of *The Times* from 1841 to 1877, but now stood at 35,000. A paper that sold for 3d cost 6d to produce. *The Times* was almost bankrupt and threatened with extinction. Eight years later it was sold to Lord Northcliffe, founder of the *Daily Mail*.

On January 1, 2000, as *The Times* enters the third new century in its 225-year history, Peter Stothard, the Editor, has not yet been in prison (though some in today's Tory leadership might wish him there), sales are rising and the future of *The Times* is more secure than at almost any time in its history.

Sales have doubled to 750,000 within six years, advertising revenue has tripled and *The Times* stands to make a modest profit for the first time in almost a century. It publishes more pages with more columns of news, comment, criticism and entertainment than ever in its history, and the editorial department employs a record number of staff.

Three hundred and sixty of them – editors, writers, reporters, sub-editors, columnists, leader writers, designers, artists, photographers, researchers, secretaries and messengers – can be seen in the photograph on the next page which was taken on a windswept stretch of grass across the busy Highway from our offices in Wapping, E1.

There are 408 staff in the editorial department of *The Times* as well as least another hundred stringers, critics and freelances who work regularly for the paper, but many were at work away from the office and were featured separately. Our Moscow correspondent Giles Whittell, for instance, was in Vladikavkaz, North Ossetia, reporting the battle in the Chechen capital of Grozny. Twenty other staff foreign correspondents were at their posts across the world from Beijing to Los Angeles. Christopher Martin-Jenkins, the chief cricket correspondent, was reporting the England tour of South Africa,

William Rees-Mogg's Editor's conference, 1967

where the "Boers" were yet again giving England a hard time.

There are no staff records of *The Times* until 1920. We do know, however, that the weekly wage bill for the compositors, readers, pressmen and messenger boys on *The Times* in 1799 was £35-10-4d. We can guess perhaps that there were at most ten to 15 journalists.

In 1800 *The Times* was a 6d tabloid – slightly larger than the contemporary versions – set laboriously by hand and distributed by the Post Office on mail coaches along six main roads leading from the City of London and sold in London by hawkers.

The Walters had already established many of the editorial principles that survive 200 years later. In 1792 they had established "a new correspondence" at Brussels and Paris which they trusted would furnish *The Times* with "the most regular and early intelligence that can be obtained". The paper's reputation rested on its foreign news and the new year papers

published long reports from France and shorter dispatches from Berne, Augsburg, The Hague, Berlin and Madrid. During Napoleon's blockade Walter employed professional smugglers to get news across the Channel.

There is a letter to the Editor, a law report, a court circular, reports from the courts and notices for the Theatre Royal, Drury Lane, where Charles Kemble and Sarah Siddons were appearing. There is a review of the Christmas pantomime.

By 1900, when it was edited by George Buckle, *The Times* was more recognisably the paper of today. It was distributed by steam train, and had become a big broadsheet, though its 16 pages of dense text set in small type and unrelieved by crossheads or photographs seem forbidding to a modern eye. The main leading article on December 30, 1899, a review of the year, covered two pages with about 10,000 words. News on the front page, however, was 66 years away and it

Editor Peter Stothard with many of *The Times* team, 2000

was to be another 20 years before photographs were published.

The foreign department was the powerhouse of the paper, with more than 30 staff correspondents working to the Imperial and Foreign news editor who now also used the services of Reuters. More than 14 columns of *The Times* on January 1, 1900, were foreign news, with a strong emphasis on the Boer War.

There were also about 24 home specialists, including musical and dramatic critics, golf and racing correspondents, a weather expert and chess correspondent, as well as 12 reporters and 11 parliamentary staff. A staff list of 1877 also listed 64 assize, law and police reporters and 185 country correspondents.

There were obituaries, mostly brief

and on the lines of a contemporary *Who's Who* entry, more than 40 letters to the Editor (though scattered all over the paper), as well as nearly three pages of City news and some sport, with a heavy new year concentration on the turf and rifle shooting and short items in less than a column on rugby, football and golf. The emphasis is heavily on official news, undoubtedly important but deadly dull.

Walter's paper was set by hand, Buckle's set in hot metal. What neither could have foreseen was the electronic revolution of the 1980s which transformed the power of journalists and which is symbolised by the number of editorial staff who now work on *The Times*.

On both Walter's and Buckle's papers, journalists were in a minority.

There are so many more editorial staff now because journalists, sitting before their PCs, controlling the editing and production of their newspapers until the moment they go to press, have added to their daily work the jobs once done by a small army of compositors, typesetters and proofreaders.

When staff records were first kept in 1920 there were 633 mechanical staff on the books of *The Times*, which sold 35,000 copies a day. Now there are 700 for four newspapers (*The Times*, *Sun*, *Sunday Times* and *News of the World*) printing more than four million copies a day.

That is only one of the ways in which a century on from 1900 *The Times* occupies an utterly different world from Buckle's. Britain is no

longer an imperial power; radio, television, Ceefax and the Internet are the primary sources of news; generations have been reared on visual images from television and computers; and women not only have the vote but work as well. Overall newspaper sales, moreover, are declining in the world's fiercest newspaper market.

So if newspapers are to prosper in the new century editors must attract, instead of inhibiting, the post-literate generation who allegedly don't read, are uninterested in politics or the arts and especially don't want long articles on Whither Nato? That is why they are embracing new areas of interest – in sport and entertainment and travel, for instance – beyond the traditional areas of focus on British politics and foreign news.

So *The Times* today is a very different – and, it ought to be said much more comprehensive – newspaper than Buckle's and is edited for all decision-makers rather than the select few in Whitehall and Westminster.

Women, for instance, are now an integral part of the paper. There were nine women on an editorial staff of 185 in 1920. Now some 40 per cent of the editorial staff are women. They head nine departments including the foreign, business, weekend and features sections and *The Times* Magazine. Four of the six leader writers are women.

Buckle's paper concentrated on politics and foreign affairs but its coverage of home news, the arts and books was minimal. In *The Times* of 2000 there are 11 pages of book reviews a week. There are more than 20 full-time arts critics appearing on three to four pages a day. There are more obituaries and the letters editor gets 300 letters a day and publishes 17. Sport and home news are now the biggest spenders.

There were four pages in *The Times* in 1800 and 16 in 1900. Now there are usually 48 to 64 as well as a daily tabloid supplement – and on Saturdays, when the paper achieves its highest sale, there are seven sections. Among them are *Mega*, the award-winning and interactive children's newspaper for eight to 12-year-olds, and the 48-page *Metro*, the listings magazine that publishes six regional editions and turns over 156 pages a week.

Another revolution has been in the speed of communication. News still took time to travel in 1900. The paper of Saturday, December 30, 1899 carried reports from South Africa dated from December 20, another sent by messenger to Pietermaritzburg and another from Reuter's sent by heliograph via Pietermaritzburg.

The main tools of the contemporary foreign correspondent are no longer the heliograph or even a portable typewriter but a laptop computer, mobile or satellite phones and, in the most distant parts of the world, a car cigarette lighter in which to charge the satphone – the system used by some of the *Times* team during the 1999 Kosovo conflict. Their reports arrived within minutes instead of days.

The same revolution in speed has occurred with the arrival of digital photography – which was being put to its biggest test yet last night when 14 of the 16 photographers recording the millennium celebrations around the world were using digital cameras. The target was to get New Zealand pictures on screens in Wapping within 17 minutes instead of an hour.

Studying *The Times* of 1900, however, shows that some controversies are familiar through the centuries. Two days ago there were four letters to the editor on the issue of whether the century ends in 2000 or 2001. It was the same in 1899 when Moberley Bell, manager of *The Times*, sent an acerbic and exasperated letter to a correspondent – written in his own hand. "AD1900 does not mean 'when our Lord is 1900 years old'," he wrote. "It means Anno Domini 1900 or In the nineteen hundredth year of our Lord. Today we are in the eighty second year of Queen Victoria's life, in the 64th year of her reign, in the nineteenth hundredth year of our Lord."

At the turn of this century *The Times* has decided to go with the flow and celebrate the new millennium today.

The Wapping revolution of 1986 swept the methods of producing newspapers that had survived for nearly two centuries into the dustbin of history. As well as transforming journalists' working lives and ending the role of printers, it introduced satellite printing – *The Times* is now printed simultaneously in London, Liverpool, Belfast, Cork and Charleroi in Belgium – distribution by road instead of rail, and photographs in colour.

One certainty of the new millennium is that the speed of change will be still faster in the next 15 years, particularly as newspapers respond to the threat - or challenge – of the Internet. At *The Times* it is seen as a challenge. Online journalists now work alongside traditional reporters and the daily Internet edition is getting 12 million page impressions a month.

" YOU ARE HELD IN A QUEUE . YOUR CALL WILL BE ANSWERED SHORTLY ... "

Welch goes back to the Stone Age at 59

LIKE SOPHIA Loren before her, Raquel Welch discovered yesterday that opening a Harrods sale is fraught with danger.

In July, the Italian actress was attacked by a cockatoo called Peaches and fell flat on her back while opening the summer sale. Yesterday, Miss Welch sprained her ankle at the winter sale. Considering the madhouse that confronted her, she was lucky to get out alive.

Her first problem was that the Harrods owner, Mohamed Al Fayed, could hardly keep his hands off her. At 59, Miss Welch seems to have come no distance from her film adventures in *One Million Years BC*. It might now be AD2000 but Neanderthal Man is still thriving.

Things began sedately enough. Miss Welch, in a tight, white T-shirt, black slacks, red high heels and an extravagant fake fur-collared coat, arrived at the store at 8.30am in a horse-drawn Harrods carriage, waving at the crowd like an ageing princess.

But thank heavens she is not royalty. As soon as she descended, she was greeted by Mr Al Fayed like a long-lost lover. They posed for pictures, his arm firmly around her waist, before he grabbed her hand and led her into the store. Then all hell broke loose.

Chased by a press pack of more than 100 photographers, the deafening pipes of the Harrods Highland Band, a phalanx of security guards and incongruously, the former middleweight boxer Chris Eubank with tight safari suit, high-pitched lisp and cane, Miss Welch was propelled around the five-storey shop like a balloon in a gale.

Elderly shoppers, utterly bewildered, were flung into racks of cashmere coats and bodyslammed into perfume counters as, like some ghastly new year party conga, the throng went up and down escalators, through Small Leathers, past the Egyptian Hall, into Men's Casuals before abruptly halting in Jewellery.

Probably wishing she was, well, anywhere else in the world, Miss Welch posed for two minutes with the centrepiece of the sale – a Kojis 64-carat diamond halved in price to £1 million – before lunging into Harrods World. There she stood between two giant, life-sized, grinning teddy bears, one of whom was the chairman of Harrods.

The whole extraordinary whistle-stop mystery tour lasted nearly an hour. Later, after breakfast, the American actress emerged in a pair of black, rubber-soled shoes, given to her by Mr Al Fayed, because, she said, she had twisted her ankle during the tour.

"What did you have for breakfast?" someone shouted.

"Harrods sausages!" Mr Al Fayed guffawed.

Miss Welch said that she was about to embark on a television project that was "reality-based".

That's more than she got in Knightsbridge yesterday. Let's just hope that the five-figure cheque she was paid was worth it.

Tim Reid

Raquel Welch with the £1 million diamond yesterday after a run-in with Neanderthal Man

The foundling who got a life and a history

In the last of our series in which *Times* writers explain who or what has inspired them, Jane Shilling pays tribute to her grandfather, who was abandoned as a baby at St Pancras station

Jane Shilling
................................

NOT LONG before Christmas, in the early hours of a winter's night in 1902, Police Constable 472 of the St Pancras Police Division was walking his beat – the network of dark streets and passages between Euston and St Pancras stations – when he heard a baby cry. In the angle of a wall, on a narrow alley called Weir's Passage, he found an infant, a few months old, left there with nothing to show who he was or where he had come from. Transferred from the arms of PC472 to the care of the St Pancras Workhouse and, later, the Royal Navy, the child grew up, made a life for himself and became, eventually, my grandfather.

By the time I can remember him, he was in his sixties, a shiny-faced old man with an elephant's nose and ears, Captain Mainwaring glasses and the dissolving remains of a powerful build. You see lots of men just like him every Remembrance Sunday, parading past the Cenotaph, or gathered at village war memorials with their bad anoraks, jaunty berets and their memories of their dead friends.

When I first knew him, he lived in Cumberland, where he worked as a Civil Defence Officer (whatever that was). What I can recall of that time is little more than a jerky series of disconnected images, like a very old black-and-white film: steam trains shrieking under the high, glass roof of Carlisle station; the throng of grown-ups' legs rushing back and forth in Carlisle market, where I held tightly on to my grandfather's hand, and he bought me a Chinese rag doll, with pursed scarlet lips, delicate, arched black eyebrows and carved wooden feet; his fascinating habit of keeping his teeth in a glass by

his bed at night, so that when you went bouncing in, early in the morning, for the latest instalment of his never-ending story of Gertrude and Ermintrude, two little girls who had a great many outlandish adventures, his face was all hollow and he looked like an elderly tortoise in striped pyjamas.

My grandfather was a great man for stories. Not just about Gertrude and Ermintrude, but even better ones, which had really happened, about voyages to China, where he saw the Great Wall, and a lady's foot that had been squashed up so small that it was almost the same

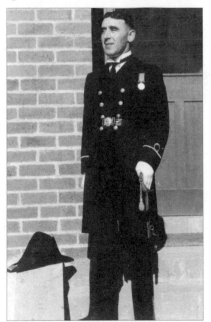

From St Pancras Workhouse to the Royal Navy

size as my five-year-old foot, and where he once captured 18 Chinese pirates, with pigtails, in a single day. Then there were the stories about the ships he had served on. Ships with oddly frivolous names – *Bluebell*, *Phoebe*, *Curacoa* – for the grim duties that they performed and the violent things that sometimes happened to them – shelled, torpedoed, cut in half by other ships – but always, miraculously, while Grandpa was somewhere else. When we went back home, he would write us letters, always ending with the same series of little drawings - a pig, an ostrich, a dockyard cat, a bell-bottomed matelot (who was him) and one of his ships.

When I was about seven, my grandfather retired and he and my grandmother moved down to Kent, to be closer to us. From this time I began to know him better, and the disconnected images start to flow into a narrative.

He was having a house built near Canterbury, and I often used to go with him when he went to survey the site on which this hideous bungalow was rising, as proprietorial as some great aristocrat overseeing elegant improvements to his estates – discussing the position of a lake (fishpond) here, or an orangery (flowerbed) there.

After the site visit, quite often we would drive into Canterbury to visit one of Grandpa's old shipmates – a wizened, bent-over old man with a crimson-flushed nose, name of Ikey, who ran a small, dark, one-bar pub called the Black Dog. I used to sit in a corner, swinging my legs on a bar stool drinking orange squash while Grandpa and Ikey and any other old sailors who happened to look in grew uproarious over their half-pints of bitter, remembering the old

days of racing the weevils that dropped out of their biscuits, and the long, complicated story of the wooden haddock, which made them laugh so much that I never found out how it ended.

The convivial atmosphere would continue on the way home, with a bag of toffees and more stories including, quite often, the story of How Grandpa Was Found. I knew this was a true story, because I had met the lady he was sent to live with, Great Grandma in the Country, whom I had once been taken to visit – another disconnected image of a black-clad crone of unimaginable decrepitude, crouched on a kind of carved wooden throne in semi-darkness under a stained-glass window.

Grandfathers are, of course, supposed to dote on their grand-daughters. But it seems to me now that I was extraordinarily lucky, even so, in the amount of concentration and energy mine was prepared to devote, not just to amusing me, but to listening to me – apparently just as keen to hear what I had to say as to tell me his own stories (a remarkable luxury, this, in a family where the greatest of all crimes was "drawing attention to yourself"). At the time, it didn't strike me as at all strange that my grandfather should be willing to spend so much time with someone 60 years younger than himself. We were happy together, that was all there was to it.

This negligent assumption of love carried on into my teens, when I turned from a good, quiet child into what nannies call A Right Little Handful. So much of a handful, in fact, that for a while I went to live with him and my grandmother – an ideal arrangement, I thought, certain that nothing I could do would cause so much as a flicker in the bright beam of their devotion.

In fact, they were appalled – the bad attitude, the heavy black eye make-up, the cigarettes and unsuitable boyfriends and, the worst thing of all for an old serviceman, the Army surplus clothes (I was heavily into Patti Smith and fatigues at the time) caused him acute dismay. He wrote a pained letter to my

mother, of which I knew nothing until much later. At the time, neither he nor my grandmother said a word to make me think that I was anything other than utterly loved and approved of.

Perhaps they thought it was just a phase, and that university would knock it out of me. Lacking an education himself, my grandfather was intensely proud of having sent his daughter to college, and just as enchanted when I got a place too. The deal was that he was to drive me in glory up to Oxford, see me installed, give me a hot dinner, and then drive all the way back to Kent. Quite an excursion for an elderly man with a stomach ulcer, if he had made it. But he didn't. Shortly before we were supposed to set off, he went into hospital for a routine operation and died, quite suddenly, with no time for anyone to say goodbye, or thank you.

Instead of arriving triumphant at the gates of my college in Grandpa's erratic and cholerically driven motor, I took the train, with so much stuff in my suitcase that I could hardly lift it. "Will you help me with my bag?" I asked the taxi driver at Paddington station. "No," he answered, shortly, and drove off, leaving me, like my grandfather before me, abandoned at a railway station.

Of course, our situations weren't really alike at all. I was 18, with a family and a place at Oxford, not a destitute infant foundling bound for the St Pancras Workhouse. But for a sharp moment's despair, until another, more amenable taxi driver came chugging up, tut-tutting at his colleague's bad manners, that is what it felt like. He, who had loved me, was gone and I was nobody's little girl any more.

Few days have passed since he died when I have not thought about him. Living, as I do, in Greenwich, with the masts of the *Cutty Sark* and the domes of the Royal Naval College visible every time I go out for the papers, it is hardly surprising that my mind should turn quite often to ships and the people who sail in them. But though being a sailor was of immense importance to

After a long courtship by post, my grandfather married in 1929

my grandfather – the essence of his character – as I grow older it is not his adventures, and the exciting and funny stories he made of them, on which I find myself dwelling, but the qualities of character that allowed him to make so much of so little.

A couple of years ago I was given a parcel containing his photograph album and a bundle of papers. Looking through the album was extraordinary – like watching a silent film of the stories of my childhood. On this page a photograph of the Chinese lady's feet – one naked and folded over on itself in a neat wedge with a single toe, the other clad in a tiny embroidered satin slipper; on that, the 18 Chinese pirates, as cruel and bloodthirsty-looking as you like, tied up and crouching furiously by the wheel of HMS *Bluebell*. Here is my grandfather dressed as Father Christmas, larking about with his shipmates; here he is, handsome in tropical whites, a dead ringer for Stewart Granger; and here piping King George VI aboard.

In almost all these pictures I realise with a shock that he is younger than I am now – a vigorous man in the prime of life, with springy black hair and

bright blue eyes, always, unless he has on the poker face demanded by ceremonial occasions, laughing and at the centre of a large group of people. Lucky for him, I thought when I first saw these pictures, to have been the possessor of such high spirits. They must have been what kept him going through the workhouse orphanage, the foster homes, the training ships, the incident in 1940 when his ship, the *Curacoa*, withdrew, leaving him, a gunnery officer in charge of 12 sailors, ashore in Norway and under attack by German aircraft – and countless other difficult moments. When I think of grandfather, this is what comes to mind – the high spirits, the funny stories, the jokes.

Strange, then, to open the bundle of papers and to find there a different version of the story. I knew, vaguely, that my grandfather was keen on writing. He had a tendency to mark great national occasions with effusions of solemn verse, aspiring to the manner of Alfred, Lord Tennyson, but achieving something closer to that of William McGonagal ("Oh valiant knight, whose heart with fierce and vibrant pride/Stirred men's souls o'er all four corners of the earth and oceans wide ...") begins one, on the death of Sir Winston Churchill) I had not realised, however, that he had begun to write his life story.

It is no more than a fragment – 70-odd typed pages – and hard going; heavily influenced by Grandpa's hero-worship of everything about Churchill, including his prose style, and strongly flavoured by an autodidact's self-conscious literary preference for the polysyllabic and fancy, rather than the pungent, vivid language in which he told his anecdotes.

It tells of his life from the moment when he was picked up by the policeman in Weir's Passage, to his first naval posting aboard *HMS Lion*, just after the end of the First World War, as Captain's messenger to Capt. Wilfred Tomkinson. The resemblance to the jolly, rollicking picaresque with which he used to entertain me is not very close. He did not tell me, for example, that aged six he was transferred from the orphanage to a foster mother in the village of Hatfield Broad Oak who made him eat his meals separately from the rest of her family, and beat him vigorously with a stick that she kept hanging on the wall, lodged behind a tin plate painted with flowers. Eventually the vicar and the schoolmaster, who had taken notice of the clever little boy with a good treble voice, arranged for him to be transferred to a kinder household – that of the old lady I met – but not before he had developed a crippling stammer which caused him no end of trouble and bullying in the Navy, and which he attempted to cure by hiding in remote corners of the orlop deck and reading aloud to himself.

He had, he writes, "often thought of running away to sea", and so the decision by the guardians of the St Pancras Workhouse not to permit him to take up a scholarship to Bishop's Stortford Grammar School, but to send him instead to the Training Ship *Exmouth*, did not seriously upset him. What does seem to have caused him distress is finding out, at the age of 15, when he had to swear his age before a magistrate in order to enter the Navy, that he had no history at all.

No one seems to have bothered to tell him that he was a foundling. Perhaps the distinction between an orphan, or a child whose parents could not provide for it, and one who had been abandoned without a clue as to its identity – not even a name – seemed to the authorities too fine to be bothered with. Not to my grandfather, though. He had, he writes, "always hoped that one day I would be reunited with my real father and mother, and perhaps with brothers and sisters".

Consciously or unconsciously he seems to have made a kind of decision at this point about the direction his life was to take. After all his misfortunes – the abandonment, the unkindness, the beatings, the chance of an education offered and then denied – this discovery, that he came from nowhere, and belonged to no one, might have crushed him altogether.

Instead, it seems to have been the beginning of a process that turned the shy, serious, tongue-tied child who gazes warily from his school photographs into the jolly roaring boy of the later pictures – the man who joined the Navy as a barefoot boy sailor and left, 35 years later, a lieutenant with a Mention in Dispatches; who got himself a life, a family and an honourable history.

Few things are more attractive than courage, cheerfulness and optimism. But they take on an extra dimension when you realise that they are not a lucky assembly of character traits, but the result of an act of will – a deliberate attempt to tackle an unkind destiny with strength of purpose and good humour. This was my grandfather's decision, and the older I grow, the more remarkable it seems to me.

The one injury that courage and optimism could never quite heal was the question that troubles most of us at some time or another, even those with the normal complement of relatives. Who was he, and where had he come from? Was he even – with that unusual colouring – English? And what was the train of events that conspired to make the beginning of his story so very nearly the end of it? He tried and tried to find out something – anything – but never got beyond the brick wall in Weir's Passage.

These days, with a son of my own, I too, wonder how his mother came to leave him there. However desperate to be rid of the burden of a baby; however distracted with poverty, drink or despair, her anguish must have been terrible. This was, after all, not the panicky dumping of a newborn by a terrified teenager, but the deliberate rejection of a healthy baby who had been well cared for by someone for several months.

Poor woman, whatever her reasons. Perhaps she hoped the London streets would offer him a better chance of life than she could herself. And when you consider what he made of nothing, and the richness of his legacy of love and encouragement, you might even say that if that is what she hoped, her wish was granted.

BLAIR'S BIG TOP

Almost no one wanted the Dome to fail – but it does

The Greatest Show on Earth, shouts the ringmaster when the circus comes to town. But no one, except a few unknowing children, is assumed to believe him. In the Big Top the disbeliefs of the crowd, like the bodies of the acrobats, are suspended in the bigger interest of having a good time. If asked the direct question, we watchers would say that there are certainly greater shows on earth, probably greater shows in the next village. But we are not asked and we do not want to be asked. We pay and we lose temporary touch with reality and we go away happy.

So if Tony Blair's Millennium Experience is not the greatest show on the planet, not even much of a show at all, that is something that a part of each one of us would rather not know. The unthinking, celebratory bit of all of us wanted nothing better this week than to roll up, see the man in the high top hat, enjoy the crack of his whip and go about our business. The idea, somehow held within Downing Street and the Dome's organising company, that the nation's critics have been lying in wait to pounce on their good deeds at Greenwich is paranoid nonsense.

Yet, if the Government and its bureaucratic creatures are disappointed and angry this weekend, they have only themselves to blame. For months they have manipulated hopes and expectations in ways that politicians normally only dream of. And now, suddenly, the illusion is over. It must seem years since they last heard complaints about the schools, hospitals and Third World

debt ratings that could be improved with the £758 million spent on the nation's big tent. Although once there were many with queasy feelings about the lottery funds from Liverpool's poor being spent to fuel the architectural fantasies of Hampstead's rich, few wanted to poop the party once the decision for a national good time zone had been made. The press, particularly those newspapers whose editors spent most of the millennium evening in a Stratford train queue, have been criticised for vengeful harping upon the project's failures. In truth, the press should be criticised for too much suspending its reason in the days when the first night fiasco was still a thing unknown.

That night is now the least of Labour's Dome problems. Frank Dobson said yesterday how amusing he found the news that "toffee-nosed people" were forced to queue for hours in the care of London transport. Fortunately, most of those at Stratford station, the sponsors' staff who were being "thanked", the competition winners who were being "rewarded", and the children in wheelchairs who were asked to share this "one amazing night" shared his view, and *The Times*'s view, that humour was the only sensible response. Otherwise there might have been a riot.

New Year's Eve at the station did have one significance, however. It showed the first hint of the organisers' contempt for what is any real ringmaster's top concern. To anyone in showbiz the

words "first night" produce a frisson of fear about the audience. To the bureaucrats of the New Millennium Experience Company (NMEC) a first night is simply the first time that a plan is put into action, hopefully to be better on the fifth night or the 105th. If a circus, or a Broadway musical, were run like the Dome on December 31 there would not even be a second night.

The NMEC chief executive, Jennie Page, is a determined, dutiful and heavily overburdened juggler of other people's balls: but putting her in final charge of a piece of popular entertainment, as became increasingly clear throughout that first evening, was like deploying Mrs David Beckham to head the public spending round. And since then the problem of creative management has become clearer still. The content of the Dome turns out to be a collection of educational toys, politically correct propaganda, sculptured building trials, a few good games and the billboards of discontented sponsors. Much of the work is still to do.

In retrospect we should not be shocked by this. The Dome's prime progenitor was Michael Heseltine, a long-time giganticist whose interest in size for its own sake was the hallmark of his career. Its second master was Peter Mandelson, the ultimate symbolist politician: if he had been allowed to keep the circus whip for longer, he might just have persuaded more people for more time that the show was the greatest; but reality of a different sort drove him far away out of town. The

politicians' aiders and abetters were architectural aesthetes for whom a plastic dome by Lord Rogers of Riverside, ideally empty but if necessary stuffed with a few unpopular objects, was the closest they would ever get to commissioning the cathedrals of their imagination. Those left to put these ideas into practice were part-time committee men, struggling bureaucrats, deceiving spin-doctors and Mr Mandelson's replacement, the straightforward Lord Falconer of Thoroton who was hardly trained as one of his generation's finest lawyers to deal with fluff and nonsense like this.

When Tony Blair had to decide on continuing the Heseltine project, the only serious Labour question about the Dome was the help that it might give him at the next election, the feel-good spirit that he spoke this week of wanting to bottle. Now there will be all too many serious questions, the means to make the Dome worth going to, the dissatisfaction of business sponsors, Treasury and taxpayer if they fail, and the sense among the press that it will not be caught again. Sceptical Cabinet members who, like the newspapers, were more accepting than they should have been, already want to disentangle their Government from Greenwich rather than bind Dome and Downing Street further together. Labour now has an empty symbol, a giant mint-with-the-hole, an all year breeding ground for metaphors against itself. And this circus, unlike the real ones, does not even leave town.

"BULLDOZING IT SEEMS TO BE THE MOST POPULAR ONE"

Master thy mobile & other rules for the new century

How do you keep your cool when others around you are adrift in a minefield of political correctness, rampant technology and fragmented family life? John Morgan, *Weekend*'s maestro of Modern Manners, delivers his ten commandments for the new millennium

John Morgan

OUR MANNERS have come a long way in the past 1,000 years. In the 11th century, the fork was still several hundred years away, thus nipping in the bud any dilemmas about polite pea-eating. Chivalry, that apogee of medieval manly achievement, was only embryonic thanks to nasty habits picked up in the Dark Ages and vociferous woad-wearing proto-feminists. And since few, apart from the odd cleric, could write, there was no seasonal foot-stamping about the dearth of thank-you letters.

Weddings, our great repository of ancient convention, were pretty rough and ready, too. The concept of romantic love was an Enlightenment away: the Saxon groom had to chase his prospective bride over hill and dale and catch her like a hound pursuing a fox. This, by nobody's standards, could be described as polite behaviour. It was, nevertheless, the basis for our tradition of grooms giving bridesmaids presents, as the less-athletic swain was wont to bribe his intended's girlfriends so that they would lure her into a convenient dell where he could pounce.

Now, life, despite the wailings of the pessimists, is relatively polite as we enter the third millennium. Indeed, I suspect that the imminence of new millennia are good for manners: they are times fraught with nervous

expectancy that can make us insecure about the big things that we cannot entirely control, such as natural catastrophes, millennium bugs and that thorny old improbable – the future.

Manners, on the other hand, make the little man feel powerful in the arena of everyday existence, help him celebrate his rites of passage and just make his life nicer to live. Hence our affection and respect for ritual and, moreover, the recent revival of interest in etiquette.

The comfort of manners is also highly useful in times of cultural confusion, such as the present. It strikes me that the great expressions of human confidence and artistic, intellectual and social achievement such as Periclean Athens, the establishment of Christianity and the Renaissance tended to happen mid-millennium, leaving the edges to the smaller vexations of life.

Where do we stand today as we peer across the precipice into the new social landscape? We see a country of cultural pluralism but also one of social and ethical muddle. We perceive a topography where relaxation is thought more appealing than rules and the casual has outclassed the *comme il faut*.

However, far from inculcating an optimism for a brave new world of best behaviour, people find themselves treading tentatively across a minefield of modern mores.

This is simply because, much as we affect to be cool and thus above

such things, most of us actually like rules. They provide a bulwark for the conventional to hold on to and a punch-bag for the rebellious to fight against, and for those of us in between they plant a forest of sociological signposts that we can either adopt, adapt or abjure.

Yet certain pundits maintain that rules are as passé as the steel corset. This is a specious argument. Beneath the trendy veneer of plurality, there lurks a Medusa-like myriad of diktats about what sociologists tell us are our increasingly atomised and tribal lifestyles in the melting-pot of modern Britain. Without some guidance, no matter how subconscious, our lives would inspire a new and terrifying definition for the term Chaos Theory.

This, probably, we will not have to endure, and indeed we enjoy a world that our ancestors would find quite alien. Sexual politics, after technology and widespread prosperity, have been one of the most important catalysts in bringing forth many of the new manners.

Hard-line feminists may complain that it took far too long for woman finally to metamorphose from Saxon quarry to Seventies bra-burner, but now that we enjoy the fruits of the post-feminist age, the sexes gambol not just on a level playing field but on an enhanced one as well.

Among educated people of my age (40) and younger, sexual equality is a professional *donné*. Indeed, so confident do young women feel in their new, almost-Amazonian status that they are happy to enjoy the civilities of chivalry, albeit within prescribed parameters. For instance, whereas in the office environment it would be archaic for men to stand up when women enter a meeting, these same women, out of office hours, enjoy the new gallantry: they happily encourage men to hold doors, pay the bill when on a date and send flowers the next morning.

Moreover, the choice to reject an Eighties-style *über*careerist lifestyle

"Our fragmented society has swept aside many of the old certainties about what people should wear and when"

in favour of part-time work, child-rearing and simply fulfilling one's personal potential are seen as of equal value to holding down a demanding job in the City. Modern manners must respect all these choices.

Modern manners also respect the many ramifications of marriage *à la mode*, whether it be first, second or third time around. Where once the conventions of a white wedding were cast in adamantine royal icing and a second one had to be a small, discreet affair, we now see a multiplicity of marriage conventions brought into being by changes in the law, the complexities of the modern extended fam-

ily and the increased emphasis placed upon the preferences of the bride and groom themselves. Never, as my weekly column reveals, have good manners been so vital.

I suspect that marriage, rather like Christianity, may soon be practised only by a few true believers, while everybody else will select, smorgasbord-like, the components with which they feel most comfortable as the framework for their personal morality and relationships. It will be well-mannered to accept these compromises without value judgments.

Contemporary conventions also embrace the personal choices of those

who live together outside marriage. Full social status (and in France, legal status) is accorded to those who cohabit without a wedding ring, whatever their sex and orientation.

Millennium manners respect money and achievement. Commerce is sexy and creative careers have been transformed from the artisan to (to misquote Sheridan) "the pineapple" of professionalism.

I remember chatting to the previous Duke of Northumberland at a party. He spent much of the conversation trying to impress me with his credentials as a wildlife film maker. I nodded, smiled and "Oh really'd" but privately

mused that only a generation ago it would have been quite enough just to be the D of N. In the new millennium it will be fine to be a duke, providing it is a duke who does.

This incident also illustrates how manners have adapted to the ever-increasing domination of professional life. Once it was extremely rude to ask people what they did and only in emergencies was social life disrupted by work.

Now we discuss our jobs at the drop of a Prada glove, dinner parties are delayed and lonely wives of investment bankers dream about having a social life that their husband's pay could provide if only he were around to share it. Although a cancellation because of a better offer remains a severe social solecism, pulling out because of a business trip or global conference-call is reluctantly accepted.

There has also been a total inversion in the prestige of the generations. A thousand years ago our social structures were similar to those still practised in the Orient. The old were venerated, if for no other reason than tenacity and survival. Children, who tended to perish easily, were popped out like Smarties. But our millennium is witnessing a social and familial reversal in fortune which explains why one of the strongest leitmotivs in Modern Manners remains inter-generational dynamics.

Many older people feel a burden on the salary-earning majority, and the young pack a bigger punch than their size, demographic influence and intellectual capacity deserve. This is a tedious trend and an excuse for bad manners masquerading as progressive parenting: mothers turning up with uninvited babies in tow, ill-disciplined children and crass commercialism.

A similar change has happened between host and guest. To be invited to share a stag at a Saxon hearth was one of the greatest compliments. The enacting of the ancient rites of hospitality was a dance of deference that had been performed since the Stone Age and when conviviality and comfort were scarce.

THE TEN COMMANDMENTS FOR A WELL-MANNERED MILLENNIUM

1. Thou shalt not be an -ist. i.e. racist, sexist or ageist.
2. Thou shalt not believe that political correctness is a substitute for good manners. It is not.
3. Thou shalt not love thyself more than thy neighbour. Narcissism can be dangerous.
4. Thou shalt keep thy child under control. There is room for only one Messiah in a millennium.
5. Thou shalt be punctual.
6. Thou shalt tame thy technology.
7. Thou shalt not assume thy sex life is of public interest; 1963 was a very long time ago.
8. Thou shalt remember that good manners are a sign of strength rather than weakness.
9. Thou shalt still say "Please" and "Thank you".
10. Thou shalt be kind and generous in all thy actions.

Conversely, we enjoy an Aladdin's cave of recreation. Today's put-upon hosts are affronted by guests who do not RSVP, turn up late and rarely write a thank-you letter. This lack of appreciation is bad manners in any millennium.

These problems relate to a disregard for common courtesy, one of the most enduring aspects of good manners. This can encourage the "antis" to declare that conventions cast us in aspic. They do not. Manners adapt to change. See how they are taming new technology. The Internet has spawned netiquette, correct syntax is refining e-mail and lovers flirt electronically across cyberspace. Mobile telephones, once a calling card of the pariah, are essential.

Manners and etiquette are alive and well. They should prove remarkably resilient, adaptable and inspiring in the 1,000 years ahead of us.

Hollywood slips into Brit-speak

THE AWARDS season is upon us and connoisseurs of pseudery are preparing to savour some fine moments.

Under particular scrutiny are not so much the words with which winners gracefully accept, but the pronunciation of those words – a wave of phonetical phoniness is sweeping through the worlds of celebrity and fashion. Most people agree that it began with Madonna, who, despite growing up in Detroit, has taken to accepting her gongs with a distinctly un-American "Thank kyeeew".

According to *The New York Observer*, this tendency has infiltrated the Manhattan fashion world, where young editors are over-enunciating, tossing in a continental "no?" at the end of sentences and using that very English qualifier "quite".

Unabashed, one fashion stylist, Polly Mellen, admits that she has always been described as sounding a bit British. "Probably because I always went to private school and had a really, sort of, very, how can I say it, privileged education and life."

Over on the West Coast, Gwyneth Paltrow – who has also had a privileged life and who mastered a perfect English accent for *Shakespeare in Love* – seems to slip into British-speak on all sorts of not necessarily opportune occasions. So is this sort of thing becoming widespread in LA?

"I really hope not. They're a little bit more like that out East," Phillip Bloch, the Hollywood stylist, said as he was wading his way through possible Golden Globe outfits for Jim Carrey, Jenna Elfman and Halle Berry when I called.

"But if we're talking about Madonna's Detroit-British accent, well, I've often wondered about that. I really hope it's not going to catch on."

Grace Bradberry in Los Angeles

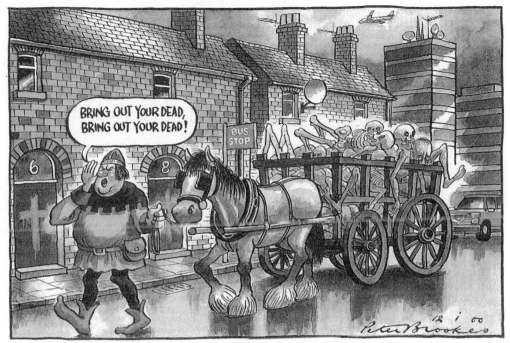

FLU CRISIS — THE NHS GEARS UP...

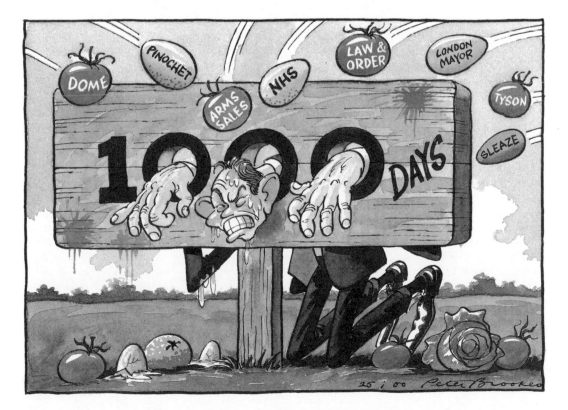

Taking a chance on life

I HAVE JUST become a human guinea pig – the first person in the world to be given a British-developed vaccine for liver cancer. If it works, it will make medical history. If it fails, I will be lucky to see my first grandchild, due to be born in late June.

On the face of it the trial does not look inviting. "This could result in you having a fever and flu-like symptoms or very rarely cause you to collapse," an information sheet given to patients says. "A second possible reaction could be the white blood cells attack your own tissues instead of the cancer. This might cause skin rashes, joint pains or diarrhoea."

But the decision to be a guinea pig at the age of 59 was easy to take. Liver cancer is one of the rare types of the disease, with 1,400 cases reported in Britain each year, compared with 40,000 lung cancer or 33,000 breast cancer cases. But liver cancer is the most deadly, killing 91 per cent within a year of being diagnosed. Only 2 per cent survive for five years.

The most successful treatment is to have the tumour surgically removed, but mine was already too large to be cut away. Chemotherapy has at best a 20-to-1 chance of marginal success, with terrible side effects guaranteed.

It was three months ago that I discovered I had joined the 130,000 who are annually consigned to Britain's cancer death row. Until then I had been building towards a comfortable retirement.

It was almost by accident that I found out anything was wrong. I had gone into hospital to have a prostate cancer removed, a relatively simple operation which should have meant a five or six-day stay in hospital and

Ian Murray, The Times medical correspondent, has liver cancer. His options are few, his chances of survival slim. Which is why he has become the first person in the world to try a vaccine that gives him some hope of seeing his first grandchild, due to be born in June

then a gentle recovery period.

Instead of five days, I spent five weeks in hospital. During that time I had an ultra-sound scan of the bladder and the radiologist noticed there was an abnormality with the liver. The abnormality turned out to be a malignant tumour, 17cm long, on the right lobe and there were signs of early tumours on the left lobe and a small secondary in the lung. The liver specialist told me the tumour was inoperable and that chemotherapy would probably make me so ill, for so little chance of benefit, that it would not be worth having. He called in my daughter to tell her the news and left us to work out how to tell my wife. She took the news stiff-upper-lipped but clung to the hope that the oncologist, then on holiday, would find a treatment programme when he returned.

For a short while we had hopes that I could join a trial for a promising new drug for liver cancer. The specialist in charge came to my ward, read my notes and left without seeing me. Because I'd had prostate cancer, I was excluded from taking part even though I might have benefited.

As a medical correspondent I was writing nearly every week of break-throughs in cancer treatment. It seemed inconceivable that something could not be found to help. But the oncologist could offer nothing more than the promise to "treat the symptoms" – which I took to be a

euphemism for saying that when the pain became unbearable, I would get as much morphine as I needed.

Stunned, my wife and I went home and cried a little. Physically, I was weak after losing more than two stone in three weeks and the grim news from the oncologist bowled me over mentally and spiritually. I could scarcely believe I was being thrown on to the scrap heap until the following morning when I heard a discussion on the *Today* radio programme with a junior health minister trying lamely to explain why a potentially life-saving cancer drug was not available in the teaching hospital where it was discovered because the cost was too high.

The minister repeated parrot fashion in answer to every question that this Government, unlike the last, was taking cancer seriously and reorganising the system under a new cancer supremo. It would take a year or so, but things would get better.

Life-saving cancer drugs are available, but many health authorities do not allow them to be prescribed because of cost. None exists for liver cancer, but they exist, for example, for women with ovarian cancer. They could be helped now and it will be small comfort to them and their families to learn that in a few years' time things will be better. Time in the treatment of cancer is supposed to be of the essence, which is why the Government has set targets of seeing all those suspected of having it within two weeks. But that is a fat lot of good if you get a positive diagnosis and then get told there is no treatment available or affordable.

The fact that drugs that can extend or save lives are not made available

Ian Murray and his wife, Carol. Their hopes are pinned on a new vaccine made using the patient's own blood. The vaccine should seek out and destroy cancer cells

makes a mockery of the claim that the NHS is available "according to need, regardless of wealth and free at the point of delivery".

What is even sadder is the fact that successive governments have been happy to allow cancer charities to provide at least 90 per cent of the money spent on research. Although Britain has some of the best brains in cancer research, scientists are often forced to go abroad to do their work and their discoveries – which ought to have been obtainable by British patients first – are often not available here because of the cost.

I had to face the fact there really seemed to be no treatment available to me so I contacted Gordon McVie, the extrovert director-general of the Cancer Research Campaign. He put me in touch with David Kerr, who runs the Institute for Cancer Studies unit at the Queen Elizabeth University Hospital in Birmingham. "He's a Partick Thistle supporter," Professor McVie said. "He knows all about fighting lost causes like yours."

Professor Kerr was to see me in Birmingham but rang the day before to say he had been summoned to London to discuss cancer care with the minister. We met in London and he outlined two possible treatments. One was Japanese. Liver cancer is relatively rare among Western races, but common among Asians. That is why the CRC liver research is based in the Midlands where there is a large Asian population.

The Japanese treatment involves injecting the liver with a drug which kills the tumour, but in my case the growth was so large it was unlikely to work. The second treatment was a drug developed by the CRC which homes in on the liver and then delivers a toxin which causes the cancer cells to self-destruct. Professor Kerr felt this was the best option. Full of hope, we went to Birmingham expecting to join the trial.

Once more it was not to be. Once again the trial protocol excluded me on the grounds that I'd already had prostate cancer. The journey back to London was infinitely depressing.

Professor Kerr, however, was not to give up that easily. Two days later I was told that other treatments might be available and he took time out on a Sunday to call and tell me about the vaccine: trials in the US on melanomas (skin cancers) have shown promising results, with half the patients showing remission.

The vaccine for liver cancer has been developed because of similarities between the melanoma and the hepatoma (liver cancer) cells. David Adams, professor of hepatology in Birmingham, who leads a team of immunologists dedicated to translating their laboratory research into novel cancer treatment, worked with Professor Kerr to develop the treatment.

The vaccine is made using the patient's own blood. Last week I travelled to Birmingham and had 28 small test tubes of blood taken from my arm to be used in manufacturing the vaccine.

Since then dead cancer cells taken from a patient with a similar tumour have been broken into tiny pieces and put into a test tube containing my white blood cells.

The idea is that inside the test tube my white blood cells, which run the body's immune system, will be taught to hunt out and destroy cancer cells. The solution was then washed and the remaining solution was put into a salt solution and reinjected into my vein.

If the theory is right, this vaccine should already be seeking out and destroying cancer cells. Over the next three months I am to have a series of further similar infusions, increasing the cancer-destroying power of my own immune system.

Nobody, including the two professors, knows whether it will work, but in theory it should. If it fails at least we will have tried. I may need the morphine later, but hope at present is proving the best painkiller.

Dog's dinner for the man who bumbles through OK

Ben Macintyre reports on the mangled messages from the Republican front-runner

GEORGE W. BUSH had the audience eating out of the palm of his hand until suddenly, in the middle of a riff about free trade, he appeared to launch an unprovoked attack on a species of small dog. The world will be a better place, the front-runner for the Republican presidential nomination said, when "all the terriers are torn down".

Gasps were heard. Could it be that beneath Mr Bush's affable exterior lurked a hidden hatred for dogs, a certain disqualification for America's highest office? Indeed not. Mr Bush is a friend to all canines, but language is not a friend to him. In the flow of his own oratory, the candidate had somehow crushed "tariffs" and "barriers" into a single word, in the sort of linguistic snafu that has become an almost daily feature of the Bush campaign.

For not only has Mr Bush taken on his father's presidential ambitions, he has also inherited his uncanny knack for mangling words and syntax into the oddest shapes. When George Bush the elder was on the campaign trail, he declined "to kind of suddenly try and get my hair coloured, and dance up and down in a mini-skirt or something, you know, show that I've got a lot of jazz out there and drop a bunch of one-liners, I'm running for the President of the United States, I kind of think I'm a scintillating fellow." The son is prone to the same sort of verbal chaos, and as he swung through Iowa last week in the run up to today's caucus vote, the first step in the nomination process, Mr Bush's minders were on hand to provide simultaneous translation.

"When I was coming up, with was a dangerous world, we knew exactly who the they were. It was us versus them, and it was clear who the them was were," Mr Bush told a bemused audience in a gymnasium at Iowa Western Community College. Undeterred, he ploughed on: "Today, we are not so sure who the they are, but we know they're there."

Earlier in the week, he sent reporters into a flutter of confusion by telling 2,000 supporters at an oyster roast: "It's a world of madmen and uncertainty and potential mential losses." Even Mr Bush's spokesman was uncertain quite what a mential loss might be. Mr Bush tends to be coasting along comfortably on mental autopilot when he runs into a brief but jolting pocket of grammatical turbulence, finding it hard to broker agreement between subject and verb. "Rarely is the question asked are: Is our children learning?" he informed supporters at a community barbecue.

Mr Bush is also prey to what might be called the jammed compact-disc stutter, when he gets impaled on a single word. "We must all hear the universal call to like your neighbour just like you like to be liked yourself." Then there is the grand word glitch, triggered by his occasional forays into the deeper bits of the dictionary. Three times in two days, Mr Bush said that, if elected, he would never "obsfucate". It is a measure of the Bush charm that when the candidate finds himself up a blind verbal alley being assaulted by his own syntax, he is as amused as anyone else. "Bumble through OK?" he grins.

After more than seven years of syntactical precision by Bill Clinton, it is refreshing to have the Bush-isms back, and a candidate who does not obsfucate but say things how they are is.

Tongue-twisters that tie new Labour in knots

THEY SOUND innocuous enough but Pops, Spads, and Roscos have become a major thorn in the side of new Labour.

Apart from a select band of civil servants, very few people, including many senior ministers, know what they mean. Some Whitehall departments have drawn up acronym crib sheets to help ministers to get to grips with the proliferation of baffling terms.

Others are attempting to remove them from speeches amid fears that they are alienating the electorate. The Department for Culture, Media and Sport, or DCMS as it is known to insiders, is one of the worst with 300 acronyms.

For its ministers, a BLT is not a sandwich filling but the Better Life This initiative, while the clumsy-sounding Naccce is the National Advisory Committee on Creative and Cultural Education. The difficulties were highlighted this month when Alan Howarth, the Arts Minister, had to announce the results of the DCMS/MGC IT Challenge.

John Prescott, as head of the DETR (Department of the Environment, Transport and the Regions) has to cope with RDAs, VOAs, ECAs, PPGs, ETRACs, VEDs and ACREs.

When he refers to Pops he means persistent organic pollutants. A LUL is not a quiet period but the London Underground, while Roscos are rolling stock leasing companies. The Spad is a signal passed at danger, in other words a train going through a red light.

John Lister, of the Plain English Campaign, suggested the terms might be a neat way of making unpleasant things sound innocuous. "Two Spads at the same time means a train crash, let's not forget that," he said. "People use this jargon to dress up what they are saying to make it sound more impressive.

"John Prescott is someone you would think would speak plain English but in fact he tries to make his speeches sound more important by loading them with gobbledegook."

A Culture Department spokesman said: "The reason there are so many acronyms is that we have a lot of NDPBs." These, on further investigation, were revealed to be non-departmental public bodies.

A few of the more popular acronyms used by government:

POPs Persistent organic pollutants
PLR Public Lending Right
PPP Public Private Partnership
PPG Planning policy guidance
VED Vehicle Excise Duty
ROSCOs Rolling stock leasing companies
ICT Information and Communications Technology
NMEC New Millennium Experience Company
RDAs Regional Development Agencies
ECAs Enhanced Capital Allowances
VOA Valuation Office Agency
IPPC Integrated Pollution Prevention and Control
ETRAC Environment, transport and regional affairs committee
ACRE Advisory Committee on Releases to the Environment
LUL London Underground Limited
OPRAF Office of Passenger Rail Franchising (not to be confused with:)
VCRAT Vehicle Crime Reduction Action Team
ASCOBANS Agreement on the Conservation of Small Cetaceans in the Baltic and North Seas

Melissa Kite

Spellar's error leaves MPs blue in the face

STILL ONLY 52, in mid-career, having reached the level of junior Defence Minister, and on a grey Monday, it must be depressing for a chap to realise he has just said the most interesting thing he will ever say in his life. Even more depressing to realise it was just a slip of the tongue.

Poor John Spellar. Virginia Bottomley struggled to control herself, such was her mirth. Up in the Press Gallery, professionalism pushed past breaking point, journalists heaved with laughter. MPs hardly tried to restrain themselves. Paul Keetch (LD, Hereford) was even moved to offer "sympathy" to the minister "in his first answer". What Mr Spellar meant to say was "cuts". How the errant "n" crept in, none can say.

The old joke about the difference between Billy Smart's circus and the Folies Bergeres should signpost the pitfall to any MP, but Spellar tumbled straight in, and emerged blushing. He ploughed bravely on with his answers, stuttering miserably, aware nobody was now listening to a word he said.

The intended sentence – "those cuts in Defence Medical Services have gone too far" – had acquired quite another meaning, amended by Spellar. Being Minister for the Armed Forces is

Matthew Parris

Parliamentary Sketch

one thing; adopting the sort of mess talk one might expect in the Armed Forces is another. Spellar quickly corrected himself.

But it was too late. Unfortunately for this minister, he does anyway talk in the most irascible way. As even his most pedestrian answers are spat out like the outbursts of a man provoked beyond endurance, the offending word did not in this case sound completely out of place ...

But enough. A polite sketch must now draw a veil over the subject, venturing (alongside a modest bet on the prediction that this morning's *Hansard* will have cleaned up Spellar's prose) the thought that we now know the difference between Prime Minister's Questions and John Spellar's Answers. The first is a cunning row of stunts, the second a stunning row of cuts.

Geoff Hoon, Secretary of State, recovered his composure fast enough. Mr Hoon is a very cool cookie indeed, amiably lowering the temperature with intelligent courtesy. The Emperor Hirohito is said to have broken the news of the US nuclear strike on Hiroshima with a broadcast announcement: "An event has occurred which is not necessarily to our advantage"; the Emperor Hoon is developing a comparable range of understatement. "Let me first of all question his use of the term 'severely'," cooed Hoon, when foam-flecked Julian Brazier (C, Canterbury) suggested that Britain's Armed Forces were hard-put to maintain commitments.

When Richard Ottaway, Tory spokesman, described an under-supplied Royal Navy "stuck in port" over Christmas, Hoon shuddered at the language. "There was a point when a significant number of ships were, er, tied up alongside," he allowed. For turkey and Christmas pudding, apparently.

A secret deal to pool our independent nuclear deterrent with France's? "The, er, great majority of that *Spectator* article was based on fantasy." Massacre and terrorisation of Kosovan Serbs by Albanians? "There have been, er, difficulties in encouraging Serbs to return to their homes and their jobs."

I can see the indispensable Rt Hon Sir Geoffrey (as he then will be) Hoon in 15 years: reliable, moderate, pleasant, bright – "a safe pair of hands". Every administration needs its Sir Norman Fowlers and this latest is critically short of them. Hoon will go far.

The Saint comes marching back

Matt Dickinson

A YEAR is nothing when you expect to live for several thousand life times, so it was daft to expect that Glenn Hoddle might have changed. Same haircut, same sharp suit and same bizarre use of English, the new manager of Southampton was even parroting the old line that "I never said them things".

Hoddle is back, plumage unruffled, a year to the day since his interview with *The Times* unleashed a whirlwind of publicity, and you would never have guessed that he had been away. When the Saints go marching in, Hoddle will be leading them and the blessed Eileen Drewery, his spiritual guide and mentor, will be by his side.

And, strange as it may sound, good luck to him. No one ever said that he had nothing to offer football or that he and his faith healer should be banished from the game. Hoddle knows more about tactics than Kevin Keegan possibly ever will and Southampton, increasingly unsettled by the criminal charges against David Jones, have turned to the most obvious candidate as they fight against relegation and Jones goes off to fight for his innocence.

Hoddle, the coach, will probably guide Southampton to safety, and yet there was a reminder yesterday of the crassness of Hoddle, the man. When he compared his experiences of 12 months ago with Jones's fight against 13 charges of child abuse, the best that could be said of it was that he, too, stands on a type of trial.

In Hoddle's case, it is the struggle to regain the credibility that, as the England coach, had been stripped away like a coat of paint. A talented tactician, he had allowed his judgment to become obscured in a cloud of vanity. He had

Hoddle has not changed in the 12 months since he left the England job – same haircut, same sharp suit and same confidence in his own ability

taken to humbling the best young players, such as David Beckham and Rio Ferdinand, in training sessions in some needless assertion of his own playing greatness, and it was the same belief in

> What has been added to Hoddle only God or Eileen knows, but repentance does not come into it as he continues to blame anyone for his sacking but himself

his own infallibility that led to him speaking so candidly, and offensively, about his views on reincarnation and the disabled.

The opprobrium that was heaped on

him would have humbled other men, but Hoddle's self-esteem glares like a spotlight and it was apparent yesterday that it remains undimmed. "I came out of the England situation with a draw and two wins and got the sack," he said, "so at the end of the day I have nothing to be not confident about. I have had a lot of support from the public. Thousands of letters of support. That gives you confidence. I have no bitterness. It does not change you as a person. Every experience adds to you."

What has been added to Hoddle only God or Eileen knows, but repentance does not come into it as he continues to blame anyone for his sacking but himself. "Them things were not portrayed anywhere near what I was talking about," he said. "They were untruths and it has been unfortunate for anyone who is disabled to get upset about it."

It was the only time Hoddle allowed himself to be drawn on the past in a press conference which, after the mayhem of his last one, was like comparing The Dell to Wembley. Although considered by Aston Villa before their fortunes turned around, Hoddle has not been spoilt for offers from big clubs and so it was yesterday that the former Chelsea and England coach ended up taking on a relegation battle down on the South Coast.

The refusal to jettison Drewery will have put off many clubs, just as it infuriated his former employers at the Football Association. Happy to allow the players to see her in their own time, they became increasingly miffed when the bills started arriving and when it became clear that some England internationals were feeling under pressure to visit her. She remains Hoddle's guide, though, and he, with the backing of the Southampton board, will continue to push players her way.

"If any player wants to see any healer in the country to get their careers back on track," he said, "then I won't be averse to that at all – if it is Eileen or whoever. I know for a fact that players have been to healers all around the country and, if they want that, it can be arranged. I am open-minded enough to let them do it."

At Southampton they tend to worship the name of Matt Le Tissier and it will be one of the fascinations of Hoddle's reign to see whether the great maverick can enjoy one last heyday.

It was as England coach that Hoddle unexpectedly threw Le Tissier into a crucial World Cup qualifying game against Italy at Wembley, but he never picked him again. "He's a quality player," Hoddle said, "and he has still got the quality to be one of the best players in the Premiership. If we can get him fit he can prove that. But he is injured at this moment in time."

Hoddle, whose contract is fixed for 12 months, has a week until his first match at home to West Ham United to become acquainted with his new staff and he will be assisted by John Gorman, his sidekick when he first began in management at Swindon Town, and later with England, who had a clause in his coaching contract at Reading that allowed him to leave the moment Hoddle was back in work.

Southampton are fourth from bottom of the FA Carling Premiership but, with Watford, Bradford City and Sheffield Wednesday all caught in the quicksand, Hoddle is entitled to be optimistic.

His batteries recharged after his first break from the game since he was 16, Hoddle returns as ambitious as when he was in charge of Swindon and Chelsea, but there is a substantial difference this time around.

However successful he is, the England job is gone for ever and, Hoddle being Hoddle, he will regard that as a tragedy not only for himself but the entire country.

A brief history of political sleaze

UNTIL THE autumn of 1948 few people had heard of John Belcher. A Labour MP since 1945 and a junior minister at the Board of Trade since 1946, he occupied just a dozen lines in *Who's Who*. He was soon, though, to become a household name.

Almost without warning the roof fell in on Belcher's quiet, unostentatious existence. The first sign that something was amiss was a brief statement that, at the request of the Lord Chancellor, the police had inquired into irregularities at the Board of Trade. A week or two later, after a Commons debate, a judicial tribunal of inquiry was set up. Its report came out in January 1949 – they managed things rather more speedily in those days – and poor Belcher's political career was over.

He retired to obscurity as a railway booking clerk, from which modest vantage point he would occasionally be summoned back to face some fresh journalistic impeachment as part of a "Where are they now?" feature in a Sunday newspaper.

Belcher, though the phrase had not then been coined, was the first postwar victim of "political sleaze". His transgressions were all in a very minor key – a family holiday at Margate, the gift of a cigarette case, a visit to the dog races at Haringey – all supplied at the whim of a "contact man" known as Sidney Stanley.

Stanley was a Mr Fixit, a product of the austerity world of coupons, licences and regulations. He was a kind of founding father of today's armies of political lobbyists. Not to put too fine a point upon it, he was also a "conman" who tended to claim friendships with the mighty on the basis of having once asked them for a favour.

There had, of course, been more serious episodes of corruption before Stanley – the Marconi Affair of 1912, the strange episode of Ramsay MacDonald and his Daimler car supplied by a biscuit king in 1924 and the

sad business of Jimmy Thomas leaking Budget secrets to a business crony on the golf course in 1936.

Yet the Belcher case was a kind of benchmark in postwar politics. Such was the shock it caused that no similar tale of corruption surfaced in high places for 25 years, when Reggie Maudling was forced to resign as Home Secretary.

On the whole, the wonder is just how clean a record we in Britain have had in terms of financial corruption. There has certainly been nothing to compare with the enormities now revealed in Helmut Kohl's Germany or Bettino Craxi's Italy.

One reason for this may have been because the words "political scandal" in Britain have tended to be linked not with money but with sex. From the days of Charles Parnell and Charles Dilke onwards, it has generally been what politicians get up to between the sheets that has got them into trouble – and the "Swinging Sixties" certainly produced the sexual scandal to chime in with the mood of the times in the "Profumo Affair".

Since then, public opinion has undoubtedly become more relaxed. By the time the skeletons started falling out of the cupboard in the days of the Major Government, this whole aspect of political life had begun to look more like bedroom farce than classic tragedy.

Yet "sleaze" remains a word guaranteed to strike terror into the heart of any politician. No doubt strong governments can fight off most allegations of personal misconduct but weaker ones will remain susceptible to the cumulative damage that such allegations can do. The last melancholy days of the Major administration are sufficient proof of that – and it would be a bold spirit who would maintain this weekend that the whirligig of time will never bring his revenges against even as powerful a government as that of Tony Blair.

Anthony Howard

THE TIMES

February
2000

Battered rebels flee ruined Grozny

Chechen fighters are beaten back but remain unbowed

 Janine di Giovanni

THE UNLIT room of a makeshift first-aid centre a few miles from Grozny is full of dozens of badly wounded Chechen fighters who had retreated from the capital and stumbled into a minefield.

They had left at dawn, a group of rebels and civilians several hundred strong. Now, after weeks of living hell, the uninjured gather. It has been one of the Chechens' blackest days and while they remain defiant, the truth is that they have abandoned the city for which they fought so long.

"We have not retreated from Grozny," a sector commander leading the fighters says as the windows around us shake from the bombardment. "If we got out of the town, it means we're going to do something more effective."

A soldier near by adds: "This is winter. What can we do in the winter? Just wait and see what we do in the spring."

One of Grozny's most senior combatants, Commander A, who came out with the fighters, puts it another way. He says that the Chechens no longer need Grozny. They are regrouping and considering tactics. "What does Grozny mean now? Empty walls? Empty buildings?" he says. "There are more beautiful cities for us to take. Even Moscow. We have enough trained guys. We have enough will to fight."

He denies that the retreat is a loss. "We have not changed the strategy that we have had for 400 years. We have changed tactics," he says.

Dozens of the Chechens in the first-aid centre have been seriously wounded and were dragged here by their comrades. They are being treated by local women who run through the corridors with blood on their hands and have little knowledge of medicine.

In a small room, a lone doctor in bedroom slippers performs an amputation with minimal anaesthetic while the patient squirms.

A sobbing woman wanders from room to room, looking for her brother. "Where is he? Please tell me where he is." She finds her soldier brother shortly afterwards, dead and covered with a white sheet on a stretcher in the corridor.

The fighters, many of whom have been inside the city since October, wander through the first-aid centre, helping the wounded. Dirty syringes and ancient drips litter the floor; bloodstained stretchers are propped against walls. One soldier tries to stitch a wounded friend's bloody feet with a needle and thread while the man faints from pain.

All the time the bombardment continues. Dje, a 26-year-old woman fighter, says the past few weeks inside were a living hell. "The Russians are dropping every kind of bomb imaginable," she says "Cluster bombs, deep penetrating bombs that wipe out the basements, even chemical bombs. The only thing they aren't dropping are nuclear weapons."

Dje says she received the order from her commander to gather her things and leave Grozny through the Russian defence ring. At one point, along a 60-yard corridor, the Russians were so close, she says, they could practically see each other. "But they don't like to fight us man to man. They have artillery and planes – we have fighters."

Losing so many of her comrades in the minefields, she says, was the worst incident of the war. She says there are still several thousand Chechen fighters inside the city centre, as well as 40,000 civilians, mainly ethnic Russians, the elderly, women and children who cannot make the treacherous journey out.

Early in the morning many villagers tried to flee, taking their belongings and children on carts. The ones here have no electricity, heating, water or telephones. They are terrified that the Russians will enter and take the women away.

One villager, sharing her lunch of pickled corn and bread, shakes her head as a mortar bomb crashes in the distance and a machinegun rattles. "Hear that?" she says nonchalantly. "This is the music we live by."

Perhaps the most hideous aspect of this conflict is the sense of isolation. Unlike Bosnia, Kosovo or East Timor, there are no aid workers inside Chechnya, no medical relief teams, no United Nations. Apart from me, a German photographer and another European, there are no journalists reporting from the Chechen side.

The Chechens are bitter about this. "Why doesn't England do anything?" asks Yeva, a 33-year-old international lawyer from Grozny. "Only two or three times in our history have we had our statehood. There is no nation in the world that has had to fight so hard for it. Every time our population rises to a million, we get cut down." Her young daughter clutches her hand.

By late afternoon, as the light dims and the deep Caucasus cold sets in, the floors of the field hospital are sticky with blood, my boots sticking to them. The thin mattresses where the young fighters – all in their 20s –

lie are soaked red; the doctor is on his fourth amputation.

On the second floor, in a small room at the end, a 26-year-old fighter named Muslim lies in a corner with half a foot covered in a bloody rag. He has been defending the capital since August and came out last night. "I stepped on one of those mines that injure but don't kill," he says. "It was a gift from the Almighty."

The man in the next bed was not so lucky. He was blinded by a "frog" mine, which springs into the air before exploding. The place where his eyes once were has swollen like grapefruit. His face is purple with bruises and he mutters incoherently as his comrades try to soothe him. When Commander A enters to check on his men, he stands by the blind man's bed for a

long time with a look of terrible regret on his face.

"To go into the centre of Grozny now is suicide," one soldier says. "There is nothing left there, nothing! We defended it until it was time to leave."

Later Commander A also asks why the West has done nothing but stand by and watch the disintegration of Chechnya. "Our first war was for independence," he says. "When we fought for independence, they called us bandits. Now, when we fight for Islam, they will call us terrorists."

The soldiers, in their agony, call out *Allahu akbar* to each other. But Yeva, the young lawyer, says the war is not really about religion – it is about freedom. "Can't anybody help us? Don't we warrant any mercy from the world?"

Cricket therapy

From Mr Neville Denson

Sir, How dare Michael Atherton say that county cricket "serves no purpose whatsoever" (report, Sport, January 26).

It serves the very useful purpose of giving whingeing old gits like me the opportunity to sit in the rain on a virtually empty ground and complain about most things – including county cricket.

Yours faithfully,
NEVILLE DENSON,
12 Abbots Way,
St Bees, Cumbria CA27 0HD.
January 26.

VLADIMIR PUTIN, VICTOR OF GROZNY

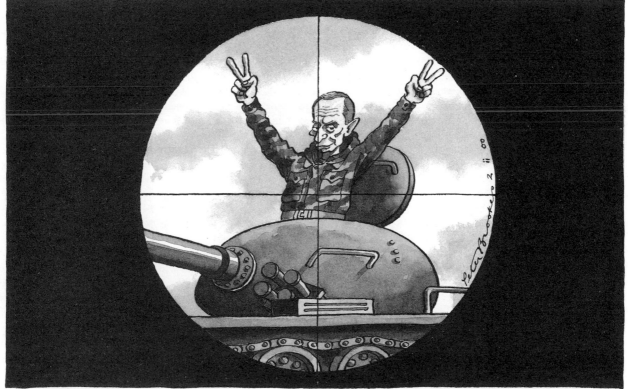

(VIEWED FROM BEHIND TREE ON CHECHNYAN HILLSIDE)

Litany of life sentences fell on him like hammer blows

Alan Hamilton witnesses the final act of a courtroom drama built on the heinous perversion of medical skill

 Alan Hamilton

HAROLD SHIPMAN'S face registered nothing but blankness behind its grizzly beard, but his body told all. As the judge reeled off his litany of 15 life sentences they fell on the prisoner like hammer blows to a stake, and he appeared to shrink into the ground.

He had started the trial a small, grey-bearded balding man. By its end his bones stuck through his thin brown suit, his tonsure spread to expose more of his pate, his hair seemed to have turned even more ashen, and his face displayed the pallor of a man who has not seen daylight for more than half a year.

At the end of what must have been the longest week in his 54 years of life, he came up the 24 steps from the cells below, walking in quick, jerky movements as he had done on his previous 56 days in the dock. But now he looked like a shrivelled old man whose three white-shirted prison guards towered over him.

Each day last week Shipman had been brought up those 24 steps at 4.15pm to hear Mr Justice Forbes dismiss the jury for the night with the reminder that they must feel under no pressure of time. They took him at his word. Yesterday the court assembled as usual for close of play, but there was an indefinable buzz that spoke of a result.

There were clues. Time passed; the judge's clerk placed a glass of water and a blue folder on the bench. The clerk of the court made a whispered phone call.

The strain of waiting may have told on the prisoner, but it told even more on the relatives of his victims who had daily filled half the public gallery to listen to a heinous perversion of medical skills. At 4.30 the judge took his seat, the jury filed in and its shirt-sleeved foreman was asked to stand up. So many were the

verdicts that he had them written on a sheet of paper in his hand. As he responded 16 times to the clerk's inquiry of their verdicts, each one answered unfalteringly with a "guilty", Shipman stood motionless between his jailers, looking neither to left nor right, his hands clasped behind his back and his eyes occasionally closing.

From the walls of the lofty Baroque Edwardian courtroom, oil portraits of past high sheriffs gazed unblinkingly down. They may have seen much in their time, but nothing quite like this. As the verdicts were announced, there emerged from the relatives in the public gallery sighs of relief, quiet cries of "yes" and the sound of weeping. What they had endured was almost too much to bear.

The defence case was in ruins. Nicola Davies, QC, Shipman's barrister, did not even ask for leniency. "The sentence for murder is set in law. There is no discretion. There is no more I can say." It was a brief, pointed concession of defeat.

Mr Justice Forbes, soft spoken and avuncular but displaying a catch of emotion in his voice, chose to pass the sentences individually. As he intoned "life" 15 times over, relieved only by "four years" for the fraud charge, Shipman's erect posture crumbled.

His body seemed to sink into itself, but his only other movement was an occasional slight heave of the shoulders as the prospect of the rest of his life in prison sucked the breath from his body. Lest there be any doubt, the judge unusually announced in open court his

recommendation to the Home Secretary. "The crimes are so heinous that in your case life must mean life, and that you must spend the rest of your days in prison."

Ignoring the packed court, Shipman turned and walked swiftly back down the 24 steps between his guards. He will never be seen in public again.

In the public gallery, well separated from his victims' relatives, his wife, Primrose, and his eldest son, Christopher, absorbed the verdict and the sentence with no flicker of expression, as though already anaesthetised against any enormity.

Shipman had no opportunity to hear the judge heap unstinting praise on the police or the lavish quiet-spoken sympathy he poured on the relatives – a short and kindly homily for which he took off his wig.

Again unusually, he praised the professionalism of the legal teams, and offered profound gratitude to the jury. All those involved in the case will receive a memento – a copy of his sentencing and closing remarks, printed at public expense. More immediately, he informed the jury that "suitable refreshments" awaited them backstage.

It was the end for Shipman, the end of an historic trial, the end of an unimaginable strain for his victims' relatives, and the end of a grisly entertainment for a dedicated knot of local people who queued every day throughout the trial for a third-row seat in the gallery.

They were the latter-day *tricoteuses* who sat by the steps of Robespierre's guillotine, although these spectators picnicked rather than knitted. But in the end, they were rewarded with the metaphorical rolling head they had waited so long to see.

MPs' worst side exposed in ritual of trite outrage

Matthew Parris
................................

Parliamentary
Sketch

WE KNEW something was up when we saw how low Michael Portillo was wearing his quiff for Health Questions. It was flattened right against his skull. Portillo-watchers know that this is always a sign that Portillo is lying low, preparing to pounce. His question was low-key. The session was followed by a statement from the Health Secretary, Alan Milburn, on the Shipman case.

A sensitive area. We venture warily to suggest that if one were both a GP and an MP, and if one's surname were Wolf, Ferret or Shark, one might have judged the occasion a time for discreet silence. No such caution restrained either Dr Fox (C) or Dr Stoate (Lab). Perhaps Dr Wright (Lab, Cannock Chase), though never a medic, should have been left to speak for doctors?

But what could MPs usefully say? It is customary to call these occasions "the Commons at its best" – on the grounds that everyone is grave, polite and full of goodwill, wants to be helpful, and avoids party-political point-scoring. But subtract thrust, counter-thrust, invective and abuse from MPs' deliberations, and what have you left? Trite, unexceptionable and for the most part amateurish suggestions – or, worse, ritual expressions of outrage or regret. It is the Commons at its worst.

And it took an hour after Milburn had, in a measured statement, promised a full inquiry. Proceedings were lengthened further by the frontbench habit of trying to add to, or comment on, every backbench suggestion, rather than say "thanks; the inquiry will take note". From among Milburn's many ceremonious statements of the glaringly obvious, the sketch offers: "The overwhelming majority of family doctors will be appalled." The overwhelming majority!

Through all this cotton wool the rare spike of a useful inquiry sometimes pricks through. Nick Harvey, the Lib Dem health spokesman, pointed out that the proposals for tightening up on doctors (by requiring disclosure of criminal convictions, for instance) looked more likely to expose the feeble than the evil.

It might have occurred to a Shipman not to disclose his previous convictions.

Peter Lilley (C, Hitchin & Harpenden) thought it would be useful if the tragedy led to seeking out incompetence by GPs, which he suspected caused more deaths than murder. Christine McCafferty (Lab, Calder Valley) believed a potentially huge number of relatives of Shipman's deceased patients might now suspect murder. She suggested a helpline.

These practical and, in some cases, new ideas were helpful if not brave. Douglas Hogg (C, Sleaford & N Hykeham) was brave. Commenting on Milburn's promise to consider annulling Shipman's pension, Hogg asked him to have a care for the prisoner's wife. He queried the assumption that, if it had been known that Shipman had taken drugs, his murders could have been uncovered. And, in the case of those further deaths of which Shipman might be suspected, Hogg doubted whether a fair trial would now be possible.

I doubt whether there are many votes in Sleaford or North Hykeham for these thoughts. Hogg is unlikely to have been steered by the results of any focus group survey. He said these things not because they were popular truths likely to occur to many, but because they were not. He said it because he thought it worth saying. How eccentric, for a 21st-century MP.

global village a weekly posting from cyberspace

THE FOLLOWING was asked on a University of Washington chemistry mid-term. Bonus question: Is Hell exothermic (gives off heat) or endothermic (absorbs heat)?

Answer: First, we need to know how the mass of Hell is changing in time. So we need to know the rate that souls are moving in and the rate they are leaving. I think that we can safely assume that once a soul gets to Hell, it will not leave.

Some of the religions in the world today state that if you are not a member, you will go to Hell. Since there are more than one of these, and since peo-ple do not belong to more than one religion, we can project that all souls will go to Hell. With current birth and death rates, we can expect the number to increase exponentially.

Boyle's law states that in order for the temperature and pressure in Hell to stay the same, the volume of Hell has to expand as souls are added. This gives two possibilities:

1. If Hell is expanding at a slower rate than the rate at which souls enter Hell, then the temperature and pressure in Hell will increase until all Hell breaks loose.

2. Of course, if Hell is expanding at a rate faster than the increase of souls in Hell, then the temperature and pressure will drop until Hell freezes over.

So which is it? If we accept the postulate given to me by one Ms Teresa Banyan during my freshman year, "that it will be a cold day in Hell before I sleep with you", and take into account the fact that I still have not succeeded in having sexual relations with her, then No2 cannot be true, and thus I am sure that Hell is exothermic and will not freeze.

The student received the only A given.

Diary

Valet of Tears

P.G. WODEHOUSE would approve. The executors of the comic writer's literary estate are presently engaged in a legal hoopla with "Ask Jeeves" – the Internet search engine that uses the name of Bertie Wooster's manservant to promote its services.

They believe "Ask Jeeves" should have sought their permission to use Wodehouse's most famous creation. The search engine not only carries Jeeves's name, but also uses a picture of a chap who looks remarkably like a gentleman's gentleman.

This is all too close for A.P. Watt, who have looked after the literary estate of Wodehouse since his death in 1975. They have sent letters to "Ask Jeeves" informing them that the name is protected under copyright and asking them for redress. "There are discussions in place, but they are confidential," a spokesman for A.P. Watt tells me.

If the outcome is favourable, and many believe the claim has a fairly sturdy pair of legs, the beneficiaries, a few great-grandchildren, look set for a bumper payout. "Ask Jeeves" is a Nasdaq-quoted company with a market capitalisation of £1.2 billion.

Gallows

GALLOWS humour, from John Major. Collecting his prize for Political Book of the Year at the Channel 4 Press Awards yesterday, he announced: "If I had stood unopposed at the last election, I would still have come second."

Mark Inglefield

I walked into Grozny and met the man who sacked it

Giles Whittell confronts the broken city that was Grozny – and the avuncular Russian general responsible for the devastation

Giles Whittell

JUST HOURS after I walked into the shattered heart of Grozny, I was seized and thrust into a Russian Army Jeep – and found myself face to face with the general who has commanded the entire Chechen war.

I was bundled into the back seat of the Jeep returning from Minutka Square. In the front sat General Viktor Kazantsev, commander of Russian forces in the North Caucasus, reconnoitring the bombed-out locale of his latest victory.

"I want Europe to know why we're doing this," he said. "We're doing it to prevent extremism spreading throughout the continent. We're doing this so there will always be peace. Why don't you people bother to explain that?"

General Kazantsev is the human face of the Russian bombardment: a big, avuncular man with a sense of humour and the confidence publicly to defer to subordinates with a better grasp of detail and statistics. He had laughed at my inability to drink more than three shots of vodka on an official trip to Shali in the south of Chechnya two weeks ago. He told me I was lucky he had picked me up, and maybe he was right.

We drove to the Khan Kala Russian base east of Grozny, where officers fed me, offered cigarettes and disbelievingly quizzed me on how I had hitched a lift in one of their helicopters from the base to Grozny, walked into the town centre, and been driven back by the general.

I had been deposited by their helicopter on the outskirts of the town, suddenly empty of the 4,000-odd rebel fighters who had defended it for three months.

For a surreal hour, stumbling over mud and snow, under a constant rocket and artillery barrage coming from unseen dugouts, I had walked towards the heart of the city which had been cut off from the world for 102 days.

Avoiding eye contact with every passing officer and driver, I entered a strange world, almost devoid of people and utterly demolished.

Opposite block 1428 a makeshift convoy of two trucks and an armoured personnel carrier was loading the contents of a five-storey block of flats which had been reduced to a charred concrete frame. The street was littered with blasted masonry, shards of broken bathtubs, a crushed child's bicycle.

The air was heavy with the smell of explosives. Enemy or no enemy, the bombardment of Minutka Square grinds on.

Armoured personnel carriers crisscrossed the city but I did not see one civilian until brought up short by a heap of 21 discarded Russian grenade launchers, and the sound of a cat. A woman, her face grey with grime and her torso fat with layers of jumpers, emerged from the wreckage of her

home with three saucers. "This is what they left," she said. "I never believed this would happen to us. It's awful, but I must say it: only the Russians would do this."

Until two weeks ago, Kurpat Alkanova lived with ten relatives in this house, now a shell. On January 16, the bombing started in earnest: "Artillery, rockets, aeroplanes, they used everything," she said. All ten moved 200 yards to the nearest bombproof cellar.

Two dozen others had been there since October. "We brought in plenty of wood in the autumn when there were still trees on our street," one man said, huddled with 14 others round my notebook. "I bought flour then, too. We bake bread every day in an oven that we made from odd bricks, and we eat it with warm water. We eat, we drink, we sleep. That's it." Another

woman, Raisa Mastaeva, cut in: "And we say to the nice Russian soldiers: 'Thank you for not killing us'. This isn't life. It's hardly survival."

Some do not survive. Two days ago, after living for four months with 30 other families in a cellar in central Grozny, Khava Ayubova made a run for it. Three friends had been killed the day before when a shell shattered the building above. "We decided that to stay there was to stay and die," she said, and she had heard on the radio that a safe corridor was being opened to the southeast of the city. She and nine others left on foot at 4am on Tuesday. Within minutes her sister-in-law, Fatima, was hit in the head by a stray bullet in Minutka Square.

Khava stayed in the square all day under heavy fire, trying to move Fatima's body. Yesterday, in another

basement east of the square, she wept quietly: "I couldn't move her by myself. If I can't bury her today the dogs will have her."

The bombing stopped and the Russian Army inched on towards Minutka Square on January 28. But the rebel fighters had disappeared – vanishing, most Russian troops believe, after reaching a deal with the ring of armour that supposedly had trapped them in the capital.

My return to the real world was almost comical. Within minutes of returning to street level, the general's Jeep had found me. The Russian Army is not used to unescorted foreigners; by demanding and routinely denying special accreditation they have successfully shielded most of this war from the outside world. But they treated me impeccably, more preoccupied with the question of their security than my motives.

DRs ER's A&E seek viewers with GSOH

THE RETURN of television's top medical drama series with an episode entitled *ER: Leave it to Weaver* (Channel 4) reminded us that if, God forbid, you should ever be involved in any kind of accident, the place to have it is within reach of Chicago County General Hospital. There never seems to be any shortage of highly skilled doctors ready to treat accident victims in Chicago County's emergency unit. Better still, each patient seems to be the recipient of a volume of costly drugs and medical technology that would swallow the entire weekly budget of many British hospitals' accident and emergency departments. And, contrary to the legend, nobody is ever refused treatment until after they have handed over details of their medical insurance.

Moreover, if you're lucky enough to be conscious during your treatment,

Joe Joseph

you'll find the time passes far more entertainingly than it does in a British hospital. This is because the medical staff at Chicago County intersperse their medical diagnoses and their calls for surgical implements, or for increased drug dosages, with juicy gossip about who's sleeping with whom, who's angling for promotion, and so on.

What is odd is that they make no attempt to camouflage, for the sake of discretion or Hippocrates, the identities of the people they're gossiping about; a task which would be easy for them, given how the rest of

their vocabulary is a glossary of acronyms.

In fact the medical terminology bandied about in medical dramas in general – and in *ER* in particular – is now so indecipherable to the general viewer that you half suspect that the scriptwriters may be followers of Tristan Tzara, the Dadaist poet who constructed poems by clipping words from newspapers and reassembling them in random fashion. It's quite possible that, to real surgeons, the medical conversations between doctors Greene, Corday and Benton seem as surreally entertaining as Tzara's verse.

Who knows, *ER* may be responsible for the fashion for abbreviating all sentences into a string of letters assembled from the first letter of each word – a practice once confined to classified car ads (OIRO); which spread to personal ads (SWM,

GSOH); then became the norm in the new breed of coffee bars, because if each customer ordered in full English (asking for "double tall latte, with wings, low fat milk, no sugar, with cinnamon" instead of "DTL-WWLFMNSWC") only three people would get served a day; and has now become the dominant form of expression in electronic mail via computers or via mobile phones with messaging services, since office workers who have enough free time in the day to message their entire circle of friends, apparently don't have enough time to write "see you later" instead of "CUL8R".

Maybe it was to distract us from the departure of George Clooney that last night's launch of the sixth series seemed more frenetic than usual. All the familiar ingredients were there: the wham-bam pace, the simmering personal and professional rivalries, the hints of potential romances, the gore, the sentimentality and the shamelessly interwoven plot-lines.

Last night's episode seemed rather crowded, perhaps because we were being introduced to new faces who will be laced into the story over the coming weeks. The most prominent of these belonged to Goran Visnjic, a tall, dark, handsome heart-throb who plays Dr Luka Kovic, a Croation survivor of the Bosnian War. He has clearly been measured up for Clooney's shoes, right down to making Julianna Margulies's pregnant Nurse Hathaway swoon when she sees him comforting a young girl whose mother was injured by a car crash. In particular, he shares Clooney's habit of following his instincts rather than the rules, even if this behaviour lands him in hot water. By the end of the series Visnjic should also know whether or not, like Clooney, this behaviour lands him a lucrative film deal with Warner Bros.

Anyone watching *Surrogate Babies* (BBC1) who did not know anything about surrogacy wouldn't have been able to tell from this thoughtful, sensitive documentary that surrogacy is still a deeply controversial subject, morally and legally. This was what made the film such a success. There was an admirable lack of controversy or sensationalism. The makers hadn't tried to turn these life stories into any more of a moving soap opera than they needed to be. We glimpsed what makes a woman agree to bear a child for another couple, and the childless heartache that leads a couple to consider asking a stranger to carry their baby. It was like an X-ray which revealed the secret lives of people you probably walk past in the street every day. If you believed surrogate mothers were purely commercially motivated, you may have to think again. What may be most controversial about surrogacy is not that it happens, but that it doesn't happen more often.

In *Soap Secrets II* (ITV) we met Peter Kingsman, who has made his Essex home a shrine to *Crossroads*, a series which ran for more than 4,500 episodes before being mercifully put down in the late 1980s. Kingsman owns the writing bureau at which Meg Richardson (Noele Gordon) sat in the drawing room-cum-office of her Midlands motel, which jangled with more drama and intrigue than even *ER*.

Kingsman also owns Noele's personal four-poster bed, her *This Is Your Life* red book, special-edition magazines, photographs, and a record brought out when Meg Richardson married Hugh Mortimer in 1975 in Birmingham Cathedral. He even has the original Crossroads Motel sign. For *Crossroads* fans it must be reassuring to know that there is such an ardent keeper of the *Crossroads* flame. For the rest of us, it is reassuring to know that, with people like Kingsman around, we have five-lever mortice locks on our front doors.

My rent-a-quote ring-round hell

Giles Coren

WHEN A *Daily Mail* reporter telephoned Martyn Lewis this week to ask him if he had read *Beowulf*, the cheery newsreader told him that he was "no longer in the rent-a-quote business". In doing so, Lewis may inadvertently have done young journalists of the future a great service. For if other celebrities were to follow his lead and refuse, en masse, to take part in celebrity ring-rounds then trainee hacks might be spared the most appalling labour of modern times.

As someone who was on celebrity ring-round duty for what felt like about forty years in the mid-1990s, I can assure you that there is nothing on earth more terrible than having to ask Isaiah Berlin if he puts milk in his scrambled eggs, or begging Margaret Thatcher to tell you which Beatle she fancied in the 1960s.

The nervousness that comes with speaking to famous people, coupled with the desire to appear interesting and personable despite the idiocy of the question you are asking, is quite crippling. Some celebs are quite nice. Berlin, for example, seemed genuinely fascinated by the eggs question and mulled it over for some time. Thatcher, on the other hand, sounded so frightening just saying "hello" that I slammed the receiver down and told my editor that his number for her was no good.

Then there is the embarrassment caused by the lazy writing down of phone numbers – I must surely be the only person in the world to have had a

conversation that went: "Er, hello, is Bob Monkhouse in?" – "No" – "Oh, sorry. Will he be there later?" – "I doubt it" – "Is that Mrs Monkhouse?" – "No, it's Germaine Greer."

So if Lewis can save future generations from the misery of the celebrity ring-round then he will truly have left a journalistic monument worthy of himself. Had he done it a few years earlier, I might have been saved the worst conversation of my life. It was with J.G. Ballard, in 1995. I asked the

great novelist what books he'd be reading on holiday that year, or would send to a friend in prison, or take to the Moon, or some such thing like that, and he said: "I'm not really in the mood today, Giles. Who have you got so far?" Looking down at my open address book I said, "Well, I've got William Boyd, Julian Barnes, Beryl Bainbridge, Melvyn Bragg..." "Good work," he said, just before he hung up, "why don't you go on to the Cs?"

Anne Robinson

I'VE STARTED wearing glasses on television. Unfortunately, unlike David Dimbleby chairing *Question Time*, I'm not very adept at putting them on and taking them off quickly, so quite often they stay put for an entire programme.

I rather thought the effect was to make me look more intelligent and also saved handsome young *Watchdog* researchers having to say sweetly: "Annie, we printed the briefing notes in big type so you can read them." (It could be worse; Des O'Connor, I understand, has very tall prop men holding up the words on big boards.) Anyway, the odd thing is the public response. "Congratulations on being so brave," boomed a woman in the queue at Lidgates, the butchers, last week. "You speak for all us middle-aged women." Crikey!

Stars suffer awards fatigue as ceremonies rise to 332

AS THE awards season builds before next month's Oscars, a debilitating virus is sweeping through Hollywood: recognition fatigue.

Symptoms include chronic weariness when faced with red carpet, and a severe aversion to backslapping. Prominent sufferers include Brad Pitt and Madonna – they both admitted this week that they were sick of award ceremonies.

Brad Pitt was needled into his admission by Richard Zanuck, producer of this year's Academy Awards. Zanuck had publicly criticised both Pitt and Leonardo DiCaprio for rejecting requests to present at the Oscars. It was "disturbing", the producer said, that young stars did not want to be part of the film industry's biggest night. Pitt finally caved in, but he also defended his initial refusal. "Although the Oscars are still the Everest of awards for our industry, there is now an over-saturation of these events," he said through a spokeswoman. "Every time you turn on the television someone's getting an award. My wish is that it was still the golden days when there were only the Oscars."

Leonardo DiCaprio is standing firm and not going to the Oscars, while Madonna stayed away from the Grammys on Wednesday. "I've always

felt it silly to believe that people can say these musicians or these actors were the best for a particular year," she said. "The Grammys and the Oscars and all those awards are not really that important. People in the industry know that, yet they continue to pretend that they are."

The number of ceremonies has reached epidemic proportions. In 1997 there were already 252 entertainment awards ceremonies. Now *Variety* has counted 332.

This year sees the first Hollywood Makeup Artist and Hair Stylist Guild Awards, which take place a week before the Oscars. There is also a gala night for the unsung heroes who make movie trailers. One upshot of this craze is that virtually any film, no matter how terrible, will eventually be honoured.

Instinct, which starred Anthony Hopkins as a scientist who takes on the violent characteristics of the gorillas he's researching, was widely considered one of the worst films of the year. Despite this consensus, the film can bask in glory at the 14th annual Genesis Awards. The event is dedicated to animal welfare. Unless you count Disney's *Tarzan* there hasn't been a lot of competition.

Grace Bradberry in Los Angeles

Plus, during the programme, a fair number of male viewers now e-mail with marks out of ten depending on which specs I'm wearing. And an optician in Worcester is determined to get me into styles "more suited to my face". Moved by all the interest, I spent a disgusting amount on a dinky new aubergine pair from my own optician Cutler & Gross and, prior to their television debut, gave them their first outing at the Royal Academy's *Art at the Crossroads* exhibition. Then a bombshell letter from Sir Patrick Cable-Alexander, director of the Institute of Optometry, who had spotted the aubergine jobs at the RA and wrote: "Sadly they won't do at all" and "Please could we meet to discuss improvements".

HATE AND HAIDER

EU governments have gone too far, too soon, with Austria

Austrians should have predicted the outcry against the inclusion of Jörg Haider's ultra-rightist Freedom Party (FPO) in the Austrian Government that will finally be sworn in today. They have been there before, when they ignored Kurt Waldheim's involvement in Nazi atrocities and elected him President. But they cannot have expected the other 14 European Union governments to threaten a diplomatic boycott of a fellow EU democracy.

To abhor Herr Haider's xenophobia, and to deplore the outcome of Austria's parliamentary election last October in which the FPO won 52 of the 183 seats and became the second largest party, is one thing. Effectively to deny the legitimacy of the Austrian ballot is quite another. This was an attempt to block Herr Haider through intimidation; and for every Austrian who approves, dozens will be outraged by such blatant interference and by the hypocrisy of much of this week's political rhetoric. Rather than fight intolerance with intolerance, as they have done, Austria's EU partners would have done better to judge the new Government on its policies. It was stupid to treat this as the rerun of Hitler's accession to power, which it is not.

The FPO's Nazi roots are not in doubt. As for Herr Haider, his parents were keen Nazis long before the Anschluss and the basis of his considerable fortune is an estate inherited from them, which was Jewish-owned until it was "aryanised" in 1938. He is famous for past praise of Hitler and of the Waffen SS's "struggle for freedom and democracy in Europe" – for which he has apologised – and less famous for telling one interviewer that Churchill was the last century's greatest political villain. He is a racist xenophobe who, although there is no record of him making any anti-Semitic remarks, deliberately plays on anti-immigrant prejudice.

Yet he is more opportunist than ideologue; and the reason why so many people – including half of all male voters under 30 – voted for the FPO is that they were heartily tired of the never-changing Austrian grand coalition of socialists and conservatives, the "reds" and the "blacks". They were sick of the way the same old faces carved up political patronage. The FPO offered change – and change on the basis of a fairly innocuous platform of lower taxes, higher family allowances and economic liberalisation. That was not all; Herr Haider's opposition to immigration and to enlargement of the EU is undeniably a strong part of his appeal. But he also embodies, to many Austrians, a genuine democratic need for change.

What, then, did Britain and its partners think they were out to achieve? President Klestil had no real alternative to asking the conservative People's Party and the FPO to form a Government. Together, they have a clear majority. He cannot call new elections unless parliament votes to dissolve itself. If he did, there is now a backlash that could well give Herr Haider outright victory. Yesterday the President insisted that he sign a joint "declaration of responsibility" with Wolfgan Schüssel, the People's Party leader who will take the Chancellorship. It condemns discrimination and "demagoguery", says that "xenophobia, anti-Semitism and racism have no place" in Austria, somewhat too obliquely refers to Austria's "responsibility arising out of the tragic history of the 20th century" and explicitly condemns "horrendous" Nazi crimes, singling out the Holocaust.

Herr Haider may not believe a word of all this. But there is no gain, and some risk, in condemning what has not yet happened. Fears that other far-right parties will milk resistance to European integration underly much of this week's uproar. Herr Haider feeds on racism because it is there. That is more troubling than the man himself.

The hills are alive with rage

The new Right is thriving among the disgruntled people of the Alps

Roger Boyes

COWBELL conservatism or Alpine fascism? There may be disagreement about the label but a chill wind is certainly gusting down the mountain slopes as a new right-wing populism challenges the political orthodoxies of Europe.

The heroes, or anti-heroes, of this rightward lurch are a strange collection of Porsche-driving yuppies, bruisers and highly-strung millionaires. Some, such as Jörg Haider, who is causing such an upheaval in Austria, cannot conceal a sympathy for the work ethic of the Third Reich. Others, such as the Swiss businessman Christoph Blocher, gain votes by denying the Holocaust.

Jean-Marie Le Pen, of the National Front in France, beat up a female critic. Munich's Gerhard Frey uses a far-right publishing and travel empire to puppet-master a neo-Nazi revival in eastern Germany. The Italian separatist Umberto Bossi admires Slobodan Milosevic. Gianfranco Fini, the National Alliance leader in Italy, less controversially admires Mussolini.

Put them in a room together and you would have the cocktail party from Hell, a roar of egos. Yet somehow these fringe politicians have managed to hit the popular nerve. They have rough tongues, a feel for power and, most importantly, a nose for the rancid corruption that became part of the established political culture during the Cold War – the era of slush funds, back-channels and back-handers.

In Austria and Switzerland the voters are revolting against the idea that public service jobs can be shared out by politicians who, although technically in opposition, are sleeping under the same duvet. In Italy Signor Fini is seen as one of the few politicians with clean hands.

The trend towards centre-left government in Europe and, in particular, the Third Way version, was an expression of the desire for change, a recognition that the collapse of communism had altered the ground rules. Social Democrats started to shed traditional positions, break taboos and occupy terrain normally associated with the Right: a tougher line on immigration, on criminals, on school truants.

Opposition from the Right started to wither away. In Italy the Christian Democrats evaporated. In Germany the party will be lucky not to split. The resulting chaos has spawned the current crop of far right-wing politicians who claim to speak for the disgruntled. The most dynamic protest is coming from around the Alps and although "Alpine fascism" is too overblown a description – there are no fascists in the 1930s sense – it is plain that the region is restless. Mountain farmers complain that their children are leaving for the cities because agricultural income has dipped

> Weighed down with debt, farmers feel nothing short of hatred for their capital cities

so dramatically. The farmsteads are dying out. Weighed down with debt, these farmers feel nothing short of hatred for their capitals – Vienna, Berne, Rome and, beyond, Brussels.

This is more, however, than a peasants' uprising. It is about the failure of subsidiarity – the principle that European decisions should be taken at the most appropriate level – and the future of the European idea as defined by the tired Franco-German axis. It is about feeling left behind.

Herr Blocher's Swiss People's Party took the largest share of the vote in general elections last autumn. Voters were full of resentment about Kosovan refugees, about Jewish criticism of the Swiss war record, about unemployment and the failure of the political class to stop the apparent international decline of Switzerland. Herr Blocher, says a shrewd Swiss observer, is "popular because he tells the Swiss what they learnt when they were children". Not all the extreme rightists are flourishing. Umberto Bossi may be on good terms with Jörg Haider, but he does not enjoy the Austrian's success. The influence of Signor Bossi's Northern League is seeping away.

By contrast, Signor Fini has become one of the most credible opposition figures. He benefits from a trend apparent in Germany and Scandinavia: when left-wing parties harden their line on immigration, workers move even further right. The German People's Union (DVU) won important seats in the last Hamburg election when the ruling Social Democrats came out against the euro and for stricter treatment of foreign criminals.

The basic lesson, learnt by Herr Haider, is to keep the message simple and well contoured to focus on one enemy – the EU or the foreigner.

Ernest Hemingway once made the mistake of confusing simplicity of message with simplicity of mind. Before interviewing Mussolini, he noticed the Duce was absorbed in a book. Creeping up, he saw that the Italian leader was pretending – the book was a dictionary held upside down. Hemingway concluded that Mussolini was a performer and a

buffoon. But neither Mussolini nor the current generation of far-right politicians are simpletons. Even the most brutal, Bruno Megret, who heads the breakaway National Front in France, have a rugged intelligence, a shrewd eye for an opponent's weakness.

The measure of their intelligence is their ability to shift from rabble-rousing to respectability, from the fringes to the centre of power without losing their core constituency. The man most admired by the German-speaking far Right is Edmund Stoiber, the Bavarian Prime Minister, who is tipped to be the next conservative candidate for the German chancellery. His views on Europe and on immigration are little different from Herr Haider, but he has packaged them in a way that places him firmly in the mainstream. His party is peppered with provincial clots, almost all on the Alpine fringe, who blurt anti-Semitic comments during rallies. He ignores them.

This is a trick to which all the ambitious far rightists aspire. For some it is too late. But Signor Fini has shown the possibilities of reinvention and Herr Haider, we can be sure, will soon be more Third Way than Third Reich.

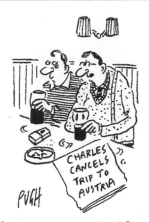

"IF HE WANTS TO HEAR RIGHT WING VIEWS IT'S EASIER TO POP ROUND TO HIS DAD'S"

A week in the arts

Richard Morrison

SPLENDID TO see that Mike Leigh, that warts-and-all chronicler of British idiosyncrasy, has turned his attention to Gilbert and Sullivan in his new film, *Topsy-Turvy*. I hope he strips away the mystique. A century of veneration has turned the most abrasive creative team in British theatre into a sacrosanct piece of Victoriana, like the pavilion at Lord's.

In fact, in life and art, they were the antithesis of stolid respectability. The words man, W.S. Gilbert, was an embittered barrister who mercilessly lampooned a conformist Establishment. Would that he were around today to mock the Blair babes and backbench poodles who "never think of thinking for themselves at all".

But the really startling figure was the composer, Sir Arthur Sullivan. The publication in the 1980s of his long-suppressed diaries revealed all. Purveyor of teashop tunes to Victorian high society he may have been, but he led the sort of private life that fuels bonkbusters. He liaised with two married mistresses, recording his sexual exploits, coded according to piquancy, in his diary. He gambled away more in a night than most men earned in a year. And he thought nothing of staggering home at 4am to dash off a sparkling ditty needed for a 10am rehearsal.

Naturally, he pegged out at 58. But what a life! When future scholars uncover the diaries of Lord Lloyd-Webber, will they read of similar excitements? One has one's doubts.

Call no man a has-been until he's dead. That's the morale of this year's Grammy Awards, where Carlos Santana – the hippy guitar hero who wowed Woodstock 31 years ago and returned to decent obscurity soon afterwards – snatched eight trophies away from rivals young enough to be his grandchildren. Nor was he the only wrinkly to triumph. Grammys also went to Elton John (aged 52), Cher (53), Tony Bennett (73), B.B. King (74), Eric Clapton (54), Sting (a comparative colt at 48), and, in the heavy-metal category, Black Sabbath – after 31 years headbanging.

Only the patron saint of pensioner-pop, the blessed Sir Cliff, missed out. All of which may say more about the parlous state of rock now than it does about the enduring genius of Sixties leftovers. Even so, the success of the 52-year-old Santana's comeback album, *Supernatural*, is astonishing. The last time the Mexican had a No 1 hit, Ted Heath was Prime Minister. But this triumphant return came as no surprise to the man himself. Old psychedelics never die, they merely babble away – and Santana says an angel called Metatron forecast his success two years ago: "We want to hook you back to the radio-airwave frequency," the angel had told him. "This is for all the people who don't have water or electricity," Santana shouted as he collected his awards on Wednesday.

Clearly the hippy dream is alive and well and living in a vast mansion overlooking San Francisco Bay. But the prognosis for popular music is less healthy. Not since the heyday of Vera Lynn has it seemed so middle-aged.

Lucy Pinney

Country life

LESS THAN a month ago, every creature on this farm – except one – had a clear, if perhaps rather dull and stodgy, idea of how their life was going to continue. The sheep were still with the ram, and dreaming phlegmatically of late spring lambs; the calves were about to be weaned from their mothers, and the bull brought in; the two stallions were settling in for a lifetime of bickering and fighting; the fattening ducks were eating two meals a day, and being petted and played with by a small boy. I was getting accustomed to my third child starting school, and beginning to make preparations for a huge summer party to celebrate the millennium and 25 years of happy marriage.

And then my husband announced that he was running off to live in Scotland with a much younger woman. He has been gone three weeks now, and it still seems unbelievable, but it is definitely true. He has taken all his horse machinery, and even his old tractor, and the only equipment now left to do any farming with is a wheelbarrow, a pitchfork and a shovel.

Before he left, I had never realised the obvious truth that if a farmer bolts from his marriage it is not just the wife and children who are thrown into confusion – the animals are, too. The first on our farm to feel the change were the horses. My husband was adamant that wherever he went his beloved Picasso was going too: so this moth-eaten stallion, together with all the numerous ointments he needs to keep his skin complaint under control, was loaded into a box and whisked up to Scotland.

Ever since, I have often found myself thinking of him up there, standing on some remote, windswept hillside, and forging an uneasy alliance with a black Highland bull. Meanwhile, the other stallion was sold locally. Though he went to a kind home, his new owners are bent on gelding him as swiftly as possible – so it is probably safe to say that he will soon regret my husband's departure as much as I do.

At first, it seemed that the other animals were largely unaffected. But gradually, they began to realise that the farm had passed into smaller, and less competent, hands. Since he hates carrying bales, my husband had big-baled all the hay and silage, but if you happen to be small and slight, as I am, unrolling a big bale and feeding it (in a wheelbarrow) to hordes of impatient animals is a fairly slow process. It always reminds me of *The Borrowers*, where the tiny but resourceful family constantly has to tackle nightmare challenges, like cutting into truckle cheeses or balls of string.

It was not long before the sheep decided they had had enough of my dodgy stewardship. They fled through the hedges to a neighbouring farm, and the only solution was to send them to market as quickly as possible. The ewes were loaded up and dispatched, but for a few days the ram remained, along with a sheep that was too rickety to be sold, called Helicopter.

Although she is not the most physically attractive animal I have ever seen, I have always admired her dignity and character. The ram certainly did not, though. In a bizarre parody of earlier scenes at the farmhouse, he decided that he was simply not interested in such an ancient – if loyal – companion, and set off across the fields in search of something more appealing.

It would have been easier if the cows could have gone to market, too, but, sadly, another minuscule flaw in my husband's make-up is his unwillingness to do paperwork. As a result he forgot, until the day before he left, to apply for cow passports.

Nowadays, if a cow does not have a passport it enters a Kafka-esque limbo where it does not officially exist. It cannot be sold, nor can it be killed in an abattoir and eaten. It just lingers about, making a thorough nuisance of itself: escaping into people's gardens, bellowing noisily, and eating frequent heavy meals. Yesterday, in an uncharacteristically lighthearted mood, I rang the British Cattle Movement Service to inquire if I was allowed to stab the cows to death (with a pitchfork) and bury them, but I was told that I needed to apply for a permit if I wanted to do this, too.

The one creature on the farm that is thrilled with the new regime is the cat. He and my husband never truly got on. Their whole relationship was a low-key struggle for mastery of the farmhouse – a struggle that my husband always won, by the low stratagem of taping up the cat-flap. Soon after he disappeared in his lorry the cat bit all the tape off, and joyfully took possession of the house, where he ate a pizza before going upstairs to pass out on the marital bed. In the last three weeks he has doubled in size, and if you look closely at his black, hairy face, he now seems to be smiling.

I hope the cow passports arrive soon, but when they do, and the cows can finally be sold, I shall be a rather strange farmer's wife. The only livestock on the farm will be a cat and some ducks – and, of course, there is no longer a farmer.

THE REV HENRY THOROLD

Bentley-driving clergyman who campaigned to save ancient churches and lived in a very cold house

THE Rev Henry Thorold deserves a place in any gallery of great English characters of the past 50 years, having maintained the tradition of clergyman-squire with tremendous panache into a grand and very active old age. Nonetheless, he was never properly a "squarson": as patron of the living at Marston, near Grantham in Lincolnshire, where the church stood close to the family seat, he would never have dreamt of appointing himself incumbent. James Lees-Milne described him as having "a profile like George III's and a stomach like George IV's ... Knows Lincolnshire backwards and all the families that ever were, they being to a man his relations."

Henry Croyland Thorold's father was Chaplain-General to the Armed Forces and chaplain successively to George V, Edward VIII and George VI (receiving instructions from the Archbishop not to marry Edward and Mrs Simpson). Thorold's lifelong passion for architecture was awakened by his father's postings, in the cathedrals of Cologne, Chester and Salisbury, in the Royal Military Chapel at Sandhurst and then at St Paul's, Westminster Abbey and Southwark (which had been elevated to cathedral status by his kinsman Bishop Anthony Thorold).

After Summer Fields, Eton and Christ Church, he prepared for ordination at Cuddesdon Theological College and was ordained into the Scottish Episcopal Church during the Second World War, becoming personal chaplain to the Bishop of Brechin. In 1946 he became a naval chaplain, serving in the cruiser *HMS Leander* and then in the depot ship *HMS Forth*, surprising his fellow officers by regularly taking the ratings off to admire the glories of Maltese architecture.

Thorold in the grounds of Marston, the family seat in Lincolnshire, which he did much to embellish and restore

From 1949 to 1968 he served as chaplain and then also as a housemaster at Lancing College, where he would treat the boys as undergraduates, entertaining them (by rota) to lunch or dinner and taking them on memorable outings to cathedrals and museums and to Glyndebourne. Though formal in class, and a stickler for correct pronunciation (Thorold had to be pronounced "Thorough"), he never used the cane.

After a spell as chaplain at Summer Fields (1968-75) he spent the rest of his life at Marston, the remnant (or really the Great Room) of the family house which he extended and embellished in three bouts with the help of the architect Francis Johnson, introducing a magnificent pendant plaster ceiling rescued from Burston (a Devon seat of the family) which, reset only 7ft up, looked as if it were about to

crush his guests. Here he was surrounded by portraits and reminders of generations of ancestors, including numerous priests and nuns who had taken vows before the Thorolds became Anglicans when they rallied to the support of Charles I. At Lancing Thorold had driven a Rolls-Royce, but in later years he was to be seen at the wheel of a splendid 1951 Mark VI Mulliner Bentley.

In 1952 Thorold founded the Lincolnshire Old Churches Trust, the first of the county churches preservation trusts which raise funds for repairs to ancient parish churches and discourage closures. As chief trustee and chairman for nearly 50 years, he frequently came into conflict with clergy who had little interest in their churches per se, and had a particular gift for inspiring local families to adopt and look after neglected churches, such as

Fenton, that would otherwise have crumbled away. Never an incumbent himself, he would tour the county holding services in remote churches. His declamatory style of preaching, often involving long pauses which kept the congregation on the edge of their pews, was famous. He was a great believer in the dignity of worship and was firmly of the 1662 persuasion.

He became a prolific author, writing the Shell guides to five counties: Lincolnshire, Staffordshire and Nottinghamshire (the unfashionable ones of which he was a doughty champion). He also wrote the *Collins Guide to Cathedrals, Abbeys and Priories*, a volume on *Lincolnshire Churches Revisited* and completed a long-awaited study of Lincolnshire houses shortly before his death. His was a "long-hand life" – his books written with a pad resting on his knee, with not a television or radio in the house. For his writing, he was awarded a Lambeth degree by the present Archbishop, nicely complementing that given to his father.

At Marston he entertained a constant stream of visitors, young and old, taking them on long church crawls (as many as 17 in a day). Marston rated high among the many English houses which claim to be the coldest in Europe, but Thorold was not amused when a guest published a magazine article drawing attention to the chill.

The Rev Henry Thorold, clergyman and antiquary, was born on June 4, 1921. He died on February 1 aged 78

From Mr Nigel Heppenstall

Sir, Diversions were frequent during Henry Thorold's Latin lessons at Lancing in the early 1960s.

On one occasion, he announced to the class that he had used one single Wilkinson Sword razor blade for six months and had sent the blade to the manufacturers, who duly replied that they were delighted to hear of their customer's satisfaction and would he please accept with their compliments a year's supply, two razor blades.

Yours faithfully,
NIGEL HEPPENSTALL
Walnut Tree House,
Nothiam,
East Sussex TN31 6NB
Feburary 8.

From Mr Peter Wakefield

Sir, Henry Thorold's great claim was that he would put his Rolls-Royce into fourth gear at Lancing and drive all the way from the South Downs to his home at Marston in Lincolnshire without once changing gear.

Yours faithfully,
PETER WAKEFIELD
11 Holmesdale Road,
Kew,
Surrey TW9 3JZ
February 8.

From Mr Richard Hare

Sir, I was saddened to read of the death of the Reverend Henry Thorold, Your obituary (February 8) mentions his years at Lancing College, first in the chaplaincy and then as a house-master.

When he arrived at Lancing, I was a teenage pupil there and even now, half a century later, I still vividly remember him and the impact his arrival made on the boys at the time.

An abiding memory is being taken in his Rolls-Royce with a few other boys along the coast road to the Ship Hotel in Brighton. We all sat down together and enjoyed conversation as equals whilst being treated to a ploughman's lunch and a sherry each and offered a cigarette. I can therefore attest to the accuracy of your remark that Henry Thorold treated the boys as undergraduates. Half a century ago this was education with an avant-garde touch.

Yours sincerely,
RICHARD HARE
5 Whitecross Drive,
Weymouth,
Dorset DT4 9PA
February 8.

City invaded by alien jargon

THINKING outside the box can improve e-tailing and catch good low-hanging fruit.

If that statement seems like gobbledegook, you could be one of thousands of workers in the City and elsewhere feeling alienated by the new corporate jargon. Knowledge of the latest buzzwords is splitting workplaces as ambitious types try to spout the right words to gain an advantage.

The Oxford English Dictionary will recognise the new jargon, imported via American sports coaches and management gurus, in its first online edition released next month. A survey of 1,000 employees by the recruitment consultancy Office Angels has found that 65 per cent of workers are now spouting the jargon.

This is greatly to the irritation of the remaining 35 per cent, who gain revenge by playing "buzzword bingo", ticking off meaningless phrases on a card until someone cries "House". Labour MPs have adopted the game to liven up Tony Blair's speeches.

One City trader said: "I went to one presentation and couldn't understand a single word. But there was a sea of nodding heads so I thought it must be a good stock to buy."

John Simpson, chief editor of the dictionary, said: "People use the vocabulary to gain an advantage, to seem knowledgeable, or sometimes to display pomposity."

Adam Sherwin

BUZZWORDS AT THE BLEEDING EDGE

Bleeding edge:	beyond the cutting edge
Greenwash:	environmentally responsible company propaganda
Herding cats:	management jargon to describe something difficult or impossible to achieve
Hurry sickness:	caused by excessive work-related concerns
Low hanging fruit:	the easiest targets, people on the brink of doing something
Mindshare:	consumer awareness of product
E-tailing:	Internet retailing
Thinking Outside the Box:	forget what you know
MBWA:	management by walking about
MBWAWP:	management by walking about without purpose
Analysis paralysis:	caused by too much information
Censorware:	used to screen Internet sites
Co-branding:	collaborative marketing of two or more brands
Co-opetition:	co-operation between competitors, especially in the computer industry
Flexecutive:	multi-tasking executive
Info-dump:	indigestibly large amount of information
Infoholic:	person addicted to acquiring information
Off-topic:	not relevant
Portfolio career:	composed of successive short-term contracts
Presenteeism:	reporting for work even when sick, for fear of losing one's job

Valentine roses bought from New Covent Garden Market

The talented Miss Roth

Ann Roth, costume designer for *The Talented Mr Ripley*, knows what each character would have worn, down to the buttons on the 1950s suits

Lisa Armstrong

RIGHT NOW the banes of Ann Roth's life are trainers and tracksuits. Oh, and tattoos. "Could somebody find me a girl without one?" she wails plaintively. "In Italy we couldn't find any extras who weren't smothered in them, and you can't cover them up with make-up properly, whatever the cosmetic companies say. And another thing with Italian girls – why is it they don't like getting their hair cut?"

Big hair was just one challenge she confronted on the set of *The Talented Mr Ripley* (the official film of London Fashion Week), set in the late 1950s. In one crowd scene she had to transform a generation of trainer and tracksuit-wearing extras into upper-class, ocean liner passengers. "It was not a shoulder-bag period; it was corsets, stockings and small heads. It's not easy; half of them don't know how to walk in heels or skirts. And that wretched hair dye they all use; a natural head of hair is a rarity."

Roth's CV reads like a canon of some of Hollywood's most memorable films, including *Klute*, *The Day of the Locust* (for which she won a Bafta award), *Dressed to Kill*, *Working Girl* and *The English Patient*. Even the turkeys (*The Bonfire of the Vanities* and the remake of *Sabrina*) were well dressed. She also happens to be of an age – she grudgingly admits to being 68 – at which she can look as far back as the late 1940s with a degree of authority. When she says that a nicely brought-up girl, such as the character Gwyneth Paltrow plays in the film, would have spent her summers in Nantucket and would have worn a nice suit with stockings and gloves to meet her mother in town, you believe her. After all, Roth's family were of that ilk themselves, taking holidays in Ocean City every year along with Grace Kelly's clan.

Listening to her talk about the fabrics worn in the 1950s ("blue serge suits said Arkansas; alpaca was very nightclubby") or the kind of places where people such as Dickie Greenleaf (the character Tom Ripley most admires) shopped in the 1950s is to gain an insight into her grasp of detail. "If you were upper middle-class and lived outside a big city, twice a year the men from Brookes Brothers would come to a little hotel 18 miles away or so and send out invitations. The - buttons on Greenleaf's Italian made-to-measure suit would have been thick silver, monogrammed and probably taken off his old blazer. In those days even the rich didn't like to wear clothes that were too amazing," she says.

On *Ripley*, where time was short, she and the director, Anthony Minghella, were mostly on separate continents. One senses that she can be autocratic and that the sensible director would leave her to her own devices. Revered and formidable, she does not suffer fools and the under-informed. "I'm strong and opinionated but I am a big support for actors. I am their friend." She does not push them into clothes that make them feel uncomfortable, unless she thinks they are not doing enough to get into character. "There was an actress on Broadway recently who was playing a Jew. So I produced a Star of David for her to wear and she said she would never wear something like that. I said 'It's not about what you would wear, sweetheart, but what your character would wear'. I hadn't heard that kind of thing for years – most actors these days will go a long way to nail their characters."

She will spend months tracking down just the right coat – for Ripley's infamously shabby corduroy jacket she went to J. Press, "who have been making it since the war". Once she and Dustin Hoffman were in despair because they could not get his character's jacket right. "We had spent so much money trying to get it exact and then one day a pizza delivery boy turned up and ta-da! There was the jacket."

She says authenticity is essential, but that ultimately the clothes are dictated by the character. "With Gwyneth the look in the first half of the film was set by the fact that she had travelled lightly. She probably hung her clothes over the back of the chair at night." She would have liked to have used only original pieces for *Ripley* but ended up making a lot herself. "There's a blue coat Gwyneth wears – what did you think of that?" she suddenly asks. I tell her it's up there with several other indelible images from the film. "Good," she snaps. "I made it. That leopard coat, that was vintage, though. You read the literature," she says sternly, "and all is revealed." She cut Jane Fonda's much-copied feather cut in *Klute* herself. "That idea came from the proportions of the clothes she was wearing. I cut it so badly I had to send her to some guy in the village to redo it." The clothes in *Ripley*, which are sensational, may well turn out to exert as much fashion influence as those in

Klute did. Already we have seen full skirts at the Chanel couture show, and Harvey Nichols's windows now have a distinct 1950s feel.

Roth, who was brought up in Pennsylvania and still lives on a farm an hour's drive from Philadelphia, never intended to work with costumes: "I wanted to be a set designer." She went to work for the doyenne of costume designers, Irene Sharif, and got hooked. What keeps her coming back for more is the way that she can help actors to define their characters, and even propel a film.

This is especially true of *Ripley*. The film's two halves are underscored by the characters' shift from relaxed holiday clothes to a more brittle kind of glamour. "Actors often say they didn't really understand their character until they put on the clothes. A simple thing like a corset can alter the way someone walks," says Roth.

Even so, she is resigned to the inevitability that, in such a big collaborative piece as a Hollywood blockbuster, visions often get diluted. "That long period before shooting starts, when you're just sketching on your own, that's the part I love best. Irene Sharif once said that if you get 75 per cent of what you want on the screen, you're very lucky. I've been very lucky, most of all on *The Day of the Locust*, my all-time favourite. But that blue coat in *Ripley*, you get to see it only for a second, but I'm pretty proud of that, too."

Joanna Coles
in New York

THOUGH THEY may like the simple design elements of the red cross on the white background, I wouldn't expect Americans to recognise the English flag. Last week our son Thomas was sporting a new cap, from Boden, the British catalogue, with the St George Cross emblazoned across the front, when we were approached by a smartly dressed woman on Madison Avenue. "That hat is so cool," she exclaimed, stopping the stroller to get a better look. "Is that a Helmut Lang design?"

But the Union Jack fared no better

Diary

Glad hands

THE latest batch of would-be Labour MPs have been instructed to carry "moist cleansing wipes" by Millbank after it was discovered that many of them suffer from sweaty palms and, worse, atrocious table manners.

The problem, I can disclose, was discovered during a series of training seminars – grim beanos that aim to tutor fledgeling politicos about wooing the public and media. According to my source, the young hopefuls were

last week at the gym, when I noticed a hyper-worked-out woman staring at my Reeboks which, rather curiously I admit, have a small red, white and blue flag embroidered on the back of each heel. "Hey," she said, throwing a towel round her shoulders, "I love that design on your sneakers." "Thanks," I replied. "Actually it's the Union Jack." She stared at me blankly. "You know,"I tried again. "The British flag?" "Britain has a flag?" she asked, a mauve vein pulsing in surprise on her forehead. "Hey, that's great."

told that watery handshakes, which I am sad to report were widespread, are deemed the kiss of death by voters. As were, needless to say, traces of food particles around the mouth. "This was identified as a bad thing, although that's not to say that all of our new people are cursed with such problems."

But the initiative has not won the support of Martin Salter, Labour MP for Reading West, who recently addressed the new recruits. When told about the "wipes" he sniffed and launched into a speech about the old socialist values.

Mark Inglefield

Diary

Bosom pals

SIR EDWARD HEATH, the former Tory Prime Minister, has made an astonishing boast – that he once considered marrying the busty starlet Jayne Mansfield.

Sir Edward dropped his bombshell earlier this week before appearing on a Granada Television programme. As he chatted to fellow guests, among them

the actor Warren Mitchell, he said: "It was not totally inconceivable that she (Ms Mansfield) could have joined me as my wife at No 10."

He went on to say that he met the actress "several times (at her request)", and that despite her provocative image "she was a highly intelligent woman". One can see her attraction for the musical Heath. Despite being labelled as "all bust and no substance", the well upholstered actress played the violin and was

also an accomplished linguist. Her interest in Heath arose when she visited the House of Commons in the 1960s. Although she had been married three times, she asked friends if he was a bachelor. Sadly, the interest was prematurely curtailed. In 1967, Ms Mansfield died in an horrific car crash aged 38 in New Orleans. Heath added: "Her death was a tragedy, who knows what could have been?"

Mark Inglefield

The Times is voted Newspaper of the Year

THE TIMES was named Newspaper of the Year at the *What The Papers Say* awards ceremony in London yesterday. The judges said that the biggest stories of the year had been produced by *The Times*: in February, it was Glenn Hoddle's slur on the disabled; in the summer, the investigation into the business dealings of Michael Ashcroft; in September, Michael Portillo's homosexuality; and two days later the Melita Norwood spy scandal. Within a week of the Glenn Hoddle story, the England manager had been forced to resign.

The judges' citation said that *The Times* had shown its "world-class credentials". "*The Times* obviously got a taste for setting the news agenda," the judges said. "And it proceeded to do just that time and again throughout the year. No one else has delivered the depth of journalism that gave anything like this impact. And that is why *The Times* broke through the pack." Peter Stothard, Editor of *The Times*, was named Editor of the Year.

The citation said: "The paper has been much criticised for its price war tactics. But to be fair, it has kept many of the readers it gained by its low price policy. Editor Peter Stothard had built up a reporting team of first-rate journalists. All the judges were convinced that in the last year of the 20th century *The Times* has been Newspaper of the Year."

The paper won the Interview of the Year award for Ginny Dougary's profile of Michael Portillo, in which he confessed to having had homosexual experiences as a young man. The judges were also impressed by the story of Melita Norwood, the 87-year-old great grandmother whom *The Times* exposed as a KGB spy.

The next story that contributed to the award, the judges said, "was to run for six months, giving the Conservative Party a bloody nose". This was *The Times*'s investigation into Michael Ashcroft, the Belize-based Tory party treasurer, who was donating up to £4 million a year to the party. The judges said: "Having got the story, *The Times* just wouldn't shut up. Even when Ashcroft issued a writ for libel, the paper and its Editor carried on. Eventually the matter was settled and Mr Ashcroft issued a statement saying he intends to return to live in Britain."

The awards were presented by William Hague, the Leader of the Opposition. Other winners included the *News of the World*, which won the Scoop of the Year for its exposé of Lord Archer of Weston-super-Mare's fake alibi for the night he was accused of having spent with a call girl. *The Sunday Times*'s A. A. Gill won the award for Writing on Broadcasting.

Deborah Orr and Robert Fisk of *The Independent* were Columnist and Foreign Correspondent of the Year respectively. Clare Hollingworth won the Lifetime Achievement award. Paul Foot of *Private Eye* was Campaigning Journalist of the Decade. The *What the Papers Say* Awards will be on BBC2 today at 5.30pm.

Mark Inglefield

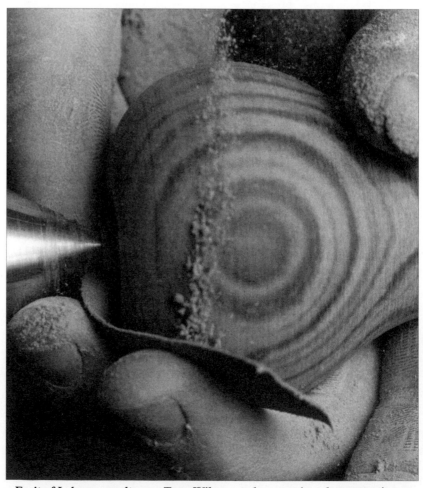

Fruit of Labour: woodturner Tony Wilson sands a pear in a demonstration at the International Woodworking Exhibition at Wembley

SIR STANLEY MATTHEWS

Footballer whose ability to fox his opponents dazzled crowds for decades and earned him the game's first knighthood

STANLEY MATTHEWS was the most famous of all English footballers, and perhaps the greatest of all wingers. Other players may have come close to matching his celebrity or his skills, but none has been held in such affection or esteem, and as a symbol of all that is best in the game he was beyond compare. His professional longevity, too, is unlikely to be challenged. He was past 50 when he played his last league game, yet he felt that he had retired several years too soon.

In his heyday, his presence in a side could add 10,000 or 20,000 to the gate for a match. In those days, before televised sport, crowds would queue all morning at the turnstiles to be sure of seeing "the Wizard of Dribble" in action. When he returned from Blackpool to second division Stoke City in 1961, 36,000 turned out at the Victoria Ground, six times the normal attendance. He was, wrote Geoffrey Green of *The Times*, "the Pied Piper supreme of his day. He belonged to the nation as a whole. He was Britain's most valuable and treasured export, and woe betide any full back who resorted to cruel, rough or unethical means to stop him. At once such a player became an enemy of the people."

Matthews's play at outside right was superb, unique. He was not impressive in physique. About 5ft 9in and weighing 11 stone, he was shallow-chested and inclined to stoop. His paramount gift lay in his dribbling. He could bring a ball up almost to the feet of an opposing defender, show it to him, tempt him into the first balance-change of a tackle, and then suddenly set off in another direction at such speed that, even in his forties,

none could catch him. Generally he feinted to go left and then, having thrown the defender, went outside.

That, however, will seem an over-simplification to every footballer who opposed him and to the spectators who were charmed and amazed by the almost magical skill which carried him clear past the best defenders in a quarter century of world football. To see him manipulate the ball was to see an unfathomable talent at work. "Have you ever watched a dragonfly," the Labour MP (and perceptive football writer) J. P. W. Mallalieu was moved to ask – "how it hovers in one spot with its wings vibrating and then, apparently without changing gear, darts away at top speed?"

Matthews's sensitivity in control was such that he seemed almost to caress the ball with his feet, and he could sell the dummy with shoulders, hips, feet, or even, it sometimes seemed, with his eyes. His ability was instinctive, not analytical; asked once by a journalist to demonstrate his famous swerve, he replied "Honestly, I couldn't do it in cold blood. It just comes out of me under pressure." Nevertheless, football was for him as much a psychological as a physical game, the overriding aim being to dominate and demoralise the opposition. "If I can show the man tackling me the ball by taking it close to him and then whip it past him, causing him to lunge when he thinks he has cornered me, I will soon have caused an inferiority complex from which my opponent will not easily recover," he explained. "A successful dribbler must develop a superiority complex in his own mind."

In his case, that mental superiority was never arrogant or vain. On and

off the field he was a modest, reserved and courteous man. He was a scrupulously clean player who avoided physical contact; he never sought it, and his deceptive movements ensured that he rarely suffered it. "Don't allow anybody to persuade you to play the rough stuff," he advised young would-be footballers. "It does not pay in the long run." He was never booked.

It was most unusual for him to head a ball: he preferred to play football on the ground. He was sometimes accused of being reluctant to go out and win possession, and of being too keen on keeping it once he had it. But charges of selfishness are unfair. Early in his career, he admitted, his only aim had been "to get as many goals as possible", and for a time he was the leading goalscorer at Stoke. He scored four, for instance, when his team thrashed Leeds United 8-1 in 1934, and for England he scored three in a notable 5-4 win against Czechoslovakia at White Hart Lane in 1937. In his later years, however, he became the great provider, winning games more often by creating goals than by scoring them. He scored only 24 times in 461 postwar league appearances, but the statistics give no hint of the hundreds of scoring opportunities he selflessly made for others.

Stanley Matthews was born in Hanley, Staffordshire. His father, Jack Matthews, "the Fighting Barber of Hanley", had a considerable local reputation as a featherweight boxer and inspired in him what was to be a lifelong passion for physical fitness, buying him a pair of spiked running shoes for his fourth birthday and encouraging him out into the open air for breathing exercises on freezing

winter mornings. Even in his eighties, Stanley Matthews was up at 6am to start his fitness regime.

It was Jack Matthews who settled his son's choice of football club. From the age of eight the boy had been an ardent fan of Port Vale, but it was his team's detested local rivals ("I hated Stoke City") that he joined after leaving school at 14. As an apprentice at Stoke he made the tea, licked stamps in the office, and played for the juniors on Saturdays for £1 a week. In his first year, at 15, he had two games for the reserves.

He signed professional forms on the first possible day: his 17th birthday. The signing fee was £10, the weekly wage £3 in summer and £5 in the season, with a £1 bonus for every win. A few weeks after his birthday, in March 1932, he played his first league match for the club, an away game against Bury. His last appearance for Stoke came more than thirty years later, when in 1965, five days past 50, he became the oldest man to take part in a first-class match.

In all he played more than 700 league games. His playing career lasted 33 years: 15 with Stoke, 14 with Blackpool, then another four back with Stoke. He won second division championship medals at 18 and 48, and in between won everything except the League championship. His first cap for England (against Wales) came in 1934, and in all (including unofficial wartime internationals) he played 84 games in an England shirt.

On his great days he won football matches on his own at the highest level. For England in that 1937 game against Czechoslovakia, for instance, he played with such effect that, though two or even three men tried to mark him, he cut open highly skilled and organised defences and won the matches virtually alone. But he once said that his own fondest memory was of beating Italy 4-0 on a blazing hot day in Turin in 1948; and what he recalled then was not so much his own performance as the outstanding team – Stan Mortensen, Tommy Lawton, Wilf Mannion, Tom Finney - of which he had been a part.

Many would declare his finest performance to have been in the FA Cup Final of 1953 ("the Matthews final", as it became known) when he suddenly took up a match which Blackpool were losing 3-1 to Bolton and, imposing his skill and direction on the game in its closing stages, won the Cup for his team with a cross that allowed Bill Perry to score in the very last possible moment. Yet he played with equal brilliance on scores of occasions: for carrying a ball down the right wing of a football field against any opposition was at once his abiding urge and his supreme gift.

When he first decided to leave Stoke, public meetings were held at the town hall in the attempt to keep him there. Hoardings went up, saying "Matthews Must Not Go!" He was, however, transferred to Blackpool in 1947, for a fee of £11,500 and a bottle of whisky. He became one of the seaside town's biggest attractions, dazzling the crowds and taking the team to two unsuccessful Wembley finals before the famous victory in Coronation year. In 1948 he won the first Footballer of the Year award.

He returned to Stoke City in 1961, giving his old club a new lease of life, and playing a considerable part in its return to the first division in the following season; he was again named Footballer of the Year. In 1965 Matthews became the first footballer to be knighted (he had been appointed CBE in 1957), and five days after his 50th birthday, he played his last league game, a 3-1 win against Fulham.

Shortly after retiring, he became general manager of Port Vale Football Club, and he went on in the next three decades to coach all over the world – in Malta, Ghana, California, Canada and Australia. Wherever he was, he knew he had only to look at the underside of his dinner plate to be reminded of his roots in the Potteries.

In Soweto in South Africa, he trained an all-black schoolboy team, "Sir Stan's Men". Those South African links brought him much pleasure, but they were not universally appreciated while apartheid held sway, and he was banned, for instance, from attending a Sportsman of the Year contest in Zimbabwe in 1985.

In 1997 he was due to be the guest of honour at a friendly game between England and South Africa at Old Trafford. Taken ill the previous day, he was unable to attend, and found himself instead one of the first patients in a new cardiology unit he himself had officially opened only a fortnight before.

Stanley Matthews married Betty Valance in 1934. They divorced in 1975, and he married Mila Winterova, who died last year. He is survived by a son and a daughter.

Sir Stanley Matthews, CBE, footballer, died yesterday aged 85. He was born on February 1, 1915.

Final taste of the fine life for Clinton

BILL CLINTON is putting on the Ritz for his last days in office. The President who once gloried in his redneck roots is going out in a welter of glitzy state dinners, visiting royalty and French sauces.

In the early days Mr Clinton was not one to stand on ceremony, but seven years as the most powerful man on the planet can give a President a taste for formal trappings and the good life.

Where Mr Clinton was once happy to scoff a doughnut while chewing the fat with other heads of state, he is now more likely to preside over a table boasting such delights as roasted Atlantic salmon nestling on a bed of caramelised fennel and endive with just a hint of coriander.

He waited more than a year before giving his first formal dinner at the White House, preferring instead more casual shirt-sleeves meetings with foreign leaders in the Oval Office.

As a youth he reportedly glued Astroturf in the back of his pickup truck "to make his dates more comfortable". But now he is now rolling out the red carpet. He has hosted 26 state dinners, even more than those held by his predecessor George Bush, who was widely seen as a devotee of pomp and pageantry.

Last Wednesday the Clintons hosted a white-tie dinner for King Juan Carlos and Queen Sofia of Spain, complete with bouquets of Virginia roses, orchids and white gardenias, Spanish wines made in California, trumpets, 21 guns saluting and 170 guests munching medallions of grilled lamb with Vidalia onions, cooked by Walter Schieb, the White House chef.

Mr Clinton has relaxed into his tuxedo and his role as First Host. When the Spanish Queen came a cropper on the steps of the White House, the President rushed to her assistance while Mrs Clinton looked mildly disapproving as Her Majesty took a dive.

But even the Spanish royal dinner pales beside the spread laid on for their millennium celebration: caviar, lobster, foie gras, and a chocolate and champagne pudding that threatened to make the 360 guests simultaneously fat and drunk. The actor Jack Nicholson was on the guest list and offered this assessment: "This is America here. Yeeaahh."

Gastronomic fashion at the White House has changed markedly, from fast food to health food to the sort of richly elaborate spread now on offer. Mr Clinton could once be seen "inhaling" junk food without a care for appearances or his arteries. He was following a long Democratic presidential tradition; FDR served hot dogs to George VI, much to the King's delight and the fury of the British press.

When Mr Clinton's taste for fast food became a running joke, Mrs Clinton imposed a more politically correct food policy. "Bill and I do a lot of fibre," she once said. The hors d'oeuvres and cheese course went, and in came low-fat nutritionist Dean Ornish and tiny portions of steamed halibut and cauliflower.

But Mrs Clinton is now often away campaigning for the Senate, and a more relaxed and epicurean tone has crept back into the menus. Mr Schieb has not abandoned the First Lady's health commandment: "No gratuitous fat and cream." Yet his creations are becoming more lavish and complex as his boss heads into the political twilight.

But old habits die hard. Frank Meeks, the owner of Domino's Pizza in Washington, has revealed that the First Lady's political ambitions were having a positive effect on his profits. "When Hillary is out of town more late-night pizzas are going to the White House, more toppings are on the pizza," Mr Meeks said. "When Hillary is in town, a lot of veggie pizzas are delivered to the White House. I am happy that Hillary is in New York running for senator."

Ben Macintyre

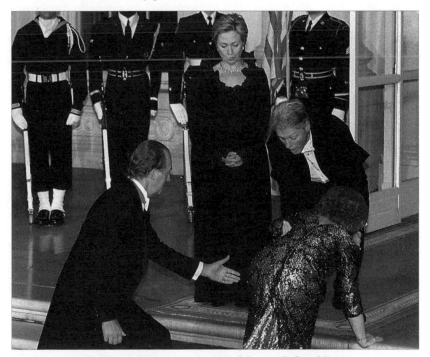

Bill Clinton springs to the aid of Queen Sofia of Spain

Help me – I'm strangely attracted to Ian Beale

It wasn't clever and it wasn't fun – in short, the *EastEnders* birthday bash was about as inviting as breakfast at the caff

Caitlin Moran

WHILE EASTENDERS has long been the master of drop-dead brilliant for one month, dull as a dead hedge for the subsequent three, it was unfortunate that its most recent spate of rigor mortis should coincide with the 15th birthday celebrations. We knew what part of the cycle we'd entered when the much vaunted face-off between Matthew Rose and the man who landed him in prison, Steve Owen, ended up with the ex-bass player from Spandau Ballet wrapped up in Sellotape while a lizard-eyed Britpop boy in a cagoule said "I want to see the snot run down your face," in the same way he'd obviously said "I'd like the new Oasis single, please," the week before.

And so, inevitably, the actual Birthday Week turned out to be the sorriest collection of make-do cobblers since the Dome's Cogsworthy and Sprinx. Theoretically 15 years in the making, it sucked goats. The *A Question of EastEnders* quiz show was nothing more than another BBC attempt to find Gaby Roslin something to do – always difficult, given that Roslin's presenting style is basically to point at something and say "I like that. Do we like that? We like that." *EastEnders Family Album* began promisingly, with cast members past and present saying "It's one big happy family, but as with all families, we have our ups and downs" – the standard televisual cue for incipient bitching. Except there was nothing. No fights. No cocaine. No "they were at it hammer-and-tongs in a props cupboard and we had to separate their fevered coitus with water-

cannon and a chair" incest. Just – grrrrrr – Classic Clips. Look, BBC, you must understand – it's just not a great treat to watch the Den/Angie/divorce papers/Christmas Day thing any more. It's in the same box as Del and Rodney dropping the chandelier, Compo and Clegg tobogganing in a runaway bathtub, and some antelope being chased by a lion. A montage of Great Microwave Pings would thrill us harder.

The only shred of peel in this clip marmalade was Arthur's breakdown, where he tore around his living room like a batey ape in a dressing gown from the Boer War, pushing over Pauline's ironing board while shouting, and I think I've transcribed this

> Birthdays are always rubbish, but this – this was a chickenpox twenty-first

accurately, "Nwohd". This particular scene – mainly for its accurate simulacrum of how Prince Edward would play a Cockney breakdown, given the chance – should be used as the new BBC ident, just to cheer the sickly and woebegone.

How unlike the "special" hour-long episode on Sunday. This was

"special" in the same way there are "special" reinforced pants in the Big Ladies Pants section of Marks & Spencer. On hearing that the entire cast were to be locked in the Vic, due to the discovery of an unexploded Second World War bomb, the celebrations started early. What could be better than a tense hour-long bitch-fest with everything going a bit *Lord Of The Flies*/*Who's Afraid Of Virginia Woolf*, ending with half the cast being blown to jam? Instead, Barry got horny and tried to do Natalie on Peggy's sofa; inadvertent murderer Steve went and had some kind of weird spasm in the shed that was only cured by Pat admitting she'd once killed someone, too, so never mind; and Barbara Windsor and Mike Read pretending they were going to leave "Stenders" for Spain when we knew full well they wouldn't, given that the *News of the World* would have splashed it back in September if they were.

The whole thing felt cobbled together in the back of a cab, and acted with an eye on the celebratory buffet. Particularly taken by the cheese pinwheels was Wendy Richards who, over the years, has reduced the energy driven into making Pauline's cod-faced whining believable from Olympic Sprint to Snuffly Jog. She's long been the most absurd Stender – her Rajah status in the BBC caste system means she can get away with having perfectly manicured nails and £200 hair, all apparently on the wages from an East End launderette. She literally couldn't act her way into a crisp-bag on Sunday, and called Mel a

"slut" in the same jaded drone she presumably used to tell cagoule boy to turn the new Oasis single down.

But the most face-burning moment of *EastEnders'* birthday horror came from Ian Beale. Here, I have to admit a quandary. For while, like any sane cathode half-citizen of the Square, I am sworn to burn Beale and wish him dead at all opportunities, something strange has been happening recently.

The more belittled, defeated and reviled he becomes – the more he sinks into the Loser's Seat by the toilets in the Vic; the more he yowls "Melw" piteously at Mel's retreating back; the closer he comes to growing an unconvincing beard and knocking over Pauline's ironing board while shouting "Nwohd" – the more, well, beautiful he looks. He's started to take on the look of a consumptive Lakeland poet being bled to make black puddings for the locals: his skin has become as translucent as Byzantine marble and his lips have the feverish, bitten qualities of chewed roses. I think – I think I might love Ian Beale.

But the BBC made me do it. While its policy of letting "no one actor become bigger than *EastEnders*" is laudably communistic, it has to realise we're not watching the programme for the sets. I have seen enough crappy launderettes and scraggy veg markets in my time to render the thrill rather muted. We watch *EastEnders* for the people, and in the last year Tiffany, Bianca, Kathy, Carol, Grant, Matthew Rose and the gorgeous half-gay doctor have all done a bunk, soon to be followed by Ricky. By the time *EastEnders* hit 15, all that was left was Ian Beale's disturbing luminosity.

Birthdays are always rubbish, but this – this was a chickenpox twenty-first. Every present was from PoundStretcher. Every guest was unwelcome. All the cool kids went somewhere else.

And they couldn't even arrange a punch-up in a pub.

kate muir
that woman

SINCE WE spoke last century, it's all been happening out on Hickory Creek Road. This winter we gained a daughter in more of a rap-fest than a labour, and then lost her temporarily in cyberspace. We observed that Southerners are what we Scots call "big girl's blouses" when faced by even a hint of a snowflake, as Washington DC ground to a halt. Cut off from the outside world by ice storms, we kept up with politics by reading SUV bumper stickers. Cut off from Safeway, we prepared to eat possum.

Before we go into the ingredients for Possum Pot Pie, we'll take it from the beginning: the birth. My daughter was due on January 1, but she rejected Millennium Baby ignomiy and the lifetime supply of Pampers. Instead, she made her escape on December 30, which, let's face it, was much classier.

That night, when my accent and oaths became sufficiently Glaswegian, we roared the Sport Utility Vehicle into Emergency. Since it was holiday season, most qualified grown-ups in the hospital had done a runner for Florida, leaving the night shift in the hands of the MTV generation. This inculcated a devil-may-care party atmosphere in the delivery room. There were processed Velveeta cheese sandwiches all round.

"Yo, girlfriend! Whoa! Did ah say push? Did ah say push?" rapped LaTisha, a big-boned nurse from Atlanta, when I got a bit ahead of myself. (The whole thing only took two hours. Third child.) As LaTisha said, slapping her thigh in delight: "Hey girl, we havin' a ball here!" which was absolutely true once I got the epidural.

There was a certain slapdash entertainment to that, too: "Whoops, missed! Hit a blood vessel! I'll just have another try," hooted the anaesthetist, plunging various sharp instruments into my spine. When our daughter shot out, amid much "Go, mama, go!" from LaTisha, she was greeted by high fives from everyone. She is proud to be an American.

The morning after, I awoke to discover The Goddess in her see-thru cot by my bed, and was mighty pleased. But on the other side of the bed, under a tin dome, was a horrifying sight: a mass of ageing Ready Brek, cold "low-cholesterol" scrambled egg, and brackish coffee. I thought longingly of my last birth in Paris, of the bowl of hot *café au lait*, the freshly baked croissants and the red wine with hospital dinner (for iron, they said).

It was with some relief that I saw the proud father arrive, bearing not flowers, but a plate of fresh sushi (a foodstuff mysteriously banned during pregnancy) from Dean & DeLuca. By December 31, when outside food supplies ran out, I thought it best to discharge myself. I feared the hospital's "Millennium Menu Specials", the "2000!" paper napkins, and the man with a screwdriver who kept entering my room saying, "Just checking you're Y2K-compliant". Thus we celebrated the millennium in style: at home in bed, drinking champagne and changing The Goddess's divine newborn nappies.

Then a few dandruffy flakes fell from the sky. Washington went psycho. The city government declared a series of "Snow Days" and shut all the schools. Roads were left unploughed, museums (warm, free, indoor places) were shut, and I was home alone with two testosterone-packed boys and a baby. Only

McDonald's stayed open against the white tide, so we went for Happy Meals every day, and acquired seven plastic Tarzans and Janes. The paper stopped being delivered and I got news by reading the neighbours' bumper stickers. They'd replaced "Clinton-Gore 96" with "Bradley 2000", indicating they were lifelong Democrats who were punishing Al Gore for Clinton's tomcattery.

I reckoned it was time to leave the country until the weather improved, and rang to ask for The Goddess's birth certificate for her American passport. After half an hour on hold to the records department, I spoke to a man called, appropriately, Urbane. "Nothing under the father's name here." We tried my surname. "Nope. She doesn't exist. Try the hospital."

"Computer's refusing to take her number," they said at the hospital. Although the Y2K bug caused no problems whatsoever everywhere else, it ate my daughter. At the time of writing, The Goddess remains lost in cyberspace.

It grew colder, and outside the wild animals grew hungrier. Inside, we ate the staple known as "back-of-fridge salad" and fishy-tasting chicken nuggets. The varmints were equally desperate: they ripped open our rubbish bags every night for scraps. Huge claw marks appeared in the snow, and we were sore afraid.

One night on the deck I saw something scavenging, a sort of shag-pile rat the size of a dog, with a long tail and black, beady eyes. Sensibly, I screamed, but an American we had allowed indoors laughed. "It's a possum," he said.

Whatever it was, I didn't like it. I looked it up on the Web, and found, to my delight, *The Possum Cookbook: the Real Flavour of the South*. This offers roadkill recipes for rednecks including Wild Possum Kebab, Possum Creole and, for the daring, Possum Tartare. "Boil the possum for three minutes to loosen the fur, skin and gut it... marinade overnight." Unless we get to Safeway soon, that possum is toast.

Grumpy old men spoil the birthday party

Labour finds that its centenary celebration is a gathering for the Red Flag brigade

Jasper Gerard

SO GRUMPY was the atmosphere, one could have been enjoying a Harold Pinter revival. Angry old men in cheap suits munching aubergine sandwiches marched into the Old Vic for the matinee of *The Birthday Party*: Labour at 100, still banging on, not making much sense and not much fun.

It is the fashion at Labour jamborees to fawn at the freshness and flashness. One then has to contrast this with the Zimmer-framed dourness and dumbness of Tory gatherings. But the most energetic investigation could not have found a single Blair babe babbling about the future. This was a day for Reg from Peckham, and Keir Hardie; for those who kept the Red Flag flying for a century and who have had the good manners, in the main, to shut up since the election. Tony Blair was dreading this: these are not his people – and they are not too certain about him, too.

The Methodist Memorial Hall, where Labour was born, was unavailable, as it is now a BT executive suite, yet we were still treated to a video on how this had been Labour's Century, assuming credit for founding the welfare state (no mention of Lloyd George) and apparently for England's victory in the World Cup (no mention of Geoff Hurst). All was part of a great tradition: "from Beatrice Webb to the World Wide Web", yet few here would have recognised a mouse if it nipped their chip butty.

Only Stephen Fry had the grace to point out that Labour had been out of power for 77 of the 100 years: "I was brought up in a hovel – in the grounds of my parents' estate in Gloucestershire." A rare moment of self-mockery. Others thought it their role to attack every pillar of new Labour's coalition (*Horse and Hound* readers, the Spice Girls and Margaret Thatcher were among Blair fans lampooned by the singing trio Fascinating Aida).

The winner of the Lady Antonia Fraser Award for Avoiding Reconstruction was Tony Robinson, hitherto considered an amusing if minor popular performer. In jeans, T-shirt and crewcut, he took us back to the students' union, where the question of whether to drink or not to drink Nicaraguan coffee was the most compelling moral quandary. He railed against the "dark age". Not when children were sent down pits before Labour rescued them; no, the dark ages were 1979 to 1992.

Tony's nice friends, Ken Clarke and Michael Heseltine, are actually "greedy manipulative monsters", Baldrick told us. "Portillo may have come out, but he is still a bloody dinosaur."

After this, even John Prescott seemed house-trained. "We civilised the last century," he thundered, jabbing his finger like a thug in a transport café. He roared on about the Tories voting against the NHS and democratic socialism, and the cloth caps were thrown to the gods. Nelson Mandela was invoked by five speakers; Labour can at least agree that Apartheid was a Bad Thing.

Blair looked nervous. As if recognising that this rabble was not his milieu, he recalled his agent's advice on his first visit to a working men's club: "Don't ask for Perrier." He made obligatory noises ("We are idealists, romantics even") but that was not his message: you may be 100, he reminded them (many almost were), but you haven't grown up. He managed to extract a thread of Blairism through the Labour century, recalling Tony Crosland's demand for "better pottery and gayer street cafés". At the curtain, we were treated to *Swing Low Sweet Chariot* (rendered in reggae, naturally), but as soon as Tony and Cherie left, the comrades sang *The Red Flag*. Perhaps it was not so much *The Birthday Party*, after all, but more *Look Back in Anger*.

The Jazz Ramblers celebrate Labour's 100 years, against a backdrop showing some of the party's leaders

THE TIMES

March
2000

DOUBTS THAT LINGER

Troubling aspects, for liberals, of the Pinochet case

The Home Secretary's decision, on medical grounds, not to allow Senator Augusto Pinochet's extradition to Spain has ended the former Chilean dictator's enforced stay in Britain. His huddled dash for the waiting plane belied Jack Straw's legally accurate observation that he is a man "who must at this stage be presumed innocent" of the grave charges against him. Politically, he is broken; morally, the extraordinary saga of the past 17 months has left him effectively condemned without trial. To a case that has made legal history, this is an unsatisfactory outcome in all respects but one; the exception is that, albeit for medical not judicial reasons, Chile's demand that, as a sovereign democracy, it should have jurisdiction in this case is now a matter of fact rather than of legal argument.

It is not surprising that the old man's humiliation should delight human rights activists; nor should there be any doubt about the terrible human rights abuses associated with his regime. Yet by showing a zeal bordering on the vindictive, Spain's Judge Garzón and his supporters have reinforced suspicions that this has been a thoroughly politicised affair, in which justice has been invoked to *chercher l'homme*. It opens questions about whether other former heads of state might face arrest outside their countries less because of what they are accused of having done, than because of who they are.

Mr Straw must, as he has promised, review the workings of the 1989 Extradition Act. It is perturbing that the senator was originally detained under a warrant that the House of Lords judged legally unsound. It is worrying that the Crown Prosecution Service, which as Spain's agent in this case, yesterday confirmed the Attorney-General's view that there was "insufficient admissible evidence" to justify his prosecution in Britain and that there was no "realistic prospect" of his conviction on "any criminal offence". In a case whose legal and security costs to British taxpayers have exceeded £7 million, the CPS had spent more than £350,000 marshalling evidence – so eagerly that, when the second and decisive law lords' ruling reduced the charges against him to three, it wrote to Judge Garzón requesting more evidence to "help strengthen the case of Conspiracy to Torture and provide a basis for other charges". These, as the Act allows, were then added. The CPS exceeded what was required under the law on extradition.

None of this detracts from the importance of the legal precedent established by the House of Lords ruling that former heads of state cannot claim statutory immunity from arrest or extradition, for grave crimes under international law committed when they were in office. Dictators are now liable to be called to account, wherever they hide; the current prosecution in Senegal against Hissene Habré is the first "post-Pinochet" test case.

This ruling will strengthen human rights if it deters against the worst abuses of state power. But in the ugly real world, there could be costs, too. It was only because Haile Mengistu Mariam fled Ethiopia for Zimbabwe, at US instigation, that a bloody battle for Addis Ababa was avoided. Haitians benefited, if justice did not, when France spirited "Baby Doc" Duvalier off to the Côte d'Azur; Ferdinand Marcos's flight ended his dictatorship without bloodshed. If emergency exits close, evil rulers may choose to stand and fight the course, rather than risk prosecution by going quietly.

Had Senator Pinochet stood trial, it would have been neither here, where he was arrested, nor in the country of his alleged alleged crimes, nor in an international court, but in Spain. Leaving aside Spain's reluctance to prosecute its own citizens for crimes committed under the Franco dictatorship, ground rules for third-country prosecutions are needed if the Lords' legal precedent is not, as Latin Americans have complained, to be discredited as "colonial" justice. Where the rule of law prevails, justice should be for a suspect's own courts. Should third-country prosecutors have unquestioned power to override amnesties – in South Africa, say, or Northern Ireland – issued by democracies in search of political reconciliation? These questions of primary importance cannot be ducked. Many will hail the Pinochet case as a triumph; but it has had aspects that should disturb all true liberals.

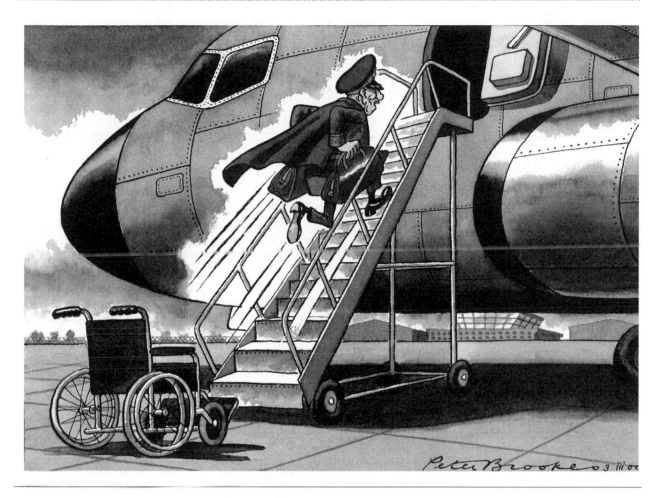

"SMIRKING OR NON-
SMIRKING, GENERAL PINOCHET?"

Anthony Howard

THE *What The Papers Say* lunch last week was only the second time I'd heard William Hague speak in a non-official setting. He did pretty well – certainly much better than his two immediate Labour predecessors, Gerald Kaufman and Peter Mandelson, who were both gruesomely bad.

But there remains something that makes Hague a stranger to star quality. Technically, he's an extremely accomplished public speaker: inflection, timing, pace – he understands it all. But the sum of the parts doesn't add up to a satisfying whole.

Before lunch last Friday I asked him (tactfully leaving aside his debut at the age of 16 at the 1977 Tory conference) how he had picked up so many tricks of the trade.

"Oh," he said, "that's easy. If you do as many functions as I have to do in the constituency – Rotarians or whatever – you can't avoid learning a bit about the art of making a speech."

What, of course, you don't necessarily learn is that different types of audience demand different performances. Perhaps that's the real trouble with Hague. He possesses everything except the ability to play any given audience as if he held the bow and they were the violin.

Labour sees red over racy diary

IT HAS homosexual acts on every page, an uncannily accurate account of Peter Mandelson's diary dates and the Labour leadership hunting for the loose-tongued traitor in its midst.

The thinly fictionalised account of life inside new Labour has been described as the British equivalent of *Primary Colors*, the anonymously written account of President Clinton's 1992 election campaign. But while *Primary Colors* was the work of a journalist, this manuscript – provisionally titled *A Politician's Diary 1999* – bears the fingerprints of a party insider.

The book, sections of which have been passed to *The Times*, undeniably gives off the whiff of a close acquaintance with the levers of power. The author is thought to be a Labour MP in his early forties who was an unexpected victor in the 1997 general election. But that narrows the field only a little. Labour captured dozens of true blue Tory seats it was not expected to win.

A senior Labour official said that the party was determined to unmask the author.

The search has extended to Labour's vast army of spin-doctors. Benjamin Wegg-Prosser, who was Peter Mandelson's special adviser, could be the culprit, not least because much of the diary is devoted to attempts to save the Millennium Dome from becoming a public relations fiasco. But Mr Wegg-Prosser said: "Last year I had neither the time nor the energy to do it." Another suspect is Derek Draper, another former adviser to Mr Mandelson. He was not available for comment, but was recently thought to be considering writing a drama.

Andrew Pierce

Vegetarian Antichrist is 'walking among us'

THE LEADING conservative contender to succeed the Pope yesterday said that the "Antichrist" was already on Earth in the guise of a prominent philanthropist whose concern for human rights and the environment and advocacy of ecumenicism masks his real aim: the destruction of Christianity and "the death of God".

Cardinal Giacomo Biffi, 71, the Archbishop of Bologna, said the Antichrist was not the beast with seven heads described in the Book of Revelation but a "fascinating personality" whose outward charm and plausibility had deceived his enemies. Cardinal Biffi said the Antichrist espoused vegetarianism, pacifism, environmentalism and animal rights.

He also identified the Antichrist as an expert on the Bible who nonetheless promotes "vague and fashionable spiritual values" rather than the Scriptures. He advocates ecumenical dialogue between the Roman Catholic Church and other Christian denominations, including Anglicanism and the Orthodox Church. This appeared to be a worthy aim, but was in fact being used by the Antichrist in an attempt to water down and undermine Catholicism to the point where it collapsed.

The cardinal did not say whether he had any particular world figure in mind, and his real target seemed to be the substitution of "feel-good" causes, such as ecology and humanitarian aid, for "true religion". His remarks appeared to mark out part of the conservative agenda ahead of the next conclave to elect a Pope. The physical decline of Pope John Paul II, 79, has sparked off jostling for position among the cardinals who stand to replace him.

Cardinal Biffi was speaking at a conference in Bologna on the work of Vladimir Solovyov (1853-1900), the Russian philosopher and mystic, whom he praised as a "forgotten prophet" who had "lucidly foreseen" the horrors of the 20th century. In his last writings, the cardinal said, Solovyov had predicted the rise of the Antichrist after a century of bloodshed, wars, revolutions and the breakdown of the nation state.

Richard Owen

Diary

Foot and Mouth

JOHN PRESCOTT has gaffed again. During the course of a live BBC interview yesterday evening, the Deputy Prime Minister offered a typically coherent resumé of his housebuilding plans.

Bamboozled by the distinction between "single parents" and "single occupancy", Prescott asked: "Can we do that again? I made that crap." After a telling pause, the interviewer, Nick Robinson, spluttered: "Deputy Prime Minister, do you realise we are still live?", before moving back on track.

The moment, shown on BBC News 24, threatens to join great on-air political moments: Sir John Nott storming out of an interview with Sir Robin

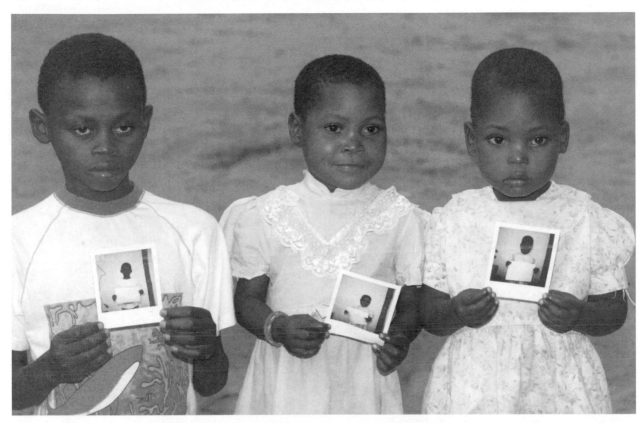

Orphaned survivors of the Mozambique flood holding the Polaroid photographs that Save the Children workers hope will help them to trace their families

Day during the Falklands war; John Major seething to ITN's Michael Brunson about the "bastards" in his Cabinet; and Prescott (again) explaining that he used his Jag for a 300-yard journey "because the wife doesn't like having her hair blown about".

The BBC smirks that "copies of the tape have been made".

General Pinochet

General Pinochet has been garlanded on his return to Chile. Opponents of the old dictator conducted a spoof Oscars ceremony outside the Armed Forces building in Santiago, awarding him Best Actor for an "outstanding performance" in *The English Patient*.

Mark Inglefield

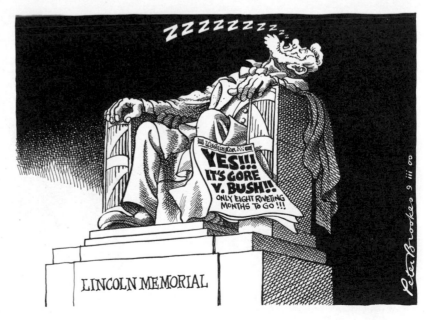

The personification of British art: artists gathered on the steps of the Tate Gallery to celebrate its reopening as Tate Britain

Vladimir Putin flanked by the Blairs at a performance
of Prokofiev's *War and Peace* in St Petersberg

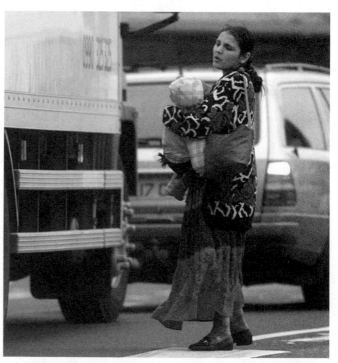

A Romanian mother and her child walk between traffic on
the Euston Road in London begging for money

A young Afghan asylum seeker, unsure where he will be sent, sits by the telephone at a centre run by Kent County Council

Pete Goss, skipper of the Team Philips 120-foot long super-catamaran, inspects its damaged hull in St Mary's bay, Scilly Isles

New look today for Newspaper of the Year

TODAY THE printed version of *The Times* has a new look. For the first time in many years, a broadsheet section contains all the paper's classic news and comment. Alongside it comes, for the first time in *The Times*'s history, a separate features and arts section in a tabloid format.

Inside this first section are home and overseas news, business news, and fourteen pages of sport. Our unrivalled columnists, Simon Jenkins, Libby Purves, Anatole Kaletsky, Matthew Parris and today, William Rees-Mogg and Peter Riddell, remain on the comment page opposite the leading articles and letters. The court page and obituaries keep their place after the letters.

The launch of *Times 2* is a major new commitment to the features which helped to win *The Times* the title Newspaper of The Year in last month's Granada *What The Papers Say* awards.

Followers of the arts will be given expanded coverage of film, theatre, music, television and radio by *The Times*'s top critics. Today, Benedict Nightingale interviews Sir Peter Hall.

Regular coverage of health, science, education and family finance will also have a broader canvas. Today, in six fashion pages, Lisa Armstrong, our fashion editor, interviews the style guru John Galliano.

Many of these improvements are a response to the requests of *Times* readers. When the *What the Papers Say* judges selected *The Times* as the newspaper of the last year of the 20th century they praised its "world-class credentials" in setting the news agenda "time and time again". With this new format *The Times* commits itself to matching and advancing its own highest standards for 2000 and beyond.

Shock of the new in Times changes

From the Reverend John Fairweather-Tall

Sir, First you change your name from *The Daily Universal Register* (a snappy enough title, when all is said and done). Then you introduce photographs, followed by news on the front page. After that, it's two sections (at least both were broadsheet). Now another change (letters, March 15).

How is any reader supposed to settle contentedly into a lethargic rut while coping with these constant alterations?

Yours faithfully,
J. A. FAIRWEATHER-TALL,
18 Portway Close,
Elburton, Plymouth PL9 8BA.
March 15.

A week in the arts

Richard Morrison

CAN YOU name the London art exhibition that half a million people have seen and not one critic has reviewed? The answer can be found on a disused platform at Gloucester Road Tube Station, which the enterprising Candid Arts Trust has filled with a parade of large glass sculptures, sumptuously lit.

Some are beautiful, some are funny, and some – like the "human spider" that looms alarmingly outside your train window – are startling. But what a brilliant way to cheer up commuters trapped in that netherworld of suspended animation known as the Circle Line.

Of course artists have tried to brighten up the Tube before. In the 1930s, London Underground commissioned a famous poster series that blazed with wit and colour. And in the 1960s Eduardo Paolozzi devised mosaics for Tottenham Court Road station. They can still be seen, just about, under 30 years' grime.

But we have far to go before any British transport system can rival Stockholm's Underground for artistic flair, or Moscow's Metro for spectacle. Yes, I know the first priority is to make our trains run properly. But most commuters spend a tenth of their waking hours on public transport, and anything that raises their weary spirits should be encouraged.

Candid Arts now intends to transform the Tube bridge at Golders Green into "a work of art". Good luck to it.

We may never recapture that excitement about trains which inspired Turner to paint his turbulent masterpiece, *Rain, Steam and Speed* – The Great Western Railway, or Dvorak to base an entire symphony (his Seventh) on the characteristic clatter of a Czech railway carriage. But we should not meekly accept that travel is necessarily a soul-destroying chore.

In aesthetic terms, we in Britain have been travelling third-class all our lives. It is time we demanded an upgrade.

Begging to learn

The Ugandan schoolgirl below is one of many children who have written to prominent people, listed in *Who's Who*, asking for money for their education. Many benefactors have sent cheques. But have any of the pupils benefited?

Anne Barrowclough

BRENDA KAJUMBA and her sister Fiona Nabagala are orphans. Like thousands of other Ugandan children, they tell a harrowing story.

Brenda and Fiona, both 18, had the same father but different mothers, all of whom died of Aids two years ago. After becoming orphans, Brenda and Fiona left their village in north Uganda and moved to Kampala to live with their sick grandmother, whom they look after. They earn a few pence an hour carrying water, slashing grass in compounds and cleaning people's homes, to buy food and clothing for the three of them.

Like so many in Uganda, Brenda and Fiona are desperately poor. Showing me around their home takes less than two minutes. It is, after all, no more than a one-room, 12ft by 12ft mud shack, with a bench the only furniture. Outside, by the front door, is a small fire where yams are simmering in dirty water.

Brenda and Fiona's situation is no more and no less desperate than that of millions of other Ugandan children, many of them orphaned by Aids. What makes these girls different from all those other devastated children is that they have almost certainly become the means by which wealthy British benefactors are induced to send money for the children's schooling. The principal beneficiaries are the school staff, who appear to be masterminding begging letters.

Over the past year scores, perhaps hundreds, of prominent English men and women have been targeted by Ugandans who have gone through *Who's Who* and then written to many of the names within. The British Embassy in Kampala says it has had on average one inquiry a week during the past five months from concerned Britons who have received such letters, and the Ministry of Education and Sports in the Ugandan capital says it has already investigated several letters, all of which have proved to be misleading or, in some cases, fakes. In the past few weeks I, too, have been contacted by a dozen people, some of whom hold identical letters.

The epistles, deeply religious in tone, tell of appalling tragedy. There is the one from Miiro Margret, who says her mother was buried alive in a mass grave and her sister murdered "by a sharp metal which pierced her private parts". Then there is the one from Catherine Lwasa, whose entire family has been wiped out in tragic incidents, from murder and disease to a car crash. Or the one from Ruth Tukke: her father died in a car accident, her mother while giving birth. These children don't want much, £200 at most for one term's school fees, a small sum for many of the people to whom they write. The letters are accompanied by authentic-looking documents, school reports and demands for fees, to allay any suspicions.

Yet while these letters may tug at your heartstrings, several factors mark them as suspect. For one thing, most of these schools do not exist. When I traced the fax number on one school report I found myself in a tiny, dusty computer office above a row of shops where the school's "director of studies" is a regular customer, and which he uses as his accommodation address.

And when I showed letters written by Miiro Margret and Catherine Lwasa – who had told of atrocities committed on their families by rebel thugs – to Eric Naigambi of the Ugandan Police, he saw they were fakes by the names: they were from central Uganda, where there has been no fighting for a decade.

Even the sums requested were suspicious. While they sounded small, particularly to the well-off English people to whom they were addressed, they were nearly four times the fee charged by most schools – £200 is about four months' salary for the average Ugandan.

The school that 18-year-old Brenda Kajumba attended cannot afford equipment, books or to carry out much-needed repairs

Even adding the cost of books and uniforms, £50 a term would usually suffice.

What was even worse was that many letters, such as those written by Brenda, Fiona and their friend Joel Walusimbi, were genuine, asking for fees for real schools and giving the school bank account number so people could pay straight into it. What was not genuine was the sum demanded, or the promise that the children would automatically receive the benefit of that money.

In the past year Brenda, Fiona and Joel have written 35 letters each, sending them to people in England and other European countries and Uzbekistan – where the British Ambassador in Tashkent, Chris Ingham, received one of Joel's letters.

The children are in desperate straits, having been told they must find a minimum of 320,000 Ugandan shillings (£145) for one term's tuition fees at Kololo High School in Kampala. Accumulated debts from the previous year have left Brenda owing 360,000 shillings, Fiona 430,000. These sums were requested on the children's school reports, though the letters all asked for £165.

When I arrived unannounced at Kololo High last week, the headmaster, Ishak Kamoga, told me that Brenda had probably left school because of unpaid fees. Yet last month Lady Christine Jennings, whose husband, Sir Robert, is a former international judge, sent £165 for Brenda in the form of a bank draft, which was paid into the school's account. But repeated questioning of Brenda, Kamoga and the school's director of studies, James Kaweesa, elicited a negative response: Brenda had never received any money from any of the people to whom she had written.

Lady Jennings is upset that her money never reached Brenda. A generous woman who donates money to CamFed, a Cambridge organisation that helps African girls with their education, she had thought she was giving direct help to a needy child. "I did send the money with some reluctance," she says. "I didn't know if this child existed or what the money would be used for. I did all I could to ensure it went to Brenda, specifying this on the bank draft. Perhaps I should never have sent it."

I visited Kololo High to find out what had happened to Lady Jennings's money and to check the veracity of the sums requested. From the street the school looked more like a bombed-out building in Beirut and, once inside, things were even worse. Many windows were broken and a sheet of tin covered a huge leak in the roof. The school library is empty: there have been no books in it since 1986. The children sit, in their spotless, starched uniforms, at rickety wooden desks and study from books they have bought or borrowed themselves.

As I walked around the school with Kaweesa and the deputy headmaster, Dirisa Kalule, they explained the school's financial problems and the cost of the children's education. Over at the "canteen" – a shed in the courtyard where lunch of maize and beans is sold to the children at 13 pence a portion – Kaweesa, an avuncular man whose name appears as a reference on the children's letters, explained why the school needs so much money.

Kololo High simply had no money for anything. It could not afford school equipment, it could not afford to fix its windows, it could hardly afford to pay for the 45 teachers, whose annual salary is 3 million shillings (£1,363) each. This sum had to be paid for almost entirely out of the children's fees, which came to 320,000 shillings per term, paid directly into the school's account. On top of that the children had to find extra money to buy new books, around eight a year which, he said, could go up to 80,000 shillings each.

"We need much financial aid," added Kalule. But when I asked where the money went, since the fees clearly had not been spent on the school, he pointed at the roof. "As I said, we have a big leak and had to buy tin to cover it. That is expensive." Then he indicated some empty classrooms, saying that while the school usually had 2,000 pupils, many had not returned this term because they could not pay their fees.

Which took us back to the letters: just how did these children obtain addresses of wealthy people from all over the world? Kaweesa was at pains to explain that he knew nothing about the children's letters until some recipients rang to check up on them. "I didn't know that they had written the letters but I was glad they showed such initiative," he said. He added that if money was put into the school's account for the children's fees, the children were given the balance once the fees had been paid. But none had received money from anyone they had written to. Not even Brenda? "No, not Brenda. A relative helped her last year but there has been nothing since."

This wasn't the story Fiona and Brenda had to tell. As the three of us went window shopping, they said they got the addresses from a cousin, who in turn was given them by a white man, possibly English, at their local church. The cousin had since married and moved "far, far away". But when I checked with Jim Lowestoft, an American minister at Potter's House church, he knew nothing about it. "I am the only white man here," he said, "and I never give out addresses." So who helped the children? As she became more voluble, Fiona told me it was one of the school staff, but then quickly switched this to: "He gave us advice. We showed them to him and he told us if we had the right spelling and used the right words."

When I asked the girls if they had to buy eight books a year, and find 80,000 shillings per book, they giggled. They could not afford to buy books, they told me, none of the children could; they borrowed each other's. They bought maybe one book a year, for 20,000 shillings, a quarter the cost quoted to me. They added that they had never received anything from the school's bank account; they

assumed that any money that went in was swallowed up in fees. Sometimes Kamoga gives them money if they ask, around 5,000 shillings.

So what is the truth? Over at the Ministry of Education and Sports, the Commissioner of Education, Fajil Mandy, looked at the letters I brought. He studied those from Kololo High School at length and tried to find an explanation for the high fees demanded. But he could not.

What he did say, however, is that Kololo was a government school. As such, fees were fixed at between 80,000 and 100,000 shillings a term. Government schools also had most of their needs paid for by the Government, including the teachers' salaries – which averaged around £818 a year, and which he claimed had to be paid out of school fees. It was true that the children had to pay for their own books, as they did throughout Uganda, but most borrow from each other, and the most expensive books cost 20,000 shillings each, as the girls had said.

"We have a problem with our high schools," Mandy admitted. "They must be tightened up. We have suspected for some time that many schools are demanding much higher fees from the pupils than they are really owed, and the extra money doesn't go on equipment, but on topping up teachers' salaries. I have had complaints about this from some parent-teacher associations and your letters seem to show the same thing. We also think some headmasters are running two schools at the same time and taking money from each.

"If they are now demanding money from people in England as well, they are abusing people's generosity. This will be stopped."

Eric Naigambi confirmed that a large-scale scam was being run. "We had the same situation a few years ago. Children had been paying into a high school's account, believing the money was going towards exam fees. But when exams came around they weren't allowed to sit them because the fees

hadn't been paid. The headmaster had gone to Rwanda with all their money."

The British Embassy also confirmed that while many of the inquiries received have been about fake schools, the only real school about which they have received worried letters is Kololo High.

The Ministry of Education is now to commission an investigation into the high schools' finances. Fajil Mandy is to set out regulations for how money is to be spent, and says the Inspectorate of Education will carry out spot checks to ensure that finances are not being misappropriated.

Of course, despite the anomalies in their stories, the people at Kololo may be genuine. There may be a perfectly reasonable explanation for the exorbitant sums quoted, and Mandy is keeping an open mind, as we must.

Yet even on my final visit nothing really added up. I told a member of staff that Fiona had told me he supplied her with addresses of people in England. He denied it point blank. When I added that she had also said that he helped the children to compose the letters he said: "No, no. Well, perhaps I tell them how to spell a word or two, but that's all." He insisted once more that no money had been sent for Brenda, and when I said this was not true, that the money had been sent to the school's bank account weeks ago, Brenda's face glowed as if a lamp had been lit inside. "Thank you, Ma'am, God bless you," she said, mistakenly believing I placed it there. I explained that Lady Jennings was her benefactor and the staff member offers an implausible explanation. "You see, at the beginning of term we don't really check the bank account. So maybe the money is there and we don't know about it." He promised to check the account and to ensure that any money left over went to Brenda, but his smile had vanished.

The Bank of Baroda, where Kalolo High holds its account, confirmed that Lady Jennings's money had arrived. A bank source added that since February, 1, 121 million shillings had arrived in the account from foreign banks.

I have given my file to the Ministry of Education and Sports for its own investigation. The Ugandan Police will also launch an investigation into the letters. They will be checking out people such as the mysterious James Kintu, whose name appears on the Barclays Bank account number quoted in Ruth Tukke's letter to the former Lord-Lieutenant, Sir Andrew Buchanan. Ruth, who wants 450,000 shillings for her college fees, says the bank account is that of the widowed Jackline Gwokyalya, who is looking after her. Yet a check with Barclays shows that it is Kintu, not Gwokyalya, who is the holder of the account.

What is most tragic about this story is that millions of Ugandan children desperately need help with their school fees. Many depend on sponsorship, but when scams are uncovered, and people's generosity is abused, those who would like to help may decide to withhold their money.

Not all schools cream off their pupils' money. One of the first people to contact me when I began this investigation was Sir Leslie Smith, a former chairman of British Oxygen, who last June sent £200 to Harriet Namuwonge, a Rwandan refugee who now attends St Catherine's College, a private school. Sir Leslie was understandably angry when I told him that he might have been conned. "I am not a rich man and do not like to be taken for a fool," he wrote to me. After sending money to Harriet, Sir Leslie had received a letter thanking him for the money but asking for more for her "private personal use". Suspicious, he desisted.

I visited St Catherine's and spoke to Harriet and her headmaster, John Kamya. Harriet spoke little English and did not understand why I was here. She explained haltingly that her parents had been killed in Rwanda and she had moved to Kampala with her three sisters. Her "guardian" had brought her to the school's director of studies as a house girl but he had put her into school instead. The perfect English of

her letter jarred with her limited use of the language, but her teachers said she was helped by an older sister who speaks fluent English. They added that Ugandan visitors to England return with copies of *Who's Who*, which they distribute to the needy and conmen alike.

Kamya's explanation of how Sir Leslie's £200 was spent on two terms' worth of school fees was backed by the Inspectorate of Education. Harriet now boards at the school free of charge (several orphans are supported by the school itself) and her dearest wish is to have her own mattress, which she must buy herself. Until then, she must share a bed with another girl.

St Catherine's did seem to be spending its money on the pupils: a new centre was being built to teach practical skills such as carpentry and weaving to those who don't have the academic talent to finish their studies. Children who could not pay their fees were paid to help with the building work – the girls carrying water, the boys digging mud for bricks, with their earnings going towards their fees.

Lady Jennings was relieved when I told her it seemed that Brenda would receive the money she sent but appalled at the scale of the deception and sad that Brenda never received the encouraging letter she had written to her. "These children live in terrible poverty," she says. "You want to help them but when you hear about things like this you become reluctant because you don't know how it's being used."

At least Brenda has some hope for the next few months. Fiona has none and Joel is also struggling. The outlook is depressing. What is worse is that these children are the tip of the iceberg. Even if high school regulations are tightened up, it will not stop conmen writing begging letters.

As Naigambi put it: "We can arrest these people but after a couple of years they start again. The men running this scam may be the ones we arrested a few years ago for other scams. We are determined to catch them but don't know if we can stop them."

Gordon's mixed bag for Tony's brood

Jon Ashworth

IT MAKES for such a happy occasion – Tony the proud father, Cherie with babe in arms, family and friends crowding round. However, as the Blairs gather for the christening of their fourth child, there is unlikely to be a place for their Downing Street neighbour, Gordon Brown.

Brown made much in his Budget speech about mothers wanting to be at home with their young. He noted the "extra costs families face when a child is born" and pledged improvements in maternity pay and parental leave. Only this week, Cherie was dropping hints about fathers being allowed to take paternity leave.

The Blairs, however, should not get too excited. The Prime Minister draws a salary of £112,951. His wife can earn up to £200,000 a year as a barrister. No working families tax credit here. The Blairs could hardly be further removed from Mr Brown's "low-paid family with two children on a wage of £10,000 a year".

Trimming 1p off the basic rate of income tax leaves the Blairs jointly £530 a year better off. Against this, the loss of the married couple's allowance will cost them £197 a year. Not owning their own home, the Blairs will be unfazed by the abolition of Miras. This would have cost them £240 a year. However, selling their Islington home just as the property market was taking off has lost them an estimated £400,000.

With her taste in designer clothes, Cherie would like to have heard more about clothing allowances. In 1983 Baroness Mallalieu, a barrister, brought a case against the taxman in which she claimed that she should be allowed tax relief on the cost of replacing her barrister's robes. The case failed, even though others, such as the clergy, can claim on garments.

There will of course be a place at the christening for Ros Mark, the former Blair nanny and aspirant author. Mark may have forgotten that her past employers were also lawyers, but she remains "a good friend of the family". All those mutterings about the black economy will be greeted with alarm in households where nannies are paid in cash.

Elderly relations are always good at christenings and few come better qualified than Cherie's father Tony Booth, who played the Scouse Git in *Till Death Us Do Part*. With seven daughters and four marriages to his name, Booth, 68, has held more than a few babies in his time. There is no tax relief on "crumpeteering" but at least he won't be caught by the rises in beer and wine. He gave up drink 20 years ago.

Booth might enjoy debating the merits of the National Health Service with Tony Blair's father, Leo, 76, who switched to private healthcare a couple of years ago. Of the two, only Leo will benefit from free television licences for the over-75s, saving him £104.

The christening will provide an unmissable photo opportunity for Lauren Booth, Cherie's fun-loving half-sister. As a single career woman in her thirties, she is likely to be about £260 a year better off under the Budget, according to Pannell Kerr Forster. Booth once referred to Tony Blair as her "charming, Marmite-eating brother-in-law" and recently described Cherie as a "trophy wife". Still, just you try to stop her.

All those references to alcohol will have had a familiar ring for Alastair Campbell, the Prime Minister's

teetotal press minder. Campbell gave up alcohol years ago, citing the day he drank "15 pints of beer, half a bottle of Scotch and four bottles of wine over lunch with David Mellor".

There will be a special place, of course, for the Lord Chancellor, Lord Irvine of Lairg, who gave Tony Blair and Cherie Booth their first places in chambers in London in the early 1980s. With his £167,760 salary, Lord Irvine will be taking the loss of allowances on the chin. But then this is the man who orders hand-printed Pugin-designed wallpaper at £300 a roll.

Lord Falconer of Thoroton, Cabinet "fixer" and one-time Blair flatmate, was reminded that tax, rather like the queues at the Millennium Dome, is something that affects "both VIPs and ordinary people". With a working wife and four children at private school, he will have felt Brown's tightening fiscal noose.

No such occasion would be complete without Geoffrey Robinson, the former Paymaster General and unofficial travel agent to the Blair family. Halving air passenger duty on economy fares within Europe will go down a storm on those flights to Tuscany. It may well be true that up to 3.5 million Britons do not have a bank account, as the Chancellor tells us, but then with friends like Robinson, who needs banks?

Gordon Brown, the Chancellor, leaves for the Commons to deliver his Budget

Sooner or later, Gordon Brown's luck will run out

Anatole Kaletsky

IF EVER there was a quintessentially political pre-election Budget, Gordon Brown delivered it yesterday. But this was a pre-election Budget with a crucial difference. Instead of the crude tax giveaways that used to be acclaimed as the height of Budget wizardry in the 1980s and 1990s, Mr Brown pulled a very different political rabbit out of his red box. Instead of bribing voters with their own money, Mr Brown did something much shrewder: he offered people reasons for believing that two successive Labour Governments would be much better than one.

This Budget was designed to send a clear political message, especially to traditional Labour voters. The first Labour Government brought you prudence, stability, economic growth and falling unemployment, but this was just a warm-up act for the second Labour Government. This second Labour Government, the one you wanted all along, will improve the National Health Service, will raise educational standards, will halve child poverty and will give even the poorest pensioners a decent life.

But none of this could have been achieved in a hurry. The second Labour Government – reforming, redistributive and socially conscious – could only succeed by building on the economic foundations put in place by the cautious, patient, business-friendly Labour Government of 1997. That was why Tony Blair always said that he needed at least two terms at Downing Street. "Prudence with a purpose," was how the Chancellor

himself described what he was doing yesterday.

Politically, his strategy is hard to fault. By offering much more money to the NHS than anyone expected and by hinting at generous settlements for education, transport and other public services, Mr Brown has effectively challenged the Tories to turn the general election into a referendum on health versus tax cuts.

To pick up this gauntlet would be perilous under any circumstances for William Hague. But Mr Brown has made things far tougher for the Tories than any previous Labour Chancellor. He has neutralised many of the Tories' traditional weapons. In fact, this Budget will have recruited many of the footsoldiers of Conservatism to Labour's side.

Consider the key Tory weapon – taxes. While Mr Hague may rail against the increase in Britain's overall tax burden under Labour, the perception will be very different among ordinary voters – and especially among key groups of Tory voters who have been treated with remarkable generosity by Mr Brown. Not only has new Labour belied the Tory scare stories about confiscatory income and inheritance taxes, yesterday the Chancellor announced a "radical" reform of capital gains tax which, for once, lived up to the billing.

The cut in capital gains tax on business assets from 40 per cent to 10 per cent after a holding period of only four years could genuinely transform the climate for venture capital and small businesses in Britain. Combined with the many measures announced in previous years to reduce corporate tax rates and encourage small businesses (not least the popular inquiry into bank

charges), this Budget has identified new Labour with entrepreneurship in a way that consistently eluded the Tories after Nigel Lawson's great tax-cutting Budget of 1988.

It is a mystery why Tory Chancellors never got to grips with the sort of simple and inexpensive reforms of capital gains tax, charitable giving and entrepreneurship which have gradually been put in place by Mr Brown. Part of the explanation was the dogmatism of Nigel Lawson, who believed passionately that taxes should be as "neutral" as possible, making no distinctions between activities that were socially beneficial and those of which the Government disapproved. There was also the institutional opposition of Treasury and Inland Revenue officials, which Mr Brown has casually swept aside.

Whatever the explanation, the fact is that the Tories missed their opportunity to put in place many of the pro-business tax policies now implemented by the Chancellor and, as a result, Mr Brown has been able to win many friends in the Tory heartlands and the Rotary clubs.

The political benefits of this policy of cosying up to business were evident in the redistributive elements of yesterday's package. Mr Brown has been able to pump billions of pounds extra into income support for pensioners, single parents and the working poor without arousing any serious resentment from the middle-class taxpayers who ultimately foot the bill.

And to judge by initial positive reactions to yesterday's long-term programme to accelerate the growth of public spending, neither the business community nor the middle classes are

going to raise any ideological protest about preserving and expanding the role of the public sector, especially in health and education, during the Blair Government's second term.

Politically, then, it is hard to fault the strategy of yesterday's Budget, either as a short-term electoral gambit or as a long-term programme for a left-of-centre Government. But what about the economics? Will Mr Brown's numbers add up?

This question can be left to the end, because the Budget will do very little to change economic prospects in the short term. There were no reckless tax cuts that might fuel an unsustainable boom. And even the immediate additions to spending on health, education and transport announced by the Chancellor will do no more than counterbalance the unexpected reductions in public spending on social security and other programmes. Thus there was nothing in this Budget that would force interest rates to rise further or faster than would have done anyway.

Looking further ahead, there is much greater uncertainty about the economic plans. The Chancellor intends in future to increase public spending, including investment, by about 3.25 per cent in real terms, a much faster pace than during the first Blair Government. Assuming that the economy performs in line with the Budget's forecasts, this faster growth of public spending should not present any problem and should be easily financed through slightly higher public borrowing, rather than extra taxes.

But sooner or later, Mr Brown's luck will run out. At some point the economy and the public finances will be hit by recession. Only then will Mr Brown's love affair with small business and the voters' faith in new Labour be truly tested. Luckily for Mr Brown – and for Britain – that day of reckoning is probably still several years ahead. And the Chancellor, to his credit, did nothing yesterday to bring the day of reckoning forward.

Prudence loses its buzz

THE NATIONAL Health Service has replaced prudence in Gordon Brown's affections, according to a statistical analysis of the Chancellor's favourite buzzwords.

The 51-minute oration was packed with the new Labour-speak pioneered by Mr Brown. Although "prudence" was proudly displayed on 12 occasions, traditionalists will be pleased that the late boost of "investment" allowed the "NHS" to steal the repetition prize with 15 mentions.

But MPs, who tick off the phrases in a game of "buzzword bingo" during dull speeches, should note the words that are slipping out of the Labour lexicon. "Enterprise" and its corollary, "entrepreneur", are in favour, with ten name-checks. But the socialist stalwart "inequality" had only one mention.

"E-commerce" and "high-tech" were mentioned five times, but "redistribution" never made the final draft. "Rights" received two acknowledgements but the tougher-sounding "responsibilities" had seven.

The US was referred to five times as a source of comparison to Britain but the euro, out of favour with Mr Brown, was not worthy of a passing mention. Old Brown favourites such as "boom and bust" and "cutting the costs of social and economic failure" were wheeled out but the Chancellor failed to use this year's favourite buzzword "dot-com".

Adam Sherwin

Brown's top 20 buzzwords

NHS....15 times	opportunity....4
investment....13	manufacturing....4
prudence/prudent....12	fairness....3
enterprise/entrepreneur...10	e-commerce....3
responsibility....7	high-tech....2
growth/growing....7	boom and bust....2
America/US....5	sound....2
surplus....5	sustainable....2
stability....4	radical....2
hard-working families....4	long-term....2

Brown's bogey words

Rights....2	redistribution....0
equality....1	euro....0
inequality....1	defence....0
socialist....0	stealth tax....0

The future of sex

What sexual revolution awaits us this century? The experts predict that we will be freer, more playful, and less inclined to choose a partner for life

Hannah Betts
.....................................

Nicola Smith returns home after a heavy day at the office where she manages an erotic website called Whatever. She is greeted by her children – Tom, the son she had with Liam, who now lives in an adults-only commune, and Leah, the child she conceived with a female friend whose intellect and bone-structure she had always admired.

A friend drops round to see if she would like to go to a neighbourhood S&M party, but Nicola says that she'd rather indulge in some cyber-fantasy. The truth is, she's distracted. Tom is still a virgin at 14 and she's starting to think he may have a problem.

Plus, her current partner, Paul, is talking about moving in with his girlfriend, which will be the third time she's had to divide up the household in two years...

AS WE stand at the dawn of the 21st century what sexual revolutions await us? Is the family as we know it on a path to extinction? Will serial monogamy continue to be the way people reconcile their sexual and emotional needs? Who or what will give us pleasure? What sexual battles will there be left to fight? In an age of virtual sexuality, will anything be taboo? More to the point, will anyone care – or will we have moved on from our collective sexual fixation?

Veronique Mottier, a Cambridge sociologist specialising in sexual mores, says that to predict our sexual future, we first need to understand our sexual past. "In the early 20th century there was a shift from a religious way of understanding sex to a biological model," she says. "Instead of morality and immorality, biology defined sex in terms of normality and perversion and

set about cataloguing different types."

In the second half of the century this was superseded by a sociological approach that looked at sex in a cultural context. Within the past decade there has been an explosion of interest in genetics, reviving the biological model and reigniting ideas of the normal or pathological.

Helena Cronin, a Darwinist and co-director of the Centre for Philosophy at the London School of Economics, is one of the most compelling advocates of this biological revival. Our sexual future, she believes, can be forecast by looking at the interplay between evolutionary constants and social change. "The most likely thing about this next century will be the way in which new technologies will enhance the things that natural selection has been doing for the past two million years," she says.

According to Cronin, the greatest area of impact will be technologies such as the Internet, or the plethora of dating gizmos being developed in Japan that will give us access to infinite numbers of partners. Cronin predicts that we will end up with a kind of biological global village in which prospective partners will put each other through their paces in a vast, virtual pick-up joint.

Cronin's second prediction is born of the knock-on effects of feminism. "Women have traditionally married up in terms of status and men married down, because women need resources to cover their offsprings' prolonged

period of dependency," she says. "As the economy changes and women begin to get resources for themselves, they may well change their criteria for choosing a mate."

In these circumstances, a woman might reject a relationship with a solid, not particularly attractive, high-status partner, in favour of a fling with a good-looking young man who satisfies more immediate requirements. Though she may have this man's baby, she will not stay with him because of an intuitive understanding that he will not be a steady partner, just someone who can give her an attractive child.

Men in turn are likely to exploit this situation by enjoying greater promiscuity, leaving women to grow old alone, something that Cronin predicts will become an increasing social problem. Male parental support will be compensated for by ever greater reliance on grandparents and female relatives.

Robin Baker is the guru of reproductive forecasting. A zoologist and former academic, he is the author of *Sex in the Future,* a book that creates a series of fictional case studies that turn biological predictions into compelling soap opera. Baker believes that the 21st century will bring a complete divorce of sex from reproduction. "By about the mid-century we will be in a world in which we are sterilised as adolescents, banking eggs and sperm until we are ready to fuse it with somebody else's in the future," he says.

"The need to love the person you have children with will disappear. The person you love, or get along with well enough to live with, will not necessarily be the person you reproduce with. Having a baby will be more of a personal thing than a couple thing and

Will serial monogamy continue to be the way people in the 21st century reconcile their sexual and emotional needs?

more people will become single parents by choice."

Baker does not necessarily see people living alone, but believes that relationships will be even more short-lived, and that there will be greater mobility between partners.

Gay parenting will finally be realised in the most literal of terms as men become able to fertilise other men, women other women. As Baker explains: "For men, this will mean buying a woman's egg, removing its nucleus and replacing it with the nucleus from one man's sperm, then fertilising the egg with the sperm of his partner. Their baby will be a result of the fusion of these nuclei." Lesbians will use a parallel process, although where men will be able to generate offspring of either sex, women will be able to produce only daughters.

Ethical objections will carry little weight, says Baker. "As long as people are creating a demand for any of these technologies, they will happen."

The climate will be so changed that

many taboos will disappear. Baker sees an end to the distaste about sex between young people once unwanted pregnancy is no longer an issue. The incest taboo will survive, he believes, and inadvertent incest will need to be guarded against by some sort of gamete marketing board.

Sexual predictions are not merely confined to the traditional sciences. Adrian Coyle, a Surrey University psychologist and editor of *The Lesbian And Gay Psychology Review*, believes that in the future sexual acts will no longer be seen as the basis for sexual identity. Coyle has amassed evidence to suggest that the boundaries between hetero, homo and bisexual are becoming ever more permeable.

"We see these categories as fixed and stable," he says, "but think back a couple of hundred years and they didn't exist. The sexual behaviour was there but without an identity built on it. This fluidity is returning."

Homophobia will be socially unacceptable. As a result, gays and lesbians

will be less likely to feel a need to build a political argument out of their sexual choices.

Heterosexuals will incorporate "queer" behaviour into their erotic repertoires and society will no longer feel the need to define a sexual norm.

This may sound like a libertarian paradise, but Coyle envisages a conservative backlash. "What happens when society finally tolerates these categories and then people dare to step outside them?" he asks.

"If the idea of homosexuality was threatening, imagine how much more threatening it would be if sexual identities dissolved altogether. I can hear how it would be described: a sexual free-for-all."

Irma Kurtz, the writer and broadcaster, is *Cosmo*'s agony aunt. She says: "We're all pleasure seekers now. You would be astounded how rarely I get letters about pregnancy or sexually transmitted diseases. People are increasingly giving in to funny little appetites that used to be seen as

obscure or depraved. Sex has become much more like a sport – and a team sport, too. Reduced to a recreation, sex will become increasingly public."

With reproductive intercourse behind us, Kurtz sees 21st century sex being an entirely commercialised phenomenon, with the hippy mantra "make love not war" superseded by the axiom "make money not love".

In this consumer environment, our bodies will become mere products that can be traded-in to plastic surgeons if they are unable to be bartered for what we desire.

And it may well be a case of what rather than whom we desire, as the technology of cyber-sex becomes increasingly sophisticated, to the point where it satisfies all the senses and can be personally tailored to one's needs.

But cyber-sex will throw up more fundamental issues than where to get your next thrill, as Sadie Plant, the writer and cyber-feminist, reveals: "At its most profound level cyber-sex will raise all sorts of questions about sexual identity, our ability to be individuals outside our bodies and where such boundaries end. The idea of its creating a third sex – beyond conventional associations between sexual acts and identities – is very possible," she says.

In some cases, Plant maintains, drugs may be used as a source of pleasure and stimulation that supersedes sex, or at least make its pleasures more diffuse. At the same time, not everybody will be into the artifice of cyber-sex and Plant can envisage that there may be a movement in favour of a new purism or simplicity, akin to the fashion for organic food.

Teenagers may become the unlikely exponents of this sexual simplicity. Sophie Wilson, the editor of *J17*, the longest-running teen magazine, believes that young people are becoming coquettish rather than hedonistic. "If anything, teenage romance is becoming more light-hearted, more to do with a return to the outward trappings of dating," she says. "E-mail flirting,

mobiles and pagers have put emphasis on the fun to be had hooking up with a member of the opposite sex."

Teen rebellion is typically based on rejecting parental ideals. If society at large becomes more permissive, then virginity-promoting organisations such as True Love Waits and Straight Edge could become more influential. As Wilson observes, a significant number of today's youth heroes – from Boyzone to the Spice Girls – are married with children. Wilson is optimistic about the way in which these new puritans will deal with the bedroom farce acted out by their parents. "Teenagers adapt – they're already adapting. As long as they are in a stable emotional environment, young people can handle anything."

Teen abstemiousness apart, Mottier gives warning that however epicurean we become, two old enemies will remain with us: women not getting the satisfaction they want and men experiencing masculinity as a source of anxiety. In addition, the continued threat of Aids will restore the traditional association between sex and disease – lost so fleetingly for the post-Pill generation – which may also inhibit sexual exuberance.

At the same time there is likely to be a growth in paraphilias – ways of achieving sexual pleasure that have traditionally been seen as deviant or distorted.

Martin Cole, retired surrogate sex therapist and a leading campaigner in the Sixties and Seventies, argues that a libertarian society will allow all manner of genetic predispositions to come to the surface. "There will be more of everything – including some things that haven't got a name yet," he says. "Not least among these will be that great late-20th century sexual scourge, paedophilia." As many as one in 200 people may be paedophiles, half a per cent of the population. That's a lot of people and a lot of victims, says Cole. "There's an urgent need to be able to talk about the subject. As a behaviour,

paedophilia is beyond the pale, but it should not be beyond the pale rhetorically – and it should be researched. We need to understand the neurobiology of paedophilia because once we understand it we can do something about it."

Our paranoia about paedophilia might not be as great were it not for the media. By the close of the last century the media told us whom and what to want and when and how to want it.

Carol Lee, a visiting lecturer at City University, specialises in media portrayals of gender and sexuality. She argues that society has become so desensitised to the media's obsession with sex that we will no longer worry about censorship issues, such as the depiction of sex acts or erect penises. "The media has gone from an in-your-face to an in-your-crotch approach and frankly I think people are going to get bored," she says.

"Its attitude to sex is already so consumerist. I think we will all get so bludgeoned with sexual images that they will cease to do anything for us. People will end up going to bed without the newspapers and falling back on their imaginations."

In case our sexual prospects sound a little too bleak, the Cambridge philosopher John Forrester does offer some words of comfort. "In the 20th century sex was about communication. It went from being something that could not be spoken about at the beginning of the century to that which is spoken about by the period's close. The debate about Clause 28 expresses this perfectly – a debate about what people are allowed to be told, not what they are allowed to do.

""We can't know what will replace this in the 21st century, but the question of the relationship between sex and beauty should never be underestimated. Somehow sex embodies people's everyday attempts to bring some sense of transcendental experience into their lives. In sex, through their partners and the acts they perform, people strive to give beauty to their lives."

21st-century sex: the experts predict

IRMA KURTZ, the agony aunt for *Cosmopolitan* magazine

"As we divorce sex from reproduction, the motto will be 'make money, not love'. Sex will be an industry – and I don't just mean pornography. We will all approach sex as consumers. We will indulge our vices and sex will be just another little thrill. Its status will be like gambling, and while it's nice to have a little flutter, some people will become addicted.

"Women worked very hard to argue that they should be seen as human beings, not as objects, but this new commercial approach means that people will become their own objects. If a woman has cellulite or her breasts are too big, she will want to change them. We will be our own products, and buyers of other products, and sex will be colder and more humourless. Our attitude will be increasingly experimental. As recently as the Fifties and Sixties homosexuality was the love that dared not speak its name, but now S&M is so in vogue that it has even hit the high street. Sex will be subject to fashion: one week it will be foot-lovers, another week nappy fetishists.

"As sex becomes more commercial, public and entertainment-orientated, government will find it easier to regulate. Government has never been able to take control in the bedroom but it can control the marketplace. It won't be long before we see things such as a bondage tax.

"There will always be eccentrics, of course. Perhaps at some point in the next millennium, a group will go off to found a society on another planet where everyone falls in love and gets jealous and gets married."

DR ROBIN BAKER, a former reader in zoology at Manchester University and author of *Sex in the Future*

"Two things will happen that go hand in hand: sex will become divorced from reproduction and there will be an increase in one-parent families.

"Love will have exactly the same place in relationships that it has today. It will not decline or go away. It is programmed into us as part of our brain's hard-wiring and body chemistry. We will still fall in love or feel jealous. We will still go through the jousting that goes with relationships even if the sex we are having is not leading to children.

"Relationships will tend to be shorter and people may fit in more intense relationships during their lives. The love between parent and child will be just as powerful, even though fathers may spend far less time living with their children. In fact, paternal affection may increase as fathers are able to know for certain that a child is theirs, increasing their parental pride and putting fatherly love on a par with the maternal bond.

"The extended family will continue to forge new categories of affection. If a woman has children with three different men, there will be six grandparents on the male side, and two on her own.

"Children will be resilient enough to cope. So long as financial support and hands-on care are there, children learn to take advantage of whatever situation they grow up in.

"It is quite possible that our lexicon of love will be expanded. Biologists have always thought in terms of different types of love, splitting it into the different functions it fulfils. Society is about to catch up with this."

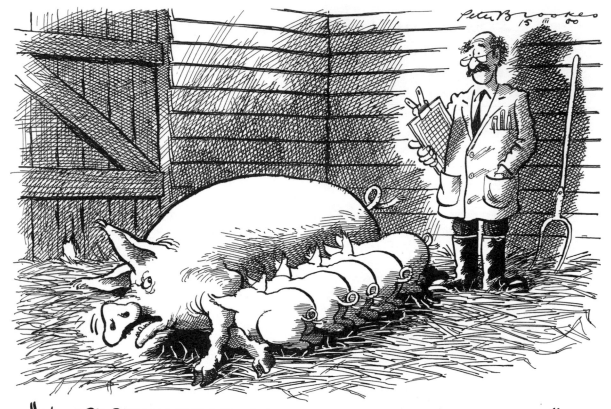

"NOW BE REALLY CLEVER, AND CLONE INTENSIVE CARE BEDS!"

Beggaring Belief

Giles Coren
.............................

LAST Sunday a tabloid hackette wrote a piece on her "day as a Romanian beggar". She boasted of how she was "swathed in a chiffon scarf to conceal my salon hairstyle", and went on to attempt a career-furthering exposé at the expense of refugees who beg to feed their children.

As I read the piece, it dawned on me who the social lepers exploiting others for their own ends really are. The quotes leapt off the page: "I found a bit of aggression helped", and "It was grubby and undignified work". You couldn't better describe life on a tabloid if you tried.

It would be far more indicative of the rotting soul of Britain to dress up a Romanian beggar in a pinstriped skirt suit with bright red lipstick and stiletto mules, and send her into a tabloid for a day to pretend to be a feature writer.

Imagine the outrage of her prose: "I just couldn't believe how much money it was possible to make doing nothing of any value whatever"; "I have never seen such hopelessness, such spiritual squalor in all my life ..."; "All I had to do was prey on the weaknesses of ordinary, hard-working people and the money started rolling in." Send 'em home, I say.

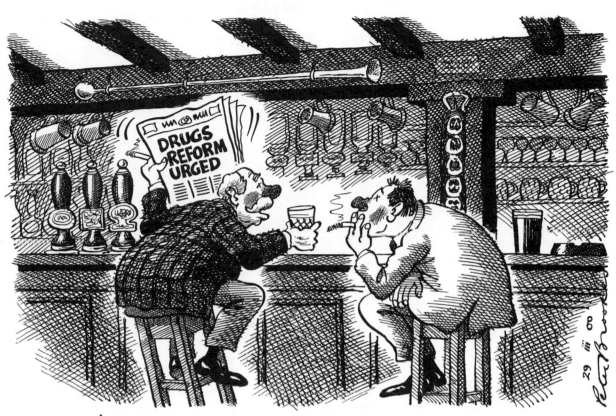

"ABSHOLUTELY BLOODY DISHGRASHEFUL!"

"I'M SORRY - I WAS EXPECTING GEORGE CLOONEY"

"WITH LUCK IT'LL PUT TONY BLAIR OFF THE IDEA OF A NANNY STATE"

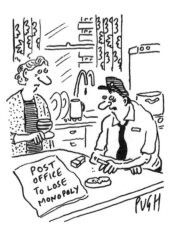

"OF COURSE I'M WORRIED. THEY'VE PUT MY REDUNDANCY CHEQUE IN THE POST..."

Times journalists scoop more awards

THE TIMES added to its collection of awards last night when it picked up the Feature Writer of the Year and Sports Journalist of the Year prizes at the British Press Awards in London.

Just a month after *The Times* was named Newspaper Of the Year at the *What The Papers Say* Awards, Ann Treneman won the Features Writer of the Year Award. The judges described her winning article as "a masterpiece of sleuthing" in tracking down one of those behind the massacres in Rwanda.

Matt Dickinson, the *Times* football correspondent, won the award of Sports Journalist of the Year thanks to his interview with Glenn Hoddle, which led to the England manager's resignation. The judges said that the story won out because: "There are not many sports stories which echo beyond the sports page but this one is still having effects a full 12 months later."

The former Editor of *The Times*, Harold Evans, was given the prestigious Gold Award, for what the judges described as "a lifetime of honest reporting which has made him an icon of his trade".

The Times secured a record number of nominations – more than any other newspaper – in what has been a particularly successful year for the paper.

The Times Magazine was nominated for Supplement of the Year; Dominic Walsh was nominated for Business Journalist of the Year; Matthew Parris was nominated for Columnist of the year; Matt Dickinson's Glenn Hoddle Interview was nominated for Scoop of the Year; Ginny Dougary was given a special mention by the judges for her interview with Michael Portillo under the category of Interviewer of the Year.

Others who were nominated for award were Pugh, the *Times* cartoonist, for Cartoonist of the Year; and photographers André Camara and Peter Nicholls, who were both up for Photographer of the Year.

Paul McCann

But will I miss you when I'm gone?

Each of us dreams of something which will force us to leave our lives behind for a while

Matthew Parris

EVERYBODY, every busy man or woman, must have experienced the urge to drop everything. In moments of fatigue, moments when either the workload or the routine – the sameness of things – get on top of us, who has not offered a silent prayer: "Beam me up. Pluck me out. Whisk me away. Sweep me off my feet. Take me hostage. For three ha'pence I'd chuck all this in."

Each has an impossible dream about how we might abdicate. For some it would be holy orders in a monastery beneath Mount Sinai; for some, the ascent of Everest, the Foreign Legion, or a new life sketching wild flowers on the Isles of Scilly. And for others it might be a glorious slide into as many of the seven deadly sins as it proved possible before death. There can hardly be a living soul who has not felt this: the same urge in many different forms.

For most it's never more than a whim, wild, impossible, and passing. Yet the persistence with which something so foolish returns, seldom to wrestle us to the ground but instead to tug fleetingly at our sleeve, must mean something. There is a theme common to so many of these whimsies, but I struggle for the right words to describe it. "Conscription" is too military, "vocation" too mystical and "bondage" too sexual. Maybe *force majeure* serves best; but each strains after the same thought: that the matter should be taken out of our hands.

We need rescuing from choice, especially moral choice. I am convinced that the deliciousness of helplessness helps to explain the handcuffs and harnesses you will find in sex shops, the NO which does not mean NO, and the deeply incorrect fantasy entertained by some women (and, if the truth by known, men) of being taken by force.

But the secret, insistent appeal of the loss of personal autonomy goes much wider than sex. It is why some men seek to return to prison.

It is why the idea of being kidnapped so appeals. If – by force of arms, by tempest, by fire, by war or by the voice of God ... by anything we cannot cannot control – the "all this" in our lives should be taken from us, then persistent among the tears, a small voice within us would rejoice. The baggage has been swept overboard. Hooray. And it was not our fault.

This is why gay men make such a ridiculous palaver about it not being our fault, as though we would be diminished by the act of choice. But not being our fault is important wherever an act of will would be hard to justify. Any character we can wholly admire, including our own, contains at its core some sense of duty.

A good person does not abandon wife, husband, family, children or work; a good person is faithful as far as he can be to all who love or depend upon him. And so, as our life proceeds,

we build a network of obligation until we are caught in its web. That we should break the web is unthinkable – but oh that some sudden gale should blow it away! How we would weep. How we would laugh.

Whether the *deus ex machina* takes all this from us, or takes us from all this, matters less. Look at myth and literature. The idea of being snatched away props a thousand plots. Dorothy would have lost our sympathy if she had abandoned her kingly Aunt Em, but the whirlwind did it for her. Prospero loved his island, but it was the tempest, not choice, which cast him there. A fisherman who abandoned boat and family would not normally attract respect; but, commanded by the Son of God to drop everything and become a fisher of men, he becomes exemplary.

For many still living, the Second World War was the adventure of their lives, spoilt by no stigma of having turned their backs on home, but crowned with the honour of serving as their country demanded.

Dutifulness and adventure: a new chapter, a clean slate to write it on, and yet a record unblemished by waywardness. Dutiful as far as we could be but, glory be, placed by fate in a new world.

Perhaps I paint my fellow men from the palette of my own experience, but that is all we can ever do. Passing 50, I was feeling weighed down, in a rut.

Especially in my world which lies along the curious frontier between creativity and observation, many men and women are kept fresh by an invigorating sense of potential still unrealised. Some are sure they have within them the great novel, the great column as yet unwritten, the epoch-making proposal for television or radio, the idea which might change the world.

A suspicion that thus far the world has not quite discovered you, that you possess talents others have yet to recognise, can be frustrating, but like Chekhov's Cherry Orchard, it gives a man something to live for: a dream unfulfilled. Every second comedian

hopes he might one day play Hamlet. Many columnists hope that with practice or luck they might yet become a Bernard Levin, a Hugo Young, A Cyril Connolly or an Orwell.

But I never have. Working right at the limit of my abilities and extracting from my work a fair return, all the credit and attention I deserve, and more, I know I am good at what I do, but also that it is all I can do; write alpha to alpha-minus stuff, fairly consistently and quite fast; one of life's easy 2:1s and a voracious thief of other people's ideas, jokes, even phrases; a magpie with good powers of discrimination.

This has been true from the start and one might as well recognise it. As a boy I performed better in exams, on less work, than almost all my classmates. Quick-mindedness and confidence were the key. But in my class there would sometimes be a boy or girl who really was original. It was never me and never will be.

I do believe in luck and don't believe it's only what you make of it. Fate knocks some people down so hard so early that they never get up again. Fortune can raise another up and give him the confidence to fly; and thereafter, perhaps, he makes his own luck. That isn't humility but observation. I look at a rather neglected journalist like Ed Pearce, erratic but touched sometimes by a genius I shall never know, and feel a sense of undeserving. I have also noticed creeping into my recent work (of which I am a busy critic) a certain careless abusiveness. This is easy for columnists to fall into and makes tolerable reading, but it is lazy and rude. Leafing through one of my books recently I found inserted a scrap of paper on which a friend, presumably after some drunken evening, had scrawled: "Piss off Parris, you overrated bastard." That's not far from the truth, and seemed like a sign.

So it was time to piss off, at least for a while. But how? Where was the tempest, the war, the dreadful fire in which all my obligations perished, which

could take me away on a long journey that did not look like impetuous caprice, or some kind of pitiable midlife breakdown? Then – my good luck again – it arrived.

I can almost deny instrumentality in my banishment to Desolation Island until August. A single shred of contrary evidence had better be confessed. Some months ago I was feeling fed-up and itchy-footed when Jeremy Bugler, who runs the TV production company sending me there, mentioned that the vile weather to which Kerguelen archipelago is prone might just make it impossible for me to reboard the ship which had dropped me. In that case I'd have to await her return in August. I blurted out "too bad; it would be a blessed relief" with a passion which perhaps he noted.

But there instrumentality ceases. When, a few weeks ago, we realised how fleeting would be the ship's wait, and I had the chance to cancel altogether, I can honestly say it was out of obligation to Jeremy's enthusiastic team that I opted to stay; or almost honestly say. So you see I did not choose this: it happened to me … didn't it?

And here I sit now, awaiting the ship which will take me, on the Isle of La Réunion, sweet birdsong and flowers all around me, the sky blue, the sun high, the Indian Ocean crashing on the reef beyond the white sands at my feet, penning a column of such sloppy self-indulgence as to send a Simon Jenkins shuddering for the "search for an 'I' and erase" function on his laptop – and expecting *The Times* to print it.

And you think I'm not lucky? In my Protestant soul I know I must pay for this. Maybe the island will be unendurable. Maybe the little group of French scientists there will dislike me. Maybe I'll freeze to death or sink in the notorious bogs, or be blown away – as, on Desolation Island, a thousand brave dreams have been.

But the experience will be genuine and it will be new and – oh sweetest of phrases – it's out of my hands now. I am beamed up.

Let us give thanks for the vicar of Fleet Street

 Brian MacArthur

THE JOURNALISTS and printers departed the Street of Adventure ten years ago, but it is still to Fleet Street – and Wren's St Bride's Church – that journalists return to mark the most solemn of moving moments of their lives, their marriages, the christening of their children and deaths.

After 15 years as the vicar of Fleet Street, Canon John Oates, the Rector, will officiate at his last service on May 14 – and his imminent retirement at the age of 70 is prompting his flock to note his remarkable achievement in maintaining St Bride's as journalism's parish church.

Oates has brought God into the lives of thousands of journalists. He has been a source of consolation during their moments of distress or despair and lifted them up in moments of joy. "I wish he could go on for ever," one of his sidesmen – Christopher McKane, a senior journalist at *The Times* – said this week.

"When my youngest brother died, although John didn't know him and didn't take his funeral service, my parents and I went to the 8.30 am Communion in the crypt, which he turned into a simple and unforgettable requiem.

"A month later we went to the Christmas Eve Midnight Mass, always absolute pandemonium, and when he brought us the bread at the Communion rail he whispered 'God bless Andrew'. It was a moment of tremendous intensity and showed an astonishing awareness of an individual family in the middle of that most public and pressured service of St Bride's calendar."

That anecdote encapsulates several of the reasons why Oates has been so successful. One is that prayers are said for the newspaper industry every morning when Holy Communion is celebrated in the crypt.

Another is his gift for pastoral care. When *The Observer* journalist Farzad Bazoft was hanged in Iraq ten years ago Oates rang the Editor, Donald Trelford. *Observer* journalists were in a state of shock and grief. Trelford invited him to the office. Surrounded (as Trelford puts it) by cynical, gnarled old hacks with tears in their eyes, Oates led prayers in the newsroom. His prayers united the journalists, transformed the atmosphere and they were able to get on with their work again. "That's what the vicar of Fleet Street is supposed to do," says Trelford. Recently, Oates joined Bazoft's parents at his graveside in Highgate.

When John McCarthy was being held hostage in Beirut, Oates was challenged by a young woman whom he didn't know (it was Jill Morrell, then McCarthy's girlfriend). "This is the journalist's church, isn't it?" she said. "What are we going to do for him?"

Oates responded with an all-night, candle-lit vigil in St Bride's on the eve of Good Friday. When he had tried to contact Robert Runcie, the Archbishop of Canterbury, for support, he had been rebuffed by an official.

More than a hundred people joined that first vigil and McCarthy's plight was featured on the television news. There was another result – on Saturday morning Runcie rang to offer support.

McCarthy now pays tribute to Oates's ability to orchestrate the campaign. When McCarthy's mother died, for instance, Oates contacted John Major, who had just been appointed Foreign Secretary. Major agreed to read a lesson at the funeral. Runcie was also there.

The vigil became permanent. News of the campaign reached McCarthy and helped to sustain his morale. "When I wend to the service of thanksgiving (after his release), it suddenly dawned on me how much the St Bride's team had done," he said yesterday.

There is no other journalists' church in the world. That is why Moscow correspondents come back to St Bride's to christen their children. And when journalists die in action, wherever they fall, their memorial services are held in Fleet Street.

Oates led the service for Dan Eldon, and American journalist, who was hacked to death in Mogadishu (his family flew in from Los Angeles); for John Schofield, shot dead at 26 in Bosnia when his wife was pregnant; and for John Harrison, the BBC correspondent who died in a car crash in South Africa.

One of his most difficult periods occurred after *Sun* printers lost their jobs when News International moved its four newspapers to Wapping in 1986. Oates again led an all-night vigil with prayers for the newspaper industry.

A few days later he agreed to bless a new union banner that was being paraded on a protest march to Wapping, but on two conditions – that there would be no placards in the church and that he would pray for proprietors and journalists as well as printers. Afraid of disturbances, the police advised him that he had made a terrible mistake. He would not be diverted.

The service went ahead, the church

was packed, the congregation joined in saying the Lord's Prayer, there were no clashes – and the next day St Bride's was featured on the *Morning Star*'s front page. Oates had succeeded in reaching all the parties, without having taken sides.

Most journalists, however, remember Oates for his memorial services and the singing of his outstanding choir. Oates once produced *Call Me Madam* in a monastery and he puts on a good show. (After he blessed my recent marriage, friends said the service had been as good as a night at the opera, and Jewish friends said they were tempted to convert.)

Services are tailored to the person. When a *Guardian* journalist died. Oates was discussing the choice of hymns with his parents. The going was difficult until Oates asked whether their son had any special interest. He had supported West Ham. At the subsequent service the choir wowed the congregation with a new arrangement of *I'm forever blowing bubbles*, the West Ham song. It has become one of the most popular pieces in its repertoire.

The simple secret of Oates's success has been that he is a holy man in an unholy world, the good pastor whose goodness defeats cynicism but who is also worldly. There should be a notice above the church, he says, that proclaims For Sinners Only: "There's no point in anybody perfect coming."

His faith remains strong. He quotes Dostoevsky: "Faith in the last ditch asserts I would rather be wrong with God than right with anybody else."

Newspapers have returned the compliment – they sponsor choristers and help in all sorts of significant ways. The Press Association and Reuters paid for the floodlighting of the steeple, for example, while the *News of the World* recently helped to raise more than £5,000 from readers for Oates's campaign to help a Zimbabwean school.

I took my mother to St Bride's for

Canon John Oates celebrating his 70th birthday and officiating at his last service at St Bride's

the Christmas Eve Midnight Mass in the year before she died. She was a weekly churchgoer but never had such a memorable experience in church. After her death eight months later the order of service was still on her bedside. That is why I am not alone in venerating Canon John Oates.

THE TIMES

April
2000

Euphoria ends as party spins into control

Labour divides as ministers celebrate together but in separate compartments

Tom Baldwin

THE LAST time new Labour massed on the South Bank of the Thames it was the bright May morning three years ago when Tony Blair was there to hail the landslide victory in the general election.

But this week they returned to the scene of their triumph to hail the 50th birthday of the Prime Minister's personal pollster, Philip Gould.

Mr Gould was in effervescent mood. "It's really not for the glitterati," the poll-king said as Sir David Frost slipped past. "It's for my old friends from university days – oh, look! There's the American Ambassador!"

Mr Gould had thought of everything: there were champagne and canapés at the old County Hall building, which was decorated with "Vote Labour" posters on the walls of the loos, as well as the receptions rooms.

There were even free tickets for the nearby Millennium Wheel so that his 200 guests could experience the joys of spin for themselves.

Unsurprisingly, two of the first to share a cabin were those masters of that particular art, Peter Mandelson and Alastair Campbell, who stared out across London from their pod, surveying what is, until May's mayoral elections, still theirs.

And yet, for all the jollity, the atmosphere at the party on Thursday night was subtly different from three years ago when Mr Mandelson had jigged along with John Prescott to the tune of *Things Can Only Get Better.*

Unlike the sunlight and soaring optimism back then, it was a wintry and windswept night outside the London Eye. This party did not rock till dawn like it had in 1997; it broke up before midnight.

There were missing faces. Some of the stars of that night have already crashed to earth. Derek Draper, the former lobbyist and Mandelson aide, was not there, and neither was Geoffrey Robinson, the millionaire former minister who might once have been persuaded to pay for the bash.

This was a Government serious now about power, chastened by a rough political winter.

Gordon Brown did not turn up, Mo Mowlam wandered off looking disconsolate and Mr Blair slipped away early to prepare for a Cabinet strategy meeting at Chequers.

Mr Gould was partying before planning to address the meeting himself. His private polls show Labour on course to win a second term. And yet he was one of only a few feeling buoyant enough to take to the dance floor.

Another was Neil Kinnock, the former party leader and now a European Commissioner. "You can tell I don't have to stand for election because I'm holding an empty glass," he said as he arrived for his trip on the wheel, adding: "Some of us spin and some of us just stick around."

How had he chosen his companions for his trip on the London Eye? "Oh, we're all just mates in our pod," he said. The "mates" were a variegated social *galère*, including Robert

Harris, the author, Fiona Millar, the partner of Alastair Campbell, as well as the radical QCs, Baroness Kennedy of The Shaws and Geoffrey Robertson. Others appeared to choose their pods with greater fastidiousness. The glass cabins serve as perfect private meeting rooms but are no place to be trapped in for 20 minutes with someone whose star is falling.

Lord Irvine of Lairg, the Lord Chancellor, went up with not only Sir David Frost, but an array of some of the Government's most senior aides and advisers including Pat McFadden, the deputy head of the policy unit, and Ed Balls, from the Chancellor's office.

David Miliband, head of Downing Street's policy unit, was picked as a token man in a women's pod containing Harriet Harman, and the ministers Tessa Jowell and Estelle Morris.

Lord Hollick, the proprietor of the *Express*, went up in an "Eighties radical chic" pod with Lord Eatwell, the former economics adviser to Neil Kinnock, and Will Hutton, the former Editor of *The Observer*.

David Blunkett, the Education Secretary, and Baroness Jay of Paddington, the Leader of the Lords, slipped into their respective pods quietly with family and friends. Sally Morgan, the Prime Minister's political secretary, travelled with Lord Birt, the former BBC Director-General.

Some of the guests celebrated in a more restrained style. Benjamin Wegg-Prosser, a former aide to Mr Mandelson who is now setting up the British version of the Internet magazine *Slate*, was one of those drunk on power in 1997, gyrating into the night until his master pulled him off the floor.

But at Mr Gould's party, he was a calmer creature, content to spend his night sharing a pod all of his own with a female friend. New Labour may still know how to party, but it seems it also needs consolation more than ever.

jonathan meades
at George

ST GEORGE has been the patron saint of England since the early 13th century or the latter half of the 14th century. England does not get exclusive use of his patronage since he is also patron saint of Moscow, boy-scouts, soldiers (and the Portuguese army in particular).

Busy guy, and what a flag. The flag appears, of course, to be of fairly recent devising, mid-19th century very likely – that was the golden age of flags. It can't be said to have enjoyed the happiest of recent histories. An astonishing broadcast poll of people in the street, the sort of people, that is, who are willing to stop and answer an importunate clipboard's questions, concluded respondents are more likely to recognise the French or Swiss flags than England's. Which proves merely that a) such people don't watch England's international football matches, which are invariably graced by face-painted philosophers and artists wrapped in beer-soaked flags of St George, and b) the appropriation of the flag by the far Right has also gone unremarked – this may be because such people take little notice of those sad losers.

The BNP's website assures us that it is not "fascist or racist" and then introduces us to the Society for Nordish (sic) Anthropology – "dedicated to the previous physical-anthropological research into the indigenous populations of northern Europe … the knowledge presented herein is founded chiefly on sources from before 1945, as there has been little progress in the field since that time". That could just be because the SS's Ancestral Research Department went out of business at that date. The site's British Folklore Links directs us

straight to The Germanic Heritage Page … Not that British after all, then. And, oddly, the flag isn't used.

Still, I wonder at the wisdom of Sir Terence Conran's decision to use the flag and the name for what is his first pub. George (there is no article in front of it) is yet another part of the Great Eastern Hotel, which I wrote about a couple of months ago. Sir Terence may reckon that putting the flag on the menus, on the ashtrays and on the sign above the door is an act of defiant reclamation – which it is. And he deserves praise for that act of bloody-mindedness. But it would be rash to discount the possibility that this repeated device will not act as a magnet for white trash from Rotherhithe and Deptford and Eltham. After all, the City after dark is a yob's paradise where cab drivers are increasingly loath to pick up fares.

The night I went to George, a man was peeing on the shop window next to the entrance in front of the unconcerned black bouncers (yes, this is a pub with bouncers) and another man was staggering drunkenly through the Bishopsgate traffic with not a care in the world for the damage he might inflict on a bus's tyre: there's nothing particularly joyous about the City's bibulousness – it is, rather, a question of the first to chuck ralph, the first to oblivion, the first to get thrown out. In more civilised countries the point is to avoid such public exhibitions of inebriation: the idea is to hold your drink rather than to release it into the community.

I am sure George is no worse than countless others in contributing to the air of unease and potential violence that hangs over the City. It comprises two rooms. The first is a bar with tables of differing heights and wall-to-wall people yelling at each other. The second is a comfortable, and rather comforting, little mustard-coloured dining room that seats about 35 people, six of them at a solid communal table in the centre. I guess the hazards here are a neighbour with a skinful, and the potential of acquainting oneself with the chunder of strangers. Still, the night I was there the diners' cheer was never more than boisterous.

The cooking is just the sort of stuff that St George, who was probably Palestinian, would have heard about from travellers to this heathen land. It's pub grub. And some of it is pub grub from before the advent of gastro-pubs. Steak and kidney pie, for instance, is one of those jobs in a little bowl with a pastry hat added. Shame! And fish and chips here constitutes a convincing argument for this being a national dish that ought to be buried with the sullied flag. The fish, plaice, was overcooked in retro-batter, thick, greasy, floury and the sort of thing that the British specialised in before they learned how to cook. Each chip was the size of a Mars bar.

Toad in the hole was unavailable – I gather that this is always the case. Something to do with the porousness of the dishes … Why not reprint the menu? Calf's liver was just right; so, too, the bacon with it, but not the faggot – and it was the promise of faggots that had attracted me in the first place. This specimen was distinctly underpowered, lacking offal and bite, eager not to offend.

A commendable pâté was served with a commendable piccalilli – made properly, this is a fine chutney. Pickled mackerel was excellent. The brine cut the fish's oiliness leaving the flavour intact. It was served with pickled veg and a mustardy vinaigrette. British farmhouse cheeses are served in gargantuan portions.

The bread, incidentally, is delicious, though the staff seem nervous about leaving the bread basket in case, I suppose, someone decides to yawn in it. A bread and butter pudding was pleasant enough. For reasons that are hard to fathom, George offers no real ales, only a meagre selection of bottled beers and one industrial cider. The short wine list is slightly more promising.

George 2/10 The Great Eastern Hotel, Liverpool Street, London EC2 (020-7618 7300). Lunch and dinner every day. £65 plus.

Lenten abstinence

From Mrs Frances J. Arthur

Sir, If I possessed the stoicism of the Reverend Jonathan Jennings (report, March 29) then I too might have given up *The Archers* for Lent. At least I would have been spared the unfolding drama of saintly Shula's public abstinence from chocolate.

Far be it from me to suggest that Shula Archer, Ann Widdecombe and the Prince of Wales have all got it wrong; but I've always worked on the principle that a Lenten commitment is fundamentally a private matter between oneself and one's Lord.

Yours faithfully,
F. J. ARTHUR,
Dunshee,
Machrihanish, Argyll PA28 6PT.
March 30.

From Mrs B. Kuen

Sir, You report that Prince Charles has given up lunches for Lent.

We practise this in our household, to be honest in an effort to lose a little weight – so chocs, alcohol, biscuits, in fact anything fattening and scrummy, go by the by. However, according to my calculations, the Prince is depriving himself for more days than he needs to. If you count 40 days and 40 nights from Ash Wednesday it takes you to Palm Sunday, not Easter Day.

Are we cheating, or is he suffering 47 days and nights?

Faithfully,
BARBARA KUEN,
67 Heathfield Road,
Wandsworth, SW18 2PH.
March 30.

From Prebendary G. Sunderland

Sir, I like to remember the apocryphal story of the penitent who confessed: "I have fasted on Sundays to spite the Church."

Yours faithfully,
GEOFFREY SUNDERLAND,
22 Blackdown View,
Sampford Peverell,
Tiverton, Devon EX16 7BE.
April 4.

From Mr Chris Partridge

Sir, Sundays are not days of fasting, which explains why there are more than 40 days between Ash Wednesday and Holy Saturday, as noted by Mrs B. Kuen (letter, April 4).

This can be taken as an excuse for overdoing it on the Sabbath. Evelyn Waugh, a devout Catholic convert, noted in his diary for Monday, March 1, 1948:

A hangover from Sunday's remission of Lenten abstinence ... When the hangover is over I shall work on *Helena* (his biography of the saintly mother of Emperor Constantine).

He wasted no time ending the fast. On the Holy Saturday following he wrote:

The fast over I smoked and drank. Laura gave a cocktail party. The boys at the school acted an indecent farce.

Yours sincerely,
CHRIS PARTRIDGE,
The Globe House, Fishbourne,
West Sussex PO18 8AR.
April 4.

From Mr James M. Reilly

Sir, In recent years, I have adopted Mrs F. J. Arthur's principle (letter, April 4) of being private about Lenten abstinence. It is now a joke in our family that no one knows whether I am having sugar and milk in my coffee during Lent, because I won't tell anyone for fear of being proud.

But the Prince of Wales has succeeded in doing more than appearing boastful about his fast; he has made people think about Lent and Easter, quite unexpectedly.

Yours faithfully,
JAMES M. REILLY,
113 Sutton Road,
Birmingham B23 5XB.
April 4.

From Mr Barry Hyman

Sir, I would have thought that giving up not listening to *The Archers* for Lent (Mrs Arthur's letter) was a much greater penance.

Yours faithfully,
BARRY HYMAN,
4 Priory View, Bushey Heath,
Hertfordshire WD2 3QZ.
April 4.

Ashcroft's peerage

From Mr Tony Booth

Sir, Even though the hereditary process has been abandoned, Michael Ashcroft (letters, March 31 and April 1) would appear to be part of that historical tradition. It would seem that the purpose and role of the House of Lords is redefined only in that it is now to be stuffed with Tony's cronies or William's bankers.

If the Labour Government had kept its promise on radical change in representative democracy and made the Lords into an elected second house then we would not be witnessing this latest distasteful spectacle.

Yours,
TONY BOOTH,
6 West End, Broadbottom,
Cheshire SK14 6BE.
April 2.

"SWAP YOU ALL MY DAD'S HI-TECH SHARES FOR ONE POKÉMON CARD?"

Anne Robinson

I CAN'T quite work out why Kathleen Turner getting her kit off every night in *The Graduate* in the West End is causing such a stir. The first time around, when Dustin Hoffman starred in the film with Anne Bancroft, it was wonderfully radical for Mrs Robinson to shamelessly seduce her daughter's boyfriend. But now I am Mrs Robinson's age-plus, I think it would take no time at all to get Benjamin into the sack.

If only because these days Elaine, her daughter, would be a terrifyingly ambitious young woman with her sights set on merchant banking and million-dollar bonuses, doubtless scaring Benjamin witless with her power and desire for success. In contrast one can see the middle-aged Mrs Robinson as a very comforting alternative and needing to do little more than whistle to persuade an insecure lad to jump into bed alongside her.

BINGO FOR THE OFFICE

Counting the clichés can concentrate the mind

The mindset of most movers and shakers is so fixed that they cannot think outside the box, go the extra mile or touch base with best practice. If only they would look at the big picture: out there, there's a game plan that is sweeping the boardrooms and has already set a new benchmark. Based on the lessons learnt from American hardball management, it uses fashionable buzzwords to empower employees by adapting an old game to today's conference calls and business briefings. In Bullshit Bingo, those who can line up the clichés first shout out a farmyard expletive. The result is a win-win situation: it has a knock-on effect on employees' attention, stretches the envelope of what meetings can do and shows up today's cutting-edge jargon for what it is.

'Twas ever thus. A cliché is a dullard's best friend, a limp metaphor that no longer stands up to scrutiny, a piece of verbal wallpaper to cover flaws in argument and gaps in thinking. It is the favourite currency of politicians, journalists, salesmen, commentators – all those who live by a ceaseless flow of words that promise much and signify little. Two or three generations ago clichés were drawn from hackneyed verse, popular sentiment and the folksy proverbs of old England. They lasted for years. Nowadays, they pour into the language from sport, commerce, technology and the multitudinous sea of showbusiness lapping around our lives.

Nowhere has the cliché flourished as luxuriantly as in the boardroom. The very art of management is defined in terms of maxims to be memorised and aphorisms to be aped. For every straight-talking chairman, there are scores of image-makers relying on phrases that once drew lively parallels but now draw yawns. Powerpoint poppycock is worse: no conference is complete without the overhead projector flashing up the company motto, the less than pithy phrases to define a pithy new sales pitch.

Cross-borrowing spreads the buzzword like a virus. Politicians borrow from the battlefield, managers from football coaches, journalists from pop stars. No longer does Westminster reverberate with Burkean oratory; second-hand soundbites and plagiarised posturing define the rituals of Prime Minister's Question Time. Counting the clichés may be a cynical response to today's speechifying. But if even the mumbler is now heard with rapt attention, it doesn't take a rocket scientist to work out that this is the bottom line.

Caitlin fears Jerry may be the cheatin' Kind

I used to believe in Jerry Springer. Then one day I greeted the postman in sardine-stained pyjamas at 3pm. Tell it, Caitlin Moran

I DIDN'T watch it. Jerry Springer was on *The Brian Conley Show* last Saturday, and I was out. Last year it was so very different. My love for Jerry was strong. If something good happened to me, I would chant "Jerry! Jerry!" Conversely, if something bad occurred, I would chant "Jerry! Jerry!" mournfully. I never missed a show. I had a friend who would come over at 2pm, Springer Time – and if we didn't have much on

Caitlin Moran

the next day, we'd play the Springer Drinking Game: a shot for each cousin, mullet, bitch-slap, hair-pull and physical intervention from the floor-manager, Steve. This often kept us drunk until 2am, and Late-Night Springer – the episodes where Jerry did a *Jim'll Fix It* for girls from Ohio who'd always dreamt of spraying aerosol custard on to their breasts on networked television.

We bought the videos the day they came out – *Jerry Springer – Too Hot For TV* and *Bad Boys and Wild Women* – and rationed ourselves to 20 minutes a day, like kids licking their Easter eggs to make them last longer. Yes; last year was very different.

In the long hours between Lunchtime Jerry and 2am Jerry, we would debate why Jerry meant so much to us. There was the Jerry Talk – "Don't GO there, girlfriend"; "I'm all that and a bag of chips"; "How many cousins you fit in your trailer?"; "Jerry! Jerry!" And there was Jerry himself: a former mayor who managed to end every episode, however bloody, with a homily cudgelled from *Reader's Digest,* capped with the line: "Until next time, take care of yourself, and each other," as the production assistants hosed the gore and shanks of hair from the stage.

However, in the end, our love for Jerry came down to the Kennedy Assassination. Anyone under the age of 40 lives in a state of permanent regret that they weren't born in time to gape at the coverage of the most famous person in the world getting shot on TV; and with the soi-disant promise that if we watch enough TV, we won't miss the next one. Of course, by the age of 15 we realised that however often we watched *Today's The Day* Martyn Lewis wouldn't fall crumpled to the floor, the side of his face shattered by a single exit-wound, and so we started to strategise. Live TV holds the most promise, and often gave hints of just how good things could be: Anthea Turner having her hair set alight on *Blue Peter*; a viewer calling Matt Bianco "a bunch of wankers" on *Saturday Superstore*; various combinations of Oliver Reed, dour northern presenters and Emu. But it was only with Springer that there came, as a

Bible written by Schoolly D would have it, The Advent of the Ruckus. It was the only show guaranteed to have stuff go wrong on it – fights and crying and formerly canned worms all over the place. Oliver Stone might never find out who'd assassinated JFK; but we knew which half-stage transsexual had made Chyerri pregnant, and what she'd been watching (*Jeopardy*) when it happened. For the first time, the world was a certain and entertaining place.

When my friend abandoned Springer Time for a proper job, I barely noticed: at least now I didn't have to get dressed at all during the day. I carried on the drinking game solo, and started shouting "Don't go there, girlfriend!" at the television. Even the sudden realisation – telegraphed by the look of disgust on the postman's face when I had to sign for my Bad Boys and Wild Women T-shirt in sardine-stained pyjamas and reeking of whisky at 3pm – that my hardcore Jerry habit was turning me into one of Jerry's slack-jawed gimps didn't stop me. It was only when my ex-Springer friend popped round one evening to look at the Wild Women T-shirt for old times' sake that the world started to melt underneath my feet. His job had taken him to countries where Springer didn't exist, and he'd had time, dangerous time, to reflect on the whole thing. "How come," he said, with a look I'd never seen before, one of independent thought, "that in America, the most litigious country in the world, no one has yet sued the programme for having a chair thrown at

their head?" I cowered, as baby rooks do when the polecat's paw first sweeps the nest. "Jerry! Jerry!" I chanted, defensively yet querulously. "Jerry?" I had never, for one second, considered that some of Springer's Spats might not be, well, true. When the 14-year-old Anne Widdecombe lookalike pushed her mother's face into the pumpkin pie while screaming "Can you hear me now?" on *The Thanksgiving From Hell*, I thought that I had been lucky enough to witness a moment of televisual history. It didn't occur to me that some production assistant could have stood backstage pointing at the tray of pies, saying: "Now however you want to express your rage, you are entitled to do so: and all of America is behind you." The effect was catastrophic. I had clung to Springer in the belief I had found a certain kind of truth; a place without the usual TV artifice, where all Hell was let loose. But with the introduction of this one seed of doubt, I felt like Stone coming across documents proving that JFK had faked his own death in order to get £250 for sending the footage to *You've Been Framed*.

There was a period of intense mourning, when I turned to *Open House With Gloria Hunniford* at the old Springer Time; but it just wasn't the same. Every guest was the same sex they'd been born with. The audience blended their foundation into their neck-lines and never, ever back-combed. The daytime TV magic was dead.

Readers – I washed my pyjamas.

We all want to know, Tony

TONY BLAIR was not entirely open and frank in a recent interview with *Marie Claire* magazine. Here are some of the questions the Prime Minister ducked: "One of your former image

advisers recently announced that you wear make-up, what is your favourite brand?"; "Have you ever thrown a sickie to skive off work?" and "Why didn't you decide to have your ears pinned back?"

News for Gordon

AMBIGUOUS news for the Chancellor. Owing to lack of interest, Politico's bookshop have dramatically

slashed the price of their Gordon Brown dog toys – they squeak when the animals try to sink their teeth into them. The Tony Blair toy, however, is a roaring success.

Mark Inglefield

At last, justice for Hughes

The opening of the late poet's archive proves that he helped Sylvia Plath's career

Erica Wagner

IN JANUARY 1975, Ted Hughes, the late Poet Laureate, was corresponding with the woman who had been his mother-in-law, Aurelia Plath. By this time Hughes had been married for five years to Carol Orchard, his second wife; Sylvia Plath's suicide was 12 years behind him, the suicide of Assia Wevill, for whom he had left Plath, six years in the past. One might have thought that by this time he would have created a new life for himself and moved beyond the pain caused by the death of his children's mother. It should be remembered, too, that when Wevill died she also killed the couple's daughter, Shura.

But Hughes was Plath's literary executor; at this time he was debating with her mother what to include in the volume that would become Plath's *Letters Home*, published later that year. *Letters Home* (a "corrective", in Aurelia's eyes, to the ghastly mother daughter relationship in Plath's autobiographical novel, *The Bell Jar*) would show unrelentingly the sparkling, good-girl, straight-A student face that Plath was at pains to keep turned towards her mother. It also contained a portrait of Hughes as the marriage began to disintegrate – faithless, a deserter, the false "smiler" she excoriated in her journals. Hughes, understandably, wished to keep her venom from the public gaze.

"I don't want to take the ginger out of these letters," he wrote to Aurelia, "but I honestly don't see why they should be a gallery of Sylvia's impressions of my dark half, for other people to continue to superimpose on me. The Chinese proverb says: describe the good, and people will believe one eighth; describe the bad, and people will believe eight times as much and try to sell it."

Try to sell it they did – and, to a large extent, succeeded.

Particularly in the United States, Hughes's efforts to keep a public silence about his relationship with Plath while gradually editing and releasing her work resulted in his demonisation. Is it an irony, then, that his archive – 108 linear feet of papers, letters, poems and photographs dating from 1940 to 1997 – should find a final home at Emory University in Atlanta, where the above letter may now be found? Or is it, perhaps, a strange kind of justice?

Hughes's literary standing in the United States is very different to his standing in Britain. Here his work is a staple of school syllabuses. I was born and educated to the age of 18 in New York, and during that time never had cause to read a single poem by Hughes, or hear his name mentioned other than as the (wicked) husband of the great American poet Sylvia Plath, whose work I certainly knew. This had little to do with Hughes's "Englishness" and much to do with his perceived relationship to Plath, who in the years after her death became a feminist icon and martyr. His "breakthrough" book in the United States was *Birthday Letters*, his poetic account of his marriage to Plath, which was published only in the year before his death. It was a situation of which Hughes was well aware, as he wrote in a letter to Lucas Myers – an old Cambridge friend who was partly responsible for bringing Hughes and Plath together, and who is referred to several times in *Birthday Letters* – in February 1988, a

letter now filed in the Emory archive. At the time he was involved "to some extent" in the production of Anne Stevenson's biography of Plath, *Bitter Fame*.

"I think, by suppressing or trying to suppress, for my children's sake, all accounts etc of Sylvia's more difficult side, I have done everybody an ill-service. Myself especially, perhaps. Colluding at every step with Aurelia's attempts to exonerate herself and sustain her dreams of the perfect daughter, I have known all along that I was in fact incriminating myself – but I'm needing all my philosophy now to tolerate the sentence which has, I see, been passed on me and which several generations of US students accept as history, in so far as they are aware of Sylvia and myself. It was certainly the end of – gradually arrived at, but now pretty irreversible I imagine – the fortunes of my verses and my reputation in the US, though I'm not sure any other course of action would have made any difference there."

Thanks to the opening of the Emory archive, that may now change. As Diane Middlebrook, an American scholar at work in the archive on a book about Hughes and the development of his public persona, told *The Times* yesterday, the release of these papers (almost all of which are available for study; there is only a single trunk that must remain sealed for some years to come) is "bound to make it possible to look at him as a poet". The weeks she has spent at Emory have been a revelation; Hughes often kept drafts of his letters, and his correspondence – with Peter Redgrove, Alan Sillitoe, Stephen Spender and Seamus Heaney, to name only a few – was prolific. "I would love to be around in 50 years' time when Hughes's collected

letters are published," Middlebrook said. "I think he'll be remembered as one of the great letter writers of the 20th century. It's clear he did a lot of thinking in his letters; often he'll start off in a quite businesslike way, about something purely practical, and then stray into a long, thoughtful discussion of something else entirely."

Middlebrook also mentions the impact of seeing how important the visual was to Hughes. In the exhibition mounted by Stephen Enniss, Emory's Curator of Library Collections, to mark the opening of the archive, Hughes's strong, slanted handwriting is on display; seeing it over and over in the archive "enables you to see the physical process of the work", Middlebrook says. The archive also reveals his close collaboration with such artists as Leonard Baskin, at whose suggestion he began the cycle of poems that would become the powerful *Crow*, its publication complemented by Baskin's work.

And there are images that reveal the earliest influences on Hughes's writing. Hughes is not usually thought of as a war poet, but his father's participation in the First World War shaped his life, and in his early collections poems such as *The Casualty, Bayonet Charge, Six Young Men* and *Wilfred Owen's Photographs* are powerful evocations of the conflict that cast a shadow over the Yorkshire valleys of his youth, emptied of their young men. "I can never escape the impression that the whole region is in mourning for the First World War," he would write. On display in the exhibition is a photograph from the Hughes family scrapbook of "The East Yorks moving up" – Hughes's father's regiment, taken in 1916. William Hughes was one of only 17 men from that regiment to return alive from the terrible battle of Gallipoli.

Yet in the first instance, at least, it is still the material that reveals his lifelong connection to Plath that will excite the most interest. What is most

clearly visible, Enniss says, is how their literary enterprise – which occupied almost every one of their waking hours – was a joint one. They wrote on the backs of each other's drafts, conscious of conserving expensive paper, and did each other's secretarial work. In the past it has seemed that it was Plath exclusively who worked to get her husband's poems published, typing his work and sending it out.

The first item pasted in a scrapbook of his work that she kept is a letter of acceptance for his poem *Bawdry Embraced* from *Poetry* magazine in Chicago; contributor's notes have it as his "first professional publication" and the letter is written to Ted Hughes, "c/o S. Plath". but there are also letters from Hughes to American editors about her work, written in her lifetime, and biographical notes composed by Hughes on Plath's behalf. "He clearly supported her in ways large and small," Enniss says, "in her writing and in the practical parcelling out of their days."

An archive's treasures are only slowly revealed, and it will be years before the wealth of material now catalogued at Emory truly comes to light. Elaine Feinstein – a poet, biographer and a friend of Hughes – is at work there now, producing what should be the first biography of the late Laureate; and I must confess to some frustration myself, having completed a book on Hughes's work just as this material becomes available. Frustration, but sadness, too – as the opening of the archive was occasioned by Hughes's untimely death nearly two years ago.

Hughes was a prolific artist and very private man: the papers at Emory begin to show the relationship between the two. There is another letter to Lucas Myers in the archive, written in the spring of 1956, not long after he had met Plath. In the letter he asks Myers to find a place for Plath to stay in London, so that the two of them can meet; but he is aware, too, of the gossips they both feared.

Hughes and Myers had once come

and stood late at night under her Cambridge window, calling up to her and throwing soil-clods to try to wake her: "The two mixed: mud and my name; my name is mud," she wrote ruefully in her journal. And so he closes his letter to Myers: "Don't forget Sylvia – and discretion."

That short sentence shadowed his life. The papers now available in the Emory Archive should bring Ted Hughes, the poet and the man, more fully into light.

Anne Robinson

I AM now getting very excited indeed about the arrival of the People's Baby, since I am resigned to the idea that this might be the nearest I ever get to becoming a grandmother. I also think it matters not one jot whether the Prime Minister takes paternity leave or, as is likely, fudges his working hours.

There are many more fun fish to fry.

As I see it, Mrs Blair is about to become the single most important influence on family, and motherhood, this century. Because the very presence of a baby at Number 10 will demonstrate how patronising and phoney it is for the Government to bang on about the importance of the family while most of its members work anything up to an eighteen or twenty-hour day.

If new Labour really cares about parenthood it is not unreasonable to ask why its leader continues to allow mothers and fathers to hang around Westminster until the early hours several nights a week. An arrangement that means MPs may only see their children at weekends and are required to give much more tender loving care to the issues of the day than they can to a new baby at home, or a teenager who feels misunderstood.

Gym jams

WESTMINSTER MAY soon witness the bizarre spectacle of Gerald Kaufman waltzing Virginia Bottomley around the floor of the House of Commons gymnasium.

Plans are under way, I can disclose, to offer ballet and tap dance lessons to MPs, a scheme that is being heartily promoted by Hazel Blears, the Labour MP for Salford. Ms Blears, an accomplished tap, jazz and ballet dancer, as well as being PPS to the Health Secretary Alan Milburn, tells me that up to a dozen heel-clicking MPs have expressed an interest. "Dancing is just the best thing in the world for relaxation and to take your mind off things," she says. "Dancing gives people grace and confidence. It is an antidote to the stiffness of politics."

Although arrangements are not yet finalised, Blears, whose parents were ballroom dancers, is currently negotiating with the Imperial Society of Teachers of Dancing to supply a tap and ballet teacher and a roll-down floor.

Other MPs likely to sign up are Baroness Blatch and the allegedly nimble Sir Patrick Cormack, both of whom have a passion for dance.

Mark Inglefield

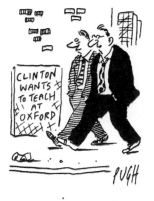

" WELL, ITS A GREAT WAY TO MEET GIRLS "

Racist who twisted the truth

DAVID IRVING'S reputation as an historian was demolished yesterday when his High Court libel case ended with him branded an anti-Semitic, racist Holocaust denier and pro-Nazi polemicist.

"Irving has for his own ideological reasons persistently and deliberately misrepresented and manipulated historical evidence," Mr Justice Gray said at the end of the 32-day hearing. "For the same reasons, he has portrayed Hitler in an unwarrantedly favourable light, principally in relation to his attitude towards and responsibility for the treatment of the Jews".

And while the judge said it was not his function to express a view of what happened during the Nazi era, his verdict will set a benchmark for historians of the period and Mr Irving faces a future as an academic pariah.

The crushing defeat has also left Mr Irving facing a £2.5 million legal bill which he claims he cannot pay. Costs have still to be settled at a future hearing, but the judge warned the historian that he would have to pay the "vast bulk" of the expenses incurred by the American academic Deborah Lipstadt and her publisher Penguin Books.

Mr Irving had sued them for libel over claims in her book, *Denying the Holocaust: the Growing Assault on Truth and Memory*, that he was a "Hitler partisan" who had denied the existence of the gas chambers at Auschwitz.

Before the judgment Mr Irving, who claims to have no significant assets but his spacious flat in Mayfair, told *The Times* that he expected Penguin Books to make him bankrupt if he lost. Penguin said it would take "active steps" to pursue him for its costs, but sources accepted that the company was unlikely to recoup its outlay. A statement from the publisher said: "What today's judgment has proved is that we were right to stand by the content of our book and that it was entirely inappropriate of David Irving to seek to suppress the book by way of a libel action."

The defendants had turned down an offer from Mr Irving to settle out of court for £500 to be paid to charity. They decided to fight because it would have been "morally repugnant" to concede.

Mr Irving says he has raised a fighting fund of $500,000 (£317,000) in an Internet appeal, but refuses to say who his backers are. After the verdict yesterday, he was escorted through the rear exit of the High Court by security staff to a waiting taxi, saying only: "The judgment was perverse. I shall be appealing."

The judge had refused him leave to appeal, but said he was free to apply directly to the Court of Appeal.

Later, at his home, Mr Irving said: "I would describe the judgment in two words – firstly, indescribable, and secondly, perverse." He refused to talk about the cost of losing the case. "Why is everyone talking about money? I'm not interested in money. It is all about reputation," he said.

He remained unrepentant about what the judge saw as racist and anti-Semitic views, saying: "I am not at all anti-Semitic. It is not anti-Semitic to be critical of the Jews. But the leaders of the Jewish communities around the world have used the most horrific methods to try and destroy me. Some people are vindictive, but that is not in my nature. I am a Christian through and through."

A jubilant Professor Lipstadt said she was delighted and felt "exceptionally vindicated". Later she told a press conference: "One of the most moving moments did not happen in the court proceedings but outside when I was enveloped by (Holocaust) survivors who said thank you."

Professor Lipstadt had received a call

David Irving in his study after the judgment

Joanna Coles
in New York

READERS may quake but striving writers will rejoice at the arrival of Xlibris, a publishing website that promises to give full public vent to all literary offerings – no matter how dreadful. This week Xlibris, in which Random House has a significant stake, has unleashed an advertising campaign aimed at seducing budding authors whose previous canons have remained frustratingly unpublished.

"There is only one thing worse than the feeling you get when you put your fingers to the keyboard and nothing happens," the ad sympathises. "And that's the feeling you get when your prose flows like a mountain brook in March and you finish the book and it's the best thing you've ever done and no one will publish it because you're not famous."

Xlibris promises to reject none of the half a million books that failed to find an outlet in America last year. Unappreciated authors simply upload the manuscript on to Xlibris.com, which will design the cover, assign it an ISBN number and register it with booksellers, from where it can be ordered and then printed on demand. But, scarily, Xlibris will not edit or check the accuracy of any material to which it is midwife. And all rights to the published work will be owned by the author.

"In short," threatens the ad, "every book written can now be published."

the night before from a man who had been in the Resistance in the Warsaw ghetto. He had spoken indirectly on behalf of all Holocaust survivors to say: "Deborah, you sleep well tonight, because we're not sleeping." She added: "I've had enough of Irving's cesspool for the last five years. I would expect no respectable institution or publication to give him a platform. I hope this victory will save other authors from having to face such trials and tribulations."

The judgment was hailed by Lord Janner of Braunstone, chairman of the Holocaust Education Trust, as an epic victory for truth. "The Irving case shows the crucial importance of educating our young people in the tragedy of the Holocaust especially as a symbol of the dangers of allowing racist dictatorships to rule," he said.

The Israeli Minister for Israeli Society and World Jewish Communities, Rabbi Michael Melchior, said the judgment delivered the message that Holocaust deniers should be regarded alongside the worst of the Nazis. He called for the ruling to be taught in schools everywhere.

Michael Horsnell and
Alex O'Connell

A very British day with the asylum-seekers

Refugees seeking asylum have to persuade the immigration appeal authorities that they are genuine. Ann Treneman spent a day in the hearing rooms listening to their horror stories

Ann Treneman
Feature Writer
of the Year

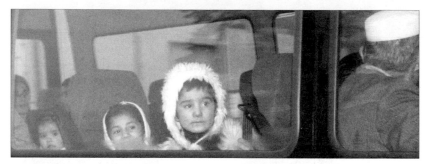

Hostages freed from the hijacked Afghan Airlines plane leave Stansted

MAREK KARASZ is 23 years old. His occupation is making screws for cars. He is married to Gabriella, also 23, and they have two children. They were born and bred in what is now the Czech Republic. In January they came to Britain, seeking asylum. The Home Office has rejected their claim. So, when I meet them this week, Marek and Gabriella are those most famous of news-makers: Romany Gypsies who have been found to be bogus asylum-seekers.

They have come to the immigrations appeals authority to tell their story yet again. It is a mangled and at times incoherent tale, but after 15 minutes I find myself gripped. "It is like a detective story, isn't it?" whispers the interpreter to me. Actually it is not. It is a horror story. There are sticks, stones, dead cats, petrol bombs and wrecked laundry. But the question before us on this day is: is it horrible enough?

We are in Hearing Room Nine at the authority's new building at Taylor House on Rosebery Avenue in London. This is the sharp end of the immigration crisis but the building is just two years old and the furniture newly fitted. The people, too, seem caring and polite. This dignity is somehow surprising in a week where politicians have been letting rip. Shadow Home Secretary Ann Widdecombe says Britain is a "soft touch" and that bogus asylum-seekers are "flooding" the country. The Prime Minister's spokesman, Alastair Campbell, says Labour will never use immigration as a "race card" but adds that, apart from Kosovans, some 70 to 80 per cent of

asylum-seekers are not genuine.

The Home Office says that 71,160 people applied for asylum last year. Kosovo accounts for 11,465 of these, but even without Kosovo the figures show a marked increase from the figure of 46,015 the year before. Most cases are refused: last year it was 54 per cent, the year before 71 per cent. But there is a backlog of 102,000 cases and the figures have concentrated minds at the Home Office. Claims are now being processed at the rate of 9,000 a month. The new Human Rights Act in October is expected to slow progress even further and this week a £10 million crisis package has been announced, with the number of appeals judges being doubled.

The fact that the system is in crisis cannot be hidden, despite the new blue carpets at Taylor House. There are 26 hearing rooms here and on Wednesday most were in use, with at least 100 cases scheduled for that day. The reception room is like a mini-United Nations on every weekday. I dropped in on three cases, chosen at random. In the first, involving Marek and Gabriella, the Home Office did not bother to send anyone to defend its position. The second case was extremely out of date: the woman, a Colombian national, had first applied for asylum in 1992. In the third,

which involved a Kurd from Turkey, it had taken more than a year for the hearing to be set.

Hearing Room Nine, like all the rooms here, is square with white walls. There are four desks, arranged in a square. The judge, called an adjudicator, has a desk slightly higher than the others and a green chair that looks slightly more substantial, but that really is the only sign of his or her status. The setting is informal by design and there is only room for one line of chairs along one side of the room. In every room, I am the only one watching.

Every asylum-seeker here has already been turned down by the Home Office, so this day is one of the most important of Marek and Gabriella's lives. They come in casual clothes and carry a sandwich in a plastic container that, as the morning goes on, they pass back and forth to each other. Gabriella goes first, speaking in Czech through an interpreter. She was set on fire in a racist attack when she was five and her solicitor spends some time establishing that some of her attackers had been sent to prison. Perhaps, he says, this explains why she and Marek have been singled out for abuse in the past few years.

She says her attackers are "white Czechs and skinheads". "They attack

me because I am a Romany. They can't stand that somebody's skin is dark. The people want to eradicate the black race and they want only white people in the Czech Republic." She says the police will not respond "unless there is a body" and that they cannot move because no one will give a Roma a state flat. Often they refused to speak to her at the council offices.

There are two main attacks described and many lesser ones. One was in May, after which Gabriella came to Britain by herself. She returned home in October to be with her husband but an attack in January drove both of them to Britain again. Her descriptions of the attacks jumble the severe with the trivial. She talks of petrol bombs and of being slapped and kicked, then describes how her neighbours kept cutting her washing line too.

Marek is thin and wears round glasses. His testimony is more precise. He talks of cats being thrown into his garden, stones and insults about his "black face" and "black mouth" being thrown at him, and more. His solicitor wants him to be more specific.

Solicitor: What did they do?

Marek: They shouted abuse, threw stones.

Solicitor: Anything else?

Marek: They put their fists to the doors. Every day there was something else.

Solicitor: Did they throw anything else?

Marek: Those petrol bombs. I couldn't live there. I couldn't. (He keeps talking and the interpreter interrupts to talk to the judge: He is saying "Isn't it enough that my wife has plastic on her?" I think this must be referring to plastic surgery after the fire when she was five.)

Solicitor: If you had to go back, where would you live?

Marek: I couldn't. I would be frightened. I have nowhere to live. I would have to go to France. If you go somewhere in the Czech Republic, they will find you.

The case ends after two hours. No one is on hand from the Home Office, so the final arguments are lopsided. The solicitor speaks of case law regarding persecution. He says he has shown that there is no protection for them back home and presents human rights reports on the overall situation in the Czech Republic. The adjudicator, who is unfailingly courteous, listens to it all and says she will make her decision within two weeks. It will be sent to them in the post.

Next stop is Room 20. Here the language is Spanish and a woman named Sara is telling a story from another place and time. The year is 1988 and Sara has been drawn to the grassroots politics of the Frente Popular (Popular Front) in Colombia. The party was against violence and its goals were socialist: to feed the poor, empower the workers and provide education and healthcare for all. "The peasant gives everything to us – he is the one who works the land – and then they steal everything from him," Sara says.

The representative from the Home Office asks a question: "Would you describe this group as having a socialist aim?" Sara replies: "No, for us it was not socialist. For us it was to be united." Whatever you label it, the Popular Front was a threat to the men with guns who run Colombia. In August 1988 its leader, Beatriz Monsalve, who was six months pregnant, was assassinated. "After they killed our leaders, they harassed and harassed us because they thought we didn't have strength to fight for the people," says Sara. The party split into sub-groups.

On December 27, 1989, Sara was kidnapped from a bus stop by six paramilitaries. For three days she was beaten, tortured and raped. She gave them three names. The Home Office representative, who is a barrister, asks her why only three. Sara says they were the only ones she knew well. "These were the ones who were always with me. I carry it in my heart that I betrayed them." The three were later arrested and killed. Sara, however, managed to escape on the

sixth day and went to her brother, then to her parents' house. She decided to leave the country and on October 27, 1990, she arrived in Britain.

She did not claim asylum until 1992. It was four years before the case was rejected. Evidently at one point there was an administrative error that took a year to correct. Now it is being heard again, as if for the first time. Her case rests on the fact that were she to return to Colombia, she says, she would get involved in the politics of the people again and the paramilitaries would harm her. The hearing ends with the Home Office raising three points about her credibility. Her solicitor rebuts these. The adjudicator rises. It is 3.10pm.

At least half the rooms are empty now. My last stop is Room Two. This is an appeals tribunal and slightly more formal. There is a panel of three and the cases before it have already lost on appeal once. Here they are asking the tribunal to reconsider on a point of law.

The case involves that of Fernhat Kilic, a Kurd from Turkey who arrived in Britain on May 10, 1998. He is seeking asylum because of his political views, and because he does not want to serve in the Turkish Army and be sent to the southeast of the country, where there has been a civil war against the Kurds. Mr Kilic was granted leave to appeal to the tribunal in March 1999 and 13 months later he was having his day. He has a barrister. The Home Office has a civil servant. Everyone has stacks of papers and there is a general discussion about what exactly might be going on in southeast Turkey now.

At the back, Mr Kilic has dozed off. His barrister notes that Mr Kilic has come all the way from Glasgow and apologises. The chairman immediately says that dozing off is not a problem. Then Mr Kilic, now wide awake, apologises. The Home Office man makes a genial observation about it all. It is a very British moment. But then this has been a very British day and that, given the circumstances, seems a bit of a triumph.

Is there no cure for the sickness they call Queens Park Rangers?

 Jasper Gerard
.................................

BEFORE THE summer sun has streaked across the nation's football pitches, the year has already finished for the majority of fans. While the sports pages swoon as Manchester United and Chelsea prepare for Premiership and FA Cup glory, those of us who support sides of quieter reputations must accept another season of sadness. Why allow ourselves the extravagant dreams of September, when we can already anticipate the despair of May? I have seen more dexterity in an elephant, more fleetness of foot in a tortoise, more life in Shergar than in the 11 players who hold my happiness in their leaden hooves.

I have tried to rehabilitate myself by just saying "no" to offers of tickets for Saturday. I have done cold turkey trundling round Tesco and even contemplated DIY. But by 4.45 I will have come over all shaky and turned the dial to confirm that we have been vanquished by the colossus that is Crewe Alexandra. I will be inconsolable. And it is then that women can be at their most cruel. "If you must enjoy childish games, why don't you at least follow a team that wins, not necessarily all the time, but just once in a while?" The logic is irrefutable; but loyalty is even blinder than love. Perhaps I should found a society called Queens Park Rangers Anonymous for my damaging addiction, but then our supporters are fairly anonymous anyway. This year we have even been denied the end of season frisson of a relegation battle, marooned in mid-table mediocrity. It seems harsh punishment for a youthful indiscretion. It was 1977 and I was nine when I first visited Loftus Road. QPR's stylish, swaggering, swashbuckling team finished runner-up, missing out on the Championship

on the last day of the season. Since then I have witnessed 23 years of decline. As with all doomed relationships, there have been fleeting joys, but scant success to merit all my support.

Running alongside this cavalcade of despair has been my real life. But no career or emotional humbling has hurt quite as savagely as the sloppy goal conceded in the last minute (a Rangers party piece). Watching QPR bears no relation to anything that matters – or indeed, to football – yet still I cannot grow, I cannot kick the habit.

Nor am I the only screwed-up junkie. The dopeheads from Shepherds Bush have spawned an entire literary movement. Look in the new-writing section (tragedy) in all good bookshops and you will find copious studies on the heart-rending story of the boys in blue and white. Chelsea might be at Wembley but it isn't so cocky at Waterstones. As for the Whitbread, the interest of Chelsea fans doesn't extend much beyond the beer tent. QPR, by contrast, can boast the winner of the Whitbread First Novel Award, *White City Blue* by Tim Lott. Other important contributions include *Time for Bed*, by David Baddiel, and *London Fields*, by Martin Amis.

It can do strange things to you, a football team. A female friend is convinced that she was conceived in Loftus Road (her parents courted there). She feels drawn to her homeland, to the extent that she has even been known to turn up for reserve games – which is about as sad as it

gets. Her mother entertains hopes of her beloved girl's betrothal at Westminster Abbey, but daughter knows that the Tony Ingham Executive Suite overlooking the muddy pitch beckons (which rather cuts down her choice of mates – a very eligible Spurs fan was recently spurned).

But there are compensations. One meets a better class of hooligan in West London. "That was the most pitiful attack since the Spanish Armada", and "the goalie is as sound as a pound when we crashed out of the ERM", are about as vicious as the abuse gets. Mohamed Al Fayed has been subjected to crude racial taunts when he has travelled elsewhere with his Fulham team, but on his visit to Loftus Road Gerry Francis's Blue and White Army contented itself with the refrain: "Gerry's got a passport, la, la, la." Indeed, so gentlemanly are our defenders, that they often let the opposition walk the ball into the net without the faintest protest.

It is also immensely character building. Who needs boarding school or trenches when one can suffer instead as a staunch supporter of a struggling team, loyal even when one's childhood hero is sold to a bigger club? Arriviste Chelsea fans will never fully grasp the joy of victory, because they have not felt the pain of defeat. When their team eventually receives its comeuppance, they will abandon footy for the next rock and roll (Morris dancing, perhaps). All the defeats have been worth it for the memory of a perfect 50-yard pass from Tony Currie, a jinking run by Stanley Bowles or an overhead scissor-kick by Simon Stainrod. Oh, and of course, it's all going to be so much better next season.

Death of Times writer

IAN MURRAY, *The Times* medical correspondent, has died of liver cancer.

Mr Murray, who was 59, had been on the staff for nearly 30 years, serving as a correspondent in Paris, Brussels, Jerusalem and Bonn. He had been medical correspondent for the past three years.

His writing described the experimental treatment he was being given at Queen Elizabeth Hospital in Birmingham, in which his immune system was "educated" to attack his tumour.

In a recent article he wrote: "My pregnant daughter has a little lump inside her which is kicking and fighting for life and in three months will, I pray, be ready to start the miracle of life. I have a little lump in me which is kicking and fighting for my life and it will win. As an old hack who has seen a lot and done a little, I can say that it is an exchange I am prepared to make."

He was a journalist of the old school; this was one of the few times he permitted a glimpse of the man behind the words. Mr Murray discovered that he had liver cancer last year when he went for treatment in hospital for prostate cancer. He died in a hospice in London on Saturday night.

Nigel Hawkes

From Dr Mac Armstrong, Secretary of the British Medical Association

Sir, We learned with sadness of the death of Ian Murray (report and obituary, April 17), the medical correspondent of *The Times* since 1997.

During the past three years, BMA doctors and staff members alike have appreciated the professionalism, accuracy and knowledge that Ian brought to the job of writing on health matters. He was unfailingly courteous, whatever deadline pressures he was under, and we will miss his wry humour and personal charm.

His courage in dealing with cancer and taking part in a clinical trial were evident to all who knew him and to readers of the two personal accounts of his illness (articles, January 22 and April 8).

Press conferences at BMA House will be diminished without one of the opening questions coming from "Ian Murray of *The Times*" in the front row. He will be missed.

Yours sincerely,
E. M. ARMSTRONG,
Secretary,
British Medical Association,
BMA House,
Tavistock Square, WC1H 9JP.
April 17.

For those of you who Have It All: keep it simple

Joanna Coles

in New York

FOLLOWING THE debut of *Real Simple*, the glossy magazine which launched last month instructing readers to "simplify your life" – by purchasing lots of simple things including a simple wool T-shirt for a simple $360 (£223) or a simple cotton skirt for a simple $380 – come two more journals surfing the current wave of secular self-improvement.

The first, *Simplicity*, presents its mission statement as follows: "We'd like for you to think of us as the Big Comfy Armchair you can curl up to anytime, anywhere." It then kicks off with several pages of moody photographs before offering, with no apparent irony, a website address containing "thousands of pages of information about publications and tools for those wanting to lead a more simple and restorative lifestyle".

The lead story in *Simplicity* offers seven key steps to Living Simply. You may want to reach for a stylus of your Palm Pilot to write these down so you won't forget them: "1. Go to Bed Early 2. Slow Down 3. Prepare Your Own Meals 4. Dress Simply 5. Write Letters 6. Love Your Work 7. Travel by Foot..." As they say here, Duh!

Also jostling for attention on the newsstand is *O*, that's O as in Oprah Winfrey – not as in "Oh what is the point of all these magazines?" Or even "Oh, if only I didn't buy all these magazines my life would be a lot simpler." *O*, which in its premier issue has simplified its need for models by featuring Oprah in no fewer than 14 photo spreads – is also majoring in simplicity – indeed, it even doubles as a notebook offering several blank pages for readers to fill in on their own thoughts (at least it's simple for the editor).

"Something to Think About," announces one largely blank page, asking readers to answer questions including "Am I satisfied with the life I am living?" and "What is my heart's deepest desire?"

A more salient question might be how come three magazines offering to simplify your life have launched in the last three weeks? "Simplicity has evolved into a secular religion for affluent North Americans in recent years," explains the writer Joe Queenan. "At heart simplicity buffs yearn for an earlier, simpler time when people did not have BMWs, villas in Tuscany and registered retirement plans, because they had simplified their lives by being poor.

"Since no one these days actually wants to give up the villas in Tuscany or be poor again, the alternative is to read books and magazine articles about how simple life would be if only it weren't so complicated."

News from nowhere

The first occasional
dispatch from our writer
cast away in the
Southern Ocean

Matthew Parris

FOR THE first time in my life this morning I blew over. I had no idea people could. Chickens blow over in Derbyshire but are we not more solid? Then it happened. One moment I was stumbling up the track to my cabin; the next, a great buffet knocked me forward, throwing me on to my knees in the gravel. I rolled over, cradling the precious video-camera to my chest.

No harm done. Camera safe, knees grazed and a lesson learnt: here on Kerguelen, weather is not a backdrop but a foreground to your life: a rogue variable, wrecker of plans. Man proposes here; the wind disposes. It has blown a score of human dreams away. The Roaring Forties, in whose path this huge island lies, generate more weather than can be consumed locally. Supply so exceeds demand that for a howling gale we hardly raise our eyes from the soup, while a briefly drooping windsock becomes an object of wonder and thanksgiving.

Yet the mercies of the weather in the Southern Ocean are as capricious as its cruelties. All at once the wind does drop. Suddenly the ocean is flat. Seals on the shingle burp and scratch. The water turns indigo in the sun and the hillsides are lit in russets and browns. Livid moss and soft green grass shine and, reflected in a thousand lakes and ponds, snowy peaks float in an immense pale blue sky. Seabirds, innumerable, wheel around.

In minutes this can pass but sometimes it stays. The Southern Ocean cheated me last week of the tempest I had secretly hoped for. We sailed from La Réunion to Mauritius, to Ile Crozet and then across to Kerguelen – eight days, 2,800 miles – on a stiff wind and a heavy swell, but mostly in sunshine. It was glorious. At night the great 6,000-tonne *Marion Dufrense* lunged forward, pitching with swell and the wind behind us, diesel throb-

bing and the Southern Cross bright in the sky. I stood out on the bows and thought: "Were you kidding us, Captain Cook? This is easy. This isn't frightening at all."

But now? Hail shotblasts my window. People run from cabin to cabin with faces buried in Gore-Tex. This is the kingdom of Gore-Tex. Umbrellas are half-remembered jokes, the precipitation here being horizontal. Goggles make more sense. I expect to pass my four months on Kerguelen without ever seeing a raindrop fall, for the rain does not fall, it is a sideways phenomenon. As the sudden gale hits the ocean the sea is picked up in a blinding white sheet, racing across the water to the terror of yachtsmen. Every raindrop stings.

Some of this I have already experienced, some is report. I have been here less than two weeks. And my early impressions? My first sight of the only settlement, Port-Aux-Français, was from the Alouette helicopter that brought me ashore. It looked ugly, dispiriting. The dwellings and laboratories, comfortable within, are really glorified Portakabins. The generators and stores are in huge sheds. Masts and transmitters litter the hill. Everything required to stick up into the air is secured by steel cable rigging. Almost all we eat, drink, burn, sit or sleep on is

shipped in and was being unloaded as I flew in: the *Marion* does not return until August. This is an artificial life.

Landed, I scampered from the Alouette. Unpacking in my new room, I peered from the window at a rusty, empty 44-gallon drum, bowling unattended across the gravel in the wind. The heart sank. I videoed the territory's only two trees, imported conifers cowering behind a hut. The whole complex scores a great gash from waterfront to hilltop. The sub-Antarctic environment being as fragile as it is harsh, rabbits have eaten off chunks of the slow-growing vegetation, eroding the soil beneath.

To what sort of hell-hole had I condemned myself until August? As the *Marion* sailed away, I knew there was no backing out now.

The first night found me awake, in the small hours, disturbed not by the howl of the wind – that was familiar – but by the thump. Thump is the closest description I can find for the sort of sound even the deaf could hear, for it is felt in the stomach: violent, low-frequency pressure changes that my video-camera microphones do not pick up. I snuggled under the blankets.

At dawn I opened my eyes to a new kind of morning. I looked out. Waves raced each other into the shore, smashing spray over basalt. Against a clear sky, a silvery light flooded a landscape which wasn't quite Cromarty and wasn't quite Mars. Strange peaks, black cliffs and volcanic cones paraded across the skyline, softer hills and glowing greens sloping down to the far shore of a vast bay. A choppy sea seemed almost to glitter. Mount Ross, snowy and pink, hung on the horizon 40 miles away.

Walking along the shore I nearly tripped over a young basking elephant-seal. He offered a snarl more admoni-

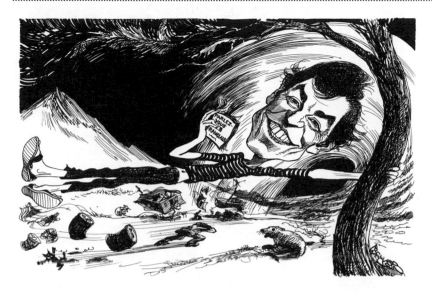

tory than hostile. Every animal here comes from the sea and is preparing to return there for the southern winter, for the ocean is now warmer than the land and full of food. Birds of all kinds, from giant albatrosses to tiny diving petrels, seals as big as sofas, hundreds of thousands of king penguins lining every beach – all of them are, not "tame", but blithely unafraid of man. They blink at us, waddle round us, mildly bemused. We are not within their ken.

From this same shore I looked back yesterday towards the base. Now I saw a different place. Shelter! Company! Heat! Food! The bar! A safe haven – and I knew people there. I was in Port-Aux-Français, after all, not as an architectural critic but as a fellow-hivernant – winterer. I will never again be able to see this place as I saw it on landing. I don't give a stuff about the appearance any more. This is home.

I have been welcomed so warmly as to be in severe danger of becoming a Francophile. My accommodation is cosier and more generous than I had expected, and that's almost a pity – except that the truth is, this is no gulag; nobody suffers here. It's a sociable and well-provisioned base camp in a very, very isolated place. At any one time there are some 40 souls – scientists,

students, weathermen, satellite trackers – in a close-knit community where everyone mucks in.

I have volunteered to take my turn on the morning rubbish collection, with tractor. My school French is proving adequate – just – to communicate but not to chat or banter. I miss the nuances and my *Lonely Planet* phrasebook is useless for "And how are your transplanted Kerguelen cabbages doing this morning?" at breakfast. There is no big practical problem for me in this, but there has been at first a problem of self-confidence. I found myself slightly dreading mealtimes, hanging back, worried about which table to choose, terrified at the silence which fell when I spoke, anxious in a way I cannot remember since the first weeks of boarding school.

I still grin inanely, or panic, when people talk to me. I suspect the cause of this occasional depression, which speaks ill of me, is nothing to do with loss of company or communication: it's because I have lost the social predominance which my own gift of the gab has always afforded me. Cut down to size, I am learning what it is like, not only to be an Englishman among the French, but also to be the kind of shy, halting Englishman with no particular gift, who lacks confidence among his own

people. Never again will I slap someone on the back and tell them to snap out of it, plunge in, and be jolly. For the first time I know how it feels to be nervous of company.

But this will pass – is passing. Names and faces are beginning to gel. Many here seem to be Breton, have odd names like Loic, and enjoy dreadful communal singing. I have been reminded how deeply politically incorrect are the French. What other nation would include, from among 58 scientists and support staff, 56 men and two women?

If I ever thought that the documentary I'm making for Channel 4's *To the Ends of the Earth* series would show Port-Aux-Français as some kind of pemmican-provisioned trench in the snow, I have had to revise that view. The base is a crowd of chummy blokes getting on with their work, eating well, watching videos and playing table football.

But Port-Aux-Français is not Kerguelen. This archipelago is wildly beautiful, serenely desolate and quite dangerous. From here all kinds of expeditions venture, some very tough. The interior is as precipitous as the weather is demented. There are bogs, cliffs, sink-holes and crevasses, and always there is the wind and the rain. It takes two weeks – a walk of perhaps 150 miles – to reach Christmas Harbour, where Captain Cook dropped anchor on December 25, 1776.

My first sally will be more modest: I have enlisted on a four-day walk to Port Jeanne d'Arc, a whaling and sealing station abandoned early in the last century. There we shall overnight in a cabin, spending five days seeking the feral cats whose ancestors were ship's cats and which now threaten the nestling albatross. There will be radio contact with the base and, all being well, they will send a little boat for us when we've finished.

We set out on April 20. My 16 kilos of Mars bars will come in handy. Damn. Why didn't I think of seeking sponsorship from Mars?

Thanks so much for having me, Mr Blair

Simon Jenkins

From the President of the Russian Federation

To Tony Blair

Dear Tony,
Thank you for your hospitality. I am a man careful of his words and of little wit. I enjoyed lunch and was happy to meet your press. What fools. As for the lady to whom you sent me for tea at Windsor, what was that supposed to be about? Anyway, thank you.

To business. I am told I do not smile much. I do not smile. I am trained KGB. Governing Russia is no smiling matter. The place is rotten and without discipline. You see two bags under my eyes? One is Chechnya, the other is corruption. That is why I do not smile.

I am afraid Westerners still do not understand Russia. You talk all the time of Chechnya, as if you meant to rule the world. I wish to rule only Russia. We have Muslim fanatics raging through our southern provinces. Why do I need to defend my actions to your press? We fought these terrorists and then tried letting them rule in Grozny. It did not work. Chechnya was in anarchy. Those people killed anyone, including British civilians. They were invading Dagestan. This is a dangerous, turbulent part of the world. It is our Balkans. We must be firm, and I had to let our soldiers do the job we asked them to do. As you unleashed Nato's bombers last year, so I unleashed mine. The difference is that I persuaded your enemy to cave in before mine did.

The Russian Army is charged with flattening cities, creating refugees and committing human rights atrocities. Democrats cannot have it both ways. I have the same problem that you had in Yugoslavia with infantry casualties. Nobody wants them. So we used bombs, not bullets, which are less accurate. You are still bombing Iraq, killing people every week. You do not tell your country about this. You claim only to be standing firm against Muslim extremism. That is what Russia is doing in Chechnya.

I am apparently accused of using "disproportionate firepower". Last year Nato bombed the cities of Belgrade and Novi Sad and Nis. You hit houses, markets, offices, railways, bridges and said you would go on until Milosevic capitulated. From your rhetoric, I am sure you would have "flattened" Belgrade. Did Nato kill more civilians than has Russia? Who knows? Is morality in the body count? There are also 250,000 refugees in Serbia, driven out of Nato's puppet state of Kosovo, often in Nato trucks. Your press publicises Chechen refugees, my press publicises Serbian ones. You claim not to be responsible for what your KLA allies do on the ground. We shall doubtless say the same in Grozny. We are both members of the realpolitik club. The difference is that Chechnya is part of Russia. I did not lecture you on Northern Ireland.

Some journalist had the cheek to ask me about human rights abuses. What of the human rights of Iraqi civilians, of Serb refugees, of Kosovan Gypsies, or of the hundreds of children orphaned by Nato bombing? Where do your two-faced journalists think Grozny is located, somewhere north of Islington? I have agreed a commission to look into military abuses. I can tell you, it will be fudged and do no good.

I see you have a commission looking into your own military atrocities in Northern Ireland. I note that it is dealing with killings 30 years after the event. I offer you a deal, Tony. I will activate my Chechnya commission, British style, in 2030. You Westerners are still imperialists at heart. You cannot keep your noses out of other people's business.

There is, however, a matter on which I would appreciate real help. I admire the way you slipped in ahead of Clinton and the others and came first to see me. There was little in this for you except some glamorous photo calls at the Mariinsky Theatre. But you could be a useful intermediary, like your hero Margaret Thatcher, between Russia and the pestilential Americans. I am now slashing our nuclear arsenal. The Duma ratified Start 2 last Friday. Do not underestimate the historic significance of this. I soon intend to eliminate all our multi-warhead missiles, the most feared of Russian weapons. Under Start 3 the arsenal will reduce to just 1,500 single-head missiles. Nato has demanded this for three decades. We will deliver.

So why is Washington seeking to abrogate the ABM Treaty, to push ahead with its anti-ballistic missile Star Wars programme? The programme is a technological fantasy. You know that. Yet any treaty revision will infuriate Russia's military. The way to contain rogue states is by fighting them, as in the Gulf and Chechnya. None of us needs Star Wars against Pakistan or Iraq. Nuclear war is avoided by us all sticking with non-proliferation and continuing to destroy missiles.

Russia is not joking. It has swallowed one humiliation after another. We pulled back from Serbia and even got you off the hook in Kosovo. We endured your moralising on Chechnya. We accepted the bitter pill of Nato enlargement. We did all this with no predicted nationalist coup. I kept our hawks in line. Why can't Clinton do the same on ABM? Perhaps the Communists were right. Washington is

all military-industrial complex and no government. Perhaps it is as corrupt as Moscow. You claim to be a nuclear disarmer, Tony. Prove it.

On the subject of corruption I heard the CBI say that they "can do business with Putin". Tell them the days of doing business with people like Putin are over. They must do business with the Russian people, and that means opening their doors to trade. For ten years I have watched your bankers in bed with our bankers, laundering World Bank and IMF aid. I watched that aid make Russia's rich richer and its poor poorer. Our growth rate was negative. Even our population is declining. Half the aid has been stolen, the other half channelled back to Western banks. In St Petersburg I watch aid corrupt my friend, Mayor Sobchak. Russia's biggest problem is corruption and the biggest corrupter is aid.

I know I must police Russia's new economy. I must collect taxes and enforce company law and regulate internal markets. If Poland can do it, then Russia can. But what it needs above all is trade, and that is what you are least inclined to offer. We poor states are the same. You love lending us money, because it makes you seem generous and your taxpayers guarantee it. We waste it and then have to give it back with interest. Trade is different. The European Union hates it as much as America hates it, because it upsets the producer lobbies. Yet a free market for trade is the one aid that can discipline Russia and generate a market economy.

That and order. Russia needs order. It needs the culture of the KGB at its best, of my one-time lord and master, Yuri Andropov. It needs the cunning of the spy and the discipline of the State. It needs nastiness. I must be nasty to venal businessmen and corrupt officials. I must be nasty to provincial governors. I must be nasty to the press, and perhaps to many one-time dissidents much loved in your country. I will be described as backsliding on democracy, as "a disappointment". The best news I can offer you is that my enemies would be yours: the incompetents, speculators, black marketeers, Yeltsin courtiers and mafiosi. They are the ghosts of Russia's past, of a gigantic history and a world power.

You may think that my cold exterior hides a warm heart. Pray that it does not. I am young and have yet to suffer the occupational disease of Kremlin occupants, that of vanity. I am determined, sober, clever, plain-speaking, uncorrupted. History suggests that I will not be this for long. You can lecture me all you like. It will merely earn my contempt. Your interest must lie in a stronger, more confident Russia. With Putin, you have a window of opportunity to get that Russia, or do you want another Yeltsin?

By the way, they tell me you like big cars, motorcades, VIP fast lanes, the old Communist stuff. I confess, I like them too. Perks were the one thing the old guard got right. Let me send you the new Zil 7-seater stretch-limo. It is armour-plated top, bottom and sides, leather interior, V8 engine, with 118mph top speed. With outriders, it did Windsor to Heathrow in five minutes. It will show your Ken Livingstone who's really in control.

Yours ever,
Vladimir

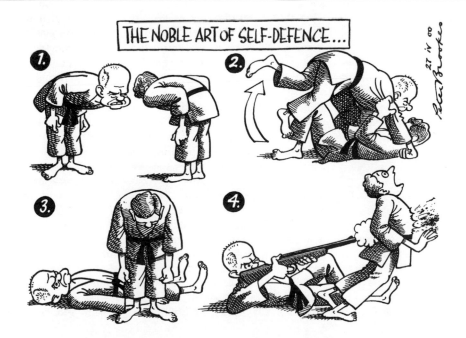

THE NOBLE ART OF SELF-DEFENCE...

SYMPTOMS AND CAUSES

Where the asylum 'debate' has gone off the rails

There was little in the tone of William Hague's speech on asylum policy last night that his political opponents could in honesty attack as racist or xenophobic. Not that this stopped them. All three parties are outbidding each other in a highly political game, removed from practicalities, which can only aggravate the problems. For Jack Straw, the Hague speech proved that the Tories are "exploiting the asylum issue" for May's local government elections; Mr Hague's proposed remedies were "a cruel deception from a deeply cynical party".

But Mr Straw, with next year's larger electoral test in mind, is not above cynicism himself. He never stops telling Cabinet and country that his new policies to deter asylum-seekers – vouchers instead of cash benefits, the "pilot" detention centre at Oakington, a £2,000 fine per stowaway on lorry drivers and the hideous plan, dropped under fire, to require all visitors from the Indian sub-continent to post a £10,000 bond – are, in a vivid phrase, "kicking in".

As for Simon Hughes, who seems to model himself on John Bunyan's character, Mr Facing Both Ways, he declared the Liberal Democrats to be "comfortable" with "reception" centres, so long as the inmates were "generally" free – which he knows they are not – to come and go. At least David Blunkett had the honesty to blurt out the Government's real grouse; Labour, he said, "would not tolerate people believing that Britain is a soft touch". In what passes for debate on asylum, "tough" has become synonymous with "efficient".

Mr Hague made some effort to elevate his rhetoric above his party's recent scaremongering about the "flooding" of Britain with "bogus" claimants. He dwelt on Britain's history of welcoming refugees from persecution, which was not only a source of pride but had "brought important benefits to our country". Each new influx had "widened and advanced our sense of what it means to be British". He came to praise asylum, not to bury it; if tough policies were needed, this was to protect a "proud tradition" which was "near collapse". A system that was weak, "arbitrary and unfair" was losing public support.

But this is not quite the point; the huge welcome given to Kosovan refugees all over the country last year shows that what angers voters is rising criminal exploitation of the system, not the system itself. Against abuses, Mr Hague offers three main remedies; virtually automatic detention in special centres of all new applicants for asylum; a presumption against those from countries deemed "safe"; and a "removals agency" to deport those rejected. This is hardly thought through. Detention would be hugely expensive; the new Oakington centre – to which barely more than 20 people have so far been sent – is expected to cost £537 a head a week. And deportation even of non-refugees may, in October, fall foul of the Human Rights Act.

What Messrs Hague and Straw both need to address, and do not, is the cause of the sharp increases in asylum-seeking. Partly, it is political turmoil. But a deeper reason is that all other routes into Britain are closed. UK immigration policy is simply this: "To reduce and keep new immigration to a small and inescapable minimum." That closed-door policy has manifestly failed; what is more, this is just as well. For as Britain's population ages, it will need more, not fewer, immigrants.

To maintain the ratio between workforce and dependants, the EU will need 40 million immigrants over the next 25 years; unless Italy, admittedly an extreme case, accepts 2.2 million a year, it will need to raise the retirement age to 77. The vital question is whether this will be recognised and organised, or whether 400,000 economic migrants a year will go on paying traffickers to smuggle them in. The record is that the firmer their legal status, the more these mostly ambitious incomers contribute to national wealth; those from the Commonwealth have created, proportionately, the most companies of any immigrant group in Europe. Foreign-born EU residents earn around £290 billion and they pay £95 billion in taxes. Their costs, in welfare bills, are £57 billion. Political honesty on economic migration is urgently required. Only then will either sense or principle be restored to the asylum debate.

So God created woman

Every European is descended from seven heroic women who survived wolves, cave bears and Ice Ages to populate a continent. Anjana Ahuja interviews the man who discovered our ancestral mothers

Anjana Ahuja

BRYAN SYKES spends much of his time wondering about a woman called Tara. "I imagine her to have mid-brown hair, clear blue eyes and olive skin," says Sykes, Professor of Human Genetics at Oxford University. "She was obviously physically fit and she must have been a good mother, able to hunt if she had to."

Sykes feels a genuine closeness to Tara, whom he has never met. For she is his ancestral mother, one of seven important women who lived tens of thousands of years ago. Sykes, who gained media coverage recently for his finding that seemingly unrelated men with the surname Sykes had an identical genetic imprint on the Y chromosome, implying that they had a common ancestor, has made another profound discovery.

With his team at the Institute of Molecular Medicine, he has revealed to *The Times* that the people of Europe descended from just seven women who lived between 8,000 and 45,000 years ago. The Seven Daughters of Eve, as he has called them, provide unequivocal proof that people settled in Europe long before the advent of farming 8,000 years ago, and before the last Ice Age, about 18,000 years ago.

The seven women, whom Sykes has named Ursula, Xenia, Tara, Helena, Katrine, Valda and Jasmine, can be identified with certainty because they left a biological imprint in their descendants that persists unchanged to this day. The imprint lies not in the nuclear DNA contained in each cell in

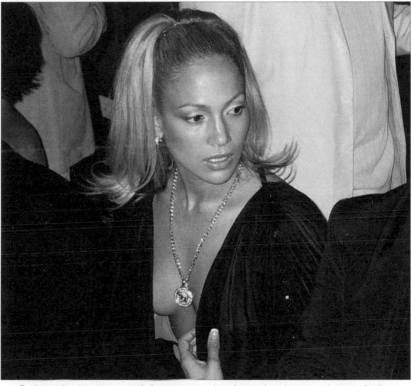

Is Jennifer Lopez one of the women who share the characteristics of what Professor Bryan Sykes calls the Seven Daughters of Eve?

your body, which is the biological code that makes you unique. It lies instead in mitochondria, small sausage-shaped structures in the cell that help the cell to metabolise oxygen. These mitochondria have their own DNA, called mitochondrial DNA, or mtDNA.

"Mitochondrial DNA is maternally inherited," says Sykes. "Sperm don't have this DNA in them. It should follow then that all the mitochondrial DNA of all the humans in the world should be the same, plus any mutations." The mutations are not prompted by the environment but are random. On the whole, this special DNA

should represent an unbroken line of ancestry on the mother's side.

Sykes wanted to check the theory out before embarking on a massive research project on thousands of people. He chose an unusual test subject – the Syrian, or golden, hamster. He recalls: "As a boy, I read that all the hamsters in the world had come from one pregnant female found in the Syrian desert by a zoological expedition in 1930.

"So we got in touch with the Syrian Hamster Society of Great Britain, who put us in touch with international clubs. We wrote to branches all over the world asking them each to send

Professor Bryan Sykes. If he has a daughter, he will call her Tara

dried hamster droppings. These contain enough DNA from the intestines for us to amplify and sequence. For months we would have packets of these arriving – you could shake the envelope and hear them rattling around. To our surprise, we found that all the mitochondrial DNA was absolutely identical. I'd never really believed the story but this showed it to be probably true. And we realised that mitochondrial DNA might well be stable in the human population over thousands of years."

Sykes then switched to human beings and proved that the mtDNA in Polynesians matched that found in people in South-East Asia rather than in America, settling a longstanding mystery. The "crystal clear" results prompted Sykes finally to turn this powerful genealogical tool on Europe. He took 6,000 samples of tissue brushed from the inside of the cheek, in each case sequencing 500 of the 16,000 letters that make up the entire mtDNA code. This stretch was not picked at random – it lies in a portion of the mtDNA where mutations are particularly prevalent. It is therefore a reliable guide to the differences

between different samples.

Sykes plotted all the sequences and found that they clustered around seven main groups. "I just can't get over it," he says with quiet pride as we sit in a university canteen poring over a chart of the clusters. "Each of those clusters is derived from a single woman. Every time a European takes a breath, he or she is using the same genes to metabolise the oxygen as one of those seven women. It brings it all alive to think that these were real people who had to survive, and that we have a direct, unbroken line to them." It seemed only fitting to bestow names on these remarkable women. And he points out that, although the names are figments of his imagination, the women are definitely not.

Previous research suggests that one mutation (which arises when the DNA is copied erroneously as the cell divides) occurs in human mtDNA every 10,000 years; this allows Sykes to guess when each woman arrived on the scene. This varies between 8,000 and 45,000 years. This provided the biggest surprise – the arrival of migrants in Europe seems to have happened tens of thousands of years

earlier than many anthropologists thought. The figure of 45,000 years ago also coincides with the first appearance in the fossil record of modern human beings. The finding fits perfectly with the Out of Africa theory – the idea that the modern human being descended from an African ancestor. Sykes has traced the seven maternal clans back to the Lara clan, one of three clans existing today in Africa.

Sykes, who has patented his techniques and is setting up a company called Oxford Ancestors, stumbled into this research by accident. In 1986, he had been called in to look at some medieval bones dug up near Oxford where a supermarket was being built. Nobody thought that DNA could survive burial for hundreds of years; it would surely be broken down by bacteria. However, new techniques allowed even tiny amounts to be amplified, and the test on the bones was successful. It has since been used on ancient corpses.

Despite his work, he has been largely unbothered by the mystery of his own heritage. But now he feels an affinity with Tara, the woman from whom he is descended, who lived about 17,000 years ago, and is even motivated to think about tracing his family tree. He knows Tara must have been brave and resourceful to have pulled through the Ice Age, and to have borne descendants that led over thousands of years to the Sykes lineage. If he ever has a daughter (he has an eight-year-old son, Richard) he thinks Tara would be an apt name. "Tara Sykes – well, that's not a bad name at all," he smiles.

This aspect of his work struck him when he was doing DNA tests on the Ice Man, a 5,000-year-old corpse found in a glacier in Austria. He says: "It was a revelation to me. A friend in Bournemouth, a management consultant, turned out to be related to him. She began to have feelings of kinship with the Ice Man, and

began feeling quite sorry for this relative of hers who had been dug up from the ice and was being shunted between freezers.

"Knowing your ancestry gives you a sense of self, a sense of connection with other people and a depth to your own heritage. And it's entirely democratic – many people could trace their ancestry back if they were an aristocrat but this work has nothing to do with that. This is a deep, deep ancestry. I was reminded of this when we did tests on Cheddar Man (a 9,000-year-old corpse found in the Cheddar caves in Somerset). Lord Bath, a delightful old cove whose estate contains the caves, rang up and asked me if I could do a test to see if he was related. So we took a cheek swab and he turned out not to be. But his butler was!

"It shows that, everywhere in Europe, people have a bit of everything, even in the Scandinavian countries. The only group that doesn't seem to have any mixing is the Lapps in northern Norway and Finland. So these results make a nonsense of a genetic basis for ethnic division."

Sykes says that his analyses – he is preparing a similar chart for other continents, as well as a detailed chart for Britain –– should make us feel rather proud that we exist at all. "I don't mean this in a disrespectful way, but even the most mixed-up, hopeless person has an amazing genetic inheritance. Their fantastic genes survived the Ice Age, and survived a trek across Europe over freezing plains, having kids on the way. None of us really appreciates what our genes have gone through to get us here."

Professor Sykes has compiled a probable history for each of the seven women from whom Europeans are descended.

URSULA (Latin for "she-bear"): Living about 45,000 years ago in northern Greece, she was a slender and graceful contrast to the Neanderthals she lived alongside. Using stone tools to hunt, her clan spread across Europe, including Britain and France. Cheddar Man was one of her descendants. As the atmosphere cooled and the Ice Age neared, her descendants moved south. Afterwards they reclaimed the frozen lands of northern Europe.

XENIA (Greek for "hospitable"): A mysterious woman, she lived 25,000 years ago in the Caucasus Mountains near the Black Sea, sharing her territory with wolves and cave bears. As the Ice Age neared, her children spread to other parts of Europe and to America.

TARA (Gaelic for "rock"): Sykes's own ancestral mother lived in Tuscany 17,000 years ago, when the Tuscan hills were thickly forested. As the climate warmed, her descendants trekked through northern Europe, across the English Channel (which was then dry) and on into Ireland.

HELENA (Greek for "light"): Her descendants are the most abundant in Europe, and have settled in every corner, field and mountain range on the Continent. Helena came from a hunting family, and lived near the glacier-covered Pyrenees. As the ice melted, her descendants moved north, reaching England 12,000 years ago.

KATRINE (Greek for "pure"): Boasting the Ice Man as one of her descendants, Katrine lived 10,000 years ago near Venice. She lived mainly on fish and crabs, but her descendants, who ventured north, hunted ibex. Her clan persists in the Alps today.

VALDA (Scandinavian for "ruler"): The family of Valda, a Spanish woman who lived 17,000 years ago, shared the land with Ursula's clan. She would never have known the Neanderthals, who died out 25,000 years ago. Any rivalries were forgotten as the Ice Age ended, and the two clans pushed north together, reaching northern Scandinavia. Together with wanderers from Arctic Russia, they became the Lapps of northern Finland and Norway, who still exist.

JASMINE (Persian for "flower"): Jasmine was born in Syria, and arrived too late to know the misery of the Ice Age. With a constant supply of gazelle and small game, which could be dried and stored, there was no need to keep moving. So Jasmine was one of the first inhabitants of a semipermanent settlement.

The realisation that plants grew from seeds led to the invention of farming; as wheat became the dominant food, animals could be domesticated instead of hunted.

As Jasmine's descendants drifted around Europe, they taught their nomadic hunter-gatherer cousins the settled comforts of the agricultural way of life.

Harry's help

HARRY ENFIELD is to advise the original Tory Boy on how to tell a few good jokes. The comedian – much less of a lefty these days – is offering tips to William Hague on "loosening up".

"William is a really nice guy in person," says Enfield, bubbling enthusiastically about his project. "But he always comes across like a blackboard. Really stiff."

Harry has travelled a long way since he ridiculed "loadsamoney" Thatcherites in the Eighties. A client of Cazenove, the Queen's stockbrokers, he recently snuggled into a £3 million house in Notting Hill with his wife, Lucy. Emboldened, at a No 10 reception after the last election, he drunkenly told Peter Mandelson: "Nobody likes you, you are ghastly. You should resign," and urged the PM to "stab him in the back".

Enfield, who admits that his Tory Boy character was inspired by the teenage Hague, may be acting to please his eccentric father, Edward: last year Enfield Sr joined his local Conservative party, declaring that the Blair Government was "awful".

Mark Inglefield

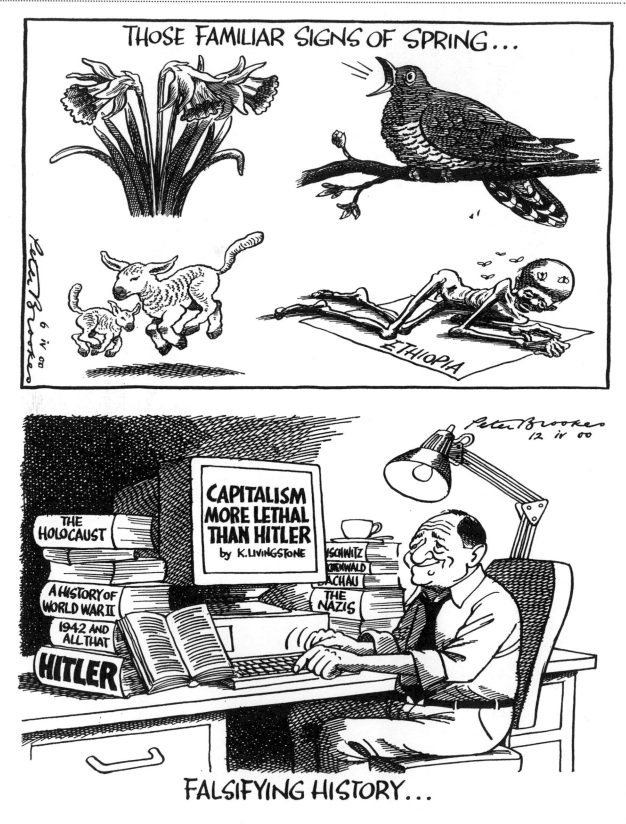

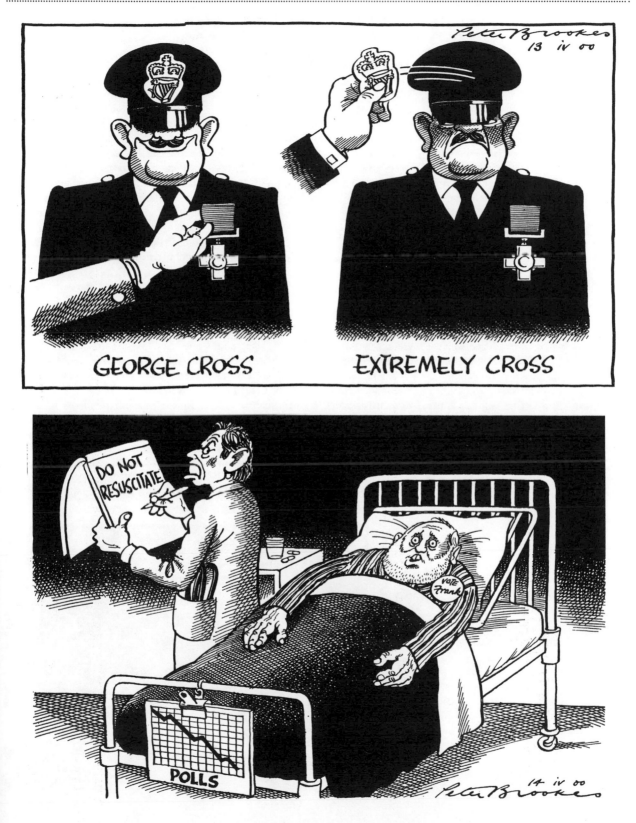

GEORGE CROSS EXTREMELY CROSS

TERENCE READ

The day the barrister nearly shot the judge in a divorce case at Winchester Assizes

AT WINCHESTER ASSIZES in the 1950s there was a famous incident, documented in Sir James Comyn's Watching Brief (1993), in which the hero was the optimistic Irish barrister Terence Read. The victim was the judge Lord Merriman, whose *DNB* entry notes "a temperament which led him at times to explosions of anger". In 1933, in the then political mode, he had been advanced from Solicitor-General to be President of the Probate, Divorce and Admiralty Division.

For the husband in the case, Read was in the process of challenging the wife's contention that he had threatened her with a revolver. "Look, my Lord, at the instrument which he is alleged to have used. There are even cobwebs on it now. Not used since the Crimean War, I expect." He took up the gun and said: "I doubt if it will ever fire." Aiming at the bench, he then pulled the trigger.

A bullet whistled from the muzzle, missing Merriman (who dived under his desk) by inches, and lodged in the wall. The usher (later transferred) was heard to say: "Christ, they've killed the old bugger at last."

The court retired until next morning when Read – ever the optimist in spite of this setback – felt confident of judgment. He could not have been more wrong. The President began his judgment by saying: "I am lucky to be alive." Read lost – and the revolver was forfeited.

Euan Terence Stafford Read was born in Cardiff, the son of Euan Stafford Read, a journalist, and his wife Doris. He was brought up in Ireland, went to Trinity College, Dublin, but left to join the Army.

He served with the Glosters in Burma, after which he returned to Trinity and graduated with honours in legal and political science and an LLB in 1948.

The Regius Professor of Laws was the celebrated Fanny Moran, one of the first women barristers. By this time he had married Jean (née Ellis).

Called to the Bar by Middle Temple in 1950, Read did pupillage with Granville Wingate, later a Circuit Judge, and brother of Orde Wingate of Burma fame. After a spell in Southampton chambers Read went to 2 Mitre Court Buildings in the Temple, headed for most of his time there by Sir Joseph Molony, son of Ireland's last Lord Chief Justice.

Read, who lived in the Winchester area, was one of the busiest members of the Western Circuit. His professional standing and Laughing Cavalier good looks induced the Winchester Liberals, long in disarray – they did not fight the 1959 election – to ask him to stand in 1964. He agreed, but said he would not canvass. He had 6,510 votes (16.1 per cent), which he increased in 1966 to 7,390 (18 per cent). Later, the Liberals put up two Wykehamists, one a Classics don, and in 1997 the Liberal Democrat Mark Oaten won a remarkable victory. Read had been the reviver.

In 1967 health problems made him and his wife leave England, ultimately for Andorra. He is survived by her and four children.

Terence Read, barrister, was born on January 18, 1922. He died in Andorra on April 13 aged 78.

Shaolin monks practising in London before the start of a national tour with their *Shaolin Wheel of Life* show

HENRY BIRD

Nudes, theatre scenery, pub signs, religious murals – and more nudes

HENRY BIRD was the very image of a "real" artist, with a real artist's studio in a vast and dusty attic above a sort of gentlemen's club in the centre of Northampton.

To this studio, with cream cakes, sherry and gin, he tempted models, preferably big and beautiful in the manner of his revered Rembrandt's Saskia, to pose for his prolific drawings of nudes. Those who modelled for him, and there seemed to be a steady and willing stream, were usually worn down by his persistence rather than the lure of pastries and alcohol.

But there was never any fear of the traditional seduction of model by artist, despite Bird's obvious enjoyment of his favourite subject, the female form. His gimlet eye was concentrating purely on the line drawn at his easel, 30ft away at the other end of a room cluttered to the very beams and roof lights with paper and canvases, easels, brushes, caked and ancient palettes and paints, and a plethora of extraordinary and decaying props.

To the mingled studio odours of paint, inks and pastel dust was added that of Danish pastries toasting on top of the two-bar electric fire which warmed the models. Bird continued, well into his eighties, to visit his studio, which was reached by frightening, almost vertical stairs, the way up indicated by a flight of delicately drawn birds.

His public works range from pub signs to the vast and impressive fire curtains for the Royal Theatre, Northampton, and the Ashcroft Theatre, Croydon, his technique for these drawing on his experience as head scene painter at the Old Vic and at Sadler's Wells. Murals and panels of religious, decorative and figurative subjects were carried out for Northamptonshire churches and chapels at Earls Barton, St Crispin, Denton and Charwelton. Bird was one of comparatively few artists to be thoroughly comfortable with the grand scale of ambitious public painting projects.

He was thorough in his research and knowledge of his religious subjects and was a great authority on the pagan roots of Christian ritual and symbolism. His original and novel ideas on techniques and iconography came directly from his research and experience as a practising artist. Very often it was these ideas that brought him into conflict with the art history establishment, but encouraged his students to question received wisdom and practice.

As a drawing tutor at University College Aberystwyth and at Northampton School of Art, he demanded high standards of his pupils, requiring them to study, for months, a brick, a milk bottle and an egg. In their first class with him, students innocently surrendered their pencil rubber, which he then instantly ejected through a window on to the car park beneath.

He organised packed whirlwind tours for his pupils to exhibitions and museums and to the final-year shows of his alma mater, the Royal College of Art (where, at a party as a student, he was reputed to have swung from the rafters dressed as the Archangel Gabriel). Dressed always in one of his distinctive hats – a felt fedora in winter and a panama in summer – he set a cracking pace, with only a short stop for a glass of lemon tea in the restaurant of the Victoria and Albert Museum.

Processing through the galleries, he could pause without warning in front of any painting and expound in detail on the artist. His knowledge of pre-20th-century art was formidable in its breadth and detail. When he was not drawing or painting he was a notorious raconteur, recalling at the drop of a hat long-distant and immensely protracted anecdotes about his many acquaintances and experiences.

Listeners interjected at their peril. "Don't interrupt – I'm talking" would silence the most determined attempt at conversation. He could orate on the most obscure subjects at random and in depth, but without a doubt his favourite subject was himself. When he left University College Aberystwyth, his students presented him with a trumpet, so that he could continue to blow his own.

His commitment and devotion to his work was matched equally by his commitment, devotion and admiration for his wife, the actress Freda Jackson, who died in 1990. His first sight of her was her face, suspended halfway up the stage curtain, painted green as a witch in a production of *Macbeth* at the Royal Theatre, Northampton. With typical decisiveness he said: "That's the woman for me."

Henry Bird, artist, was born on July 15, 1909. He died on April 16 aged 90.

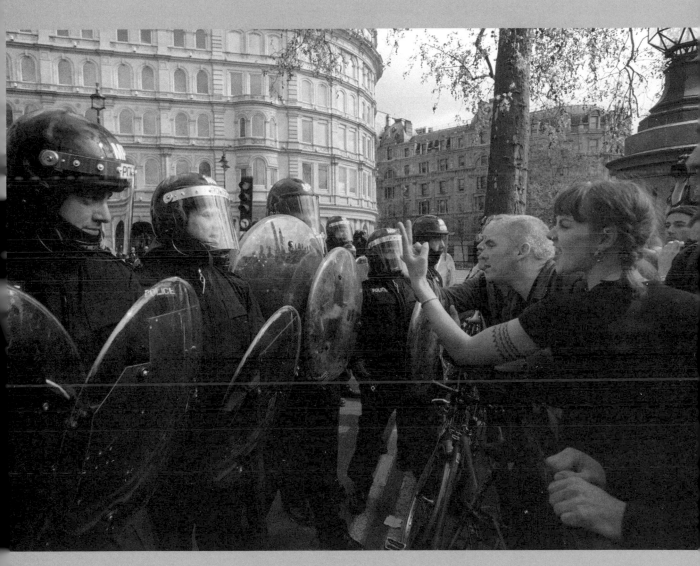

May
2000

Shaken and contrite? Not a bit of it

Peter Riddell and Philip Webster interview the Prime Minister

ANYONE EXPECTING Tony Blair to be shaken or contrite after Labour's big losses last Thursday is going to be disappointed. He was in an unrepentant mood, several times referring to his mission, as he talked to us yesterday morning in his Downing Street flat surrounded by cards for his 47th birthday on Saturday.

The Prime Minister brushed aside criticisms made by some Labour MPs over the weekend and laughed at the suggestion that he should learn to love his party more. There was no hint of any olive branch to Ken Livingstone, or of his swift return to the Labour Party. He talked of the "resentment" in the Labour Party at Mr Livingstone's decision to stand as an independent, having previously promised to stay in the party.

Mr Blair was relaxed, buoyed by progress in the Northern Ireland peace talks, and also, increasingly, thinking about the imminent arrival of his fourth child. There was no hint of a name. "I am gradually getting used to it. Every time I walk into the flat, I see a new manifestation. I still occasionally find it quite hard to believe that I am going to be a father again. It's such a big thing. I really do feel that life will begin all over again. On the other hand, it is fantastic. I should consider it a blessing."

Perhaps these events have given him detachment, and perspective, in his reaction to Labour's current problems. His emphasis throughout was on the long term, on intensifying Labour's radicalism. He looked forward to "big reforms" in the National Health Service in July and to providing further help for pensioners.

Mr Blair also gave hope to Charles Kennedy, the Liberal Democrat leader, by suggesting that he wanted to keep open the question of electoral reform.

Asked whether the co-operation project was still on, he said: "Absolutely. It is important since we agree on significant areas of policy. But we have a profound disagreement on spending policies, particularly on pensions, where (there) is a tendency in parties not likely themselves to be in government to promise more than they can afford."

After describing Romsey as "a truly disastrous result for the Tories", he said that it was "a tribute to Charles Kennedy's leadership because he showed courage in taking on the Tories". In face of strong party pressure to rule out proportional representation unequivocally, he said that the issue would be "decided at a later date. I have always made it clear that there is a case for looking at this."

We put to him the recent warning by Lord Jenkins of Hillhead, his friend and mentor, that great Prime Ministers make the weather and do not hide under an umbrella. Mr Blair accepted what Lord Jenkins had said. Emphasising that changes will take time to feed through, he said: "If you ask people within the health service, they will say there is a revolution going on. It is important in the second term to carry on driving through radical reform. In the first term, inevitably, you are laying the foundations, so it can still look like a building site. But the work is going on that allows you to make the construction.

"The fact that you have a big majority does not mean you do it in a hurry: it means you have the strength to get it right for the long term. We have reversed the pattern of past Labour Governments and most Tory Governments, we have been very tough, now we can make the investments the country needs. Once you

have sorted out public finances sustainably, you can make that investment year on year.

"What is important is to keep focused on the mission for the Government and to emphasise to people that we are in this for the long term. We recognise there is still a great deal to do. We have done a lot. It is not unknown for governments in mid-term to do badly in local elections. I do, of course, take the results seriously. The most important thing is, for the Government and me personally, to come out fighting for what we believe in and to have the confidence to say to people 'this is the long-term strategy', and to make the changes and reforms necessary to get there. There is no way that I will ever depart from what I believe in."

He admitted that "the most frustrating thing for me in politics, apart from the obvious difficulties and time it takes to get things done, is the claim that if you don't have convictions that are either 'old Left' or Tory, somehow you don't have convictions.

"I believe passionately in Labour as a modern, progressive, political party in the radical centre of British politics. This is where I am. That is where I will stay. That is what motivates me."

Refusing to be compartmentalised as either old Left or Tory, he stated his belief in "the goals of full employment, strong public services, the reduction of inequality and poverty. You cannot pursue those things at the expense of a strong economy.

"In the first two years we could have spent a large sum of money and not bothered so much about public finances. But, then, right now we would not be launching the biggest-ever investment in health. We would be cutting back."

Mr Blair said that the Government would have had an easier life if it had

Tony Blair, right, with *Times* journalists Peter Riddell, left, and Philip Webster
during the interview in Downing Street

avoided difficult decisions and ditched performance-related pay for teachers, and decided not to go ahead with literacy and numeracy tests "which were deeply unpopular at first".

He said: "We could have put all the money into the basic state pension, but then the poorest pensioners would not be better off. We decided rightly, in my view, to help them; now we have to move with the pensioners' credit to help those who are above benefit levels, the middle third of pensioners."

While expressing sympathy with manufacturing companies and exporters suffering from the strong pound, he firmly rejected any proposal for "artificially" reducing its value through direct action which would make the situation worse. He noted that sterling had hardly moved against the dollar or the yen and had risen just against the weak euro. He stuck to the often repeated official line that the Government was "in principle in favour of joining a successful euro", provided the economic conditions were met.

Mr Blair was dismissive of left-wing criticisms about his style of running the party. "I will never cease wanting a disciplined and coherent Labour Party. Of course, we should always try and learn the lessons and recognise that what we did in Wales made it far harder when we came to London.

"But it's important that we do not allow our strengths to be turned into weaknesses by our critics. A disciplined Labour Party is a good thing. A Labour Party whose annual conference is not a beanfeast for people to tear the party apart is a good thing. A Labour Party that is progressive and modern is a good thing. A Labour Party that is pro-business is a good thing. There will be people who want to turn those strengths into weaknesses: discipline becomes control freakery; well-run party conferences become suppressing debate; Labour pro-business becomes anti-working people. Of course, you can learn the lessons, but don't let us fall into what is a Tory trap."

Mr Blair described his party as "remarkably disciplined. I have never known the party to be more ideologically united." He pointed out that the person fighting for the public-private partnership in the Tube and air traffic control is John Prescott, the Deputy Prime Minister, "and he is doing it excellently with total conviction".

"People now understand that the notion of 'new Labour' is not to get rid of the Labour Party. It is to ensure that the Labour Party modernises the means to fulfil its essential ends and objectives."

Mr Blair claimed that Labour was "winning the argument about ideas. The Conservative Party has certain populist tones. But there is no intellectual argument coming from the Conservative Party. They are trying to make people cynical towards this Government. It is a strategy based around developing cynicism."

In answer to the charge that the Government was over-concerned with presentation, Mr Blair claimed that "we are infinitely more spun against than spinning" – to the evident approval of Alastair Campbell, his press spokesman, who was present during the interview.

Mr Blair then trotted through a list of the Government's achievements. Giving health as an example, he said: "We have done a lot but you don't transform the health service in three years. It is all very well to announce extra money, but people want to see that money take shape on the ground. I have several meetings every week about health service reform. They don't get publicity, but when we publish the proposals in July, people will see a really serious plan for the transformation of the health service."

While coy about the details, he added: "We are quite a long way down the road to preparing the next manifesto. People will find it radical and reforming. I will not move from the path of reform."

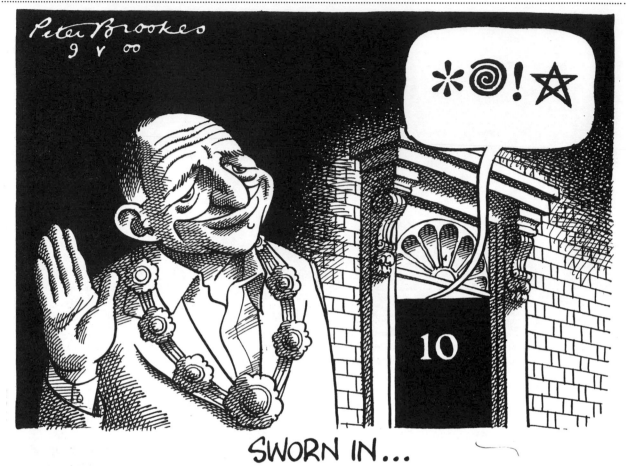

SWORN IN...

Cheat of the Week
Henry Harris

LAMBS' TESTICLES are a doddle to prepare. The trick is to ensure that they are soaked in salt-laden water for at least two hours. This draws out any excess blood and bitterness, leaving a cleaner flavour.

If you live in the country, order some from your local butcher or, in town, from an halal butcher – they are very popular in Muslim countries.

Lambs' Testicles

8 lambs' testicles	
Salt	
300ml lamb stock	
A generous pinch of saffron strands	
Plain flour	
Extra-virgin olive oil	
2tbsp finely chopped shallot	
2 cloves of garlic, finely chopped	
1 small red chilli, chopped	
2tbsp capers, rinsed	
Juice of one lemon	
1tbsp chopped fresh mint	
1tbsp chopped fresh coriander	

In each testicle make a small incision through the outer membrane and cut along the length. Slowly and carefully peel away the outer membrane and discard it. Place in a large bowl of cold water, add two tablespoons of salt, stir to dissolve and leave for two hours. Drain, rinse and pat dry.

Heat the lamb stock with the saffron and set aside. Heat a splash of olive oil in a large frying pan. Season the testicles and roll them through the flour. Fry them briskly on both sides until browned, add the shallot, garlic, chilli and capers and cook for a further minute. Pour in the stock and a splash of the lemon juice, bring it up to a gentle simmer and cook for another 15 minutes, turning frequently. If the liquid reduces too much then add a splash of water.

Finally add the two herbs, check the seasoning and serve. A little couscous makes a nice garnish and is ideal to soak up the juices in place of bread.

Henry Harris is head chef at Hush, Mayfair, W1

MICROSWOT MOLESWORTH

Who do new Labour think they are to blame us for cribbing?

Chizz! Chizz! Mouldy Cheddar!!! Why duz the guverment think that they can punish us pore skool boys for using the Internet? I do not suppose that you have read the rest of today's paper before turning, as always, first to the third leader, hem-hem. But in the nuse pages you can read a shocking story by that noble brave fearless heroic investigative etc. mole, David Charter.

Master Charter has uncovered a dastardly plot to stop us pore boys using the Internet for our prep. We used to take our essays out of the encyclopeedias, borrowing alternate sentences from Britannica and Chambers. Even new bugs kno about copying the principle parts of Latin irreglar verbs onto their thumbnails as skolarly ades. At my sister's skool, Saint Crumpet's, the girls carry such examination aids in their nickers, where no proodent examiner dare think of looking these days.

But the Internet has made all our lives easier. Now there are websites offering essays on all topiks and for all grades of pupl. All you have to do is call up the subject of your essay, and select a grade above what Old Chalky would expect you to score. Then you cut and paste it out, which is much quicker, easier and more accurate than copying it out in blotchy ink. There is a noble boy at Malvern who specherlises in such aids to skolership. I expect he hops to be bought out for ZILLIONS by some dot-com interpreneur.

And Old Chalky sez well done molesworth. very commendable, considering that it is you. i did not kno you had it in you. And beastly swots and uter weeds like fotherington-tomas who never crib stand as if amazed. In the world in cyberspace in the universe there is no better xsample of a goody-goody who rites his own projects with-

out "reserch" than fotherington-tomas.

And now Michael Wills, the teknology minister, is giving skools advice on how to beat what he calls the internet cheats. There is a devious Headmaster in Plymouth who has invented a way to detect us who are wizzbang computerwise. He has a Cribcheck to measure your essay against your customary style of speling, gramer, etc. And he has another programme that deleets every 10th word in your essay. He then invites you to fill in the gaps. I mean to say. How sneaky can you get?

But they will not beat us. What bizness is it of new Labour to complain about anyone borrowing the best ideas he can find? Exams have always been a game of bluff and fumble. How do you suppose that all those prime ministers with names in gold on the honours' boards of St Custard's got there without a bit of free enterprise? Up skool, up skool. Floreat eyeturnum.

Voters needed a PhD to work out the form

I THOUGHT I would pop along to my local polling station on the way to work yesterday and vote for a London Mayor. It was more like taking a 14-hour calculus exam. I actually heard a senior citizen whimpering in the next booth.

There were two voting "slips", big enough to cover the average bay

window, and the returning officers were gamely trying to explain how it all worked. "Well, first there's the mayor vote. This is very simple. You have two votes, one for a first choice, one for a second choice. You don't have to vote twice, but if you do, don't vote twice for the same candidate. And if you don't, make sure you put your vote in the first column."

One elderly woman, pushing a pram full of doilies and table napkins, walked out. "I'm going for a cup of tea," she said. "I need to think a bit." The presiding officer continued: "Then

there is the election for the local constituency member, and a vote for the London member."

"Oh dear, it's not your fault, I'm sure," Anthony Boulay, in his mid-50s, said to the officer. "I've got the mayor bit. But the rest of it, well, I haven't the foggiest what I'm meant to do."

Then Peggy Jolly, 71, emerged, paler than before. "It's very confusing, especially when you're getting on a bit," she said. "What's that radio station you put on when you can't sleep? LBC, that's it. I was listening at 4am. Lots of people were saying they couldn't

understand it at all."

Doris, 76, said: "A lot of the older people won't get it. Our brains don't work that quick. But I do a lot of crosswords, which I think help. I'd like the Mayor to make it simpler."

Robert Beeston, 24, said: "It was clear and simple." He is just finishing a PhD in electronic materials at Imperial College. Lucky blighter.

Tim Reid

A guide to voting in London on May 4

Voting for the Mayor
All London will be treated as one constituency.

You have two votes, for a first and second choice. You need not give a second choice but if you do not, be sure to put your vote in the first choice column. You cannot vote twice for the same candidate.

If one candidate wins more than half the first choice votes he or she becomes mayor. If no candidate wins more than half the first choice votes the two candidates with the most first choice votes remain in the election, with their second choice votes added to their scores. The candidate with the most first and second choice votes becomes mayor.

Voting for the Assembly
London will be divided into 14 constituencies, each covering 2-3 London boroughs. There will be one member for each of the 14 constituencies, topped up by 11 London members.

You have two votes, one for the person you wish to represent your constituency and another for a London member. The constituency ballot paper names candidates and party if they have one. The person with the most votes wins.

The second vote will determine how the 11 London member seats in the full 25-seat assembly will be shared out. The name of the party and independent candidates will be listed. The 11 seats will be distributed in proportion to the votes received.

King Ken tries hard not to let his crown slip

Giles Coren

TONY BLAIR'S wildest dreams came true yesterday when Ken Livingstone was carted off by the police within minutes of becoming London Mayor. Was it his advocacy of direct action that had the rozzers bundling him into the back of the Maria? Was it the loose statements about the Holocaust? Or was it, perhaps, the fact that the naughty man had gone back on his word about not standing as an Independent?

No, it was for his own protection from a press pack that had not slept for 30-odd hours. Deprived of the promised 2am declaration because of fluff-clogged computers and a machine that fell off a table in Enfield, scores of journalists had loitered through the night until they were tense, overtired and excitable. Frank Dobson was jostled almost to the floor when he arrived and immediately went into hiding.

For hours, after the principal players had retired for a kip, the pack had been fed on such feeble prey as were offered by the more minor candidates. There were two pretty Green girls in short green skirts attracting far more attention than their purely political accomplishments seemed to merit. There were the scarily serene candidates for the Christian People's Alliance. There was Peter Tatchell in his sandals, standing uncomfortably close to two lugubrious heavies from the BNP, dressed in black, chewing gum and apparently playing a game that involved using only words that began with "f". In the background, Geoffrey Clements, of the Natural Law (Yogic Flying) Party, hovered beatifically in his white suit.

As the hours dragged on, tiredness brought on intermittent hallucinations, featuring visions of a world in which one of the above slipped through the net and was elected mayor. Or perhaps a composite candidate generated by all of them. After all, there is not much to choose between the Ken Livingstone of

Labour Party propaganda and a gay, vegan Nazi on a flying bicycle.

Emerging into the Westminster sunshine to face the horde, the man who promised that his election would guarantee improved weather for London looked up at the cobalt sky as if to say: "There's one election pledge delivered already."

His first act as mayor was to sign an autograph at the roadside for John Bird, 67, a retired RAF man from Faringdon in Oxfordshire, who had cycled up to the crowd to see what all the fuss was about. But that was the last contact that Ken had with the public. Thereafter, he disappeared into the ruck of hacks and cameras, the police battled to keep them off and then tossed him into the car.

Ken roared off with sirens screaming and his words of acceptance still ringing in our ears: "I pledge you my work, and I go from this count to start that job

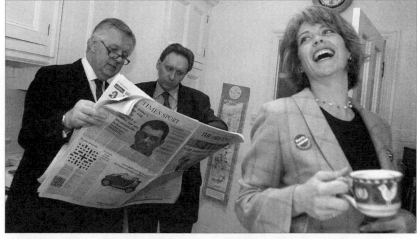

this afternoon in the new building at Romney Road." If it resonates more strongly than it should, it is because these portentous, martyr-like words are faintly reminiscent of Dickens's Sidney Carton, another hero who sacrificed himself for his principles. "It is a far better place to which I go, than I have ever known," is what Ken really meant, and there is no doubt that those with bad memories of the GLC will hope that he does far, far better things than he has ever done. This is only the beginning of *A Tale of One City*, but Ken knows that already his head is – more than ever – on the block.

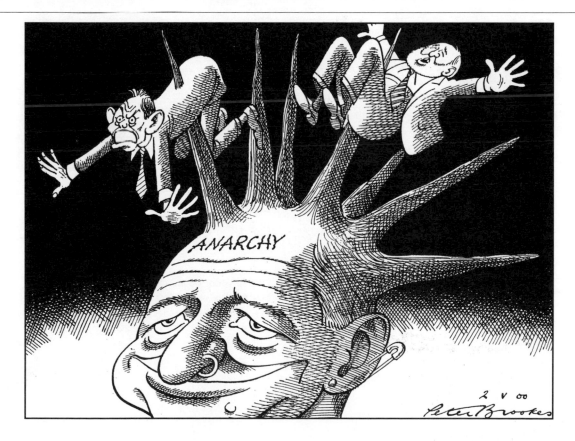

THE TEST
Nicky Gavron

Public image

Quango queen and Tony crony whose public profile is about to rocket. Her mission, should she choose to accept it, is to be deputy to the new London Mayor, Ken Livingstone, and act as a "mediator" between Red Ken and Downing Street. Suddenly Senator George Mitchell's job looks strangely attractive. **9/10**

Intelligence

Perplexing. Ms Gavron, Labour member for Enfield and Harrow on the GLA, sits on 16 – yes, 16 – government groups, presumably because she wants to. If the woman wants a hobby, what's so wrong with basket weaving? **7/10**

Compassion

We must give her bucket loads. Being deputy to Ken must surely rank alongside carrying Margaret Thatcher's handbag or trying to corner a very loose cannon. **10/10**

Sex appeal

Appeals to posh and plebs alike. On the ballot paper she described herself as "GAVRON Felicia Nicolette (Known as 'Nicky')". But there are those who might say being Ken's deputy is about as sexy as a slap in the face with a wet newt. **6/10**

Humour

As chair of the London Planning Advisory Committee, she once described her experience on a delayed train thus: "The guard announced 'We are sorry for this further delay, but the driver is having a ...' The guard apparently had second thoughts about finishing the sentence. In my compartment, the suggestions were a cup of tea, a nervous breakdown, a c*** and 'all three'." **7/10**

Family values

Formerly married to the millionaire Labour peer and ex-chairman of the Guardian Media Group, Bob Gavron. They had two daughters before divorcing. Lord Gavron has donated £500,000 to the Labour Party, which makes his ex-wife's £51,743 salary as deputy mayor look like budgie feed. **9/10**

Antecedents

After 30 years in London politics, we can assume paperwork, meetings, briefings, forums, caucuses, executives, paperwork, meetings, briefings, briefings, paperwork. **2/10**

Durability

Apparently invincible. She has worked in politics for longer than some Blair babes have been alive and seems to have avoided making enemies. During the dark days of the mayoral campaign, she managed to stay true to new Labour while keeping communication lines open with Ken. A clever political survivor. **10/10**

Ambition

Totally driven and 100 per cent committed to politics. A dark horse to succeed Ken in four years' time? **9/10**

Future prospects

May prove one of Blair's most important allies but if she is to act as a peacekeeper between Ken and Tony, must learn to look stylish wearing a tin hat. **8/10**

Examiner:
Carol Midgley

Score
77%

The new Tate Modern gallery on London's Bankside is illuminated to mark its opening

The office secret of Bridget Jones

THE SECRET of an office's unusually classy "work experience girl" was revealed yesterday. She was a Hollywood actress working undercover to prepare for the part of the English heroine Bridget Jones.

Renee Zellweger, 31, spent 2½ weeks before Easter as a "dogsbody" in the London offices of a publisher before filming for *Bridget Jones' Diary*. Some of the older men in the office took quite a shine to the new girl, offering her advice on how to get into the books industry.

Unknown to them, the temporary employee – known in the office as Bridget Cavendish – was already quite successful in her own right. The actress's personal driver would take her to work for 9.30am and collect her at 5.30pm every day. For lunch, she was whisked away to expensive restaurants where she would eat hearty meals in order to put on weight to play Helen Fielding's calorie-counting character.

The carefully planned ruse was almost exposed when it fell to her to get a cake for a colleague's leaving party. She arrived back at the office with £100-worth of hand-made tarts from a Soho patisserie.

The actress, a Texan, starred alongside Tom Cruise in *Jerry Maguire*, but has been trying to acquire the right English accent. "I'm trying to familiarise myself with the culture," she said yesterday in Cannes. In the book, Bridget Jones is a publicist. "I feel a very strong responsibility to make sure she's as truly British as I can make her."

She tried to copy the inflections of Camilla Elworthy, the head of publicity at Picador, the only person in the office in on the secret. Ms Elworthy said: "Nobody knew. We often have people doing work experience, so that was the story. No one missed her at

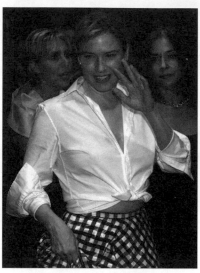

Office mole: Renée Zellweger

lunchtime because work experience girls don't usually go out for lunch with people who work here."

Lucy Henson, head of publicity at Pan, who shared the same open-plan office, said: "I kept thinking, she sounds exactly like Camilla, despite being American. It kept throwing me. She was prettier and had nicer clothes than most work experience people but I didn't really think about it." In the book, Bridget wears skirts which graze her bottom, and layers of mascara.

But Zellweger, who was a waitress in a topless bar before she made it in films, and is dating the American actor Jim Carrey, opted for casual clothes and no make-up. "She was making an effort to dress down," said Ms Elworthy.

She made cups of coffee, photocopied, answered the telephone and rang literary agents with word of new publications. Ms Elworthy added: "Imagine how it felt to get a Hollywood actress to do your photocopying."

Alex O'Connell

Beckham a temple idol

A SCULPTOR in Thailand has taken football idolatry to new heights by producing a gold-plated statue of David Beckham, the Manchester United midfielder, for a Buddhist temple in Bangkok.

The foot-high effigy stands at the base of a huge Buddha effigy in the city's Pariwas temple, beside dozens of other minor deities in a spot normally reserved for angels.

The statue is the work of Jumnong Yantaphant, an avid United fan whose previous creations have depicted politicians and cowboys. He was paid £15,200 by the temple, whose commission specified merely "something modern".

It appears that when the statue was delivered, the monks did not recognise the subject, despite such authentic touches as Beckham's previous floppy hairstyle.

Visitors have complained that the image is disrespectful to Buddhism. But unabashed, the abbot, Chan Theerapunyo, has sprung to the statue's defence, saying: "Football has become a religion with millions of followers. So to keep up with the times, we have to open our minds."

The issue is unlikely to rest there. Officials at the Government's Religious Affairs Department plan to send an official to inspect the statue and ascertain its suitability for a place of worship. An official said: "This is a sensitive matter."

The Pariwas temple is no stranger to controversy. The walls are adorned with several paintings on distinctly non-religious themes, including one of a scantily dressed woman hugging a boyfriend.

Manchester United have a large and enthusiastic following in Thailand, as they do in most of Asia.

Simon Ingram

Happy to be a loser for Britain

Our Eurovision entry wasn't called *Don't Play That Song Again* by mistake

David Sinclair

DOES ANYONE remember an episode of TV's *Father Ted* in which the clueless cleric was commissioned to write and perform the Irish entry for the Eurovision Song Contest? The idea was that having won the competition four times in the previous five years, Ireland simply couldn't afford to stage another Eurovision show (a duty which falls to the winning nation each year), and was thus prepared to go to any lengths to ensure that it did not walk off with the damn prize yet again. Father Ted's offering, a meandering ditty called *My Lovely Horse*, was more than equal to the task – a composition of such extreme inanity that even the voters in this annual jamboree of poor taste and musical mediocrity proved unwilling to choose it as the winning entry.

Having watched the real Eurovision Song Contest last weekend, I think the writers of *Father Ted* were on to something. For, in a show that journeyed beyond the furthest shores of satire, it gradually became evident that not only Ireland, but all the countries that have won the competition in recent years were actually trying their best not to do so again. What other logical explanation could there be for the Israeli entry, a song called *Happy* performed in Hebrew by a group of malnourished girls known as Ping Pong? Jumping out of time, running out of breath and singing out of tune, they represented their country with a performance of such surpassing ineptitude that Israel – whose trans-sexual diva Dana International won the competition only two years ago – was this time able to claim a safe berth at No 22 (out of 24) in the final countdown.

Similarly, last year's winner (and therefore this year's host), Sweden, was clearly in no great hurry to incur another ant-like invasion of its capital city by an unruly cavalcade of TV crews, showbiz journalists and Jonathan King wannabes. Its entry, *Spirits Are Calling My Name*, featured a bizarre trio of cross-dressers in Viking, Eskimo and Native American regalia performing a shambolic war dance that made the routines of the Village People seem as graceful as Swan Lake. Amid billowing smoke effects and roaring columns of flame, their goose was well and truly cooked as they cruised to a relatively safe No7.

The UK, which last won in 1997, was likewise taking no chances this time. *Don't Play That Song Again* pleaded Nikki French, whose East Croydon hausfrau outfit chimed perfectly with a performance of unbelievable naffness. Even the dimmest voters couldn't fail to get that message, and the UK landed with a reassuring bump at No 16, our lowest-ever ranking. While conspiracy theories have never been my bag, to suggest that the country which produced the Beatles could not have come up with something better than that simply beggars belief. There has to be more to it.

The idea of groups making records that are not designed to be successful is, of course, nothing new. When the Rolling Stones were forced to supply one final single in order to fulfil the terms of their recording contract with Decca in 1970, the resulting *Cocksucker Blues* was never likely to provide much work for chart statisticians. And Prince, who famously spent his last months with Warner Bros at loggerheads with his tyrannical paymasters, delivered a last album in 1996 called *Chaos and Disorder* that was so true to its name that his career has never fully recovered. Monty Python's Flying Circus helpfully identified the syndrome with their *Contractual Obligation Album*, released in 1980. Ironically, it became the most successful of their recording career, and you don't have to be Margarita Pracatan to appreciate the fine line between abject failure and cult acclaim.

A similar theme was explored in the Mel Brooks movie, *The Producers*, in which a pair of crooked entrepreneurs plan to stage a Broadway musical that they make sure will flop on the first night, leaving them free to pocket all the money from the investors. The wheeze is rumbled, however, when the resulting show, *Springtime For Hitler*, turns out to be a roaring success.

Something similar almost happened to Germany's entry in the Eurovision contest, *Wadde Hadde Dudde Da*, a preposterous conflation of the Spice Girls' song *Say You'll Be There* and *Wham! Rap*, performed by a bunch of preening wallies dressed in gold lamé jumpsuits and cowboy hats. It was such an obvious and over-the top send-up of the whole sorry affair that the voters responded to the humour and integrity of the performance and rewarded them with a final placing at No 5, presumably a little too close to the top for comfort.

Still, the iron law of statistics dictates that out of the 24 entrants, 23 will be losers, and in Eurovision as in life, a miss is as good as a mile. The runner-up slots of Nos 2, 3 and 4 were occupied by a cluster of former Eastern bloc countries – Russia, Latvia and Estonia – who, never having won the competition before, were still playing it straight.

That said, who would have thought that the eventual winners would be Denmark's answer to Chas and Dave? Swept along on a tide of popular approval, including a full 12 points awarded by their local arch-enemies, Sweden, the two old geezers known as the Olsen Brothers lifted the poisoned chalice with what looked suspiciously like tears in their eyes.

Next stop, Copenhagen.

She was born to make us happy

For £15 you can enjoy Britney all night long – and still have change for a Big Mac and twirly fries

Barbara Ellen

FIRST, A ROUND of applause for the shameless two-page schmooze-athon in the sleeve notes of the new Britney Spears record, *Oops! ... I Did It Again* (Jive 9220392). Nestling towards the end of the very long list of people whom Britney loves and respects beyond all reason are MTV and Pop Radio. "Where would I be without you?" coos Britney, with good reason, particularly in regard to MTV.

Much more so than her pop heroine, Madonna, Britney, or Britney Inc to use her full name, owes a lot of her success to the fact that she looks the teen-queen part, but has a mind like a middle-aged businesswoman who knows what she wants (fame) and doesn't much care how she gets it.

Never mind all the acres of press devoted to whether Britney has had breast implants, the real question is whether the 18-year-old is the result of a gene-splicing experiment employing the DNA of Hillary Clinton and Debbie Gibson, or a scheme Billie Piper and Eva Péron might have hatched. If Britney isn't any of these things, then whence came this cute pop cookie with the backbone of steel who, after just one single, passed into one-name legend à la Madonna and Whitney? What people forget is that Britney Spears is nothing if not "on purpose". Before Britney ruled, Britney was smart enough – bonkers enough – to want to rule.

In such circumstances, the music becomes almost immaterial. However entertaining Britney is, and she is wildly entertaining, you only have to watch her move, listen to her sing, recoil from her more outlandish "sexy" grunts (a cross between a possessed Linda Blair in *The Exorcist* and peak-period Jimmy Connors) to know that she doesn't give a cheerleader's pom-pom about music. Which isn't to say that Britney's music

is worthless. Passionless, heartless, soulless, and humourless, yes, but worthless? No. Personally, I like Britney, precisely because she makes so few emotional demands on the listener. Her music is just there – just another slice of the great American pie eternally cooling on the sill of popular culture. Trying to analyse it further would be like writing a restaurant review about a stick of chewing gum – doubly so because Britney doesn't even write her own material.

On *Oops*, Britney has only a "co-writing" credit for *Dear Diary*. And what pigtail twirling dross it is. It makes you wonder who the "co-writers" are (the cast of *Dawson's Creek*? *The Smurfs*?). It is also Exhibit A in the case for Britney actively and cynically searching out the dirty old man vote.

However vile this thought is, and however worrying her choice of schoolgirl costume was for *Baby, One More Time*, it serves us well to remember that dirty old men existed long before Britney Spears appeared. What's more, in my opinion, Britney, although genuinely young, has always seemed too old (hard, ambitious) to capture the rainmac pound. Which could be why Britney insisted on wearing the kinky schoolgirl kit in the first place. Without a gymslip, Britney resembles Olivia Newton John's Mum.

The rest of *Oops!* turns out to be exactly what you'd expect from Britney Spears's second album. Sadly, there are no truly iconic, era-defining moments, such as at the start of Baby ("Ooh (groan, slurp), baybay, baybay" etc).

Nevertheless, there are a few really nice, infectious pop tracks that twine

around your mind and heart before you know it like fast-growing poison ivy. The title track, *Stronger*, *Can't Make You Love Me*, and my personal favourite, *One Kiss From You*, are all good. The hiccuping, panting cover of the Stones' *Satisfaction* is at once risible and unmissable. A ballad called *When Your Eyes Say It* should make young girls chew their pencils and swoon all the way through double physics about the zitty boy of their dreams.

Even odder than the cover of *Satisfaction*, though not as funny, is *Girl In the Mirror*, which sounds like Britney enjoying a folky philosophical cappuccino with Suzanne Vega.

Presumably, this last track was included to show off Britney's "range", but she needn't have bothered. Range can come later, maybe after Britney's failed movie career. What movie career, you might ask? Well, narrative tracks such as the Grease-esque *Lucky* show that Britney badly wants to be in the movies, and what Britney wants, Britney usually gets.

For now, Britney Spears is the perfectly pitched millennial pop dream. A moderately talented, magnetically attractive, shamelessly corporate stage school brat.

Meanwhile, old men want to drool over Britney (and worse), younger men delude themselves they're in with a shot, and little girls want to be her when they grow up. What those little girls don't realise is that ambitious hardbodies such as Britney were born grown-up, that they popped out of the womb slick, ready, and hungry for fame. It's ironic really, considering that Ms Spears is a former Mouseketeer, but no one could ever dismiss Britney Inc as a Mickey Mouse operation.

Football and its ugly fans must be sent off

Simon Jenkins

ONE QUESTION baffles me. What possessed the citizens of Copenhagen even to contemplate hosting that ceremony of ritual hooliganism, the Uefa Cup final? What entered their minds when the city fathers cried, "Great news, we've got the Arsenal-Galatasaray match"? Not since the days of Helga the Grim and Gorm the Old has the Viking city's fate seemed more certain. The drunken, punching, vomiting, foul-mouthed Berserks that pass for English football fans unleashed their predictable mayhem. Next month they will move to the so-called European championships at Charleroi and Eindhoven, and behave in the same way. The media will follow. Why cover an ineffably tedious penalty shoot-out when you can transmit a real-time, on-screen fight?

The answer to my question is, as always, follow the money. The answer is greed. The Danes are as vulnerable to the dominant ethic of modern football as is football's ruling officialdom. They want the cash. They knew perfectly well that a thousand Arsenal fans are not going to sit in Tivoli Gardens swapping Hans Christian Andersen stories with the natives and debating Kierkegaard. They will get drunk and look for a fight, as will their Turkish foes. They will carry knives and there will be dead or injured. But their wallets will be full. So the Danes will not be sensible and warn other tourists and close every bar, let alone turn back drunken football supporters at the airport. Nor will they cancel the match or tell the two teams they can kick penalties together on an island in Jutland. Like cities throughout Europe, they will rush to their tills and count the money.

I used to think that the violence associated with soccer had to do with its numbskull scoring system. Any sport that can call a nil-all draw "thrilling" and a one-nil lead "crushing", let alone decide contests by the luck of penalties, is vulnerable to constant accusations of unfairness. While a low-score system may give matches a sense of the unexpected, it breeds injustice among the defeated. The number of goals scored in world championships continues to fall each year. The frustration of players and spectators must be rising. Since big money raises the commercial stakes, the frustration is fuelled by greed.

Yet even this cannot explain the riots that precede as well as follow so many international matches. It may seem unfair on other supporters to be tarred with the brush of hooliganism. But that is like opposing gun laws for being unfair to honest gun owners. Hooligans have attached themselves to soccer and soccer must ask itself why. Soccer refuses to institute a scoring system less vulnerable to luck. Soccer proliferates championships in its restless search for profit. Soccer diminishes community pride in clubs by allowing them to hire mercenary armies of foreigners. Boxing and wrestling are no less popular, violent or working-class. Yet they are not attended by street riots.

Football violence has been studied to exhaustion. We are told that it is a classic of "risk displacement theory". Body chemistry demands that we push ourselves to a certain threshold of danger. This may take many forms. Some people eat shellfish, drive too fast or ski off piste. Some climb mountains or indulge in high-risk sex. This "danger thermostat" is often adjusted when people go abroad. Tourists accept standards of health and safety which they would never tolerate at home. They eat in Mexican restaurants, drive on Spanish roads and do unmentionable things in Thailand.

Most of these risks affect only ourselves. Football violence is different. Those with a yen for a punch-up that must be suppressed at home can find in an overseas football match an ideal venue to get drunk and have a fight. This violence is a curse on communities, towns and nations. We may ridicule the American gun lobby when it claims that "guns don't kill people, people do". Equally thin is the argument, adumbrated by the Football Association, that football matches do not cause hooliganism, hooligans do.

Something about football fixtures is clearly conducive to collective violence. Load an English football match with money and point it at any European city and you can nowadays be sure that streets will be smashed, heads broken, police assaulted and the nation's reputation smeared. Some football journalists yesterday had the gall to blame the Danish police and thugs who were nothing to do with football. They will apparently blame anyone rather than impugn the goddess football in her Parthenon. Her reputation must be spotless.

International football is a global industry that gives pleasure to some but, in doing so, seriously pollutes its immediate environment. As during the 1998 World Cup in France, it magnetises large crowds who roam distant cities in search of excitement. Some find it from the game. Others behave like medieval bandits, tearing up streets, terrifying people, showering some with money and others with blood. Football clubs are misnamed. They are businesses. Their assets are expensive players acquired from across the globe and owing no particular loyalty to the town or city where the club is located. They used to be called "scratch teams". They are mercenaries assembled each year ad hoc to make money for shareholders.

Were this any other industry it would be ruthlessly regulated. Its so-called fans would be treated not as tourists

entitled to the normal courtesies of international travel. They would be treated as part of the product, many of them causing the most noxious effluent. These people are sold tickets by a cartel of clubs who know well that they will commit acts of violence abroad. That the clubs should seek to pass the buck to the police or "society" is absurd.

The polluter must be curbed. There is talk that Copenhagen will refuse to host any further international football matches. Perhaps all Europe's cities should agree to this. At least the rest of us might be given a break from this pollution, as used to be the case, during the close season from May to September. The alternative is to treat international soccer as no longer a spectator sport. If the big money is in television rights, why not hold matches behind closed doors and broadcast them on television? If the absence of a crowd makes for bad viewing, then technology can supply virtual audiences, as it does for sitcoms. Fans can be seen as a backdrop, gasping and roaring their obscenities with the

flow of play. Or have the penalty shoot-outs before the game, leaving the players to enjoy a friendly kickabout in a spirit of genuine sport.

The best news yesterday was that the behaviour of British soccer hooligans may jeopardise Britain's hopes of hosting the 2006 World Cup. This is a silver lining to the Copenhagen cloud. The 2006 World Cup should go to South Africa, as far from Europe as possible. Why any British city should want to stage these matches, and police their riots, passes comprehension. Yesterday the BBC gave free publicity to "ordinary Arsenal fans" to declare that they were "delighted at the way the Turkish animals were beaten up" in Copenhagen. This is the sort of welcome that British soccer now offers the world. It is appalling and I would like no part of it.

Soccer apologists glory in the language of tribalism. They rightly point out that love of the game has always bred fierce loyalty. In the 1920s, Arsenal and Spurs fans met on the

streets of London each Saturday with knives and iron bars. Referees regularly needed police protection. The Jean-Paul Sartre of the golden turf, Eric Cantona, eulogises the English game for its raw machismo. To such theorists, if a man cannot go to war or fight bare-knuckle or buy beef-on-the-bone, he can at least scream racist abuse on a Saturday afternoon at Highbury. He can kick a Mancunian in the groin and stab a Turk. He will even get on television for doing so. Football gives him the cover, the excuse.

I have a solution. There is a small oasis near the Saharan resort of Tozeur in Tunisia. It has an international airstrip and a small football ground which could be equipped with television facilities. It would be an ideal place for all future European fixtures. Nobody is around to get hurt. Fans can fly in direct from their drinking haunts and bake in the sun. The sand will soak up their vomit and their blood. The rest of us can be left in peace.

Now, back to the cricket.

All God's creatures

From Dr J. A. D. Ewart

Sir, Are, say, dogs and cats Christian? I ask because the media love to state the obvious with the politically correct "Christian people" instead of "Christians".

Yours faithfully,
J. A. D. EWART,
Delgany,
Solesbridge Lane,
Chorleywood,
Rickmansworth,
Hertfordshire WD3 5SW.
May 4.

From Mr Colin McKelvie

Sir, Dr J. A. D. Ewart (letter, May 5) queries the Christian status of animals. The Roman Catholic countryfolk of my Irish childhood were in no doubt. On calling at a stranger's house, their conventional salutation was: "God bless all here, saving the dog and the cat" – the implication being that, having no souls, the animals were not candidates for divine blessing and that it would be blasphemous or heretical to wish it upon them.

Of course, St Francis of Assisi and the many obscure Celtic saints, who were so devoted to all creatures great and small, might have had a different view, as do those of us who hope to be reunited with our much-loved pets on the far side of the River Styx.

I remain, Sir, etc,
COLIN McKELVIE,

Tundergarth House,
Lockerbie,
Dumfriesshire DG11 2PU.
May 5.
From Mr Mike Lawlor

Sir, My Yorkshire terrier, Max, exhibits that ultimate Christian precept, namely that of being non-judgmental of the sins of others.

As many Christian people appear to be far more intolerant than Max, I must conclude that he is, indeed, a Christian. It is hard to say whether he is Episcopalian, Dissenter or Papist. I suspect that he may be Quaker, due to his silence on matters of dogma.

Yours sincerely,
MIKE LAWLOR,
1 Old Chiswick Yard,
Pumping Station Road,
Chiswick W4 2SN.
May 5.

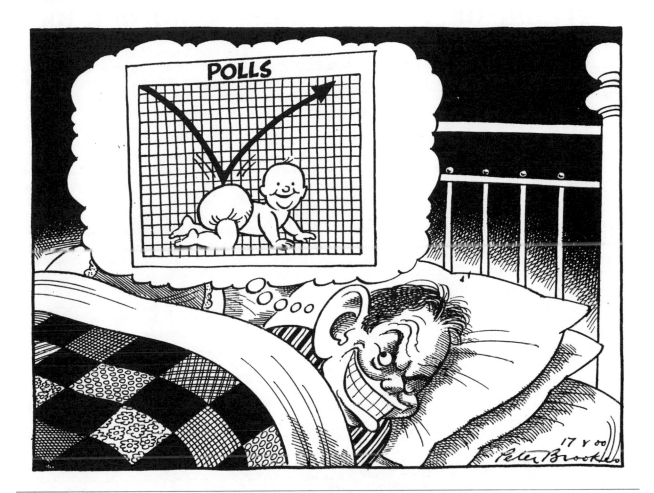

From Dr Michael F. Hopkinson

Sir, My great aunt's black labrador, Wallace, attended Mass daily (letters, May 5 and 9), reposing silently at the back of church until it was time to accompany his owner home. As this was in pre-Vatican II days, when the rite was in (dog) Latin and no responses were required from the congregation, it would be difficult to prove that he was not participating in his own way in the service.

Yours, in the true faith,
MICHAEL F. HOPKINSON,
204 Stockton Lane,
York YO31 1EY.
May 11.

Can't find the time, can't do the crime

JACK STRAW is a very smart man indeed. He has realised that crime, like writing, is a vocation, not a job. Because of this you do not have to lock villains up for long spells at a time, but can combat crime equally effectively by making them go to prison every day, from nine to five. Ideally by Tube.

As any aspiring novelist who has tried to spend time on his *meisterwerk* in the interstices between sleep and work will know, this will scupper any plans for extra-curricular activity.

Burglars meeting each other at cocktail parties will say, "Hello, Lefty, what are you up to these days?" and Lefty will reply: "Well, Fingers, you know how it is. I've been trying to work on my bank raid for months but I just can't seem to find the time. You come in from chokey, knackered, and the last thing you feel like doing is sitting down and planning a robbery.

"I don't know, sometimes I think I should jack it all in and move to a little place in the country so I can finally get it done."

Giles Coren

Heritage of secrets and lies – murder, too

BABY BLAIR'S family tree reveals two murderers, a family of pro-slavery campaigners, a convict, a deserter, five drunks, 11 infamous actors – and a family secret.

Cherie's side of the family must take the lion's share of the blame for this rogues' gallery. The worst Booth was Leo's maternal great-great-great-great-grandfather's brother's son, the most notorious assassin in American history. John Wilkes Booth, who was also a famous actor, murdered Abraham Lincoln in a theatre in 1865.

A member of a celebrated acting dynasty, he was also a drunk and a womaniser who seduced most of his leading ladies – one of whom slashed him in the face with a knife when he refused to marry her.

He was the son of Junius Brutus Booth, a notorious British actor and drunk, and Mary Ann Holmes, a London flower girl. The couple emigrated to America in 1821 and had 11 children. They were slave owners and campaigned for the trade to continue.

In 1912 his young nephew, Junius Brutus Booth III, depressed by his failure as an actor, killed his wife, Florence, and committed suicide.

Other notorious Booths include Leo's great-great-grandfather, Sidney Booth, jailed in the First World War as a pacifist, his great-grandmother's father, Robert Thomson, a deserter in the same war, and his grandfather, Tony Booth, famous for his acting, drinking and womanising – he has seven daughters, including Cherie, from two marriages and two other relationships.

The Blair family tree, while less eventful, is no less intriguing because of a family secret that was only recently revealed to Tony Blair himself. The secret, closely guarded by the Prime Minister's paternal grandmother, Mary Blair, was that the Blair name entered the family via a fostering.

Mr Blair's father, Leo, was fostered in 1925, when he was three months old, by a Glasgow shiprigger and his wife, James and Mary Blair. His parents were travelling variety artists, Charles Parsons and Celia Ridgeway. When they tried to reclaim him, Mrs Blair, who had already had two miscarriages, was determined to keep him.

She threatened to kill herself and barricaded herself inside their tenement home in Govan when they came to get him. She finally wrote to them during the Second World War to say that he was missing, presumed killed in action. When their Christmas cards and presents stopped, Leo concluded they had forgotten him.

In 1948 he changed his name by deed poll to Blair but kept Charles and Lynton – his father's stage name – as his middle names. He passed the names on to his son Tony, but never revealed their origin.

Leo Blair discovered the reason why his parents lost touch only when he met one of his half-sisters after a newspaper revealed her existence during Tony Blair's leadership campaign in 1994.

As Leo is to be brought up a Roman Catholic, it is appropriate that there have been no fewer than 13 Popes with the same name, though not all will be ideal role models.

It is fortunate that his parents did not follow the example of Leo the Great (d. 461), who believed that sex, even within marriage, was evil. In the 16th century, Leo XII reintroduced the Inquisition.

But it is Leo XIII (d. 1903) who is the most likely to influence him – he was a socialist who championed trade unions and social reform.

Laura Peek

THREE CENTURIES OF BLAIR-BOOTHS: ACTORS, LAWYERS, A PRIME MINISTER AND A PRESIDENTIAL ASSASSIN

Synchronised spinning isn't our cup of tea

Blair should know that using his family for political advantage is a mug's game

 Michael Gove

WHAT ON earth was Tony Blair drinking out of when he faced the cameras this weekend? No one would deny our newly sleep-deprived leader a draught of caffeine. Or indeed the real pleasure which the blessing of a child can give. But what possessed the Prime Minister to face a hundred clicking cameras and confide his private joy at becoming a father again while prominently holding a mug emblazoned with a picture of his children?

We may not yet have reached the stage where the readers of colour supplements are invited to send off £19.99 for their limited edition Blair baby coronation china set. But it's not for want of trying on Downing Street's part. Not only was the Prime Minister pictured with his mug, but his father, Leo Senior, also posed with a cuppa bearing the children's features. Coincidence? Only if you think it's a thousand to one shot that the guy in the white robes in the Vatican could be a Roman Catholic. The appearance of those mugs was as free-wheelingly spontaneous as a dance routine by Steps. It was Olympic Gold Medal level synchronised spinning.

The conception of the Blair baby may have been a happy accident. And there is something particularly precious, especially in the youth-obsessed Britain of Martha Lane Fox and Billie Piper, in celebrating a forty-something mum giving birth. But the natural joy which many of us wanted to feel at the Blair family's good fortune has cooled like the coffee in the Downing Street mug. For what should be a private occasion has become more than just a carefully handled matter of public interest, it has become an exercise in political propaganda, a contribution to the cult of personality which breaks down the barriers between the personal and political to the detriment of both.

In retrospect, we can now see that Leo's gestation, birth and presentation to the world have been overseen with cynical precision. Shortly after the Prime Minister was informed of his wife's pregnancy, Mr Blair delivered a party conference speech in which he talked of his worries for his children and the differing fates which awaited two mythical

> ## The appearance of those mugs was as free-wheelingly spontaneous as a dance routine by Steps

babies born in adjacent beds in an NHS maternity unit. A subliminal message was being planted which was reinforced, weeks later, by the announcement of Mrs Blair's pregnancy.

The conference speech sought to establish, and the pregnancy announcement to reinforce, the link in the public mind between caring about children, "the kids" in Blair's own words, and caring about the future. Blair's own, renewed, fatherhood became a powerful metaphor for his simultaneous vulnerability and virility, his capacity to be both tough and tender. And, as ever with this Prime Minister, the playing of a role, the creation of a spectacle, was designed to distract attention from the faltering machinery behind the stage. Questions about "the year of delivery" were to be effaced by speculation about the most remarkable delivery in years.

There is nothing new in the manipulation of childbirth for political ends. Indeed, it is the precedents for such a practice which are the most disturbing aspect for democrats. Medieval monarchies used their children for dynastic advantage in a manner which was both cynical and romantic, both, as it were, tough and tender. The presentation by Edward I of his infant son to the people of Wales as their Prince was driven by the realpolitik of binding in a restive province, but designed as a piece of emotional theatre. The populace were to have their loyalty secured not by bread but circuses.

And so it is with the presentation of the Blair baby to the nation. Every aspect of the process is a conscious piece of ceremonial theatrics. From the choice of Mary McCartney as court photographer, a celebrity herself who knows something about dynastic magic, to the stately, gazetted, progress of the child from Downing Street to Chequers and thence to christening at Sedgefield, there are echoes of past monarchical splendours.

So it is no surprise that Mr Blair has chosen to use the birth of Leo to avoid Prime Minister's Questions this week. It is a perfect metaphor for what he hopes to achieve more broadly by this birth – the replacement of politics as normal with politics by gurgle. Just as medieval monarchs, and indeed any leader uncomfortable with the scrutiny of the people, sought to secure support by manipulation of image, icon and emotion rather than appeal by reason, so we now have approved photo portfolios, emblazoned mugs and the false intimacy of sleepless night anecdotes

rather than an adult conversation between Prime Minister and people in Parliament.

But, artful as this process has been, its contrivances are ultimately too transparent to inspire anything but cynicism. Mr Blair should ask Peter Mandelson about the latest addition to his household. When the Northern Ireland Secretary acquired a dog it could have been a humanising touch. But Mr Mandelson spoilt it when he chose to name his puppy Bobby. It was a self-conscious reminder of his intimacy with the Prime Minister, an evocation of the codename he was given during the Labour leadership election, when he was christened "Bobby" to Blair's John F. Kennedy. What sort of Government is this when even the dogs are on-message?

There is something more than arch and really quite alienating about the use of a pet to advance a political ambition. How much more so when it is children, albeit on a mug, who are used to similar effect. It can only, ultimately, harm both the integrity of the political process and of family life. I think I know what Tony Blair was really drinking from at the weekend. A poisoned chalice.

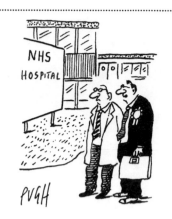

" GIVE IT TO ME STRAIGHT, DOC, HOW LONG HAS IT GOT ? "

Cynical spin or art of communication?

From Mr Colin Byrne

Sir, In claiming to detect cynical spin-doctoring (article, "Synchronised spinning isn't our cup of tea", May 23) behind Baby Blair, Michael Gove is simply exhibiting his own cynicism. It is a cynicism I have witnessed in political journalism over the past decade and a use of power without responsibility in a way no politician would be allowed to operate.

The term "spin-doctor" was imported from the US – by a political journalist in the 1980s at the same time that the Labour Party was professionalising its communications. Journalists, no longer able to freely distort and misrepresent Labour to voters, found a new target.

As Labour's Chief Press Officer and deputy to Communications Director Peter Mandelson, I witnessed this first-hand. It was much easier for many political journalists to write about trivia, personality and "spin" than to report on the battle that was taking place for the soul and future of Labour. Much easier to write up Mandelson as the "king of spin" than to accept the truth: that he only ever regarded communications as a means to an end – getting Labour's new policies across to the voter with the minimum of distortion and interference from a then largely Conservative-supporting press.

As to Gove's abuse of power, I knew Tony Blair reasonably well before he and his family became public property. I know that he would never allow his family to be used in a cynical communications exercise. But most voters do not have personal experience of their political leaders. They rely on journalists to shape their views, and have to take commentators like Mr Gove at face value.

Like politicians, political communicators – and journalists – should rightly be questioned and scrutinised. But the tendency to cry "spin!" at even the most joyous and human events is part of the corrosive cynicism about politics that Mr Gove and others are injecting into an already demeaned public life.

Yours faithfully,
COLIN BYRNE
(Chief Executive, Public Affairs),
Shandwick International,
15 Queen Street, EC4N 1TX.
May 23.

From Mr B. V. Field

Sir, Hurrah for Michael Gove (article, "Synchronised spinning isn't our cup of tea", May 23). What a perfect anti-dote to the nausea-inducing, though admittedly mug-free, photocoverage upon pages 4 and 5 of the same issue.

Yours faithfully,
B. V. FIELD,
63 Finches Gardens,
Lindfield,
West Sussex RH16 2PB.

From Mr Henry Howard

Sir, We urgently need a new press code to protect the public from exposure to innocent young children.

Yours faithfully,
HENRY HOWARD,
38 Nottingham Place, W1M 3FD.
May 23.

Serge, and other timeless material

Debra Craine on the Royal Ballet's quadruple bill celebrating the legacy
of Diaghilev and his Ballets Russes

EVEN TODAY, almost a century after the Ballets Russes made its debut in Paris, the name Diaghilev conjures up a magic vision of unparalleled creativity. The 20 years of his Ballets Russes were a time when the most exciting painters, composers and choreographers of their day worked on ground-breaking ballets that still stand among the most important ever made.

It was thanks to Serge Diaghilev that Stravinsky composed his first ballet, *The Firebird*, and that Nijinsky choreographed the scandalous *L'Après-midi d'un faune*, two of the ballets currently being performed at Covent Garden as part of the Royal Ballet's new quadruple bill celebrating the Diaghilev legacy.

Two of the four have a long history at the Royal. Bronislava Nijinska's *Les Biches* (1924) was first staged at Covent Garden in 1964, in a production overseen by the choreographer herself. A portrait of beautiful young things on the French Riviera in the 1920s, *Les Biches* is one of the most delightful pieces of elegant irony ever to grace the ballet stage. Not all the Royal dancers understand this, least of all Darcey Bussell, whose uncorked hostess is far too scattered. Jonathan Cope is hilarious as one of the trio of narcissistic men in swimming trunks, while in an alternate cast Zenaida Yanowsky adds a handsome maturity to her tipsy hostess. *Les Biches* is set to an eventful score by Poulenc and looks wonderful in the sorbet colours of Marie Laurencin's original designs.

Fokine's *Firebird* (1910) was revived for the Royal in 1953 by Diaghilev's old *régisseur*, Serge Grigoriev, and his wife, Lyubov Tchernicheva. The potent primitivism of Fokine's writing for Kostchei's grotesque entourage is still a highlight, as are Natalia Gontcharova's Russian fairytale designs. Miyako Yoshida and Leanne Benjamin are two of the scheduled Firebirds, Yoshida beautiful and idealised, Benjamin wild and turbulent.

Although he is now considered one of the pioneer choreographers of the 20th century, Nijinsky made only four ballets in his short life as an artist, and three of them are lost. But thanks to Ann Hutchinson Guest and Claudia Jeschke, who cracked the code of Nijinsky's own notated score, we have *L'Après-midi d'un faune* (1912), 11 minutes of dance that stand as Nijinsky's sole legacy.

This is the first time that the Royal has performed Nijinsky's notated ballet. And what a treasured acquisition it will prove to be. Bakst's designs are intense and gorgeous; Debussy's tone poem is wonderfully evocative of a luxuriant sensuality; and the Nijinsky choreography, flattened like two-dimensional vase paintings, is fascinating. The subject-matter, which deals with the sexual awakening of a faun – and depicts bestial masturbation – still carries shock value, although the absorbing stylisation of its eroticism lends it a surprising tenderness. Irek Mukhamedov is sensational as the Faun, holding us in the spell of his fantasy with a remarkable fervency and grace. Carlos Acosta, in the second cast, is feral and carnal.

The choreography for Nijinsky's provocative tennis ballet *Jeux* (1913) is, on the other hand, a matter of pure conjecture. With no written score to hand, Millicent Hodson has relied on contemporary photographs, paintings and written eyewitness descriptions for her "reconstruction". She did have one great advantage: Nijinsky's detailed scenario. We will never know how close Hodson has come to the original. Her *Jeux* is an eccentric juxtaposition of Nijinsky's strange, unyielding body sculptures and her own fluid imaginings of what linked them. A *ménage à trois* involving Bloomsbury Set tennis players, *Jeux* combines sexual curiosity with emotional immaturity, something the dancers (Deborah Bull, Gillian Revie and Bruce Sansom) make clear in their games of love. Debussy's scintillating Modernist score and Bakst's vibrant garden designs (reconstructed by Kenneth Archer) are wonderful.

Diary

President Clinton

PRESIDENT CLINTON'S old Oxford tutor has perked up at the news of his possible return. Professor Alan Ryan, Warden of New College, recalls that the young Clinton missed his last tutorial in favour of hiking around Eastern Europe. Professor Ryan drawls donnishly: "I would still appreciate his essay, even after a gap of 30 years."

Lord Puttnam

LORD PUTTNAM offers a scientific explanation for the spiky hairdos adopted by many members of the House of Lords (viz Lord Longford). "The inbuilt amplifiers in the Lords benches create a lot of static," says Puttnam. "If you listen to debates for a long time your hair is left standing on end."

Glen Owen

Organic Oxford and the Harvard henhouse

A strong whiff of new Labour hypocrisy hangs over the Laura Spence furore

Ben Macintyre

IF GORDON BROWN'S attack on Oxford as a bastion of the "old school tie" had been, say, a paper submitted in the final examinations of the university he criticises, then the Chancellor might merit, at best, what used to be called a low "Desmond", or 2:2 (Tutu), since his remarks suggest somewhat shoddy research, an over-generalised view of a complex situation and a tendency to leap to conclusions.

Mr Brown (Kirkcaldy High and Edinburgh University), backed by Tony Blair (public school and Oxford University), essentially claimed that Laura Spence had been turned down for a place to read medicine at Oxford because she comes from Tyneside, is female and went to a state school. This talented girl, with the "best A-level qualifications you can have", had been rejected "by an interview system more reminiscent of an old-boy network and the old school tie than genuine justice," he said.

First to specifics: Miss Spence has no A-level qualifications, but rather ten top marks at GCSE, just like the 22 other applicants for the five places available. She did better on the interview, accounting for one quarter of the assessment, than any other part of the test, so that was hardly the problem. Of the five who did win places at Magdalen, three are women, three are from ethnic minorities and two are from comprehensives.

Mr Blair's Cabinet, by contrast, contains just five women out of 21, and not a single person from an ethnic minority unless you count Robin Cook, who may be some sort of elf. So much for Mr Brown's desire to open "doors to women and people from all backgrounds".

More than half of all students offered places at Oxford this year are from the state sector, with almost exactly equal numbers of men and women. Certainly, the social distribution at Oxbridge (wherever that may be) is not perfect, but nor is it in America's Ivy League, where the emphasis on broad admission policy has been far greater for longer.

There is a strong whiff of cynical populist rhetoric in the air, with the implication that American money, specifically the £65,000 scholarship to Harvard won by Miss Spence, is luring away our brightest children because of ingrained prejudice. In fact, US money is about to start bringing clever young Americans and other nationalities to Cambridge University in record numbers, with the planned Bill Gates scholarships.

Critics of Oxford's decision say that Miss Spence will now get just as good, if not a better, education at Harvard, depriving Britain of the chance to train a student that her interviewers predicted would be "an excellent doctor".

Actually, she will get a very different education in America, and I strongly doubt she will ever become a doctor. Harvard, unlike the universities of Newcastle, Nottingham and Edinburgh which also offered her places, has no medical course for undergraduates. Instead she will be following the sort of broad-based science degree course favoured by US universities.

The US and UK systems of undergraduate education are as different as battery and organic farming. At Harvard Miss Spence will be nurtured and spoon-fed, she will have a personal academic adviser, a financial adviser and an in-house proctor to attend to her pastoral needs. She will learn a little about a lot of different subjects, some of which she will already know from A level, and she might become rather bored.

At a British university she would be left to roam more freely and find her own path through the academic pastures in ways that can sometimes foster intellectual self-confidence faster than the more controlled American model, or the reverse.

At the postgraduate level, the two systems complement one another excellently. Thousands of Rhodes scholars have thrived at Oxford, and a new generation will do so in Cambridge; the Fulbright scholarships and, until they were idiotically done away with, the Harkness fellowships, have done the same for Britons wanting to study in the US after leaving university.

But at the undergraduate level the mesh is often less easy. Some Americans at British universities tend to flounder when presented with broad academic freedom and a demand for specialisation, or else end up pretending to be Sebastian Flyte and talking to teddy bears. While some British undergraduates at American universities flourish, others chafe at the boarding school atmosphere of dorm and frat house.

Since Gordon Brown cannot possibly know the comparative academic standards of the five applicants who did win places to read medicine at Magdalen, he can only be basing his claims that Miss Spence's rejection was an "absolute scandal" on the evidence that she was accepted by Harvard. But Harvard has different admission criteria, an ethos and curriculum that fit some Britons but not others, and

a $14 billion endowment that enables it to offer scholarships to 70 per cent of its students.

Instead of pressing on the old bruises of elitism, the Government might serve the universities better by fulfilling its promise to spend a larger proportion of national income on higher education, expanding places and so encouraging the existing trend at Oxford, Cambridge and other top universities towards accepting more state school applicants.

Medicine and veterinary science are the only two subjects in which the Government sets immutable quotas.

In another discipline, Magdalen could have made an additional place for the Geordie girl as the next best candidate, but not in the hugely expensive medical course. That there was no place for Laura Spence may be the fault of the Government more than Oxford.

INCAPABILITY BROWN

A misguided populism that damages the Chancellor

Gordon Brown's harsh and uninformed attack on Oxford University showed the "old Britain" he was denouncing at its class-obsessed worst. He has left new Labour, more than Oxford, in the dock. The Chancellor knew nothing – and indeed had no business knowing – about the details of the case of Laura Spence, the sixth-form comprehensive student from Newcastle upon Tyne whose rejection by Magdalen College he described as "scandalous". The broader effect of his intervention will be the precise opposite of what new Labour should intend: by reinforcing the stereotype that, nowadays unfairly, attaches to Oxbridge, he undermines the efforts to encourage state school pupils to apply to Britain's foremost universities.

Only this week, the Chancellor roasted the Treasury Select Committee for inappropriately interfering with the selection of a member of the Monetary Policy Committee. He should take his own medicine – and should certainly not encourage another select committee to meddle in university selection procedures.

Oxbridge is an easy target for a politician looking for an opportunity, in a rough political week, to match the populist attacks that have put William Hague in the public eye. The Cabinet had been discussing the Hague challenge just before Mr Brown delivered his outburst to TUC members; and Downing Street's swift endorsement reinforces the impression that this was less about meritocracy than about meeting fire with fire. It was a cheap shot, mis-aimed.

Miss Spence may have looked like a new Labour martyr; the Chancellor should have looked more closely. True, she had ten A-starred GCSEs – no longer an exceptional score for a bright student – but then so did all her 22 rivals for Magdalen's five places to read medicine. Her rejection was hardly the instance of an interview system based more "on the old school tie than justice" that Mr Brown alleged; the college admissions tutor also hails from Newcastle, where his mother taught in a comprehensive. Mr Brown thundered about Oxbridge prejudice against women, minorities and state pupils; but of the five

Magdalen accepted, three were female and three from minorities. Of another three passed by Magdalen to other colleges, two were from state schools. Had he been right, not wrong, on every particular, moreover, it is fair to ask what the Chancellor was doing trampling both on David Blunkett's territory and on the independence of British university selection procedures.

The Treasury's almost unrepentant answer is that it is the broad point Mr Brown was making that should be taken on board, not the case he picked. The point being that it was indeed a "scandal" that although Oxbridge has raised its intake from the state school sector, where 87 per cent of pupils are educated, the ratio at Oxford is only 53 per cent. The Chancellor was, thus, right to give this issue prominence ahead of the Comprehensive Spending Review. The threat does not need to be spelt out.

Again, this misrepresents the real challenge, which is how to combine open access with excellence, in a world where competition between

universities – as Harvard's offer of a place in a different subject to Miss Spence underlines – is global. Put Mr Brown's way, the discrepancy looks glaring; but there is a narrower gap between those, 66 per cent, of state school pupils who achieve three As at A level and the 53 per cent Oxford will this year admit. Nor are these statistics the nub of the problem.

Oxford gets almost precisely the same number of applications from state and private schools and takes rather more than half from the former. The challenge for all the top universities is to get more comprehensive pupils to apply in the first place. No university can take students who do not apply. And, as the Education Secretary readily acknowledged yesterday, Dr Colin Lucas, Oxford's Vice-Chancellor, is making strenuous efforts on that front. The university runs school visits, summer schools to help state school pupils to prepare for A levels and a "target school" system for pupils from deprived backgrounds. It is seeking to introduce tests of intelligence and potential that help to identify outstanding students; that, as he writes today, "is how serious we are about being meritocratic". What it refuses to do is to lower the hurdles, at the risk of its reputation for academic excellence.

There is no harm in the Government encouraging universities to trawl widely and energetically, with the aim of harvesting the brightest pupils of all backgrounds. There would be grave harm, were ministers to set "targets" for admissions which would be quotas under another name. Access to Britain's universities has expanded far faster than funding; and the best of them now put huge effort into recruitment. Mr Brown would do better to celebrate Oxbridge's world-class strengths than to give Britain's children, in effect, the outdated idea that the dreaming spires admit only a narrow social elite.

Bach, still in perfect harmony with our age

Richard Morrison

THIS IS Bach year. But then, every year is. Was he the greatest composer of them all? The very question is absurd, as if podgy but powerful Johann Sebastian from Leipzig is to be pitted against bumptious but brilliant Wolfgang Amadeus from Salzburg in some celestial contest of musical *Gladiators*.

But there can be little doubt that Bach is the musician's musician *sans pareil*. When Mozart heard Bach's great motet *Singet dem Herrn*, he exclaimed: "Now there is something from which one can learn." High praise, indeed, coming from a man who must have felt (with some justification) that he had little to learn from anybody, let alone a long-forgotten town organist. As for Beethoven, he declared of Bach (whose moniker means "brook" in German): "His name should be not Bach but Ocean" – thus supplying posterity with a rare example of a German musical pun.

But whether brook or ocean, the name of the Leipzig cantor inspires awe even in today's music business. Ask any discerning performer or composer to name the composer they most revere, and it's odds-on that they will plump for JSB.

Yes, I know that the Classic FM-Channel 4 millennial poll to decide "the most influential musician of all time" placed Bach in a demeaning tenth place, behind such creative giants as David Bowie and Robbie Williams. But this, I fear, tells us more about the gnat-sized cultural references of our own age than it does about ultimate musical worth. Call me old-fashioned, call me elitist, but I refuse to believe that, 250 years hence, people will be placing Mr

Williams's *Let Me Entertain You* alongside the Sistine Chapel, the *Mona Lisa* and *King Lear* in the all-time premier league of human creativity.

Whereas this summer, 250 years after his death (from a bungled eye operation by a dodgy English surgeon), Bach's standing has never been higher. In the coming months his music will be everywhere. No fewer than 25 of his works have been programmed in this summer's Proms. Among them will be a bold reconstruction of his "lost" *St Mark Passion* by the Dutch scholar Ton Koopman – a musician who is so much under Bach's spell that he has resolved to play or conduct every one of Bach's 1,100 surviving works. He is more than halfway to his goal. On the other hand, he is 56 years old. Place your bets.

Bach does that to people. Another fanatic is the English conductor John Eliot Gardiner. He has vowed to conduct all of Bach's 199 cantatas, in 50 different cathedrals or abbeys across Europe, during this anniversary year. Ask him why he is doing it, and he simply smiles and replies: "Because it's Bach." No other words are needed. Musicians understand.

So what is the secret of Bach's appeal – an appeal which cuts across ages, nations, fads and fashions? Some find in Bach's music a conduit straight to God. You certainly have to be a pretty relentless sort of atheist not to be moved by the Crucifixus of the *Mass in B Minor*. Others – the people who were good at sums at school – marvel at the almost unearthly ingenuity of Bach's counterpoint. And when you examine the *Art of Fugue*, for example, when Bach turns his theme inside-out, back-to-front and upside-down and then weaves all these variations together with a tune derived from the letters of his own name, you have to admit that he could have done excellent code-breaking work in

Bletchley Park during the war.

But I think the answer lies in a paradox. As a man, he was enmeshed in dispiriting rows, family tragedies (ten of his 20 offspring died in childhood) and gnawing money worries. He spent his entire working life toiling either for tinpot German dukes who treated him as a menial (one even threw him in prison when he had the audacity to accept a better job elsewhere), or in a Lutheran Church where he constantly had to fight for resources and respect.

Unlike the cosmopolitan Handel, his compatriot and exact contemporary (whom, remarkably, he never met), Bach never knew what it was to be acclaimed by thousands in one of Europe's great capitals. "I must live amid almost continual vexation, envy and persecution," he wrote, just a few months after composing the *St Matthew Passion*.

Yet none of this bitterness comes through in the music. Bach must have had an extraordinary intellect, capable of blocking out all trivia, all distractions, and focusing like a laser on the one thing that truly mattered: his lifelong inquiry into the mysterious logic of sound, and how it could be crafted to bring joy to humanity and glory to his God.

In that sense Bach must have entered his organ-loft or study rather as a scientist enters the laboratory. Indeed, this is the main thrust of a massive new biography, *Johann Sebastian Bach: The Learned Musician*, by the Harvard professor Christoph Wolff. Comparing Bach to Isaac Newton, Wolff argues that, in his greatest masterpieces, Bach was actually trying to make a "scientific" case in music for the existence of God.

It's possible. Bach was certainly profoundly pious ("too much crude Christianity," sniffed the odious Friedrich Nietzsche, when asked his opinion about Bach's music), but he was also a creature of the rational 18th century. Some of his best friends were scientists and philosophers at Leipzig University. And one of his greatest achievements was as much scientific as

musical. With the *Well-Tempered Clavier* – his collection of 48 preludes and fugues, two for each major and minor key – Bach stamped his mighty imprimatur on the practical, all-purpose tuning system that has unified and governed Western music ever since.

It is because his music transcends the specific circumstances of its composition that it speaks so immediately to people who have not the slightest interest in Lutheran Christianity, or the foggiest notion of what a toccata and fugue is. I cannot think of another composer whose work has been so jazzed up, dumbed down, deconstructed and reconstructed, and yet has so triumphantly survived with its integrity and identity intact. You can do anything to Bach, but the music is still quintessentially Bach. There is something about his harmonic progressions, their inexorable logic and their uncanny perfection, that is like DNA: through every transmutation, they proclaim their origin and their uniqueness.

Which is remarkable, when you consider how much Bach has been messed around. Back in the 19th century, Gounod added a sickly-sweet tune to the first prelude of the *Well-Tempered Clavier*, called it *Ave Maria*, and lived off the proceeds of "his" smash-hit for years. In the 1920s and 1930s, both Elgar and Stokowski treated Bach's organ fugues to monster-raving-loony orchestrations. In the cool 1950s Jacques Loussier swung Bach for jazz trio and made his fortune. For the Mod generation, Procol Harum vamped the *Air on a G String* into a moody psychedelic ditty called *A Whiter Shade of Pale*.

In 1968 Bach was top of the pops again when he was given a Moog makeover by the synthesizer virtuoso Walter Carlos (or Wendy Carlos, as he/she subsequently became). And in the 1970s Nasa sent Bach into space. Should the *Voyager* spacecraft encounter any musical aliens on its eternal journey through the galaxy, a recording of the *Brandenburg Concerto No 2* should convince them that the

human race is not quite as primitive as dispatches from their flying saucers might have led them to believe.

So it goes on. At a recent Edinburgh Festival I saw the sensational avant garde Catalan performer Carles Santos deliver Bach in flamenco style, while his company performed what, in less arty circles, would be called a bump'n'grind show. Bach survived. In fact, the flamenco treatment – to say nothing of the strippers – brought out an ebullience in his gigues and fugues that is rarely encountered in the Wigmore Hall.

Since then, I have heard a catchy rap song superimposed on the ubiquitous *Air on a G String*, a mobile phone using the opening bars of the great *D Minor Organ Fugue* as its ringing tone, and a CD called World-Beat Bach that sets such noble chorale preludes as *Jesu, Joy of Man's Desiring* over delirious African drumming.

Fantastic, all of it. Well, perhaps not the mobile phone. But the fact is that, whether you are the snootiest of classical purists or the druggiest of rockers, sooner or later you turn to Bach if you want to learn how harmony really works. And having turned to him, you realise that you can do the musical world no greater favour than to repackage him all over again for a new generation. As with Shakespeare, he can take it.

The best news in this anniversary year is that "new" Bach is still turning up. Found earlier this year in a dusty Ukraine archive was what may well have been Bach's last musical testament: an arrangement of a motet by his uncle. Scholars estimate that as much as a third of Bach's output is missing, largely because of the carelessness of his lackadaisical children after his death. So it is just possible that another Passion to rival the St Matthew, or another concerto to rank with the Brandenburgs, lies sleeping in somebody's attic.

Go and look now. You never know. If it turns out to be any good it might just help to lift the Leipzig cantor above Robbie Williams in the all-time rankings.

How JR Ewing set Romania on path to liberty

Daniel McGrory

THE STRAW "Stetson" tipped low over the eyes and the hand-stitched cowboy boots were as close as the Romanian businessman could come to emulating his hero, JR Ewing.

Emil Radu is serious when he tells you that for many of his countrymen the fictional Texan oilman inspired them to overthrow the Communist regime of Nicolae Ceausescu. It seems Ceausescu allowed only about four programmes to be shown on Romanian television. Three were about himself; the other was Dallas.

The old dictator was a fan of the American soap opera but broadcast it to show the evils of capitalism. Mr Radu said yesterday: "Instead we saw all that glamour, the cars, the beautiful women and the huge houses and asked ourselves 'Why can't we have that?' So the people took Ceausescu out and shot him.

"I'm sure it sounds odd to outsiders, but JR saved our country."

Mr Radu, 43, a building contractor, said that ten years on from their revolution, Romanians need JR's help again. An energetic figure wearing gold sunglasses and draped in gold chains, Mr Radu is part of a business consortium struggling to renovate a theme park dedicated to JR in the Romanian countryside. The only other one is the film-set in Texas where the series was made.

This surreal Balkan version, created in the mid-1990s, rises out of acres of wheatfields on the main road from Bucharest to the Black Sea. At the end of a tree-lined drive, immortalised in the opening credits of the series, sits "Southfork", a replica of the ranch where the Ewing family fought their weekly feuds.

Businessman Emil Radu at "Southforkscu" near Slobozia

Unfortunately, the original creators of "Southforkscu", as it is known locally, built the holiday park too close to a chemical plant, and plumes of sulphurous, orange smoke belch out over the red-tiled roof and white-shuttered windows.

The first owners ran out of money, so today the swimming pool is empty. So, too, are the paddocks. The thoroughbred horses were sold to meet debts and creditors looted the place of pistols, cowboy hats, silver spurs and anything remotely connected to JR. The portrait of JR was taken from the entrance hall, but debt collectors could not get the replica Ewing grand piano out of the front door.

That apart, only a pair of clocks marking Dallas time and the time in Slobozia, the grimy industrial town adjoining the theme park, remain. Locals joke that the difference should be measured in light years not hours.

Still the faithful come, anxious to see Southfork restored to its rightful glory. Yesterday three businessmen arrived from Timisoara, the cradle of Romania's 1989 revolution.

Ursu Mirceau, 48, an accountant, said: "I was fascinated by JR. He was so malicious and deceitful. I couldn't believe a man could be as bad as him and not be a Communist and win. He had money, women, all the things we Romanians could only dream about. Dallas helped us escape our own miserable lives but it gave us strength to believe we could have better, so we took to the streets to get it.

"It showed us a world that worked and where success meant wealth. The characters talked about stock exchanges, oil and business deals, and we weren't supposed to know about such things. Just as we were getting hooked, Ceausescu realised what was happening and took the series off air. He realised, too late, the damage JR had done." Mr Mirceau's two colleagues nod as they climb the staircase to the white balcony that looks out over this imitation kingdom.

The new owners want the master bedroom to reproduce JR's cowboy Baroque style, with buffalo horns on a king-size bed and wardrobes full of his and Sue Ellen's outfits that guests may borrow. Repeats of the television series will be piped to every room and an Internet site will encourage suggestions as to what would have happened to JR had the series not been scrapped.

One key figure in the consortium, the Italian furniture millionaire Giuseppe Bacchi, explained that what they needed to regenerate Southfork was JR's fabled ability to broker deals. "Life has to imitate his art so we can defeat Romania's still-stifling bureaucracy, its chaotic banking system and an economy that is facing an onslaught of austerity measures," Signor Bacchi said.

Romanians yearn to complete the transition to capitalism, unhindered by a weak currency which a decade ago was worth 20 lei to the US dollar and today trades at 20,000 to $1. Inflation is running at more than 50 per cent, and average salaries are only about $100 (£67) a month. The present austerity drive is presided over by Mugur Isarescu, the technocrat Prime Minister, who loathes public appearances and just wants to go back to running the central bank.

Mr Radu said "We need someone with JR's charisma. If we are to become part of the European Union, we have to think like capitalists and behave like them."

The original creator of Romania's Southfork, Alexandru Ilie, did not share JR's facility to evade his business enemies. He spent brief spells in jail as banks and others squabbled over who owned Southfork.

When Larry Hagman, the actor who played JR, visited Romania recently he was fêted like a head of state. "Folk were telling me that I helped their revolution," he said. "I'm glad they got rid of an old boy like their dictator but I was speechless, and that never happened to JR. One government minister told me that more people cared about who shot me than who shot Ceausescu."

Natalie Appleton, Melanie Blatt and Nicole Appleton at the photo call for their film *Honest* in Cannes

Diary

Dome actors kick up a stink

TROUBLE a t'Dome. The actors who play Coggsley and Sprinx, the mascots who greet all visitors, are in revolt. The reason? Their tunics reek of unpleasant odours. Worse, they claim that the New Millennium Experience Company is not paying proper Equity rates – they should get £400 per week, but some actors are receiving only £275.

The NMEC claims that the costumes are fumigated "once a month", and that the terms were all properly explained. One thing they were not told is that they might on occasion be punched in the face, a not infrequent occurrence, I'm told.

Mark Inglefield

THE TIMES

June

2000

Why elitism is good news for the masses

Anatole Kaletsky

GORDON BROWN's attack on Oxford University, now being broadened by other ministers into a generalised campaign against elitism, tradition and inequality of all kinds, may go down in history as the worst political mistake made by a British leader since John Major's decision to join the ERM.

Mr Brown's campaign will prove a disaster in at least three separate ways. It will be a disaster politically for Labour. It will be a disaster for British education. Above all, it will be a disaster for Britain as a cohesive, compassionate society that is willing to sustain a decent level of welfare and social provision for the less well-off.

Let us begin with political tactics. The Chancellor has not only outraged the hundreds of thousands of Oxbridge graduates up and down the country who believe that these great universities are among the rare British institutions that have preserved their global pre-eminence largely because they have been insulated from direct government control.

Mr Brown has also managed to insult the graduates of all other universities in Britain, by implying that only Oxford was capable of offering Laura Spence, an unexceptional schoolgirl from Newcastle, an education comparable to the American Ivy League. He has angered the tens of thousands of pupils and parents who have received rejections from Oxbridge despite exam results as good or better than Laura's and who never dreamt of turning their disappointment into a political *cause célèbre*. Worse still, politically, is the signal that Mr Brown has sent to Labour's "core" working-class supporters. These are the people who have suffered most from the collapse

of educational standards and the closure or forced privatisation of grammar schools.

What can they infer about the Government's approach to education from this anti-elitism campaign? First and foremost that elitism, which is synonymous with high standards, is still a dirty word in the Labour Party. Despite David Blunkett's fine words, the Government still seems to care less about academic achievement than about tokenism and social engineering. The so-called "gold standards" of British high-school education, the A level and GCSE exams, have become so devalued that tens of thousands of students can confidently rely on receiving the highest possible marks.

Above all, voters will conclude that Labour politicians are still obsessed with reforming and levelling down the education of the top few per cent, instead of focusing on the real problem of British education – how to cope with the disruptive underclass that undermines the education of the silent majority of Britain's children.

The new Labour spin-doctors may believe that "traditional" Labour parents, dismayed by the low standards in their children's schools, can easily and cheaply be bought off with a few rhetorical attacks on "privilege" and unfairness. But voters are not so stupid. They don't give two hoots about Oxbridge and would be justifiably proud if their children went to the universities, such as Newcastle and Manchester, which the snobbish Mr Brown believes to be unworthy of Laura Spence. They want the Government to provide schools with high standards of discipline, traditional teaching methods and adequate facilities. They understand perfectly well that arguments from the Treasury about a few thousand privileged students at Oxbridge are simply designed to distract attention from the Government's

manifest failure to provide a decent standard of education for all.

Attacks on private education only draw attention to the Government's failure to provide a state education system that would make private schools obsolete. Labour's campaign against private health insurance before the 1992 election rebounded so badly because it merely emphasised the failure of the NHS ideal. Mr Brown's outburst against Oxford shows every sign of doing the same to the ideal of comprehensive state-funded education.

To see why, consider, finally, the social implications of this campaign. If the Government now forces Oxbridge and other elite universities to increase even further the handicaps they already impose on candidates from private schools, their families will be faced with one simple choice and one that is rather more complex and profound. The simple choice will be to protect their children's life chances by voting for any party but Labour.

The more difficult choices will have to be faced after the next election, assuming that a middle-class rebellion fails to oust Labour. Parents who can afford to send their children to private schools will then face an increasingly hostile university system. They will be tempted either to abandon private education or to spend even more money in order to secure their children the best possible university place. This they will be able to do either by sending their children abroad or by supporting the introduction of a system of differential fees which will allow some universities to charge far more for tuition than others.

Top-up fees of around £7,000 a year are already under active consideration at Oxbridge and other elite universities. The Treasury likes the idea because higher tuition fees would allow Britain to restore reasonable levels of university funding and better academic salaries without spending government money.

At present, however, top-up fees are considered politically dangerous, if not suicidal.

But with a growing social bias against the "rich" in university admissions, top-up fees would be positively popular among upper middle-class voters, who would see them as an opportunity to buy their children back into high-quality university education. The top universities, too, would welcome high and rising tuition fees as a source of finance outside the control of the Government and the oppressively bureaucratic state funding councils. It is easy to imagine the best universities becoming totally private institutions with no recourse at all to state funding, except for special research projects, in the same way as Harvard, Stanford and Yale.

For the top British universities, such privatisation would be almost wholly welcome, since it would allow them to manage their own affairs without government interference and to pay internationally competitive salaries to their dons. For parents rich enough to pay

US-style fees of £10,000 a year or more, the privatisation of Britain's best universities would mean extending for another three or four years the financial sacrifices involved in sending children to private schools. But many would judge this better than the other options: either accepting the deficiencies of the state school system or seeing their children excluded from the best opportunities in university education.

Who, then, would suffer? Obviously, most parents could not afford to pay for private university education and students would be reluctant to saddle themselves with debts of £30,000. As a result, the elite universities would become more socially exclusive.

But the real damage done by privatising elite university education would go much further. By taking away from the upper middle class one of the very few remaining benefits of the postwar welfare state, the privatisation of university education would further erode the implicit social contract which has persuaded high-income Britons to pay far

more in taxes than they will ever receive in benefits from the State. In fact, given the steady expansion of private health provision, the continuing decay of the state school system and the decline of government spending on arts and culture, a heavily subsidised university system has been almost the only remaining benefit for Britain's middle classes from continuing to support a relatively generous European-style welfare state.

If the Government decides that it is responsible only to "the many" and declares war on "the few", the political reaction may be slow but it will be inevitable. An American-style ideology of minimal government will take hold among the elite and will spread to the population at large. Britain will become an American-style minimal state with much lower taxes, no welfare safety net and the devil take the hindmost. In the end, the poor will be the ones who suffer. And to Mr Brown's chagrin, I suspect that elite universities will still be populated largely by the children of the elite.

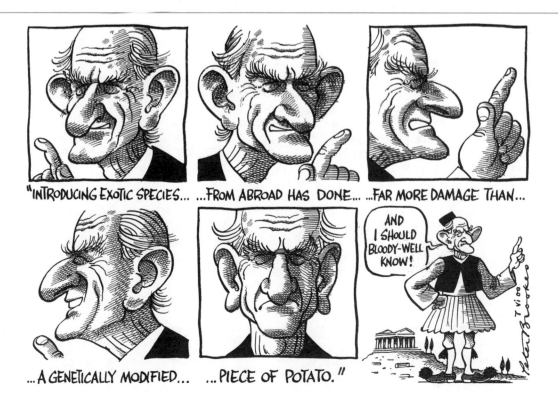

"INTRODUCING EXOTIC SPECIES... ...FROM ABROAD HAS DONE... ...FAR MORE DAMAGE THAN...

...A GENETICALLY MODIFIED... ...PIECE OF POTATO."

AND I SHOULD BLOODY-WELL KNOW!

Anne Robinson

AT THE VERY moment John Prescott was on his feet telling us about opportunity being in the hands of the few, and clever Laura Spence (rejected by Magdalen College, Oxford) was becoming a heroine of class warfare, I was taking a call from a television researcher.

"Basically," he said, "we want you to give us an anecdote, basically on what we outlined to your husband, basically saying, basically unprepared for real life".

Now I don't know much, but I do know that to become a researcher at one of the major independent production companies, you need to have very decent credentials indeed.

And whatever prejudice does or does not prevail elsewhere, independent television production companies rarely bother their independent heads about equality of class. If they wish, they can insist on hiring, to make the tea, only old Etonians, and still have a queue of applicants the length of the Friday night tailback on the West Way.

But, annoyingly in my experience, while these bright youngsters can often speak fluent Chinese (not immediately useful when you are escorting television guests from reception for a game show) they are, frequently, depressingly inept when it comes to the basics, such as booking taxis, asking questions on the tele-phone, and knowing when to listen and when to shut up.

For me, therefore, the important question is not whether heads of Oxford colleges reject pupils from comprehensive schools but why they fail to prepare students for real life.

In other words, equip them with everyday skills so when those students enter the real world they are able to express themselves in English – as recognised by the rest of us – post a letter, get to work on time or answer a simple query in under ten minutes.

"Basically, did it cost your Mum and Dad a fortune for your education?" I asked the television researcher who had called me.

"No," he replied cheerfully, "Basically I got a scholarship to Oxford."

Beaten off by the old boy network

Brian MacArthur

ONE REASON why Philippa White, education correspondent of *The Journal* in Newcastle, is the North East's Young Reporter of the Year is that she finds the sort of story that made the front page splash three Saturdays ago – and which has obsessed the political nation ever since.

It was she who got the scoop that Laura Spence, a sixth-form student at a Newcastle comprehensive school with ten A-starred GCSEs – and expected to get straight As in her A levels this summer – had been given a scholarship by Harvard after being rejected by Magdalen College, Oxford, to read medicine.

The story was picked up by the *Daily Mail*, followed up by *The Times* and *The Daily Telegraph*, but by Wednesday had died. No more would have been heard about Laura Spence if Gordon Brown had not made a speech about her on May 25 attacking Magdalen's decision as an "absolute scandal".

Brown got exactly the response he was seeking. "Gordon's blast at snobs of Oxbridge," said *The Sun*. The speech made the front page lead in *The Times*, *The Guardian* and *The Daily Telegraph*. Snobbery and class are a potent mix – almost everybody has a view on the "snobs" of Oxbridge, which is why two weeks later the story rumbles on.

It featured in five of the first six articles in *The Spectator* last week, has inspired one of *The Times*'s biggest postbags, and was still alive yesterday in most newsapers as commentators tried to explain the hostile reception Blair got from the ladies of the Women's Institutes. New Labour believes that spin can conquer all, declared the *Daily Mail* yesterday. Yet the story of Laura Spence has shown that it can't and doesn't. On this occasion facts beat spin, and newspapers did their proper job of subjecting a new Labour speech to equally sustained scrutiny and showing that the Chancellor had chosen the wrong target.

For those of us who have not suffered the experience, it is difficult to comprehend quite how alarming, indeed frightening, it can be to become a "news object" of the new Labour agenda. On May 25 Magdalen became that news object as the subject of a sustained attack orchestrated from Downing Street.

Its dons were upset and insulted. "I just lost it. I got very angry indeed," John Stein, Magdalen's senior tutor in medicine, told *The Observer*'s Euan Ferguson. Andrew Hobson, Magdalen's

admissions tutor, found the experience alarming. As he says, Oxbridge dons aren't trained in dealing with the press.

Their learning curve was steep, although Anthony Smith, Magdalen's President, has worked for the BBC and Channel 4 and knows how to tap the media. Magdalen's old boys in Fleet Street were certainly quickly alerted to the facts – that Miss Spence was beaten to the five medical places by three women, three candidates from ethnic minorities and two from comprehensives.

They went to work. A day later Ben Macintyre (whose father was a Magdalen don), commissioned by Graham Paterson (Magdalen), was writing on The Times op-ed page on why Brown deserved a 2:2 for his "shabby" research. In The Daily Telegraph Daniel Johnson (Magdalen) was writing about Brown's "extraordinary indifference to inconvenient facts". A day later in The Sunday Telegraph the battle of "Laura's Brain" was the subject chosen by Matthew d'Ancona (Magdalen) for his weekly column. D'Ancona also knew that Mr Smith had been a regular breakfast guest at Brown's breakfast seminars and had dined at Magdalen.

Journalism does well by Oxbridge and Oxbridge does well by journalism. Over the following week, in The Times alone, Brown was condemned by William Rees-Mogg (Balliol), Anatole Kaletsky (King's, Cambridge), Libby Purves (St Anne's, Oxford), and Michael Gove (Lady Margaret Hall, Oxford).

What made Magdalen's response to Brown so damning was that it was so obviously inspired by genuine outrage at the injustice of his attack. The responses of Mr Stein and Andrew Hobson, his successor as admissions tutor, resonated with angry sincerity.

After meeting Stein, Euan Ferguson described him as perhaps the most sainted academic in Britain. Not only had he almost found a cure for dyslexia – and repeatedly been refused funding by the Government – but he was

also close to discovering a cure for Parkinson's disease.

The main point, however, was that he has also campaigned for years to increase the proportion of students accepted from state schools.

"I've been in the business for 30 years," he told Ferguson. "I can tell a bullshitter when I see one, and a lot of independent school applicants are bullshitters. The great thing is how surprised they seem when we turn them down."

Mr Hobson, a Geordie who is a keen supporter of Newcastle United, has shared Stein's aim. His main anxiety was that the effect of Brown's speech would be to discourage students from applying to Magdalen and spoil the work done by himself and Mr Stein. After talking to Philippa White, he dreamt up a PR tactic worthy of new Labour's sharpest spin-doctors. He wanted an opportunity to put his case, unedited, to the students of the North East.

So he caught the dawn flight to Newcastle, wrote an article on the way, donned a Newcastle shirt and "made a bit of an idiot of himself" on arrival, and was pictured in his home city for an article in which he made his point: Magdalen wanted more students from the North East – even if they were Sunderland supporters.

Four per cent of all UK students applying for universities were from the North East but only 2 per cent of those applying to Oxford, he added, but nearly 45 per cent got offers from Oxford against 42 per cent for the rest of the UK.

"If twice as many of you applied to bring the 2 per cent up to 4 per cent, twice as many of you would, statistically, receive offers. Please think about it!"

Two truths have emerged from the great debate. One (against Brown) is that Oxbridge is trying to recruit more students from state schools, as Brown's Oxbridge-educated speechwriters ought to have known. The other (where Magdalen dons would agree with him) is that Britain does still recruit its elite

from too narrow a social base.

As The Guardian argued this week, Brown ought to apologise to Magdalen but that in no way disqualified the wider case he made.

QUOTES

'It is about time for an end to this Old Britain where what matters more are the privileges you are born with rather than the potential you actually have'
Gordon Brown

'Harvard's system is not perfect but it is much fairer. There's no old school tie'
Dr Paul Kelley, headmaster

'Oxford seeks out the most able – whatever school they have been to, whatever their background'
Colin Lucas, Vice Chancellor of Oxford

'I don't want to become a political football'
Laura Spence

Diary

Ann Widdecombe

ANN WIDDECOMBE has proved once more that she is forged from tungsten steel. Last week she took her 88-year-old mother on a Norwegian cruise. Suddenly, a force nine gale blew up and her fellow passengers headed for their cabins. Not Ann. She went swimming. "We were in the North Sea at the time," she tells me. "The ship does move in a force nine gale, so at times I would find myself in a half-empty pool, and then the water would come back on top of me. It was rather wonderful, actually."

Glen Owen

Theatre pests can't be sweet and low

SCIENTISTS HAVE uncovered proof for a phenomenon well known among theatregoers: it is not possible to unwrap a sweet during a performance without being annoying.

The annual conference in Atlanta of the Acoustical Society of America will today hear evidence that unwrapping a sweet slowly and carefully still creates the same amount of exasperating noise and prolongs the nuisance.

Eric Kramer, of Simon's Rock College in Massachusetts, and Alexander Lobkovsky, of the National Institute of Standards and Technology in Maryland, analysed the sound with computers and discovered that it is not continuous but consists of a series of individual bursts of noise or clicks, each taking thousandths of a second, caused by tiny creases in the paper.

Sweet-eaters who try to unwrap slowly are merely extending the agony. Broadly speaking, all sweet unwrappers are equally loud, according to the physicists, who conducted their research using Mylar, the plastic combined with aluminium foil used on most US confectionery.

The finding may bring scant comfort to anyone who has had the soliloquies of Hamlet or Mimi's death in *La Bohème* wrecked by a neighbour, but the research could have other applications. Scientists say that the physics of wrappers is comparable to shapes assumed by protein molecules in the human body and could help pharmaceutical research.

More immediately, the new study offers one fundamental rule to those who insist on eating sweets during performances. As Dr Kramer told *The New York Times*: "Unwrap it as quickly as possible and get it over with." Or, better still, leave the sweets at home, along with the mobile phone, the beeper and that cough.

Ben Macintyre

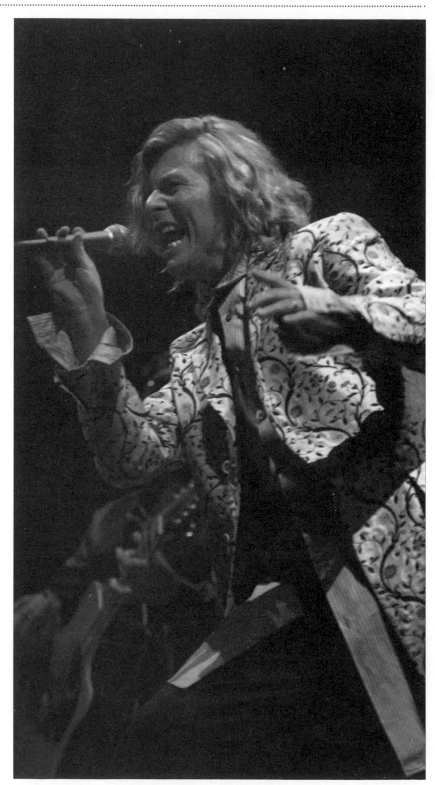

David Bowie at Glastonbury

john diamond

the last word

BY THE time you read this, I should be in Ibiza. Yes, I know: a fortnight ago it was St Petersburg and in August – touch wood, DV, all of that nonsense – it should be Cape Cod, so call me Judith Chalmers The Holiday Queen if you like, but I went for a couple of years without a proper holiday – ie, one that didn't involve telling the local hospitals that we were coming and could they set the oxygen bottles up please – and now is the time to make up for it.

Indeed, it's the time to make up for a lot. And, as it were, to make up for it in advance.

I was sitting in what used to be my club in the days before kids, and then cancer, when I could hang out in Soho clubs with the worst of them, when a woman I've never met came over rather timidly and did the accusatory "You're John Diamond" thing. Surprised though I am when strangers recognise me, I'm not sure why they so often do this; I could understand "Are you John Diamond?", or even "You look like John Diamond", but "You're John Diamond" seems to be the equivalent of those people who say "You've had a haircut!" as if they were telling you something you didn't know.

She was, she said, surprised to see me there. Me too, I said: it was past 2am and the place was meant to be well closed. No, she said: the surprise was seeing me with what was obviously not my first vodka-and-water of the evening, a cigarette burning in the ash tray in front of me and the knot of my tie somewhere around the middle of my chest. It didn't fit in, she said, with the life she imagined I must lead.

And what life would that be? I asked, although I knew the answer. She gave an expansive "well, you know" with a wide sweep of the arms which suggested teams of worried surgeons, intravenous tubes, beeping heart monitors, the full panoply of medical pathos. I'm afraid not, I said: this is the life I lead.

And much of the time it is. With the feeding tube gone, no medication to speak of (I'm even off the antidepressants and not much more depressed, apparently, for it) and a wardrobe of moderately well-fitting clothes, I look much the same as I did before the first diagnosis, except thinner and with bleached hair. As long as I don't try to speak, or eat, or perform too strenuously on the dancefloor, you'd probably never guess. And so I do most of the same things I did ante-cancer, and often enough to excess.

"Does this count as a miracle cure?" my editor e-mailed me the other day. Well, no. According to every medical statistic available, the chances are infinitesimally small that there aren't a knot of cancerous cells sitting around in my neck waiting until my back is turned so they can get back to the job of killing me.

Knowing this, said the woman in the club, staring pointedly at the fag and the booze, shouldn't I be looking after myself a bit better? Why she should take my excesses as a personal insult I really don't know, but it was plain that she did.

But it seems to me that I have a choice. Either I can treat my body as a temple, fill it only with carefully chosen nutrients, go to bed early, keep clear of stress and do all the things which, had I thought to have done them before I got ill, might have made a difference, or I can enjoy myself. Fair enough: my rackety idea of enjoyment might not be yours, but it is, I promise you, enjoyment nonetheless. But whatever one may like to think about the moral causes and effects of this sort of life, the physical truth is that there's little I can do now in terms of lifestyle to alter the cancer's prognosis. Sure, I eat as properly as I can, and I make up on the sleep the next day and I take more than my quota of vitamin pills, but that's about the extent of it.

For, let's face it, which would you prefer: to find yourself lying in bed in a month or a year or whenever, doped up on morphine and drumming your fingers, waiting for the end, thinking "Thank God I spent the last six months getting to bed early and thinking pure thoughts", or "Well, at least for the last six months I've had the best time possible and enjoyed myself no end"?

Which is precisely what I hope I'm doing in Ibiza as you read this.

Diary

Peace paws

IAN PAISLEY and Gerry Adams have at last found common cause – a mounting distrust of Peter Mandelson's cherished labrador, Bobby.

The reason for their shared animus, I can disclose, stems from the Northen Ireland Secretary's habit – some might describe it as a killer strategy of introducing the dog whenever debates about the peace process overheat. Mandy did this the other day when he met a truculent delegation from Mr Paisley's Democratic Unionist Party, cutting them off in mid rant with the words "Have you met Bobby?". No sooner had he said this, than up jumped the Bobster, tail a'wagging. The Orangeman, I am told, was momentarily disarmed.

Mr M appears to have deployed the same tactic with the Sinn Fein leader, who was recently heard to remark, none too quietly, that he was "sick of that f**** Bobby". "It is a great way of defusing things," a Northern Ireland source tells me. "Bobby, you could say, is playing a vital part in the peace process."

Mark Inglefield

Training that makes your hair curl

Patience Wheatcroft

AT MY LOCAL hairdresser, I recently encountered a new phenomenon: the graduate shampooist. Her touch with the conditioner was beyond reproach, but did not reflect the benefit of three years spent at university. Neither did her conversation convey that her degree in English literature had been particularly fruitful.

She referred to her fellow students as pupils and it appeared that her time spent at what was not so long ago a polytechnic was merely an extension of school. Like an increasing number of university students, she had lived at home throughout the course.

She was not someone whose ambitions had been thwarted by an elitist society. On the contrary, she told me she had always wanted to be a hairdresser and she was now thoroughly looking forward to the three years that she expected to spend getting her NVQ. But her schoolteachers had persuaded her that she should get her degree before doing anything else and she saw no reason to disagree.

The Government is terribly keen that more and more students should progress from school to higher education. But is a formal degree course really the best option for an ever-growing proportion of school leavers?

For the country to be investing in creating graduate shampooists may not be the best use of national resources. There are skills shortages in many areas, not all of them requiring high levels of academic training. In his project to turn the Great Eastern Hotel from eyesore into one of the most enticing venues in London, Sir Terence Conran found that work was hampered at almost every stage by the shortage of building trades people who could meet the standards that he demanded.

Despite the advent of e-commerce, there is still a real world that requires real buildings but we have not been training the people to produce them.

The same is true in almost every sector. The rules on immigration are having to be loosened in order to enable droves of tekkies to come to the rescue of technologically disadvantaged Britain. A couple of days ago, the Foresight Financial Services panel reported that one of its concerns was the growing skills gap "as education and training systems become less able to deliver the workforce the future needs".

The panel, one of many established by the Government to do a bit of crystal ball gazing, has been trying to envisage what the financial services sector will look like in ten years' time. Its investigations ranged across personal finance and the funding of small firms to the running of the institutional financial markets, and at every level, skills shortages were a matter for concern.

It is important that Britain should train people such as Laura Spence to be doctors if that is where their vocation lies. But we need to throw out the idea that degrees are universally useful. My hair did not notice the benefit.

Is this Reggiecide?

Benedict Nightingale on a Coriolanus played with overtones of Leonard Rossiter – and none the worse for that

RALPH FIENNES played an elegant, courtly Hamlet for the Almeida five years ago, and is currently an interestingly precious, bitchy, smug, vulnerable Richard II at the company's summer quarters, the Gainsborough Studios in London's East End. But the subtleties that qualified him for those roles would seem, on the face of it, to disqualify him for the leading role in the *Coriolanus* that now joins the English history play in the company's rep.

What, we wondered, would he make of a character whom one of the most influential academics of my youth summed up as an "iron mechanical warrior" and a "human war-machine", tougher than anyone except his own mother, who is able to rule him as a lioness might an uppity cub?

The answer is that, yes, Fiennes plays Coriolanus as a relentless war-machine, but one that is more a sleek jet fighter than a bomber. He strides onstage, hair slicked down, wearing a magnificent sneer that he scarcely ever removes afterwards. Talk about arrogance, talk about hubris. You almost believe he has undergone a nose-lift or smelt so many whiffy proletarians that his olfactory organ has moved upwards of its own accord. And though I occasionally thought I caught the tones of the late Leonard Rossiter reacting to rising damp, Fiennes's voice mostly exudes a ringing contempt, a scathing superciliousness, an eloquent anger.

It is undeniably impressive, but surely even Coriolanus, the most monochrome of Shakespeare's heroes, could do with more colour. That comes only very occasionally, as when Marcius, as he then is, gives a tiny, satisfied smile on being awarded the title of

Coriolanus. But when he yields to his mother Volumnia's pleas to spare Rome, taking her by the hand, falling to the floor, and sobbing, it is too unprepared-for to be wholly plausible. Fiennes has not shown us the unreconstructed boy inside the fighting man who kills for his city, is rejected by it, and joins its foes in an ecstasy of pique.

About Barbara Jefford's Volumnia, though, there can be no cavils. Think of some lady Amazon handing out white feathers to passing wimps and, no, you still haven't done justice to this monster-mother, with her gloating glee in all that's violent and destructive. And the intensity of her ferocity gives special meaning to Emilia Fox as Virgilia, Coriolanus's neglected wife. She sits silently, tending her boy and her embroidery, her very diffidence a reproach to the warmongers.

That's one of several apt touches in Jonathan Kent's modern-dress revival, which comes with a peppy Aufidius in Linus Roache, a majestically troubled Cominius in David Burke and a more-than-usually serious and thoughtful Menenius in Oliver Ford Davies. The production is probably more sympathetic to Rome's balky, changeable proles and less sympathetic to its senators than Shakespeare, who was no leveller, would have wished – but that's par for the political course nowadays.

A couple of quibbles. Menenius's light-blue-dark-blue tartan looks so odd amid the nobs' tunics and workers' caps you wonder if he should be called McMenenius. Again, when Fiennes emerges from battle, should he look quite so much as if he has swum a couple of lengths in the stage gore that half-drowned Peter O'Toole after his Macbeth had murdered Duncan? But let's not forget the moment the gates of besieged Corioli, a slab of rusting metal in the surrounding brickwork, open to a roar of white noise and white light. I have not seen war so simply yet terrifyingly evoked in ages.

Heading for Euro 2000: David Beckham practises his ball control

At last we tell The Spinne Doctour's Tale on the Road to Canterbury...

 Philip Howard

In the Yeare of Our Lorde
 Fourteen, Zero, Zero,
Died Old Engelond's
 Greatest Barde and Hero.
The Father of English
 Story-Telling and Hackery,
From Will Self to William Thackeray:
Our Owne Beloved Poet, Geoffrey
 Chaucer,
From whome I coude euere read
 more, Sir.
And so to honour dear olde Geoff's
 Sescenary,
Here's the Missing Man to make his
 Pilgrimage Plenary:

A Special Advisour was there, with a
 forked tongge,
Who coude mak Blakke White, and
 Old Money Yongge.
Spinning cobwebbes for Hackes was
 his entire life,
And penning speeches to mak for
 Bathe's Wif,
And her Volumnias at ye Wimmin's
 Institute.
For which that Goode Wif did not yaf
 a Hoot,
But raither gave him a slow hande-
 clappe,
And a receptioun that was distinctly
 frappe.

But this Maister of Ye Puffe did not care:
He was Svengali to his Puppete Blair.
Nowher so bisy a man as he ther nas,
And yet he semed bisier than he was.
In Party Politiks was his hole Life,
He had no training other than in Party
 Strife.
He had a Maister's Degree from
 Bizness Skule,
And ran his Bizness by this Goldene
 Rule:

Do others ere they do it unto you.
He was less gentil than his Maisters
 knew.

Now is that nat of God a full fair grace
That swich a lewed mannes wit shal
 pace
The wisdom of an heep of Lerned
 Men?
Of Lobby Journos had he thries ten
At his immediate Becke and Pager
 Kalle.
So whene'er Wooster's Morwi Polle
 looked poorly,
Than wood he fighte for everich Loude
 Headline,
As wood turne shiten Water into Wine.

His clients were of Scoopes experte
 and competing,
Of whom ther were a duszeyne at
 everich Lobby Meeting,
Worthy to mak Ye Splashe, and
 Scoope, and Page Lead,
Of ony Redtoppe simple folkes read.
LABOURE POLLES PUSHE
 BOTTELS UPPE YE TORIES
Was one of his most successful planted
 stories.

This Famose Spinner ne'er admitted
 Wrong,
But "Journo's Error" ever was his song,
Or "Tory tosh" "Editor's a Fule",
To Pass the Bucke was his Inky Rule.
He could spin faster than arrow can fly,
Or Paparazzo snap, or hot Story die.
He could selle angles where there
 werre nun,
Unite a long-lost mother with her
 sonne,
Reveal Cabinet Plots, and Shocks, and
 Cabal,
And all Sensatiouns Unimaginable.

To live In Nuendo was evere his funne,
For he was Trickster Hermes owene
 sonne.
And in Ye *Sonne* and eke Ye *Mirrour*
At alle *Times* was his Beste Endevour.
Wel koude he fortunen Ye Leaders
And Spinnen his ymages for their
 Readers.
He knew the cause of Focus Groope's
 rot,
Were it of moyste, or drye, or coolde,
 or hot.

His Briefing, and his Moone, and his
 Thinke-Tanke,
Ther nas none swich from Central
 Office to Millbank.
Ther nas BackBencher, Minister nor
 other hyne
That he knew nat ther Sleighte and ther
 Covyne.
He kent the Sexe Rompes of all
 Celebrities,
And helde a Doctourate in oothers'
 Sleaze.

Ful riche he was astored pryvely.
His Premier koude he plesen subtilly,
Hym thoughte he rood al of the newe
 jet;
The Bo Brummel of the Cool Britannia
 Sette.
This Spinne Doctour let olde thynges
 pace,
And heeld after New Laboure the
 space.
He yaf nat of that text a pulled Hague
 (nat ye Field Marshal)
That saith that hackes ben fearless and
 impartial.

He was a gentil harlot and a kinde;
A bettre Spinne Doctour sholde men
 noght fynde.

Road signs

From Mr Trevor Lyttleton

Sir, On the way to Glengariff in Ireland a few years ago I saw the following: "Beware! Extreme Danger! Church Entrance Ahead!"

Yours faithfully,
TREVOR LYTTLETON,
23 Bryanston Court,
George Street, W1H 7HA.
July 19.

From Professor Emeritus Deryke Belshaw

Sir, At the risk of implying that Professori Emeriti are engaged primarily in a search for esoteric road signs (letters, June 20, etc), I wish to bring to wider attention the following sign in English and Hindi located beside the road from Kalimpong to Gangtok, Sikkim State in the Himalayan region of India: "If you wish donate blood, kindly do so at Blood Bank, not on National Highway 31A!"

This wordy expression of concern with travellers' welfare was painted on the outside of a 300-degree bend.

Yours sincerely,
DERYKE BELSHAW,
33 Bracondale,
Norwich NR1 2AT.
June 20.

From Mr Ernest Spacey

Sir, Travelling near Washington DC about 24 years ago, I saw a large billboard by the roadside. Beautifully painted in letters a foot high, was the legend: "DISREGARD THIS SIGN".

Really and truly,
ERNEST SPACEY,
192 Hollingwood Lane,
Bradford,
West Yorkshire BD7 4BJ.
June 23

English fans cool down in Charleroi

SECRETS OF CREATION

The greatest scientific journey of this century starts

Imagine that you are exploring a gigantic underground cavern whose walls are covered with three billion extraordinarily detailed drawings and alphabetic squiggles that are thought, if you could only see them perfectly, to hold the secret of life itself. With only matches to light your way, you have spent decades trying to copy just a few of these drawings. Now, suddenly, the entire expanse is illuminated by brilliant searchlights that leave no corner, no crack in darkness.

That is what will happen on Monday, when scientists on both sides of the Atlantic formally present the first "working draft" of the entire human genetic code. It is not entirely finished yet; that may take another two years. But already, with 85 per cent in the public domain, the data show the sequence of virtually all the DNA bases present in the human body's 1,000 billion cells, arranged in the right order. The human genome "map" contains both the geography of life and an evolutionary history stretching back some billion years.

This is a breathtaking moment for genetic science, for human health, even for philosophy. The charting of the A to Z of life is one of those rare paradigm shifts. It is a discovery of the first magnitude. It could transform thinking about the instruction manuals of Creation as profoundly as did Charles Darwin's theory of evolution.

The publication of the human genome is both an end and a beginning; it is the culmination of a process that began in 1869, when DNA (deoxyribonucleic acid) was found and took a great leap in 1953 when James Watson and Francis Crick unravelled its "double helix" structure; by 1984, DNA fingerprinting was possible. Yet, as little as 15 years ago, it took ages to locate a single gene. Now that the genome chain has been linked up, it can be found at the click of a computer mouse.

The greatest scientific journey of this century starts here, with this directory; as its alphabet is decoded, the prediction, treatment and understanding of disease should be revolutionised. Yet, unlike Darwin's theory, the fact that we can now "see" the genome tells us, in itself, nothing. Science cannot yet understand what it says. The genome is a sort of instruction manual of life; it passes on genetic traits and makes the proteins needed to build an organism – enzymes, cells, organs, skeleton or brain. But there is as yet no theory which explains how it does that unimaginably complex job. This billion-character manual is followed by each human cell; yet for humans themselves, it is as mysterious as a stack of paper 480 miles high, in a strange language without grammar. It will take decades to decipher in its entirety.

None of this detracts from the magnitude of Monday's event. The gripping story of the race to complete the sequencing of the human genome, biology's "tree of knowledge", is told in Times 2 today. It is a David and Goliath tale, with Goliath represented by the Human Genome Project (HGP), a vast and stately £2 billion scientific collaboration funded by American taxpayers and, in Britain, by the deep charitable pockets of the Wellcome Trust. The HGP was painstakingly mapping the genome, a process that involved isolating genes and locating them on one of the 23 pairs of human chromosomes, on a research schedule planned to end in 2005. Into that calm landed the pebble hurled by Dr Craig Venter, the innovative and unconventional scientist whose methods and motives the Establishment united to denigrate. Insisting that he could map the human genome far faster and for a fraction of the cost, he proceeded, with private backing, to prove it. That electrified the HGP into altering course, reallocating and concentrating the work and racing him to the finishing line – five years ahead of its original schedule.

This very public quarrel, patched up just in time for Monday's announcement, has been about more than personal feuds or mere amour propre. At its core are vital questions for policymakers about the most effective ways – public funds or venture science – to pursue hugely expensive research. However considerable the merits of the HGP approach, which has throughout published its results immediately on the Internet as a tool that any scientist can use, the lesson to be drawn seems clear. It is that,

when a discovery could bring exponential benefits to human health, and when the research to make this happen costs fortunes, commercial competition driven by market incentives is an indispensable goad. The name of Dr Venter's company, Celera, is the Latin for "speed"; and his impatience has done the world of genetic science signal service.

The arguments about the exploitation of this great discovery have, however, barely begun. The human genome is destined to provoke secular controversies, both scientific and ethical, as intense as the charges of heresy that followed Galileo's discovery that the Earth revolves round the Sun. Recognising its potential is one thing, and even that is a matter of scientific dispute; realising it is another. The hope is that, within a couple of decades, it will enable science to probe into the genetic roots of illness and find new cures. It should enable greatly improved diagnostic tests and better understanding of the side-effects – on each individual – of drugs. Eventually it may be possible not only to identify defective genes but to replace them with "healthy" ones. It could, in particular, revolutionise the treatment of cancer, which is caused by malfunctioning genes.

But this medical coming of age of genetic engineering contains possibilities that are less welcome; of new forms of eugenics; and of the risks if genes are manipulated without full knowledge of which genes do what and how they do it. The human genome sequence is full of dead ends, the detritus that scientists call "junk DNA"; it is a dauntingly vast haystack from which to extract the healing needle. There may be many reasons why a gene misfunctions and science will find it difficult to pinpoint which mutation to rectify.

Developing treatments that are both safe and effective will therefore take not only time, but billions of pounds. Such sums will mostly come from the private sector, and only then under patents that protect any profits. Stiff resistance to the patenting of "life" will have to be overcome, possibly by requirements that companies that have obtained gene patents must offer research laboratories "affordable" cross-licensing royalty agreements. Investment and pure research must be enabled to cohabit. But politicians must sift prejudice from well-founded anxieties; and remember that private enterprise has the power to accelerate scientific progress. As humanity crosses this historic scientific threshold, the aim of policy should be to place as few impediments as possible in its way.

Benefits 'some distance in future'

SCIENTISTS DECLARED yesterday that they had read the book of mankind, providing for the first time a "working draft" of the three billion letters that make up the human genome.

The achievement was compared to the invention of the wheel, putting a man on the Moon and – more accurately – the first steps to understanding human anatomy taken 2,000 years ago by the Greek physician Galen.

But the teams still do not know how many genes there are – it could be as few as 38,000 or as many as 115,000. Actual benefits to health still lie some distance in the future. In London, scientists from the Wellcome Trust's Sanger Centre near Cambridge, where a third of the genome has been sequenced, were the first to make the announcement. Dr Michael Dexter, director of the Wellcome Trust, which spent £210 million building the centre, called the result "the outstanding achievement not only of our lifetime but in terms of human history".

Professor Richard Dawkins of Oxford University said that along with Bach's music, Shakespeare's Sonnets and the Apollo space programme, the project was "one of those achievements of the human spirit that makes me proud to be human". Sir Aaron Klug, President of the Royal Society, called it "a momentous occasion". And Lord Sainsbury of Turville, the Science Minister, said: "We now have the opportunity of achieving all that we hoped from medicine."

Human genes are made up of four "bases" that constitute the crosslinks in the spiral staircase of DNA: adenine, cytosine, guanine and thymine. The order of these bases along DNA forms a code that tells the cell which protein to make. The code is formed in groups of three bases for individual amino acids, which are assembled by cells into proteins. The entire complement of DNA carried by human beings is three billion bases long: this is the genome. It is stored in the nucleus of cells in the form of discrete packages, the chromosomes.

The Human Genome Project, and the privately funded initiative in the US run by Celera Genomics of Rockville, Maryland, aimed to "read" the entire sequence of three billion letters. The sheer volume is daunting, sufficient to fill two hundred 500-page telephone directories. If recited at one base per second for 24 hours a day, it would take a century to complete.

The project has now sequenced 85 per cent of the genome, and produced maps of 97 per cent of it. Much of what they have found is meaningless, DNA that carries no code at all but is simply endless repetitions of the same few bases.

But among the identified sequences, 38,000 are definitely genes and as many as 115,000 are possibles, Dr Richard Durbin of the Sanger Centre said. He expects the final total to be at the lower end.

Dr Dexter cautioned against expectations of immediate cures but said that the genome would ultimately open up a vast range of new treatments. "Our genes make us susceptible or resistant to disease, tolerant or intolerant of medicines," he said.

"What the sequence information will allow us to do is to identify precisely what goes wrong when we develop disease. Once we know this, we open up a tremendous number of new therapies."

It will be another two years before a "gold standard" genome is completed.

Nigel Hawkes

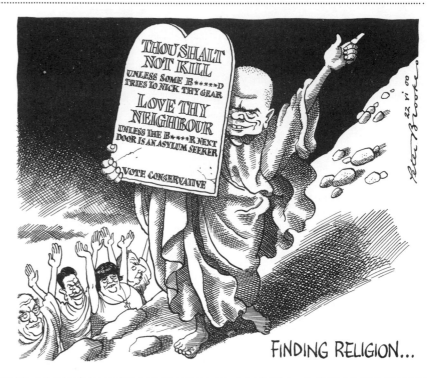

FINDING RELIGION...

Seek and ye shall find – even in a cowpat

Derwent May has found the book that explains many of nature's secrets

Derwent May

......................................

YOU CAN'T see the countryside by looking through a car window. Well, you can – and very beautiful it is just now, with the wild roses in the hedges and the poppies out in the fields.

To see it properly, however, you have to look more closely – and there is an extraordinary amount not just to see, but also to discover behind the appearances.

A new book, *The Countryside Detective*, is a splendid guide to what you can uncover by getting out in the air and looking about you more attentively. You can begin in your garden. Have you ever noticed a mysterious powdery imprint of a bird's head and wings on your window? It was probably made in the night by an owl – a tawny or even a barn owl – who collided with the window pane. Owls have special

down feathers that crumble into a powder to keep their plumage clean – rather like a dry shampoo. If they hit the window they leave traces of this behind.

Just watching carefully in the garden can reveal fascinating episodes in a bird's life history. Last week I heard an oddly brief, strangulated burst of song from a hedge, then a bird flitted out into an apple tree. Peering into the shadows I saw a young robin with its breast still spotty and only a faint golden glow behind the spots hinting at the red breast-feathers that would soon be growing there. It was a crucial moment in this speckly adoles-

cent's life – it was trying out its first song.

The Countryside Detective covers many aspects of nature beside birds. What about butterflies – and their caterpillars? Butterflies flit by so fast that it is often hard to see the patterns on their wings and identify them – and if they settle they often close their wings tight, so you still cannot see. But if you look for them in the early morning you will find them with their wings open, because they need to sunbathe in the morning air. In fact they cannot fly until their body temperature reaches 30C (86F).

Spiders are not overlooked here. The book points out that it is a myth that spiders come up through the plug-hole of baths. They could not possibly get through the water lying in the U-bend of the pipe: they gener-

ally fall from the bathroom ceiling when they are chasing a mate or building a hammock-shaped web in the corner.

Going out into wilder countryside, the book guides you to when and where you can find grey seals coming ashore to calve, or dolphins moving inshore. If you see one fin cutting through the water it is probably a dolphin you are looking at, but if there are two fins it is probably a basking shark. If you go out by boat off the northwest coast of Scotland you have a good chance of finding minke whales and the gigantic fin whales, or even a killer whale.

On the moors in autumn, by contrast, you can look for berries. The commonest is the delicious bilberry, the "blueberry" that can cover miles and miles of hillside, but there are also jewel-like red cowberries, with bright, evergreen leaves, and cloudberries, which are like little ground raspberries.

The book does not forget the weather, explaining that "Red sky at night, shepherd's delight" is a saying with some truth in it. Red skies occur when the light is scattered by dry air or dust, and as the weather in Britain comes mainly from the west, a red sky round the setting sun indicates that there is dry weather approaching from that direction.

In the end, though, *The Countryside Detective* concentrates on the smaller pleasures we can uncover - and it even has some pages on the humble cowpat. A whole novel could be written about the creatures that cluster round this small circle. Dung flies lay their eggs in it while it is still warm and can act as an incubator. Slugs and woodlice shelter in it, butterflies and wasps sip liquid from its surface. Then along come hedgehogs and shrews, jackdaws, starlings and lapwings, to feed on all these little inhabitants.

Sit quietly and watch a cowpat and wonders will unfold before you. That, it might be said, is the message of this excellent and brilliantly illustrated book.

In Britain, it's always all our yesterdays

Richard Morrison
........................

IS BRITAIN going forwards or backwards? That's a rather grand question for a Saturday morning. But it must have occurred to anyone who observed the three startling vignettes that 21st-century Britain presented to the world this week.

First, Prince William was snapped on his 18th birthday wearing garments that seemed to come straight out of Billy Bunter of Greyfriars. Gushing commentators declared the pictures to be (as one broadsheet put it) a "delightful portrait of a thoroughly modern Prince". But "thoroughly modern" wasn't the view of my children and their chums. "Sad" was their verdict. To millions of teenagers the pictures proclaimed William to be about as relevant to modern life as a Saxon spoon. Not an auspicious coming-of-age for a future monarch.

Then came the rioting English football fans in Belgium. Whole forests have been felled to allow press pundits to ponder that national humiliation. Yet only one thing seems clear. The potbellied louts of Charleroi are stuck in a mental time-warp, in which the year is forever 1940 and Britain is perpetually standing alone and embattled against a hostile world. No wonder that the Germans say we are obsessed with the war.

And the third vignette? Less glum, but no less telling. A large lump of rock sank in the sea this week. The reason it sank was that it was being rowed across the Bristol Channel on a replica Stone Age boat by a bunch of fanatics trying to prove that the bluestone slabs of Stonehenge had been carried from West Wales (the only place where the rock is found) to Wiltshire by the brawn and guile

of early Britons, rather than deposited there by glaciation.

Some £100,000 of lottery money had been invested in this jolly jape. Compared with the £750 million spent on the Dome, of course, that is a drop in the ocean. Unfortunately, a drop in the ocean is literally what it turned out to be.

So are we a country, or a giant nostalgia factory? Whatever level of British society you choose to examine – from princes to hooligans, from hippies to wrinklies – the answer appears to be yes and yes. In Britain even the counter-culture is regressive. This weekend 100,000 people gather in a field near Glastonbury for a festival that celebrates not only music, but a mythical and mystical Arthurian landscape, conjured by the word "Glastonbury" itself. "We are seeing a return to Celticity," announced Tim Sebastian, Archdruid of Wiltshire, as he surveyed a similar crowd gathered at Stonehenge this week for the dawn of the solstice.

Indeed we are. But also a return to every other era as well. In fact we don't mind where we go, as long as it's backwards. Not only do we sustain a mind-boggling array of museums (2,500 at the last count), plus hundreds of historic castles, prisons, mansions, churches and piers, we also seem determined to relive the past with as much realism as we can muster.

Next month we will flock to the Museum of London to experience a full-scale reconstruction of "High Street Londinium", in which we are assured of a "full-on sensory assault" from the sights, sounds and smells of a Roman city. The fact that the museum promises "a weekend break in Londinium during the first century

BC" (sic) does not inspire confidence in the scholarship involved. But that won't stop the crowds from coming.

Similarly, the National Army Museum plans to reconstruct "authentic" medieval meals for visitors – or at least as authentic as modern hygiene laws permit. "We want to be realistic," a spokesman says, "but obviously you can't go around poisoning people."

And so this national cavalcade of nostalgia whirls on. Iron Age villages are being reconstructed on the Western Isles. Medieval jousts are being refought in English castles. Cavaliers and Roundheads clash each summer in Sealed Knot battles. Last summer Jacobite nostalgists bizarrely re-enacted Bonnie Prince Charlie's transvestite escape.

Our national nostalgia disease now extends even to the Industrial Revolution. Devotees of Victorian engineering are lovingly restoring the pumping machines that kept Sir William Bazalgette's London sewers flowing sweetly. Former copper mines, such as Morwellham Quay in Devon, are reincarnated as complete Victorian villages. Even disused coalmines are being tarted up as "national museums". No aspect of British history, it seems, is too grimy or grim to excite fanatical attention. People even take guided tours of Whitechapel in search of "haunts of the Ripper" that were mercifully demolished decades ago.

In the arts, too, Britain leads the world in its dogged pursuit of the past. We pioneered the use of "period instruments" and "authentic performance practices" in medieval and Baroque music. Now, in a painstakingly recreated replica of Shakespeare's Globe, we are pioneering the revival of ancient theatrical practices too, right down to "groundlings" who ad lib their own contributions to the drama. "Self-conscious, phoney role-playing," said *The Times*'s theatre critic. He's probably right. But the public can't get enough of it.

The more complex our working lives become, the more we seem to need to retreat in cultural terms, to eras that appear simpler and less threatening. Even our domestic architecture signals a psychological withdrawal from contemporary life. Our suburbs are mock-Tudor, our new "executive estates" overwhelmingly mock-Georgian. And

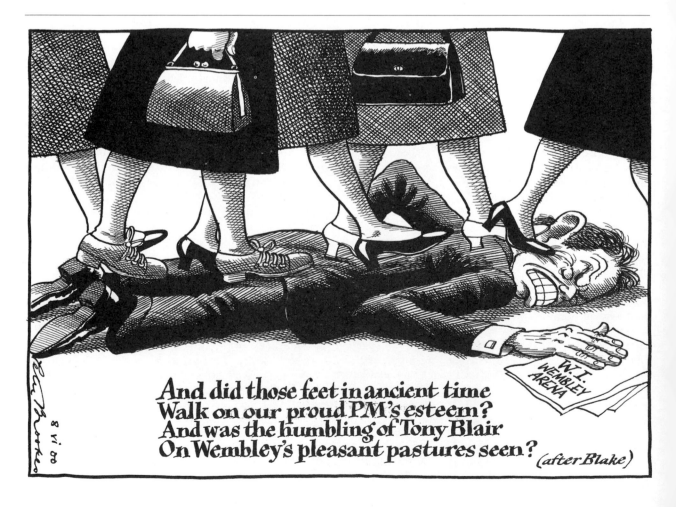

And did those feet in ancient time
Walk on our proud PM's esteem?
And was the humbling of Tony Blair
On Wembley's pleasant pastures seen? *(after Blake)*

what's the big new idea from Lord Rogers of Riverside and his Urban Task Force? Why, that the ideal house for the 21st century is the Victorian terrace!

But hang on a minute. Wasn't all this nostalgia supposed to stop when Tony Blair reached Downing Street? Indeed it was. New Labour came to power promising to blitz the nation's regressive cultural tendencies as swiftly and ruthlessly as it had purged socialism from its own manifesto. The arts were retitled "cultural industries". The tweedy Department of National Heritage was recast as the ultra-cool Department for Culture, Media and Sport. British embassies across the globe were told to dazzle the natives with Brit-art displays of pickled sharks. As for that dreary old classroom subject called history – well, it was swiftly relegated to the margins of the national curriculum so that teachers could devote more time to zippy "information technology".

All in vain. Britain's love affair with the past has, if anything, intensified since Labour came to power. There is one clear reason for that – television. It created celebrity chefs, celebrity gardeners and celebrity handymen. Now it has created celebrity historians. Whole nights on Channel 4 or BBC2 are currently filled by these jolly, photogenic scholars, rolling up their sleeves to reconstruct fearsome medieval siege machines, re-enact Victorian weddings or fathom the mysteries of Norman plumbing. So fanciful are some of the speculations presented as "history" on these shows that you feel the programmes should be prefaced by Nietzsche's sour observation: "There are no facts, only interpretations." But one fact is unarguable: they offer a nightly escape into history for millions.

Of course, flamboyant historical reconstructions can be found outside Britain as well. The world's oceans are crowded with primitive reed-rafts crewed by macho "scholar-explorers" attempting to prove – in the swashbuckling style of Thor Heyerdahl's Kon-Tiki expedition –

that Peruvian natives reached Polynesia before Asians did, or that the Phoenicians reached America before the Vikings, or (the latest theory) that intrepid Scots mariners crossed the Atlantic while Alfred was burning his cakes.

But only in Britain has the retreat into the past been accorded the status of a national cult. One way or another, we are all at it. Why? Well, the "return to Celticity" noted by the Archdruid of Wiltshire clearly has a significant romantic appeal for many people, especially since no two scholars can agree on who the Celts were, or what they stood for. Thus the Celtic cult usefully serves the causes of Europhiles and Europhobes, pagans and New Age Christians, devolutionists and English nationalists.

But just as intense is our subliminal desire to return to an age when Britain really was a green and pleasant land, untainted, unpolluted, uncomplicated. Whether we locate that age in Celtic, Roman, Saxon or Tudor times hardly

matters, since the myth is inside us, not lodged in historical exactitude.

And finally, there is our national Peter Pan syndrome. We cling to the past because it is a comfort-blanket, and we don't want to grow up and face the real world. We don't know where Britain is heading, if indeed it is heading anywhere as a united kingdom. But we do know where it has been. And we imagine that if we concentrate hard enough on celebrating that past we can somehow stop history from advancing into the terrifying unknown region called the future.

But the wagon of time does roll inexorably onwards, and mature adults learn to cope with change and decay. So do mature nations. Britain spent most of the 20th century lamenting the passing of empire, power, and glory. Now we really must snap out of it. Museums are fine to visit once in a while, but not to live in. The future beckons, and it's high time we shouted: "Stop the world – we want to get on."

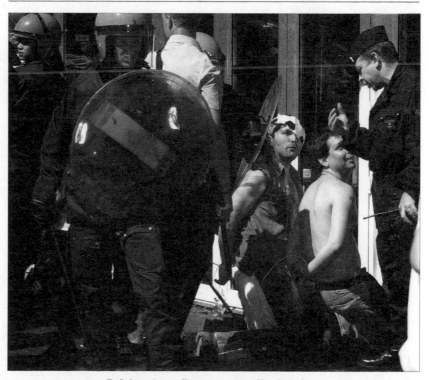

Belgian riot police arrest two English fans

Swaying pedestrians
brave seasickness
crossing London's
Millennium Bridge

john diamond

the last word

THIS IS what happens.

You feel a pain: ear, throat, inside the mouth, around the stump of a tooth, along the neck. It's sometimes sharp, piercing, quick; sometimes dull, hangs around for a while, moving slightly, so you can never quite say, yes, that's where it is. It doesn't much matter either way, because you ignore it. Three, four years ago when you were still a fully fledged hypochondriac, the pain would have had you round at the surgery that afternoon, even though it would probably have meant nothing very much, but now that throat pains, neck pains, ear pains might actually mean something, you take a couple of paracetamol and forget about it. Or, more accurately, block it out of your mind. After all, if you can pretend that the Inland Revenue hasn't been sending you all those ominous manila envelopes for all that time, what's so difficult about a little neck pain?

But Nigella catches you rubbing the lump on your neck one night and asks whether, you know ... and you say, well, actually ... And Nigella looks at you head-on to see if it's your imagination or whether the lump really has got a bit bigger, but it's impossible to say. It's not as if the lump itself is indicative of anything very much: it's in the place, after all, where they sewed a flap of muscle taken from your back as a lining to the base of your mouth when they took the tongue out. Is it bigger? Who knows? When you have a cold, or have been in the sun for too long, or have smoked too much, or the pollen count is high, then it certainly feels bigger, but then the next day comes and it doesn't any more.

So Nigella makes the call and you go to see Peter Rhys Evans in his consulting rooms, and he says, "Is it bigger?", and you say, "Well, what do you think?" And he feels it for a couple of minutes and asks if there are any other symptoms. Well, yes and no. There's a bit of pain, but that might just be toothache, mayn't it? Is it harder to swallow food? Sometimes you think it might be, but then it's impossible to know what to compare it to because it's impossible to remember how things were. Can you really remember throwing the stuff down your throat without all the drips you seem to get these days? Was that before the last op, though, or after it? Last week or last year? The thing is, you can remember actually being able to eat with a knife and fork as if it were a couple of weeks ago, when in fact the last time you used cutlery to any useful effect was some time in 1997.

So Peter phones up the hospital and puts in an urgent request for a scan. Urgent? No, no, he says: that's just his way. He only means urgent in the sense of wanting to know sooner rather than later. And you think, thanks for the thought, but you'd prefer to know as late as possible, all things considered. You look at Peter's face. Is that his worried look? His neutral look? His I-know-something-but-I'm-not-saying-until-I've-got-proof look?

And the next morning you go for the scan. The radiologist lays you down, fires up the machine and then five minutes later comes back in to do it all again. Why? What has she seen on the first set of images? Why, this time, are you being moved so that your neck is closer to the scanning head? What does she know? What she knows, she says, is that she'll courier the pictures round to the scan specialist at the Marsden as soon as they're ready, and that he'll get in touch with Peter, who will phone Nigella and

pass on the news. But he doesn't phone. Is that good news or bad? Why would he not phone if he had good news? It can only be that he's spent the day – you being his only patient, after all – clucking over the pictures with other specialists, inspecting the tumours which they have seen there.

So Nigella phones him and he says that he didn't realise that you'd had the scan so early and thus didn't chase up the scan specialist. He will, he promises, let you know tomorrow.

But you know already. Because as you lie down on the scanner you could feel the dozen tiny symptoms which you know you've been denying to yourself and to everyone else. And the ridiculous thing is that your greatest wish isn't that the symptoms hadn't returned, because they were bound to, but that you hadn't been so reckless as to get in touch with a doctor and have them looked at. I'll let you know next week.

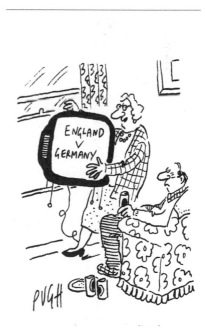

" I THINK THE GAME SHOULD BE MOVED "

On being a Christian and a Prime Minister

We can cope with politicians' religious views only if they are insincere

Alice Miles

DOWNING STREET could not have moved faster to block suggestions that Tony Blair was going to make a religious speech to the conference organised by the Swiss theologian Hans Kung in Tubingen, Germany, this week. When he addresses the Global Ethics Foundation, an organisation set up by Mr Kung to expound and develop his views on the need for a worldwide consensus on basic ethical values, the Prime Minister will, his press aides insisted, talk of values, globalisation and his own political philosophy, but not, repeat not, about religion.

But it will be a speech about religion anyway. For one thing, the whole point of Mr Kung's work is that religion and politics intertwine. He views Jesus Christ as an outsider who challenged the religio-political-social establishment of His time. *On Being a Christian*, his book which is said to have impressed Mr Blair, contains subheadings including "Radical change" and "Not for the elite, but for all" (I am not making this up). Moreover, we are assured in it that Jesus was – and it is italicised to ram the point home – "not a member or a sympathiser of the liberal-conservative government party". Nor was Jesus a member of the Establishment or a revolutionary, but somewhere in between; difficult to understand (even for His friends), "more moral than the moralists, more revolutionary than the revolutionaries … different".

One political commentator wrote yesterday that when the Prime Minister has in the past talked about his faith she felt that "he was dangerously close to pronouncing 'Jesus was the first moderniser, y'know'." Well, I haven't studied Mr Kung in depth, but I think this is one of his points.

And if Mr Blair's is really just a speech about his political philosophy – Women's Institute Mark II, as it has been dubbed – then why make it to a religious conference in Germany? He has often chosen to make landmark speeches overseas; in opposition it added gravitas, and he protests that he gets a better press abroad: they take the Third Way seriously; they regard Mr Blair as an asset rather than an embarrassment.

But the foreign commentators – like the foreign heads of state who so admire the Prime Minister – do not live here. They do not use our hospitals, our schools, our appalling public transport system. What they admire about Mr Blair is his electoral success and his way of winning friends overseas. These are fine qualities, but they don't mend hospitals.

No, the reason for this speech at this time and to that audience is that Mr Blair is a man in search of a vision. (Incidentally, the blurb on the back of another of Mr Kung's books, *A Global Ethic for Global Politics and Economics*, is headed: "Wanted – A Vision.") It is not enough for him to deliver better public services; he needs it to be in the context of a broader purpose; a "mission" for the transformation of Britain. Hence the endless attempts to define Blairism and the Third Way, and his speech in Tubingen on Friday.

It is not about winning votes; a cynical attempt to steal the religious vote from under William Hague's nose. Mr Blair means it, which is far more disturbing. When Mr Hague dresses himself in vestments we can be sure a cynical electoral exercise is under way, which is as it should be: the man is a politician. But when Mr Blair dons a mitre, it is genuine.

When, therefore, Mr Hague tries to harness religion to his cause, nobody minds – because they know and he knows, and he knows that they know, it's a fraud. When Mr Blair does the same, although he does it very rarely, it is met with at best howls of derision and at worst a queasiness of the stomach. And precisely because his Christian beliefs are deep-rooted and sincere.

He was confirmed in the Church of England in his second year at Oxford and joined the Christian Socialist Movement, a socialist organisation allied to the Labour Party (and a militant opponent of Clause Four reform), in 1992. He is private about his beliefs, and confused: a member of the Church of England who attends Roman Catholic Mass. He has said with honesty that he "can't stand politicians who go on about religion", and he is neither moralising nor judgmental. When, at Easter 1996, he aired his religious views in public, in an article in *The Sunday Telegraph* entitled "Why I am a Christian", it was met with ridicule and warnings from his advisers never to do it again. It is a gift to the school of critics who see Mr Blair as the moralising and hypocritical "Saint Tony".

And people don't like it. Rightly or wrongly, we don't want our politicians to moralise or preach; a fact Downing Street recognises, which is

why the suggestion that Mr Blair would make a religious speech in Tubingen was quickly quashed. More, we don't really want to know about their religious beliefs at all. Religion, at least as practised by Mr Kung and Mr Blair, means uncertainty and confusion. Which is a good thing in a human being, but probably a bad thing in a politician.

The tension has always existed within the Prime Minister. But something, probably his new baby, has brought his uncertain side to the fore. He is looking for something, and tried to express himself first in the original draft of his WI speech, described by one baffled person who saw some of it as "vomit-making".

Politicians need to lie, cheat and be utterly ruthless. "Tony is all those," an ally reassured me yesterday. But they are characteristics which are inconsistent with deeply held religious beliefs.

The fact that Tony Blair holds those beliefs makes him a nicer person. But, regardless of whether you agree with him or not, it makes him a worse politician.

" PLEASE REFRAIN FROM TALKING
ABOUT HARRY POTTER WHILE
PLAY IS IN PROGRESS "

One of the many small spectator craft at the Henley Royal Regatta ties up to the floating edge of the course to view the racing

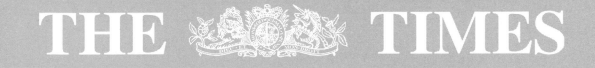

THE TIMES

July
2000

Thank you Zinedine, Edgar and Jan, what a swell party that was: Euro 2000, The Final Reckoning

Lynne Truss

WELL, THE party's over, it's time to call it a day. And I have to say it's unsettling. Rarely does a three-week period become so distorted as when a big tournament is on. Only three weeks ago that the gigantic inflated footballer was wheeled, striding elegantly, on to the pitch at the King Baudouin Stadium in Brussels? Only three weeks since, in the opening match against Sweden, Filip De Wilde, the Belgium goalkeeper, took delivery of a back-pass, diddled with it perilously and had it nicked off him for a goal by Johan Mjallby?

Seems like years. Seems like minutes. The European championship has been a colourful dream of astonishingly good football which has, rather too persuasively, created its own world. It's a world in which every time you look up you see Gheorghe Hagi staring into the mental abyss of yet another yellow card; or the dainty Filippo Inzaghi caught offside with his hands in his hair; or a blur where Thierry Henry has just streaked through open country to score a brilliant goal. Over? Euro 2000 is a way of life, mate. How can it possibly be over?

Before the tournament, I noticed with some alarm that Belgium (where I've been stationed throughout) did not appear ready for it. I accepted that I might be an incorrigible fusspot in such matters and that it was always a mistake to arrive at a party too early, while the host was still deciding on his socks and there was only an old half-bottle of Tizer on the kitchen table. But I must whisper, as delicately as possible, now that it's over and we know that the nibbles never did turn up, that hosting a football tournament may be something that Belgium does not do best. Spending all the money on bouncers was a valid choice, but not a particularly endearing one.

But did this matter, in the end? Unless you are a deported England fan, not too much. The Netherlands, the co-hosts, evidently extended a warm welcome to visitors – they even controlled the England fans in Eindhoven without bother. Besides, with the quality of football from the qualifying teams, a good time was absolutely guaranteed. It's the people who make a party, after all!

And there is not a single team that didn't turn itself inside out for the sake of this competition, as their fans well know. Even poor old Denmark (played three, lost three) gave their all, with the poignant banner "TAK FOR ALT BOSSE" displayed in Liège during the Czech Republic match, in genuine gratitude to Bo Johansson, the outgoing coach, for leading Denmark blind and weaponless into the valley of the shadow of the group of death.

So, what I'm saying is, they invited Zinedine Zidane to this party – and memories of this event will rightly focus on Zidane, performing at the

Michael Owen celebrates prematurely in England's 3-2 defeat against Romania

height of his talent. From the moment France took the field against Denmark on the first Sunday in Bruges, the pre-eminence of the man was evident.

Unlike Paul Gascoigne, who always suffered from having a brain like a foot, Zidane has a foot like a brain and a brain like a brain. In fact, he is simply the brainiest footballer I've ever seen. At semiconductor speed, and with three opponents closing in on him, he simply bends his balding pate over the ball, calculates all coefficients and simultaneous equations, and then not only works out an unfussy way to retain the ball (swivel, counter-swivel, hop, turn, tap), but comes up with a miraculously improvised way to pass it as well.

What everyone has loved about Euro 2000 is the open, forward, dynamic play. More than 80 goals and a million saves; only two goalless draws. High passion, committed athleticism, fabulous hair and great goals. There's nothing to beat it. Hoorah.

England fans will cherish Michael Owen's goal against Romania and, of course, the glory of beating Germany; less so, perhaps, the false dawn of the two exciting openers against Portugal, before our opponents regrouped and blasted holes through us at close quarters. I was looking at a computer graphic of Luis Figo's goal against England the other day, incidentally – and do you know, it was preposterous! It showed Figo charging directly towards goal, leaving defenders collapsing on both sides, firing through Tony Adams's legs and straight past David Seaman as if he wasn't there. Well, I thought, lucky this was only a graphic. Imagine if such a thing could happen in the real world!

Unsurprisingly, Figo got the man-of-the-match award. It's an award system that has recognised goalscorers in a quite unimaginative way. On the night Martin Keown heroically worked his socks off for England against Germany, for example, it was Alan Shearer who got man of the match.

Goalkeepers, defenders and play-makers don't get a look-in, so the amazing Alessandro Nesta, of Italy will go officially unrecognised, as will all the goalkeepers, despite the fact that the quality of goalkeeping in Euro 2000 has been one of its great revelations. Toldo's saves in the Holland-Italy match were magnificent; I remember Rustu, of Turkey, taking Emile Mpenza's rocket shot like a bullet to the chest in the match against Belgium; meanwhile, Barthez's vertical salmon-leap to palm a shot from Raul over the bar in the France-Spain quarter-final was frankly unbelievable.

Plus there are players who just physically summed up the tournament. Edgar Davids, in his swimming goggles, proving that even girlie hair and specs can be elevated to footie fashion if the will is strong enough. Patrick Kluivert having the time of his young, strutting life against Yugoslavia (It's three! It's four! No, hang on, it's three again!) Pierluigi Collina (top ref, Julia Roberts fan and stickler for discipline) giving red cards to players who weren't even on the pitch, with his eyes popping out of his already quite scary head. Christophe Dugarry with his nostril splints. Jan Koller, of the Czech Republic, biggest man in the world, roaming the field as if looking for someone to eat.

What a shame if an event such as this is remembered for the water cannons in Charleroi. So think of Zidane instead, waiting several minutes for the explosive Portuguese protests to die down at the semi-final in Brussels, knowing he must put the penalty away, his whole body whirring and ticking with controlled concentration. This is not only a contested penalty, remember; it is potentially the golden goal.

But though a few more hairs fall out, this is the only sign of the strain he is under. For Zidane is the Pete Sampras of football. The whistle blows. He makes a short run, fires it into the roof of the goal, into Baia's right top corner. And France are in the final, and on this night in June in the year 2000, Zinedine Zidane is the best footballer in the world.

Ball testing at the Slazenger factory in Barnsley, South Yorkshire

Fading Henman heads down road to nowhere

Oliver Holt

THERE IS something beautifully apt about the nickname, Scud, which decorates Mark Philippoussis. Its connotations of aerial bombardment are what really make it special, but it also manages to convey size, awkwardness, bullying and a certain merciful lack of accuracy. Scud defines Philippoussis in the way that Tiger Tim gets absolutely nowhere near Tim Henman.

If it is metaphors for air attack that are the language of tennis pseudonyms, the effectiveness of Henman's performance in the first set on Centre Court yesterday most closely resembled a piece of wet lettuce in a food fight. At the end of that 6-1 demolition, the huge flag beneath the scoreboard that read "Tiger Tim, He's Grrrrreat" seemed so wide of the mark that it was embarrassingly funny.

Tigerish will never, ever describe Henman. He made only one advance on alliteration in his defeat to Philippoussis yesterday evening when he displayed all the tentativeness that has characterised his failings over the past few years. Philippoussis, after all, had won the right to play Henman only by triumphing in a marathon five-set victory over Sjeng Schalken that lasted for one minute over five hours.

Henman deserves none of the same credit for taking this match to a final set. Before his fighting spirit is subjected to too many eulogies, it needs to be pointed out that he was playing a man who had been on a saline drip the day before, so exhausted and dehydrated was he after his match against the Dutchman. Henman deserves credit for refusing to be unnerved by the way Philippoussis came at him in that first set, but this is not the time for charity.

More and more, the Wimbledon spirit that Henman serves up for his admirers at the All England Club every year is acting as a camouflage for his lingering limitations. His upward progress has ground to a shuddering halt. Stirring though his performance against Philippoussis might have been in isolated incidents of defiance, it still served to confirm the commonly held view that Henman has reached a plateau in his climb up the tennis mountain.

It may be unpalatable to those who have made it their annual rite of summer to journey to southwest London and torture themselves with Henman's journey to the edge of glory, but there is a gathering danger that the player they urge on with all the shrill intensity they can muster has reached that perilous

stage of his career where he is going nowhere fast.

It is sobering to admit this, but those who were willing him to win Wimbledon this year were living in the same land of delusion as those who believed England could win the European championship in Belgium and The Netherlands. That scale of expectation was as unfair to Henman as it was to Kevin Keegan and his hapless team.

Never mind Philippoussis. One brief look at Pete Sampras in majestic form on Centre Court earlier yesterday was enough to reinforce the obvious truth that the six-times champion plays on a different plane from the British No1.

For all his false, thigh-slapping ferocity, his theatrical stares and his Arthur Scargill clenched fists, Henman is starting to look like a man at the beginning of a slide, a one-tournament-a-year wonder who flares briefly and brightly at Wimbledon and then subsides into a slow-burn for the rest of the year.

The other big tournaments do not bring the best out of him. The clay of Roland Garros is utterly beyond him: he has gone out in the first round in Paris in three of the past five years. In the other grand-slam tournaments, in Melbourne and New York, he has never reached the quarter-finals. He has given British tennis a huge shot in the arm by getting this far, but now it is time to take stock and to think long and hard about how he can become a real contender.

If Henman were not guaranteed an annual jaunt in the sun by the profile of Wimbledon, he would be Britain's equivalent of Jonas Bjorkman, a useful player devoid of any real charisma or any obvious stand-out quality. He is a good server without being great, a good volleyer without being destructive. His returns are average.

For all the awesome serving ability of Philippoussis, the Australian, too, is essentially a limited player, a one-trick pony. Players with greater talent than

The Australian, Pat Rafter, makes a dramatic dive in his five-set victory over Andre Agassi

Henman can disarm that serve and expose the emptiness beneath. That proved beyond Henman yesterday and left domestic tennis contemplating the returning nightmare that, by the Monday of the second week of the tournament, there are no British players left in the singles. As if to confirm that parlous state of affairs, the ghost of mediocrity past, Jeremy Bates, watched proceedings yesterday.

Philippoussis, admittedly, played like a man possessed in the first set, raining aces down on Henman like shooting stars and destroying Henman's own serve with a series of blistering returns. He could never keep that up, but Henman still deserved credit for not folding thereafter.

Henman does have courage and resourcefulness and began to make some advances by digging his returns back at his opponent's feet in the second set. Still, it was a bad sign when it took him seven set points to clinch the third-set tie-break. His 11-9 victory was a triumph for grace under pressure, but it was his last fling.

His failure to close out a match against an exhausted opponent is a damning indictment of Henman's failure to progress. All the old advice about needing a new coach will resurface now and if Henman does not make changes, he will only be guilty of being a fool to himself.

Otherwise, in the nickname games, it will be goodbye Tiger Tim and hello Pussycat.

I'm beginning to wonder now which bank will produce the best fudge

Patience Wheatcroft

MY REQUIREMENTS from my bank are relatively simple and entirely to do with matters financial. I want standing orders that are met on time, regular statements, the lowest possible charges and an absence of embezzlers.

I would not ask Lloyds TSB to supply me with a trouser press, a karaoke player or even a vacuum cleaner. Others, however, have done just that and the bank has been happy to oblige. In the past 12 months it sold £1.5 million of household goods alongside the credit cards and mortgages.

Access to the home shopping service is one of the perks offered to customers who opt for a current account on which fees are charged. In a neat double-entendre, Lloyds refers to these as "added value" accounts; its enthusiasm for selling them indicates where it expects the "added value" to accrue.

Now that supermarkets sell financial products, banks have all decided that they must become a little more imaginative in what they offer their customers. Abbey National, however, is threatening to fight the grocers on their own territory. Its sales development director has suggested that there is no reason why Abbey National branches should not sell pizzas, "as long as they were approved".

What would constitute an approved topping for an Abbey National pizza? Would Northern Rock consider this the moment to launch a selection of cakes? Which bank would produce the best range of fudge? These are all questions which will, no doubt, already be the subject of inquiry by the Financial Services Authority as Sir Howard Davies prepares to recruit a new force of taste-testers to add to

the battalions he has now amassed at Canary Wharf.

The head policeman of the financial world will, however, have found more than the right balance of capers and pimento to concern him in Abbey's new ideas. For the pizzas are just part of a new corporate recipe that involves the bank franchising its branch network. Before long, Abbey National could be joining Dyno-Rod and Kentucky Fried Chicken as a business opportunity for those in search of a degree of independence under a well-known brand name.

The bank believes that franchising may be a way to release the latent entrepreneurial talent among its managers. The conventional view of those who run financial establishments tends more towards the "jobsworth" type than frustrated creatives who, let off the leash, would transform their offices with new energy and ideas. Abbey, however, has faith in the talents of its staff and says that there has already been a surge of interest from managers who would be prepared to take a cut in their basic earnings in order to try out the role of franchisee.

Abbey reckons that giving the managers effective independence, and a more direct interest in what business they can generate, could have a dramatic impact on sales. The average Abbey customer at the moment buys only 2.1 products from the company, despite expensive efforts to persuade him or her to load up with Isas, deposit accounts and insurance as well as the mortgage.

Why customers should be more inclined to buy pizzas, or vacuum cleaners, or frocks from their bank than they are financial products is something that the Abbey's marketing men have researched. Much may depend on who is doing the selling and the environment they create. Even before the franchising scheme gets under way, Abbey is experimenting by opening a Costa Coffee franchise in one of its City branches. Perhaps some hard-working dealer will wish to order a cappuccino, a BLT and an insurance policy simultaneously, but nutritionists would probably advise against such a combination.

Some purchases are best made after cool consideration and the benefit of good advice. That is why Sir Howard will be warily watching the franchising experiment. Franchising is often portrayed as an easy way to make money. Those armed with redundancy cheques wander round franchise exhibitions in search of the idea that will give them a relatively easy life and a decent profit. Sadly, such ideas are rare and the average franchisee works long hours for an unspectacular income. Franchisors provide differing levels of support but generally make tough demands on those who operate under their banner.

But banking is not the same as selling fast food or printing services. Drafting in an uncle or aunt to help out during busy times or when a member of staff goes sick may help a Wimpy franchisee to get through a crisis, but it could have disastrous results in a bank.

Selling financial services is not the same as selling pizzas: badly done, the ill-effects can be much more long-lasting than indigestion. I want to be able to bank on my bank.

Cockney Bible teaches Jesus was currant bun

WOULD YOU Adam and Eve it? A teacher is hoping that his translation of the Bible into Cockney rhyming slang will make more people read it.

Mike Coles, 37, head of the religious education department at the Sir John Cass School in East London, has spent four months rewriting St Mark's Gospel and says that the children love it.

"To start with I would just teach the lessons and translate some of the passages into Cockney as a fun way to learn," he said. "Then I thought that this could be even more interesting if more of the Bible was translated. My main aim is for people who would never consider picking up a copy of the Bible to start reading it. If people pick up some of the life lessons and moral teachings, then it is all to the good."

One of his favourite phrases so far reads: "Jesus took the Uncle Fred (bread) and the Lillian Gish (fish) and fed it to the 5,000."

At the Annunciation, the Angel Gabriel says: "Oi, Mary, you are going to give birth to a currant bun (son) and you are going to call him Jesus." Mary replies: "You what, I ain't been with no fella, you're telling me porkie pies (lies)." And on healings, the translation says: "Then 'e said to the geezer, 'Stretch out your Gorman band (hand)'. He stretched it out and blinky blonky blimey it was made well."

Mr Coles is looking for a publisher.

However, Nick Tate, head of the Qualifications and Curriculum Authority and soon to become Headmaster of Winchester College, said: "I cannot see the QCA recommending it in one of our official publications. The core purpose of English in the curriculum is to introduce children to standard English.

"The Bible exists in many versions. Children ought to be introduced to it in its standard English version and literary versions such as the Authorised Version. If using a Cockney version gets them interested, I would not say it shouldn't happen, but it should not be the main source."

David Charter

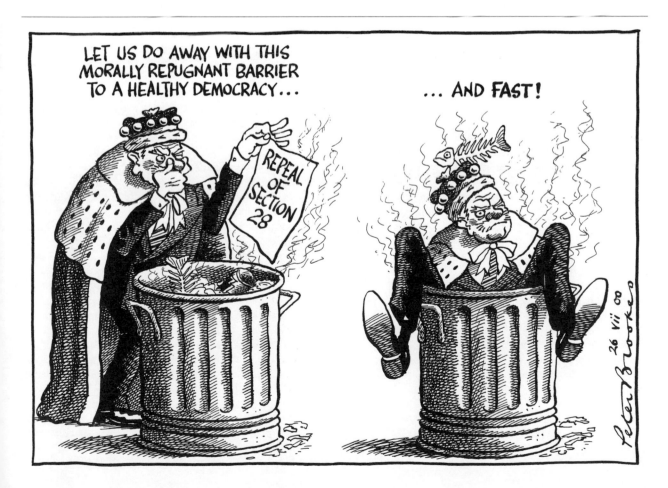

JOHN MORGAN

Elegant author and man-about-town who stood up for good manners in a boorish age

IN ITS three-year existence, Morgan's Modern Manners became an institution in the Saturday edition of *The Times*. Occupying a prime back-page slot in the Weekend section of the newspaper, the column provided a thoughtful, erudite and wry look at contemporary mores. It was both serious and light-hearted, always seeking to define good manners as the path of least offence in its advice to readers. The aim was to remove snobbery and class-consciousness from proper behaviour, and at the same time provide expert guidance on matters of protocol both formal and informal.

Behind the column lay a dapper, well-dressed bachelor who had made himself Britain's leading authority on etiquette. A Burlington Bertie character of his own invention, John Morgan dedicated himself to living the life of a latter-day Mayfair boulevardier.

From his tiny set in Albany, just off Piccadilly, crammed with 60 made-to-measure suits, 300 monogrammed shirts and 90 pairs of shoes, he relished the social whirl of fashionable London. He was always immaculately dressed in a Savile Row suit and silk tie. He had an encyclopaedic knowledge of style and an informed love of opera. His handwriting was impeccable, his correspondence witty and courteous, his personal stationery and luggage labels as elegant as could be. He cashed his cheques at Claridge's.

While Bond Street and Jermyn Street adored him, there were others who dismissed his column in *The Times* as froth. But the size of his weekly postbag was evidence that his column met a genuine yearning for guidance among readers who aspired to practise both courtesy and civility in an age of often boorish informality.

The challenge facing Morgan and his readers was that the old hidebound rules were not always appropriate in the post-Sixties society of relaxed sexual and social manners and the end of deference. Those who stuck too rigidly to the old form could easily find themselves ridiculed as pompous and outdated. Yet the relaxation of strict codes of conduct caused consternation among those who lacked social confidence and wished not to be conspicuous or to feel awkward.

Morgan was a guide through a life which had become an unfamiliar minefield of absurdity and petty humiliations. He offered timeless solutions to the dilemmas of the day. How to open automatic doors for ladies; the polite way to consume such challenging fruits as the banana; and whether the wearing of a trouser suit at a Buckingham Palace garden party might cause offence: these were the subjects dealt with in his most recent column and were typical of the problems which trouble the sensibilities of *The Times*'s socially fastidious readers. As Morgan recently wrote of his correspondents: "En masse they paint a fascinating picture of Britain today: a nation that both enjoys its traditions but also relishes experimenting with innovations in behaviour."

A recent compilation, *The Times Book of Modern Manners*, brought together the best of Morgan's columns under such headings as First Impressions, Holy Deadlock and Sexual Diplomacy. Last year he plotted a path through the minefield of modern behaviour by completely rewriting *Debrett's Guide to Etiquette*. He used the publication to ostracise breast-feeding in public, chastise those who openly discuss their change of sexual orientation, and condemn the poor corn-on-the-cob to be shunned by all right-thinking dinner party hosts. Widely consulted by those who believe in good manners, the book was derided in less refined circles. *The Guardian* sniffed that "The trouble with social dictates is that they stifle humanity. They leave no room for instinct, warmth or spontane-ity." This was to ignore the warmth and humanity which informed Morgan's always sensible advice.

Though Morgan's manner or manners might have suggested a typical product of Eton or Harrow and Oxbridge, his background was a little more unconventional. Born in Perth, the son of a Shell employee, Anthony John Morgan studied at Cheltenham Art School, supplementing his student grant by playing the piano in a local restaurant. He then headed for London where he found a year's employment as an assistant to the Australian fashion consultant Percy Savage.

During the course of a series of low-level jobs in the capital Morgan nursed a burning desire to join the magazine publisher Condé Nast, and when the company founded its *Gentleman's Quarterly* (GQ) magazine in 1988, he was signed up as a style writer serving under a series of editors including Alexandra Shulman, the late Michael VerMeulen and, most recently the current editor, Dylan Jones.

Through all the changes at Condé Nast, Morgan remained a permanent fixture, rising to become style editor with responsibility for a section of the magazine, and was fondly regarded by staff at all levels. Away from his successful writing career he found a lucrative niche providing tailor-made advice to captains of industry on their visual appearance and was recently consulted on matters sartorial by William Hague, of whom Morgan was a great supporter, and whom he advised to stop flirting with baseball caps.

He was regularly called upon by radio and television programmes to dispense advice or commentary on social situations or matters of style.

John Morgan did not marry. He is survived by his parents and a brother.

John Morgan, author and arbiter of style, was born on May 28, 1959. He was found dead on July 10 aged 41.

The best of Modern Manners

MANY READERS have suggested that as a tribute to John Morgan some of his advice should be reprinted. Here is a selection.

Q

There seems to be confusion about the etiquette of social kissing. When – and whom – should we kiss on the cheek? Should we kiss once, twice or even three times like some continentals? Standardisation of a practice, which can cause awkwardness and embarrassment, is surely long overdue.
Philip Watson, London W9; September 1997

A

Social kissing, as the name suggests, is usually reserved for social life, unless you work in lovey-dovey metiers such as fashion, magazines, the theatre and so on, where no professional greeting is complete without osculatory over excitement. It is crass and presumptuous to kiss people you are meeting for the first time: a traditional handshake or small nod of the head is all that is called for. The only site for a social kiss is the cheek: attempts at mouths, foreheads or any other part of the anatomy display distinctly sexual rather than social intentions. One kiss is usual for the older generation, two quite permissible for young people, but three is quite excessive for any age. If kissing twice, it is usual to adopt a left-right sequence.

Q

Whenever I am telephoned out of the blue by a friend with a ghastly invitation, I find it hard to think of an excuse fast enough and always end up either accepting it or sounding like a lying hound. Can you help me with a nifty formula?
Mrs G.Page, Norfolk

A

You need a DDD, also known as a

John Morgan

Double Diary Device. It allows you to play for time while you make up your mind. All you have to say is: "I'd love to but first I must look in my office/home/upstairs/downstairs/husband's/wife's diary. Can I ring you back?"

Q

How can I avoid uncomfortable silences after making introductions at a party?
Oliver Ryder, London SW6.

A

Immediately after introducing people, follow up with a short biographical detail such as "Peter has just been to Antarctica" or, even better, say something that establishes common ground between guest and host, for example: "Peter and I met when we had holiday jobs as Butlin's Redcoats."

Q

I am not normally clumsy, but while with a new girl friend at a restaurant I accidentally knocked my drink all over the tablecloth. My embarrassment was made worse because the staff took a long time to clean up the mess. What should I have done?
Name and address withheld

A

Insouciance is called for. If waiters do not respond immediately, quickly spread your napkin over the offending stain, which at least hides it from view.
 Anna Wintour, the super-cool editor of American *Vogue*, showed great aplomb when a dead animal was thrown on to her table at The Royalton in New York by an anti-fur protester.

Unperturbed, she placed her napkin over the offending article before imperiously summoning staff to remove it.

Q

I have known my parents' next-door neighbours all my life. I went to school with their daughter, and yet they still expect me to call them Mr and Mrs Morton. I am now 28, married with a child, and frankly I find this demeaning. I tried calling them "Mr and Mrs M", and have now given up addressing them altogether. How do I coax them into letting me call them by their first names?
Nicholas Gordon, London W11; September 1997

A

Theirs is a generational attitude. Do not flout it.

Q

There are many conflicting opinions about the use of fish knives. Would you please, once and for all, put paid to this problem.
Maurice Taylor, Shrewsbury

A

Poor old fish knives, what scorn these tools attract. The prejudice around them developed in the 19th century, when there was a simultaneous proliferation of new money and novel eating implements. Fish eaters (as they were called) became associated by some with the *nouveaux riches*. Those who wished to make a point continued to eat fish either with a fork and a small piece of bread in the old Georgian style, or later with two forks. Despite this, fish knives are to be found at some grand tables. So if you've got 'em and like 'em, then use 'em.

Q

I have long been fascinated by the idio-syncrasies of the English language, and the intricacies of its correct usage. But one thing has always puzzled me. Why is it "common" to say pardon and serviette?
Mrs Victoria Stubbs, Leicester

A

A very old peeress once told me that reservations about the words "pardon" and "serviette" go back to the Napoleonic Wars, when it was deemed unpatriotic to use words of obviously French origin. This seems a valid expla-nation, and, as they say, "plus ça change".

......................................

Q

When is it acceptable to tell someone there is something about their appear-ance that they would find embarrassing, such as having spinach on their teeth, their flies open or, as I witnessed at a party, a woman with her skirt tucked in her knickers?
G.W., Cirencester. October 1997

A

Always.

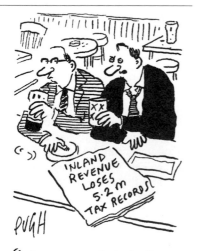

" I'M GOING TO SUE FOR INCOMPETENCE - THEY DIDN'T LOSE MINE "

How smart are you?

Our *Easy Money* team tests your financial acumen

Anne Ashworth

......................................

ONE OF the great things about being grown-up is that you need never again spend the summer taking examina-tions and waiting in dread for the results. But we r\ain a sneaking fond-ness for those magazine quizzes that test whether you are a loser in rela-tionships, or have the entrepreneurial stuff of which dot-com millionaires are made.

In *Easy Money*'s quest to keep you focusing on your cash, we offer a quiz to test your knowledge of personal finance facts. Find out whether you are financially fit or whether people could kick sand in your face.

1 The Isa is new Labour's own tax-free scheme. But what do the letters stand for? (a) Investment Savings Account (b) Individual Savings Account (c) Inclusive Stakeholder Account.

2 Which of the following is not a building society? (a) Nationwide (b) Abbey National (c) Britannia.

3 What is your annual Isa investment allowance? (a) £500 (b) £50,000 (c) £7,000.

4 A customer of NatWest withdraws cash from a Barclays hole-in-the-wall machine. What fee will he or she pay to NatWest? (a) No fee (b) £5 (c) £1.

5 The Halifax owns Intelligent Finance; the Co-op Bank has smile. But what is the name of the Abbey National's Internet operation now being widely advertised? (a) abbey-ness.com (b) cahoot.com (c) habit-forming.com

6 How large is the Premium Bond jackpot? (a) £1 million (b) £1,000 (c) £10 million.

7 What is the Footsie? (a) a stock mar-ket index based on the 100 largest companies (b) a stock market index based on all companies (c) a game played under the table at parties.

8 What is an OEIC? (a) an EU direc-tive (b) a stock market investment (c) an ill-mannered lout.

9 What is the basic rate of tax? (a) 10 per cent (b) 40 per cent (c) 22 per cent.

10 What is an Australian-style mort-gage? (a) a loan where the interest is recalculated every day (b) a loan from an Australian-owned lender (c) a loan for those who like drinking lager.

11 What rate of stamp duty is payable on the purchase of a £150,000 flat? (a) nil (b) 10 per cent (c) 1 per cent.

12 Your partner to whom you are not married dies without leaving a will. What are you automatically entitled to inherit? (a) everything (b) nothing (c) nothing, but you may have rights under the Inheritance Act.

13 What is this year's deadline for the completion of self-assessment forms for those who want the Inland Revenue to calculate their tax? (a) January 30, 2001 (b) April 6, 2001 (c) September 30, 2000.

14 Tax avoidance is (a) legal (b) ille-gal (c) it depends whether you have friends in high places.

15 Your overhear someone say: "Of course, I'm DC." What is he referring to? (a) his sexuality (b) the company pension scheme of which he is a mem-ber (c) his stock in electricity compa-nies.

16 Advertisements for credit cards, personal loans and other credit deals carry information about the APR. What do the letters stand for? (a) Annual Percentage Rate (b)

Approximate Percentage Rate (c) Astronomical Percentage Rate.

17 Which credit card has the highest rate of interest? (a) Barclaycard (b) egg (c) Nationwide.

18 What is the current average interest rate on an instant access savings account? (a) 1.73 per cent (b) 7 per cent (c) 10 per cent.

19 What is the Halifax's current standard variable mortgage rate? (a) 10 per cent (b) 7.74 per cent (c) 5.5 per cent.

20 The FSA is the City watchdog. What are the letters FSA an abbreviation for? (a) Finance Standards Agency (b) Financial Services Authority (c) Financial Swindlers Administration.

YOUR SCORE

15 to 20 points: We are impressed by your knowledge. Indeed, we are even surprised that you had time to complete the quiz in between checking the rate of interest on your savings account, calculating your potential pension payout and walking miles to find a cash machine where you will not be charged a fee. Woe betide if your bank makes a mistake as you will spot it immediately.

However, there may be a downside to your solvent state: we suspect that your friends are always touching you for a loan. If you are unattached, your financial acumen – always an attractive feature – should ensure that you do not remain so for long.

Seven to 14 points: If your score is at the lower end of this range, remedial action is necessary. Your optimistic nature is leading you astray, deluding you into thinking that the financial services industry has your best interest at heart.

If you erred on such questions as the self-assessment deadline and the average rate of interest on a savings account, we suggest that you consult the Inland Revenue website (www.inlandrevenue.gov.uk) and check what rate you are earning on any savings and paying on your cards. For loan and savings best buys, consult Weekend Money in Saturday's *Times*. Or visit the website of Moneyfacts, the financial information group (www.moneyfacts.co.uk). If you are looking for love, we advise you to ask potential partners to take this test and steer clear of anyone with a low rating.

Nought to six points: As the song says, *The Only Way is Up*. But, fear not, the process of financial empowerment will be enriching. Remember that banks and other financial services providers profit from customer ignorance and inertia.

If you are on the hunt for a significant other, your search should not be for a ten but someone with a score of 15 to 20 in our quiz.

ANSWERS: score one point for every correct answer.

1-b, 2-b, 3-c, 4-c, 5-b, 6-a, 7-a, 8-b, 9-c, 10-a, 11-c, 12-c, 13-c, 14-a, 15-b, 16-a, 17-a, 18-a, 19 b, 20-b.

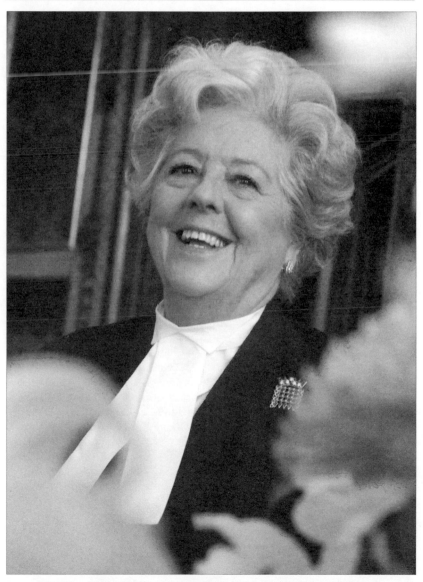

Speaker Betty Boothroyd looks forward to an "active retirement"

WINDOW ON WHITEHALL

Blair's blend of presidentialism and populist concern

Labour has begun to spring leaks. All parties do, in government. But the latest, a document from Tony Blair's own hand, will cause particular consternation in Whitehall. This is not because it reveals a Prime Minister "out of touch", but because it shows him to be worried to the point of obsession by popular sentiment. The spirit of Labour's fabled focus groups runs through the Blair memorandum reproduced in *The Times* today. Written on the weekend before the local elections, this short missive reveals more about the inner dynamics and underlying thinking of Downing Street than the weekend's "candid" television camera playing on Alastair Campbell ever could.

The two most striking aspects of Mr Blair's note to colleagues are the implicit presidentialism and the explicit sensitivity to the power of what are described here as touchstone issues. He acknowledges that there are important matters of perception to be addressed. His response is then – through his own men, not necessarily the ministers concerned – to insist not merely on a shift in media approach but on additional policy innovation. Some of Mr Blair's detractors will seize upon sentiments such as "I should be personally associated with

as much of this as possible" as arrogance bordering on megalomania. Others might regard it as no more than a recognition that the Prime Minister alone can promote a new message.

Yet this window on No 10 also suggests that there are limitations on Mr Blair's authority. It accurately outlines a new communications effort – on crime, defence, "Britishness", adoption and the attempt to be more respectful of tradition and less devoted to modernity – that became the hallmark of a series of speeches and initiatives in the months since it was written. The redeployment of Mr Campbell, which finally occurred in the aftermath of the Laura Spence saga, becomes clearer, as does the backdrop to Mr Blair's address to the Women's Institute. The core features of this week's Comprehensive Spending Review – an emphasis on law and order and caution over defence cuts – are also anticipated.

It cannot be claimed, however, that this blueprint was executed smoothly. To the enduring frustration of Downing Street it has not been possible to redirect the political agenda by central command. Crime continues to be an area of embarrassment and the latest attempt to liberalise adoption

has not dominated the headlines. The Women's Institute, inexplicably to Mr Blair, proved an unsympathetic audience for a speech crafted to appease its members. The Prime Minister has the standing to ensure that his words can move the national debate in a different direction. He does not, though, as is now evident, have the capacity to control the course of the subsequent conversation. This should, in truth, be welcomed by voters.

The public manifestation of the private musings of a Prime Minister is a mixed blessing for his opponents. William Hague will doubtless exploit admissions such as "we are perceived as weak" and "soft" or "insufficiently assertive". But Tories would be wise to observe that at a time when most of the Labour Party was obsessed by the imminent victory of Ken Livingstone in London and the discontented "heartlands" Labour elector, the Prime Minister continued to see as his primary target the "borderland" citizen who backed Labour for the first time in 1997, or who could be converted to the cause next time. The Conservatives have been setting the pace on populism. But this memorandum serves them warning that this is territory which Mr Blair will not easily concede.

Oops, the real Tony Blair just slipped out

The leaked memo reveals the egotist behind our smiling Prime Minister

Michael Gove

......................................

WE'VE HAD the articles ("My love for the Pound", April 17, 1997, *The Sun*); we've had the interviews ("My hatred of suits", *Prima* magazine, May 5, 2000); and we've had the speeches ("Why tradition is holding this country back", Labour Party conference, September 28, 1999, then "Why tradition is such a good thing", Women's Institute conference, June 7, 2000).

All these contrived pronouncements are designed to imprint the personality of the Prime Minister on our minds. Yet the harder he tries, the greater the confusion. Tony's a kinda modern, sorta traditional, really tough, nicely tender, mug-bearing, chino-wearing, kid-smacking Diet Bloke. But apart from saccharin and fizz, what is there to the PM? Will the real Tony Blair please slip up?

Now he has. The memo leaked to *The Times* and *The Sun* yesterday is more revelatory than any other statement made in Blair's name. It comes direct from the anguished heart of power and lays bare the persona. Now we can see that the real TB (Testosterone Bully?) is an image-obsessed, spin-driven, ego-absorbed, hucksterish hypocrite. The man who denounces William Hague for shallow populism asks for an initiative such as "locking up street muggers" with "immediate bite". The junkie needs his fix, so he lashes out on the streets: TB needs his headlines, which is why he lashes out in print.

And hits Jack Straw square in the solar plexus. Lamenting the rise in crime, TB takes a sideswipe at the man responsible for explaining crime policy to the voters. TB notes "the Met Police

are putting in place measures to deal with it; but, as ever, we are lacking a tough public message along with the strategy." This is the authentic TB (Teenage Boy?) in full strop mode. If I were Mr Straw I might say that I was carrying out what was believed to be the correct strategy, that I hadn't noticed any recent press profiles suggesting I was a pansy and that if anything undermined our reputation fighting crime it was allowing a compulsive stealer of the limelight ("I should be personally associated with as much of this as possible. TB") to operate with impunity.

Indeed if I were Home Secretary I might say that the dignity of my office, and respect for the rule of law, were not helped by an accelerating blitz of half-baked announcements designed to reassure TB (Tetchy Bossyboots?) that he was still loved by the focus groups of Basildon. As it is, Mr Straw must suffer in silence. Or "attend Cabinet"

as it is now known.

For all those who thought TB's style of government would be kinder, gentler and more inclusive, for those like Paddy Ashdown who asked if TB was a pluralist or a control freak, this memo underlines what has been apparent to the rest of us for a very long time now. This Prime Minister is driven to the point of mania by the need to control, and dominate, not just his colleagues but every detail of how he is perceived by the public.

It might be argued that there is something of Margaret in his madness; that TB (Thatcher's Body-double?) wants to be seen, like Maggie, as the interventionist populist on the electorate's side against the entrenched Establishment. But wanting to be seen in the same way as Thatcher is very different from wanting to act in the same manner.

Take their attitude to the most important responsibility any Prime Minister

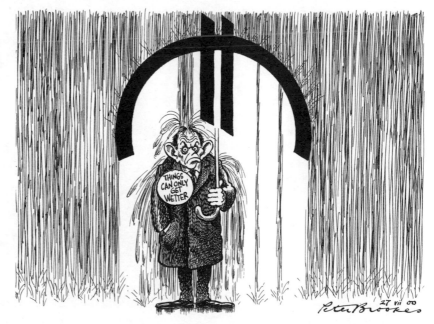

has – defending the realm. Reading TB's memo, one doesn't get a sense of a Premier, as Thatcher did during the Falklands, agonising over what high national purpose our defences should serve. Instead, the Kosovo War is an opportunity to lay to rest doubts about his "strength", the defence budget an occasion to win back electoral ground by being seen to be "standing up for Britain". But then what else can we expect from a Prime Minister who prepares for a statement on the bombing of Iraq by watching Harrison Ford's *Air Force One*?

Where Thatcher knew, in her guts, that she was right, TB steers by the sound of applause. The difference between them is the difference between activity and facsimile, Henry V and Kenneth Branagh.

Those still disposed to see the best in TB may try to draw comfort from his obvious assiduity in taking the pulse of Middle England. But even as Blair recognises that crime, asylum, the family and defence are "touchstone issues", he fails to realise that he cannot win back trust on them with another instant withdrawal from the policy Cashpoint. We know Blair's broader values are inconsistent with how he now wishes to appear.

These "touchstone issues" are important because they reveal the man within in a political world where we want authentic personalities not economic technicians. One of the enduring consequences of Thatcherism is that voters regard wealth as something individuals earn, not something governments deliver.

So, increasingly, politics is about the culture, dummy. Voters want to know if the Government is on their side: patriotic, supportive of the law-abiding majority, defending embattled families. And we want politicians whose personalities are instinctively in tune with those values.

What we don't want is someone constantly seeking our approval while proceeding to trash our values. From the release of terrorist prisoners, through the setting of quotas in the police force, to the remorseless transfer of powers to the EU, TB has already proved he is "out of touch with gut British instincts". No matter how many "eye-catching initiatives" TB now personally associates himself with, we've got the picture. He's weak on terrorism, soft on political correctness and out of touch with national feeling. The real Tony Blair just slipped up. Shouldn't he now stand down?

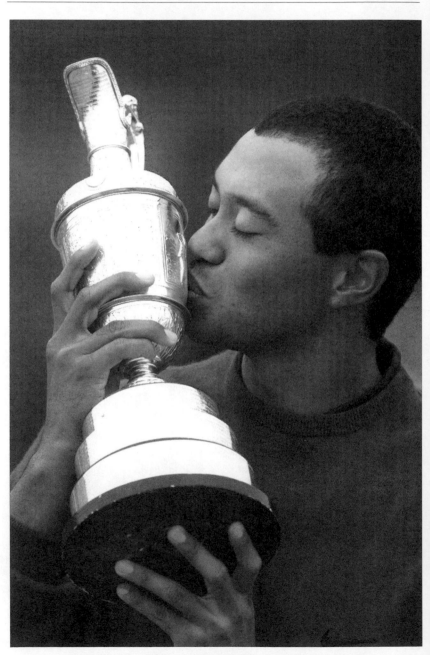

Tiger Woods celebrates victory in The Open at St Andrews

Chasing a transport of delight

Valerie Grove talks to a belligerent John Prescott about his plan to get Britain moving

Valerie Grove

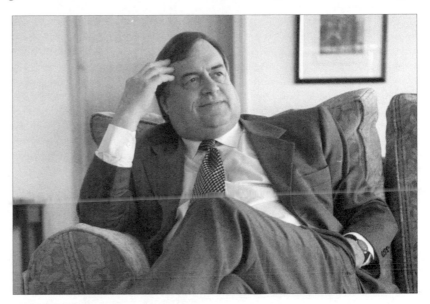

I ONCE SHARED a nightmare journey on the Piccadilly Line Tube with John Prescott. It was rush hour and we had to stand cheek-by-jowl all the way to Heathrow Airport. We were then crushed like sardines in a British Midland plane to Brussels that took off hours late and Mr Prescott, a rumbling volcano, was in no mood to enjoy talking about Fleur Adcock's poem about kissing John Prescott in a dream, which in 1996 had turned him overnight into the sex god of the Shadow Cabinet.

Yesterday I avoided the Tube when I went to see Prescott, 62, at his plush office in Victoria. But I had a terrible journey (by car) and thought I'd tell the Transport Secretary why. Big mistake. "The dustbin-men," I began, "jamming the road at 10.15am. The commuters parking on both sides of narrow roads. Then the cable-digging navvies, who had carved up the road, fenced it off and sat eating their sarnies in the sun while an almighty jam formed."

"What do you want me to do, cry?" stony Prescott said, unmoved. "Why didn't you come by public transport?" He is a hard taskmaster. When I said bins should be emptied at times other than the rush hour he got really sneery. "So the bin men stop you driving about in your car?" As for the cable-digging navvies, "Oh give over," he said, "for God's sake. They have human characteristics and sometimes have a sandwich and a cup of tea. I can see you now, fuming behind the wheel, saying: 'Everybody's wrong but me. They should use public transport – particularly the ones in front of me.'"

He then lectured me on bus lanes and the idiots who park in them ("radical solutions will have to be adopted") and said his mission in life was to get even people like me using buses. I am too busy to stand in queues. "But if buses were frequent and reliable? Buses are running around empty. If I could get six more people on each bus, the industry gets £400 million more revenue and fares reduce. Look at all the flak I got when I suggested a bus lane on the M4. Twelve months later the buses go faster, and cars get there quicker, because we reduce the speed and control the flow. That's integration. These aren't theories any more, they're happening. The problem for me is, most people associate stress with public transport and it takes money and a whole change in culture to change that."

Dear old Two Jags. "Two Jags! I've got one Jag which is mine, I've got one car, one house. The second Jag is a government car.

"Ministers, ex-Prime Ministers, we all get bloomin' Jaguars, and I'm not objecting, it's a British car, I like it. My own is second-hand, nine years old. I've actually got three Jaguars, but one's a bike, built by Raleigh." He sometimes cycles on it around the leafy bike lanes of Hull.

I remark that when people get together, the main talking point is now not the weather but the tale of their terrible journey. "I am delighted," he said, "that transport's top of the political agenda. In politics, if you got a job in transport, it used to mean you were on the way down."

He remembers the Marples Must Go car stickers, when Macmillan's Transport Minister, Ernest Marples, was the motorists' hate figure. "But transport's always been plagued by short-term decisions. It's easy to cut capital programmes when you've got a problem in the economy and that had a massive effect on public transport industries. When I came in three years ago I said: 'Right, we're looking for fundamental change.'"

So his long-awaited grand plan was presented on Thursday, with the personable Gus Macdonald fielding Jon Snow's and Paxo's batsmanship, and two toughies, Sir Alastair Morton and

Tom Winsor, to assure us that the rail companies would deliver. Ken Livingstone kept popping up with a pained expression, griping about having to pay off the Jubilee Line debt.

"Well, I've been paying an awful lot of money for the Jubilee Line, which cost £2 billion more than it should, but the bills still have to be paid. He is now responsible for the London budget. So what's surprising? Whatever Ken thinks, he's got more money than London's ever had for its transport."

What does he think of Livingstone's congestion charges for Central London? "We gave all mayors that choice and he says he's getting on with it. Good. But he's got to use the money he raises for the improvement of public transport; otherwise he can't have his scheme. It takes two to tango."

He was irritated to be asked about Livingstone at all. "Yours is a national paper isn't it? Ken's London, Ken's not a national figure."

He would rather speak of the successes of park-and-ride in York, the light railway in Manchester, speed humps and 20mph limits that have reduced child road deaths in Hull and the £59 billion he has given to local councils for improvements, which include school buses. And of the growing popularity of pedestrianised streets and canal walkways. He would rather defend his bypasses, although everyone knows new roads simply attract more cars. He even speaks of restoring and enhancing some of the old rail track lost under Dr Beeching's axe, with single freight tracks.

"The greatest thing that has happened to transport, to my mind, is that it's become a growth industry. Traffic is a problem of growth, not of decline, which has dictated the transport system for decades. One reason is the strength of the economy: there is a correlation between economic success and people moving about more. And now industry sees the increase and they're queueing up to invest, because they realise this Government believes in public transport in the long term."

He is going off diving this summer. Didn't he get into difficulties while diving off coral reefs in the Maldives once? It was on the BBC news bulletins. Prescott protests it was rubbish, a journalist who had never dived in his life had come with him and when Prescott's mask leaked the journalist saw it as a crisis. "Journalists like characters," he said, "and they've decided I'm one, and they'll write any kind of rubbish that makes people smile. So when I do serious things, that's what happens. I have to live with that."

On the *Today* programme that morning he'd sidestepped Jim Naughtie's question about the Philip Gould memo, but murmured: "All that glisters is not Gould." Good joke. Who said it was a joke, said Prescott. He has cleverly kept outside such Machiavellian intrigues. Now he was off to do the Jimmy Young show, by cab. "I use all forms of transport. I won't say one is superior to another." I had a long hot drive home: jams, roadworks, diversions, clamps. Next time I'm Tubeing it.

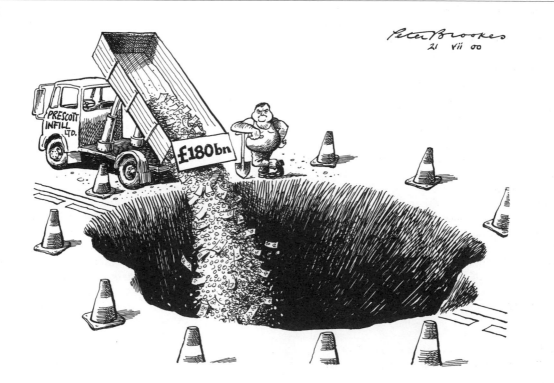

ginny dougary

new york stories

POOR KELSEY GRAMMER. What a drubbing he received from the New York critics for having the temerity to transform himself from one angst-ridden hero ("Hullo, I'm Dr Frasier Crane, how can I help you?") to another ("Is this a dagger which I see before me?").

Among all the slings and arrows of *Schadenfreude* – the play closed barely a week after what was intended to be an eight-week run – there was a distinct feeling that it somehow served Grammer right, a mere TV star, for having the vaulting ambition to think he could carry off one of the big Bard roles.

I caught his Macbeth during a brief visit to New York last month, and found myself wondering whether the critics hadn't missed the point about the theatre. Could it be that in England – for all our reputation as elitist snobs – we are rather more open than our American cousins to the idea that actors are, indeed, acting and not just displaying different aspects of a character whom we have become accustomed to seeing in one particular role? There are times when our tolerance seems to extend even to non-actors getting in on the act – vide Jerry Hall replacing Kathleen Turner as Mrs Robinson in *The Graduate*. Neither do we seem to have any problem, quite the contrary in fact, with welcoming celluloid Hollywood stars on to our boards. Turner, Donald Sutherland, Kevin Spacey and Nicole Kidman have all strutted their stuff of late on the London stage.

Perhaps Grammer should have tried the same route.

What did rather astound me was my New York friends' hostility to the actor. I lived in Manhattan for a year in the early Eighties, and the past – with apologies to L.P. Hartley – is also a foreign city, certainly in this case, since the Big Apple was rotten to the core in those pre-Giuliani days, which for some of us was part of its rackety, edgy appeal. In the intervening decades, I have had little occasion to be reminded of the great gulf in thinking which lies between Los Angelenos and New Yorkers. I was reconnected with it during various robust discussions with my gay pals; the upshot of which seemed to be that since *Frasier* is an LA creation, and it also happens to be where Grammer lives, he should have damn well stuck to his own turf, and left New York to showcase the talents of its own tribe.

I have been back to Greenwich Village on numerous occasions since I lived there, with my then freshly minted husband, in a series of tiny sub-let rooms. In those bad old days, you could not pass a street corner without someone rapping: "Smokes, coke, uppers, downers, loose joints, loose joints." In Christopher Street, the gayest of the gay streets, the men would cruise openly, almost defiantly so, and the whole village was charged with the rush of expectant sex. I worked in a vintage clothing store, The Good Old Days (now a sex-aids shop called Pornocopia) run by an elderly Jewish couple called Bernie and Ethel. Perhaps because their sons were big-shot Hollywood film producers (no, really), but certainly because their schmutter was of a very high quality, a lot of stars – from Robin Williams to David Bowie –

would shop there. This intermittent brush with celebritydom certainly gave the life of a shop girl a little lift: "Mr Bowie, can I interest you in this pair of Gatsby flannels, 28-inch waist, I think they might suit?" With the onset of Aids, everything in the Village became sober, in every sense. Until my recent visit, my old stomping ground seemed progressively bleached of any kind of atmosphere at all. Safe sex, safe everything, seemed to prevail. Which was why it was so extraordinary to be there, this time round, during the Gay Pride weekend. I missed the parade itself, unfortunately, but en route to my chums' chum's party in West 10th street, I contented myself with examining the debris of discarded stickers on Fifth Avenue: "God made me an Asian Queer" was one of them.

As I walked on, approaching the heart of the Village, there were drag-queen hookers squabbling over their patch, and men in vests and shorts snogging, a sight I have not seen for a very long time. Turning into West 10th towards Bleeker Street, I saw half-a-dozen youngish and not so young men sitting on the steps of a brownstone house, drinking and hanging out and surveying the talent. It took a second or two to realise they were my fellow guests at Charles's, the Swiss banker's party.

Two of our best friends from the time we lived in New York have died, one last year, and he owned an apartment on the top floor of the same building I was in now. And every one of our friends from that carefree era – and there are a lot of them – has Aids. I forget that they are ill when I am sitting with them, smoking and drinking and arguing about *Frasier*. But, actually, I suspect that they, like me only more so surely, relished that strange kind of oblivion – the sense of time collapsing, but also, more hopefully than that suggests, being somehow regained – on seeing the streets thronging with happy, and, yes,

proud, gay men projecting all the narcissistic hedonism that culture, for good or for ill, used to project.

At some point in the evening, before we had adjourned to watch the fireworks a few blocks away, when I was trying not to look too hard at the Poodle Men (two guys in pink fluffy bikini pants and brassieres, with very erect tails, cerise Louis Quatorze pompadours, and Rollerblades covered in layer upon layer of pastel rose petals – well, OK, I confess I had a photograph taken with them), it hit me with some force how extraordinary it was that the first place my husband and I had lived in was in the apartment block opposite this one.

It was one room, attached to a minuscule kitchenette. Below us was a nightclub, which we figured catered to a rather exclusively antiquated gay clientele, since the only music pumped out were songs by Neil Diamond. Oh God, the horrors of waiting for that 3am start-up of *Sweet Caroline* and *Cracklin' Rosie* played again and again in an endless loop.

"What was the club called?" my friends at the party, old and new, asked me somewhat urgently. Of course, I could not remember and probably never even knew its name. But what I could recollect, with absolute springy freshness, was what it felt like to be that young childless woman in her twenties, again, leaving that strange little room, to go out to work at midday round the corner at The Good Old Days, or dressed up at night in the great Fifties frocks I blew all my hard-earned wages on, off to some club in Harlem, where my husband worked, or to the pubs where Dylan Thomas drank or Bob Dylan sang, a generation or two earlier, and it was like one of those arrows where real-life memory, summoned so vividly but from a place so far in the past, had already been transformed into some kind of potent fiction of the present.

The slow toil

As the task of clearing the Concorde crash site begins, local people grimly accept that their town will be for ever linked to tragedy

 Carol Midgley

TWELVE HOURS after you first smell the acrid, billowing white smoke, it still clings to the back of your throat. It has a curious taste – nauseous, cloying and sickly sweet – and the local bystanders who walk away gagging and covering their mouths don't want to think about what they are inhaling from the charred hulk that was Concorde Flight AF4590.

Anyway, they say, this pall of smoke will eventually disperse. But the pall of shock and wretchedness that hangs over the town of Gonesse will probably never fade. The people of the town are resigned to the fact that their home, an unremarkable suburb housing 25,000 people, now has its place in history as the town where Concorde died.

Like the Dunblanes, the Hungerfords and the Omaghs of this world, it will be for ever synonymous with catastrophe, tragedy and grief, and there is nothing the townspeople can do about it.

This air of weary despondency is obvious among those who have trudged along the dual carriageway between Gonesse and Le Bourget to gaze at the forensic operation. Some lift their children on to their shoulders for a better view; younger people bring radios and beer; others just stare in silence. But most of the onlookers acknowledge that, sometime or another, an air disaster was going to happen here. With 500,000 aircraft passing over Gonesse every year, the odds were always stacked in favour of "a big one". Yet no one expected it to be quite as big as this.

Some of the bodies, say those who have been watching for a while, have been placed in bags and taken to the local morgue. Two young men, who have defied the police cordons to seek

A grounded Concorde stands at Heathrow

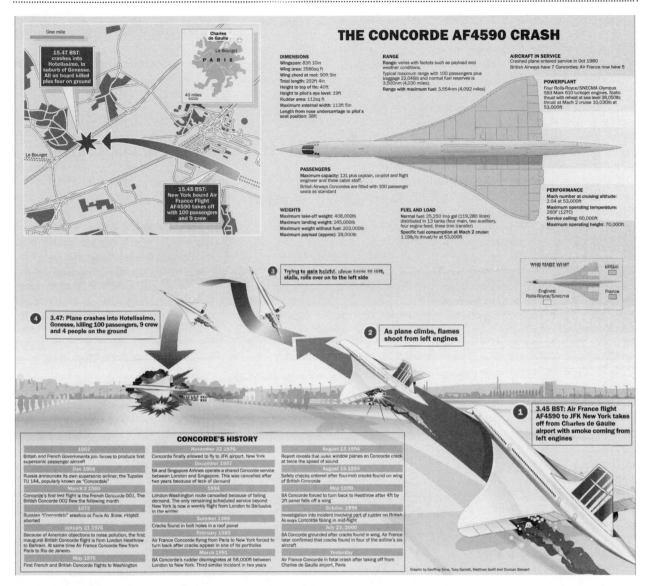

out a vantage point in a field close to the nearby Hotel Ibis, speculate that the orange cones being put around the site indicate where bodies lie.

From a certain angle there does not seem much wrong in the cornfield 14 miles north of Paris. A large white sign welcoming guests to the Hotelissimo and Restaurant stands intact.

Only when the smoke clears, as it does every so often in a gust of wind, do you see that the Hotelissimo no longer exists. It has been flattened, vaporised, save for a ragged, blackened stump that resembles the crenellations of a ruined castle.

The modest three-star hotel was built of wood and was incinerated within minutes of the crash. Alongside it the wreckage of the most glamorous aircraft in the world, the ultimate symbol of affluence, looks like something that might be found in an average scrapyard.

Apart from a twisted chunk of metal here, perhaps a wheel, a nose-cone over there and, most pitifully, a suitcase, virtually nothing is left. The rest was scorched into the earth as the plane dropped out of the sky just two minutes into its journey to New York.

That the bodies of human beings still remain in this wreckage is hard to believe, and it is even harder to try to rid yourself of the image of most of the 100 gloriously happy holidaymakers raising Concorde's customary complimentary welcoming glasses of champagne and preparing themselves for the experience of a lifetime – a supersonic flight to New York to join a luxury cruise around South America.

Unbearable to imagine that, having

watched the cabin crew perform the safety demonstration, they would have been expectantly watching Concorde's speed display, perhaps telling their excited, wide-eyed children to watch for the moment when the aircraft would break the 1,200km/h (750mph) sound barrier and the words "Mach 1" would appear on the electronic board near the front row.

Throughout the night and into the early hours of yesterday the emergency services worked in the rain, sifting the wreckage for any clue to the cause of the fire and any scraps that might help to identify any of the 113 victims – 109, including the crew, on board and four on the ground. There was no sense of urgency, no lives to save, just methodical, conscientious toil to make certain that everything would be done to try to ensure that nothing like this would happen again.

Jean Pierre Blazy, the deputy mayor of Gonesse, is concerned about the number of flights passing over the town from Le Bourget and Charles de Gaulle airports. "This is an aviation town," he says. "We are not anti-airports – we live with airports, we have an aviation museum. We are devastated by this. And we don't exactly live in fear. But you can't help thinking that sooner or later there will be a crash. Statistics prove it, and the awareness is always there." He says there is particular concern about the increasing number of charter flights coming over the town, a figure beginning to become "unacceptable".

Others in the town speak of the grotesque sight as the pilot tried in vain to keep Concorde's elegant nose aloft. The most incredible thing about this disaster, they say, is not the number killed but the number who were not. Gonesse's local hospital is directly under Concorde's flight path, as is the town hall, and the death toll could have been much higher if the pilot had not taken heroic evasive action.

Patrick Rival, one of the locals who came from work to watch, says: "People should realise how lucky the people of this town were today, and think how this luck might run out in the

future. We should ask ourselves whether we really need to be putting so many planes in the air every day of the year. How many lives are we risking?"

As he speaks, another jet drones over his head, directly above the smoking

crash site, to land at Charles de Gaulle, as others have been doing every minute since the airport reopened four hours after the accident on Tuesday afternoon.

Tragedy or no tragedy, it is business as usual.

Man about the kitchen

Forget barbecues: they're for wimps, says the Naked Chef.
But a primitive, Maori-style pit oven – now you're talking

JUST BEFORE the lovely Jules and I got married we had a bit of a mad session with 20 or so of our best friends, including a couple of the characters who have cropped up in this column before – my oldest mates Jimmy the zoologist and Andy the gas man.

Jamie Oliver
.................................

It was Jimmy's birthday, so we got together in his garden, and the three of us were in charge of the cooking, which was hilarious because we have a bit of a habit of trying things we know very little about – and this was a classic.

I had just got back from a book tour in New Zealand where I'd spent a bit of time with the Maoris, who are really proud of their tradition of cooking underground. They dig a pit, light a fire in it and chuck in a load of big fat rocks. They let them get really hot, then take half of the rocks out, put a whole goat or a wild boar on top of the rest, put the hot rocks back over the top, and cover the whole lot with earth. Half a day later they come back and dinner is ready – that is, if they can remember where they buried it.

One of the most commonly talked about recipes was pork bones and poo haa, which is basically pork bones cooked for a fairly long time like a stew, with carrots, potatoes and a wild kind of dandelion/watercress.

Jimmy and Andy were well up for a spot of primitive cooking, Maori-style. Of course we didn't really know what we were doing, but we are all strong-

willed in our own way, so we think we know best. Andy, being the gas man, reckons he knows everything about cooking appliances, Jimmy's the biologist, so he thinks he and the earth are at one with each other, and I'm the chef, so I think I know it all when it comes to cooking. Eventually we agreed on a plan.

I hung the Maori greenstone I'd been given around my neck to get in the right mood, and we started digging our hole, about 1m square and 15cm deep, but when we tried to light a barbie inside, so we could get the rocks hot on the cinders, the fire just went out. I was having flashbacks to the last time we lit a fire in Jimmy's field 15 years ago and went off to the corner shop, thinking we'd put it out. Half an hour later we came back and an area of grass half the size of a football pitch was burnt out and Jimmy's dad was trying to slap out the fire with a shovel – never seen a man move so quickly.

We were beginning to lose faith, and to stink of the bonfire, and the thought of Andy cooking on his beloved gas was becoming more and more appealing. Then Jimmy had the idea of putting an old parrot cage on its side inside the pit, with the door at the front, like an oven. He covered the top and sides with slate, which seemed cool, then covered that with bits of metal – his dad's a builder, so there's always stuff like that about – put on another

whole lot well. Then I added six table-spoons of vinegar, to add a sharpness to the onions, ripped up three quarters of a loaf of stale bread and mixed the lot up. When it cooled down it was beautiful: a kind of mushy bready stuffing, which I rammed inside the pig. For the salmon, we did the old classic of stuffing and covering the fish in herbs – parsley, mint and fennel tops – and lemon juice and olive oil. Then we rolled up the fish in a wet newspaper. I'd seen that done some-where, but none of us had tried it before.

We were determined not to do any-thing normal with the pheasants, either. So Jimmy plucked them, then we rubbed the birds with olive oil, and shoved lemons inside with some thyme and garlic. We got some pottery clay from an art shop, which we moulded around them, so they were nice and air-tight. The French do a similar thing with a flour and water dough; they use it as a great seal for stews, too. As the food cooks, the steam has nowhere to go, so it just keeps whatever is inside really moist and beautiful.

By this time we were all pretty revved up about our cunning, earthy, gutsy oven. This made barbecues seem like nothing. We were geezers from Essex at our best, the next greatest thing to cave-men, providing the food for the women. The fire was lit and roaring, Andy had made a little flue, smoke was coming out, cinders were cindering.

Then we realised two things were hap-pening. We had packed so much turf on top of the oven, the cage was warping dramatically. But more worrying was the fact that the fantastic flexible metal that was packed in and around the slate was actually lead piping, which has sent thousands of people completely mad and killed them in water pipes and mugs, etc – as if we needed any help. It was just beginning to melt like mercury and drip on to the cinders – fortunately we hadn't put in the food yet – so we whipped off all the turf, got out all the lead, put the slate back and started again.

Eventually we got the suckling pig, which was going to take four hours,

layer of slate, and finally covered the top and sides with mud. It was starting to look pretty impressive.

We had four things to cook: a suckling pig, which I'd brought, a wicked brace of pheasants, which Jimmy had got, and a great big wild salmon Andy's mate had caught and he had kept in the freezer - not ideal, but what are you going to do when your mate catches you an enor-mous salmon, except save it for a barbie? We also had some chicken drumsticks that Jimmy had bought, ready marinated

in sunflower oil – thanks, Jim: sunflower oil, the flavour enhancer of the year!

I slashed the pig all over and rubbed it with olive oil, cracked fennel seeds, sea salt and pepper. Then I made a really choice stuffing by frying about three chopped red onions with six chopped cloves of garlic and little bit of thyme in about four knobs of butter until the onions were soft. Then I put in some pine nuts, and when they toasted a bit I chucked in a handful of chopped sun-dried tomatoes in oil and seasoned the

inside the parrot cage. We put the chicken drumsticks on the tiles on the top which had got really hot like a griddle, for the last two hours, covered with tinfoil. The pheasants had an hour and a half on the cooler side of the "oven", and the salmon had 20 minutes on to the cinders at the front.

The pig needed to cook gently, so every so often when the temperature fired up a bit, I poured a can of Fosters into the tray in which it was roasting, so it kind of steamed at the same time – I think it probably had about four cans of beer over the four hours. As it cooked, the fat came out, as did the juices from the onion stuffing, which all mixed up with the beer and made a really tasty gravy. There wasn't that much meat on the loin, but the legs were sweet as anything with mash and gravy.

After 20 minutes the paper wrapped around the salmon was completely black, and the salmon, even though it was a little overcooked, was still really lovely and smoky flavoured. The real surprise was the chicken, which ended up a bit like a confit: lovely and crispy on the outside, with really melting, tender, tasty meat, because it had been cooking so long.

The best things, though, were the pheasants. The sauna effect inside the hard clay meant that the thyme and lemon had steamed through and flavoured every millimetre of meat. When we cracked them open it felt quite romantic. It reminded me of when I was a kid. Some of my best friends who were gypsies used to roll hedgehogs in clay and chuck them on the cinders of the bonfire. When you eventually cracked open the clay it pulled the prickles off, and they would eat the meat. I could never bring myself to try it, but it's the same principle.

By the time we got to eat it was about 11 o'clock at night. Jimmy, Andy and me completely stank of smoke, and none of the party wanted to come near us, not even the mozzies, so we sipped the best cheap lager into the night, until Andy pulled, and me and Jimmy fell asleep. Everyone had a hilarious time, and somehow we managed to end up with some brilliant – and some OK – food. But we were all certainly more at one with the great outdoors.

FLOUR AND WATER CRUST CHICKEN

This is a more conventional way of cooking chicken (or pheasant) than our effort. The crust holds the steam inside, giving you beautifully tender meat infused with herbs and lemon.

For a 1.5kg chicken, use 1kg of flour, and add water a little at a time until you have a dough consistency. Leave to rest while you prepare the chicken. Bash some sage, thyme and garlic in a pestle and mortar and add four lugs of olive oil and plenty of seasoning. Peel a lemon, add to the herbs and oil and scrunch together, then rub it all over the bird and inside the cavity. Slice up the peeled lemon and stuff that into the cavity, too.

Roll out your dough, then mould it around the chicken, so that it is airtight. Let it sit for 20 minutes, then bake in a preheated oven at 230C for an hour and a half. Let it rest for 20 minutes before carving.

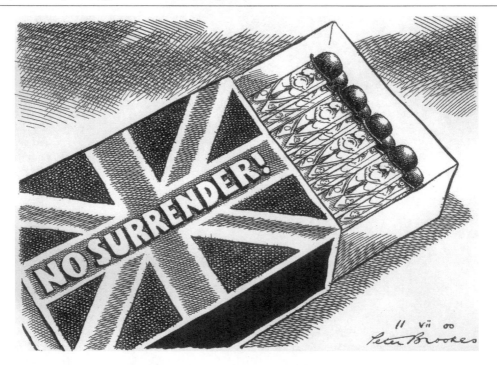

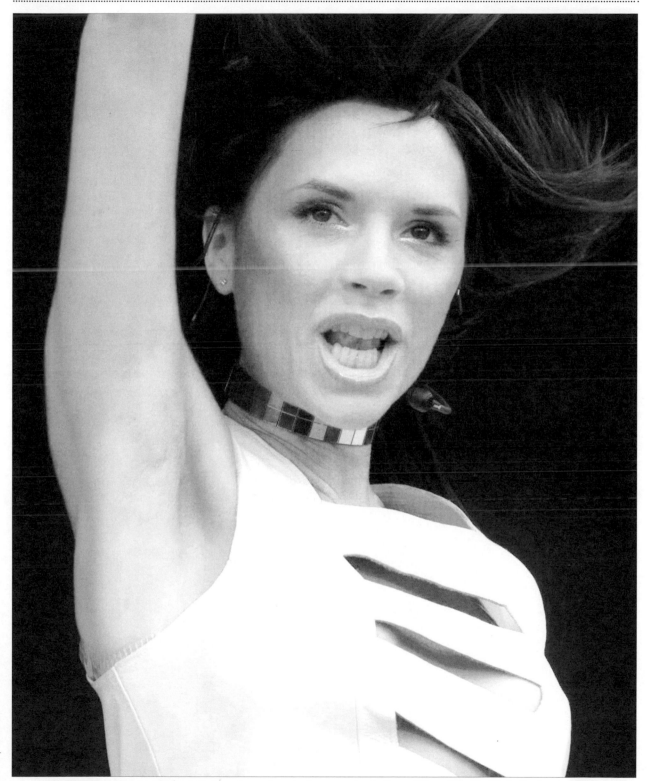

Victoria Beckham, aka Posh Spice, sings along to her new single *Out of Your Mind* in Hyde Park yesterday

THE TIMES

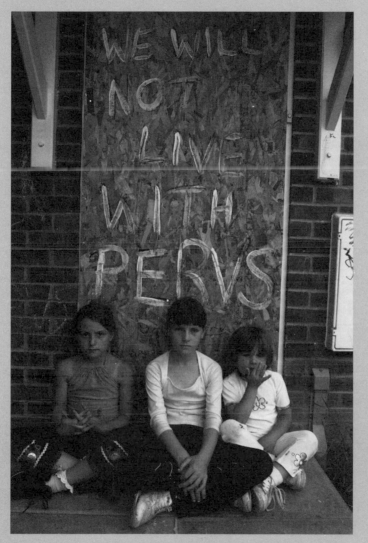

August
2000

SOS for the incredible shrinking euro

Anatole Kaletsky

WHAT AILS the incredible shrinking euro? Ever since the currency's official inauguration in January last year, this question has been perplexing the best economic minds in the Governments and central banks of Europe. It has flummoxed the world's best-paid economists and investment managers, who work in banks and hedge funds in Wall Street and the City of London and, almost without exception, have got their currency strategies completely wrong.

Yet rarely has a major question of political economy admitted of such simple and convincing answers – and, most importantly, of answers that are not just theoretically persuasive, but are vindicated in practice daily by market events.

As the euro sinks back towards the record lows it plumbed in May against the dollar, yen and sterling, it seems worth repeating these answers – and promoting them from the business to the main comment pages. For the chronic weakness of the euro is more than just a business story with an important political angle for countries such as Britain and Denmark, which have yet to decide whether to join the euro club. It is also a saga of political hubris, diplomatic cunning and intellectual self-deception. But let us begin with the dry economic answers. There are essentially three reasons why the euro has been so weak since its launch. First, the American economy has proved much stronger and healthier than almost any economist predicted in early 1999.

Secondly, the European economy, although it has begun to recover from the five years of recession induced by the preparations for monetary union,

has remained disappointingly weak and certainly much weaker than that of the US.

Thirdly, the euro began life at an impossibly expensive level. When it was launched, the costs of doing business in most of Europe were far above costs in America, Japan and Britain. Germany, in particular, was hopelessly uncompetitive, with hourly labour costs 60 per cent higher than those in America and 80 per cent higher than in Britain. These exorbitant costs (related not only to the high euro but also to the funding of social policies) made it very difficult for European companies to compete for new investment and internationally mobile capital in an open global market. And since Germany's labour costs when it joined the euro were 40 to 60 per cent higher than those in France, Italy and The Netherlands, it is hardly surprising that locking-in this disadvantage has quickly transformed the former economic dynamo into the sick man of Europe.

Of course, all these answers beg their own questions. Why was the US economy so strong? Why was the European recovery so feeble? And if the euro was so overvalued from the outset, why wasn't this spotted by the policymakers, economists and investors whose job is to work these things out?

Technology and finance are certainly not the main explanations of the transatlantic gulf in economic performance. After all, in an open global economy, American technology has been available to Europe. And some of the most important advances in mobile telephony, enterprise software, biotechnology and microchip design have been led by European companies. Europe has also been catching up with America in new business formation and in the availability of venture capital; so much so, that the stock-market valuations of Internet and mobile telephone companies are now higher in

Europe than they are in the US.

Meanwhile, the rate of improvement in business conditions has been faster in Europe than in the US. Strikes have become even rarer than in America, deregulation has proceeded apace and competition has intensified. Yet the soaring stock markets, technology fever and price stability that supposedly powered the boom in America (and to some extent in Britain) have produced little more than a dull thud in Europe.

America has taken full advantage of rapid productivity growth and the unprecedented lull in class conflict to expand its economy much more rapidly than before. Unemployment is back to levels unseen since the 1960s and growth has been running at almost 5 per cent a year since 1998, roughly double the average from 1975 to 1995.

But European policymakers have made the opposite choice. They have restrained their economies to grow at roughly the same rates as in the 1970s and 1980s. Breakthroughs in productivity and industrial relations have been used to grind down inflation to unheard-of levels, instead of promoting higher employment and faster growth.

Why have European leaders made this choice? Politically, a deflationary policy was the line of least resistance for the European Central Bank (ECB). The Maastricht treaty was essentially a French trick to neutralise Germany's monetary power. It mollified German sensitivities about inflation at the height of the reunification boom, by making "price stability" the sole objective of the ECB. It left the central bankers at liberty to define this as they saw fit.

The ECB council, displaying a degree of arrogance extraordinary even for central bankers, immediately set itself an absurdly demanding objective – an inflation ceiling of 2 per cent. This

ceiling was lower than the average inflation – and much lower than the maximum inflation – achieved even in Germany for any extended period in the 20th century. Given the inevitable divergence of economic performance between different countries in Europe – a divergence that is becoming more extreme by the day – the ECB should have started with a broad, flexible target.

But the politics of EMU made this impossible. Because the ECB was constituted as a Tower of Babel of conflicting economic interests, its council members were all the more determined to avoid controversy by tying their own hands with rigid and arbitrary monetarist rules.

As a result of its absurdly rigid and over-ambitious inflation target, the ECB is now almost duty-bound to raise interest rates simply because European inflation has blipped up to 2.4 per cent, despite the fact that this blip is caused entirely by volatile oil prices. This further monetary tightening will probably intensify the decline in German business confidence revealed by figures published this Tuesday. Since this decline in business confidence was what triggered the latest fall of the euro, the chances are that an increase in interest rates will weaken the euro even further, in turn provoking new concerns about inflation.

The self-defeating nature of Europe's monetary policy leads to the final question at the heart of the euro conundrum. Why were investors so enthusiastic about the euro in the first place and why do they remain extraordinarily bullish even today? According to the latest Merrill Lynch surveys, 64 per cent of international investors pick the euro as the world's strongest currency for the next year, exactly the same percentage as in January 1999.

The main explanation of the euro's initial popularity was probably herd instinct. Everybody bought euros at the official launch because everybody else was doing the same thing. City economists performed their usual function of rationalising the herd behaviour. And the euro remains so popular today because few of these investors are yet ready to admit their mistakes.

Unfortunately European politicians and central bankers mistook this herd instinct for a vote of confidence in the new monetary union. This made them even more arrogant in ignoring the evident economic problems that a single currency that was overvalued from its inception was bound to produce.

Having fallen by 25 per cent in less than two years, the euro is bound to turn at some point and it is tempting to predict that this point may be quite soon. But two other predictions can probably be made with greater confidence.

The euro is unlikely to turn as long as the ECB keeps raising interest rates and stifling economic recovery. And the turn will come only after most investors, having been so wrong for so long about the euro, finally give up hope.

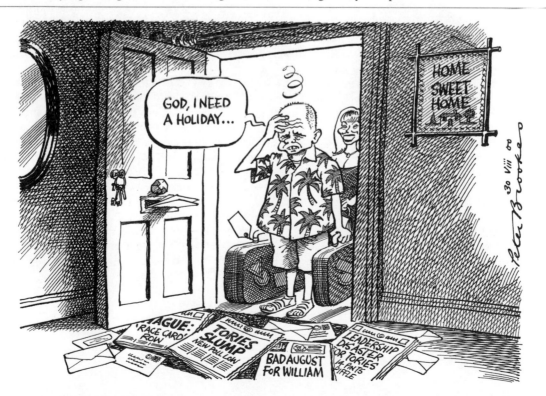

THE BEST OF BRITISH

How to keep in step with the long march of history

To live for a century is a notable human achievement. But for Queen Elizabeth the Queen Mother, to score her century is also a symbol of national continuity. In three overlapping generations from George III through Victoria, her line stretches back to the recently United Kingdom of Dr Johnson and Dick Turpin, John Wesley and General Wade "civilising" the Highlands. She was born at the end of an era, the death of Victoria. In the year of her birth, Oscar Wilde died, Mafeking was relieved, and her future grandfather-in-law's horse Diamond Jubilee added the St Leger to victories in the 2,000 Guineas and the Derby. She has fast-forwarded from the Hansom cab to space travel, and from the new telegraph to cyber-space.

But she has lived not just diachronically down her century of change. Her century has also been synchronic. For she has kept in step with the changing world. And so she has remained a royal matriarch with whom the British can identify.

Her childhood in Glamis Castle was as privileged as living in a Van Dyck picture. But the little girl showed the sense of fun that the British consider their national peculiarity. When short of pocket-money, she dared to send her stern father a telegram: "SOS. LSD. RSVP. ELIZABETH." The First World War cut down the Bowes-Lyon men, as it did every other family. The Queen Mother's favourite jewellery is still the insignia of her family regiment, The Black Watch, with whom her brothers and uncles fell. So she shares the common private as well as the national public tragedies of the Great War.

Then she became the star of debutante jazz society, and a celebrity of the new picture magazines. An unsuccessful suitor described her national characteristic: "She could be very funny – which was rare in those circles. She was a wag." To marry into the Royal Family, however, is not a common experience. Elizabeth kept the Duke of York waiting for two years before she accepted him. But everyone could identify with her support for his shyness and the unwelcome shock of the Abdication. They understood her bitterness about the failure of royal duty which brought her husband to the throne, and so may have shortened his life.

They admired her devoted family life, and her steadfastness during the Second World War. She refused to evacuate her daughters from the home front, and was relieved when Buckingham Palace was bombed, so that she could now look the East End in the face. When Harold Nicolson expressed surprise that she was being given daily instruction in firing a revolver, she replied: "Yes, I shall not go down like the others."

So the British identify with her corgi courage. They share her love of horse-flesh. When her Devon Loch collapsed within a few strides of winning the Grand National, dismay shook the rest of the royal party. But the Queen Mother never turned a hair. "I must go down," she said, "and comfort those poor people" – her jockey, trainer and stable-lads, who were in tears.

She likes a drop of alcohol, and so do many of her subjects. Like other British, she is amused by charming unattached men of a certain age. The British enjoy a cheerful face that they recognise, and a matriarch who can shout over the banisters to her quarrelling staff: "I don't know about you old queens down there. But this old Queen up here is dying for a drink."

Few of her people have lived so long and seen so much. Few have borne the changes and chances of the century so gallantly. But for all of us the Queen Mother's century is also an anchor to that elusive but strong substance, the best of British.

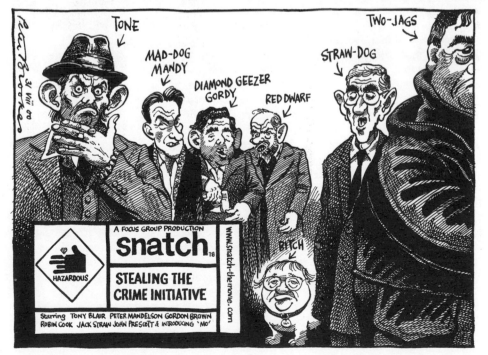

Now there is silence where Robin sat

**William
Rees-Mogg**

LAST WEDNESDAY I was watching a live broadcast on CNN. Al Gore was presenting his chosen vice-presidential candidate, Senator Joseph Lieberman, to a small crowd. The two men and their wives were standing on the steps of a courthouse somewhere in Tennessee. Unfortunately, the CNN camera was placed so that Mr Gore, who is a tall man, totally obscured Mr Lieberman, who is much smaller. Both Gore and Lieberman are shy and awkward performers, who make jerky body movements. From time to time, Gore made some emphatic point about the excellence of Lieberman. From behind Gore's back would emerge a puppet-like nodding head and a single waving arm; then the head and the arm would abruptly disappear again. I reflected that an American campaign which cannot get its camera angles right may not be getting anything else right. Then I thought how amused Sir Robin Day would have been to see those clumsy shots; they were just the trivia of television and US politics which he liked to gossip about. Robin had died in hospital the weekend before; my conversation with him, which had lasted for more than 50 years, is now silent.

For all of those 50 years we knew each other well, and for many of them we had regularly discussed the news of the day, mostly news which arose out of journalism. I remember him in the chair of the Oxford Union, or at party conferences, or in the Commons gallery for great debates, Profumo or the abolition of Stormont. But most frequently of all, we had lunches together – more lunches than I have ever had with anyone else who is not a member of my family.

We started lunching together at the Oxford Union. Robin had risen inevitably to the presidency; he was so pre-eminent a debater that other ambitious candidates tried to get out of his way. I tottered towards the presidency in my last term, after having been defeated for every office, and for the presidency twice. Robin took an avuncular interest in my career. We usually sat together on the committee table. From 1949 to 1951, we must have lunched together three or four times a week in term-time. I am not sure exactly when Robin joined the Garrick Club, but it was about the same time as I did in 1961. From the beginning I lunched at a table in the corner which in those days was still thought of as associated with *The Times*, because it had for many years had three or four regular *Times* attenders. It soon also became Robin's table: in his later years, he lunched most days at the Garrick and was the centre of that group. I go in once or twice a week, not so often as he did. In all, I must have lunched with Robin, at Oxford or at the Garrick, somewhere between 500 and 1,000 times.

We did know each other well apart from these lunches; we knew each other's families, we had been to each other's houses, we had occasionally worked together professionally. But it was the 50-year conversation at the lunches which formed the core of our friendship. As a result, we saw each other on our own relatively seldom. With friends whom I see less often, I am likely to have "catch-up" conversations in which we exchange news about our families, or have those deeper conversations in which one discusses personal problems, or issues of belief. I had little of that with Robin. As we almost always met in company, and in a constantly shifting company, we seldom discussed these deeper issues. How far that was due to circumstances, and how far to Robin's temperament, it

is difficult to say.

It was only when I heard that he had died that I realised that, after 50 years, I did not even know what Robin's ultimate beliefs were. He knew that I was a Roman Catholic. I do not think he went to church, nor do I know whether he believed in God. I'm sure God believes in him. He had, as many Englishmen of his generation did have, a personal philosophy of stoicism. He thought that a man should get through life as honourably as he can without making too much of a fuss about it. He had received hurts in life, and had suffered tragedy. He would refer to these things, but in public he did not dwell on them. As a young man, Robin was a Liberal and he actually stood as a Liberal candidate in the general election of 1959, though he was overwhelmed in Harold Macmillan's victory of that year. Even then his was an old-fashioned Liberalism, more like Winston Churchill's Liberalism of the pre-1914 years. His politics were English and traditional, based on the historic structures of liberty and national interest.

He spoke little of his childhood. Only a few weeks ago he told me, for the first time, that his family had originally come from Ipswich. His grandfather, or it may have been his father, had been born above the butcher's shop which Cardinal Wolsey's father had owned. That was appropriate. Robin was a Wolsey, Samuel Johnson, Churchill sort of Englishman, and he relapsed cheerfully from his early Liberalism into a broadcaster's proper independence. Robin did not regard himself a success in life, which was absurd. At Oxford he had expected to follow two parallel careers, the Bar and politics. He never made a living at the Bar and he never entered the House of Commons, although he was highly qualified for both. He would never accept that the career he actually had

was much more important than these other careers which he might have had. Few people outside their professions remember who were the successful politicians or the leading barristers of a decade ago.

Robin invented a form of broadcasting journalism which changed the character of British politics. That has not happened in the United States; it happened here, and because of him. He made the broadcast interview, firmly but fairly conducted, the main way in which politicians are held accountable to the modern electorate. In the United States, the most celebrated political interviewer is Larry King; in Britain it is Jeremy Paxman. That contrast is a measure of what Robin achieved, though he was not as aggressive as Paxman.

Robin based his interviews on careful research of each subject, on his strength of cross-examination, and on a superb instinctive mastery of conversational argument. He also made his interviews fun; he was an entertainer. Robin changed the balance which existed between the government and the media, not because he wished to challenge Parliament – he was, in fact, a constitutional traditionalist – but because he understood the role of Parliament as a scrutineer of government. As the House of Commons became less effective, he saw that politicians could be forced to answer questions on camera which they were increasingly able to evade in the House. If Robin had been in Parliament, where he would have liked to have been, he would not have been able to force ministers to reply as he could to the microphone.

Robin's other love was the law. He used the techniques of legal cross-examination to extract the truth from politicians.

In 1986 I retired as the vice-chairman of the BBC, a job in which I had largely failed, and was given the then standard farewell dinner. I invited Robin, and commented in my speech that he, as one man, had done more to change television than any of the rest of us – the governors, the directors-general or the boards of management. The senior administrators did not much like that – they were, in any case, glad to see the back of me – but it was true. At ITN, and then at the BBC, Robin developed the broadcast interview as a constitutional force in its own right. In *Question Time*, which has never been as good since he left it in 1989, he added the broadcast discussion as another way of getting the truth out of politicians. A love of Parliament, a love of the law, a love of truth, a strong character, underlay this historic development. I was lucky to enjoy a lifetime of his conversation, his friendship and his humour. Although he saw himself as a failure in terms of his original ambitions, Robin was a great man.

My farewell to the Big Brother world

Matthew Parris
..

LIGHTS! STRINGS of lights along the shore, glimmering in the tropical dawn. Houses! Little white cubes strewn like shoe boxes up the green slopes of the island of La Réunion. Factory chimneys smoking. Walls, fields, ditches, stamping their geometry on to the landscape.

Patterns, human patterns, cut into the hillside. Cars – tiny dots, distant, silent – moving along the coast road. Fishing dinghies bobbing out over the sea towards us – dinghies which would have stood no chance in the great waves knocking this vessel these past two weeks. Fishermen waving – do they know the storms we've been through?

The *Marion Dufresne*, that has brought me these two thousand miles from the sub-Antarctic, rocks gently in the Indian Ocean swell, waiting for a pilot to take us into dock. My journey is over. Four months on one of the world's most isolated islands are finished, and we have sailed back into the Tropics. It took ten days. There were two awful storms.

Calm sea, indigo, safe, gurgles around our keel. The breeze is warm. No gale now, no snow, no ice, no tempest. No danger. Lines of rivets reflect in quiet water. A gash of rust here, a dent, a streak, a hollow there the only traces; imprints which do not match the violence that made them. Does steel plate have a memory?

I have never, never, been so sick at sea. But nausea, too, leaves no real imprint, and I feel strong again as the memory of all that empty, violent ocean fades. These watery voyages, away from my old world in March, and now back to it, have been like sleeps: helpless, giddy voids, tossing around on an angry, meaningless ocean.

Four months propped by the bookends of two sea passages, sleep before and sleep after: rounding, isolating the stories which lie between.

Which now seems like a sort of dream – did it all really happen? Those people I left behind on Kerguelen – do they exist? Are they still there down on the 49th parallel, now that I awake in the Tropics? In my mind's eye I can see them, waving and calling from the quay: growing smaller, their voices weaker, as we sailed away. Was it I who was leaving or were they?

As that world recedes, the world to which I return – your world – looms through the sea walls of the harbour ahead. It frightens me. All at once I understand those prisoners who, released, beg to re-enter their jail.

Since March, I have never once touched money or asked myself if I could afford something. My pockets have been empty. I have never seen a bill. Such things are taken care of without the jangle of coins or the worry of calculation. When you want a drink, toothpaste, a book, a map, you sign a docket.

I have never for a second bothered about my next meal. My next meal, like my last, would be in the canteen and shared with the same 50 people. If lunch, it would be at midday prompt; if supper, at seven.

Both would consist of four courses: an entree, a main course, cheese, and dessert. Coffee afterwards would be upstairs.

Since March I have never handled a key. I have never locked nor unlocked any door. There is no crime. Everything is secure. No shadow contains any human danger. Nowhere to run and nowhere to hide. No wage packets, no fees and no expenses. There is no wealth there, no poverty, and nobody buys their own furniture. Each lives in one room where there is no keeping up with the Joneses. Nobody dresses up. I have not seen a tie, let alone a suit, since March. I polished my shoes once, in May. In June a big event: my toothpaste ran out. At the beginning of July I cut my toenails again.

Though one dresses, dressing loses all importance. I have forgotten the use of the top button. I haven't shopped since leaving England in March. You can't shop in Kerguelen because there aren't any. There's a sort of storeroom. But the goods are not on display, you have to consult a list, then write what you want on a ticket. The store opens one afternoon a week. No money is needed.

There is no illness; not, anyway, the little infections which pester in crowded countries. The ship, when she calls, delivers coughs and sneezes but they soon fade. In three thousand square miles of sterile sub-Antarctica, 50 humans are not a big enough host for the germs which bring illness to persist. Nobody gets flu – ever – and there has not in four months been a single sore throat, even after exhaustion in severe cold. I have forgotten what it is like to run a temperature.

Since March, I have not looked at a diary. I have had no appointments worthy of the name. No meetings have preoccupied me. I have invited nobody out and nobody has invited me. There is no "out". Nothing has clashed. Nobody "fits you in": there is time unlimited for everything. By midnight every night I have been asleep; by eight I put the kettle on; at eight-thirty I make my bed. And throughout I've never had to organise anything more complicated than provisions in a rucksack.

I've had no career. I've had no reputation. There's been no ball to keep my eye on. Nobody has compared me with anyone else. Little I've done has had any implications beyond the immediate. Little I've done has mattered. There being nothing to remember, I've ceased to be forgetful. Not once in four months have I forgotten a name, missed a deadline or patted my pocket before leaving my room to check for wallet, identity card, house key or notebook.

Slowly at first, but in the end completely, the knots begin to slip, the tautness goes out of things and life grows simple. Time slows. Seconds come to count, then minutes, hours, days and finally weeks. You begin to forget whether it's Wednesday or Thursday. You begin to wonder what "Tuesday" really means, and why we have weeks at all. Landmarks fade and the horizon empties.

And having emptied, closes in. What's immediately around you becomes all. The few dozen people you know are now the whole population of your universe. What you and they are doing is all there is to be done. Their company, ever more familiar, comforts you.

I did not realise this had happened to me until its end was in sight. Two weeks ago, the *Marion Dufresne* sailed over the horizon. We were excited when first we saw her coming round the headland. Then the helicopter, screaming and whirring from her rear-deck, roaring over our heads, landing. People descending, stumbling out under the whirling blades. Strange people, faces we did not know, advancing towards us, grinning. I wanted to run. From the window of my room I saw a figure walking past and knew at once there was something amiss.

But what?

Then I realised. I did not recognise the gait! Without knowing it, I had learnt the walks of every one of my fellow winterers at Port-aux-Français, and this was not one of them. I heard voices – unfamiliar timbres – and felt unsettled.

At lunch they came trooping in, intruders, and started sitting down near us and looking at us. I felt a mad, strong, instinctive urge to run under the corner table like a rat. There was a reluctance not only to sit with the aliens, but to meet their eyes. "I just want to hide," I said to my friend, Geneviève. "So do I," she said. "Let's go and sit with someone we know. Quick, before any of them come up to us!" But some of them did, and introduced themselves, and of course we were polite and made the effort to seem friendly; but really we did not even want to know their names.

I cannot speak for all, but found that my own reaction was shared by many. We did not feel curious about these new people. When a few of us saw another of us ingratiating himself with them and chatting,

we took it as a kind of treachery.

We preferred these people to keep to themselves. This was our territory.

That passed, of course, just as the strange anxiety I feel now, waiting to dock, will pass. But as I write I am conscious of a worry in the corner of my mind like a small cloud growing in the sky.

How shall I describe it? I feel daunted. Daunted not by anything in particular, but by everything in general. How much there is to do in a single day, in England! How did I ever do it all before, and how will I ever be able to do it now? How many people there are whom I must see, how many prob-lems to sort out, how much to collect and how much to deliver! How did I juggle it then, and how will I juggle it now?

Life was uncomplicated in Kerguelen and we took our pleasures simply. Just before midwinter on June 21 we all did funny things to our hair, for a laugh. Karl shaved off his eyebrows, Loic shaved a spiral into his hair, Thierry a chequerboard. I shaved off all my hair except a single lock at the front, which we peroxided blond, like Tintin, because I am a journalist. Simon dyed half his hair red and the other half green. Patrick made his into spikes, while Sylvestre took his off randomly, in clumps. Remy shaved the crown bald, like a monk, then added two Playboy-bunny ears at the back.

None of this seemed strange at the time because these japes were the events in our lives at Port-aux-Français and it would have been the fellow who refused to join in who appeared strange. Only now that I come to write this down for *The Times*, in words, does the madness strike me. What the hell did I think I was doing? Suddenly, it all seems rather embarrassing.

And there from out of the harbour, comes the pilot. Did I dream all that? My revels now are ended.

Another brotherhood

Nasty Nick Bateman leaves the brotherhood

From Mr Mark Atkins

Sir, While he was in the Big Brother house, Nick Bateman (report, August 19) showed the ability to smile insincerely without blinking; to force tears on demand; to befriend his colleagues while plotting their demise; to speak of visions that meant all things to all people; to coldly assess the weaknesses and strengths of those around him and use these to achieve his personal ambitions; to play down his manipulative behaviour and refuse to acknowledge any wrongdoing.

Forget the Big Brother house, Nick. Another House – and its accompanying political career – would welcome you.

Yours etc,
MARK ATKINS,
78 Brendon Way,
Westcliff-on-Sea, Essex SS0 0JF.
August 19.

From Mr Graham Pointer

Sir, As a way of making the Executive more accountable to the electorate, and seeing the success of Big Brother, I suggest that each month the Cabinet should nominate two of its members to be sacked, and we can vote on which of them it is going to be.

Yours faithfully,
GRAHAM POINTER,
4 Priestden Park,
St Andrews, Fife KY16 8DL.
August 20.

I am fully prepared to undergo nips and tucks – but only on my terms

Alan Coren

CLOCK, if you will, the snapshot a little to the right. I put the proviso in not because it gives the sentence the sort of bogus Edwardian flourish into which waggery sometimes traps me, but quite genuinely, out of politeness. I am uneasy about asking you to look at my mugshot. I am uneasy about looking at it myself: over the long years since it first started smirking here, I have grown weekly more irritated by the demands it makes on both of us. It says: here is a wry cove, with one auspicious and one dropping eye, who, thanks to this ocular boon, has a louche yet jocund, cynical yet lenient, view of this odd world's ways. It strikes, in short, a keynote for the text, nudging me, willy-nilly, into a certain stance and you, willy-nilly, into certain expectations. It says: here is a face to launch a thousand quips, forcing me to launch a fair number as ropey as that, letting us both down.

It is thus a career photograph. More yet, it is designed by a shrewd management (I come cheap) to keep that career going, as you can tell from the way it has been cropped to reduce baldness and chins. *The Times*, a newspaper for the youthful and energetic, does not want its readers to know how ancient and clapped-out I am. Am I happy about this? I have been, but I am suddenly less happy than I was; because it could well mean that, any day now, a *Times* gofer will turn up on my doormat and slip me the embossed card of a major plastic surgeon. One who does big stuff. I suspect this because of yesterday's report by market analysts Mintel that not only is one man in four prepared to have surgery to improve his career prospects, but also that in many cases this is suggested to him by his employer. Might, then, *The Times* now

require me to be turned into a chinless wonder with a brunette quiff, facelifted so tautly that in order to produce that keynote smirk, I shall have to cross my legs to give myself some slack?

Well I don't buy it, even if *The Times* is picking up the tab. It would merely saddle all of us with a literally fresh set of expectations: this column would be snapshotted with a clone of Harry Enfield, or possibly, if the surgeon has had a long day, Bart Simpson, and I cannot match the text to either. I should prefer to change my career. It is something I have been thinking about anyway, 40 years on the Street is a long time for a pro, you can end up relying on doubles-entendres to pass for jokes, but up until yesterday I had hesitated.

Clock, if you will, the snapshot now a little to the left, and you will understand why; not a face to do anything except waggery, is it? You wouldn't buy a used car from it, you wouldn't let it winkle out your verruca, you wouldn't want it to draft your will, teach your children, set up your pension scheme, you wouldn't even let it double your glazing.

We both know that, now Mintel has pointed the way, plastic surgery is the only solution. There is no contradiction here, no change of tack, I am fully prepared for nips and tucks and wreathed smiles, provided they are on my, not *The Times*'s, terms. I certainly do not wish to look any younger.

Older, is what I have in mind: it would be much less demanding, far less to live up to than this face has now, and amaze prospective employers with what they would see as my remarkable sprightliness. A draught or two of liposuction to those flabby cheeks, a jaw chiselled dependably square, a ginger nailbrush on the upper lip, and you would be looking at Frank Windsor, from whom any sane person would unhesitatingly snap up a retirement package, even without the free carriage clock just for phoning in. Alternatively, electrolyse the bristled chin, rivet white pincurls into the vacant scalp, pop two dollops of matronly silicone behind the nipples, and, with a pair of specs and a touch of rouge, would I not, when it came to selling stairlifts, give Thora Hird a run for your money?

And how about this? Did you know I could hold up an orange in one hand and use the other to circumnavigate it with a pea? Gum on some wayward locks, add a wattle or two, screw a monocle into one eye, and I could soon learn to find the Moon through it. I may not play the xylophone, but I play the ukulele, which is nearly as nuts. I could be a major astronomer.

Nor need it be too late for yet headier career moves: clock that face yet once more, and imagine it in the cavalier hands of a cosmetic pioneer prepared, for the right price, to have a go at excising both buttocks and relocating them either side of the smirk, and you are looking at someone whose career still flourishes thanks to the devoted electorate of Old Bexley and Sidcup. I could do that. I can doze.

This could be the first day of the rest of my life. Watch this face.

End of story

Has Liam and Noel Gallagher's fractious relationship finally put an end to Oasis? As Noel explains to Paul Connolly, definitely, maybe

NOEL GALLAGHER, tanned and looking surprisingly healthy, leans forward with a grin. "Now I've not told anyone this," he says, "but I know how all this started." He takes a drag of his cigarette and continues: "When we played the Bolton gigs about a month ago, I went back to me mam's house. I haven't been back for ages, because you always get crap, and she comes down to London loads. Anyway, she showed me the tiny room that me and Liam shared for more than 15 years and I said, 'No wonder we hate each other'."

This weekend, at the Carling Festival in Leeds, the Gallagher brothers' band, Oasis, will be playing what could be their last gig. Riven by squabbling, the band who defined the Nineties are in a critical condition. Noel sighs when I ask him if Oasis are going to split after the Leeds show: "It can't go on like it is. It's either got to stop or we break up, it's as simple as that. My gut reaction? I'd love for Oasis to go on but, well, I can't see how we can. I don't know if there's ever gonna be another Oasis record. I wouldn't hold any breath-holding contests, you know what I mean?"

He sits back in his chair and swigs a beer. "The problem is that Liam wants to be the daddio, he wants to lead the band," he says. "I didn't get this far to be told by him that this is where the band is going in the next four years. I won't take that from anyone, least of all him. Liam's convinced that he's the best songwriter in Britain. He's written one song (*Little James* on *Standing on the Shoulder of Giants*) that suggests he's anything but. I'll listen to anyone's songs. But the songs he's played me sound like Elton John and I'm not

Paul Connolly

...................................

being in a band with anyone who sounds like Elton John. It's my band. Full stop."

Liam, who at first assented to being interviewed (on the condition that it was apart from his brother), has now refused to talk to *The Times*. This turnaround has been blamed by his publicists on his split with Patsy Kensit and subsequent relationship with Nicole Appleton but Noel's not so sure. "He's been trying to blame the problems on my solo ambitions but I think it's him who needs to get songs out of his system. My songs have sold millions around the world; his certainly haven't."

In 1996 Oasis played at Knebworth in front of 250,000 people; 5 per cent of the British population applied for a ticket. It was the biggest rock gig to take place in the UK. Oasis were at their zenith.

Noel, a disarmingly bright and candid interviewee, is glad he failed to comprehend the enormity of the occasion. "If I knew that that was as big as we'd ever be I'd be a loony by now; a recluse," he smiles.

Noel was born in 1967 in St Mary's Hospital in Moss Side, "the day the Beatles released *Sergeant Pepper's*; and apparently it was played day and night on the radio for the next two weeks – so that's how that started," he laughs referring to his fondness for appropriating Beatles' riffs and melodies for Oasis songs.

The family moved to Burnage when Liam was born in 1971. It was here,

when he was 11, that Noel fell in with a group of older lads who introduced him first to the Sex Pistols and then to the Jam.

Noel smiles as he recalls how he acquired his first guitar when he was 13. "My dad went out one Friday afternoon to buy me mam an anniversary present and came back on Monday morning with a guitar, which me mam was not best pleased with. We think he won it in a card game. He used to try and play it but he was crap," he laughs.

"Anyway, as I was always up to no good and getting grounded all the time I started to play Joy Division basslines. I rediscovered the Beatles when I was about 14, because Paul Weller used to go on about them in interviews."

It wasn't something that Noel took too seriously. "I was only interested in birds, getting stoned and football. Playing guitar seemed too much like hard work. And all the people on *Top of the Pops*, well I thought, 'People from where I come from don't get to places like that'."

Noel wasn't much interested in school and left in 1983. "My first job was as a trainee signwriter – but all I ended up doing was stapling estate agent signs together. These staple guns were like staple Uzis. We used to leave bits of bread outside to entice pigeons – this is so politically incorrect, me missus will kill me – and as soon as they landed we'd go rat-a-tat-tat. Never got any of the bastards. They were too quick! Used to try it with cats as well using ham as bait – but we got caught by a copper and were sacked."

Meanwhile he had little to do with Liam even though they shared a room: "He's five years younger than me. We weren't going to be mates when I was 16 and he's 11. If you told me then that we'd be in a band together, I'd have rung for an ambulance."

In the mid-to-late Eighties Manchester's music scene took off and as bands such as the Smiths (whose guitarist Johnny Marr became Noel's hero) and New Order achieved

acclaim, Noel realised that maybe music could save him from dead-end jobs. "I was about 18 when I decided that the only thing I had a modicum of talent for was playing the guitar."

In 1988, after a chance encounter at a Stone Roses gig, Noel landed his first rock'n' roll job – as roadie to the Inspiral Carpets. "They'd asked me to try out for the singer's job but I ended up looking after the equipment instead. I wasn't complaining, I had a fantastic three years. But I was clever too, because I got a feel for how the whole industry worked, with managers, PRs, producers and journalists."

In 1990 Liam along with Paul "Bonehead" Arthurs started a band. Noel guffaws. "He actually asked me to become their manager which I thought was hilarious. I said 'I'm not going to be your manager, 'cos you're rubbish. And I've got this full-time job with the Inspirals'. But then the Inspirals sacked the whole crew for excessive drug abuse and being generally unprofessional."

Noel sighs. "So I joined the band in 1991. And at the time it was Bonehead and Liam writing the songs. I still didn't take it seriously; it was just something to do with me time. We played our first gig in October 1991 at the Boardwalk and a couple of people who saw us said, 'You've got something going here. Liam looks great, you look good with your flashy guitar but the songs aren't that good.'"

The turning point came later that year when Noel had a massive panic attack. "I went to the doctor who asked me if I smoked pot," he says. "And of course I smoked loads of the stuff; I was always stoned off me nut. So I stopped. And suddenly the world went from black and white to colour. Me brain cells stopped dying, and I started writing millions of songs. The first song I wrote was *Columbia*, then came *Rock'n'Roll Star*, a song called *Strange Thing*, which is still knocking about, and *Whatever*."

In 1993 Oasis forced their way on to a bill in Glasgow they knew talent scouts would be watching. The fact that the band had brought 12 friends helped. "They wouldn't let us play. They only had a licence for three bands and three had already been booked. We kinda persuaded them it would be for the best if they let us play," Noel grins.

"After the gig someone brought Alan McGee (head of Creation records) to see us, and he said, 'Have you got a record deal?' I said, 'No' and he said, 'Do you want one?' And I said, 'Yes'."

Back in Manchester a few days later, Noel was coming out of HMV when he bumped into Ian Marr, Johnny's brother. "I didn't know who he was," says Noel, his face lighting up at the memory. "I'd met him loads of times but when he told me who his brother was I gave him one of our few demo tapes and he said he'd pass it on to Johnny."

The next day Noel's phone rang. "I picked it up and it was Johnny Marr. I said, 'Hang on Johnny, I've left the kettle on' and ran round the flat punching the air," he says running around the room mimicking his reaction. "Johnny Marr, my hero, calling me?"

They went for a drink the next day before Noel took Marr to Doncaster to search out his favourite guitar store. "So we find this shop, and I've got about two quid in me pocket and he buys nine grand's worth of guitars on his American Express card. And I was just standing there, thinking, 'This is what it's all about. I so want to be you'."

Marr played Oasis's demo tape to his manager Marcus Russell who phoned Noel telling him it was the best thing he'd heard for ages and that he wanted to be Oasis's manager.

"So I went down to London," Noel says, "made a verbal agreement with Marcus (they only signed a formal contract 18 months ago) and came back thinking, 'Wow, we've a manager and a deal on the table.'

"I woke up the next day, wrote *Live Forever* in 25 minutes and I was the happiest man alive. I played it to the band that evening and they just applauded; it was such a good song even Liam had to realise which side his bread was buttered on, while Bonehead thought it was a cover," Noel laughs. "I must admit though, that I was taking so many drugs at the time that I began to wonder if I had written it. When it was released (in 1994) I imagined some guy flipping burgers in Louisiana hearing it on the radio, stopping and saying, 'Sheeit, I wrote that song …'"

It was Noel's most creative period. "From that point through *Definitely Maybe* (1994) until finishing (*What's The Story*) *Morning Glory* (1995), I was writing songs every day and they lasted me (the lacklustre *Be Here Now* (1997) comprised offcuts from the first two albums) until I wrote songs for *Standing on the Shoulder of Giants*."

The glory years of Oasis are well-documented, although the tension between Noel and Liam was obvious throughout; Liam walking out before the start of an American tour and various on-stage spats, fuelled, according to Noel, by drugs and by Liam's inability to hold his booze.

But it was the backstage fight in Barcelona on their recent European tour which brought Oasis to their present parlous state. "There had been an undercurrent of us not getting along for a long time which we'd not recognised," Noel says. "It all blew up that night. We were all drunk and there was a lot of truth-telling, which is what happens when you're pissed. And I've been an idiot in the past and been wrong a lot," Noel admits. "But that night Liam was laying in to me and I said, 'One of us is going to have to go. Either you go and we get a new singer or I go and we get a new guitarist'. But I didn't really want to go on, so I went. But the tour had to go on. If we'd pulled out Oasis would have been sued for everything; and I mean everything."

When I suggest that he might have been put out by their decision to carry on without him, Noel's reaction appears to be emphatic. "I was proud they played on," he insists. "I told the replacement guitarist Matt (Deighton) to use all my kit." But his mood darkens briefly when I ask him how he felt about Liam after the fracas. "When I got back it was like if anyone mentions his name I will kill them; his name will not be mentioned in my house."

So why did he agree to the UK leg of the tour? "Because we were playing Wembley Stadium, man," Noel jumps up excitedly. "It's where Dennis Tueart (Manchester City striker) scored that great goal (in the League Cup final in 1976). I had to play it."

The second of Oasis's two July weekend Wembley shows deepened the rift between the brothers. The Friday gig seared through their finest songs, peppered with the best tracks from their unfairly panned current album, such as *Go Let It Out*. The Saturday show, however, screened live on Sky, was great rock'n'roll theatre. Liam blundered around, clearly the worse for wear, hollering the songs out-of-tune and making snide remarks about his brother who glowered at him from across the stage.

Noel still smarts at the memory. "Friday was amazing, we were brilliant. But then he goes out all night with Mel C. One of Oasis out on the lash with one of the Spice Girls," he exclaims, "What has it come to?"

He continues, his natural exuberance again dampened by the memory of his brother's behaviour. "So as soon as he walked bladdered into the dressing room, you could feel the atmosphere go wallop to the floor. I just thought, 'Oh. My. God. There's going to be 60 million

people watching.'" Once on stage Noel was hugely irritated by Liam's drunken ranting. "I could have walked over and leathered him but I chose to ignore him. But I did want to say, 'If people have paid £25 a ticket the least you could do is sing in tune'. To be honest, though, we've not spoken since the gig in Edinburgh on July 29 when he asked me what song was next."

Noel leans forward again. "And this is the real reason why Oasis is so close to splitting up. When we get backstage, I'm the only one to have a go. I say, 'What was that all about? Am I going mad? Is it just me? If I turned up half-cut, and couldn't play me guitar he'd go off his nut. So why does he think he can get away with it?' And they all say, Alan (White, the drummer since Tony McCarroll's departure in 1995) included, 'It's between you and your brother'. But we're supposed to be a band.

So Liam thinks it's just me having a go at him."

Noel, who will obviously miss Oasis more than he lets on, claims that "we do plan to reconvene some time after the show to try and salvage things but I'm not too hopeful, because band meetings are a nightmare. Whenever these meetings are called, Liam either doesn't turn up or he's hammered. So if he's drunk I walk out, 'cos he's not rational. I'm like me mam when I'm drunk; I'm a happy drunk. But Liam's a nasty drunk like me old man. He's fine for three or four hours but after that he wants to fight everyone. It's just not worth it."

Noel takes a drink from his bottle of beer and says wearily, "I love him but I don't like him. If I walked into a bar and he was there, I'd walk out. We just don't get on. He's loud, he's too tabloid for me. I can't deal with that. He embarrasses me. Like that thing in *The Sun* about his hairy bum. I felt like phoning the paper and saying, 'Hey,

his hairy bum has been popping out of the collar of his shirt for the last ten years.' Of course he's got a hairy bum."

Noel has just returned from three weeks at his house in Ibiza (he owns another in Buckinghamshire – "David Seaman's a neighbour" – which he bought after selling Supernova Heights in Primrose Hill, North London).

"I came back yesterday feeling more depressed than I've ever been; I've not written a song for 18 months and we don't know what's going to happen to the band after the tour. But last night I came back, picked up an electric guitar and because the missus (Meg Mathews) and the kid (Anais) are away I pushed the amps up to ten and went for it. You can't do that with a kid around. And the song's fantastic. It's like back to the old days; it contains four chords, about eighteen words and the chorus is just 'Come On'. It's called *Revival* and it's brilliant. I hope there's a lot more on the way."

Noel nods when I suggest that maybe

he no longer has the hunger he used to. "It's like when you've got a good few million in the bank and everything you've ever wanted you just think 'I can't be bothered'. It's not that the fire's totally gone out. But our first two records hang over us; I mean don't get me wrong, we sold millions of records in America (six million so far) but we didn't become an enduring part of their culture. Here *Don't Look Back in Anger*, *Wonderwall* and *Some Might Say* were integral to the Nineties. We played to 250,000 people at Knebworth because of those songs; we were huge. And that kind of weighs you down."

Does he miss those times? "I'd be lying if I said that I didn't. I miss the euphoria of selling 600,000 copies of a new album in the first day like we did with *Be Here Now*. But if we don't get that back again or if we split up it doesn't matter. We've had it once. I'd rather have had it and lost it than never had it at all."

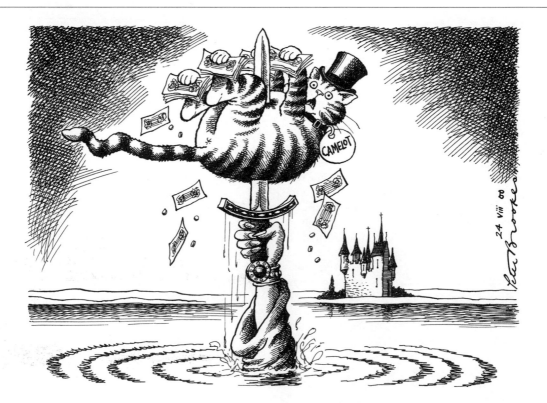

PVGH

" WHAT THE HELL DO WE
DRAW IF THE HUNT BAN
BILL GOES THROUGH ? "

Diary

Hare of the dog

THE COUNTRYSIDE Alliance has launched a cocktail to help to promote its enthusiastic pro-hunting views. "Liberty", mixed by Salvatore Calabrese, the head waiter of The Lanesborough, is a revolting-sounding mixture of vodka, melon liqueur, peach schnapps and lemon juice, topped up with ginger beer. Not to be outdone, the League Against Cruel Sports says it is "thinking about retaliating". The league tells me that its concoction "will be something along the lines of a Bloody Mary".

Mark Inglefield

A second Black Death looms in South Africa

President Mbeki should face the fact that Aids could be a modern Holocaust, believes R.W. Johnson

WHILE LAST month's World Aids Conference was sitting in Durban it seemed that South Africans had finally realised that the country has the world's worst and fastest-growing Aids crisis.

Now things have returned to normal: the President remains in denial so the Government is still refusing retroviral drugs to HIV-infected pregnant women – thus ensuring that the disease is passed on to 100,000 more babies a year – and the cheap or free drugs offered by drugs companies for five years have not been accepted. Indeed, the Ministry of Health has, at great expense, issued a leaflet justifying this genocidal nonsense.

The press say little: far more energy was applied to legal attempts to overturn the decision to give the 2006 soccer World Cup to Germany. Nobody in authority seems to be giving any thought to what Aids will do to the country by then – despite the fact that by 2006 Aids deaths will begin to reach a regular rhythm of one million a year and the number of Aids orphans will pass two million by 2010.

No urbanised society has ever had to deal with an epidemic like this: the Black Death seared rural medieval Europe and the other African countries suffering from the Aids pandemic are essentially rural societies. These village societies are more self-contained and less complex than South Africa's: some villages may be wiped out, others left untouched. Country people bury their own dead and as long as the goats, chickens and crops stand in the fields, life will continue.

Cities are different: there's no containing an epidemic that has already infected 20 per cent of adults in Johannesburg and 30 per cent in Durban. "The cemeteries in Soweto can't cope," one is told. "They used to bury adults at the weekend and children during the week. Now adults get buried whenever a space can be found." But we've seen nothing yet. The only solution will be to build a large number of crematoriums, since there will never be enough spare urban land for graveyards. And the interlocking complexities and interdependence of urban life make it far more vulnerable. Companies who lose key personnel to Aids will find it hard to survive, let alone comply with the Government's affirmative action policies – for it is the black elite who will be hit hardest. No one is sure what to do with a vast street child population of Aids orphans: many fear feral children and a crime wave.

Even more difficult to grasp are the psychological dimensions of the crisis. Take crematoriums: Africans place enormous importance on burial rites and the burial sites of ancestors are an important focus of African life. The thought of cremation, however necessary it may be, is wholly repugnant to such a tradition: the angry spirits of ancestors thus dealt with and the feelings of rootlessness and shame which the ignoring of burial rites would engender are not to be lightly dismissed.

Many African townships also suffer because their poor inhabitants tend not to pay their rates, utilities and service charges. As Aids progresses, other spending is squeezed by medical and burial expenses – and why should someone who knows they are

infected bother about paying rates? Indeed, one reason for the condition's continued spread often seems to be the irresponsible behaviour of those who know they are infected but continue to engage in multiple sexual contacts.

Twice I've had to deal with employees who suddenly became petulant and incomprehensibly demanding. Both died of Aids soon after and I realised we'd been dealing with the special dementia that often afflicts Aids victims: there is no knowing the hidden psychological torments such unfortunates suffer.

Aids also has an unequal racial incidence. Africans have by far the highest infection rate, followed a long way behind by Coloureds – in both cases women are twice as badly affected as men. The Asian and white figures are microscopic by comparison, with men suffering far more than women – the key indication that in those communities Aids is still contained within homosexual ghettos. As Africans begin to die by the million and whites are largely unaffected it is difficult to imagine that these differences will not lead to racial tensions, just as the Black Death often sparked pogroms against the Jews who, absurdly, were blamed for the disease. Already President Nujoma of Namibia has claimed Aids was invented by apartheid chemical warfare scientists and other crazy attempts to turn Aids into a black/white issue are to be expected.

For, confronted by crisis and death on such a scale, most take refuge in simple denial. Many African men still insist that Aids doesn't exist and it is very noticeable that Aids deaths are almost invariably passed off as something else or simply not mentioned. The Government's unwillingness to launch the sort of public campaigns that have worked elsewhere, indeed its lack of any real anti-Aids programme, are part of this denial, as is President Mbeki's continued flirtation with Aids dissidents who deny the link between HIV and Aids.

The frantic pursuit of the soccer World Cup is part of this syndrome, just as circuses distracted the hungry mob in Ancient Rome. It is far more pleasant to focus on enticing glitzy sporting events to South Africa than on the hospitals bursting at the seams with Aids patients as the first waves of the epidemic pour in. To divert scarce national resources to sporting extravaganzas when they are desperately needed for hospitals and public health campaigns is part of this escapism. This, as the French say, is worse than a crime; it is a mistake.

It often seems that standing up against denial is the hardest part of all, but – as the successful anti-Aids programmes in Thailand, Uganda and Senegal show – it is the only way.

THE SURVIVOR

Carman, the great defender, rests his case

Frances Gibb

GEORGE CARMAN surprised his legal colleagues yesterday by announcing that he had donned his wig and gown for the last time.

The Queen's Counsel who has become the most feared and admired jury advocate of his time said that he was retiring "with regret and reluctance" from court work for medical treatment.

Mr Carman, 70, said he had made the decision because of a "little local difficulty". He is thought to have cancer.

He plans to use his new found spare time to write a book. "I have been lucky enough to have had an interesting time over 47 years," said the man known variously as Gorgeous George, the "silver fox" and the "great defender". His earnings have exceeded £1 million a year.

Despite his usual fondness for publicity, he was unwilling to be drawn on the highlights of his career. "Those are for forthcoming books and interviews," he said from his home in Wimbledon, southwest London. A heavy smoker, he also declined to give details of his illness. "It is a private matter," he said.

Mr Carman developed an advocacy style and a reputation that made him the most sought-after brief in the profession. He was the ultimate jury advocate with an ear for the telling soundbite that would turn a case to his advantage. He notched up a spectacular list of wins. Those he bested in court included David Mellor, the former minister, who, he said, had "behaved like an ostrich and put his head in the sand, thereby exposing his thinking parts". Of Neil Hamilton's five-course meals at the Ritz in Paris, he said: "No Big Macs or chicken nuggets, ladies and gentlemen." He described the former MP as "on the make and on the take".

Sonia Sutcliffe, the Yorkshire Ripper's wife, had enjoyed a series of libel victories, including a record £600,000 award against *Private Eye*, until Mr Carman came on the scene. He defended the *News of the World* against her in 1990 and inflicted her first defeat.

Mr Carman was noted for producing a dramatic, mid-trial "white rabbit from the hat" – whether by chance or design – including the "sausage" video that destroyed Gillian Taylforth's case against *The Sun* and the diaries in the Jani Allan case.

Outside court Mr Carman, all 5ft 2in of him, enjoys the company of women: he has been married and divorced three times. Had he not been a lawyer, he might have been a priest: he went to a seminary where the rector thought that he had the makings of a man of the cloth, but women proved more appealing.

Charming but with a formal manner – one QC said he was not the sort to let his braces down in the robing room – he achieved success without the educational advantages of many of his colleagues. He was the son of a furniture salesman from Blackpool.

Yesterday those colleagues paid generous tribute. Jonathan Hirst, QC, Bar Chairman, said: "George Carman is one of the great characters of the profession and the courts will be the poorer without him."

Rupert Grey, Neil Hamilton's solicitor, said: "I am greatly saddened because he is one of the great characters at the Bar who made life colourful. He has a great zest for life and was fun as an opponent – you could have a smoke outside court with him." Mr

Carman's ability, he said, was his "extreme capacity for pulling a case round when it looked pretty tight". He added that Mr Carman was "second to none" with a jury. He was also not averse to hitting below the belt, Mr Grey said. "But I like all that. He's fine to be against. I shall miss him greatly."

Patrick Milmo, QC, a senior libel silk and regular opponent of Mr Carman, said: "He has his own style, which is a mixture of pomposity and grandeur but also quite contemporary. He'd get on the side of the jury by using jargon they'd be familiar with."

Richard Rampton, QC, described him as the "greatest jury advocate I have ever known, with an unerring eye for the points from a jury's point of view which went to the heart of the case".

Peter Carter-Ruck, the libel solicitor, said: "He was the QC most in demand by clients and they were prepared to pay for him." He put Mr Carman's success down to four of the principles of war: "Concentration of effort, surprise, reconnaissance and preparation."

Mr Carman cut his teeth in the criminal courts. His grateful clients included Jeremy Thorpe, who was acquitted of attempting to murder his homosexual lover.

He moved to the libel courts, where his successes included Elton John, Imran Khan, *The Guardian* (against Jonathan Aitken), Marco Pierre White and Richard Branson.

In 1995 Mr Carman suffered defeat when defending *The People* from a libel action by Graeme Souness, the former Liverpool football manager.

Even in retirement, George Carman's timing is right. Big, set-piece libel trials are on the wane. But he goes out on a high note after his victory for Mohamed Al Fayed, the Harrods owner, against Mr Hamilton. Mr Grey said: "I think my chances of a win on appeal have greatly increased."

WHAT HE SAID ABOUT THEM

On Sonia Sutcliffe, wife of the Yorkshire Ripper:
"She danced on the graves of her husband's victims" and "She is a clever, confident, cold and calculating woman. She has sought to excite sympathy at every available opportunity in the witness box. The truth and Sonia do not make good bedfellows."

On David Mellor:
"Behaved like an ostrich and put his head in the sand, thereby exposing his thinking parts."

On Neil Hamilton, during his battle with Mohamed Al Fayed:
"On the make and on the take." and "A man with no honour left".

On Ken Dodd, whom he defended on charges of evading tax:
"Some accountants are comedians, but comedians are never accountants."

AND WHAT THEY SAID ABOUT HIM

"Whatever award is given for libel, being cross-examined by you would not make it enough money." – Jani Allan, South African journalist who sued over claims that she had an affair with neo-Nazi leader Eugene Terre'Blanche

"We'd better get Carman – before Aitken gets him." – Alan Rusbridger, Editor of The Guardian, *on receiving a writ from Jonathan Aitken*

"I asked my solicitor who I should most dread having on the bother side to cross-examine me, and he said George Carman. I said let's get this man. Quickly." – Sir Richard Branson, Virgin chief

"He is a phenomenon of his time." – Neil Hamilton, who lost his libel action against Mohamed Al Fayed at Carman's hands

Ministers should stay, not go abroad to play

Simon Jenkins

SO HOW was it for you this summer? Was your sky god rain or shine? Did you experience a deep depression south of Iceland or a complex anticyclone off the Azores?

The past weekend was the latest in a ten-year run of awful Bank Holidays. As the isobars hurled themselves against the west coast of Ireland and cold fronts left no basement unflooded from Antrim to Kent, Britons have endured a summer like none I can remember. It has not been consistently bad. There have been moments of glory. But as the Met Office reminded The Times last Friday: "Good weather is the exception. It is raining all the time somewhere." This summer has seen freak waterspouts, tornados, fish raining on Yarmouth and giant hailstones in Hull. The forecasts have often seemed meaningless, as in "showers are expected, interspersed with long periods of heavy rain". Worst of all the weather has been unreliable, mendacious, mean and, for those who must sneak a fixed week of break, grotesquely unfair, with weekends usually worse than weekdays. It has seemed a season of climatic spite.

I blame the Government. New Labour endlessly promised "better times ahead". Downing Street has eagerly tried to control everything under the sun, or rather the clouds. Ministers who boast they will end child poverty, improve global ethics and win the World Cup for Britain cannot meekly pass the buck for a drop of rain to the Met Office or God Almighty. Where is the hot weather initiative? Where is the Cabinet Office

enforcer, the rain reduction task force, the warm-air policy unit? When are these idle politicians going to realise what matters to ordinary people?

Tony Blair promised the moon. Let him give us the sun. As I sat in an M5 roadworks tailback during a recent monsoon, I thought of him and his courtiers cruising in RAF jets between olive-drenched Italian palazzi and sun-kissed French chateaux. The thoughts were not charitable. When the nation was suffering the Four Horsemen of the Apocalypse, where was its leader? Why was he not riding out the storm with his people? He was no Churchill unsleeping in the Met Office bunker. He was carousing with the counts of San Jimmy and the cronies of Toulouse. While the peasants at home were enduring one of the most sunless summers on record, their leader had cut and run.

True, an ability to escape the English weather is no longer a sign of class and wealth. The Briton abroad these days is almost a caricature of a working-class lout, violent, drunk and a soccer supporter. But 20 million of them still holiday at home, and hundreds of thousands depend on good weather for their livelihoods. Partly because of the pound but also because of six unusually bad summers, the domestic holiday trade is in dire straits. Were hoteliers pig farmers, they would be demonstrating outside Parliament for solar deficiency payments and relief from the "grey" pound.

The weather is the one aspect of human existence that no amount of economic progress or government intervention seems able to alter. We grow happier, healthier, cleaner and lovelier. We can create higher skyscrapers and deeper pizzas. We can do ever sillier things and call it art. But we

cannot alter the pestilential British weather. Devote a fraction of the money that has gone on space or Star Wars to analysing that Icelandic depression or to towing clouds out to sea, and we might all be the better for it. But for now the same depressions that persecuted prehistoric Britons persecute us. After a hard year's work, there is nothing that seems so unfair as a rained-out holiday.

So, our returning rulers had better not mention the weather. They should not speak of the "appalling heat" of the eastern Mediterranean. They should cover their tans with plaster. For Mr Blair and his colleagues, this would have been the ideal, pre-election year to spend in the home country. They could have supported the oppressed tourist industry. They could have patronised those corners of these islands still unpolluted by planning and, in Mr Blair's case, they could have avoided the slightest hint of a scrounge.

When, I wonder, did senior British politicians last make a practice of holidaying at home? No Italian, French or American leader would dream of fleeing his country at the first opportunity of relaxation. Is there nowhere, the length and breadth of the land, grand enough for the Prime Minister? Is there no Labour tycoon to vacate his castle for a knighthood, or a luvvie his Tudor mansion? Must our leader wander Europe like Lear across the blasted heath, currying hospitality where he can? What was good enough for Tudor monarchs and Victorian politicians is surely good enough for today's rulers.

Politicians should holiday at home. An American chairman of the Senate Foreign Relations Committee once boasted that he would never travel "abroad" lest he become prejudiced in

its favour. That now applies to the rulers of Britain – except that "abroad" is their own country. They live in the metropolis and see provinces only when abroad. They know London, but beyond lies only Paris, Brussels, Florence, Barcelona, Tuscany and Gascony. They may know their way blindfold from the Pont des Arts to Les Invalides or the Vatican to the Piazza Navona. But ask them to locate the Three Choirs Festival, or trace the Coast-to-Coast Walk or tell you where is Kedleston and you will draw a blank. Which cities are graced by Grey Street, Goodramgate or Milson Street? Forget it.

The result of this neglect is all too obvious to those who still travel the United Kingdom in summer. John Prescott (holiday venue, Cyprus) cannot have visited the sprawling executive estates with which he wants to carpet southern England. John Redwood and William Hague, as Welsh Secretaries, cannot have witnessed the gigantic wind turbines with which they defaced the once magnificent horizons of Mid Wales. Mr Prescott now seeks to emulate the vandalism of the late Lord Ridley's rural hypermarkets by

freeing farmers to erect advertising hoardings alongside roads and motorways. Labour Britain is to become a Latin American banana republic. As if damage enough had not been done to the countryside by hedge-grouting and conifer planting, it is now to suffer a "presumption in favour of advertising" in every field. It simply beggars belief.

Such insensitivity to the fate of British landscape could only come from those who never visit and enjoy it. Ministers treat Britain as a place fit only for plebs and property developers. Early in Mr Blair's reign there was a rumour, doubtless in jest, that he might spend part of his holiday in Skegness. I hastened thither to see what he might find. It is sad he did not go. He would have returned traumatised by the desecration of the caravan and bungalow-infested Lincolnshire coast in which all planning control has collapsed.

William Cobbett remarked that there is no better way "to know a country than by riding it". How many people have ridden Britain, even by car? As Cobbett rode the highways and byways of England, he noted the texture of the countryside, the prosperity (or poverty) of workers in the fields.

He spoke with strangers and learnt from them the condition of Britain and the fate of paper money. As a farmer might spot a blocked stream or a wood in need of coppicing, so a politician could not fail to register the impact of a policy on the ground. No one can know a land that they see only on guarded ministerial trips.

Of course there is virtue in foreign travel. This year I have seen how much better the French handle public spaces in villages and towns, but how much poorer are their historic houses and churches. I have noticed the deterioration of Italian urban design, though it is still in advance of Britain's. I have been saddened that "local Britain" seems to have lost pride in its appearance. It is pursuing private affluence amid public squalor, as did America in the 1960s and 1970s.

Such comparisons are always illuminating. But they cannot be made by those who no longer visit Britain-beyond-London. The early Romans saw Britain as ultima Thule, a distant land of savages, cold and rain, to be ruled with the attitudes of colonial government. I sense that our rulers see it in much the same light.

Each to his own: politicians find different ways of enjoying the summer recess

Imperial measure

From Mr Nicholas Russell

Sir, According to *The Times* (report, August 22) yesterday's hailstones in Hull were "the size of Mint Imperials". Why not say that the hailstones were 11mm in diameter or whatever? I understand 11mm; I do not want to have to buy a bag of Mint Imperials to discover the size of these hailstones. Is there a British standard size for Mint Imperials? If so, what is it?

There is a perfectly good set of measurements ranging from the millimetre to the kilometre for length and from the gram to the tonne via the kilo for weight.

How many readers of *The Times* in Peru, for example, have seen a Mint Imperial? We live in a global society and *The Times* used to be a world newspaper. Your retreat into a "little Englander" ghetto is most distressing.

Yours faithfully,
NICHOLAS RUSSELL,
37 School Lane,
Haslingfield, Cambridge CB3 7JL.
August 22.

From Mr Chris G. Green

Sir, Would Nicholas Russell (letter, August 23; see also letter, August 25) object to hailstones being described as golf or cricket-ball-sized? One of the joys of reading and travelling is to experience different analogies and usages of idiom and custom.

I have always been charmed by villagers in Tibet and Nepal who describe a trek as being five, or ten, cigarettes' walk. For a non-smoker not precise, but a relatively understandable description nonetheless.

Yours sincerely,
CHRIS G. GREEN,
52 Wivelsfield Road,
Haywards Heath,
West Sussex RH16 4EW.
August 25.

From Mr Trevor Fishlock

Sir, Some years ago I wrote an article in *The Times* explaining the mysterious Oriental board game of Go and, for clarity's sake, described the counters as being the size of Mint Imperials. Now Mr Nicholas Russell complains about *The Times*'s use of this old imperial measure in relation to hailstones, and says it would have been better to describe them as being 11mm in diameter.

We can see his game: he is really speaking on behalf of the Metric Tendency, and his point is exposed as humbug.

Yours faithfully,

TREVOR FISHLOCK,
56 Dovercourt Road, SE22 8ST.
August 23.

THE ✦ TIMES

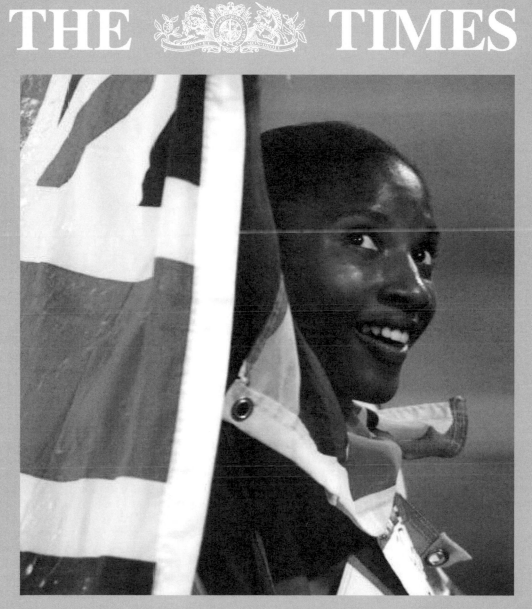

September
2000

Oval glory shapes England's future

The Oval (final day of five): England beat West Indies by 158 runs

Christopher Martin-Jenkins

THERE HAVE been some outstanding England victories at the Oval even during the long depression, but none that has meant more than the one completed in the third over after tea on the fifth afternoon yesterday. Devon Malcolm's nine for 57 against South Africa, Phil Tufnell's mayhem against West Indies in 1991 and Andrew Caddick's against Australia in 1997 were all achieved at the end of series that England either lost or drew. Yesterday they completed their first win in a Test series against West Indies for 31 years.

The margin, three games to one after losing the first Test by an innings and 93 runs, left no room for doubt that the better side had won and, as Nasser Hussain lifted the Wisden Trophy towards a sea of jubilant spectators stretching all the way to the square, the feel of a tide on the turn was palpable.

The first salty scent of it had been discernible at Durban late last year, but it was followed by familiar disappointment at Cape Town and the success against Zimbabwe that followed was no more than expected. Beating a West Indies side at an earlier stage of redevelopment was required to give hope for tougher challenges ahead over the next 12 months. Improvement is still needed if Pakistan and Sri Lanka are to be matched this winter and still more if the ultimate challenge of Australia is to be overcome next year – even in taking ten wickets yesterday England dropped four catches – but Hussain and his team deserve praise.

Five of them were among the XI

being pilloried 12 months ago after New Zealand had beaten them on this same ground to win the series. Even on the first day of the Lord's Test against West Indies a mere nine weeks ago, a columnist with an agenda felt justified in describing cricket on a cold day as "a grey game played by grey people". That it remains at its best the most completely satisfying sport of all was to be proved only the next day when Andrew Caddick, as Hussain phrased it yesterday, "got out of bed and decided to bowl West Indies out for 54". That cricket is still the national game of summer was evident from the extraordinary rush for seats once the gates were opened on a sunny morning yesterday. They had to be closed half an hour after the start, with thousands locked outside, once the safety limit of 18,500 had been reached.

The eventual receipts of £1.8 million, a record for the Oval, reflect sensible pricing, but also the national thirst for success. Cricket watchers knew, too, that if England did not win, West Indies might make history themselves, Brian Lara perhaps to the fore. He avoided a pair and played the longest and highest innings of the day, but nothing in the end could deny the England fast bowlers, Caddick and Darren Gough once more in the vanguard.

They have stayed fit all season, a justification in itself for central contracts. One must go back to 1960, when Brian Statham and Fred Trueman took the new ball in all five Tests against South Africa, to find the last full series of five or more games in which the opening pair has lasted the season.

It was, naturally, to Gough and Caddick that Hussain looked for early wickets yesterday in an atmosphere of

supercharged excitement. For a while the captain hedged his bets, starting with a third man, no short leg and only two slips and a gully. Sherwin Campbell's response was to hit Gough for two fours in the opening over and a glance for a third boundary two overs later as Gough strayed outside leg stump. What Hussain called "the little bit of doubt about whether we could really do this" must have been magnified when, in the fifth over of the morning, Campbell drove at Gough and Graeme Hick at second slip dropped a relatively straightforward outside edge.

Incredibly, Campbell chased the next, shorter ball and sliced it rapidly to second slip again, where Hick, to his unimaginable relief, clung on with both hands just above his head to a much harder catch.

It was not his only reprieve. Hardly had Lara avoided his pair before Wavell Hinds edged a drive off Gough and Hick missed another chance at knee height to his right. In only the next over, however, Caddick curved an inswinger of full length into Hinds's front boot and the first of the day's four leg-befores was granted.

At 58 for three it was already a case of whether West Indies could salvage the game, not win it. All this season it has seemed as though England have reversed their normal role, and the situation that Lara and Jimmy Adams now found themselves in was much like the one faced so frequently by Mike Atherton and Alec Stewart. Lara showed every intention of building an innings, but, as he and his successor held the fort either side of lunch, he still lifted the crowd and brought Craig White to earth with examples of those swivel-footed pulls that turn menacing 88mph bouncers into long hops.

What effectively was the terminal breakthrough came slightly fortunately, in the third over of the afternoon, when Adams turned Caddick off his leg stump and was athletically caught by White, diving to his left at square leg. The partnership that followed between Lara and the elegant Sarwan was the most attractive of the match. It never had an air of real permanence, but it took a piece of predatory fielding by Graham Thorpe to end it as Lara, calling for a quick off-side single, changed his mind and saw his young partner diving in vain to beat the underarm throw.

Fielder and batsman collided, Sarwan hurt his neck but the damage to West Indian hopes was more serious. Two more wickets went in the next two overs, Caddick's extra bounce finding the edge against Jacobs before Gough was a trifle lucky to get Lara leg-before with a ball pitched just outside leg stump.

From then on, it became a question only of time. The England players formed guards of honour as Curtly Ambrose and Courtney Walsh came in to bat, and Ambrose and Nixon McLean at least held them up until after tea on what Gough said later was "still a very good pitch".

Duncan Fletcher, the influential coach, was conspicuous by his absence from balcony scenes reminiscent – for joy if not for dignity – of those black-and-white days when Len Hutton, the shy young Peter May, Laker, Lock and the rest stood to acknowledge the crowd in the Coronation year. Not since, if memories are right, has every seat been in demand for every day of an Oval Test.

Hussain spoke after of his obsession over the past two months with beating West Indies. It has affected his batting and prevented him from sleeping. "Whatever happens in future, whatever has happened in the past," he said, "this team has to be very proud of what has happened this summer."

City Diary

Executive perks

THIS has a slightly apocryphal look to it, but the Air & Business Travel newsletter says that a big international airline recently introduced special half-fare rates for wives to accompany their husbands on business trips. Looking for comments to be used in its advertising, the airline then wrote to wives of executives who had used the concession asking for their opinions on the trip. The most common response was: "What trip?"

Martin Waller

"I'm going to spend my gap year doing VSO in Pontefract."

We have no time to stop and stare

Many of Rome's treasures have been hidden for years. Now they're on display again, Richard Cork wants more time to appreciate them

Richard Cork

FOR TOO many years, Rome was a frustrating city to explore. Boarded up, festooned with scaffolding or simply decayed, it took a perverse satisfaction in disappointing visitors by refusing access to many of its greatest treasures. Burdened by an overwhelming legacy from the past, it seemed incapable of showing off its tarnished treasures with the care they deserved. The Eternal City looked alarmingly vulnerable.

Now, at last, the long period of neglect is at an end. Go to Rome this autumn, and you will reel from revelation to revelation. Jubilee Year, celebrating the 2,000th anniversary of the birth of Jesus, has galvanised the owners of churches, galleries and temples into cleaning their finest possessions and placing them on view. Rome has refurbished more than 700 monuments, works of arts and sites. The results are spectacular.

At St Peter's, the exterior fabric has emerged resplendent. Carlo Maderna's facade glows in the Roman sunlight with a radiant intensity. The stonework looks as fresh as it must have done when Pope Urban VIII dedicated the basilica in 1626. Now, once again, it provides a dazzling centrepiece for the sweep of the colonnade that Bernini designed for the piazza a few decades later.

Bernini benefits even more from the reopening of the Villa Borghese. Shamefully closed for decades, it houses a magnificent array of paintings, sculpture and classical treasures amassed in the 17th century by the acquisitive Cardinal Scipio Borghese. Astounded by the collection on my first trip to Rome in the late 1960s, I have been impatient to return, and I

was not disappointed. The Villa has been superbly restored. But the two-hour time limit imposed on my visit is inexcusable, and a notice bossily insists that half an hour will be sufficient to view the paintings. Since they include masterpieces by Bellini, Raphael, Correggio, Titian, Lotto and Caravaggio, I could happily have lingered all day.

One canvas, Titian's sublime *Sacred and Profane Love*, had impressed me on my previous visit. A recent cleaning has removed the golden varnish, and so my memory did not tally with the brighter, less mysterious, image now on the wall. Gradually, though, the interplay between the two women –

one clothed, the other near naked – reasserted its hold over me. The contrast between the two landscapes behind them is equally arresting: the dark, secretive hillside on the left gives way to a distant panorama enlivened by riders, lovers, mountains and a Venetian sky.

But the most enthralling exhibits are on the ground floor, where four of Bernini's most eloquent carvings are displayed with irresistible panache. The earliest, *The Flight from Troy*, was jointly executed by the young Bernini and his father. Their collaboration echoes the subject, for Aeneas struggles here to carry his own elderly father away from the city. But the statue looks

subdued and cautious compared with the violence and sensuality of the carving in the next room, *Pluto Abducting Proserpina*. Her flailing attempts to resist are vigorously conveyed, and so are the imprints of Pluto's lustful fingers in her flesh. Below, the yelping, triple-headed Cerberus adds to the sense of vicious alarm.

This urgency reaches a climax in the later carving of David. Bernini audaciously shows the lean, frowning figure at the instant before he hurls the stone. Swivelling his body for maximum force, this resolute warrior could hardly be more removed from Michelangelo's posed, self-admiring David in Florence.

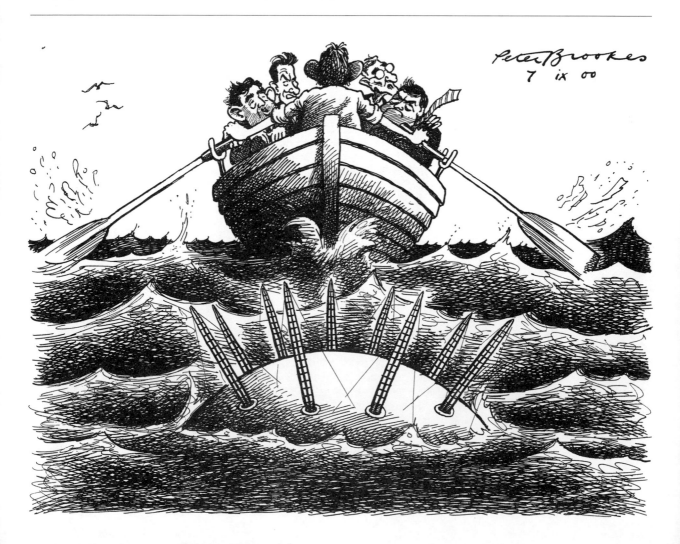

Even so, none of these carvings can match *Apollo and Daphne*. In my view, it is the most consummate of all Bernini's sculpture. He concentrates on the moment when Apollo catches up with Daphne after chasing her through the forest. But, at the very second he secures his prize, Apollo discovers that Daphne is growing into a tree. His surprise cannot, however, compare with the amazement and fear transforming Daphne's features. Mouth agape and arms flung upwards, she reacts with panic to Apollo's hand and her metamorphosis. Although she will elude Apollo, Daphne is being pitched into another form of oppression. For the bark of the tree is imprisoning her legs, and leaves sprout in terrifying profusion from her fingertips. Soon she will be robbed of her human identity altogether, and Bernini defines the shock with painful immediacy. Ultimately, though, the complex emotional reverberations are shared equally by Daphne and her pursuer. Apollo, his right leg raised in the act of running, is caught between exhilaration and despair. He realises that the attainment of his prize is being undermined by loss.

My delight in revisiting this work was marred only by the guards, who ordered me to leave long before *Apollo and Daphne* had exhausted my attention. When I first went to Rome, nothing prevented me from gazing at the sculpture for hours. Nobody should put an odious time restriction on our ability to commune with great art, and I hope that the Villa Borghese will soon revert to a more enlightened way of displaying its collection.

Mercifully, no such rules interfered with the other discoveries awaiting me in Rome. At the church of S Agostino in Campo Marzio, the priest could not have been more hospitable as he guided me towards Raphael's dynamic fresco of the prophet Isaiah. Cleaning has transformed this monumental figure, heavily indebted to Michelangelo's prophets on the Sistine ceiling. He unfurls a scroll

bearing a Hebrew inscription declaring: "Open the doors, where the people who believe may enter."

A similar spirit prevailed at the superb Villa Farnesina, where Raphael can be seen at his boldest. His fresco of Galatea, riding the sea in a shell-like chariot pulled by arched dolphins, leaps out of the wall. I remember drawing her poised yet spiralling body on my first visit, and Galatea retains all her athletic brio. The great surprise today can be found in the entrance loggia, where Raphael's pupils painted an elaborate scheme of frescoes after their master's designs. They were intended to celebrate the marriage of the Villa's owner, Agostino Chigi, to Francesca Ordeasca. Both the centrepiece, *The Banquet of the Gods*, and the other frescoes have been badly affected by damage and clumsy repainting. Now, cleaned and accompanied by an exhibition charting the restoration, they are vastly improved. Giulio Romano and other members of Raphael's workshop may have been responsible for the painting, but the master's drawings testify to his overall conception. The loggia decoration is a spellbinding display of the High Renaissance at its most confident.

Bramante, the architect who had the strongest influence on Raphael's designs for buildings, has also benefited from spring-cleaning. His exquisite Tempietto, tucked into a courtyard beside the church of S Pietro in Montorio, has just emerged from renovation. The outcome is a triumph. Built in 1502 on the site where St Peter was supposedly crucified, it looks as palpable as the most monumental sculpture.

Despite the austerity of its Tuscan Doric colonnade, this renowned building has a vibrant presence. Everything is precisely calculated and resolved, making its disposition of volumes among the most satisfying I have seen.

By no means all the finest monuments in Rome are now fully available to the public. The sumptuous Palazzo Farnese, partially designed by Michelangelo, contains, on its first

floor, an immense gallery of frescoes by Annibale Carracci. Among the most overwhelming achievements of Roman Baroque, they are supposed to be viewable. But the building is occupied by the French Embassy, and an official curtly informed me that the frescoes could not be seen. This building, though, and its decorations, are too important to be hidden away. They should be made as available as the reopened Capitoline Museum facing the Piazza del Campidoglio, which can be explored on an intriguing new route. Starting in the Palazzo dei Conservatori, we can once again relish the colossal fragments of Roman statues in the courtyard, but now a subterranean passage enables us to walk under the piazza and enter the Palazzo Nuovo, with its classical sculptures.

But the most exhilarating passageway leads to the Palazzo Senatorio, and through to the Tabularium. Here, immense arches provide staggering views of the Forum and the Palatine. Seen at sunset, the ruins silenced me with their haunting grandeur. Decayed they may be, but Rome has now ensured that its matchless legacy will survive for a long time to come.

British supermodel Erin O'Connor puts a spring in the step of London Fashion Week, while designer Roland Mouret turns an elegant back on it

WATCH WITH BROTHER

The captives emerge blinking into a brave new world

And so, at last, the event a nation has awaited. It has attracted the only queues in Britain that are not for petrol. And last night, victims of a closed-circuit kidnap were finally released. Well-wishers all over the country stayed in especially to welcome them, to see the survivors stumbling free of their faux suburban semi, emerging blinking into the flashbulbs of fame – and, for one at least, fortune. But what will the brave new world be like to these newly-freed prisoners? Nine weeks have passed since they first signed up for their cut-throat confinement. Meanwhile perspectives have shifted, world events have fast-forwarded. The survivors of Channel 4's all-seeing solitary stand wincing in the glare not just of publicity but also of their own ignorance. How will they adapt?

Nine weeks ago Concorde was still smashing sound barriers. The Russian Navy was the pride of the Barents Sea. England was languishing at the bottom of *Wisden*'s statistical tables. And Posh Spice was hopeful for a number one slot. Now the outlook has changed. Society has adopted a whole new set of attitudes with which the quarantined housemates will be quite out of sync. As far as they know, any talk of swine fever will refer to their nefarious former housemate, Nasty Nick.

Darren, an erstwhile meeter and greeter at the Millennium Dome, will find that his place of employment is Europe's biggest white elephant. Craig, who hires out marquees, might even decide to make a bid. He could even consider inviting his housemate, Anna, along to work for him. She used to be the office manager for a company making skateboards but with the summer rise of the micro-scooter she might now be out of a job.

The survivors will surely be disori-entated. But for their viewers it is almost worse. How will the screen-goggling masses adapt to the deepening nights ahead? For weeks Big Brother chatter has been Britain's condoned newspeak. Channel 4 slots have made the evening's double date. On that on-screen planet where almost anything passes, where expressions of outrage have become drearily routine, embarrassment appears to have become the new shock. And how compulsive it has proved. Nightly, viewers have writhed with delicious discomposure at the vicarious mortifications of the cast. How will they survive without these on-set placebos? Stockholm syndrome has gripped a nation. Britain is obsessed with those who have captivated it for weeks. And from this morning everything will look different now that Big Brother has stopped his bullying, is no longer there to watch.

Upkeep of war graves

From Mr Stanley J. Blenkinsop

Sir, Mr Oliver H. Perks (letter, today) tells of the British ex-soldier who was allowed by the Germans to tend a First World War British military cemetery in France without interference during the Occupation.

Indeed, as German armies swept through Northern France and the Low Countries in 1940, Hitler personally ordered that there must be no desecra-tion of Allied memorials or graves on the former Western Front (where he himself had served as a foot soldier in 1914-18).

A friend with the Commonwealth War Graves Commission once told me that Hitler's instructions had apparently been ignored only twice.

After the 1945 liberation a small swastika was found carved on the stone platform at the top of the Ulster Tower on the Somme, and a bronze Australian war memorial showing a large kangaroo bayonetting a German eagle vanished in Flanders.

My friend admitted: "We were never sure whether it was sheer desecration or removed for aesthetic reasons."

Yours sincerely,
STANLEY J. BLENKINSOP
22 Roan Court,
Macclesfield, Cheshire SK11 7AQ.
September 11.

Ceremony that turned turtle... as the band played on

Lynne Truss

AFTER FOUR hours of everything going like a dream at the opening ceremony, there was a nightmare at its climax when the Olympic cauldron – lit in spectacular ring-of-fire fashion by Cathy Freeman, the Australian gold-medal hope – failed to travel up a waterfall to end the show. The music played on, Cathy took up her rehearsed pose of awestruck athlete gazing on the Olympic flame ascending to the Antipodean night sky (there was a kind of rack and pinion arrangement) but after a brief judder, the bowl of flame refused to move. "What an anticlimax," Barry Davies, our BBC guide to the event, commented. "Cometh the hour, cometh the failure."

Oh shut up, Barry, we all screamed at home. This is bad enough without any of your "cometh" nonsense. Finally, as its music finished, the damn thing started to move. "At last," Davies informed us (in case we hadn't noticed), "it will achieve its aim."

Four hours and twenty minutes of an Olympic opening ceremony is one thing; four hours and twenty minutes of Barry Davies is quite another.

Yesterday morning, as throughout Britain sports lovers' four-hour video tapes ran out just before the climactic lighting-the-bit-tricky Olympic-cauldron moment, Barry Davies spoke without hesitation, repetition, or deviating from the subject on the card, for 260 whole minutes. Is the man human?

"St Kitts and Nevis, islands

separated by a two-mile channel," he told us. "This is Yemen, their fifth Games. And now a total change of atmosphere as we move into what is called the Tin Symphony." It was awesome. It aged all its viewers by 3½ years. And as telly, it was, of course, unmissable.

That's the thing about opening ceremonies: they are made for television. When you are in the stadium, you don't have a clue what's going on. You can't see the big picture because you are part of it; you can't see the little picture because it's too far away.

"What does that enormous turtle signify?" you inquire as a matter of urgency. "Why are those men dancing with lawnmowers? Can I smell burning eucalyptus or am I hallucinating? What does the word larrikin mean exactly? How wide is the channel between Nevis and St Kitts?"

Whereas the viewer at home is not only kept fully informed on such matters, but can marvel that such breadth of knowledge is available to just one man. The Australians put on a spectacular show, with arguably too many cabaret numbers sung by skinny women with improbable names (Tina Arena springs to mind) but compensated with fabulous dancing, aerobatic fish, stilt-walking, aboriginal patterning, and boldly expressed Olympic lyrics: Share the Spirit; Dare to Dream; I believe, I believe!

And the turtle represented the reptilian sea-life of the tropical north, so absolutely nobody could say that they were left out.

If they could only parcel this stuff out over a few days, though. As it is, one has only just absorbed the news about the agricultural value to the Aborigine of bushfire clearances, or the fact that the tin roof is coming back into fashion, when the parade of the athletes starts, and then proceeds for another – well, roughly another 2½ years. Mounting excitement, don't get me wrong.

When Matthew Pinsent strode in so

proudly with the Union Jack, it was all I could do not to cheer. He didn't use a namby-pamby harness like everybody else, oh no. Just a strong arm and a big smile. No, it's just that there are 11 countries that start with A, which makes your heart sink a bit if you thought you'd sneak along to work unnoticed when this part was finished.

"He tested positive for spinach."

But did Barry quail before this enormous task? He did not. In every case, we heard not only the identity of the person carrying the flag, but some handy geographical snippet, such as "Aruba, 15 miles off the coast of Venezuela". Personally, I'd have preferred some speculation on whether the costume could be worn again afterwards.

For example, the Austrians and Czechs wore very classy light macs, which I suspect were even reversible. Whereas the Japanese, aware of what Barry called "the kaleidoscope of colour", recklessly chose cloaks in rainbow hues, which will (I'm sorry) never find their moment again.

Still, Barry noticed other things – some "pretty ladies" among the Hungarians, for example, which was nice. "And now *Rule Britannia* being played by the band," he told us happily as the Britain team paraded past, in case we were hard of hearing. If only it hadn't been *Land Of Hope And Glory*, Barry. Oh well. Cometh the hour, cometh the fact-fatigue, I suspect. And I speak on behalf of all of us.

An epic tale of one man, five golds and 22 years of pain

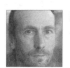

Simon Barnes

MAYBE THE 1966 World Cup was as good as this, but only maybe. This was the most powerful piece of sport I have seen. I have been struggling to place it on a scale of achievements, a scale of great moments experienced personally. Botham in 1981. Dancing Brave's Arc. Joe Montana's Super Bowl drive. Mark Todd winning Badminton on a chance ride. I can go on like that for a long time. But the hard truth of the matter is that this was, on a personal and an objective scale, the most remarkable piece of sport ever.

Steve Redgrave won his fifth gold medal in his fifth Olympic Games on Saturday, and for ever people will ask: Were you really, actually there? What was it like?

It was the most excruciating, nerve-shredding six minutes I have experienced watching sport, the more fraught because it was shared by everybody present. We journalists had forgotten our synthetic cynicism. We were all 12-year-olds with no sense of proportion, utterly caught up in the myth-making of sport.

The relief at the end was euphoric, overwhelming. The circumstances of the race, with the Italian crew's dramatic late surge, made the occasion absolutely shattering. And I thought the Italians had got there. It was awful, a blow struck right in the pit of the stomach, and I heard someone beside me utter a ghastly croak: "Oh God, no!" And I knew it was me.

I don't get like that at sporting events. And I have been wondering why I felt that way, along with everybody else there and the millions of Brits who

Redgrave calls the shots

stayed up to see it live, unfolding its terrible drama before us on the screen.

It was because it was epic. There has always been an epic quality about Redgrave, with his enigmatic and utterly uncompromising nature. And we have just finished Book Five of the *Redgraviad*: the greatest and most satisfying epic in the history of sport.

We seek drama in sport, we seek action, we seek stories. But above all, we seek heroes, for it is a hero that makes a story come alive. The hero is at the heart of the epic: deep, complex, surrounded by endless foes.

Complications are necessary to make the hero rounded, believable, sympathetic. We have Redgrave's dyslexia, his poor performance at school (the famous CSE in woodwork), poor haul for a man with a truly remarkable mind; and his powerful gratitude at finding

something at which he would excel.

And we have his troubled nature, his almost impossible degree of single-mindedness. It is a double-edged thing, that much is apparent. A true epic hero tends to be flawed by the very thing that makes him great, and that has always been the case with Redgrave. His wife, Ann, said that after this last race it was a choice between his boat and his marriage.

His is a raw nature, something for ever untamable and unknowable. He is intimidating, not because he wants to intimidate but because his force of mind makes a person with lesser force – just about all of us – feel a trifle uncomfortable.

There is something bear-like about him: a man that has never been truly domesticated. You don't house-train a man like this. And we have followed his

story. It is a peculiarly British epic because we Brits have had the advantage over the world in that we have followed it raptly from Book One.

That was set in Los Angeles in 1984. In Seoul four years later, he won the pairs with Andy Holmes, a match that ended in golden divorce. But then came the courting and winning of Matthew Pinsent, a man of amazing qualities, not the least of which is to be able to live with Redgrave, and perhaps the greatest of which is his contentment – even his delight – in standing in Redgrave's shadow, even as he won a remarkable three gold medals for himself.

With Pinsent, Redgrave entered an era of certainty: gold medals taken as of right, and by crushing margins, in Barcelona and Atlanta. This was his Tamburlaine period: Redgrave became Jack the Giant Killer.

But for epic heroes, there always has to be a last dragon, and so to the terrible conclusion of Book Five. For even mortals who are given great gifts by the gods grow old. Redgrave's wild remark, that anyone who saw him in a boat had his full permission to shoot him, was what made the final book so unspeakably vivid. It was clear that the ultimate quest was demented and perhaps doomed.

Redgrave contracted diabetes and has to inject himself six times a day. There were problems of personnel, for this was a four rather than a pair. And then came that traumatic defeat in Lucerne, when it became clear that this most heroic of quests was doomed.

But it was not. Over the course of a single, outrageous week, the hero of the epic took on the last dragon and slew the beast stone dead. It was the improbable conclusion to a tale we have been living for the past 16 years.

Redgrave is the Edmund Hillary of sport: the first man to reach the peak of sport's Everest. He is entitled to stand with Hillary and say: "We knocked the bastard off."

This has been a quest that has lasted 16 years, embracing five Olympics, and it has been an odyssey of pain. "If you do it right, it's going to hurt," Pinsent said. "It's not something you try to avoid. You feel pain in your legs, your arms, your lungs. But you put it in the background."

Redgrave has spent 22 years of his life as a full-time oarsman, 22 years of his life putting pain in the background. That is one of the measures of his greatness.

There are heroes we can identify with, but Redgrave is not one of them. He is too good. It would be like identifying with Aeneas or Odysseus. There was a long moment when he seemed vulnerable, but he was able to conquer even his own vulnerability.

Savour it. Save the moment, savour the man. Because none of us, even the youngest, will see anything quite like this again.

STOUT DEFENDER OF PROPERTY...

DECENT, WARM HUMAN BEINGS...

FINE, UPSTANDING CITIZENS...

GREAT P.M. MATERIAL.

Poor doomed Paula and our lust for fame

Libby Purves

WATCH THEM: they glitter, they mesmerise, they infuriate, they defy what is left of convention, they shriek "Look at me!". They rattle the bars of our commonsense prison. Then, for their last trick, they destroy themselves before our very eyes. They sabotage their marriages or hook up with equally doomed figures; they drink, they drug, they bloat, they make red-eyed scenes at public events, they plunge into undignified battles with their exes, they invade their own privacy to lay every emotion bare.

From respectable armchairs and decorous homes the rest of us follow their progress; for who can look away from a shooting-star? We tut and chunter disapproval, but we watch. If we ever feel guilty about our open-mouthed gaping at the wreck of real lives, we can comfort ourselves with the fact that everything they do confirms the unbelievable fact that they actually want to be watched by millions of strangers. It fills some yawning gap, some awful deficit of love.

Sometimes these wild, sad, glittering disaster-people manage to recover from it all. They embark on half a dozen therapies and then tell the tale of their rehabilitation, in return for yet more attention. Sometimes – very rarely – they are cured by time or a more solid love, and retire into private life. Sometimes they die.

Poor Paula Yates has died, leaving four daughters whom she cherished through her erratic, chaotic, unlucky life. Her ex-husband Bob Geldof, father of the elder three and currently sheltering also the confused four-year-old daughter of the late Michael Hutchence, chose the right word. The children's plight is, he said, "insupportable". He asked us to leave Paula with her dignity.

I hope I shall, but it is worth saying that the life and death of Paula Yates bring home some pretty nasty universal truths about the way we are today: truths arching all the way from Buckingham Palace to Tracey Emin's beach hut. Our taste for tawdry miniature tragedies has gone so far, and come to depend so little on the actual substance of the victim's fame, that it makes disasters ever more likely. The hollowness of modern celebrity makes it all the more lethal.

Of Paula herself I would only say that I rather took to her. We met a couple of times for interviews, and away from cameras and rock stars she was a gentle, obliging, rather witty girl who was anxious to be liked. She wrote well. She could send herself up. I much regret a project of hers which never got done because of the catastrophe of Michael Hutchence's nasty death. She was apparently planning a book called *How to look like a goddess when you feel like a dog*. It would, she had said, be full of useful hints for fast-living people like herself who have to look good at airports even at times of excess or trauma: big sunglasses, fur collars to make you appear frail and exotic, that sort of thing. I still think it was one of the best titles ever.

There will be a lot written this week about drugs, drink, family estrangement, younger boyfriends and the rest. You do not have to dig or intrude to know more about Paula Yates than is decent. You do not have to be a media shrink to mutter the words "addictive personality" or draw lines back to her ghastly parents. But let her rest: here it is the fame itself that concerns me. and our unhealthy hunger for figures who glitter and are doomed.

It is especially relevant, perhaps, in the light of Patrick Jephson's proposed book about Diana, Princess of Wales. Apart from the distress to her children, I cannot say I care much either way about its publication. Frankly, we have reached the stage of overload with books about Diana when each one is far more revealing about its author than about the late Princess. The books merely tell you all you need to know about the repressed romantic filing-clerk who lurks within Andrew Morton, the passionate bisexual class warrior that is Julie Burchill, the bees in Tony Holden's bonnet, and so forth. This one, I suspect, might as well be titled *Diana – the miffed and somewhat pompous ex-naval officer's view*.

But when you look back, it is ever more apparent that the obsessive public feeling about Diana began only when her pain was laid bare. For much of her public life she was seen as a kind, rather naive fashionplate, a decorative extra, a bit of an airhead. She had many fans and some detractors, but there was no intensity in it until she began to look ill. Then the rumours began, Morton told of hurlings downstairs and bulimia, and James Hewitt's treachery revealed the worst about her worst few years. By the time she exposed herself with big tragic eyes and careful phrases on *Panorama*, the parasitic public was latching on to her pain, feeding off it, loving it.

And then she died: it was an accident, a mundane road disaster which with bitter irony had more to do with her recovery and anxiety to be private than with the previous starrily self-destructive pattern. Yet it horribly completed that pattern: and so we got the mania of three years ago, which was only partly sorrow for a real woman. Mainly it represented a spuriously liberating, pleasantly guilty, unhealthily enjoyable hysteria about the classic story: fame, beauty, excess, doom.

Elton John sang us a hastily amended version of his anthem to Marilyn Monroe – because never mind the vast differences, never mind the truth of their individuality, they sort of go together, don't they? All doomed blondes, aren't they? Marilyn, Diana, Paula …

It would be easy to make feminist points about men wanting women to be frail candles in the wind, or cruelly virtuous women gloating over the punishments of beautiful adulteresses. But that doesn't quite work either, because the awful fascination happens with men, as well. The legend of Oscar Wilde is immeasurably enhanced not only by his trial, imprisonment, exile and death but by the decline of his physical beauty. The continuing cult of Elvis Presley is all bound up with his expiring drugged and bloated on the lavatory. The image of a rock star dead in a hotel room has become hackneyed. Dylan Thomas's hopeless hell-raising brought him followers that his poetry alone never would have. Witty self-deprecation helps: for decades Jeffrey Bernard was a legend merely by drinking himself elegantly to death on behalf of the rest of Fleet Street. He carried the torch of dissipation on behalf of every reformed Soho barfly now settled down with a strict second wife and a quiverful of golf clubs. Acolytes could read him in *The Spectator* from the safety of an early bed in the suburbs, and the more bits of Jeffrey's body gave up, the safer they felt.

As life in general grows less adventurous and risky, we seem to cling ever more unhealthily to our fascination with those who live fast and who might – with a bit of luck – die young. The more timid we get, the more hypochondriacal about food scares and obscure illnesses and the risk of being scarred by emotional trauma if anyone upsets us, the more we like to watch famous people poisoning themselves and courting sexual disaster. We like it so much that we pay them to do it, by

way of the celebrity interview circuit. Anyone reasonably good-looking and articulate who is prepared comprehensively to screw up their life in public has got a potential career. Outrage is an industry.

Or, for those with a patrician disdain of industry, there is the option of calling it art. Tracey Emin shows off her bed littered with the detritus of unhappy debauchery, entitles her beach hut *The Last thing I said To You is Don't Leave Me Here*, and relates her life story to all who have ears (teenage rape, miscarriage in taxi, hellish boyfriends, etc). Then – because ostentatious prosperity is an essential part of the doomed-glitter act – she poses

rather horribly with her naked legs sprawling, clutching coins and notes to her groin, under the title I've got it all. She has parlayed a decent talent for drawing, and a reasonably good eye, into affluence and fame by marketing her dark, feral beauty and private disasters.

Meanwhile, I see that a fellow Saatchi artist, Gavin Turk, first came to notice by grabbing for the same necrophiliac glamour with a statue of himself as Elvis. And so it goes on, round in circles: timid envious caution pays its sixpence to gawp at glitzy, witty misery. It's a devil's bargain. It's nothing to be proud of.

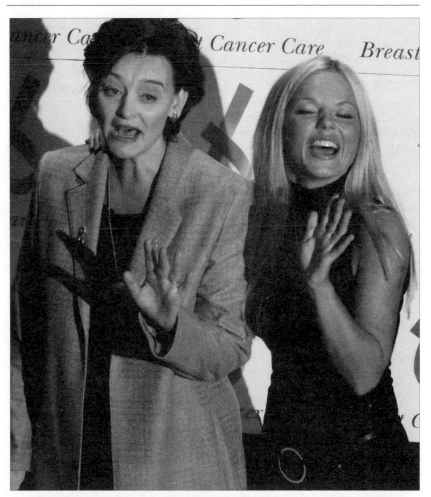

Cherie Booth and Geri Halliwell launch Breast Cancer Awareness Month

Can Blair recover from his wobbly week?

Anatole Kaletsky

HAS TONY BLAIR just suffered his Black Wednesday? One does not have to be a slavish follower of opinion poll fashion to suspect that the answer is "probably yes". The problem for Mr Blair is not just that Labour has fallen behind the Tories for the first time since September 1992, or even that the sudden collapse in support for the governing party has been bigger than the seven-point drop that followed Black Wednesday.

Polls come and go and the public mood will doubtless improve once the British people get over their collective tantrum. But even as the polls swing back towards Labour, as they surely will when the only alternative is William Hague's neolithic Conservative Party, Mr Blair will face a deeper, more intractable danger. Voters have seen him lose control in a crisis. They have watched him paralysed, like a man in a dream who pulls the trigger and finds that his gun won't go off.

There was a palpable sense last week that the Prime Minister had lost control. He seemed to have no idea how to cope with what should, after all, have been just a minor crisis. Rightly or wrongly, it looked like the country was saved from disaster only by the good grace and self-restraint of the lorry drivers and farmers. If the protesters had not gone home of their own accord, it seemed that the Prime Minister would not have known what to do.

It is very difficult for a leader to regain his authority after he has suffered a public "wobble" of this kind. That was certainly Mr Major's experience after Black Wednesday. Similar damage was done to Margaret Thatcher after the poll tax riots, to Jim Callaghan after the Winter of Discontent, to Jimmy Carter

after the Ayatollah, to Lyndon Johnson after the Vietnam protests, to General de Gaulle after the 1968 *evènements* – and most memorably to President Ceausescu in 1989 after the Bucharest crowd heckled his new year oration.

There is, of course, nothing inevitable in politics. A skilful and lucky leader can recover from a crisis - and many a wounded politician has soldiered on for years after his authority was shattered. Mr Major did for half a decade.

The question about Mr Blair, therefore, is not whether he has suffered a dreadful blow, which he clearly has. It is whether he will be permanently crippled, as Mr Major was by Black Wednesday.

There are three ominous signs. The first and most obvious parallel with Black Wednesday is the campaign of vilification which has started against the Chancellor. If Mr Blair's ministers and cronies really believe that they can stabilise the Government by making a scapegoat of the Chancellor, they are heading straight for a rerun of the Major-Lamont nightmare.

Mr Blair must be seen to accept full responsibility, both for the policies that led up to the petrol protest and for any concession that might now be made. But he must also be seen to have the Chancellor's wholehearted support. He cannot afford to fall out with his Chancellor or allow his Cabinet to split at a time like this. Yet several of the ministers closest to Mr Blair seem to be plotting against the Chancellor, while Mr Brown appears to be behaving just as divisively in his own defence. All this augurs badly for a Government which now has to struggle with the problems of weakness instead of glorying in its popularity and power.

The second reason for Mr Blair to beware the fate of Mr Major relates to his own personality. More accurately, it relates to his image, since few of us have any idea of what Mr Blair is "real-

ly" like. Mr Blair's all-powerful PR advisers seem to believe that the surest way to restore his personal standing is to "connect" him with the voters, to present him as what the Americans call "a regular guy", an ordinary middle-class family man, with ordinary middle-class problems.

This campaign began with the mawkish passage in last year's party conference speech, when he first suggested that running the country was less important to him than family life. It continued with his embarrassing statement to the Women's Institute that the "toughest" job he did was not being Prime Minister but "being a dad". And it culminated with the birth of Leo, his much publicised paternity leave and the amazing claims made by his advisers that the Prime Minister was tired because he was looking after the baby all night.

Yet, in reality, nothing could now be more dangerous to Mr Blair's political future than trying to play this demotic card. Think back, again, to Mr Major. Was he not the Platonic ideal of the man on the Clapham omnibus? Was he not likeable? Didn't everyone acknowledge his modest, self-deprecating charm?

And was he not universally despised for these very reasons as a weak leader, an indecisive, weathervane politician, a Prime Minister who would have done himself and the country a favour if had stayed on the Clapham bus?

Intimations of a leader's ordinary humanity may be popular and charming when times are good and he is riding high in the public's esteem. But in periods of crisis, the country needs more than just an "ordinary bloke" as its leader. For a Prime Minister to put his family before his job no longer seems charmingly human. It seems like a failure to understand the responsibilities of leadership and power.

The voters did not put Mr Blair in Downing Street to stay up feeding his baby. If he really thinks that "being a

dad" is more important than being Prime Minister, then maybe he doesn't take his day job seriously enough. A soldier loves his family as much as the next man, but he cannot suddenly announce when the enemy starts firing: "Excuse me, but I'm just an ordinary bloke and I think my wife and children are more important than my job."

In saying all this, I do not wish to suggest that Mr Blair really doesn't work hard enough at Downing Street or fails to take his responsibilities seriously enough. As I said above, I have no idea of what he is "really" like. What I can say, however, is that Mr Blair's authority will continue to be undermined if he keeps trying to cosy up to voters by presenting himself as just an ordinary bloke. For a leader trying to rebuild his authority, dignity and even formality, could achieve more than likeability and charm.

This brings me to the third analogy with Black Wednesday. Mr Blair is universally advised to "listen" to the public and to cut taxes on petrol.

The more intelligent commentators may acknowledge that motoring costs for the general public are lower today in relation to average earnings than they were in any year before 1999. They may admit that the Chancellor has already made huge concessions to motorists and industrial energy users in the last Budget, concessions which put Britain's environment in jeopardy and the Government's greenhouse targets in grave doubt.

They may even agree that cutting fuel costs will do nothing to solve the economic problems of farmers, since these are caused by over-regulation, the common agricultural policy, the weak euro and BSE. Neither will cheaper fuel be much help to road hauliers, since intense competition in this largely deregulated, non-unionised market will simply push freight rates down to reflect the lower costs.

But all these economic objections – and many others – must be overridden, says the conventional wisdom.

Economic facts no longer matter. The political imperative is to give the protesters what they want.

Now think back to Black Wednesday. Eight years ago this week, John Major decided that the political imperative of ERM membership should prevail over economic logic. All the panjandrums of conventional wisdom – the CBI, the TUC, the newspaper leaders – supported him with fervour. And all were wrong.

Will Mr Blair now listen to the same siren voices? Will he follow conventional wisdom and opt for a "political solution", forgetting about environmental principles and economic logic?

He should remember this. In the end, voters will always sniff out a Government whose economic policies do not add up. They will despise a leader, however amiable, who has no principles. That was the most important lesson of Black Wednesday. Understanding it is what distinguishes a Prime Minister from an ordinary bloke.

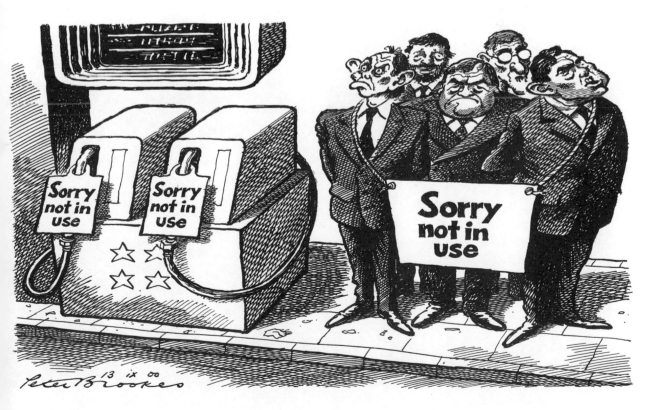

EUROPE: RUNNING ON EMPTY

Norway
Government pledges to cut fuel taxes in the forthcoming Budget but this is rejected by hauliers who block five oil terminals.
Transport unions threaten more disruption if the Budget doesn't deliver lower taxes on fuel.

Sweden
Hauliers blockade the ports of Stockholm and Malmo for the fifth consecutive day yesterday with more action to come.
The Social Democratic Government refuses to lower fuel taxes and announces it is to increase ecological tax next year.

Finland
Protests continue as hauliers reject offer to cut road taxes.
Government says it will not levy a final instalment of a haulage tax this year as a concession to hauliers, but will not reduce road taxes.

Denmark
Hauliers and farmers stage blockades of border crossings and ferries.
The Government will not lower fuel taxes but is considering tax breaks.

Holland
Hauliers call off their protest after a go-slow from all 12 provinces to The Hague on Friday wins government concessions.

Germany
For the past week lorries have paralysed two different cities a day with blockades and go-slows. Chancellor Gerhard Schröder rejects calls for fuel tax cuts. More blockades threatened.

Poland
Last week slow-moving lorries snarl traffic in most big cities. Government gives warning of tough action if hauliers participate in more go-slows.

Hungary
Last week's protests halted after the Government and hauliers come to a partial agreement that excise tax will not change as long as the average quarter-yearly price of crude oil remains above $25 per barrel.

Austria
No protests so far, but the Government is already offering to double heating cost allowances paid out to low-income families this winter.

United Kingdom
A fortnight of blockades, panic buying and go-slows bring the country to a standstill. Blair's hard line worsens protest and Labour sees its worst showing in polls since January 1992.

Ireland
1,200 hauliers stage a go-slow in Dublin and other cities last Friday and this week hundreds of fishing boats stop work. Irish Government says it will consider drivers' demands as it draws up its Budget.

Belgium
After a week of protest hauliers, lift blockades and accept government offer of compensation. Prime Minister Guy Verhofstadt says "the people's patience is at an end" and "our economy and prosperity are in danger".

Portugal
Though prices are low by European standards, hauliers, fishermen and farmers are clamouring for lower prices. Both they and the Government are watching Spain closely for developments.

Spain
A fortnight of protest has escalated this week. Transport unions are blockading a town a day and threaten oil refinery blockades. The Government is offering tax rebates to farmers and fishermen but refuses to budge on fuel taxes.

France
Fuel crisis begins with port blockades on September 7. Protesters win concessions from Government but there are threats of fresh action. Prime Minister Lionel Jospin experiences a 20 per cent drop in popularity.

Greece
The Government says it will not "give in to pressure" but there are chaotic protests, port blockades and go-slows on the motorways.

Italy
Government bows to drivers' demands for new fuel discounts, averting the threat of protests.

'London is a uniquely brutalising and ugly city'

Built on the imperatives of money, not the need of its citizens.
Author and critic Peter Ackroyd talks to Tim Teeman about the city that first
inspired, then obsessed, and finally very nearly killed him

Tim Teeman

THE BRIDE and groom are framed in the entrance of the church. Peter Ackroyd frowns. "How inconvenient. Are they getting married or not? I must show you where the Virgin Mary was supposed to have appeared. This church, St Bartholomew's, is one of the oldest churches in London. Early 12th century." We take five more steps. Ackroyd squints at the back of the bride, a billowing meringue of white satin and tulle, obstructing our progress. "She looks like a waxwork," he whispers archly.

A minute passes before Ackroyd springs forward. "Come on," he says walking straight past the stationary bride and groom. "Now where is Mary's chapel?" The groom looks at us, stunned. Surveying the shabby, beautiful interior, Ackroyd whispers: "St Bartholomew petitioned the King to build this church. All the local children brought stones and built its foundations. Mary appeared as a vision in the 12th century. She told a monk, 'You must pray for me', but it never became a site of pilgrimage."

His gaze shifts to the nearly empty pews. "How odd. A wedding with no congregation." The organ starts playing. A squirrelly man in a dog collar approaches, looking embarrassed. "Would you mind leaving? There's about to be a wedding." Ackroyd briskly responds: "Where's the chapel dedicated to the Virgin Mary?"

"Over there," he points, dumbfounded, "but you'll have to come back another time." Ackroyd nods and walks towards the exit, past the bride and groom, unabashed. "This is what appeals to me," he says, with a flam-

boyant sweep of hand. "Little bits of London that survive."

The capital in its countless incarnations, from Italianate Xanadu to medieval cesspit, has been central to many of Ackroyd's prize-winning novels, non-fiction works and biographies. Now, with the 800-plus page *London: The Biography*, he aims to endow the city with a living memoir, a painstaking work to remind us that the capital's history is alive and vibrant behind walls, beneath pavements and in the foundations of houses. Ackroyd's history, however, is not chronological, but linked by theme and laced with precise and pungent detail.

"Isn't it beautiful?" he asks as we stand outside St Bartholomew's, with its walled green. "Look at the stone [grey, muddy brown, odd bits of shingle]. We're in the centre of the city, yet it's so quiet." The church, as everywhere in his favourite area, Clerkenwell, is imbued with the past. On Clerkenwell Green (actually rather a built-up, if leafy square), he points out the Marx Memorial Library. Walking slowly and speaking in staccato bursts, the author provides an engaging running commentary. Did I know that London was first named Londinium by the Romans in 43AD? That Wat Tyler had invaded Clerkenwell? That in 1816 Henry Hunt, one of the leaders of the Chartist movement, spoke to a crowd of 20,000 above the Merlin's Tavern just north of

the Green? That the Tolpuddle Martyrs convened on the Green in 1837?

"London is a remarkable echo chamber," he says above the roar of clanking building work. "It's a visible, material relic. It is one of the few cities in the world which retains its archaic characteristics and still aspires to the future."

He smiles as he looks up at a new, four-storey office block, adorned with plaques naming 18th-century clockmakers: John Cranfield, John Moore, Sam Hutt. Incongruous? "No," says Ackroyd brusquely. "It's the old and new in embrace."

Then to Smithfield, home of the meat market since early medieval times, with Ackroyd darting left and right to look at buildings. He points over the gentrified cobbles: "The disabled lavatory is where the the martyrs were burnt." His book further details how in the 12th century the wives of Billingsgate traders were known as "fish fags" (from which we get fishwife).

In one chapter, he analyses the capital's history of hanging. In the late 18th century landlords let rooms with good vantage points to the highest bidder. Ackroyd also evokes the capital's subterranean labyrinth of pipes, old trainlines and catacombs. "One of the characteristic drawings of the city is that of its horizontal levels, from the rooftops to the caverns of its sewers, bearing down upon and almost crushing one another with their weight."

Ackroyd's fascination with the capital began early. He was born and brought up in Acton and as a boy he was taken to walk round the streets of Cheapside, in the heart of the city, by

his grandmother, Catherine. Through researching his books, he slowly acquired a coherent picture of the capital's historical geography.

"London will always retain an element of mystery," he says, gazing thoughtfully at Smithfield's sunken Roman road. "It is continual revelation. Even if you venture down streets you've known all your life you see things startling or odd. This is a city built on money, power, trade and commerce. It's uniquely brutalising and ugly. It's built on the imperatives of money, not the need of its citizens."

For research, as well as garnering material from the British and London libraries, he went for a daily, far-flung afternoon walk: "Leytonstone, Forest Gate, anywhere to explore the terrain – walking was as much part of the research as reading books, to get a sense of atmosphere, a sense of place, and people, remnants of past times."

Given that the book is being hailed as the apex of Ackroyd's career – the definitive history of the city which obsessed him – it was, he accepts, "poetic" that he had a heart attack last November just after he had completed the final sentence. "London nearly killed me. I was sort of wrestling with the spirit of the place and it nearly finished me off. I was aware of a shortness of breath and thought it might be a virus. I went to hospital a few days later. I collapsed there. It seemed I had had three heart attacks without noticing."

He was in intensive care for a week, though on waking up and "feeling fine" he wrote an essay on William Blake for the Tate Gallery and a long book review for *The Times*. He says the heart attack has had no effect on his life: a famed sybarite, he still defiantly drinks a lot.

"It certainly wasn't a life-changing experience, though it should have been because I was so close to death," he says blithely, as the bustle of Smithfield – dot-commers, tourists and white-overalled market workers – flows beneath our restaurant. "But I

didn't feel any intimate contact with anything Divine. When I came round I had a bottle of wine. What else was there to do but celebrate coming back to life? I had rather a good time in hospital, a good rest, and I shed some pounds. It's rather a vulgar concept that one's life should be changed by that kind of event. It didn't affect how I write. If you have a vision of the world, it's not likely to be changed by temporary illness or a minor accident."

Along with this disavowal of the significance of the heart attack comes Ackroyd's scathing condemnation of current confessional literature. "I would never write a book about my illness," he says. "I don't like the confessional trend. It's vulgar. My private life does not inform my work. It was only in the 19th century that writers were persuaded that their private selves had any significance."

He hates talking about himself (unless he is drunk, which he isn't today). But this much he does impart. He is single, having broken up with his partner, Carl, earlier this year. He seems sad about this, although bluffly dismisses the break-up. He is moving from the rambling house they shared in Islington, North London, to a flat in Kensington.

The house, he says tightly, is now too big for him – though he denies being lonely. "The relationship came to a natural end. It's time for me to move on." He is also selling, he says, "to make a glorious profit – I always said there was nothing wrong with being a good businessman as well as a good writer. Shakespeare and Dickens were both consummate businessmen." (Four years ago, he signed a £1.5 million contract for eight books.)

He feels he may be single "for some time". His 24-year relationship with his literary assistant and partner Brian Kuhn ended when Kuhn died of Aids in 1994; Ackroyd nursed him through his final days ("nothing special, it had to be done"). Ackroyd's mother is still alive; they are both Catholics, and they

never discuss his homosexuality – "it is not an issue. Why should anything be said?"

Work is foremost in his mind. He wrote *The Mystery of Charles Dickens*, the monologue currently starring Simon Callow at the Comedy Theatre, and will follow this first play with another about Shakespeare ("an extraordinarily opaque figure"), then a biography of the playwright, then an historical novel, then a biography of the Virgin Mary. "It's going to be tough writing about somebody who's immortal," he concedes. He says he likes the idea of retiring but can "happily imagine translating Dante when I'm 90".

But his obsession remains history – "always was, since school. I loved those Greeks and Romans but they were naughty". He never reads the papers, gets the news from Radio 4, got rid of his television earlier this year, hates mobile phones and the Internet. Bedtime reading is Samuel Johnson. He claims contradictorily to "contemplate things", and to "have no talent for introspection".

Whatever, he has transformed his childhood Catholicism into a "kind of spiritualism". He has never cared about dying ("death may just be the beginning"). He says he observes the "psychic geography" of the city as keenly as the physical: why different areas retain certain feels; why particular streets have incidents such as murders which recur through history.

For him, London is an "organically evolving city" gendered male, "thrusting not gentle. Most capital cities have a river of feminine deity. In London, we have Old Father Thames. The monuments of Big Ben, Monument and Canary Wharf are phallic. In times of distress and calm, London changes sex – the Great Fire of 1666 was, in his gender lexicon, female. "Women on the whole are bewildered by London, and find it very threatening. There is a general fear of getting lost."

Though Ackroyd was mugged five

years ago ("I said to my friend when I saw the glint of the blade, 'Give them everything darling'"), he says he feels safe. "If I ever get depressed, I just go for a walk and I'm cheerful again.

"London has no meaning or form. It is merely a succession of fleeting images, which is why it gives so much pleasure. When I was a child I used to read histories of chemistry and organic physics just to see if I could master the system. With London, my aim was much the same, to make all the information cohere."

However, he accepts that it is a project that is "necessarily unsuccessful. The city is changing all the time. But I think if people read this book and come away with a more charged knowledge, or a more charged imagination, then it's done its work."

To extend his obsession, Ackroyd has embarked with two architect friends on a £5 million scheme to reveal London's secret underground river, the Fleet, which was covered over in the 19th century because of pollution and noise. The aim is to build a glass platform under Farringdon Street so that pedestrians can see the gushing river below. "To reveal the Fleet would realise my true preoccupation – the contemporary

presence of past times," he says. "The changing physical geography of London is part of my mental landscape. This will be much more permanent than the London Eye or the Dome. It will be a constant reminder not only of the secret water beneath our feet but also of the permanence of London's geography."

This week, he plans to go down into London's "magnificent 19th-century imperial sewers", with their "brickwork and amazing vistas, like temples".

Ackroyd lights up as he talks of the Fleet and other undiscovered "secret landmarks": the hanging fields of Tyburn near Marble Arch, the relics of martyrs possibly buried beneath Smithfield. So much for London being the much-touted climax of his concerns with the capital.

"The critics were wrong," he says, hailing a taxi in the dead light of a dull afternoon. "This book is like a chapter in a long book." He smiles wryly: "Like London, my books are a work in progress."

So, will there be a final London book?

"No. It will come to an end only when I die," Ackroyd says, quietly and contentedly: a novelist at almost-peace with London, his restless muse.

" APPARENTLY MEN THINK ABOUT PETROL EVERY NINE SECONDS "

Big Brother

PEOPLE KEEP asking me in interviews if the time is ripe for satire; all I can say is that if it wasn't, the Government wouldn't devote so much time to it. For the last fortnight we've been filming a new 60-minute screenplay – a sort of *Blair: the Movie* – set in the present and featuring Blair, Brown, Cook, Mandelson, The Queen, Hague and Prince Charles amongst others. At one stage it looked as though we'd have to stop filming because the country had run out of petrol. Clearly, in its new manifestation BP stands for Beyond Parody.

As we write and film each twist in the plot, with ministers and advisers struggling like weasels in a sack, we are all too aware that at any minute events may eclipse us. There's certainly a madness abroad at the moment, rich in irony, as a disparate assortment of protesters – from foxhunters to sales reps – unites over the issue of fuel tax: the Unled in full pursuit of Unleaded.

What is becoming alarmingly clear is that the Right now hates Blair with the same passion that the Left hated Thatcher. While I'm increasingly coming to believe that the Prime Minister has hidden shallows, it does seem disproportionate. He must look down at little Leo, so happy, innocent and popular, and think: "you little bastard – that was

me three years ago".

While there is undoubtedly a frenzied atmosphere, the PM must take some responsibility for starting it. This time last year he had no real enemies, so he decided to invent one with his bizarre Conference rant against the "Forces of Conservatism". Whatever his intention (presumably to reassure his own Left wing), the speech must go down with Portillo's mad "Who Dares Wins" oration in the Top Ten of disastrous Conference speeches: at a stroke the Prime Minister identified anyone who didn't support him (and quite a few who did) as The Enemy. (William Hague has since seized every opportunity to exploit any fear, prejudice or grievance. I'm convinced that he's only worked up about the fuel crisis because he's got four bandwagons to run.)

So how can our hapless hero escape? In our screenplay, the possibility of a good war is mooted. Sierra Leone doesn't really count, even if the SAS managed to wipe out the West Side Boys (and before they'd released their first single, too). We shall have to await the PM's speech next week. In Brighton. And what's the name of the theatre there? The Dome. Oh yes. That's the trouble with satire. It's everywhere.

Rory Bremner

Mandela embraces new
Labour as, below, old
Labour looks on

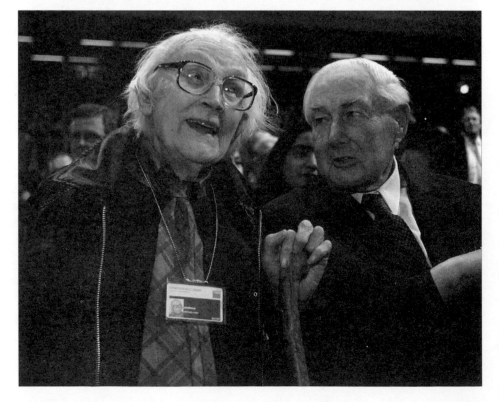

Prime Minister works up a sweat over core values

Matthew Parris

DRIPPING with sincerity and gushing with sweat, Tony Blair drenched his shirt and soft-soaped his party.

But Meatloaf got there first. "I'd Do Anything For Love (but I won't do that)" runs the hit. Tony Blair would do anything for Labour, he told his party conference yesterday. Then, with a sob in his voice and perspiration on his brow, he reeled off a list of things nobody would have dreamt of suggesting he do anyway, and insisted that he would not, should not, simply could not do them.

They were incompatible with his "irreducible core". Irreducible core? Delegates looked a bit puzzled as Mr Blair launched this mysterious entity at conference. Was it something chewy you find in one of those smart Tuscan soups?

It was brilliant stuff: Clinton-with-a-hint-of-Widdecombe.

Under pressure from the old Labour Left, Mr Blair offered a passionate pledge to resist pressure from the extremist Right. With a mock-spur-of-the-moment delivery, and departing from his text, the Prime Minister cited things such as racism, xenophobia, slashing help for the poorest. "Ah can't do i'," he protested, sweating profusely, accent dumbed down and estuarial glottal stop replacing his t's. The audience, moved, quite forgot that he was actually the Prime Minister and under no such pressure, and roared their support.

"That's right, Tony," each kindly soul in the hall murmured inwardly, "don't you let them force you!"

He could have gone on. "Ask me to rip the ears off me old aunty, and ah've gotta tell yer, ah can't do i'." Wild cheers. "Ask me to legislate for the slaughter of the firstborn, and ah've gotta tell yer, ah can't do i'." Audience weeps with emotion.

Less effective with this audience would have been: "Ask me to link old folks' pensions with younger folks' earnings, and put a penny on income tax to pay for it, and ah've gotta tell yer, ah can't do i'." But, irreducible as it is, even Tony's core has limits.

Whatever other cores this passage

Tony Blair's shirt reflects the exertion of authority

stripped bare, it was undoubtedly the core of his performance.

The rest (as befitted a speech prefaced by the pledge, "This is not a time for lists!") was a series of lists: more lists, and longer, than in any speech I have heard from this Labour leader. There were 26 lists, containing 161 items and 71 figures. If this was not, as the Prime Minister acknowledged, a time for lists, God spare us when such a time does come.

Mr Blair's leadership of the Labour Party began in a speech in Bloomsbury, his audience cowering under a barrage of abstract nouns. To what have we now come! A hail of Post-it notes, bullet points and killer-statistics.

It struck your sketchwriter that this speech won over two audiences.

The catch in the throat, the buckets of sweat, the whinnying insistence by the Prime Minister that he really did have principles, palpably moved his conference, of course. He moved much of the press, too, cynics being suckers for sentimentality.

Whether it will have moved the television audience, I cannot tell.

If only fitfully, few will have failed to thrill (as I thrilled) to Mr Blair's passionate protests and his confessional style. But it was the passion of an actor, not so much deceitful as self-induced.

Blair's is the best kind of acting, where the performer gets right inside the part, believing in and, for a while, becoming the persona he has taken. This is not to lie, but to become – to assume a mantle.

Yesterday the Prime Minister assumed it with energy and skill.

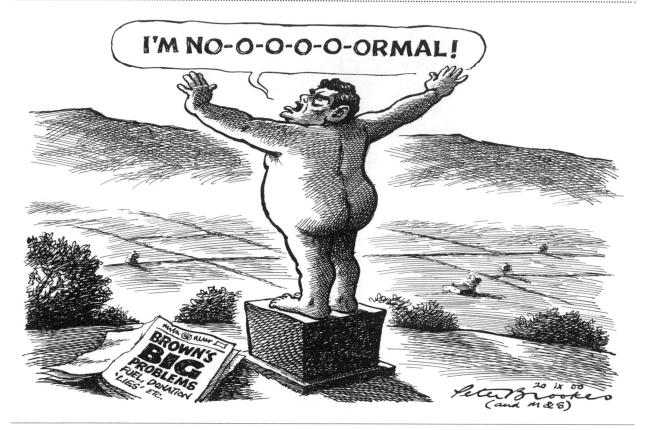

I'M NO-O-O-O-O-ORMAL!

BROWN'S BIG PROBLEMS FUEL, DONATION 'LIES' ETC.

Archer relieved at play verdict

JEFFREY Archer expressed delight at being found not guilty by a theatre audience on Tuesday night. His reaction may not have been entirely spontaneous.

The result was just as well for the peer-turned-playwright. His new play, *The Accused*, in which he plays a doctor accused of murdering his wife, has two endings, depending on the verdict returned by the audience.

The finale following a guilty verdict had not been fully rehearsed by the time the curtain went up on the first performance, so a not guilty verdict was imperative. There were backstage whispers at Windsor's Theatre Royal that the result had been predetermined and that the audience vote would count for naught, but they remained unsubstantiated last night.

Instead, it appears that Lord Archer of Weston-super-Mare was gambling on the goodwill of his blue-rinsed audience. He had further stacked the odds in his favour by penning a prosecution case so weak that it would incline even an enemy to acquit.

Michael Crick, Lord Archer's biographer and nemesis, admitted that the Crown's case in the play was so flawed that he was moved to pronounce the peer not guilty.

It was a day of extraordinary and fortuitous coincidences for the former Tory deputy chairman. He took the stage only hours after he was charged with perjury over claims that he asked a friend to lie in his 1987 libel trial. In the circumstances, it is not surprising that he could not rehearse a guilty ending.

Lord Archer said he found the audience's verdict "amazing". He added that the timing of the play on the day he was charged was "sheer coincidence".

"One cannot time that sort of thing in real life. You couldn't have got away with that in a Jeffrey Archer novel."

None of the 623-strong audience, who at the end of the play are asked to adjudge his guilt or innocence by means of electronic seat buttons, saw how the verdict was split. Within seconds of the vote, the "not guilty" finale swung into action. Lord Archer's latest gamble had paid off.

It is understood, however, that on future nights the result of the ballot will be on view to the audience as they leave the theatre. Perhaps by then Lord Archer will have had the chance to rehearse the suitable lines if he is ever found guilty in the audience's eyes.

Tim Reid

City Diary

Iuma

WANT to make an instant $5,000? There is a website named Iuma promising parents this sum if they agree to name their children after it. (Pronounced Eye-OO-Ma, it stands for Internet Underground Music Archive.)

This being America – did I mention this? – there are plenty of takers. Welcome to the world, then, Iuma Carlton, born September 8 in St Petersburg, Florida, and destined, until his parents stumbled across the website, to be plain old Michael. Some things are too weird to make up.

Martin Waller

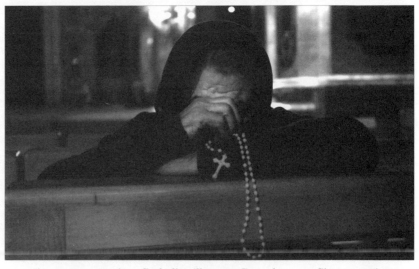

A woman prays in a Catholic village on Gozo, home to Siamese twins Jodie and Mary

Our family uncovers Ibiza

Nigella Lawson enjoyed the best of both worlds when she whisked her husband and children off to the hedonistic isle

Nigella Lawson

ABOUT a fortnight before we set off on holiday my children began singing to anyone who'd listen, "Whoah – we're going to Ibiza!" Unless you have small children and bring them up in slutmotherly fashion as I do, weekly stints in front of *Top of the Pops* being the only fixed point in our joint diary, you may not know this rendition – sung by Swedes in mock-Hispanic accents – of that popular-cultural gem, "Whoah! We're going to Barbados!". But I could see it wasn't going down well. Who goes on holiday to Ibiza? Who would dream of taking their children?

After all, if you've seen *Ibiza Uncovered*, or even if you haven't but have absorbed its message, you will know that Ibiza is the island where the sun never sets, where drug-pumped louts go from club to club, only to end up at breakfast time vomiting on the beach. I was prepared, before I went, to advertise my upcoming break in ironic fashion.

I revelled in its inappropriateness – but then I had one advantage. Secretly I suspected that it wasn't going to be inappropriate. My sister, Thomasina, had – thanks to a richer schoolfriend when we were in our teens – gone there every summer holiday, and although I'd enviously realised that she'd had a better time, teenwise, than I had on strenuous French exchanges, I knew that the place was beautiful, that there was more to do than living large there.

Anyway, I am far from being a teenager now or wanting a teenager's holiday. What I envisaged, rather, was that middle-class, middle-youth excursion: luxury villa with pool, au pair to accompany. But although it obviously makes life easier – if sleeping in in the morning is to be a possibility – to take your own child-care with you, life there doesn't depend on it.

This – and I make this assertion after years of committed Italophilia – was the most child-friendly holiday I have ever had. More to the point, one didn't have to turn it into the Waltons-on-the-Med. For much as I love Italy, the difficulty is that it's such a huge country, and any Tuscan villa you happen to be staying in is always isolated from any of the obvious attractions: beaches are going to be hours away, and you have to gear yourself up even for a restaurant visit. No child wants to be in a car on a hot day for more than ten minutes. In Ibiza they never had to be.

Not that we were energetic. For the first time in my life I learnt how to do nothing pleasurably. The villa's grounds, up-country in Santa Eulalia, were ridiculously beautiful and the pool warm. The children splashed and

we – six adults – lay propped up on recliners reading Joyce Carol Oates's *Blonde*; I'd thought a holiday reading club might be a good idea. But even that became too demanding. The mixture of sun-heavy palms, dreamy blue skies and countless bottles of *vino rosado* made us happy to lie about doing nothing more strenuous than smile indulgently at the children as they bounced about on Lilos and never, this is the great miracle, moaned that they were bored.

By late afternoon, and after day three not until late evening, we went to the nearest beach – all of five minutes' drive away – the Niu Blau, where the children made collections of shells and built sandcastles, all of those things one fondly imagines a family holiday should comprise, while the adults sat at the beach restaurant, eating grilled squid (and yes, the children did, too: it was such good grilled squid) and drinking more *vino rosado*. The sea is shallow there, there was enough to keep them on the sand to stop them wading into the water, and there were enough children for one to be able to ignore them.

As I said, that's the expected part of a family holiday. But what was so wonderful was being able to do the cosy parent bit by day and the irresponsible single bit by night. Now I don't mean we joined the ugly hordes at San Antonio, but with a babysitter in situ (and otherwise I'm sure a non-resident one could be found) we could go out at night and play.

Just as you approach Ibiza Town is the local casino: of course we went there. In fact, I had the fabulous experience one night, around the blackjack table, of being too short to double a bet, only to have a gallant Belgian throw me a couple of chips. Why, a girl could morph instantly into a simpering version of Jayne Mansfield there and then – or at the very least, feel gratifyingly unmumsy.

And we did go clubbing one night, too. Not in some sweaty dive (I don't think I'd ever feel inclined to try my hand at Manumission) but at Pacha, the relatively upmarket palace of cool, again in Ibiza Town. And one of the best things about doing all this relatively late in life is that you are not so anxiously preoccupied about one's own measure on the cool-barometer.

I took one look at the bored, skinny girls dancing listlessly on the podium and decided that it was about time they saw what a real woman looked like. And there is no more gratifying feeling than to know that one's babies are lying cherubically asleep in their beds while one is infused with the blood-beat of house music, grinding one's pelvis on a podium at Pacha.

Postpartum, even a couple of young lifetimes' postpartum, it's important to know you can still pull. And then, instead of doing what most of the rest are, which is going back to some hostel in town probably with some undesired German youth in tow, we taxi'd back to our villa and dived into the pool for an unembarrassedly naked 6 o'clock swim. It was all so damn elegant.

But I'd only want to do that once. On another night, we went to Kilometre 5, a more grown-up, less raucous club just outside the town, where you can clink glasses as you sit in one of the tented recesses that dot the out-of-doors room. Actually, it was rather like a Caribbean supper club of some Fifties film director's imagination. Sometimes, for all the uplift you can get from an occasional inappropriate evening, you do want to be with grown-ups.

But still, the best hours were spent at the villa. Although I knew it was going to be civilised, beautiful, idyllic even, I hadn't expected it to have the unpretentious rusticity that Santa Eulalia certainly has. Not the town, maybe, but the countryside around – and for a small place, there is so much of it.

True, the food isn't as good as it is in Italy. I thought I'd mind – but I didn't.

For once, I was happy not to cook myself: all you need are plates of *chorizo* and *jamon*, some *pollo asado*, that wonderful rotisseried chicken from the little roast chicken shop near the local market, cheeses and fruit – and there is exceptional fruit there – and life is easy and rewarding for even the greedy. And I should know. Evenings, as I say, there's grilled fish (chips, too, if the children want) at the beach bar, and always bottles and bottles of *vino rosado*.

And this, really, is the real Ibiza Uncovered: it's far from being the noisy, sweat-slicked place of popular imagination. And even if I might have guessed as much before I went, afterwards it's impossible not to hug that discovery to yourself as if a precious secret. I'd worry about letting you on to it now if it weren't for the fact – truly – that I've already booked our villa for the summer half-term next year. And will do for the year after that, and the year after that, forever.

"HE'S TAKEN TO WATCHING THE OLYMPICS AT NIGHT AND SLEEPING THROUGH THE LIBDEM CONFERENCE DURING THE DAY"

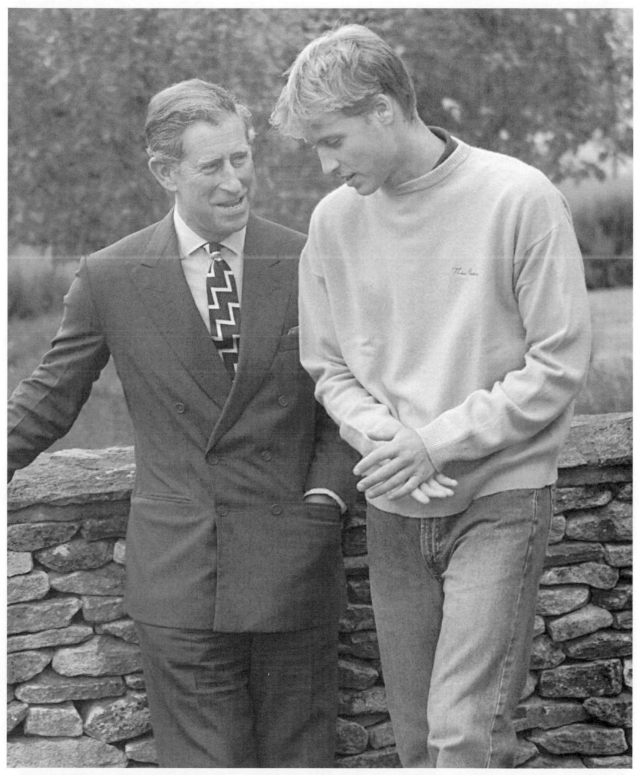

Prince William receives parental encouragement as he gives his first press conference at Highgrove, Gloucestershire

THE TIMES

October
2000

What kind of tonic would lift Tory spirits?

The conference offers the party faithful three sharply contrasting tastes

Michael Gove

IF THERE'S one message that needs to be absorbed by the unrepresentative clique gathering in Bournemouth this week it is simply this – Britain has changed since the 1980s. But sadly the BBC's political team don't seem to have realised.

Greg Dyke's correspondents persist in covering this Tory conference as they have every Tory conference since William Hague's first appearance in 1977 – by depicting it as a struggle between the decent forces of left-wing, One Nation, Conservatism and the rough beasts of the Right. As debates go, it's about as contemporary as discussing the dinner party merits of serving Blue Nun. But more of Ann Widdecombe later.

The old Tory Left has neither programme nor popularity, only personalities, in the shape of Heseltine, Clarke and Patten. Each is tarnished by intimate association with two failed administrations – Major's and Blair's. The willing collaboration of each with the Prime Minister's campaign to sucker us into the euro casts eternal doubt on their judgment. Talleyrand said treachery was a matter not of morals but timing. In the week after the Danish referendum Hezza, Ken and Chris seem, like their BBC admirers, to be on the wrong side of history.

But if the "wet" cause is antique, there are still divergent currents within Toryism which repay scrutiny. The arguments within the party that matter now are all conducted inside the Centre Right and are personified by its three most striking figures – Michael Portillo, Ann Widdecombe and William Hague. They offer, respectively, an effervescent mix of social and economic liberalism, a cloying blend of social authoritarianism with Christian Democracy, and a distinctively English, defiantly unmetropolitan, brew. The party which has always considered drinking as important as thinking now has three intellectual intoxicants – a heady Iberian sparkler, a quite Rhenish Blue Nun and a traditional, quintessentially Yorkshire, real ale.

The Widdecombe strain of conservatism has all the qualities of cheap hock – it makes the party go with a swing, but is designed primarily to appeal to older customers and overindulgence renders one increasingly ridiculous. Miss Widdecombe has grassroots popularity, an effective platform presence and a clutch of energetic allies. But there are three weaknesses in Widdecombism.

On social policy there is a strong case to be made that we have moved too far towards a corrupted liberalism of atomised individuals cut adrift from moral moorings, but Miss Widdecombe's first failing is to spoil that case with the fervour of her fundamentalism. On questions such as homosexuality and abortion her Old Testament opposition is out of touch with the complexity of human choices.

Her second weakness is her failure to think sufficiently imaginatively in her Home Affairs brief, leaving the running to the leadership on everything from political correctness in the police, zero tolerance in law enforcement and the protection of private property. Her third weakness is, perhaps, the least remarked. Miss Widdecombe is among the least Eurosceptic members of the Shadow Cabinet, a former supporter of Ken Clarke and, at heart, a Christian Democrat. In every area that matters, she sets her face against modernity.

Which could never be said of Mr Portillo. He has been on a journey since his defeat in 1997, one which is not yet complete. But the direction is already clear. The Shadow Chancellor is trying to fashion a conservatism for Thatcher's children now that nanny has gone, economically emancipatory, socially progressive, rhetorically modest. Its Euroscepticism is based not on nostalgia, but a belief in the flexibility, choice and accountability that national independence brings, a belief reflected in the particularly strong opposition to the euro among those who grew up in the Eighties.

But, if he is "right-wing" in his Euroscepticism, Mr Portillo is anything but reactionary in social affairs. Less than enthusiastic about Section 28, interested in the case for extending personal liberty for private acts, anxious to talk more about public sector reform than personal morality, he articulates a Toryism framed for a younger, more metropolitan Britain.

Which is not, quite, the case with William Hague. Although, as Tom Baldwin revealed in *The Times* on Saturday, Mr Hague was keen to promote debate on gay equality and drugs as a student, he has matured into a different politician. The most striking thing about the Paris-educated management consultant is how traditional his reflexes have become. Mr Hague's choice of friends shows he is at ease with modern life, and he is advised primarily by colleagues in their thirties, but his politics are not instinctively those of the metropolitan elite.

As anyone who watched the Channel 4 documentary *Just William and Ffion* will appreciate, the Tory leader's emphasis on his Yorkshire roots is more than Wilsonian affectation. His instincts are those of the provincial, commercial, middle class from which

he sprang – dismissive of do-goodery, robust on crime, unselfconsciously patriotic, naturally family-minded, resentful of tax and over-regulation, relaxed about sexual or ethnic difference, but suspicious of clamorous pressure groups.

It is just these people who found John Major personally sympathetic but his Government politically disastrous. And it is just these people whose hopes in Tony Blair have been shattered. Mr Major advises the Tory party to reach out. Mr Hague is already doing so, to all those voters Mr Major left behind. But the question remains, now that Mr Hague has rallied his core and his position is secure, what would bring even more people to the party? Spanish fizz or Blue Nun?

Mother praises dying act of Muslim martyr, 13

Sam Kiley

..........................

THE BROKEN, bloodied and unwashed body of Muhammad Abu Aasi was borne through the streets of his village by a howling crowd. As the open box with her 13-year-old son's remains approached, his mother sat surrounded by other women dressed in their black chadors and calmly announced that she was glad her son was dead.

The boy died in clashes with Israeli soldiers at the Netzarim junction on Wednesday afternoon. If his family are to be believed, he had gone out of his way to get himself killed.

He was shot through the heart, probably by an Israeli sniper, moments after a group of four Palestinian gunmen had opened fire on an Israeli bunker from between two buildings and then disappeared. "He told me he wanted to be a martyr," said Miriam, 48, a mother of ten girls and three other boys.

Muhammad had been at home at lunchtime on Wednesday, but he turned down the offer of food. During the previous five days of fighting and riots at the junction, which controls access to an illegal Jewish settlement of the same name in the heart of Gaza, he had joined the Palestinian protesters.

Television footage of other rioters holding up the brains of a youth killed by the Israelis in the bunker had inflamed him, his mother said. As he rushed out of the door to get back to the junction he asked whether she wanted to join him on his journey to paradise, where he believed all martyrs to the Palestinian and Muslim cause would find themselves.

With a male neighbour wagging his finger in the background telling her what to say, Miriam sat droning like a religious robot with a banner across her chest, which read: "There is no god but Allah and the Prophet Muhammad is his messenger." She might have believed what she said, but she was not being given a second to grieve for the loss of a boy who had turned 13 only five days before.

"All of the dead have died for al Aqsa (the mosque in Jerusalem) and for al Quds (Jerusalem itself)," she recited. "It is the capital of the Palestinian state and I will sacrifice all my daughters and all my sons for al Quds."

Surrounded by a high wire fence

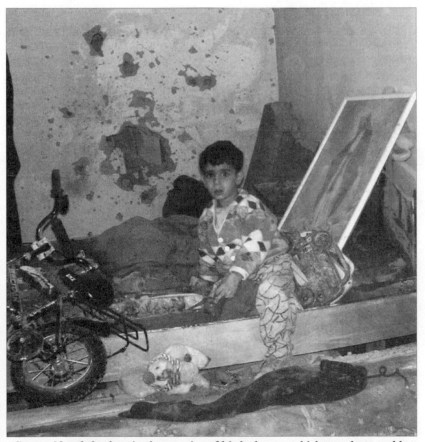

George Nazal, 3, plays in the remains of his bedroom, which was destroyed by Israeli rockets

through which only labourers and VIPs are allowed to pass, Gaza is peppered with Israeli settlements. Young people have very little hope of escaping what they call the biggest prison in the world.

In the seven years since the Oslo peace accord was signed between the Palestinians and Israelis, the 1.1 million people of the Gaza Strip, including 750,000 refugees from the 1948 and 1967 Arab-Israeli wars, have seen their freedoms restricted and their cost of living sky-rocket. But if these are grounds for violence, why send children to the front line?

Miriam replied: "I could not stop him. In fact, I said I would go with him but he said I should stay behind and take care of the family. I thank God that he is a martyr." On hearing the news of Muhammad's death, she said, her husband, Yousef, a taxi driver, "raised his hands to the heavens and thanked God". Outside hundreds of Palestinians pledged to die for their cause.

At the Eretz crossing into the Gaza Strip, Israeli and Palestinian officers met to agree a seven-point plan to try to make sure that they would not have the opportunity. At least 68 people have died over the past eight days and more than 1,000 have been wounded.

One of them, a man in his 20s, hobbled along with the funeral procession on a crutch. His foot had been bound to cover a wound he picked up at Netzarim. In his free hand he held an Israeli-made Uzi machine pistol. He said he would soon be back at the junction, which was recently renamed "Martyr's Corner" by the Palestinians.

An hour later we met Orit and Abie Dahon, settlers who work at the Paradise Hotel, a resort for ultra-religious Zionists with a mini-golf course, chalets and beaches segregating men from women. It is guarded by Israeli soldiers against Palestinian attacks around the clock.

The couple have six children, the oldest, Guy, is 13. Like the Abu Aasi family, they are also driven by religious ideology, which dictates that they should occupy every inch of biblical Israel, which includes the Gaza Strip.

"We're here for ideological reasons and because we have a good life," explained Mrs Dahon. Given that she had to live behind barbed wire protected by some 3,500 Israeli troops, did she not feel that she was putting her son at risk? "No, not at all, it's risky all over now because we have allowed the Arabs to move all over Israel," she said.

Next to her car, young Israeli conscripts were coming and going into Gaza from a mustering point. Their commander, Brigadier Tzvi Foghel, 43, whose men killed Muhammad and about 20 other Palestinians, including at least one other child, Muhammad Dura, whose death was captured by a television camera crew, sighed with resignation and offered a still small voice of reason.

"These are our days of atonement. As we approach Yom Kippur I would like to ask forgiveness from the Palestinians for their dead and beg them to stop sending children to the front line," he said. The brigadier has three children, including Amir, 13, who "plays a lot of tennis and loves computers". Did he think that protecting the settlers, whose colonies are illegal under international law, was worth the danger to his men and the huge cost in lives? "Next question, please," he replied.

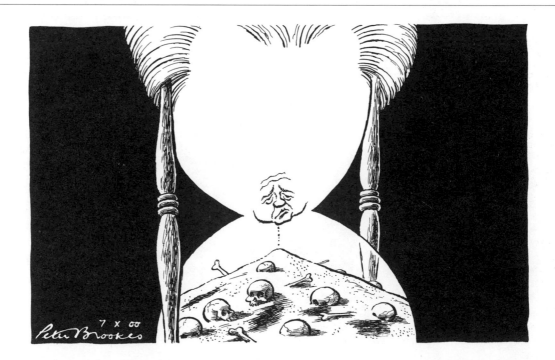

Good evening, liberated Serbia

Slobodan Milosevic's state was burning to the ground last night as a million people seized Belgrade in a ferocious outburst of revolutionary power

Misha Glenny
.................................

THE FEDERAL parliament went up in flames in the early afternoon before a vast crowd stormed Radio Television Serbia, a hated symbol of Mr Milosevic's regime, and turned it into a blaze that spewed thick black smoke across the city centre.

By mid-evening, Serbs from across the country were celebrating in a joyous hysteria as Vojislav Kostunica, the Opposition leader who claimed victory in last month's presidential election, told them: "Good evening, liberated Serbia." A Serbian revolution had begun.

"We are living the last twitches of Milosevic's regime," Mr Kostunica told the crowd. "Democracy has happened in Serbia. Communism is falling. It is just a matter of hours."

He later got down to business, calling an emergency session of both houses of parliament and broadcasting on state television a promise to open the media to all political parties.

Late yesterday evening, there were reports that Mr Milosevic had fled by helicopter and plane to Moscow; that he was in a bunker in Belgrade; that he was in the eastern town of Bor planning a coup; that Romania had given a military aircraft clearance to overfly the country today and take him to freedom. Whichever, if any, was true, there was no doubt on the ground that his 13-year rule was over. A laughing Opposition leader, Dragoljub Micunovic, told me: "He's finished. There's no way back for him now."

Parliament was torched at the very start of the mass demonstration. Police launched dozens of teargas canisters

into the crowd, but demonstrators on the steps of the parliament responded by charging into the building, led by Cedomir Jovanovic, a leading member of the Opposition.

"We just went for it," he told me with a broad, victorious smile. "We took the parliament." Young men armed with rods and sticks began sacking the building, smashing windows, trampling on typewriters and telephones and burning pictures of Slobodan Milosevic, whose own headquarters were even then being ransacked by protesters.

In scenes unprecedented even in the troubled Balkans, groups of youths armed with improvised weapons were roaming the city, smashing anything associated with the Government. Members of the Resistance movement seized the old offices of the independent Radio B92, and broadcast victory messages.

Students and workers went on to occupy all the main media centres. At seven o'clock, they seized TV Serbia's second studio in the district of Kostunik and began broadcasting "Freedom Television".

Battling through a poisonous fog of teargas that hung over the city for most of the afternoon, the crowd re-formed again and again to take complete control of the city. Police vehicles were overturned, smashed and set on fire and by six o'clock the entire police force had retreated to its stations. Terrified officers handed their shields and batons to the demonstrators and promised never again to move against the people.

In Majke Revrosime Street in old Belgrade, I watched as police fled for their lives as the mob forced its way into the building and began ripping apart everything in sight. Even 70

members of the Unit of Special Operations stripped off their uniform, helmets and weapons and left them for the crowd to gather up.

All day, the city was ringing with the deafening roar of a million people singing this revolution's hymn: "Slobodan, Slobodan, Save Serbia, Kill Yourself."

This was no longer just the students and intellectuals who took to the streets of Belgrade in 1991 and the winter of 1996-97. Yesterday's revolutionary anarchy was bolstered by hundreds of thousands of peasants and workers who streamed into the city.

By nightfall, Belgrade had been transformed into the biggest party Serbia has seen as people sang and danced in the streets to folk music blasting out of loudspeakers. "This is the end of ten years of darkness and the start of a new Serbia," a woman of 80 told me in tears. "The nightmare's over. He's finished! He's finished," Dragan Nikolic, a delirious 25-year-old student shouted.

The day's events began early as a vast movement of people left their homes in convoys of up to a thousand vehicles. Veljo Ilic, the Opposition leader from the militant stronghold, Cacak, led his people in a convoy headed by bulldozers which smashed through a police blockade, scattering them in all directions.

When 25 buses and 300 lorries and cars from Kragujevac, led by the local Democratic Party chief, Vlatko Rajkovic, encountered 50 members of the special forces on the entrance to the Belgrade motorway, they attacked them, beat them, then stripped them of their flak jackets, helmets and weapons.

By midday, several thousand tough-looking workers had gathered in front

of the federal parliament where they were greeted by police firing teargas and live ammunition in the air.

The tension was almost unbearable. It was almost possible to touch the anger of hundreds of thousands of Serbs as they streamed towards Tasmajdan Park in front of parliament. Inside the headquarters of the Democratic Opposition of Serbia, leaders were planning lists of demands that amounted to nothing less than the seizure of power.

Between three and four o'clock, as a million people waited excitedly for the proclamation of Dr Kostunica's victory, the police moved in. I saw children and old women in exceptional distress as they tried desperately to escape the teargas fired into the crowd.

But that was the signal for revolution. The parliament was stormed and a huge group of muscle-bound young men charged towards Radio Television Serbia. A ferocious battle broke out in which live ammunition was used and at least one girl was killed.

But after an hour, the police were in full retreat and the furious crowd began destroying everything in sight before setting the building alight.

Within minutes, the building had become a huge blaze surrounded by ecstatic youths. The people of Serbia look to have brought to an end one of the most despised men in recent European history.

COUNTDOWN TO REVOLUTION

April 14: Opposition demands early elections

July 27: Milosevic sets presidential elections for September 24

Sept 24: Milosevic fails to get required 50 per cent of vote

Sept 25: West accuses President of manipulating the result

Sept 27: Kostunica warns "there will be no bargaining"

Sept 28: Federal Electoral Commission gives Kostunica 48.96 per cent to Milosevic's 38.62 per cent

Sept 29: Kostunica claims he won 52 per cent of the vote

Sept 30: Electoral commission demands rerun of poll

Oct 4: Opposition sets October 6 deadline for Milosevic to concede defeat; Kolubara mine seized

Oct 5: Demonstrators seize parliament and television station

Soapwatch

SUSANNAH MORRISSEY is wearing her crimson silk nightgown. This, for the wives and girlfriends of Brookside Close, is bad news. It means she-who-speaks-properly is on the prowl. The object of her affection is Dr Darren, who wanders around the Close delivering terrible diagnoses to the residents while obsessing over his latest romantic entanglements. Dr Darren's job is not easy: most of the Close's residents are mad, or murderers, or addicts, unstable, ill or, triple yawn, infertile, so his days are busy.

Susannah breathes heavily around Dr Dazza. Her screen murder achingly imminent, actress Karen Drury is over-mugging shamelessly in the manner of a desperate, campy Carmen: "Don't go, don't leave. Hold me. Oh, Oh, Oh."

Dr Darren is helpless and sinks, as so many before him, into the rippling folds of the deep-crimson nightgown.

His dalliance is forgiveable. He was for many a month partnered with Victoria, who loved him once, but because she is inexplicably mad decided to hunker down with drug dealer Dave. Now she and dashing Dazza have rediscovered their passion. This is bad news for Susannah, who is having to fend off the poison of Jacqui "In Desperate Need of a Storyline" Dixon, keen to take her baby Harry back from the middle class harlot (Jacqui is the surrogate mother).

In another house, Susannah's ill-starred intended Mick Johnson slaps on the aftershave and voices doomily positive predictions ("Susannah and

I have a great future"). Meanwhile, Susannah's occasionally deranged ex-husband Max is now living with Lance, one of the most painfully camp homosexuals in prime time. Word has it that after Susannah dies Lance will help to bring up her children with her ex-husband who is not gay and unaware of Lance's lurve for him.

So the suspects and, yes, that's most of the cast, prepare to push Susannah down the stairs. You can't help but admire the old gal's persistence in pitching up on such hostile ground. As she told Jacqui the other day: "You're a jealous bitch and in any normal circumstances we wouldn't have met." Let's hope "the other side" has as much Veuve as she requires.

Tim Teeman

A HARD WINTER AHEAD

The new Serb leader needs help to rescue his country

The flames have been extinguished, the all-night rejoicing has given way to exhaustion and the weary people of Serbia must now face up to a challenge as great as any they have known during the 11 years of the Milosevic dictatorship: making a success of democracy. It will not be easy: euphoria has distorted expectations; last year's Kosovo War has left the economy in ruins; and civil society has been wrecked by corruption, criminality, intimidation and spiritual and material impoverishment. There are scores to settle and thugs to be arraigned. Deep hatreds will poison reconciliation between the victorious Kostunica supporters and the cronies of the old regime. And Vojislav Kostunica comes to power with no political experience and only his convictions to lead his country through a long, cold winter.

The immediate priority is to quash any further resistance from diehard Milosevic supporters. Armed opposition to the change now looks unlikely. But until it is clear what will be the fate of the beaten dictator, now hiding in his Belgrade villa, the new Government cannot afford to relax. Once secure, however, Mr Kostunica faces a prolonged challenge: to get Yugoslavia back to work. The strikes, the demonstrations, the wreckage of key installations and the cumulative effects of sanctions have all taken their toll. Yugoslavia is short of money, skills, markets and a legal business framework. A mafia economy is now the norm: smuggling has replaced imports, bribes have taken the place of contracts and cronyism has ousted tendering as the way of doing business.

It is not only the effects of wars, sanctions and mismanagement that are holding Yugoslavia back. Mr Milosevic headed the last Communist Government in Europe. The party system is the only functioning bureaucracy. In a way now unimaginable in the rest of Eastern Europe, Serbia's economy is still state-run, dominated by old-fashioned heavy industry and distorted by subsidies and centrally directed pricing. In Tito's day Yugoslavia led the rest of the Eastern bloc in economic flexibility and the degree to which the Communist system tolerated small-scale private enterprise; now it trails far behind and has barely begun privatisation or adapted to changed market conditions.

Help will be needed to pull Serbia out of this Communist-cronyist mess. Indeed it will need aid on a massive scale just to halt further economic collapse. That can come only from outside, and only with the immediate end to sanctions. The West understands this well. On Monday the European Union is expected to lift sanctions and pledge £1.5 billion to be spent on reconstruction – reopening the Danube, rebuilding the bridges and possibly supplying humanitarian aid for the winter. America too has promised rapid help. Serbia can also expect to be included now in the regional Stability Pact for Balkan development. And neighbouring countries will reopen their roads, their markets and their hearts to the new democracy.

For many, especially for the thousands of refugees waiting to go home, all this will be too slow. And in their frustration the passions pent up during years of repression will spill over. Mr Kostunica will find it hard to promote reconciliation, and even harder to brace Serbia for realistic decisions on Kosovo and Montenegro. He will not be an easy partner for the West, and his prickly nationalism may still hold Serbia back. Much depends on his appointing honest and loyal subordinates. But he has one quality to inspire those at home and abroad in the coming harsh months: transparent, shining, democratic conviction.

Andrea Davies, communications officer from the Tate, looking at *The Loves of Shepherds 2000*, oil on canvas,
by Glenn Brown

'Paxo insisted on sitting next to Mrs Rude, and we proceeded to be excessively rude about almost everyone'

Anne Robinson

I'VE NOW spent a week walking around with the title The Rudest Person on Television. As voted by the *TV Times*. Not, I agree, quite on a par with winning the Nobel Prize for Peace, or being asked to report for *Panorama*, like Mariella Frostrup, but, hey, I did beat Jeremy Paxman.

As luck would have it, Paxo was at lunch on Sunday. Charmingly he insisted on sitting next to "Mrs Rude" and we proceeded to be excessively rude about almost everyone. Come Wednesday, Ken Bates, chairman of Chelsea, is striding over to me in

Harry's Bar to say that as I am the rudest person on television and he is the rudest person in football, we should get married and "instead of shagging, we could just slag each other off".

Apologies to sensitive readers for this crude language but we are now entering new waters called Light Entertainment and Showbiz, and it's all very different.

SO much so, that this week I am invited on *Celebrity Ready, Steady Cook*. My opposition in producing a lightning gourmet meal is Dominic Cork, captain of Derbyshire and saviour of the last Test series. My assistant, the completely gorgeous, bandanna-wearing chef James Martin. Yes, of course we won. As I told Dominic later, he's just got to learn to be more competitive.

Sca-a-a-ary, but I like it

Glum? Blackpool? No, says Rachel Campbell-Johnston, not any more. Our politicians
might give it a wide berth, but for some grown-ups it has hip resort status

"THAT'S the sc-a-a-a-riest seat," he told me. And he managed to put so much fear into that one protracted vowel that I would have leapt from my place right there and then if a security man hadn't come round just at that moment and locked me tightly back in with a metal safety bar. There was no escape now. I was in for the ride.

And not just any ride. This was Blackpool's star-billed Big One: "The tallest, fastest and most sensational rollercoaster in the world." It climbs to a height of 235 feet before hurling itself down structures of iron at nerve-stripping speeds of up to 85 miles per hour.

And, clearly the man behind me wasn't going to be any help. "You are about to experience the ride of your life," he yelped into my earhole – just as the Tannoy informed me of the very same thing. And then the rollercoaster was off, trundling away from its platform, with me, like an egg in a carton, in the very front seat.

Tchika, tchika, tchika … a chain ratcheted the line of little carriages higher and higher up a slope. Far beneath, the fairground gradually receded. I could see the whole of the Pleasure Beach spread out below, its merry-go-rounds no bigger than musical boxes, its coaster tracks like Meccano toys and the frills of water that ruffled out around the log flume looked as still as waves when you watch them from an aeroplane window … Oh my God! Had I got as high as that? The man in the carriage behind me was ominously quiet.

And then the train reached the pinnacle. I could feel it crawling over the hump and could see the grey of the Irish Sea spreading way out ahead of me. I was over the highest part, beginning to descend … but still nothing,

**Rachel
Campbell-Johnston**

nothing, it seemed, was going to happen. For a moment I almost dared to breath with relief.

And then the horizon just vanished.

I was in freefall. I was hurtling through space. And there was no way

that the safety bar was going to hold me, there was no way the train was going to stay on its rail. Was that my life spinning somewhere inside me? Were those images of my childhood flashing up before my eyes? Would I faint? Oh my God, what if I was going to faint? The wind ripped my shrieking from between deadlocked jaws.

And from then I remember nothing but swooping and plunging, the terror

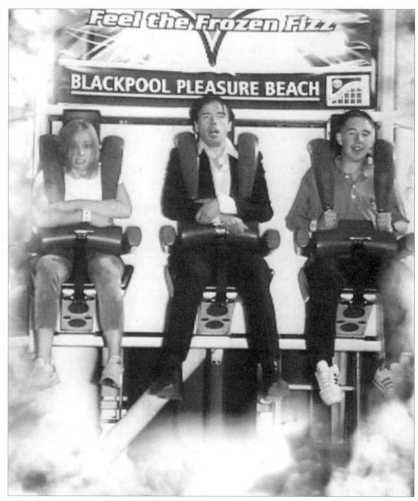

**Hold on tight: Rachel Campbell-Johnston on The Ride with knuckles
whiter than white**

of horizons being sliced away at one side, the swerves and the sidekicks, the veer and the lunge, until at last, when I thought I could take it no longer, when I thought that white knuckles could no longer grip, I was hurtling through a tunnel and the train was gradually slowing, it was drawing back towards the platform and coming to a stop.

My skull felt wobbly on its stalk by the time I got out.

"Scareeeeee, eh lass?" was all that the man in the seat behind me could contribute. Nobody else spoke. They were grinning and giggling, their throats dry with wind.

And that was it – my first ride on the Pepsi Max Big One. And was I ever going to do it again?

Well, yes actually. Because as soon as my nerves had reknitted, my adrenalin levels dipped and I found myself wondering if really I hadn't been too cowardly, if really it hadn't in fact been rather fun. And the next thing I knew, with a folly akin to madness, I was slipping through the turnstiles, resuming my place in the queue.

"This is my sixth time round today," a girl ahead informed me, sucking excitedly on a popsicle. She had come to Blackpool, she said, with a gang of university friends. "Loads of us do it," she said, "just for a laugh."

For the 16 to fortysomethings, Blackpool has long thrown off its reputation as a glum seaside straggle, the sort of place your family went, dragging you sunburnt down beaches on scratchy donkey-back while you whined for candyfloss and another go on the dodgems, and the wind flipped your ice-cream out on to the sand.

Yes, it is still everything you would expect a British coastal resort to be. The Pleasure Beach keeps its old classics alongside its high-tech rides. The Tower still serves tea to all the old dance tunes while sixtysomethings tit-tup gracefully around an expanse of sprung floor. The seafront still has its piers and its stalls of tourist tat. And at night stag and hen parties still whoop down the piers.

But for a whole generation who can't quite face maturity, Blackpool has achieved a sort of Post-Modern hip: more a sensation safari than a traditional seaside holiday. They arrive in groups, buy day tickets to the Pleasure Beach which allow them unlimited access to any ride, and then spend hour upon hour going round and around.

They are quick to recommend the best rides to any initiate: the one which catapults you off into an upside-down backflip, or the one that I liked most, which was called quite simply "The Ride". It cannons you to the top of a tower in a fraction of a second, gives you just enough time there to retrieve your heart from your heels, before plummeting you down, leaving your brains somewhere in outer space, dangling you precariously in a no man's land between land and sky.

Revellers swap stories in the queues with all the enthusiasm of kids swapping stickers outside the school gates. I hear tales of the girl whose shirt was torn off by the G-force of the Big One, who arrived back in port in nothing but her bra. I am told of handbags sent hurtling irretrievably into the lake, of dentures whipped out to land in someone else's pocket, of hairpieces sent skimming out over the sea. No wonder that this year, for the first time in some 30 years, no political party is holding its conference in Blackpool.

Perhaps it's the shared sense of experience that makes everyone so friendly. Or perhaps, for a London-dweller like me, it is that I'm just not used to northern manners. Everyone is so open, everyone talks. There is no edge of aggression. And almost before I know it I am joining a gaggle of strangers for a Saturday night on the town, I am in a transvestite club, I appear to be part of a hen-party. The bride-to-be is downing her sixth Bacardi Breezer through a penis-shaped straw.

And then I am dancing. I haven't dared dance for years. With co-ordination like mine it's a pretty scary sight. But then this is not the old me. This is the Blackpool persona. And anyway, what counts as scary when you've ridden round the Big One a dozen times?

LEAVES ON THE LINE...

Real men wear boas

If this season's catwalk collections are to be believed, men everywhere will be camping it up in cravats, feather boas and skin-tight trousers. Or will they? Robert Crampton and Alan Franks tried it, and they're not so sure..

ROBERT — I slept badly that night and woke in the certain knowledge that the day held something awful, something I did not want to do but could not avoid. Once you're clear of youth, with its exams, interviews and phone calls to girls you want to go out with, such instant dread is rare. After three seconds of consciousness, I remembered what I had to do. After four seconds, I listened for rain against the bedroom window, hoping for plenty. The rain did come, later in the morning, lashing down. Then it stopped. We were still on; butch men in nancy clothes was go.

The build-up was full of nervous fun: trying on £1,000 outfits like kids at a dressing-up box; Simon the hairdresser chatting away over the roar of his dryer; Alan and I laughing gaily, enjoying the attention, like young conscripts on leave before the shooting starts. I busied myself trying to bag the leather trousers – leather trousers connoting, albeit in a small way, at least the possibility of heterosexuality. Unfortunately the trousers stopped halfway up my thighs and refused to fight on. When the fashion department asked for my waist measurement the week before, my lie was both monstrous and, as it turned out, foolish. Alan (with, I thought, a bitchiness wholly inappropriate to our joint endeavour) stole those trousers right off my legs. "You're a long way adrift aren't you, Bob? Do you think I might squeeze into them?" But this was a phoney war, a prelude, and these were the mere logistics of embarkation. Soon, to make this story work, we had to leave the indulgent confines of the office and hit the mean streets of Wapping. The ramp of the landing craft had to come down, and we had to mince down it, handbags

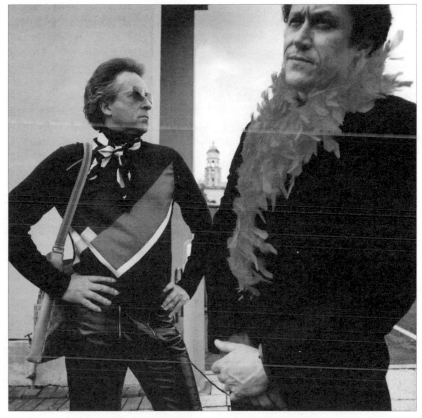

Franks and Crampton take to the streets

swinging, to face people who had no idea that we do not usually dress like Julian Clary and Quentin Crisp in party mood. My stomach heaved: it was going to be like the first 20 minutes of *Saving Private Ryan*. I dress straight. I wear grey, dark blue and black; wool, cotton and leather; Gap, Marks and Cotswold Camping. I don't carry a handbag. I don't have big hair. I don't wear anything tight, pink or nylon. I don't wear frock coats or fur. I don't wear ponyskin winkle-pickers, feather boas or chiffon scarves. I don't wear shiny Gucci slacks with little gs all over

them: they don't have nearly enough pockets. Nor do I harbour a secret desire to wear such clothes, some hidden kink that makes me want to trick strangers into assuming I am a raving homosexual stereotype from 1972. The catwalks of Paris and Milan would have us believe this look will be commonplace this autumn, that chaps will just carelessly fling that boa round their necks as they pop out to the hardware shop for a new wrench. We shall see. None of the men I know, gay or straight – especially the gay ones – would wear this gear. I would

only wear it if you paid me.

That being the case, Alan and I, pre-varication exhausted, walk to the lift. We check ourselves in the mirror during the descent. Alan adjusts his scarf. I tuck stray strands of boa away. The other occupant, a sub from sport, looks at the ceiling. Out we go into the lobby. The security guard ignores us complete-ly. I light a cigarette and drag furiously. Looking hard isn't easy when your boa starts to billow and your trousers restrict you to a six-inch hobble.

Now our friendship kicks in. They say soldiers don't fight for Queen and coun-try, they fight because they don't want to let their mates down. I think it's true. "Remember Al, that which does not destroy you makes you stronger," I quote manfully. Alan responds with a dogged, we're-gonna-do-this grimace that gives me strength. We gulp and nod, then burst through the doors look-ing for all the world like Butch and Sundance coming out to face the Bolivian Army – if you can picture two men in tight shoes who don't look any-thing like Paul Newman or Robert Redford but do have immense hair.

There is no rattle of gunfire. No shrap-nel rings off the Pennington Street cob-bles. We don't turn sepia. We just stand there in our full-colour glory, fingering our handbags, wondering what to do next. Then a colleague, a nodding-terms acquaintance, a man I'd previously liked, walks by. He does a double-take, then his face curdles into a sort of ven-omous, pitying sneer, the sort of look I imagine Lord Voldemort gives Harry Potter before trying to kill him with the death curse. I say to Alan: "I'm not staying here to be insulted." We totter off. Some mechanics at the Saab garage next door watch our approach in silent contempt, arms folded, faces grim. They do not look like the sort of men who follow the new autumn collections too closely. I'm thinking: "Thank God Alan's here." I bet he was thinking the same about me. He looks utterly ridicu-lous – and our friendship has never felt firmer. We walk on by, heads up.

Partly in mulish response to the hostil-ity, mostly because my clothes are now talking to me and simply demanding more swagger, I find myself changing. I give up trying to talk bass and narrow-ing my eyes like Paddy Ashdown. Instead, swiftly and totally, as if I've taken a potion, I go camp. As a row of tents. I suppose that in a new, anxious situation, you grope for whatever behaviour feels even slightly familiar and fitting. So, after five minutes and for the rest of the afternoon, I hear myself talking like Dale Winton, sense myself walking like Michael Barrymore, feel myself standing like Larry Grayson. Somehow, it seems natural and comfortable to flounce my boa this way and that, going "Oooooooh" a lot while we're eating our cheeseburgers. By the time we get guttural, indeciper-able abuse from a van-load of lads in a traffic jam, I'm practically blowing kisses and calling, "I'm free!" Who would have thought it? I'd be lying if I said the experience will give me cause for a major wardrobe rethink. I was glad to get those clothes off, especially the trousers. But I'm glad it wasn't raining, glad that I took the chance to be differ-ent and see different for a day. I doubt whether many men this autumn will decide to dress as we did. Any that do will have my full respect. This sounds very silly, but this silly little story hon-estly feels like one of the most coura-geous things I have ever done. I'm real-ly rather proud of myself.

ALAN — I had a top like this way back in the Seventies – the early Seventies in fact – but in those days you could still call it a jersey, or even a pully. I hated it then and I'm not wild about it now. The swirly vortex had been fine in the colours of psychedelia, but in the insecure days between Beatles and Bolan all you really wanted was for the room to stop moving. I suppose you could say that doing a reprise of that visual riff in hangover tones was on-message for a time that was spiritually beige. But doing it again

now? Nostalgia must be desperate.

And the last time I had trousers like this was never. I had them as tight, but for that epoch you need to go Jurassic – very early Sixties; I mean the Shadows, Craig Douglas, Radio Lux under the bedclothes. Jeans that you bathed in to shrink them to your shape. About 15 bob from pre-makeover Milletts. So what am I doing shoe-horning my bot-tom half into leather drainpipes? I real-ly thought this sort of thing could never happen again. Thank goodness I've already had my children – although the double-zip is a welcome advance.

A handbag? I can hear a whole chorus of disbelieving aunts with Edith Evans voices. I put it straight on my shoulder to make it into a shoulder bag, but no one is fooled. It is a handbag. Normally I have a black Alpine Lowe air-mesh rucksack (£35 from the YHA shop) slouching here from one strap, for notes and books and gym things. If I put a quarter of that load into this wafer of Gucci fabric, it would look like the snake that's swallowed a donkey. The scarf I'm not even going to talk about. I mean, look at it. But no way can I bin it, or the handbag. They are vital parts of my ensemble because Fashion's latest Statement is that proper men are great in camp clothes. Everyone says so: Paris, Milan and, most persuasively, our fashion editor. The point is, explains Heath, you can be camp without being homosexual. It's a question of confi-dence. You can be so confident that it's almost aggressive.

So it's a matter of, "OK, so I look gay but if you raise it I'll smack you in the mouth." Like boxers in fur coats. Is that it? "Well," says Heath patiently, "fash-ion is about rebellion, and therefore about change."

So have I changed much, through changing clothes?

"Completely. But fashion should also be about having fun. Part of the fun is that people are actually looking at you." Too right. They are also pointing and laughing. Part of the amusement is because they know me, or the old me,

and can't square it with this thing, this undiscovered Bee Gee, taking shape before their eyes. Any minute now, I'm to launch myself on to the Highway, Wapping, where they don't know me at all. I quite fancy the anonymity.

But first the hair. It is done by a charming session man called Simon. I tell him he is wasting his time as my hair doesn't do big. Tousled, yes, and even wavy when I chance on the right sachet in a hotel. But volume, no. He smiles and carries on. No one has spent so long on my hair since I was trapped in tinfoil at the Ginger Group, circa 1972. If you add the cost of his time, then my street value is now well into four figures, a personal best.

When I next look in a colleague's Dior hand mirror, it's up like a helmet. I'm Peter Wyngarde, I'm David Soul, I'm Paul Mariner of Ipswich and England, I'm the one in Slade whom no one can remember. Hell, I'm Peter Fonda. How did you get it to go this big, Simon? He smiles professionally and chases after me for the next two hours, precision-gunning me with his spray when the bouffon's in peril. Which it very nearly is from my first footstep on the Highway. A Mini roars by with four Asian guys. They just weren't ready for me. Down come the windows and out comes the cry, Fookinpooftaaaaahhh.

There's quite a bit more of this, some from the road, some from an older bloke in a garage who mutters and bridles as if I've done something really unpleasant in the forecourt. I think how easy it would be in gear like this, on the wrong night in the wrong place, to get yourself killed. But there's a couple of wolf whistles from women who don't look particularly tasteless. All right, they're for Robert and his fantastic deep-sea fish of a shirt. But a man can dream. I could get the taste for this. There's an innocent kind of power in being able to cause such levels of hatred and hilarity just because of what you've covered yourself with. Heath's right. Confidence is the bottom line. But I still say, with confidence, the top was a mistake.

Dewar's death is a disaster for Scotland

His passing exposes the fragility of Labour's coalition in Edinburgh

 Magnus Linklater

IT IS NOT often that one is moved to call a politician "irreplaceable". The sudden loss of Donald Dewar, like that of his friend John Smith before him, leaves Scotland bereft, and British politics an emptier place. He was, as the Prime Minister used constantly to point out, the epitome of decency, an uncommon quality in public life, and one that gained him the respect and affection of a nation. It meant that, however flawed his leadership, he held a powerful influence over his party, the Executive he headed, and the constitutional process he had begun.

It is hard to imagine what is going to happen without him. He leaves an uneasy coalition, an inexperienced Cabinet, a fragile legislative programme, and a rampant Opposition in Scotland that has already overtaken Labour in the polls. If anything were to persuade Tony Blair to rethink the date of the general election, it might be the departure of his helmsman in the North.

It was once said of Michael Foot that he was "a good man fallen among politicians". There was something of that about Mr Dewar. Indeed, for a long time when he was an up-and-coming MP, he had digs in Mr Foot's Hampstead house, and the two of them used to enjoy long conversations about books and painting, a passion they both shared.

But Mr Dewar was a tougher customer altogether. Unlike Mr Foot, he knew at first hand about the knuckle-duster approach to party infighting, and

could be ruthless in getting his own way. Behind the civilised, self-depre-cating exterior, there was a grim, almost unforgiving quality which came out unexpectedly in his dealings with rivals. You cannot be a Labour MP in a Glasgow constituency without picking up some street-fighting skills, and it was there that he acquired his unflinching hostility towards the Scottish Nationalists, and his distaste for Labour members who challenged the authority of the party organisation. Those who were puzzled by his apparent discourtesy in turning down a knighthood for the SNP-supporting Sean Connery, or for treating with disdain Dennis Canavan, the Labour rebel, failed to appreciate the iron in the Dewar soul.

Yesterday Roy Hattersley wrote about "the public persona of a gloomy man", and speculated that he had never fully recovered from the break-up of his marriage to Alison McNair, who left him for Derry Irvine, now Lord Chancellor. He was, it is true, a lonely figure, who shunned large gatherings, and preferred an evening on his own to the dinners and banquets that tend to go with high

office. But he inspired enormous loyalty among friends and supporters. It was hard not to be charmed by him. He was excellent company, a brilliant speaker, prone to barbed witticisms about colleagues and opponents alike.

Accompanying him on the campaign trail during the Scottish elections was a joy, because he broke all the rules, engaging in long debates with passers-by as his aides tapped their watches, or letting slip disparaging remarks about the places through which we passed. I remember him wrinkling his nose in distaste as he was being shown a brand new home on a refurbished housing estate, complete with flower-baskets and trim garden path. "Oh yes, very Hansel and Gretel," he remarked, to the consternation of local officials.

Politically, he was astute. He had welded a ramshackle coalition together and, against all expectations, made of it a passably united team. When Labour and Liberal Democrats first came together to form a Government in the aftermath of the Scottish elections, there seemed every chance that it would come apart at the seams. The Lib Dem element was wedded to a manifesto that placed it well to the left of new Labour, and it numbered among its members those who were determined to reject anything that smacked of London domination; it was a view that was secretly shared by several of the younger members of Mr Dewar's own party. He succeeded in winning their support, while at the same time actually consolidating his links with Westminster. On both scores that was a remarkable achievement.

One potentially hostile Lib Dem member acknowledged the other day that he had become a devoted Dewar loyalist, simply because he had never known the First Minister trim his sails to win popularity. Downing Street trusted him because, although he was as remote from Mr Blair's concept of new Labour as it was possible to be – he hated political correctness, disliked spin-doctors and would not have known a focus group if he had walked into the middle of one – he was nevertheless undeviating in his loyalty to the Government.

His weakness as a leader was that he found it hard to act decisively enough when dealing with close colleagues who had proved inadequate or incompetent in their jobs. And because he rejected the cult of personality he preferred the role of manager to that of visionary; he was interested in the art of the possible rather than the big idea.

Nevertheless, on a personal and political level the loss for Mr Blair is incalculable. Scotland was one of the few aspects of Labour policy that he did not have to worry about. Devolution had been delivered, thanks to Dewar; it had been accepted, thanks to Dewar; and it would be kept on course, thanks to Dewar.

Without him in place, all that is now open to question. There are contenders for his job, of course, but none who can adequately fill his shoes. Those who hold frontbench positions in the Scottish Parliament may in time grow into the job, as other leaders have before them. But for now the political landscape is bleak, and political life will be emptier and duller without Mr Dewar to grace it.

Zoe Jeffries, 14, a victim of Creutzfeldt-Jakob disease, lies in bed tended by her mother. She died shortly afterwards

YEHUDA AMICHAI

Israel's unofficial laureate who described private life in a land where war is normal

YEHUDA AMICHAI was a poet of genius who lived through the formation and many fierce defences of the state of Israel, unblinkingly documenting what it is for a modern people to live out their hopes, loves and disappointments in an Old Testament landscape. "Summing up Israel's 50 years is like summing up my life," he wrote. "I have never written a war poem that does not mention love in it, and I have never written a love poem without an echo of war." In such a state of heightened emotions, a lover meditates:

*How poor in years and even in days
Are those about to part but
 how rich
They are in minutes and seconds.*

Amichai was eloquent about the strain of nights and days in a land where last things are vigilantly expected, where the fragility of all relationships is palpable and everyone keeps an eye on the nearest exit. "It's hard to breathe," he wrote, "And from time to time a new consignment of history arrives."

His country's mythical, ancient and living history provided ample material – "the near past sinks into the far past, / And from the depths, the far overflows the near" – so Amichai was a prolific writer, producing 13 books of poetry in Hebrew as well as two plays, two novels, radio sketches, short stories and books for children. His work has appeared in more than 30 languages.

He was fortunate in his translators. Ted Hughes claimed that he was "the poet whose books I open most often". This may sound fanciful – how many of us turn familiarly to translations? – but Amichai's images, of the widening circle of impact of an explosion, say, or of God "on his back under the

world" where "something's always breaking down", are sturdy enough to survive being wrenched from their original tongue.

By using metaphors so simple and immediate that they appear always to have been obvious, he made connections between the everyday surface of things and their long significance. And if he did not attempt to make stirring sense of experience, he wrote wisely and poignantly about ambivalent feelings such as loyalty, horror, tenderness, repentance and sympathy,

*As when you find a lost child
After a long search and the joy
Of finding him cancels the anger
And the rising anger destroys the joy.*

Having had an Orthodox Hebrew education and lived to hear his poems set as rock lyrics, he was a link between past and future. "I was destined to be planted between two generations," he said, "a sort of double agent." He saw himself as one of a generation of "New Jews", inventing the nation but later rueful about some of what was done in its name.

He was steeped in traditional Jewish lore, yet his first book, *Achshav Uve-Yamim HaAharim* ("Now and in Other Days", 1955) brought a revolutionary realism to Israeli poetry, with its frankness about the hardware of modern warfare, and its worldly use of slang and technical jargon. Initially this was not well received by older critics, who failed to understand the disillusion and European sense of chaos that he introduced, and accused him of nihilism and deracination.

But Amichai knew both the literature of his people and the way they talk today, "in excited voices / as at airports", so he blended and contrasted different registers, from the scriptural to the irreverent. The voice of his poet-

ry is contemporary and wry, but mature, stoical and benign. And although Israel's public face was adamantine when he began writing, this generous, unstrident new poetry struck a thousand private chords.

He was born Yehuda Pfeuffer in Wurzburg, Germany, into an Orthodox family. He remembered his grandfather,

*a village Jew, God-fearing
and heavy-eyed. An old man
with a long pipe. My first memory
is of my grandmother with trembling
 hands
spilling a kettle of water over my feet
when I was two.*

When he was 11 the family fled from the Nazis to Palestine. They settled in Jerusalem, "refugees in a strange city of refuge", and during the Second World War he was a young recruit into the British Army's Jewish Brigade.

After demobilisation from that army in 1946, he paid two shillings to change his name to Amichai, meaning "My nation lives", and joined the elite Zionist strike force, the Palmach. He fought in the 1948 Israeli War of Independence and saw action again in 1956 and 1973.

There is a danger, in Israel, that war becomes normal and continuous,

*But knowledge of peace
passes from country to country,
like children's games,
which are so much alive, everywhere.*

And as the poet and translator Michael Hamburger wrote: "Although he has fought in two wars, against the Germans and against the Arabs, he cannot accept the simplifications of nationalism. Although he is steeped in Jewish scripture, he cannot accept the certainties of an exclusive faith." Shaking his fist at an empty sky,

Amichai often railed at God, like Beckett, for not existing; and yet He must, for He is so much of what Arab and Jew are fighting over.

After the War of Independence, Amichai studied biblical texts and Hebrew literature at the Hebrew University, and then taught in secondary schools. Later he taught at the university and in academic institutions abroad, but in the meantime he was publishing volumes of poems every couple of years. He dwelt particularly on the deaths of a friend who died in his arms in 1948 and of his father.

"May ye find consolation in the
 building of the homeland."
But how long
can you go on building the homeland
and not fall behind in the terrible
three-sided race
between consolation and building
 and death?

But while he understood the masculine, political world, he was consoled by the feminine realm of intimacy, his poetry always insisting that to each one of us the inner, private life is the most important. Like the great poets of the past, he saw the human tragi-comedy – and his own part in it – as if from above, but was never detached.

His *Collected Poems* appeared in 1963. One poem, *From Man You Are, to Man You Shall Return*, written during the war of 1973, became a standard expression of grief for families who lost children on active service.

Others expressed the endless to-and-fro of emotion in a city where "everyone remembers he's forgotten something, but doesn't remember what it is" – Jerusalem.

We have put up many flags,
They have put up many flags,
To make us think that they're happy.
To make them think that we're happy.

In 1987 Amichai published *Shirei Yerushalayim* ("Poems of Jerusalem") in a bilingual edition with photographs of the city; a similar volume followed in 1992. He won the Israel Prize for Literature in 1982, and was more than once nominated for the Nobel Prize. Acclaim did not turn his head, and he remained affable and charming.

In America he was praised by Anthony Hecht and Harold Bloom, and a dozen volumes of his poetry were published in his lifetime, including *A Life of Poetry 1948-1994*, which runs to more than 450 pages, and, most recently, *Open Closed Open*. He was less well known in Britain, although Oxford University both granted him an honorary degree and published him under its imprint. Last week Faber published a new *Selected Poems* chosen by Ted Hughes and Daniel Weissbort from translations by many hands.

Despite his military service, Amichai urged Israeli leaders to agree a settled peace. A wry, urgent poem, *I, May I Rest in Peace*, transcends the old piety

to ask mercy for the quick as well as the dead: "I, may I rest in peace – I, who am, still living, say, / May I have peace in the rest of my life." Having demonstrated his personal courage, Amichai here shows that it is no selfish betrayal to want peace. He also campaigned against Israel's Lebanese war.

When Yitzhak Rabin, Yassir Arafat and Shimon Peres shared the Nobel Peace Prize in 1994, Amichai read his poem *Wildpeace*:

A peace
Without words, without
the heavy thud of the rubber stamp:
 I want it
gentle over us, like lazy white foam.

Tragically, his death has been accompanied by the outbreak of yet more violence, with its unerasable pain for more fathers and mothers, sons, daughters and lovers. Ordinary life and the usual condition of war have resumed.

Remember: even the departure to
 terrible battles
Passes by gardens and windows
And children playing, a dog barking.

Yehuda Amichai is survived by his second wife, Hanna Sokolov, and by two sons and a daughter.

Yehuda Amichai, poet, was born in Germany in 1924. He died in Jerusalem on September 22 aged 76

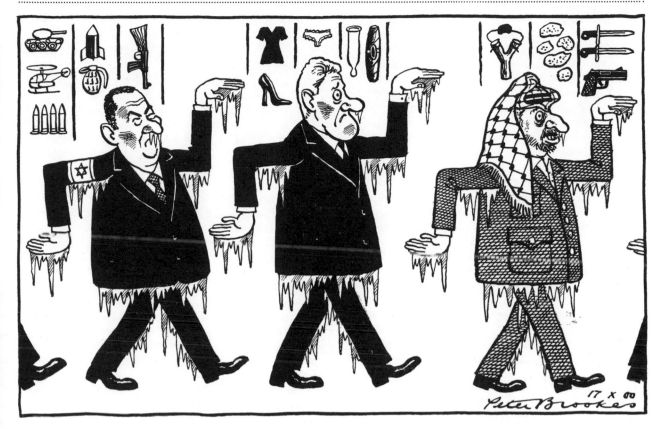

After 3,000 years, it's about time we heeded Abraham's message of peace

Jonathan Sacks

Israel is a land saturated with religious memories. I think, therefore, of words spoken more than 3,000 years ago on the occasion of the first recorded conflict in a land that has seen too much bloodshed and grief: "Let there not be strife between us … for we are brothers." Those words were spoken by Abraham, from whom both Jews and Muslims claim descent. They remind us that religion is not fated to be a cause of conflict. It

can be, must be, a force for peace.

The violence in Israel is shocking, all the more so because it has come from the search for peace. It happens at a time when an Israeli leader, Ehud Barak, elected to make peace, has gone further and made more concessions than any previous Prime Minister of Israel. In so doing, he went beyond what his coalition partners were prepared to accept, and thus knowingly put his Government and political career on the line for the sake of peace. I supported him, as I did the late Yitzhak Rabin who lost his life pursuing an agreement with the Palestinians.

Rabin and Barak were not simply politicians. They were former military leaders, who had seen with their own eyes that the cost of bloodshed was too high. The courage they showed in war they turned to the cause of peace. They were prepared to pay a high price, and in different ways they both did. That makes it all the more important not to abandon what they began through despair, for despair is what Israelis and Palestinians are feeling right now.

The cost of the past few days has been enormous. Which of us will forget the images of anger, rage, dying children, people lynched and murdered by the mob, holy places being dese-

crated, in a land from which first went forth the message of the sanctity of human life as God's image on Earth?

It is sometimes hard for outsiders to understand how deeply engraved in Jewish consciousness is the longing for peace. I have been reading Michael Howard's recent book *The Invention of Peace*, in which he argues, in Sir Henry Maine's words, that "war appears to be as old as mankind, but peace is a modern invention". That is not so. In a militaristic age, the prophets of Ancient Israel were the first to articulate the idea of peace as an ideal. Not far from the United Nations Building in New York are engraved the words of Isaiah envisioning a world in which "nation shall not lift up sword against nation, nor will they train for war any more".

Those words go to the heart of Jewish hope. My great-grandfather, a rabbi in Lithuania, was moved by that vision to travel to the Holy Land in 1872 and make it his home. At the request of the Jewish community, he became the official historian of Jerusalem. In 1881, when pogroms broke out throughout Russia, he realised the seriousness of the plight of Jews in Europe. It was a life-changing

"D'YOU THINK THERE'LL EVER BE PEACE BETWEEN GEOFFREY ROBINSON AND PETER MANDELSON?"

moment. Abandoning the life of scholarship, he became a farmer and pioneer, building the first house in a settlement which was to become the sixth largest city in Israel.

He believed, as did most of his contemporaries, that this was an effort from which all the inhabitants of the region would gain. He was not wrong, but in 1894 the village was attacked and he narrowly escaped with his life. He decided that it was no longer safe for him to stay there, which is why he came to, and I was born in, England. That was one of the first signs of the conflict that has riven the land for more than a century. It was tragic then. It is tragic now.

The Hebrew language has two words for strength. One is *koach*, the other *gevurah*. *Koach* is the ability to overcome an enemy. *Gevurah* is the ability to overcome oneself, to control the desire for victory and practise self-restraint. You need one kind of courage to win a war, but you need another to make peace. Peace is hard because it means letting go of emotions that lie close to our sense of identity itself. To make peace, Jews and Arabs must both let go of deeply rooted feelings of vulnerability and pain. That is hard, but there is no other way.

The Jews of Israel seek security. The Palestinians want dignity, the space to build a land of their own. Those are not incompatible objectives. They can be reached by negotiation. They cannot be achieved by violence on either side. If I defeat you, you lose. But I also lose, because by diminishing you I diminish myself. If, though, we can forgive one another for the pain we have caused each other, there is a chance of reconciliation and, eventually, co-operation.

The imperatives now are moderation, an end to violence, and a principled rejection of despair. Jews and Palestinians have suffered for too long. Abraham's words still summon us to a future of peace.

The author is the Chief Rabbi

Complete works of Robert Mugabe

MY co-diarist Jack, miffed at being characterised as celebrity-obsessed, has decided to take on an evil despot for a change. Acting on a rumour that Robert Mugabe suffers from a physiological vacuum shared, if folkloric song is to be believed, by one Josef Goebbels, he e-mailed the President of Zimbabwe to inquire. He received the following reply: "Dear Sir, This is to inform you that your message has been forward (sic) to interpol to investigate who you are and why you are addressing our President in the manner you have? (sic) You have become personal and in that case you have committed a crime. Kind regards Xoliswa Sibeko (Ms.) Office of the President" Next week, in part two of Do You Really Know Your Dictator?, Jack will be asking Fidel Castro to confirm or deny rumours that his beard is false, and was purchased at Angels and Bermans in the 1950s.

Giles Coren

Father and son

I THOUGHT this would be a good day to introduce readers, over their boiled eggs and digestion-improving bran and prune crunch bars, to Captain Nepo, who will be patrolling the media in search of nepotists for me in the coming weeks. The first victim of Captain Nepo's investigations is … me. And, for impartiality's sake, I must finger myself with the same vigour as I will apply to other media brats living off their surnames in the future. In a small Manchester local blatt called *The Guardian*, Captain Nepo spotted this: "Giles Coren only got the job because of his famous father, Bernard Levin." The fools. Everyone knows my father is William Rees-Mogg.

Giles Coren

Apathy holds the whip hand in cow country, as cowboys Hannah Warren and Dusty Dowell have lunch in Aunt Bea's, the only café in Tryon, Nebraska

kate muir
that woman

THE reality-TV marathon continues, with just over three weeks until the victor emerges in the ratings war. We've had *Oprah*, the late-night comedy shows, the televised conventions and debates, yet most viewers (formerly voters) still can't decide between Gush and Bore, or name an issue on which the two WASPs materially disagree.

The official presidential debates are supposed to showcase democracy at its best, but induce a drifting ennui in the swing couch potato, which I find is unassuaged by snacking on man-sized bags of Cool Ranch Doritos and Cheet-os during the broadcast. The boredom is heightened the morning after by headlines like: "Debate Changes Little – Both Sides Agree Flaws Emerged". Would you read that story or burn it?

Some argue, significantly, that: "The biggest difference between Gore and Bush in the debate can be reduced to their choices in punctuation." School-debaterly Gore punches out his colons: while Bush trails lazily away in half-hearted half-sentences unending in an ellipsis …

So if we're down to the wire, let's get really superficial. Who has the best make-up? Yes, while the political strategists talked of the candidates providing a solid foundation on the issues, the American Nation talked foundation, period. After the first debate, we squealed: "Omigosh, Gore's got too much blusher on. He looks like Ronald Reagan! And that foundation! It's so thick it's gonna crack." In contrast, the American People felt that Bush –who'd gone for a lighter application – looked "ashen".

Both candidates arrived with opposing make-up artists, but only the *San Francisco Examiner* tackled Gore's heavy penchant for pancake: "If you stuck him in a push-up bra and a sequin dress and had him sing show tunes, he'd have carried San Francisco in a landslide," it suggested.

There is talk, which we cannot confirm without the use of one of those little dental mirrors, that Gore had his lower teeth straightened this summer, his troubling "dark and uneven" chom-

pers made dazzling white. With look-ism rampant here, one can only feel pride in the British nation's fondness for William Hague.

Gore's obsession with appearance has caused a flurry of attempts at cosmetic product placement, the latest being from the marketeers of GLH9 "Spray-on Hair". You see the aerosol advertised in men's magazines, for fuzzing up that little bald patch at the back. "Gore's the perfect candidate – for the product," said the "Spray-on" PR, and offered to donate some to the campaign.

Taking a tip from the fashionistas at the autumn runway shows, Gore also carries a little spritzer of foundation about his person, and sprays himself man-tan matt for the cameras. (What candidates fear most is repeating Nixon's famous sweat-beaded, shifty-eyed debate performance.) But from foundation, Gore went straight down the rocky road to rouge, and it cannot be long before the Vice-President flirts with the idea of an eyelash curler. His make-up bill must rival that of Ivana Trump, a sign of severe political paranoia, because it turns out Gore has perfect skin.

"Not just great skin, but beautiful skin. Blemish-free and tanned," said Debra MacKinnon of Demiche Make-up Studio in Massachusetts. She charged the Gore campaign $700, including six hours' travel, for 15 minutes applying foundation "to even out the skin tones", and powder "to kill the shine", so the candidate could appear on children's TV.

I asked Debra what she thought of the recent debate. "Too much contour on his cheekbones. He doesn't need blusher – he's got great bone structure." Debra reckoned Al was spending $100 an hour on his make-up artists before appearances.

Is all this a sign of Gore's attention to detail, or is it merely cosmetic? Ask yourselves this, couch potatoes: Would you trust a man with the red button when he can't even do his own rouge?

Take off the make-up, Tony

THERE WAS a revealing moment on the night Donald Dewar died last week. All the TV news bulletins carried tributes to him from the three major party leaders. Charles Kennedy and William Hague looked perfectly normal, if perhaps a shade pale.

The Prime Minister, by contrast, appeared so heavily made up that he might almost have waltzed straight out of some West End musical. The way in which he seems nowadays to wear pancake make-up for all occasions is, I think, a terrible mistake.

It is not even as if he is, like Richard Nixon, in constant danger of "five o'clock shadow", so why does he do it?

It's true, I believe, that George VI wore make-up in public virtually throughout the war – not because there was television in those days but because he thought that it was good for national morale if he looked healthy and radiant.

Can it be that Mr Blair is influenced by similar patriotic motivation? If so, it may well put him in a refreshingly self-sacrificing light.

But I'd still suggest that, once the holiday tan wears off, he tries a sunray lamp.

Anthony Howard

The new Speaker Michael Martin poses for photographers after a press conference in the House of Commons

global village a weekly posting from cyberspace

SCIENTISTS HAVE discovered the heaviest element known to science. This startling new discovery has been tentatively named Bureaucratium Bm.

This new element has no protons or electrons, thus having an atomic number of 0. It does, however, have 1 neutron, 125 assistant neutrons, 75 vice-neutrons and 111 assistant vice-neutrons, giving it an atomic mass of 312.

These 312 particles are held together by a force called morons, and are surrounded by vast quantities of lepton-like particles called peons.

Since it has no electrons, Bureaucratium is inert. However, it can be detected as it impedes every reaction with which it comes into contact. According to the discoverers, a minute amount of Bureaucratium causes one reaction to take more than four days to complete when it would normally take less than a second.

Bureaucratium has a normal half-life of approximately three years; it does not decay but instead undergoes a reorganisation in which a portion of the assistant neutrons, vice-neutrons, and assistant vice-neutrons exchange places. In fact, a Bureaucratium sample's mass will actually increase over time, since with each reorganisation some of the morons inevitably become neutrons, forming new isotopes.

This characteristic of moron promotion leads some scientists to speculate that bureaucratium is spontaneously formed whenever morons reach a certain quantity in concentration. This hypothetical quantity is referred to as the "Critical Morass".

Do designers hate women?

There is a deeply worrying streak of misogyny in fashion

DO ALL male designers hate women? Having spent the best part of four weeks traipsing through East End warehouses, Milanese trade centres and Parisian galleries in glorious pursuit of their visions, I'm starting to wonder.

There are, of course, exceptions: Paul Smith, Narciso Rodriguez, Matthew Williamson, Michael Kors, Ralph Lauren – the list goes on. But amazingly often, the designers who have us on the edge of our seats, who set the "news" agenda, are a different matter.

It was the obscene lyrics about the female anatomy that opened John Galliano's show for Dior in Paris that finally brought it all out in the open. It wasn't so much the obscenity that grated as the virulently derogatory nature of the remarks. The smart reaction to this song is, I'm sure, a knowing, post-ironic shrug – no one wants to appear prudish or, God forbid, old-fashioned. But since I've never heard any woman in the business speak in those kinds of terms, even privately, I can only assume that I wasn't the only one who found them offensive and puerile.

Lisa Armstrong

It wasn't just lyrics that disturbed last week. You might think that bondage is a theme whose 15 minutes of fame ought to have been exhausted years ago. But no, endless tepid versions littered the catwalk. Almost every house had a go. Even Helmut Lang, erstwhile guardian angel of working women, dabbled. Conversely, Alexander McQueen, a designer whose predilection for making women look ugly/brutalised or brutal and/or robotic has been called into question as much as his genius has been praised, softened up this season – and received some of the best reviews of his career.

Ten years ago, during the reign of the supermodels, it looked as though the tables had been turned and that the power equation had shifted slightly – albeit to a handful of pampered teenagers. But now there aren't any supers – apart from Gisèle, and on her own she does not a movement make. The designers are back in the driving seat, revelling in their power to turn a girl into a star one season and ignore her the next. Woman as the ultimate in throwaway commodities – can't you just see them wishing that the rest of life could be like that?

The frighteningly fast turnover in models nowadays is only one manifestation of a mute aggression towards women in the industry. Stick around observing things for a while and you'll notice the way many male designers, writers and stylists look through a woman over a size 8. You'll see over and over again the predilection that certain (overweight) men have for putting skeletal models in their shows. You'll find it hard not to form the impression that some men in fashion secretly don't see the point of any female who hasn't entirely devoted herself to the altar of style. You'll hear the dismissive, not to say derisive, tones deployed should you be so banal as to raise queries about the

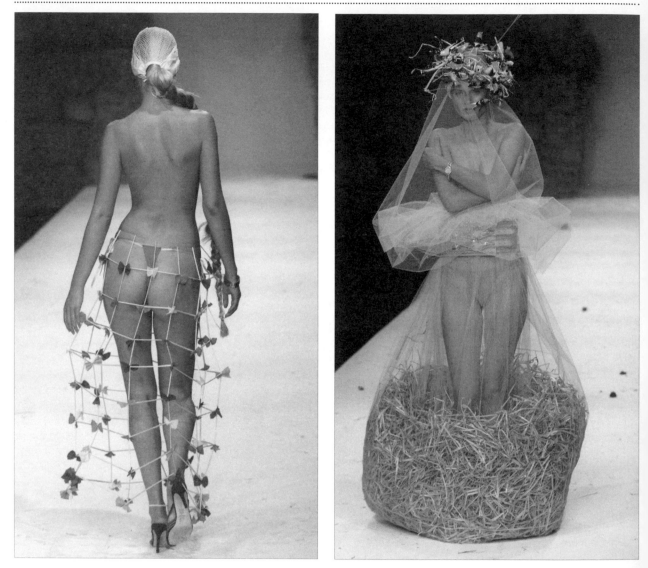

real-life appeal of a collection.

From the various sexual fetishes on parade to the facile rubbish that spewed out on to the catwalks during the past month in the name of creativity, it seemed that designers were out to get women, or at least make them look foolish. One-legged leather chaps, anyone? A caged skirt over bare buttocks? How about half a jacket? Or clothes that are more about a designer indulging his sense of himself as an Artist than actually providing something to wear? Clearly creativity is about pushing boundaries, but why is it always this one?

The really shoddy thing about all this is the hypocrisy. When Tracey Emin shocks, she at least puts her money where her mouth is. There isn't a tamer, more "accessible" version of her unmade bed back in her studio. But designers like to have it both ways; controversy on the catwalk and the money-spinners safely back in the showroom. Half the time they're not remotely interested in dressing "normal" women but in generating publicity for their perfumes and accessories. Even the ones with sizeable ready-to-wear businesses aren't playing it

straight. If they want to get rich, why can't they be honest and admit it instead of shoving a ragbag of half-baked, headline-grabbing, empty-headed "statements" on to the big stage and hiding their commercial bread and butter in a place where journalists, rushing from show to show, will never have time to visit it?

That some of them view conventionally beautiful clothes as boring and not worthy of being publicly seen under their banner speaks volumes about their attitudes towards the women who like those "boring" clothes. But it isn't just

their cynical eagerness to show the absurd and the outrageous that's alarming. It's the cumulative impression that some of them would really rather not deal with the inconvenience of breasts, hips or thighs.

When designers weren't pretending to tie women up, shove their breasts into ill-fitting conical bras as if they were blobs of jelly waiting to be dished up, or to force teenage models into demeaning G-string competitions, they were wallowing in that old Madonna-whore fantasy. Don't get me wrong – I'm not claiming that women don't want to look sexy, but there is a middle way between the unedifying spectacle of Montana's "Eastern European prostitutes" and those conceptual designers who get so wrapped up in design theory that you sometimes feel they'd be happier showing on a hanger, for all the willingness they show to take on a woman's sexuality.

Of course, female designers can sometimes resort to tacky sensationalism, but not to the same degree. There's a world of difference between the titillation that Donatella Versace serves and some of the harder-core stories her admittedly more creative brother conjured up. As a woman working in fashion, you quickly become immune to a continual low-level drone of misogyny. Designers have always sent out dubious signals. Sometimes, let's face it, women collude – although I hope not with any of the drossier elements we saw over the past few weeks.

Where does this misogyny come from? Do some men go into fashion because they don't like women, or does the antipathy come upon them later? Or is it because creative people often end up destroying the thing they love – in this case beauty?

Whatever, the upshot is the same. During a discussion about the various merits of the four different fashion capitals with a well-known pundit last week, an eyebrow was raised (his) and a nose wrinkled (his again) when I mentioned that at least Milan – in contrast to Paris – had offered clothes women might ultimately want to wear. That wasn't the point, I was told. Which is odd, because I'd always been inclined to believe the old axiom that fashion isn't actually fashion until somebody decides that they want to wear it.

The irony is that, apart from Donna Karan (a marketing genius) and Rei Kawakubo of Comme des Garçons (a visionary), the designers with the biggest reputations internationally are men. Male designers are often more radical, more controversial, more newsworthy in their clothes – because, bless them, they'll never have to wear them (at least not in public).

And that, in the end, is where the comfort is to be drawn. Because the funny thing is that when I look in my wardrobe – and those of my friends and colleagues – the majority of our clothes are designed by women.

MIND THE GAP...

john diamond

the last word

THE REASON, I imagine, that I allow myself to stay in this state of perpetual denial is that they keep on changing the rules. The first time I had radiotherapy they were perfectly clear that this was a one-time offer: the deal about the treatment was that such is the fragility of the human body and so great the potency of the radiation that you can only have it once. And then when the cancer came back they gave it to me an absolutely last-chance, no-going-back second time. But then what do you know? It turned out that I could be irradiated a third time after all. When I die they won't bury me: I'll be sent off to Sellafield in a sealed flask for reprocessing.

What happened was that they did the bronchoscopy – I mentioned the bronchoscopy, didn't I? – which was the most dreadful thing that's ever been done to me in the history of all the terrible things that have been done to me, and which involved sending sundry cameras, blades and saline solutions into my lung to collect samples of the cancerous tissue which lurks there. I was awake throughout the procedure which involved copious amounts of blood splattering the walls and a deal of heavy-duty coughing, but I have these details only at second-hand from Nigella who I insisted should be with me throughout. They gave me some version of the date-rape drug primarily to sedate me but it turns out to have the side-effect of completely deleting the event from my memory. It's an hour which is just missing from my life, an hour which happened for the four other people in the room with me, but didn't for me.

I'm loath to find some greater philosophical meaning in this phenomenon; after all, all sorts of exciting things are going on in Brisbane and Kyoto while I'm sleeping each night and I've never thought that much of a big deal. But as I noted a few months ago when I had the strange post-operative experience with the vodka and morphine cocktail, there is something rather unsettling about losing an hour during which you were actively awake and engaged in whatever was going on.

Whatever: the result of the bronchoscopy was that it turns out that the cancer in my lung is a direct relation of the cancer in my mouth. This comes as a relief, for some reason I can't quite work out other than that how unlucky would it be if I was sprouting new and unrelated cancers all over my body? The treatment for the new-old cancer is, in the first instance at least, radiotherapy, but while the old radiotherapy involved driving to the hospital five days a week for six weeks to have a 45-second burst of radiation, this version had me lying on the table for a full eight minutes while they gave me a one-off re-creation of ground-zero in Hiroshima but without the flying glass.

Dr Henk said that the only likely reaction would be that I might feel a bit miserable afterwards, which seems to be a euphemism covering everything from clinical depression to a slight grogginess, so I drove home, went to bed for a couple of hours, and then, in Nigella's book-touring absence, took Maria out to get drunk in the most unlikely place we could find, which turned out to be a lap-dancing bar in Hammersmith. No, don't ask. It seemed like a good joke at the time is all I can tell you.

So here's the state of play: the cancer in my head is still around somewhere but in such quantities as to render it invisible until it pops up again, and the cancer in my lung is still there but is not currently life-threatening. One or other of them will get me eventually, I suppose, or possibly a third or fourth as yet undiscovered relative in some as yet unscanned organ. A couple of years back, thinking forward to the time when they'd start chasing the tumours round my body, I assumed that I'd give up when it got to this stage. But I don't want to. I enjoy living, even if it does mean once in a while finding myself in a lap-dancing bar paying six quid a shot for vodka. And pixie-folk recipes aside, I'll carry on doing whatever it takes. It's funny how many people do, isn't it?

"IT'S AN OLYMPIC RECORD – HE HASN'T MOVED FOR THREE WEEKS"

Stormy weather: late October's torrential flooding as experienced at Lower House Farm, Llandrinio, where sheep had to be sheltered indoors, and by awestruck children in Uckfield, East Sussex

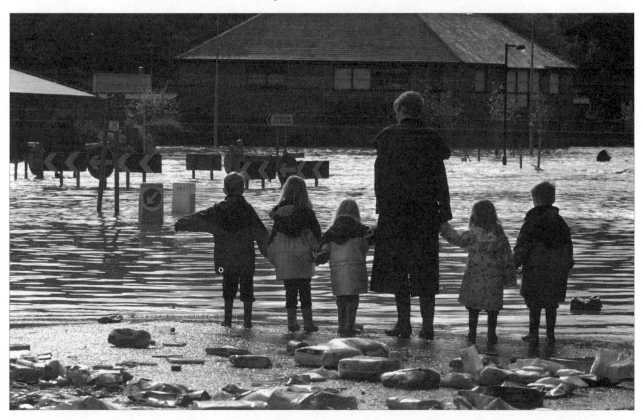

Picture credits

Most of the pictures featured in *The Best of The Times* are the work of *Times* photographers. They are credited below, together with non-*Times* photographers and agencies.

p.9 A bemused Neil Hamilton and his wife Christine enjoying a moment of light relief outside the High Court as they were mobbed by demonstrators dressed as animals: Richard Pohle; **p.10** Marc Aspland; **p.13** Sinead Lynch; **p.14** Sian Frances; **p.21** Simon Walker; **p.29** Richard Cannon; **p.33** In this south-facing view from one of the construction cranes, workers erecting the roof over the new Great Court to the British Museum are dwarfed by the dome of the former British Library Reading Room: Anthony Upton; **p.34** Chris Harris; **p.36** Paul Rogers; **p.37** Denzil McNeelance; **p.40** Chris Harris; **p.48** Eidos and Peter Nicholls; **p.51** Chris Harris; **p.57** Peter Nicholls; **p.61** South American morpho butterflies, which have inspired a video installation by Jean Fabré at the Natual History Museum in London, almost conceal Dick Van Wright, Keeper of Entomology: Roy Riley; **p.62** Richard Pohle; **p.63** Peter Nicholls; **p.63** Suzanne Hubbard; **p.66** Peter Nicholls; **p.68** Anthony Upton; **p.74** Chris Harris; **p.79** Alan Weller; **p.82** Hoddle Roy Riley; **p.85** Two Chechen children eat in a tent in the refugee camp "Sputnik" in Ingushetia near the Chechen-Ingush border: Sergei Grits/AP; **p.101** Suzanne Hubbard; **p.104** Gill Allen; **p.107** Chris Kleponis/AFP; **p.111** Andrew Parsons; **p.113** The future of sex: Roy Shakespeare; **p.117** Peter Nicholls; **p.118** (top, bottom left) Chris Harris ; **p.118** (bottom right) Richard Pohle ; **p.119** (top) Sinead Lynch ; **p.119** (bottom) Paul Rogers; **p.121** Cedric Galbe; **p.125** Peter Nicholls; **p.129** Roy Shakespeare; **p.137** Roy Riley; **p.139** An Ethiopian child suffering malnutrition drinks water in the palm of his mother's hand in Gode: Joel Robine/EPA; **p.140** Richard Cannon; **p.141** Paul Slater; **p.149** Anthony Upton; **p.150** Peter Nicholls; **p.159** Simon Walker; **p.160** Ben Gurr; **p.164** Richard Cannon; **p.167** Anti-capitalist protesters taunt police in Trafalgar Square during May Day demonstration: Anthony Upton; **p.169** Chris Harris; **p.172** Simon Brooke Webb; **p.173** Simon Walker; **p.174** Andrew Parsons; **p.175** Alan Weller; **p.176** Andre Camara; **p.190** Peter Nicholls; **p.191** Andre Camara; **p.193** The Tattooed army march into Belgium for Euro 2000: Peter Nicholls; **p.198** Pat Hannagan; **p.201** Marc Aspland; **p.203** Peter Nicholls; **p.209** Peter Nicholls; **p.210** Simon Walker; **p.213** Simon Brooke Webb; **p.215** Lennox Lewis waits patiently in a neutral corner as Francois Botha tries to struggle to his feet after a right from the champion had put him through the ropes. The contest was stopped after 2min 39sec of the second round: Marc Aspland; **p.216** Marc Aspland; **p.217** Richard Cannon; **p.218** Marc Aspland; **p.219** Gill Allen; **p.225** Richard Pohle; **p.228** Marc Aspland; **p.229** Gill Allen; **p.232** Paul Rogers; **p.237** Simon Brooke Webb; **p.238** "We will not live with pervs". Families protest on the Paulsgrove estate in Portsmouth: Sinead Lynch; **p.243** Pat Hannagan; **p.247** Richard Pohle; **p.251** Sinead Lynch; **p.255** Alan Weller; **p.258** Andre Camara; **p.258** Simon Walker; **p.259** Simon Walker; **p.261** Briton Denise Lewis wins the Olympic Gold in the Heptathlon: Marc Aspland; **p.266** (left) Simon Walker; **p.266** (right) Andrew Parsons; **p.268** Marc Aspland; **p.269** Marc Aspland; **p.270** Marc Aspland; **p.273** Roy Riley; **p.276** Suzanne Hubbard; **p.280** (top) Paul Rogers; **p.280** (bottom) Simon Walker; **p.281** Simon Walker; **p.283** Sinead Lynch; **p.285** Simon Walker; **p.287** Trickery and treat: seven-year-old Dalya Kurer of London practises the art of apple bobbing before Hallowe'en: Richard Cannon; **p.289** Sam Kiley; **p.294** Chris Harris; **p.297** John Angerson; **p.299** Michael Powell; **p.300** Simon Walker; **p.305** Simon Walker; **p.306** Richard Pohle; **p.308** Roy Riley; **p.311** (top) Roy Riley; **p.311** (bottom) Nick Ray